THE RENAISSANCE

EUROPEAN PAINTING 1400-1600

Charles M^cCorquodale

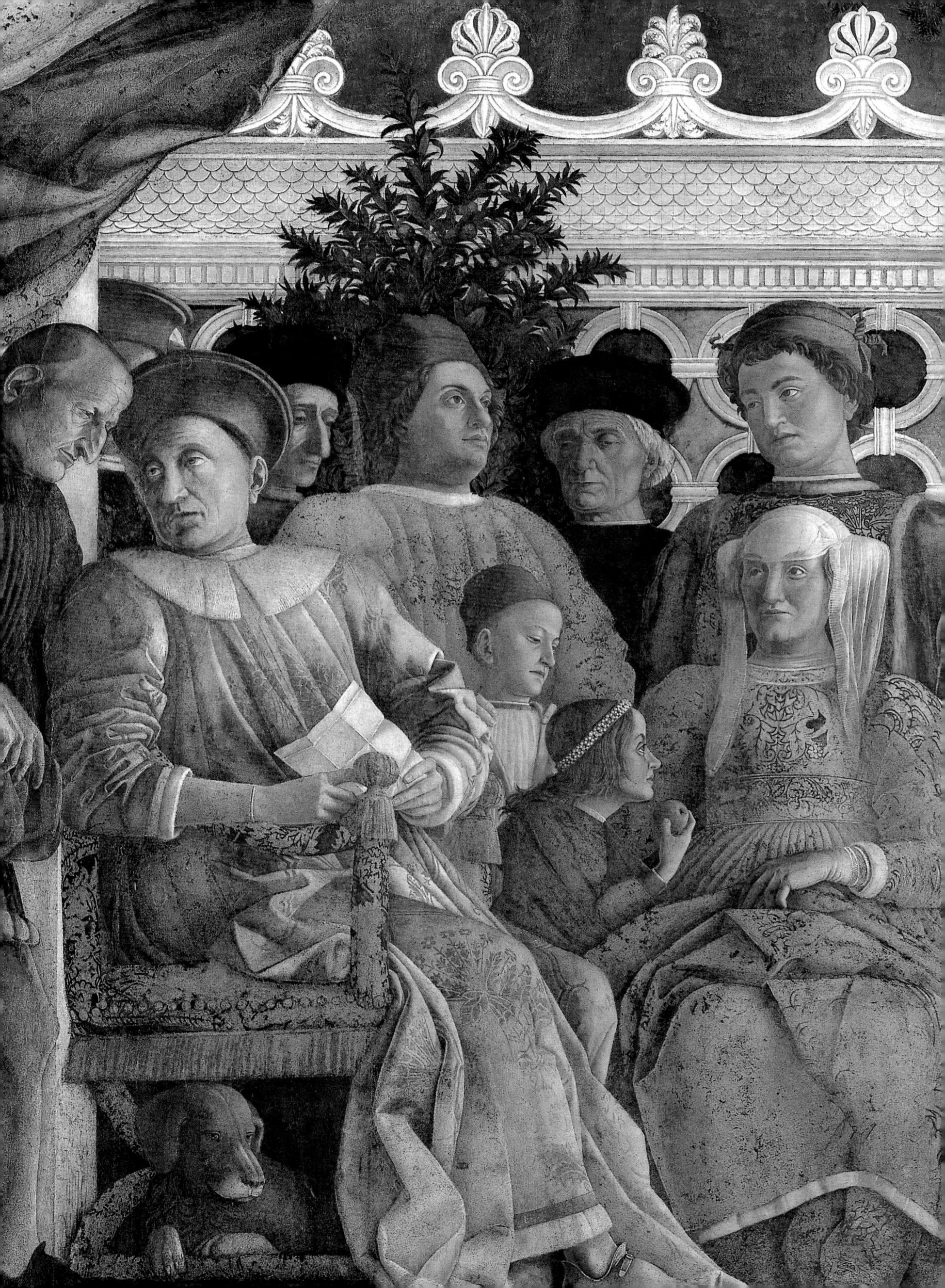

THE RENAISSANCE

EUROPEAN PAINTING 1400-1600

Charles M^cCorquodale

For David and D. and L.

First published in Great Britain in 1994 by Studio Editions Ltd., Princess House, 50 Eastcastle Street, London W1N 7AP.

Copyright © 1994 Studio Editions

The right of Charles McCorquodale to be identified as the author of this work has been asserted by him in accordance with the Copyright, Design and Patents Act, 1988.

All rights reserved. The publication may not be reproduced, stored in a retrieval system, or transmitted, in any form or by any means, electronic, mechanical, photocopying, recording or otherwise, without the prior permission of the publisher.

ISBN 1 85891 892 8

Edited by: Caroline Bugler, Alice Peebles and Robyn Ayers
Editorial Assistant: John Lee
Designed by: Joy FitzSimmons, Simon Bell and Paul Griffin
Picture Researcher: Julia Brown

Frontispiece: Detail showing the Gonzaga family from the *Camera degli Sposi* in the Palazzo Ducale, Mantua, by Andrea Mantegna (see also plate 105).

Facing foreword: Detail from *Madonna of the Rose Bower* by Stephen Lochner (see also plate 156)

Printed and bound by Poligrafici Calderara S.p.A., Bologna, Italy.

Contents

Foreword	7
CHAPTER I The Historical Background to the Renaissance	9
CHAPTER II Painting and Drawing Techniques in the Renaissance	29
CHAPTER III The Rebirth of Painting in Italy and the Prelude to the Renaissance 1250–1400	51
CHAPTER IV Fifteenth-Century Italian Painting	73
CHAPTER V Fifteenth-Century Painting in the Netherlands	125
CHAPTER VI The Renaissance Elsewhere in Europe	159
CHAPTER VII The High Renaissance in Italy	189
CHAPTER VIII The Later Renaissance and Mannerism in Italy	223
CHAPTER IX Painting in Germany and the Netherlands in the Sixteenth Century	259
CHAPTER X The End of Mannerism and the Dawn of the Baroque	289
Bibliography	296
Picture Acknowledgements	298
Index	304

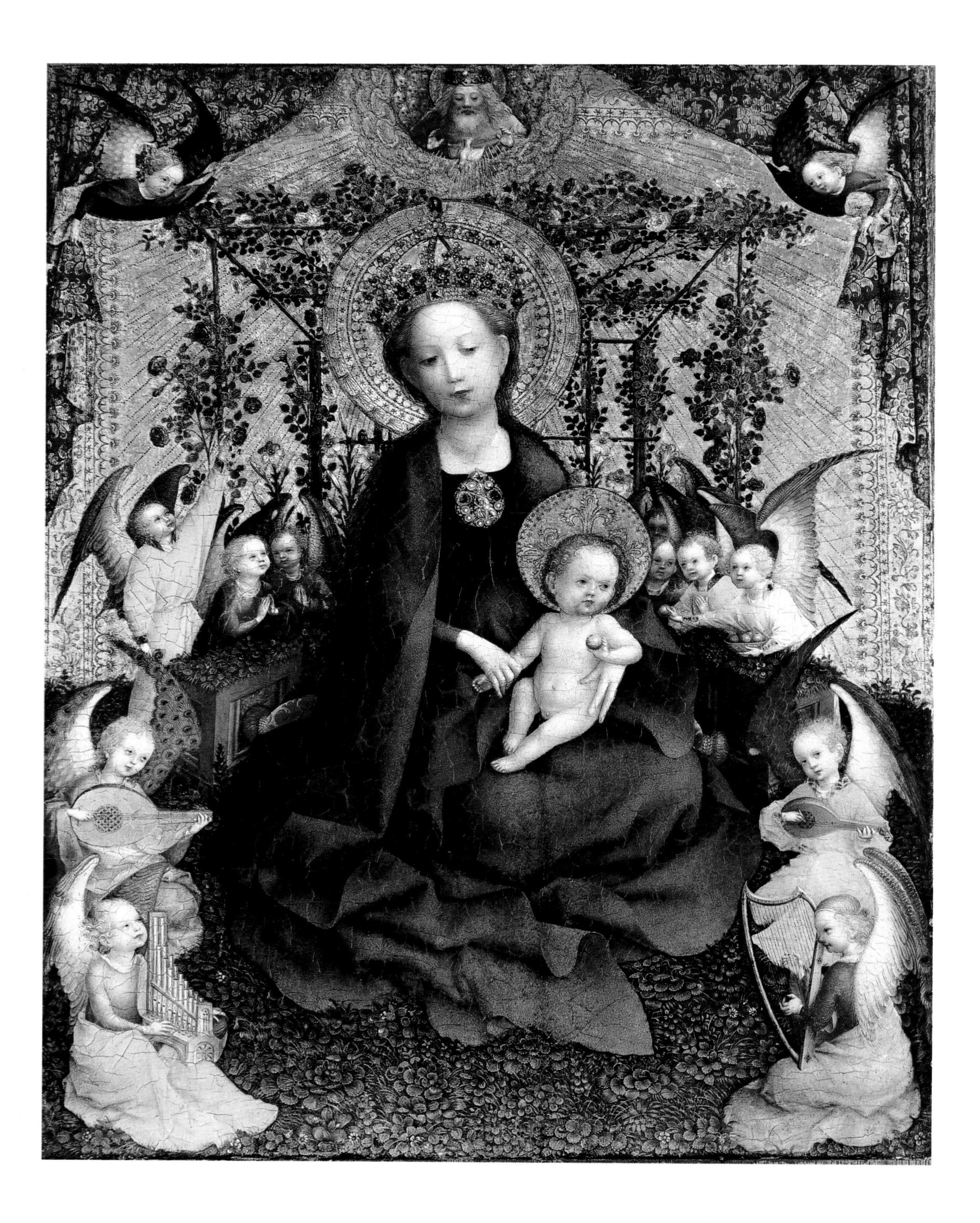

Foreword

When I was asked to write this book, my reaction was one of disbelief that a market already flooded with books on every aspect of Renaissance art could sustain yet another. I quickly realized, however, that there was no single large-scale survey of Renaissance painting across Europe, from which to obtain a wide and comprehensive view. I hope this book will fill that gap. It is intended to make comparisons between the aims, ideals and styles of the Renaissance as they evolved in the different regions of Europe.

For a book of this kind to achieve its purpose, the selection of paintings to be illustrated should be as comprehensive and balanced as possible. This presents two problems. Those who already know something of Renaissance art will expect to see many important, well-known pictures, despite the frequency with which these are reproduced elsewhere. On the other hand, the beginner's lack of preconceived ideas allows for a greater flexibility in the picture selection. I have tried to satisfy both kinds of reader, including many of the best-known paintings alongside a range of less familiar ones. Some have been selected for their art historical importance, some for the light they shed on an artist's range, and others, unashamedly, for their beauty.

This book is the result of the compilation of material from an enormous variety of sources, and its creation has been largely a solitary process. I would, however, like to record my deep gratitude to my editor, Caroline Bugler, whose infinite skill, patience and tact have been of inestimable importance in weaving together the many complicated strands of text, captions and illustrations. The same goes for the expertise and persistence of my picture editor Julia Brown in assembling illustrations from a bewildering range of sources: her informed taste was invaluable in the painful process of final selection. Without their combined professional aptitude and continuous support the book would never have reached completion. I should also like to record my gratitude to the staff of the Courtauld Institute and Witt Libraries for their help with last minute problems, and to the staff of the Villa I Tatti and the Kunsthistorisches Institut in Florence, who have sustained my love of Renaissance painting over many years.

Charles McCorquodale

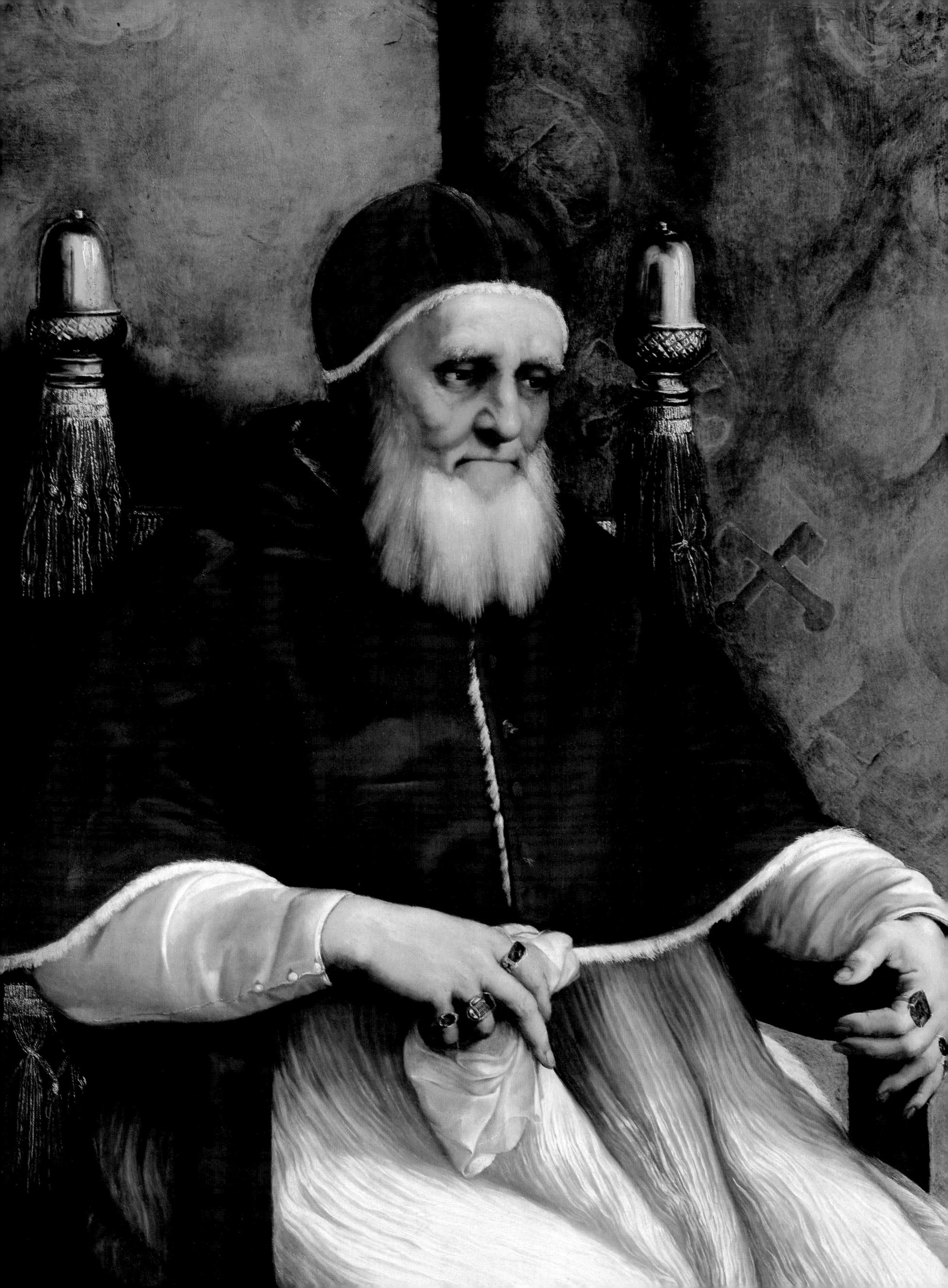

CHAPTER I

The Historical Background to the Renaissance

This book deals with the art of more than two centuries over a wide geographical area, extending from Sicily to Spain, from Edinburgh to Antwerp and Brussels to Vienna and Prague. During the period, the map of power in Europe underwent almost continuous change, and the national boundaries we know today had little relevance. Present-day Germany and Italy then consisted of city-states, duchies and principalities, often with allegiance to a larger power, most notably the Holy Roman Empire.

The empire dated from the coronation of Charlemagne in 800, but the term 'Holy Roman Empire' was first applied only in the mid-thirteenth century. At various times, much of Italy fell under German domination, a fact always at the back of the Holy Roman Emperors' minds in their manipulation of Italian politics. The ideal for the Emperors of the fifteenth and sixteenth centuries would have been to rule the whole of Europe from Germany, and this was virtually attained by Charles V, who reigned from 1519 to 1556. The highest international attainment of any artist in the Renaissance was to work for the reigning Emperor – a patron equalled only by the Papacy.

Imperial power mirrored, on a larger scale, the political aspirations of many great families. This was particularly evident in France and Italy, where dynasties such as the Valois and Medici manipulated local and international affairs for their own gain. It was to their advantage to

I RAPHAEL Pope Julius II c.1512

Raphael, like Titian, painted many of the foremost personalities of his day, among them Pope Julius II of the Della Rovere family. Julius initiated the tradition of Papal patronage which continued into the Baroque age, and left Rome its incomparable legacy of ecclesiastical architecture and painting. This is one of the most perceptive portraits of the Italian Renaissance, at the same time grandiose and informal, respectful but offering compassionate insight.

maintain friendly relations with the Emperor, who could give military support, as well as grants of lands and titles. Such power could, however, prove double-edged, as when Imperial troops sacked Rome in 1527.

It is easy, in front of most Renaissance painting, to forget the disasters such as war and outbreaks of plague and famine, that recurred throughout the Renaissance period. During the fourteenth century, social unrest at every level had ravaged Europe, from peasant uprisings to the activities of an aspirant bourgeoisie. In addition various terrifying forms of the Black Death spread rapidly through Europe from late 1347, and almost one third of the population of Western Europe died, with catastrophic social effects. The poet Boccaccio, in the preface of his Decameron (c.1350), describes the full horror of the plague, and underlines its social nature, since his upper-class dramatis personae escaped from the deadly cities to the country. During the last years of the fourteenth century the whole of Europe was in crisis, with particular unrest in France and Italy. The 'revolt of the Ciompi' or daylabourers in Florence in 1378 furthered Florence's move to an oligarchy first under the Albizzi, then the Medici. In 1380, there were revolts in Bruges and Ghent and the following year there was massive unrest in southern England. In retrospect, however, these disastrous events scarcely seem to have diminished the remarkable flourishing of court life with its attendant benefits for the arts.

One of the most dramatic changes that occurred during the Renaissance was the radical improvement in the status of the artist. This was due to the growth of wealth, to a decreased dependence on ecclesiastical patronage and to the spread of humanistic ideas. This process originated in Italy. Although Giotto achieved high social status, it was not until the last years of the fifteenth century that artists such as Leonardo and Raphael began to be welcomed not as useful craftsmen but as courtiers.

As in the medieval era, art was the greatest luxury available to the rich, and Renaissance princes indulged to the full. Throughout Europe, they surrounded themselves with the finest architects, sculptors, painters and craftsmen money could buy, and if native talent was thin on the ground, they imported artists – mainly from Italy. This practice occurred with greater frequency during the sixteenth century. For example, Titian worked for the Emperor Charles V, Holbein moved to London and a group of Italian artists was established at Fontainebleau. Many works of art served as diplomatic gifts, and the exchange of portraits between intended spouses ensured work for portraitists in addition to their normal activities.

2 Agnolo Bronzino Duke Cosimo I de' Medici in Armour c. 1545

This shows the young Duke of Florence virtually in the form of an icon, and is one of the most striking examples of International Mannerist court portraiture. One of the longest ruling dictators of the Renaissance, Cosimo united Tuscany, maintained excellent international relations with Emperor Charles V and established the type of virtual state monopoly of the arts that was later to culminate in the patronage of Louis XIV of France. The portrait's distant, inhuman coldness appears to have been regarded by Cosimo as the perfect representation for his rigid regime.

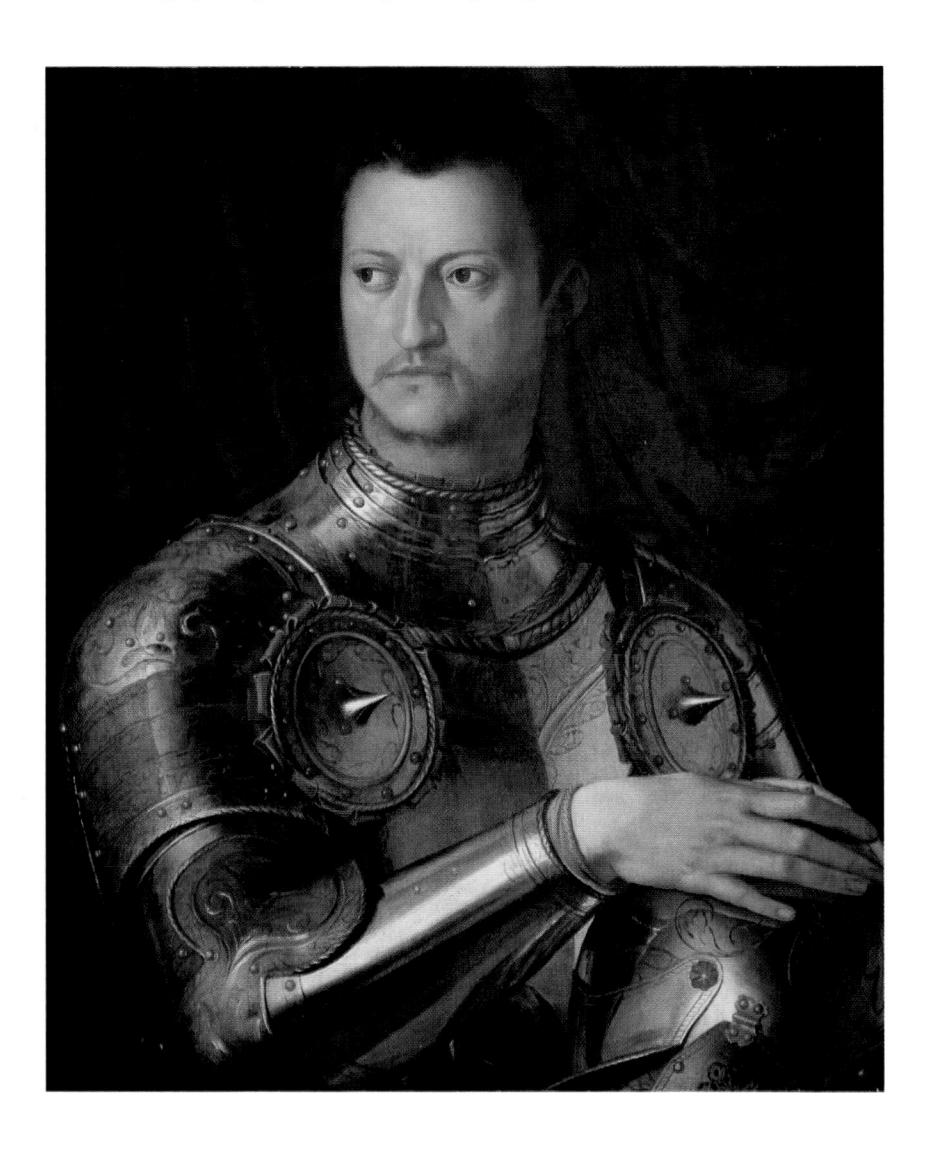

Italy

'Italy', said the nineteenth-century Austrian chancellor Klemens Metternich, 'is a geographical expression'. In dismissing the idea of an Italian nation he was correct; since the Middle Ages Italy had been made up of disparate city-states, which proved both a weakness and a strength, but was particularly beneficial in cultural terms. The diversity of the Italian regions accounts in part for the richness of its culture. At no time was this more true than during the Renaissance.

Because Florence appears in retrospect to have been the most significant artistic centre during the fifteenth and sixteenth centuries, it is easy to lose sight of the effect of political events elsewhere in Italy. Northern Italy, because of its proximity to France, Germany and Austria, was subject to constant upheaval, which only Venice resisted. Naples and Sicily were first under Aragonese then Habsburg rule, both of which had an important effect on their cultures. The ambitions of the Papacy resulted in the changing borders of its states: and within Tuscany itself, cities such as Siena and Lucca were gradually absorbed into the Medici super-state of Tuscany, led by the first Grand Duke of Tuscany, Cosimo I (see plate 2), with the help of the Holy Roman Emperor.

The reasons for Florence's primacy in the development of fifteenth-century Italian culture are complex. During the thirteenth and fourteenth centuries, the Florentines established a major European trading position, resulting in economic expansion. Florence was therefore ripe for development, and this openness was fundamental to the city's acceptance of new intellectual and cultural phenomena. The city's continuous objective assessment of Papal power and the ecclesiastical establishment was also important. This already existed in the mid-1370s when Florence was engaged in open warfare with the Papacy; mistrust continued sporadically into the later period of the Medici Grand Dukes.

Scepticism about ecclesiastical matters was inherent in the Florentine temperament, a fact signalled as early as the eleventh century by Giovanni Gualberto's concern with reforms. Florence's major churches (except the Cathedral) were all reform churches, whose independence from Papal jurisdiction was a distinctive feature of Florentine life. The Franciscan legacy from the early thirteenth century, of many large, impressive churches (with their fresco cycles and altarpieces) and other buildings in Florence, Pisa, Lucca, Arezzo, Siena and Assisi, was very important in the development and spread of painting.

Florence's wealth was based on trade in articles manufactured there from imported wool and silk. This was one

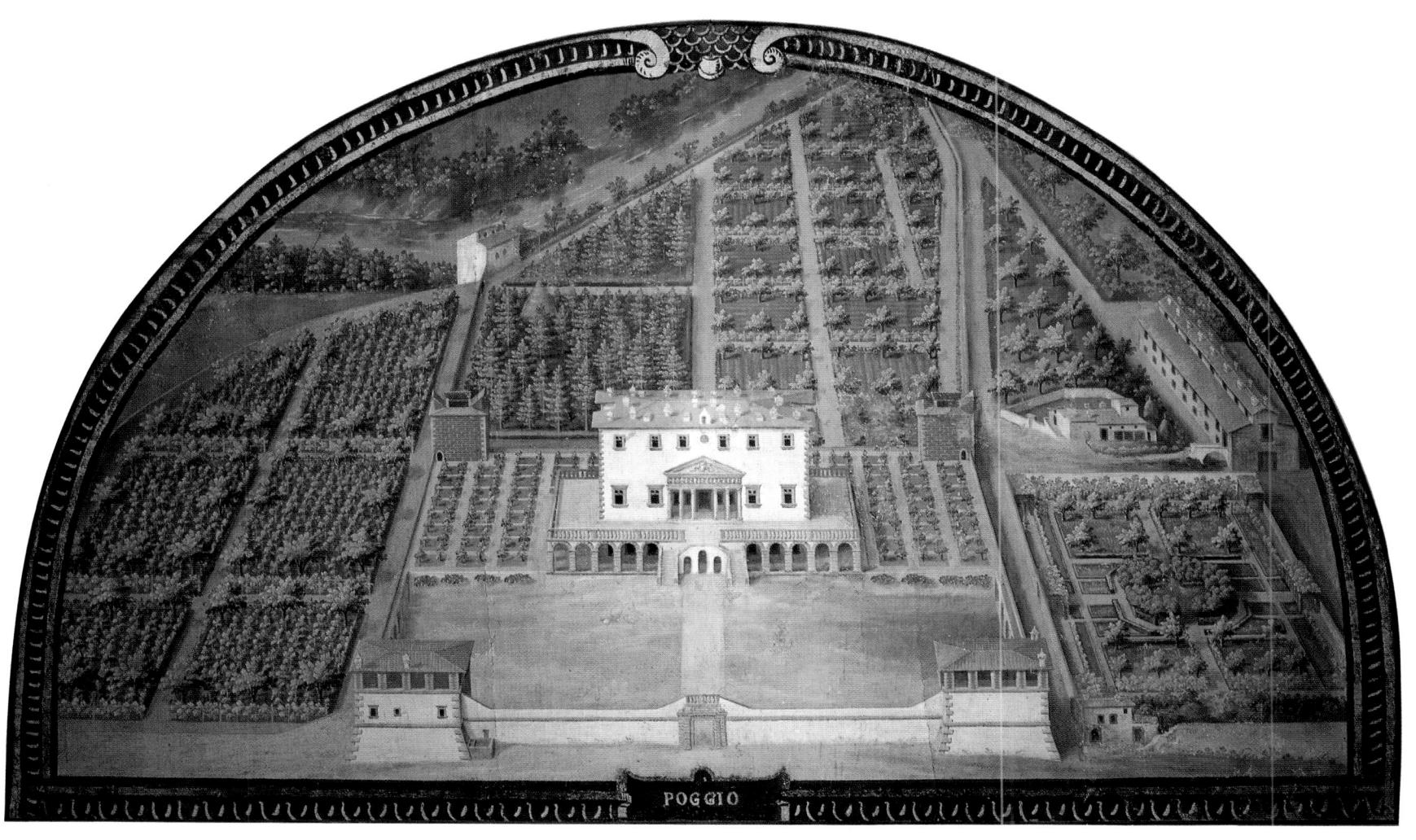

3 Justus van Utens The Villa Medici at Poggio a Caiano after 1598

Lorenzo the Magnificent bought the villa near Florence around 1480 and commissioned its reconstruction on a H-plan in the Tuscan Renaissance style from Giuliano da Sangallo in the 1480s. The villa, which was conceived as the setting for the ideal humanistic country life, became the protoype for the increasing numbers of country houses and gardens in the later Quattrocento and Cinquecento, culminating in the Veneto villas of Andrea Palladio. It remained a favourite Medici residence, and its splendid salone houses major frescoes by Andrea del Sarto, Franciabigio, Pontormo and Alessandro Allori. This is one of a group of fresco lunettes which Utens painted for the nearby villa of Artimino.

of the main reasons for its contact with the Netherlands, which had important artistic repercussions for both areas. To create independence in financial dealings, the city rapidly established its own sophisticated financial system. Florentine banks had branches as far afield as London, Paris, Bruges and Jerusalem. The basis of the currency, which the Florentines coined themselves, became the *fiorino*, which at certain moments was the principal European currency of its day. On this wealth the conspicuous and lasting visual achievements of the Florentine Renaissance were built.

At the turn of the fourteenth century, many new families came to prominence through their financial prowess.

They began to replace the old feudal aristocracy, and one family slowly gained pre-eminence: the Medici. Their political and financial star waxed first with Giovanni di Bicci (1360–1429), whose son, Cosimo, *Pater Patriae* (father of the fatherland), became Florence's first citizen in 1434 on his return from exile. Cosimo's many skills were overshadowed by his genius as a financier, aided by his family bank's international connections. He was, however, the first of his line to have an extensive and active involvement in the intellectual and artistic life of his day. He launched the scholar Marsilio Ficino, employed the architect Michelozzo and the sculptor Donatello, and founded the great libraries of San Marco, the Badia Fiesolana and the Laurenziana.

This balance between the man of commerce and the statesmen created the prototype for all the later Medici, and made the name synonymous with unstinting and discriminating art patronage. At least among the family's earliest members, it distinguished them clearly from grander patrons, who were not involved with commerce. This stigma never really left the Medici, in spite of their later aspirations and rise to become Grand Dukes.

It was Cosimo's grandson Lorenzo (1449–92) called *il magnifico* ('the Magnificent' a courtesy title), who fulfilled the family's artistic ambitions in the fifteenth century. He succeeded Piero de' Medici in 1469, and was one of the major catalysts in European civilization. The period of his

dominance saw the flowering of the Renaissance with the great age of Tuscan fresco decoration, the art of Botticelli, Filippino Lippi, Ghirlandaio, Verrocchio and the young Leonardo da Vinci and Michelangelo. Lorenzo's private taste tended more to the collecting of precious objects: cameos, gems, precious stones and gold or silver vessels set with jewels, a fashion which lasted until the end of the Medici dynasty and forms the core of the great collections still in Florence today.

Indicative of his love of country life was one of Tuscany's most serene villas at Poggio a Caiano (see plate 3), which Lorenzo commissioned from Giuliano da Sangallo. This was the setting for major works by the Della Robbias, and later, Del Sarto, Pontormo and Alessandro Allori. *Villeggiatura*, or the summer escape to a country estate, became increasingly popular with the rich in this period, resulting in the creation of the great Renaissance and Baroque villas and gardens. The effect in painting of this liberation from the dominance of urban life, which had been characteristic of the Middle Ages, may be seen throughout the fifteenth century, culminating in Botticelli's *Primavera* (see plate 115).

Lorenzo was a gifted poet, and surrounded himself with philosophers and poets: Marsilio Ficino (1432–9), Pico della Mirandola (1469–1533), Luigi Pulci (1432–84) and Angelo Poliziano (1454–94). Ficino was the most important in founding Renaissance Neoplatonism, and the intellectuals around Lorenzo played a crucial part in his and the period's approach to visual arts. Such men as these mastered the ideals of humanism, which set man, not God at the centre of the world, and escalated individualism and the full development of human potential. From this arose the passion for the ancient liberal arts: rhetoric, poetry painting, sculpture, architecture and music.

Lorenzo was the last of the Medici to enjoy a period of relative peace, and this is often reflected in subsequent nostalgia for his 'golden age'. The hedonistic aspects of Lorenzo's world, however, drew bitter attacks from the Dominican friar, Girolamo Savonarola (1452–98). His moral crusade against contemporary degeneracy briefly diverted Florentine attention from the pursuit of luxury, and had a strong impact on the visual arts. After Lorenzo's death, Florence was in turmoil, terrified by Savonarola's preaching, and on the brink of civil war. Lorenzo's heirs were expelled, and Savonarola, who had been excommunicated by the Pope, gained support from the invading French but was finally condemned to death (see plate 4). After periods of exile, the Medici made their definitive return with Alessandro in 1530 and then Cosimo I (1519-74) (later first Grand Duke of Tuscany), who was the last of the great Florentine Renaissance patrons (see

plate 2). The importance of the two Medici popes, Leo X and Clement XII, in their family's fortunes as in the arts was also considerable.

While the Medici dominate the Italian scene throughout the Renaissance, the importance of several other families cannot be underestimated. Intermarriage between members established strong links between the courts, which were often consolidated by artists and scholars working for related patrons in different cities. The Italian aristocracy set the standard for Europe in their lavish patronage of the arts, and their involvement in every aspect of court life.

Aided by Cosimo de' Medici the Sforza dynasty came to prominence through Francesco, Duke of Milan from 1450 to 1466. He was a prime example of an adventurer-condottiere rising to the position of a respected prince. His second son, Lodovico 'il Moro' (1451–1508), described by Burckhardt as 'the perfect type of despot' was a considerable patron of all the arts, including music and theatre. Much admired by Baldassare Castiglione, author of the Book of the Courtier (see plate 12), he was wily enough to marry his niece Bianca to his protector, the Emperor Maximilian. It was during Lodovico's region that Leonardo painted the Last Supper (see plate 41) and Bramante began his ascendancy in architecture before moving to Rome.

Castiglione's inspiration for the book came from his intimate knowledge of the refined court life of Urbino in the early sixteenth century. Urbino's ruling family, the Montefeltro, had enjoyed particular cultural prominence under Duke Federico (1444–82) and his Sforza wife, Battista (see plates 101 and 102). Their beautiful hilltop palace, designed by the architect Luciano Laurana, was also the setting for the artistic activities of Piero della Francesca, Melozzo da Forlì and Francesco di Giorgio Martini (1439–1502), and it had a formative influence on the youthful Raphael.

The Gonzaga dynasty of Mantua was one of the grandest of the Renaissance, and among the most important patrons of the arts (see plate 105). The family had ruled Mantua since 1328, were raised to the title of marquess by Imperial concession, and made dukes in 1530. The most notable family member was Lodovico (1412–78), one of the finest Renaissance ruler-statesmen, who ruled from 1444. He had an informed interest in art and architecture, and invited Mantegna and Leon Battista Alberti to Mantua, where he surrounded himself with humanistic scholars. An ally of Duke Francesco Sforza and of the Medici, he sponsored building in the great Florentine church of the Santissima Annunziata, where Alberti experimented with the centralized plan.

The celebrated Isabella d'Este (1474–1539) married Francesco Gonzaga and made the court at Mantua a cultural showplace. In contrast to the Sforzas and many other Italian ruling families, the Este family maintained their power over an exceptionally long period, principally by sound statecraft and by making advantageous marriages in the sixteenth century with noble Italian, French and German families. Established from 1267 as rulers of Ferrara and its hinterland, they extended their power to Modena and Reggio, and Rovigo in the north.

4 UNKNOWN TUSCAN PAINTER The Martyrdom of Savonarola 1498

Seen here is the execution of the Dominican friar Girolamo Savonarola in the Piazza in front of the Palazzo Vecchio (or della Signoria, as it was then). His vitriolic attacks on Medici materialism and abuse of power led to his own downfall and death. The Piazza was later the setting for many important sculptures.

Isabella's brother, Alfonso I (born 1476), was Duke of Ferrara from 1505 to 1534 and his second marriage was to Lucrezia Borgia, daughter of Pope Alexander VI. She did much to civilize the court of Ferrara. Alfonso and his brother, Cardinal Ippolito, both employed Lodovico Ariosto (1474–1533), best-known as the author of the epic poem *Orlando Furioso*. Celebrating the Este family and the particular splendour of their court, this was the inspiration for countless later works of art and music.

Outside these city-states ruled by dynasties lay Venice and the Papal States. Papal power centred in Rome remained largely constant during the fifteenth and sixteenth centuries, and in addition to the large part of Italy in Papal control, a vast bureaucracy maintained its contacts throughout Catholic Europe. The Protestant Reformation and the resultant loss of support particularly from England, came as a great blow. The Papacy rallied its forces with immense vigour during the Counter-Reformation of the mid-sixteenth century, re-affirming

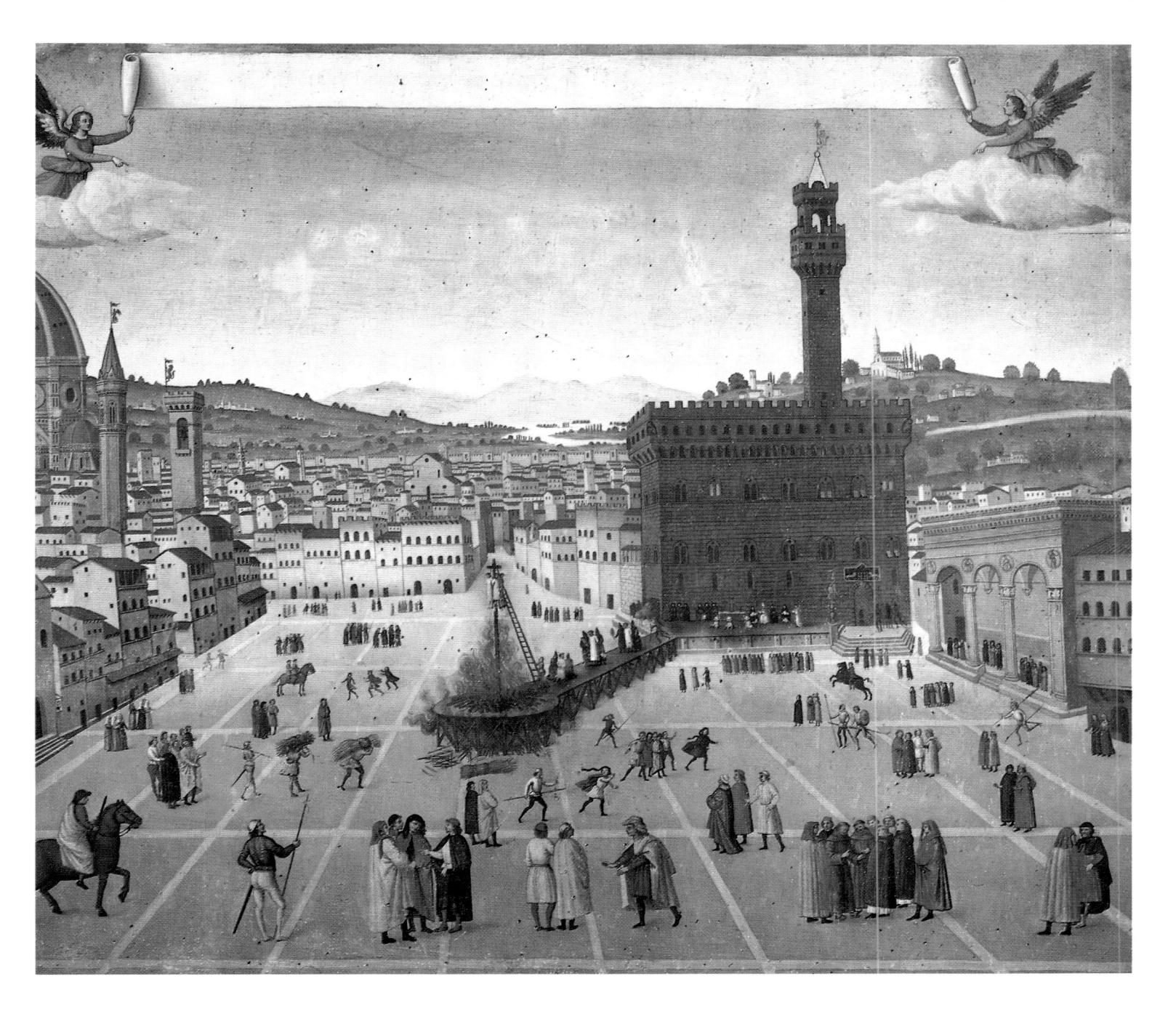

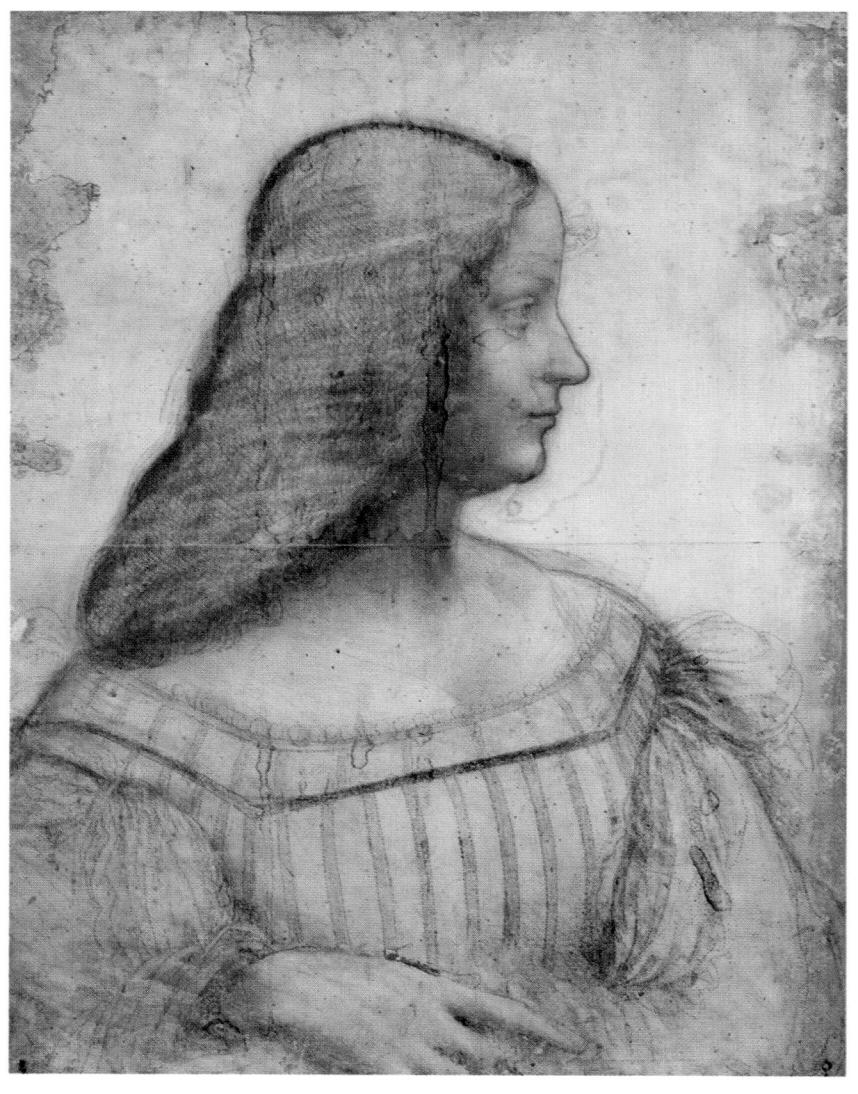

5 LEONARDO DA VINCI Isabella d'Este 1500

Leonardo made a deep impression on Isabella d'Este, who pursued him for commissions. This appears to be a much reworked cartoon for a portrait which, if it was painted, is now lost. Isabella (1474–1539) was among the most cultivated of Renaissance patrons, devoting her attention equally to the visual arts, literature and music in addition to statecraft. The precocious daughter of Ercole I d'Este and Eleonora of Aragon, she married Francesco Gonzaga at the age of sixteen and maintained contacts with many leading intellectuals and artists of her day, the most famous result of which was her studiolo.

its powers on an even larger scale, and profoundly influencing the arts. From the High Renaissance onwards, many Popes would take a direct and personal interest in art and culture.

The habitual scheming of the popes and their ruling contemporaries qualifies them for the epithet 'Machiavellian'. The Florentine Niccolò Machiavelli (1469–1527) was the leading political theorist of his day, as well as a poet and dramatist. His political missions for the Medici to courts in France and Germany and to those of the Popes Julius II and Alexander VI, gave him the material for his famous book, *The Prince*, which was published after his death, in 1532. In it he analyses contemporary statecraft, seeing it as based on ruthless calculation

- hence the transference of his name to the concept of political cunning.

After Florence's artistic dominance during the fifteenth century, a series of events saw a dramatic shift of emphasis to Rome, and by 1520 there were clear reasons for the resurgence in Rome's supremacy. Firstly, it was the seat of the Roman Catholic church, its power recently boosted by two strong Popes: Julius II (1503–13) and Leo X (1513–21). It was soon to muster all its forces in the Counter-Reformation to combat the advancing threat from the Protestant Reformation in northern Europe. Secondly, it was established as the focal point for the study of ancient Roman architecture and archaeology, which

6 Antonio Pisanello Lionello d'Este, 1441–4
Lionello was the illegitimate son of Niccolò d'Este, whom he
succeeded as Marquess of Ferrara. He had a sound Classical
education, and his court was noted for its refinement, exemplified by
Pisanello's medals made for him in 1443 and 1444. Lionello was
deeply involved in alchemy and the occult, and references to both
occur in Pisanello's medals. Much of our knowledge of the cultural
interrelationships between courts and their scholars and artists comes
from the letters of men like Lionello.

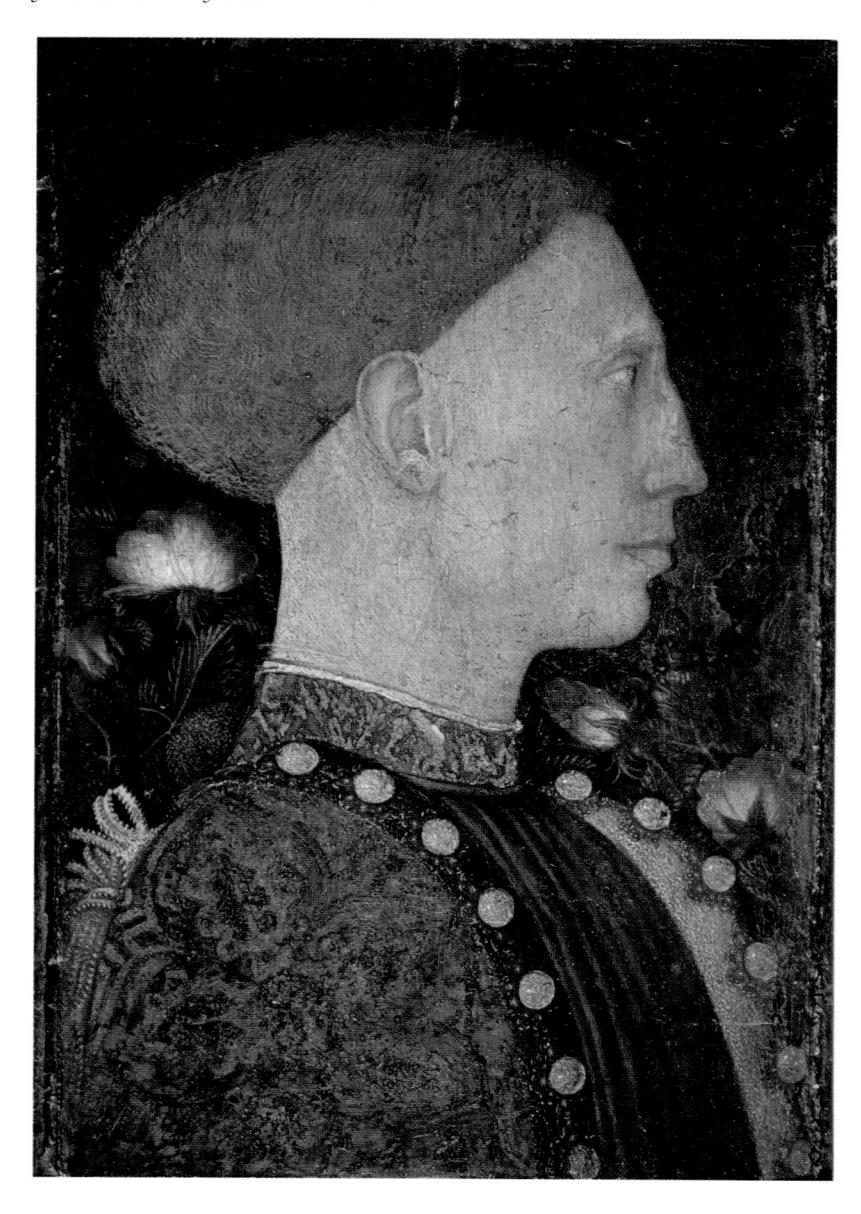

was then still in its infancy in spite of the fifteenth century's accelerated interest in all aspects of the Classical world. Lastly, it was the location of two of the most important and influential works of art in European history: Michelangelo's Sistine vault frescoes and Raphael's frescoes in the Vatican Stanze (see plates 218, 195 and 196).

Venice's position was unique. As 'the most serene Rupublic' she enjoyed internal stability throughout the Renaissance, in spite of external conflicts and the decline of her empire and economy. This provided a continuity in political, social and artistic life unparalleled elsewhere in the peninsula. Until Spain and Portugal's immense overseas expansion, Venice was alone in Europe in having colonies. The mixture of Eastern and Western culture found in Venice was therefore also unique, and accounts for much that seems exotic in Venetian art.

Venice's system of government was the envy of Europe. In 1355 the Doge Falier had attempted to overthrow the Venetian aristocracy in a bid for absolute power. The result was the establishment of the Council of Ten to ensure state security in future. In 1297, the Great Council had been closed by the so-called Serrata to all but members of about 200 patrician families, whose membership was a birthright and lasted for life. Their names were written in the *Libro d'Oro* or *Golden Book*, and this system was seen as the cornerstone of Venetian stability. The Senate was Venice's most significant governing body, and at the head of all these groups was the Doge. His election by a series of elaborate procedures ensured that his decisive role in regulating all the republic's councils could not be perverted into personal gain.

Along with the Doge, whose palace adjoining San Marco remains one of the great repositories of Venetian art, the principal sources of patronage in Venice were the scuole, the churches and a refined nobility. The Venetian scuole have been described as 'miniature commonwealths', and were favourably noted by many visitors from outside Venice. Like confraternities throughout Italy, they were formed for both sexes outside the institutional church, for mutual aid and devotion. They provided social assistance of every kind from medical help to wedding dowries, and adopted a patron saint. A close involvement with the state distinguished those in Venice, and in certain cases, their remarkable patronage of painting. In 1500, Venice had more than two hundred small scuole and five large: the Scuole Grandi. Carpaccio's Life of Saint Ursula from the Scuola di Sant' Orsola which was transferred to the Accademia in 1810 (see plate 80), and Tintoretto's vast cycle in the Scuola di San Rocco constitute only two of the many important commissions from this source. The Florentine confraternities were equivalents of the *scuole*.

Flanders

The history of the area described as Flanders in accounts of fifteenth and sixteenth century art is enormously complex. The territories comprising Flanders continually expanded during the fourteenth century contracting later to become merely a part of the Holy Roman Empire under Charles V.

Fifteenth-century Flanders was perhaps the one European country where most of the population was urban although the same was true to a lesser extent of certain areas of Italy. Flanders' leading city was Bruges, northern Europe's most active port and commercial centre. In 1435 the Treaty of Arras created new prosperity for the southern Netherlands. The court met frequently at Brussels, and Bruges' increasing prosperity attracted artists. Next in importance were Ghent and Ypres, and later, Antwerp and Louvain. French writers of the late Middle Ages tended to describe as 'Flemish' all artists coming from the north-eastern areas of France. This included Jan van Eyck, who was born near Maastricht and the Limbourg brothers from the Duchy of Geldern.

Flanders and most of the Netherlands became the property of the Dukes of Burgundy in 1346. The Burgundian Netherlands included not only the modern area of the Netherlands, but also all of present-day Belgium, much of Northern France and the Grand Duchy of Luxembourg. They had represented an immensely rich area ever since the Middle Ages as centres of industry.

In spite of being members of the Valois dynasty ruling France, the Dukes' policy during the fifteenth century was anti-French. This was partly the reason for the evolution of the so-called Spanish court etiquette which eventually reached Spain through the Habsburg succession, and even spread to Italy. Its rigidity is reflected in court portraiture of the time. The rich Burgundian bourgeoisie aspired to emulate what they saw as Spain's superior ideal of conduct, the legacy of medieval chivalry. The greatest paradox was that the Dukes ruled a people most of whom spoke variations of Dutch and Flemish dialects, or had German as a mother tongue, and whose link was often only their ruler.

The Burgundian court displayed a passion for art, shared by an aspirant and very rich bourgeoisie such as merchants and bankers. Philip the Bold (died 1404) established the tradition of Burgundian court patronage. Fortunes were poured into architecture, paintings, sculpture, tapestries and manuscripts, and music flourished at court and in aristocratic circles. Art could be used as a means of social advancement, and the ruling elite comprised a host of discerning collectors and patrons. These

included Nicolas Rolin (see plate 142), David, Bishop of Utrecht, Anthony of Burgundy and Philip of Cleves.

In addition to collecting art, the court (like most in Europe) also provided major commissions for temporary decorations. These must have occupied many artists, but little evidence of them remains. They were expected at almost any major event such as ducal weddings, state entries to towns and funerals, and included elaborate triumphal arches and street decorations, and *tableaux vivants* which were probably related to contemporary sculpture groups. The most celebrated of such displays were Philip the Good's 'Banquet of the Pheasant' held in Lille in 1454 and the state entry of Charles the Bold and Margaret of York into Bruges in 1468.

During the fifteenth century, the Catholic Church also continued to be a leading patron of the arts, commissioning not only altarpieces large and small, but also a wealth of illuminated pages and initials contained within many different types of book for use in the Mass. Private devotional images increased greatly in importance in the north at this time, and the very rich could afford the services of leading painters. Thus, donors appear on the wings of their altarpieces in adoration of the Virgin or saints, fulfilling both a sacred function, and a secular one in recording their pious magnanimity for posterity. Many such pictures are named after their donors.

The guilds were of great importance in Flemish art and civic life. Part of their work was charitable, ensuring that their members and dependents were cared for in widow-hood or old age. By demanding long periods of apprenticeship, and controlling the quality of all work produced by their members, they ensured very high standards. Through protective legislation, they monitored the quality and amount of imported work from other places.

In about 1430, the 'state' of Burgundy was formed of parts of the principalities making up the boundaries between the kingdom of France and the Holy Roman Empire. The Duchy of Brabant was the leading principality, whose main centres were Brussels and Louvain. Ghent was the central town of the area of Flanders, which was smaller in extent than its modern counterpart. Philip the Good inherited the area by the sheer chance that a very large number of his relatives were childless. By one stroke, he was made the richest Western ruler, richer even than the Holy Roman Emperor himself.

Philip the Good spent much time travelling between the numerous residences which he had inherited in Brussels, Ghent, Arras, Bruges, The Hague and Lille, but Brussels was gradually made the capital of his new 'state'. A court formed itself, with the nobility buying estates in north Brabant, not too distant from Brussels, and establishing town houses or *hôtels* in the city. In order to unify his disparate aristocracy, Philip created an order of chivalry, the Golden Fleece, and a court etiquette for the old nobility, 'national' coinage and assemblies where representatives from the various lands could meet. Thus a Burgundian nobility was formed out of diverse peoples, and through education at the University of Louvain the second generation evolved with a Renaissance not a medieval outlook. This was of enormous importance in the patronage of painting.

Philip was a man of immense energy, and in his devotion to the arts created a golden age like that of Lorenzo the Magnificent in Florence. He built up the most important library of his time and collected, much in the manner of the Medici, paintings, sculpture, plate, tapestries, jewels and manuscripts. He also had a great love of music.

At the beginning of the fifteenth century, the population of many towns, whose autonomy during the Middle Ages had been so important, began to fall. The celebrated textile trades of Bruges, Ypres, Douai, Arras and Rouen all experienced competition from the Italian towns of Florence, Siena, Lucca and Arezzo, notably in the production of luxury goods. The protectionism current in the urban production of lower level textiles led merchants to use smaller towns and rural bases which sometimes caused economic crisis in the older centres.

The wealth necessary for the lavish life at the Burgundian court and among the nobility derived from the sale of woollen cloth of every quality, urban rent-rolls from industrial and commercial tenants and rent-rolls from agricultural tenants. Bruges was the principal port for the entry of foreign goods (for customers as far distant as Germany) and the exit of exports and became enormously rich. Its luxury imports included coveted Italian velvets, silks, damasks and satins. Linen fabric was also important, as were the various productions in metal, especially brass, which were extensively in demand throughout late medieval and Renaissance Europe. Fifteenth-century Burgundy saw the rise in what was to become one of its most celebrated products - tapestry. It was mainly woven in the southern Netherlands at Arras, after which the tapestries and related cloth were named. The best-known sets were commissioned by Philip the Good himself and his son Charles the Rash, who reigned from 1467 to 1477. Tapestry was in demand at courts everywhere, and it was only much later that Netherlandish production was rivalled, for example at Cosimo I's court in Florence.

Killed in battle at Nancy, Charles the Rash left a female heir, his daughter Mary. Louis XI of France seized the opportunity to invade, but although he took Lorraine and

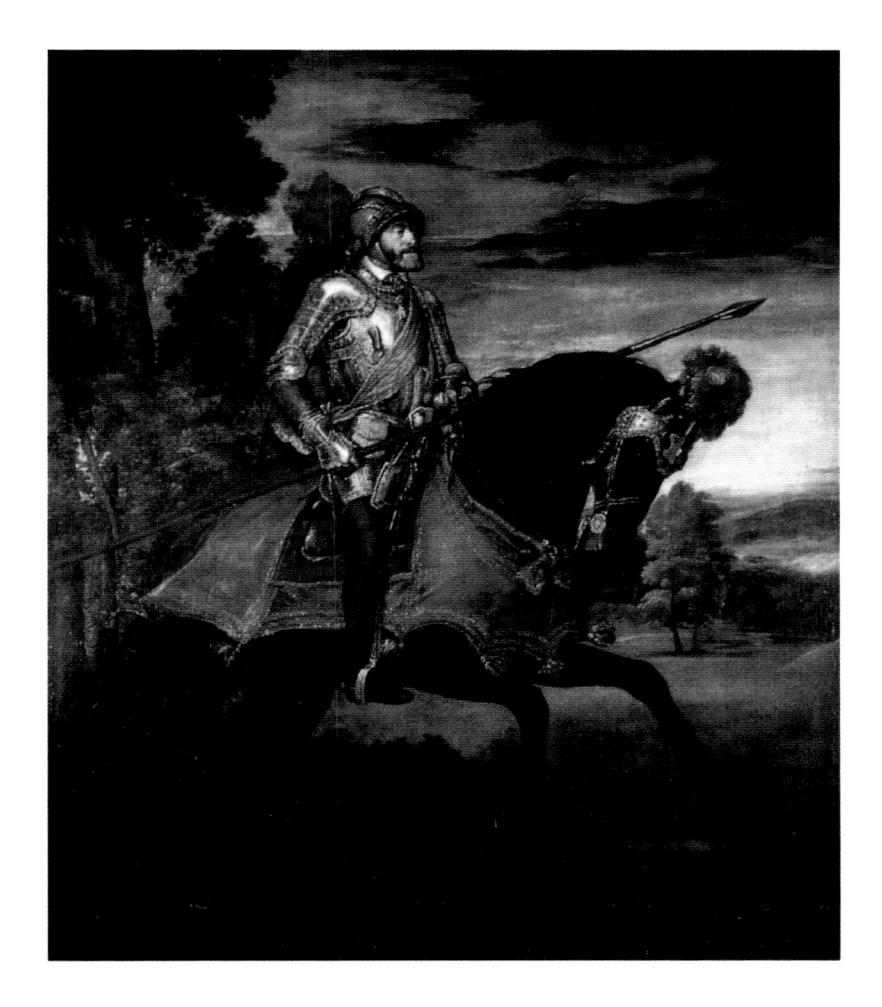

7 Titian Emperor Charles V at Muhlberg 1548
Charles V (1500–58) became ruler of Austria, Germany, the
Netherlands, Naples and Sicily, Spain and her American
possessions. Painted to commemorate the Emperor's victory over the
German Protestants in 1547, this portrait created the prototype for
equestrian state portraits thereafter. As a deeply pious Catholic, this
victory was of immense importance for Charles, who is seen with an
image of the Madonna on his breastplate and the rose-coloured sash
that was the symbol of the Holy Roman Empire, Spain and the
Catholic parties in the religious wars.

Alsace, the Netherlands stood firm in Mary's defence. Louis died in 1483 leaving France with immense debts. Although Mary died at the age of twenty-five, she and her step-mother, Margaret of York, were notable patrons of the arts. Mary had married Maximilian, son of Emperor Frederick III, whom he succeeded in 1508. Ruinous civil war resulted from Maximilian trying to force his claim to the Netherlands. In 1493, however, his son by Mary, Philip the Handsome, managed to obtain power, and was supported by the old Burgundian families.

Maximilian had arranged Philip's marriage to Joanna, the daughter of Ferdinand and Isabella of Aragon and Castile, to ensure an anti-French alliance, and in 1506, on Isabella's death, Philip laid claim to the throne of Castile. After his death, however, his nephew became king of Castile and Aragon, thus ruling Spain and its vastly rich American dominions.

In 1506, Charles also inherited Franche-Comté and much of the Netherlands, and in 1519, the Habsburg lands in Germany and Austria on Maximilian's death, followed by Bohemia and Hungary through the marriages of his brother and sister. His kingdom thus extended from Sicily and Spain to the North sea, bringing with it an immense burden visible in his face and pose in Titian's portraits of him (see plate 7), and expressed in his eventual abdication in 1556.

The map of European power had been redrawn, with a Burgundian court installed in Spain. By the end of Charles's reign however the roles had been reversed and the Netherlands was ruled by a now virtually Spanish monarch. Burgundy, so carefully created from the four-teenth century onwards, no longer had any autonomy and was merely part of a vast empire.

France

While the Renaissance was emerging in Italy, France was intermittently involved in the Hundred Years War (1377–1453) between the partisans of the Valois dynasty and those of the English Kings.

The reign of Charles VII (1422–61) was fundamental in the formation of modern France, although his kingdom at that date consisted only of the central region of the present country. The Duke of Burgundy, Philip the Good, continually encroached on new territory, while north of the Loire was under English rule.

The Peace of Arras in 1435 united Charles VII and the Duke of Burgundy and their troops took Paris from the English the following year. Charles made his solemn regal entry into the city, and gradually the Ile-de-France was reclaimed from the English, who remained mainly in Normandy. By 1453, only Calais remained in English control, and the Hundred Years War was ended, confirming Charles's power over most of present-day France. Charles VII's 'Grand Argentier' and councillor, Jacques Coeur, symbolized the rising newly rich bourgeoisie, and changes in society.

Louis XI (1423–83), who reigned from 1461, married Margaret of Scotland, thus initiating Franco-Scottish relations which were to have a lasting impact on Scottish culture. In 1465, the so-called 'Ligue du Bien Public' was formed, uniting the royal dukes of Burgundy, Bourbon and Berry in an early attempt to control the power of the various aristocratic factions. Louis XI was in advance of his time, and France prospered, attracting foreign trade, opening the English market to French production (in spite of renewed war with England) and trying to set up

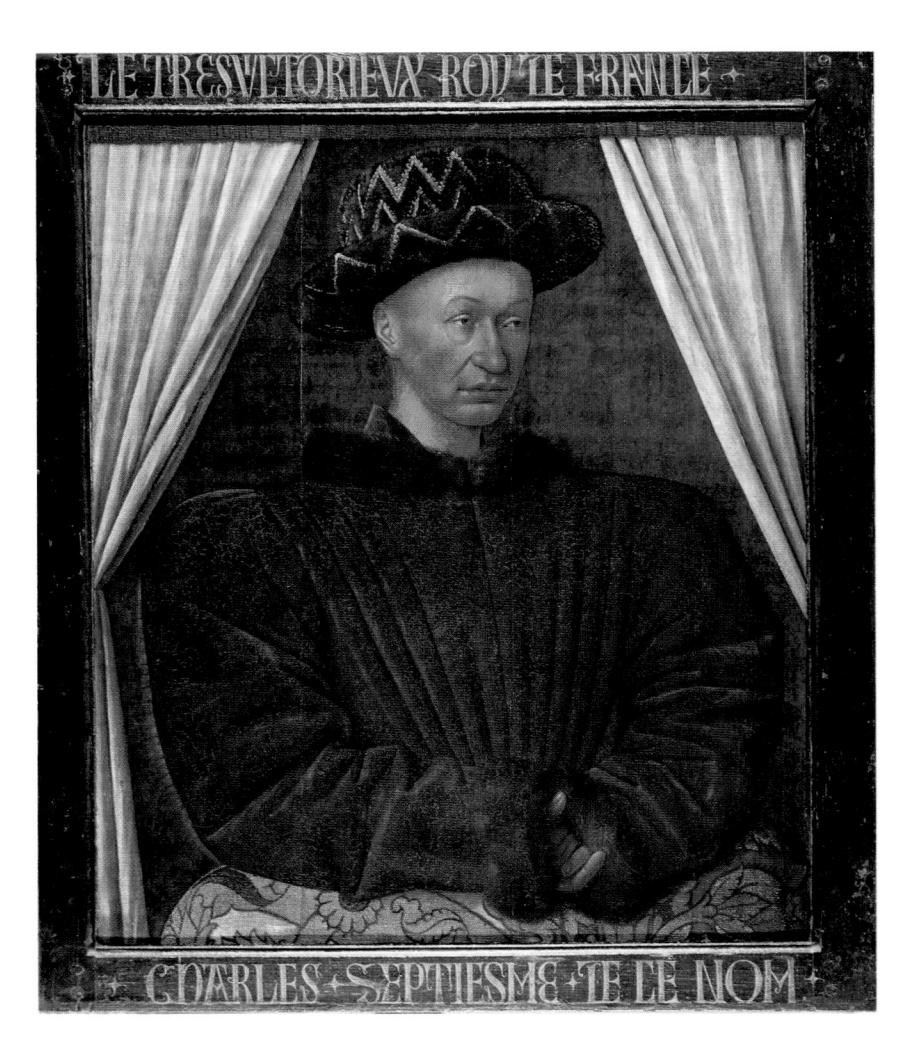

8 JEAN FOUQUET Charles VII c. 1447

This is the first surviving royal portrait by Fouquet. It was painted in 1447 on his return from Rome, where his reputation gained him the commission to paint Pope Eugenius IV and his nephews. It shows the weak and ailing king, whose reign (1422–61) saw the imposition of Valois power on a united France. Although not large in scale, the conception of the figure is grandiose, revealing Fouquet's personal knowledge of Italian Renaissance prototypes: it is thus a significant record of a highly important artistic and historical moment, and among the most striking portraits of its age.

luxury trades, such as the silk industry at Lyon and Tours. One of the most refined painters of the Renaissance, Jean Fouquet, was court painter to both Louis XI and Charles VII (see plate 8). It was only Louis's attempts to take the Netherlands which left French finances depleted at his death.

'His successors Charles VIII and Louis XII engaged in disastrous wars with Italy, whose only value was the introduction to France of the ideas of the Italian Renaissance.

The death of King Ferdinand I of Naples in January 1494 decided Charles to launch his Italian campaign, and after liberating Pisa from the Medici and consolidating Savonarola in Florence, he entered Rome that December. Alexander VI was forced to parley with him, and in February 1495, Charles reached his goal and was crowned King of Naples – and of Sicily and Jerusalem. In March,

however, the League of Venice was formed against him. It comprised the Pope, the Venetian Republic, the Duke of Milan (Lodovico Sforza) and Ferdinand and Isabella of Spain. Charles retreated to France, and then opened talks with Florence and Lodovico Sforza conditional on the restitution to France of Novarra. In 1497, he signed a treaty of alliance with Spain aimed at the partition of Italy, but his cause was already lost. Charles died the following year, when he hit his head on a low doorway at his château in Ambroise, and French ambitions for Italy took a different direction under his successor, Louis XII.

Events after Charles's invasion of Italy seemed little short of cataclysmic. The following two decades saw the first appearance of syphilis, the conflict of the Habsburg and the Valois dynasties, the shameful careers of the Borgias, the invasion of the hated Swiss mercenaries, the Sack of Rome and the Siege of Florence. The last two had an undeniably adverse effect on art, but the consequent dispersal of painters from Rome led to the enrichment of other schools of painting in Italy and at Fontainebleau – a factor of great importance for French art.

Franco-European relations in the early sixteenth century were soured by the continuous machinations of Louis XII, who reigned from 1498 to 1515. Louis pretended to the title of 'Duke of Milan', in spite of Lodovico Sforza who had been Duke since 1494. Louis occupied Milan from August to October 1499, but soon lost it. The only beneficial effect of his campaigns was the spread of limited Italian Renaissance ideas into France. Similar connivings, external to Italy (by, for example, the Emperor Maximilian) only ended with the Valois-Habsburg Treaties of Barcelona and Cambrai in 1529. At the Treaty of Cateau-Cambrésis thirty years later Cosimo I de' Medici was given control of Siena and its territory, thus enlarging Medici Tuscany. Elizabeth I of England accepted the earlier French reconquest of Calais.

Louis XII died in 1515 without a male heir, and his distant cousin Francis I (1494–1547) (see plate 16) succeeded him. He was crucial in the large-scale introduction of Renaissance ideas into France, inviting the highly influential architect Sebastiano Serlio (1474–1554), and the painters Leonardo, Andrea del Sarto, Rosso Fiorentino and Primaticcio to work there.

In 1533 his son Henry (later Henry II, 1547–59) married Lorenzo the Magnificent's great-granddaughter (and the Pope's niece) Catherine de' Medici, which further enhanced Franco-Italian cultural relations. Francis regained Milan from Lodovico Sforza's son, as well as Genoa, and a treaty with Pope Leo X. He also acquired Parma and Piacenza. Thus he took French power in Italy to its highest point.

By the Concordat of Bologna with Leo X, Francis gained control over the appointment of the higher clergy in France – a vital move remaining in place throughout the Ancien Régime. Francis was also thus enabled to combat Protestantism in France from the start. Luther's ideas had begun to penetrate France about 1518, and in 1528 the Sorbonne condemned them outright. The fact that France remained a Catholic country was important for the arts, since the church's patronage continued unbroken, alongside that of the Crown and nobility, until the French Revolution.

Between 1523 and 1525 the French persecuted Protestants, until Pope Clement VII limited the condemnation of heretics in France. On the nights of 17 and 18 October 1534, Protestants posted 'placards' against the Mass throughout the realm, with terrible repression as a consequence. The hypocrisy of the King was demonstrated by his alliance with German Protestants. It was he who sowed the seeds of the future French wars of religion, and his son Henry II became the most implacable enemy of Protestants in France.

Francis had aspired to become Emperor, having even tried to ally himself with Henry VIII of England in 1518 at the famous Field of the Cloth of Gold – one of the most sumptuous of Renaissance pageants. But Charles of Habsburg was elected to succeed his grandfather Maximilian I in 1519 as the Emperor Charles V. Attempting to save his Italian territories, Francis was captured at the Battle of Pavia, taken to Spain and released only after signing the Treaty of Madrid in 1526, which gave Charles greater power in Italy.

Henry II reigned from 1547 to 1559, and lived under constant threat from Charles V, and then Phillip II. He was faced with advancing Protestantism, nascent problems with the ambitious Guise family and intrigues in the Italian court of his wife, Catherine de' Medici. In 1548, Francis of Guise brought off a coup in obtaining the hand of his niece, Mary Stuart of Scotland for his son, the future, short-reigning Francis II. The complex problems of the successive monarchs, Henry III and Henry IV (died 1610) did not, however, prevent a great flourishing in the arts in France.

The Holy Roman Empire

Voltaire said of the Holy Roman Empire that it was neither holy, nor Roman, nor an empire. Since Charlemagne, the Emperor had theoretically exercised sovereignty from Vienna over all the kingdoms, principalities and states making up 'the Germanies'. He was also,

in theory, elected, but the Habsburg dynasty had held sway since the Middle Ages and in the case of Maximilian I and his son Charles V, for example, money from the Fugger bank in Augsburg maintained the Habsburg status quo. During the Reformation, the Emperor's power in the area we call Germany today started to wane, and the Empire expanded instead towards the east, embracing Hungary, Bohemia, the Balkans and southern Poland. Even northern Italy fell under its sway.

It was at this time that southern Germany began to prosper, which resulted in the consequent growth of the great cities of Augsburg, Nuremberg, Regensberg and Ulm. Families like the Fuggers were also rising to vast wealth through banking and entrepreneurial activities, which placed them in a highly important position within the Empire.

9 Christoph Amberger Christoph Fugger 1540
The son of the powerful Augsburg merchant Raymond Fugger,
Christoph (1520–79) is portrayed here in a restrained version of the
International Mannerist style. This type of portrait provides a
German parallel to the aristocratic portraiture of Bronzino in Florence
but shows the more middle class approach favoured in Germany. The
Fuggers were among the leading non-aristocratic families in Germany
and were among the first to commission many portraits during the
first half of the sixteenth century from painters including Dürer,
Holbein, Burgkmair, Bellini and Catena.

The age of the Emperor Maximilian I (1459–1519) was synonymous in Germany with the full flowering of the Renaissance – a golden age comparable with that of Philip the Bold and Philip the Good in the Burgundian Netherlands. It was also the age of Erasmus (see plate 14) and Dürer (see plate 19), who alone would have lent it immense distinction. During the last two decades of his life, Maximilian showed a deep interest in art, and commissioned many of the best German artists of his day to illustrate with woodcuts the large number of books whose publication he planned.

His second marriage to Bianca Sforza (niece of Lodovico il Moro) in 1493 seemed to hold out hopes of Italian conquest. The free or imperial city of Augsburg, situated at the Empire's real centre grew in importance, at the expense of Ulm, while the many other free imperial cities such as Cologne, Frankfurt, Basel and Regensburg, continued to flourish.

Charles V's career and its unprecedented internationalism spanned almost the whole of the later Renaissance. His vast accumulations of territory affected European politics for centuries to come. Charles's greatest single act of patronage was the appointment of Titian as court painter in 1533 (see plate 7). Titian was 'inherited' by Charles's son Philip II of Spain who commissioned some of the artist's greatest works.

The Reformation was a painful affair for Germany, while Austria remained staunchly Catholic and developed away from the rest of Germany. It was Martin Luther who brought to a head the upheaval of the Reformation with his provocative preaching, leading to the dissolution of religious orders and the acceptance by the clergy that reform was long overdue.

In 1517, Luther, in his *Ninety-five Theses*, denied the efficacy of the sacraments and the power of the Pope as Peter's successor 'to lose and to bind'. This was in direct opposition to the Catholic Church's position as the prime instrument of salvation, and struck a lethal blow at Catholic presumptions. The Theses were sent to Leo X, and in 1518 Luther was summoned to Rome to be interrogated on them. In response to the Pope's attempt to strike back, Luther called for a second council to challenge his position. This coincided with the commissioning of one of the greatest artistic affirmations of Papal supremacy, Raphael's *Transfiguration* (see plate 248).

In 1521, Charles V summoned the Diet of Worms and denounced the reforms, but his actions were in vain, since both ecclesiastical and social reforms were by then seen as inevitable. Charles was beset by difficulty throughout his Empire. The Peasants' Revolt of 1525 spread through south-west and central Germany before being suppressed.

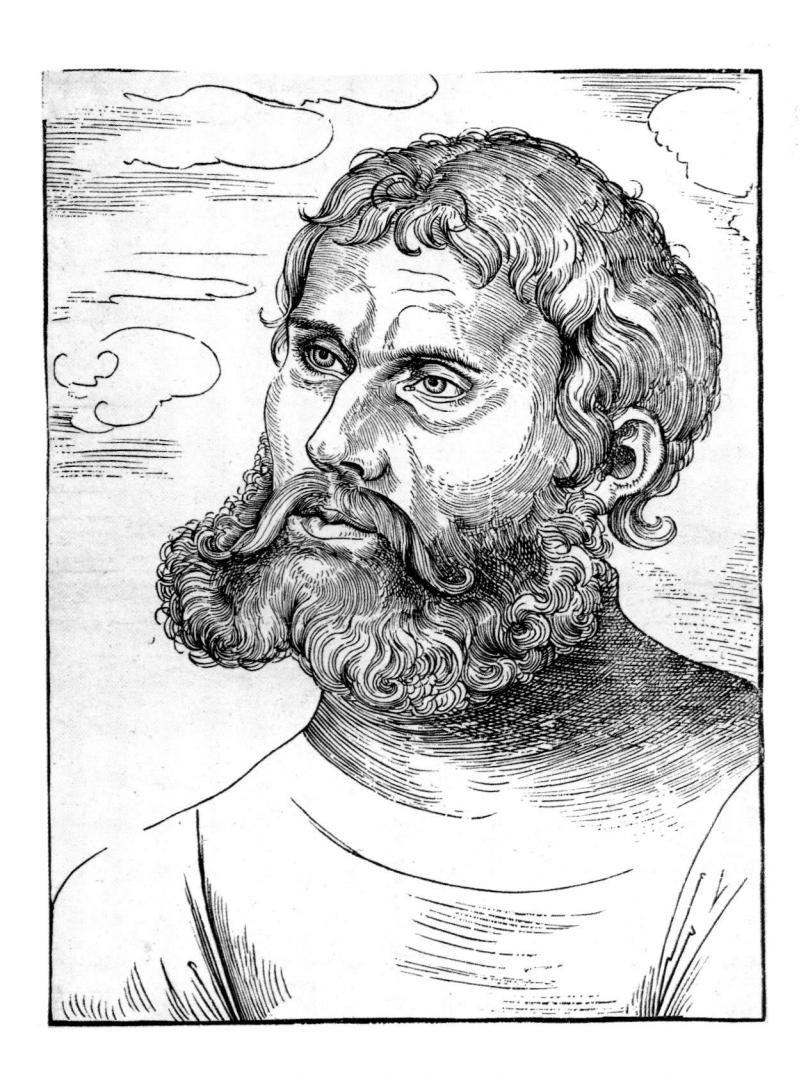

This woodcut shows Luther in the disguise he adopted on his visit to Wittenberg, having informed only Cranach of his impending protective custody after his self-defence at the Diet of Worms in 1521. The relationship between the reformer and the painter was close, and Luther mentions him in his letters. Dürer appears to have been particularly moved by Luther's fate: the interrelationship of painters and religious reformers and humanists was unique to Germany.

(Luther, who had in part prompted it, was horrified by its violence, but princes were jolted into a realization that great changes had to be made.) In the event these were much more sweeping than Luther had originally envisaged. Only with the Confession of Augsburg in 1530, did a comparative calm seem to settle in Germany. Luther regretted his earlier actions, saying, 'If I had known from the beginning what I have now heard and seen . . . I would certainly have kept silence'.

England and Scotland

The Renaissance came late to Britain, having already made its first appearance in Scottish architecture, at Falkland Palace in the early sixteenth century. In painting, the first real manifestations were seen in England under Henry VIII, albeit in the work of foreign painters, the

greatest of whom was Holbein. Henry Tudor was recognized as Supreme Head of the Church in England by the Convocation of Canterbury in 1531. This effectively ended any expression of Catholic themes in art, and Archbishop Cranmer and the Council under Henry's son Edward VI ordered the removal of all images of pilgrimage. Art was secularized overnight, and the English puritanical suspicion of religious paintings was born.

The reign of Henry's staunchly Catholic daughter Mary (1553–8) was too short-lived to reinstate religious art, and in any case too much had already been destroyed. It was during the reign of Henry's Protestant daughter, Elizabeth I (see plate 17) that the English Renaissance was fully consolidated. The limitations imposed by an almost entirely secular iconography were severe, both in terms of the number of commissions and the potential for real expression. Painting was court-centred and principally eulogistic of the monarch, and the portrait miniature was the greatest legacy of the Tudor courts. The relationship of the miniature to Renaissance ideas remains debatable.

Catholicism remained intact in Scotland until the Reformation in 1560, when the church in Scotland was radically reorganized. The Catholic Mary Queen of Scots was the last of the House of Stewart to rule an independent Scotland, albeit briefly. Scotland's monasteries had been immensely rich, but iconoclasm during the Reformation left virtually no trace of the country's ecclesiastical heritage. Partly because of foreign royal marriages, consciousness of European trends was always high in Scotland.

Works of art like the superb small portrait of *Mary of Guise* attributed to Corneille de Lyon (National Portrait Gallery, Edinburgh) along with French portrait miniatures, must have arrived in Scotland, and their technical mastery would have astonished local artists. Commerce and trading links of all kinds between Scotland and the Low Countries had always been strong, and it was because of these that the one great surviving painting of the fifteenth century in Scotland came to be there (see plates 133 and 134).

While briefly Queen of France as consort of Francis II, Mary, Queen of Scots, had been in touch with some of the most dazzling court art of the Renaissance. Her return to Scotland as Queen in 1561 should have brought the full French Renaissance style there, but her troubled reign prevented this. The irrepressible spread, however, of International Mannerist portraiture is seen in the glamorous portrait attributed to Adrian Vanson of Mary's loyal supporter George Seton, 5th Lord Seton, of the late 1570s (National Portrait Gallery, Edinburgh). Only in the eighteenth century did painting revive in Scotland.

Spain

Spain's main link with Italy was through its dominance of Naples, and Renaissance influence filtered through slowly. Flemish art, however, continued to exercise a powerful hold on Spain, with a resultant amalgamation of the two styles. In painting, as in architecture and sculpture, the initial impact from Italy was seen only in the most superficial grafting of its elements. A much more fervent religious climate pervaded Spain in this period than elsewhere in Europe. The Spanish continued to be influenced by the belief in their moral superiority in the 'crusade against the infidel' in which the Turks replaced the Moors, who had been driven from Spain only in the thirteenth century. Hispanic society and culture were already flourishing by the mid-twelfth century, when Portugal, Castile and Aragon were the three principal states in the Iberian peninsula.

Internal struggle among the Christian dynasties was partly resolved in 1412 when the Castilian Ferdinand of Antequera was chosen as King of Aragon. Thus his house, the Trastamaras, ruled Castile and Aragon until the Habsburgs inherited both Crowns through the Holy Roman Emperor, Charles V. Ferdinand's son, Alfonso the Magnanimous (1416–58) secured the kingdom of Naples, an important event for the arts of both countries.

In 1469 Isabella of Castile married Ferdinand of Aragon, thus bringing both realms together after bitter civil war in Castile. Spain entered a new age. Power became centralized, with important ramifications for the arts, since one court provided more patronage, aided by the wealth from the 'New Golden Land' – the Americas. The Pope granted the monarchs the title 'Los Reyes Católicos' – the Catholic Kings – probably in a move to unite the peninsula under Catholicism. Crown and Church were more closely integrated in Spain than in any other European country, a fact most visible in Philip II's grim, monolithic palace-monastery, the Escorial outside Madrid (1563–84).

In 1474 the dreaded Spanish Inquisition was founded, initially to solve the problem of insincere Semitic converts, not Protestantism, which was limited in Spain. Thousands perished at the stake and many more emigrated. A reign of terror gripped Spain, only mitigated for posterity by the voyage in 1492 of Christopher Columbus (see plate 13) and the discovery of America, with its ensuing flood of wealth into Castile. In the same memorable year, Granada fell and the Jews were expelled from Spain. The piety of the Crown and the Inquisition's oppressive powers are reflected in the morbid intensity of Spanish religious painting.

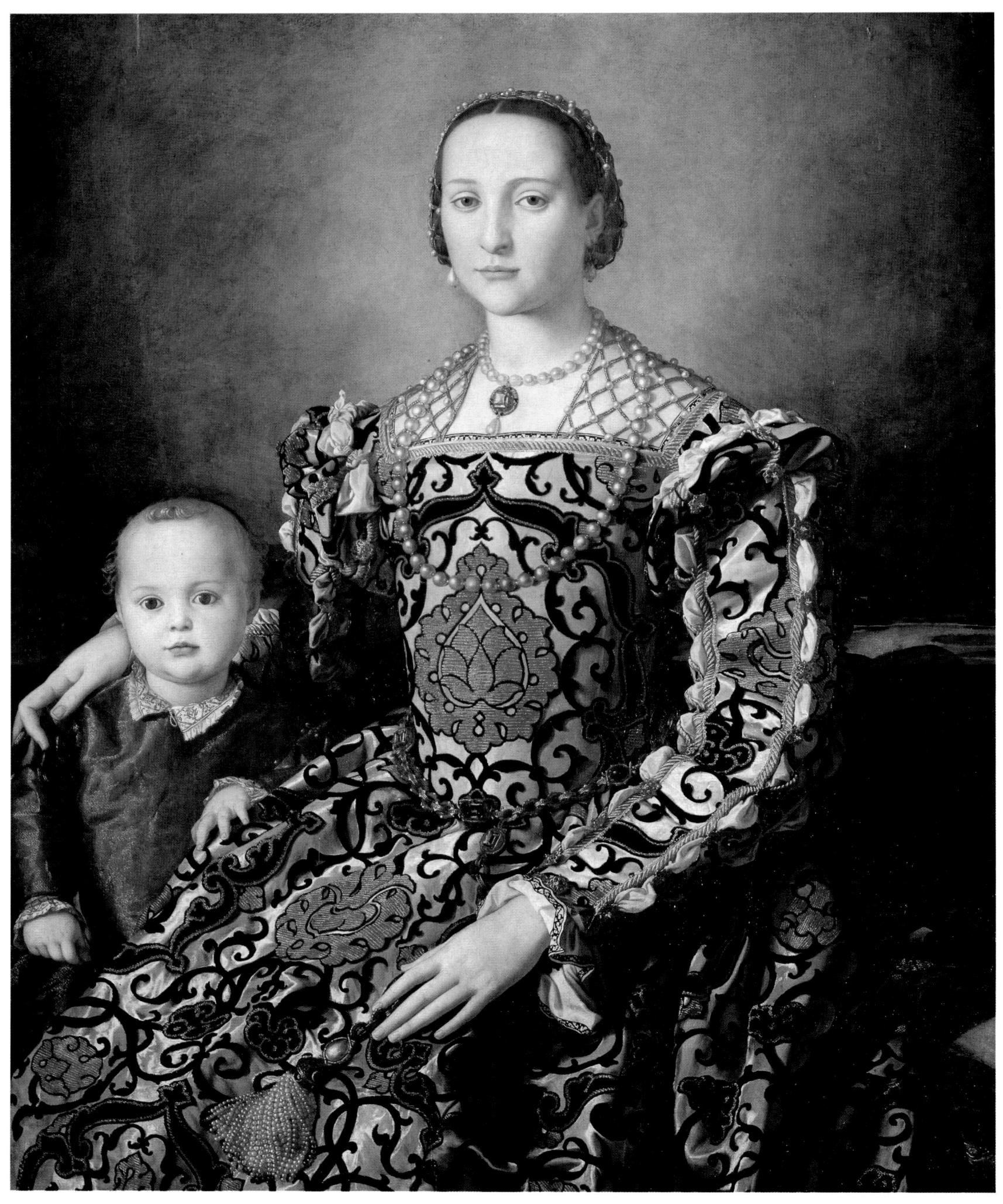

11 AGNOLO BRONZINO Eleonora of Toledo c. 1545
Although not a pair to the portrait of her husband, this portrait of
Eleonora forms an excellent counterpart. Bronzino has deliberately
rendered Eleonora's lavish costume and jewels as rigidly as her
husband's armour. Her dynastic importance is emphasized by her

loving gesture to her son, Giovanni. The Duchess belonged to a tradition of strong-willed, intelligent and active women of the period. Intensely pious and involved in ecclesiastical affairs, she also contributed positively to her husband's financial arrangements.

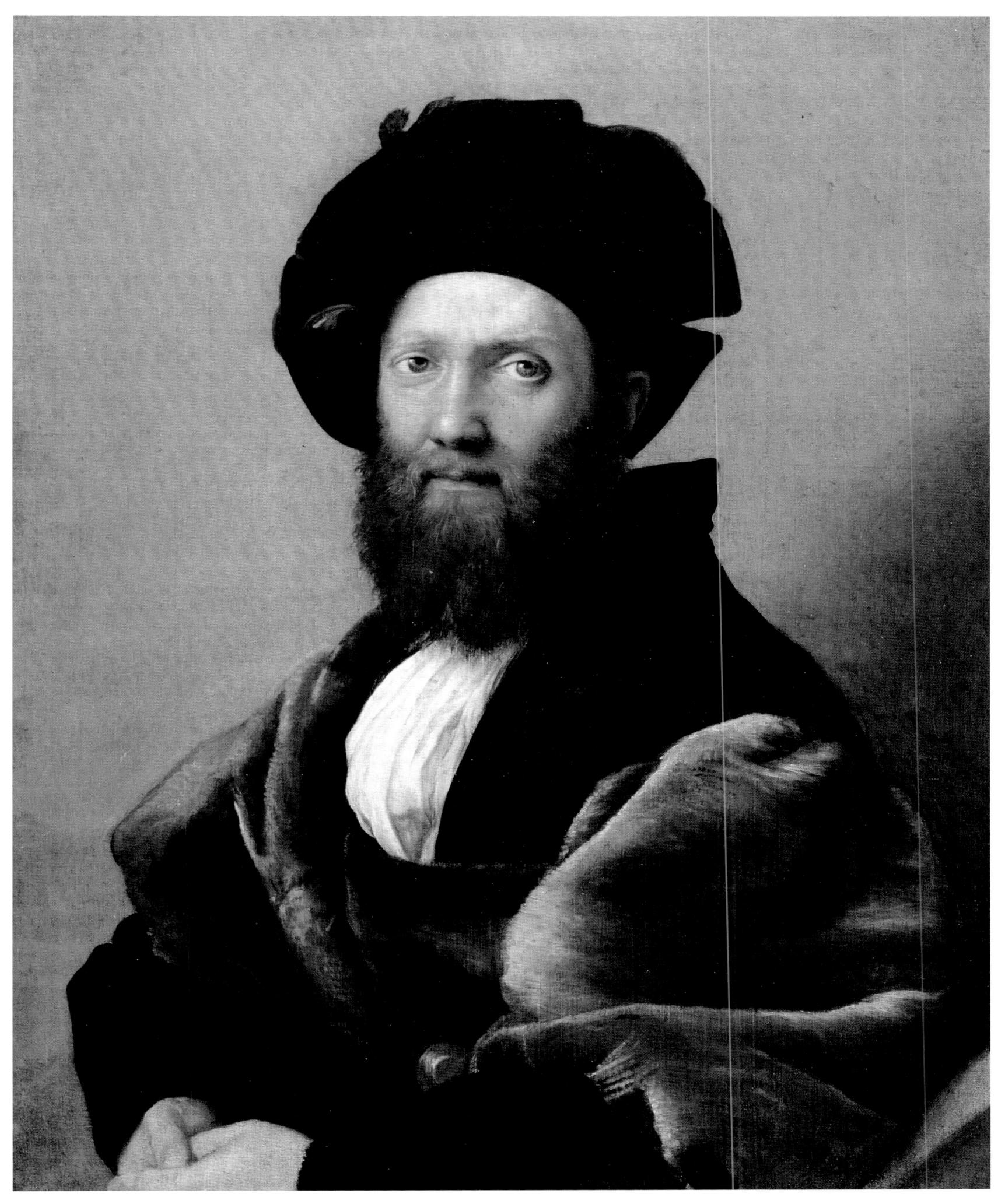

12 RAPHAEL Baldassare Castiglione 1514–15

Count Baldassare Castiglione (1478–1529) was one of the most celebrated poets and men of letters of the later Renaissance, and a friend and advisor to Raphael. Sent to Milan to enter the court of Lodovico Sforza, he rapidly gained a reputation for military and

political astuteness, and enjoyed important positions at the courts of Mantua and Urbino. In 1528 his Book of the Courtier was published in Venice. It was conceived as a portrait of the court of Urbino and a guide to the education of a courtier.

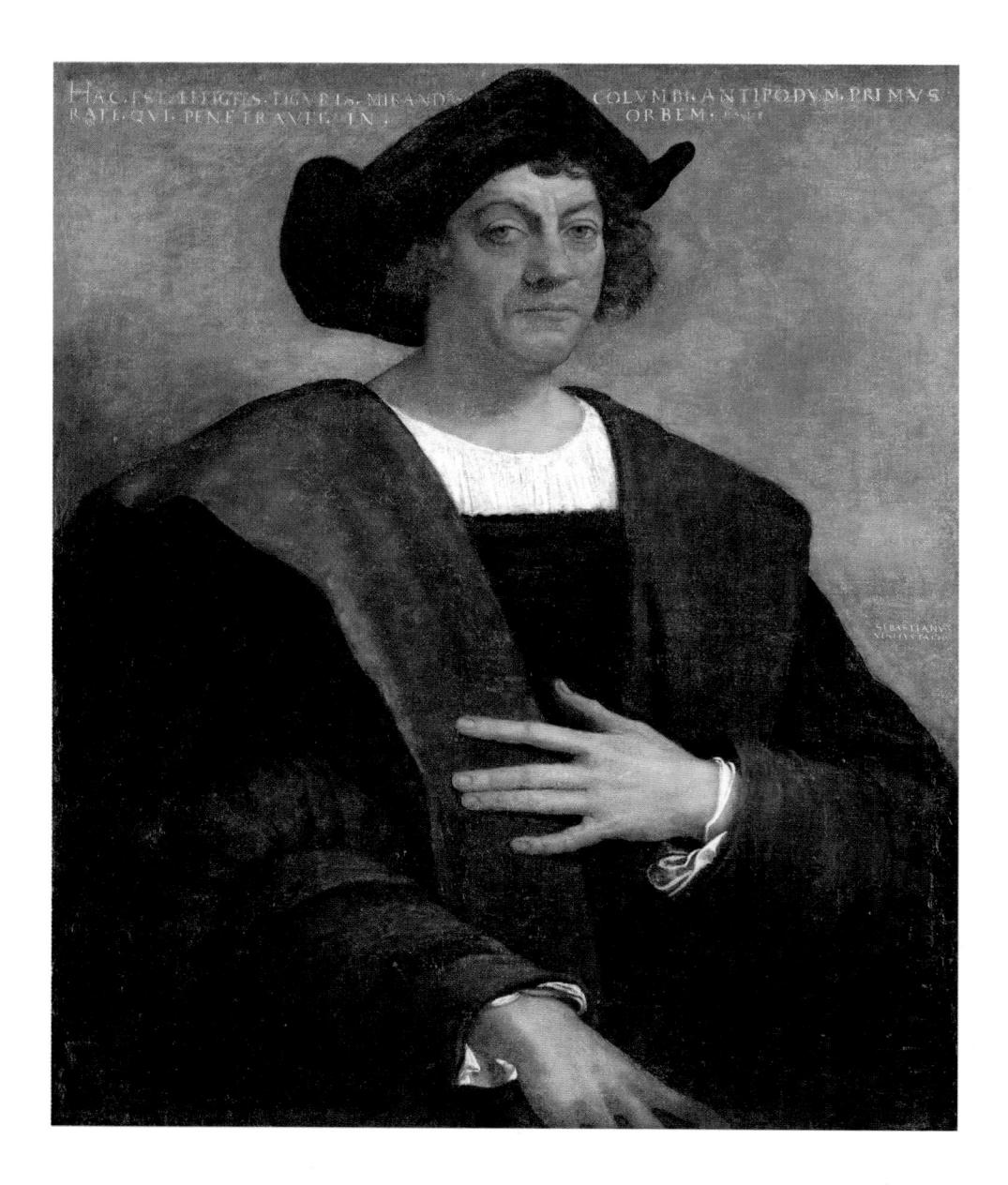

15 PEDRO BERRUGUETE Federico da Montefeltro and his Son Guidobaldo, undated

Federico (1422–82) was signore of Urbino in 1444 and Duke of Urbino from 1474, and was the first member of his family to create a stable state. Guidobaldo died without an heir in 1508, leaving the Duchy to Francesco Maria della Rovere. Federico's studiolo in the Ducal Palace at Urbino was one of the most significant humanist decorative schemes, uniting paganism and Christianity in its iconography, which encompassed theological virtues and a series of illustrious men chosen from scientists, literary figures and the law. It may have been conceived by the architect Bramante, and it included trompe l'oeil wooden inlays probably designed by Botticelli and Francesco di Giorgio Martini.

13 Sebastiano del Piombo Christopher Columbus 1519

This posthumous portrait of the greatest Renaissance navigator, who died in 1506, was probably painted from a lost portrait drawing. It shows Sebastiano's early mature style, and typifies the sixteenth century's nascent taste for portraits, often posthumous, of notable historical figures. Sometimes these were produced in series to point moral lessons, as in the Illustrious Men formerly in Federico da Montefeltro's studiolo, or Titian's Roman Emperors series for Mantua.

14 Hans Holbein The Younger Erasmus of Rotterdam 1523

The simultaneous emergence of Holbein and Erasmus was symptomatic of the effect of humanism on German culture, and each man admired the other. Erasmus settled in Basle largely on account of its pre-eminence in European printing, which enabled him to maintain his intellectual power throughout Europe. Our image of Erasmus is formed almost entirely by Holbein's portraits of him, which are intensely penetrating likenesses revealing the innermost soul. When Holbein left the troubled city of Basle in 1526 for England, he was armed with a letter of introduction from Erasmus to Sir Thomas More.

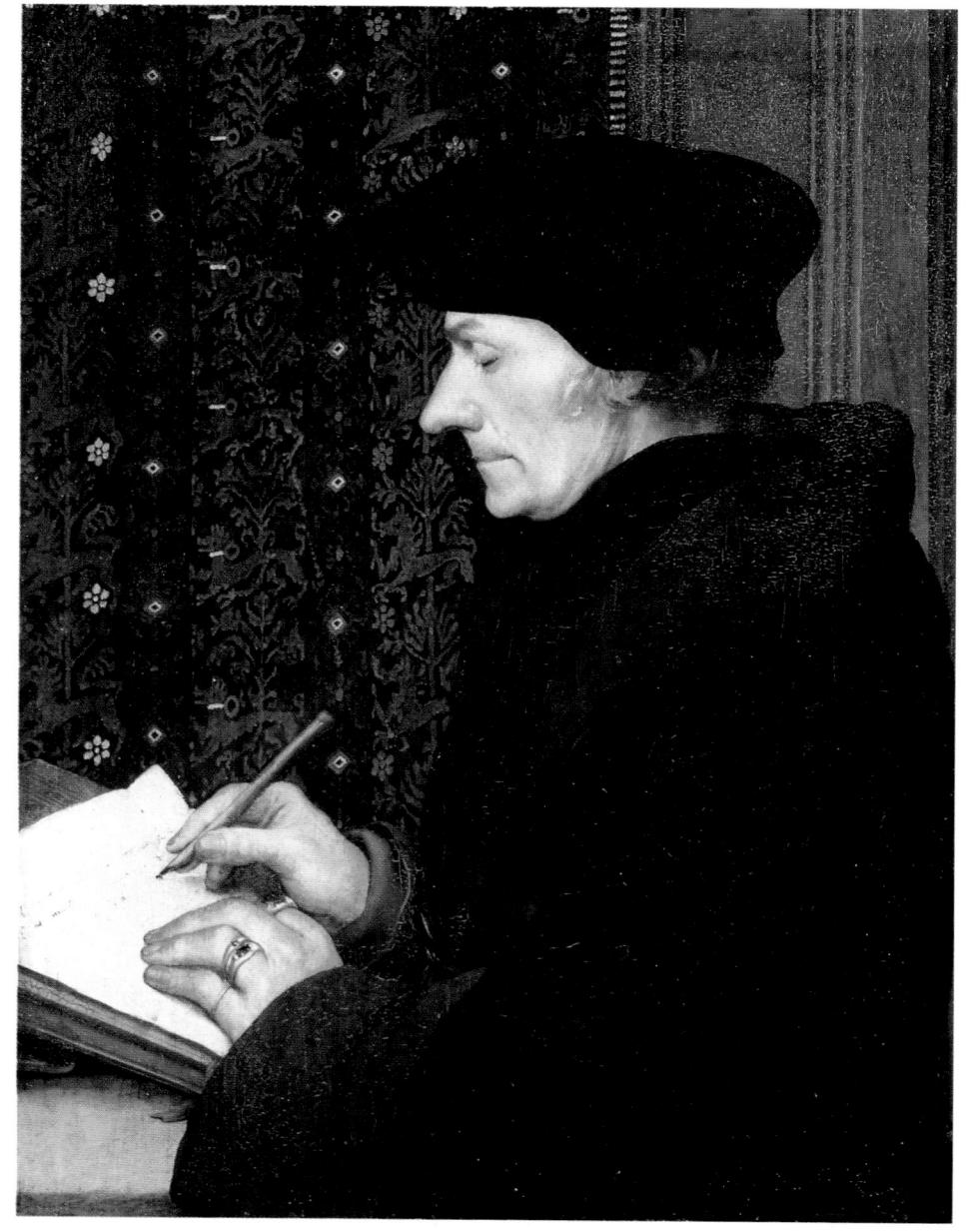

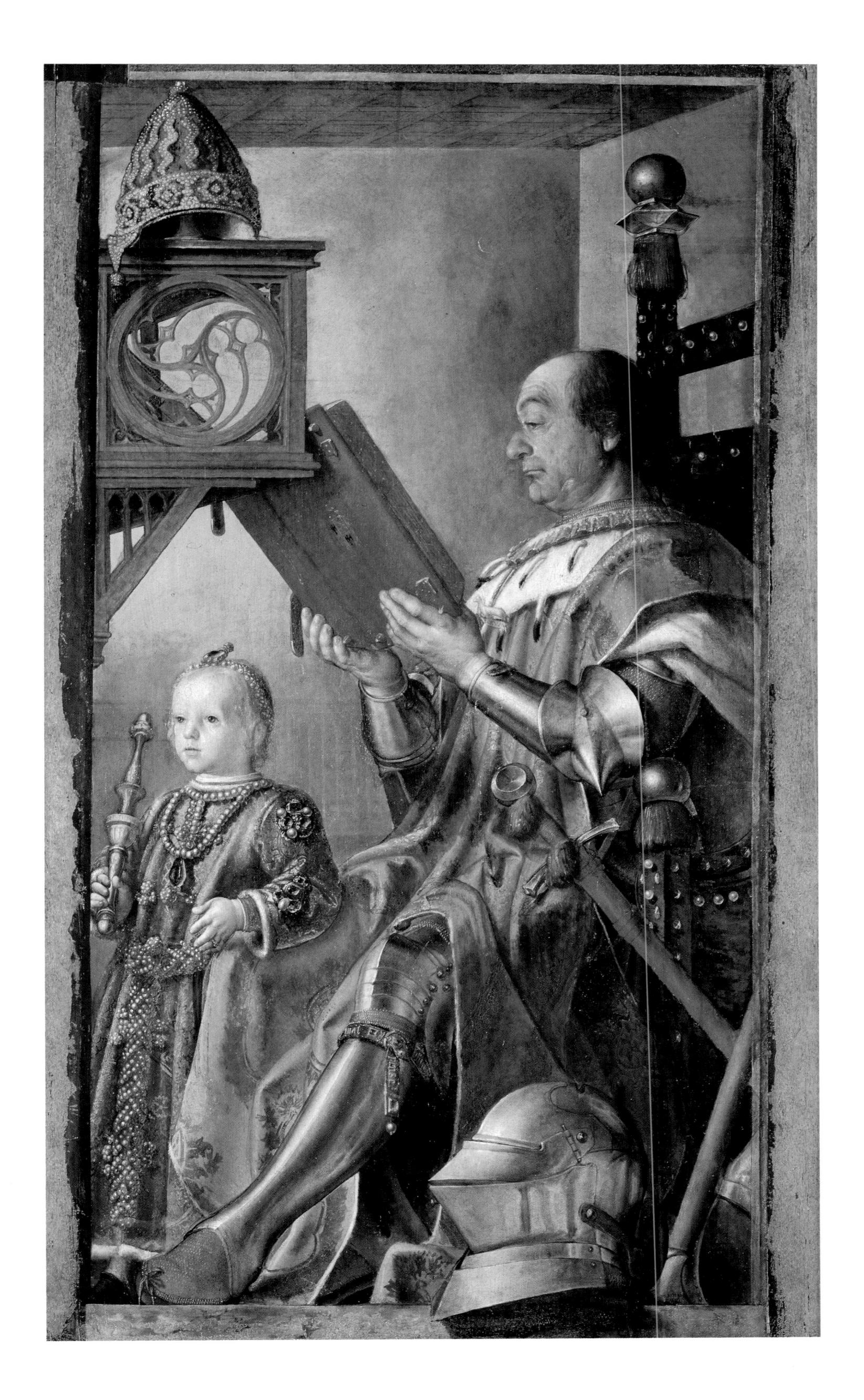

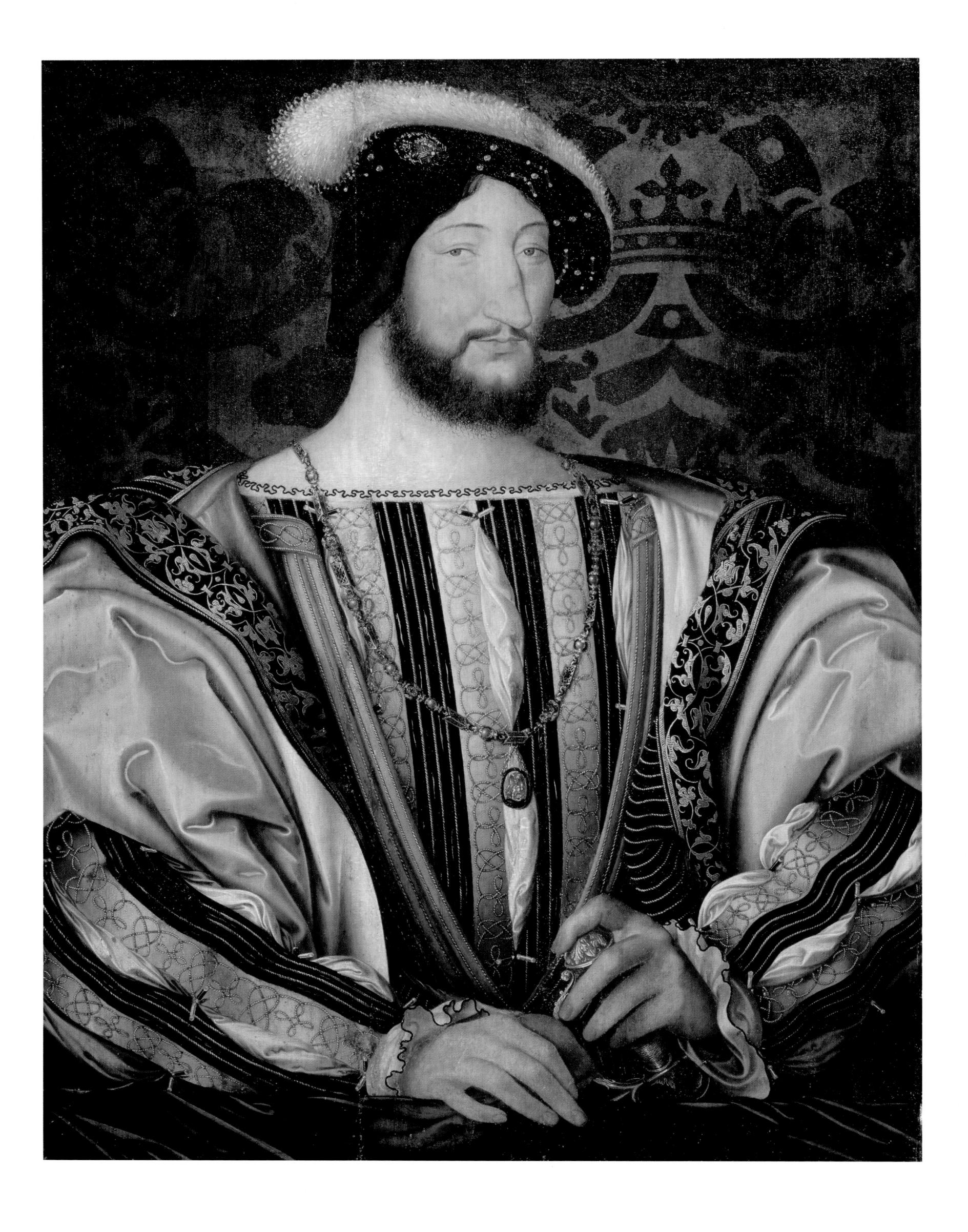

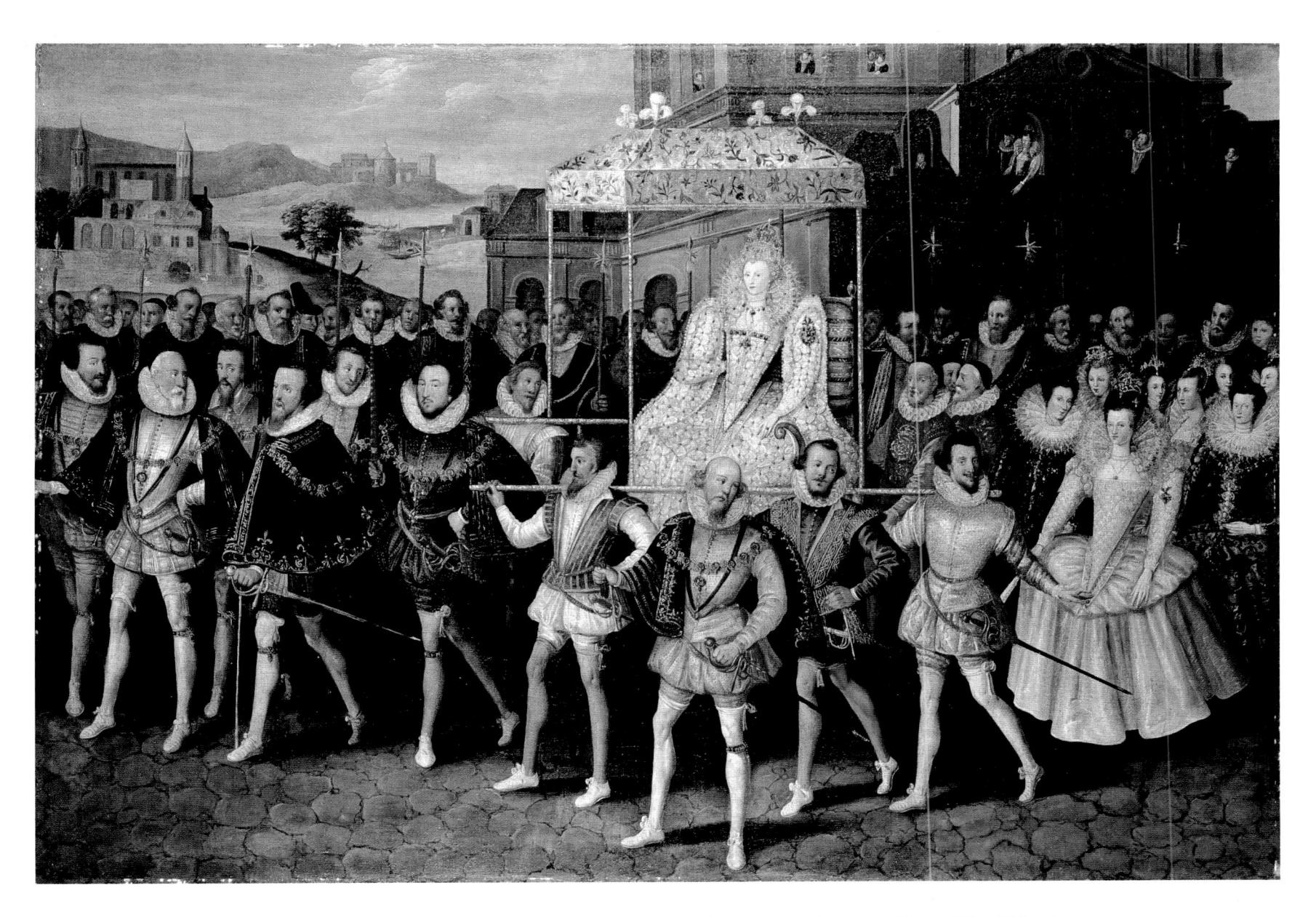

16 JEAN CLOUET Francis I, undated

This portrait and its sitter epitomize the spread of Italian Renaissance ideas throughout the courts of Europe. Francis I's obsession with Italy and things Italian opened the way for the importation of Italian art and artists into France, and the rise of native French painters like Jean Clouet who could rival them. His creation of a new Franco-Italian school of painting at his great Renaissance palace of Fontainebleau launched French art on the international level which it subsequently maintained. Clouet, listed among the king's artists in 1516, was also an exceptional portrait draughtsman, and his son François succeeded him as King's Painter in 1540.

17 Attributed to ROBERT PEAKE Eliza Trimphans c. 1600 During the reign of Queen Elizabeth I the Renaissance in England was fully consolidated. Robert Peake (c.1557–1619) was influenced by Nicholas Hilliard, and this picture corresponds to his pale palette and linear approach to form. It represents a celebration of the Queen by her last Master of the Horse, Edward Somerset, 4th Earl of Worcester, who appears immediately in front of the Queen holding a pair of gloves in his right hand. The painting seems to echo a Roman Imperial triumph (the Queen is in a chair with wheels, rather than a litter) in which Worcester is her escort.

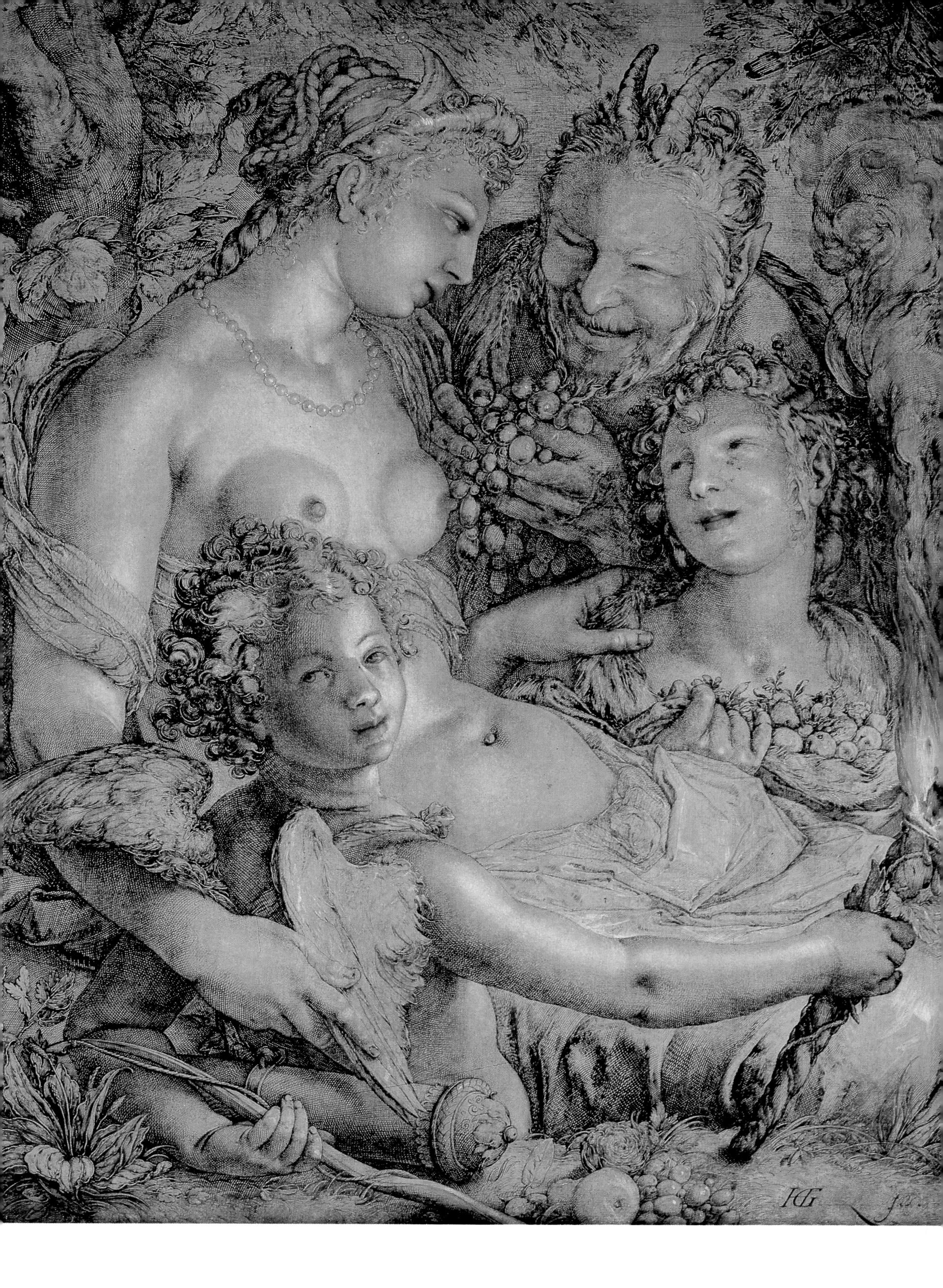

CHAPTER II

Painting and Drawing Techniques in the Renaissance

Drawing

The advance toward mastery of linear representation in drawing lies at the heart of Renaissance art. Its progress and increase in status was rapid during the fifteenth century, as painters grasped not only the new techniques but also the liberating effects of drawing. By the High Renaissance period, drawing had been freed from its exclusively functional, preparatory role to become an end in itself, a process which gained momentum throughout successive centuries. By the mid-sixteenth century, Vasari felt able to define drawing as 'the father of all the arts'.

Many of the greatest painters of the Renaissance were also its greatest draughtsmen. Outstanding examples of the art of drawing are Botticelli's magical illustrations to Dante, Leonardo da Vinci's vast corpus of studies of all kinds, the unrivalled perfection and variety of Raphael and Michelangelo's drawings, the riches of Correggio and, notably, the Tuscan and Roman schools.

Outside Italy, some of the finest draughtsmanship is to be found in the highly finished portrait drawings of painters such as François Clouet (see plate 20) and Hans Holbein the Younger (see plate 29). Dürer's draughtsmanship (see plate 19) ranks with his painting and engraving, and along with his German contemporaries, he used drawings in many new ways. In England, only a fine distinction exists between draughtsmanship and painting in

18 HENDRICK GOLTZIUS Without Ceres and Bacchus, Venus is a-Chill 1599–1602

The subject is taken from a maxim in the comedy The Eunuch by the Roman dramatist Terence. Venus is seen awakening from a deep sleep in response to the symbolic presence of Ceres and Bacchus, while Cupid turns towards us and illuminates the scene with his torch. Such virtuoso drawings in pen and brown ink and brush and oils on blue-grey canvas won Goltzius widespread acclaim.

that most characteristic of contemporary English productions, the portrait miniature (see plate 169).

The increase in the number and uses of drawings after 1400 is matched only by the new diversity of subject matter for draughtsmen. The Middle Ages' fear of, and even revulsion from, the nude human form was being replaced by the study of living models and by an understanding of the intentions and achievements of ancient sculptors. With the reassessment and rediscovery of Classical writers, it was inevitable that one of the most tangible elements in the legacy of ancient Rome - sculpture - should become a rich source of reference in the Renaissance. Contemporary developments in sculpture also exercised considerable influence on painting, especially with a major innovator such as Donatello. The human body was no longer simply the temple of the Christian soul, but, as in ancient times, an object of beauty in its own right.

The potential released by the emergence and development during the fifteenth century of new techniques came at a time of intellectual probing, which led artists to investigate every aspect of the visible world. Drawing became one of the main outlets for the enquiring artistic mind. It permitted exploration and experiment which could be carried over to other media only with the greatest difficulty, as in Leonardo's attempts to create diagrammatic drawings of storms and deluges. The sum total of these experiments greatly enriched the art of painting.

Initially the property of painters, drawing soon exerted its fascination throughout the visual arts, and became the common factor in painting, sculpture and architecture. Its role in liberating the artistic mind cannot be overemphasized. It formed the basis of linear perspective, which revolutionized pictorial representation from the 1420s, and received much attention in writings as diverse as Ghiberti's *Commentaries* and Alberti's treatises. Piero della Francesca's

19 Albrecht Dürer Self Portrait as a Journeyman 1491–2 Dürer's self portraits stand apart in Renaissance imagery for their astonishing individuality and for the artist's determination to record not only the details of external reality but also many aspects of his innermost nature. This drawing reveals most clearly how novel his approach was, and that its insights come not from the assimilation of Italian ideas but from a strong German tradition of seeking to penetrate reality.

perspective treatise, *De Prospettiva Pingendi*, was illustrated with engravings based on his own drawings. But the late fifteenth century's most exhaustive work on painting and drawing, combining theory and practice, was Leonardo's uncompleted *Trattato della Pittura (Treatise on Painting)*, which indicates the importance which drawing had by then assumed in workshop methods.

Drawing offered a far quicker way of exploring forms and ideas than painting. Its spontaneity (which increased during the fifteenth century as drawing media developed) permitted the artist to test his ideas in note form. Drawing was also fundamental to the control which a painter kept over his pupils. Imposing a studio style on the countless copies basic to every apprenticeship ensured that homogeneity which enabled works by many hands to bear a single name – the master's own. It suffices to think of the early work of great Renaissance masters, such as Masaccio or Raphael, to realize that it was only exceptional talent which liberated them from spending their lives as accomplished purveyors of the style in which they had been trained. The exchange of drawings between

studios and artists is known to have had considerable impact on the spread of new ideas.

In about 1400, most studios had model books, normally on high quality parchment (vellum) for durability, containing drawings to set formulae for use in various permutations in the creation of new paintings. But

21 LEONARDO DA VINCI The Anatomy of a Shoulder c.1510 (Right) Leonardo's almost fanatically meticulous anatomical studies represent the highest point of the Quattrocento artist's examination of the body's underlying structures, particularly as he considered them in a much broader context than any of his contemporaries.

20 François Clouet Francis II c.1553

This drawing was executed prior to Francis's marriage at fourteen to Mary Stuart. He became King of France at sixteen, dying the following year. Clouet's portrait drawings enjoy an unusual place in European draughtsmanship, since they were made entirely as works of art in their own right. His technique aimed for the finest and most detailed modulations of line and tone in fused combinations of coloured chalks, simply taking the place of painted portraits as a more intimate record kept, like English miniatures, for private contemplation.

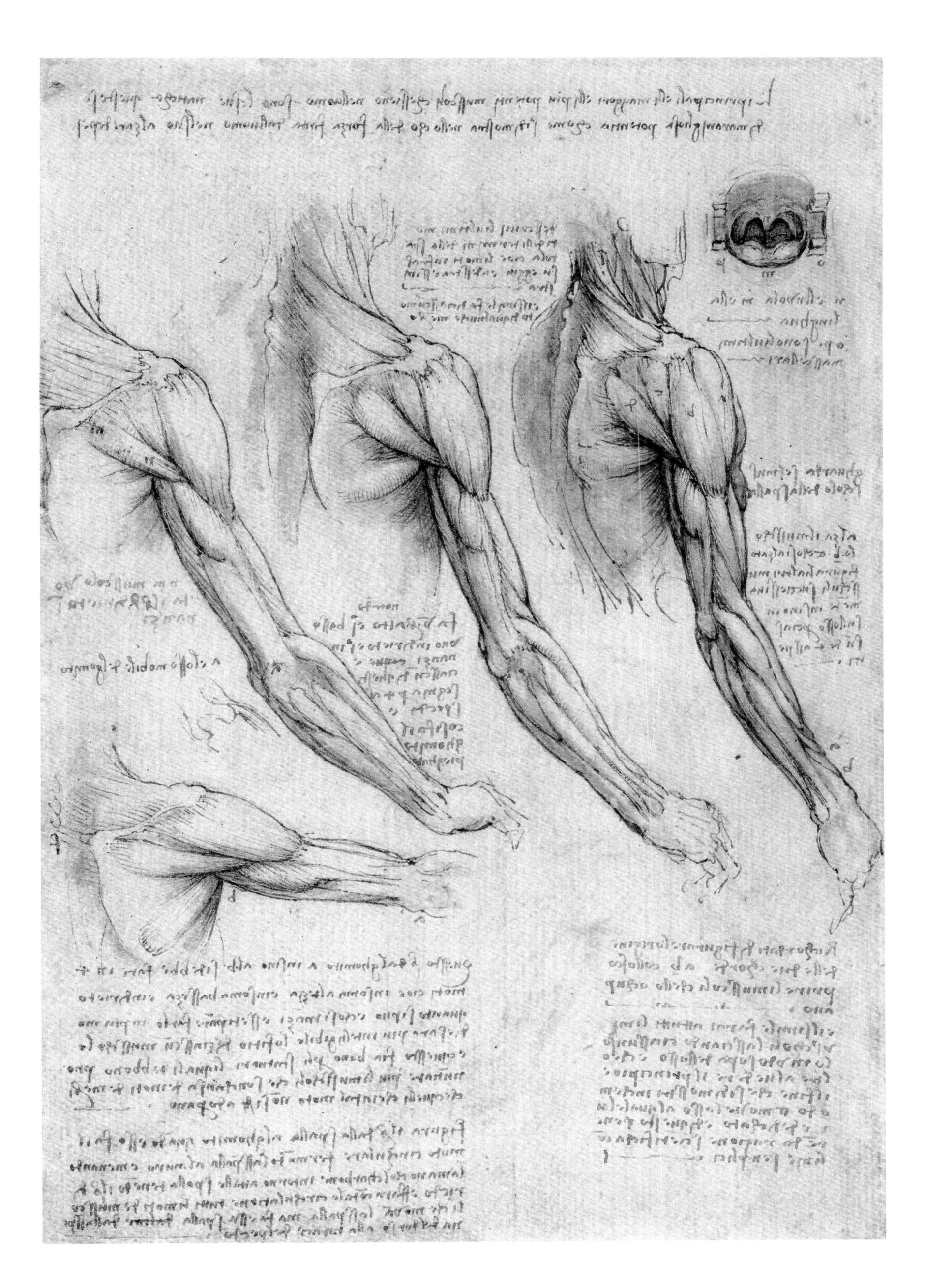

40 Michelangelo The Deluge 1508

(Above) This was apparently the first of the Sistine ceiling scenes painted by Michelangelo. The individual giornate, or sections painted each day, are outlined in black. The scene of the Fall and Expulsion from the Garden of Eden was carried out in eight or nine days. The architect Giuliano da Sangallo had to be consulted about dealing with the mould which grew because the fresco's lime base had not dried quickly enough.

41 LEONARDO DA VINCI Last Supper 1495-7

(Below) Leonardo's Last Supper has always been recorded as one of the greatest technical failures in Western art. Leonardo used oil paint rather than fresco, a serious misjudgement because of subsequent deterioration. Little of the original paintwork remains, and it is only really possible to understand the impact the work had from copies and preparatory drawings. As early as 1517–18 it was noted that it was disintegrating, possibly due to humidity.

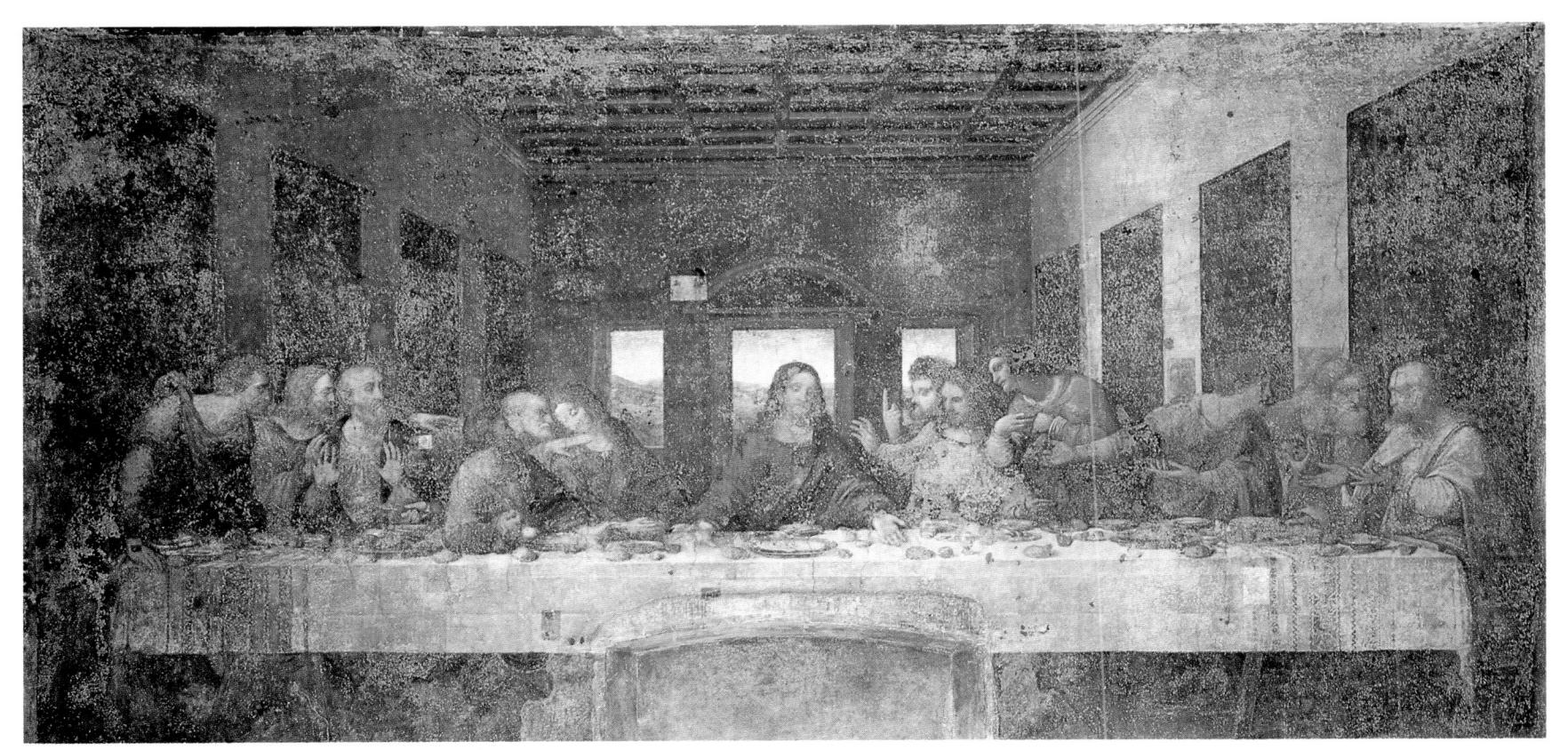

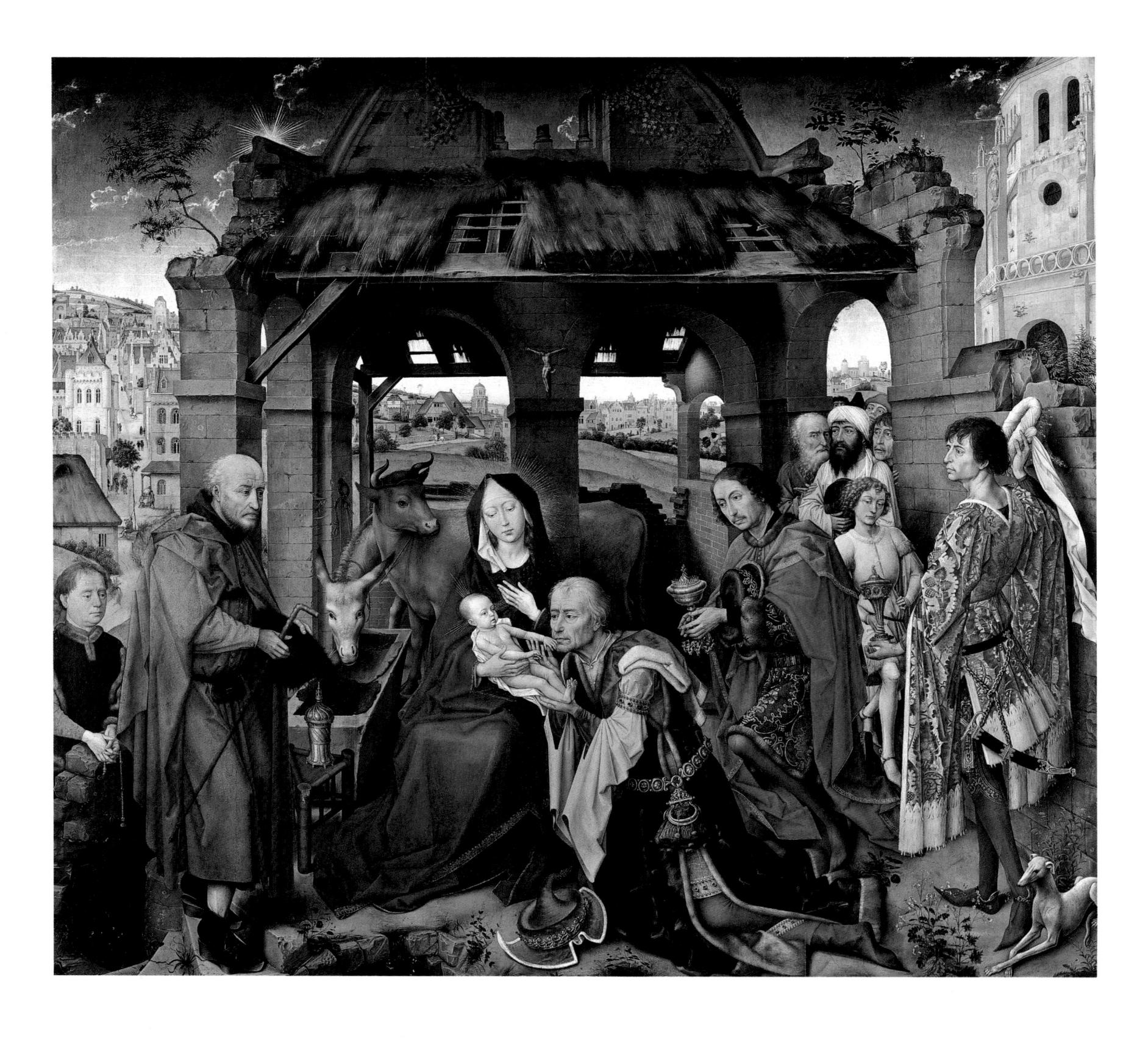

42 Rogier van der Weyden The Saint Columba Altarpiece c.1435

Coming from the church of St Columba in Cologne, this is a major work of the painter's late period, and shows his fully evolved style and technique. Rogier van der Weyden painted it on an oak panel, and it is remarkable for showing the range of brilliant colour available to Flemish painters. Van Eyck had perfected the technique of applying countless layers of oil-based paint over a white chalk ground applied to the panel. This gave an astonishing transparency to the final colours, particularly when compared to tempera, which was inevitably more opaque. It also permitted the depiction of fine detail, as in the jewellery, costume and landscape, the transparency contributing greatly to the effect of light on distant buildings. An ever-increasing level of technical expertise was required by the guilds, who maintained control over artistic production in the Netherlands.

Albrecht Dürer Knight, Death and the Devil 1513–14
This is not only one of the artist's most celebrated copperplate
engravings, but also among his most striking images. Along with
Saint Jerome in his Study and Melancholia, both of the same
years, this is one of Dürer's most ambitious plates. Death stares the
Knight in the face and the Devil waits to catch him if he falls, but he
rides on undaunted. In these plates, Dürer follows directly in
Schongauer's wake in achieving rich effects of light, shade and volume
within the limitations of line. His interpretation of forms in such
dense juxtapositions exercised an incalculable influence on painting
both north of the Alps and in Italy, Dürer himself having been
greatly influenced by Mantegna's prints.

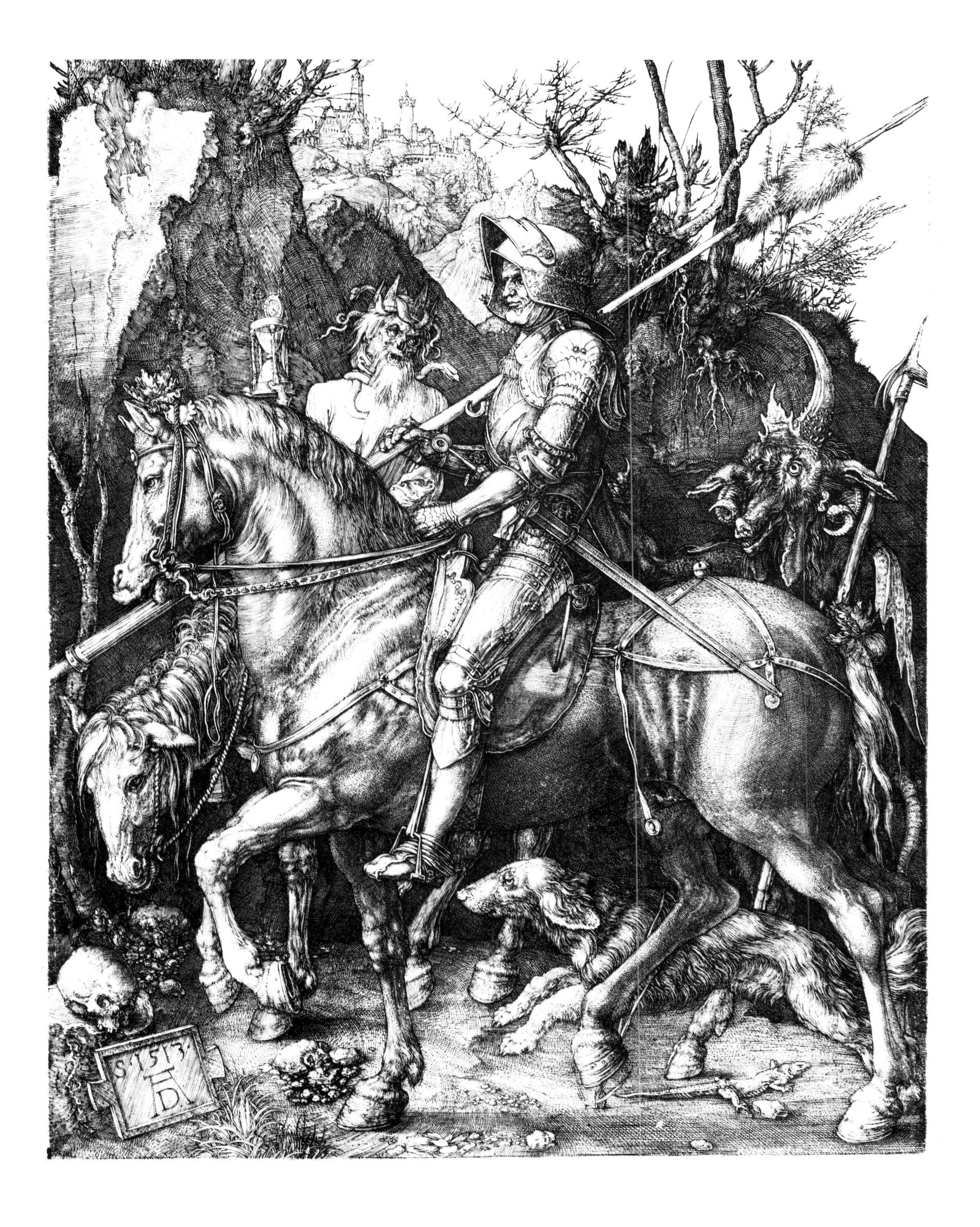
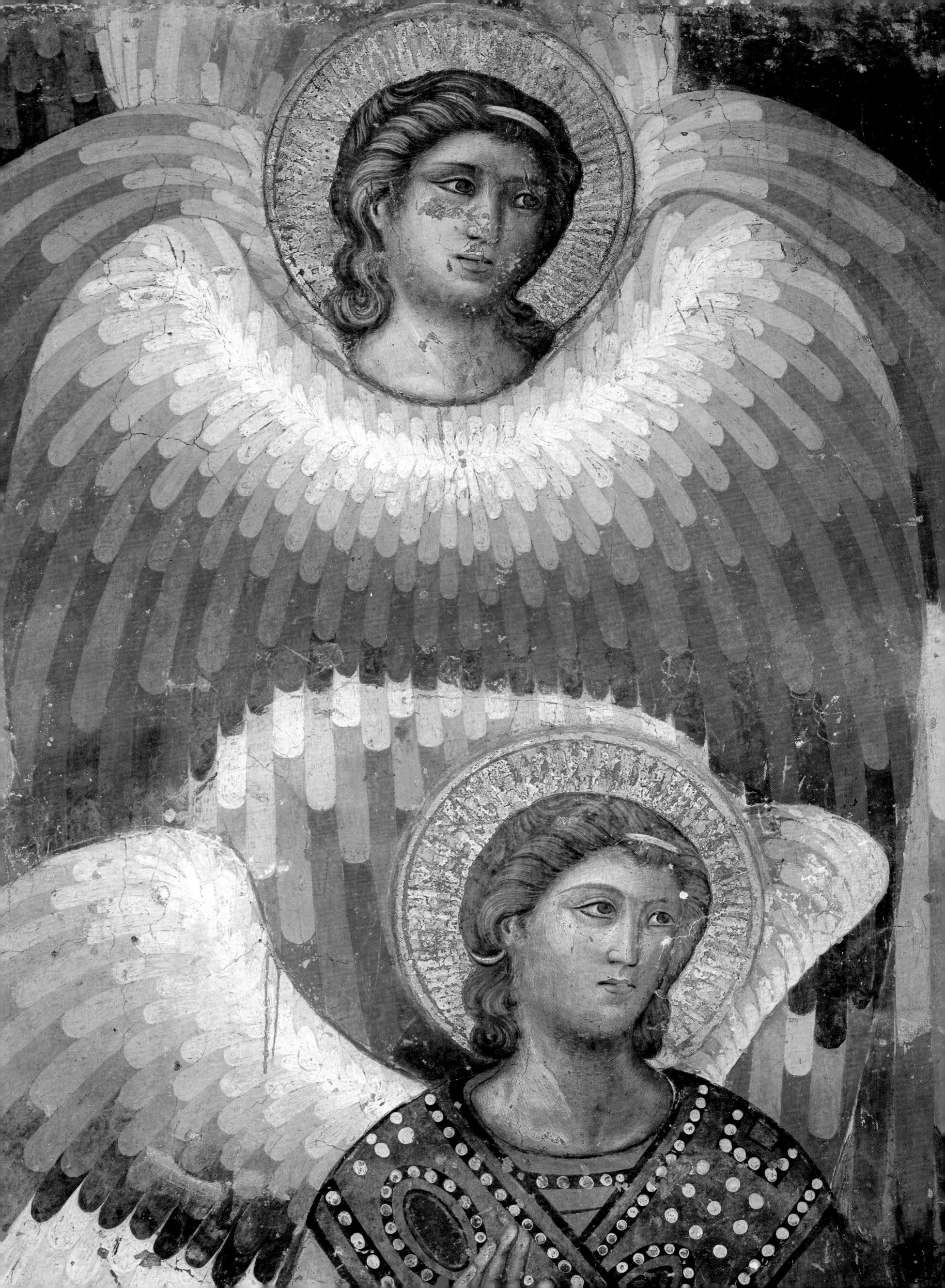

CHAPTER III

The Rebirth of Painting in Italy and the Prelude to the Renaissance 1250–1400

Rediscovering the Primitives

The art of the 'primitives' – the Italian painters of the thirteenth and fourteenth centuries (the Dugento and Trecento) was virtually rediscovered by the Victorians, unlike the art of the Renaissance, which enjoyed almost unbroken favour with connoisseurs and collectors. Indeed, it is a miracle that any painting from these two centuries has survived, given the attitude of the post-Renaissance period. Fresco cycles were white-washed or destroyed, panel paintings jettisoned and all forms of 'primitive' art were obliterated by later decoration and architecture. Had it not been for an enlightened Paduan historian, the Marchese Pietro Selvatico, even Giotto's Arena Chapel (see plate 56) – the fourteenth century's equivalent of the Sistine Chapel – would have been razed to the ground.

The ideals of the Dugento and early Trecento can seem very remote from the Renaissance, but it was the influential art historian Giorgio Vasari (1511–74) who first perceived the connection between the work of Giotto and Fra Angelico, for example, and rightly dated his examination of the rebirth of art in his native land from this period. Compared with his writing on his own period, however, the reliability of much of his information and many of his conclusions about earlier artists are questionable, and often completely unreliable. But there

44 PIETRO CAVALLINI Angels, before 1308
This is a detail from Cavallini's partly destroyed fresco of the Last
Judgement in Santa Cecilia in Trastevere. The clarity of figure
modelling and the characterization of the faces are typical of
Cavallini's attractive style. They indicate that he was almost
certainly the leading Roman painter/mosaicist of his day, and
they provide the background from which Giotto drew many
elements of his new style.

are other contemporary sources of information and attributions, particularly the wealth of documents recording commissions and payments, and the *Commentaries* of the Florentine sculptor, Lorenzo Ghiberti (1378–1455). This large incomplete manuscript comprises an autobiography, a survey of ancient art and notes on optics, together with much detail about Italian Trecento painters and sculptors.

The Church: Patron and Inspiration

Painting in the later Middle Ages in Italy, as throughout Europe, was almost exclusively religious, since the artist's first allegiance was to the Church. With the exception of rarities like Ambrogio Lorenzetti's Good and Bad Government (see plate 64), large public fresco cycles were entirely devoted to religious themes, or at the very least semi-religious allegories. The other principal type of commission was the altarpiece, and in the late Gothic and early Renaissance, frame and picture were virtually (and sometimes literally) inseparable. In early painting, the frame often served as a physical support for more than one panel, hinged to form a diptych, triptych or polyptych. Italian altarpiece frames of this date are often made to resemble cross-sections of Gothic churches, with pointed arches, small buttresses and florid pinnacles. They were frequently elaborately painted and gilded and this could be considered an act of veneration to the images they contained: as Cennini says, 'God and Our Lady will reward you for it, body and soul'.

The main source of patronage in Italy was indeed to remain the Church throughout the Renaissance and Baroque periods. Moreover, during the fifteenth and sixteenth centuries, much of the necessary finance for important private decorations stemmed from church funds through newly enriched members of Papal families.

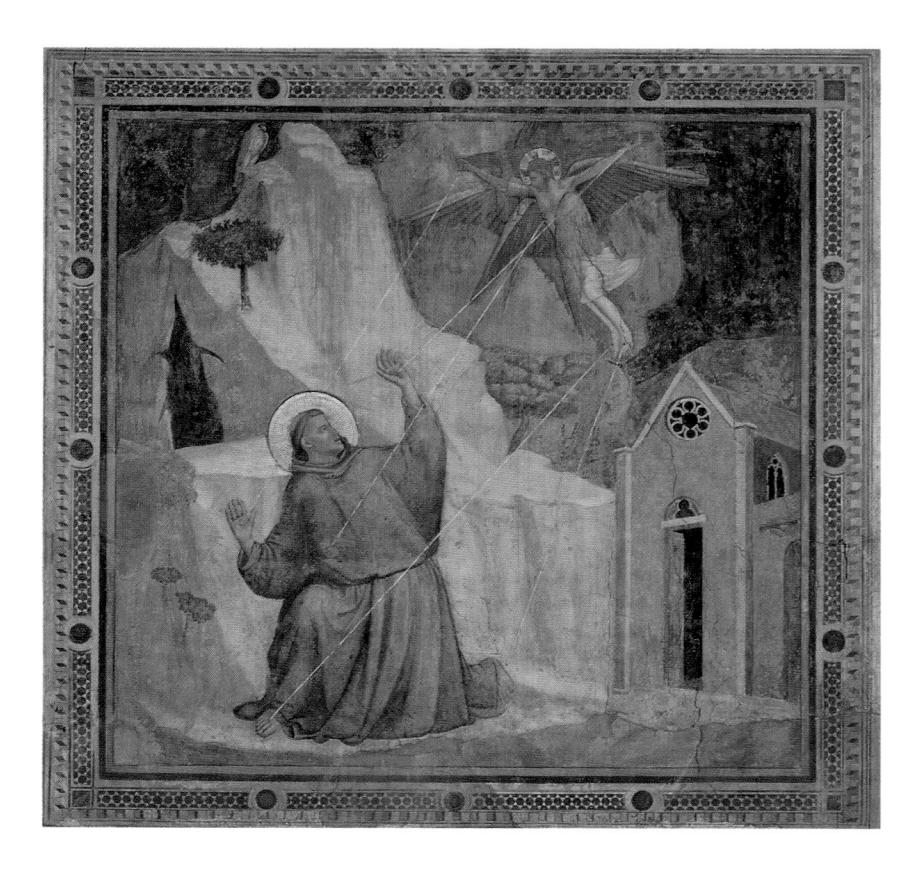

45 Giotto The Stigmatisation of Saint Francis c.1325 Giotto frescoed at least three chapels in the great Franciscan church of Santa Croce in Florence, of which two survive. Those in the Peruzzi Chapel depict the lives of St John the Evangelist and St John the Baptist, while seven pictures in the Bardi Chapel are devoted to the life of St Francis of Assisi. These are approximately contemporary with the Ognissanti Madonna. This scene shows the kneeling saint receiving the stigmata from a seraph.

The religious revivals of the later Middle Ages were of incalculable importance in nurturing the growth of an Italian school of painting. A prime influence in this respect was St Francis of Assisi (c.1181-1226), founder of the Franciscan Order, who was canonized in 1228. St Francis may be said to have given a human face to late medieval Catholicism, which is directly reflected in the aims of Trecento painting in Italy. Second only to him was his contemporary, St Dominic (1170-1221), founder of the Dominican Order, who was canonized in 1234 and established his order in France and England. St Francis's spirituality and his particular devotion to the Holy Cross and to the Virgin gave rise to many new images, and his own life inspired two of Giotto's greatest works: The Legend of Saint Francis (Upper Church, Assisi), and the Bardi Chapel frescoes in the church of Santa Croce, Florence (see plate 45). Painted images assumed rapidly increasing importance, not only as an inspiration for prayer to the faithful, but also as an accredited source of miraculous powers. A crucifix had supposedly spoken to St Francis himself, commanding him to go forth and found his order.

New writings began to exercise an immense influence before the Renaissance, notably the Meditations on the Life of Christ, probably written by John de Caulibus of San Gimignano towards the end of the thirteenth century. This book features the process of visualization which culminates in the Spiritual Exercises of St Ignatius Loyola (published in 1548). Their aim was to enable the reader, while meditating, to form mental pictures of biblical scenes, so that their symbolism and inner meaning would leave a deeper impression on the mind. Art was the natural expression of such processes, both before and during the Renaissance. Another devotional work written in the thirteenth century that was to prove immensely influential was The Golden Legend by Jacopo da Voragine. A compilation of the lives of saints, it became an important source book for Renaissance artists.

The stylized forms and expressions of earlier Byzantine painting must have exasperated painters struggling to render the new spirituality. At the same time, it was probably difficult for them to shake off their predecessors' belief in the power of a generalized image, with few if any individual features indicating character. New ideas first made their appearance in sculpture, in the cities of Pisa, Siena and Pistoia, where interest in Classical prototypes came to be united with a limited degree of naturalism. The leaders of this movement were Nicola Pisano (c.1220/5–84?) and his son, Giovanni (c.1245–50 – after 1314). Nicola's first known work is a pulpit in the Baptistery at Pisa, signed and dated 1260, which, together with the three later pulpits by the Pisani, clearly takes inspiration from Late Roman sculpture.

Elements such as facial expression, the rendering of depth, and the use of drapery as an indication of underlying form all depart from the stylized approach prevalent in European Romanesque sculpture at the time. This synthesis of antique art with Christian iconography looked forward to the achievements of Giotto and his contemporaries in painting, and indeed announced some of the aims of Renaissance art.

It was in the Tuscan cities of Florence, Siena, Lucca and Pisa that the first signs of a new and distinctive style of Italian painting made their appearance, edging away from the hard conventions of Byzantine art. The mosaics in the vault of the Baptistery of Florence Cathedral sum up the artistic background to this period. Vasari claims that these were the work of a Greek mosaicist called Apollonio, and Andrea Taffi (who is mentioned by the poet Boccaccio), who have been identified with the so-called 'Bardi St Francis Master' and the 'Magdalen Master'. The mosaics are arranged in tiers in the manner which was to be continued right up to the late Quattrocento, and the vault is

dominated by the gigantic figure of Christ. Although strongly Byzantine in feeling, the expressiveness of the figures is characteristically Tuscan and their grandeur undoubtedly influenced later artists, not least of all Giotto himself. It is tempting to see a reflection of the Baptistery Christ in Giotto's Arena Chapel *Last Judgement*.

Cimabue

The Byzantine manner of Cimabue (Cenni di Peppi, c.1240–1302) in the later Dugento was the foundation from which some of the subsequent developments of the Renaissance were to grow. Cimabue, whose nickname means 'Ox-head', enjoys a reputation built partly by his

46 CIMABUE Crucifix *c*.1288–98

The attribution of this monumental work to Cimabue is now generally accepted: it is shown here as it looked before the severe damaged sustained in the Florence flood of 1966. The work's greatness lies in Cimabue's decision to create a human and approachable image of a God suffering on the cross rather than triumphantly alive. This new approach to the human incarnation of Christ, which is also visible in Cimabue's huge Crucifixion fresco in the Upper Church of San Francesco at Assisi, looks forward to the fifteenth century's thinking on religious imagery.

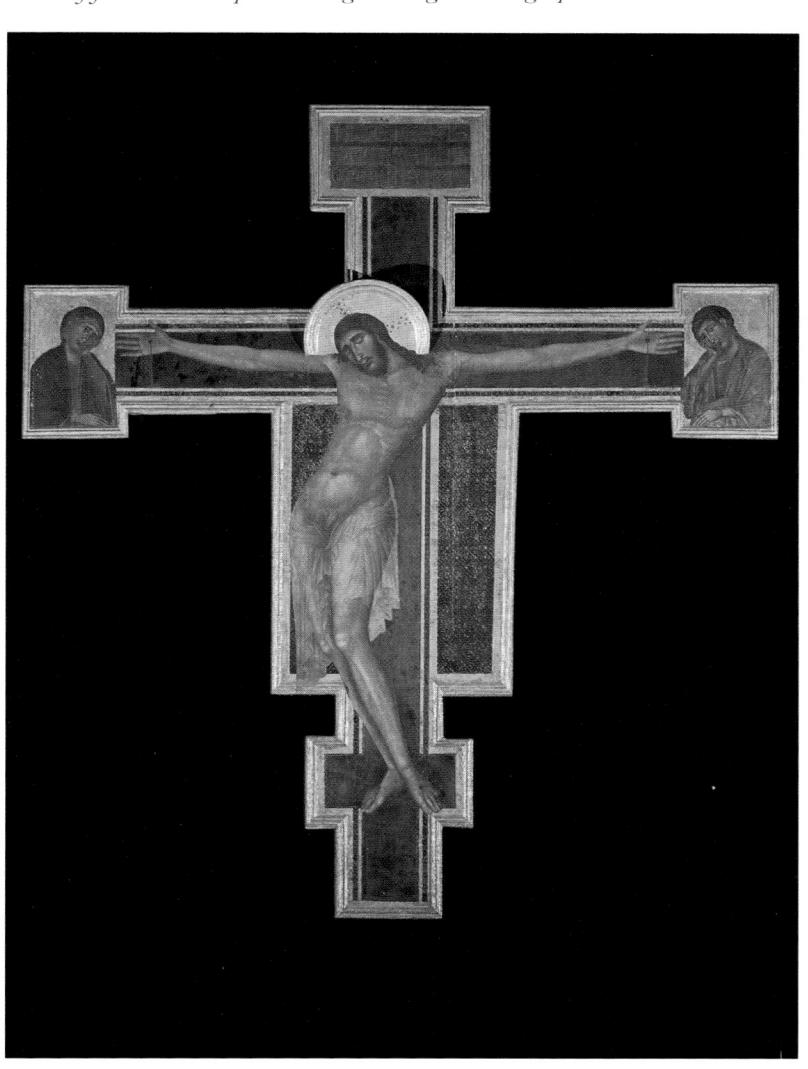

contemporary, the poet Dante, who refers to him in The Divine Comedy: 'Cimabue thought to hold the field in painting, but now Giotto's name is on everyone's lips'. Although Dante intended this as an allusion to the vanity of all earthly ambitions, the phrase was always regarded as a quasi-historical statement about Cimabue. Later writers from Ghiberti to Vasari continued to assert that Giotto was Cimabue's pupil, and Vasari used this to confirm his belief in the traceable rise of Italian art from the 'Greek' (i.e. Byzantine) to the superior art of his own day, by way of Giotto, Masaccio and Michelangelo. Vasari was correct in sensing that Cimabue was the last representative of many trends clinging to late Byzantine traditions, and his importance lay in his example to the next, reforming generation of Giotto. There remains only one work securely by Cimabue (the figure of St John in a mosaic in Pisa Cathedral dating from 1301), but his present day reputation is based on a combination of traditional attributions and modern connoisseurship.

The three principal pieces traditionally accepted as Cimabue's manifest an impressive artistic talent. These are the famous *Crucifix* in Santa Croce, Florence (see plate 46), the *Santa Trinità Madonna* (see plate 58) and a *Crucifixion*, part of a fresco cycle in the Upper Church of San Francesco at Assisi. The white lead employed by Cimabue in the lights of his Assisi fresco has oxidized and turned black, with the result that their original brilliance and most of their detail has vanished. Remarkably, the original dramatic impact of the scene is still hauntingly present, however, and from it one can deduce what Cimabue passed on to his pupils.

Pietro Cavallini

The importance of mosaic decoration in the Dugento and early Trecento (during the Renaissance itself its use survived mainly in Venice) is seen in the work of a Roman painter-mosaicist, who also opened the way to Giotto's developments: Pietro Cavallini (active 1273-1308). He was the most important painter active in Rome, and later Naples (where Giotto was to work in 1329–33). His style united Classical inspiration with the new ideas introduced into sculpture in Rome by Nicola Pisano's pupil, Arnolfo di Cambio (died 1302). Arnolfo worked in Bologna, Siena, Orvieto and Rome and in his role as an architect-sculptor was responsible for the design of both Santa Croce and the Cathedral in Florence. The peripatetic lives of these leading artists gave them much more than merely local renown, and ensured the spread of new ideas so important in later Renaissance art.

Cavallini's career was greatly helped by Pope Nicholas III, who commissioned great fresco cycles in Old St Peter's and the churches of San Paolo fuori le Mura and San Lorenzo in Rome. Sadly, our only knowledge of these lost cycles is through later drawings and paintings, but we know from Ghiberti's *Second Commentary* that Cavallini was responsible for them. The surviving fragments of his frescoes in Santa Cecelia in Trastevere (see plate 44) show that Cavallini was mastering the techniques of modelling with light and shade and architectural foreshortening – features which Giotto later made so much his own. Cimabue visited Rome in 1272, and may also have been influenced by Cavallini.

47 Giotto Enrico Scrovegni Offering his Chapel to the Virgin 1306

This is a detail of the Last Judgement on the entrance wall of the Arena Chapel, Padua. It contains one of Giotto's most memorable profile portraits, showing the donor who paid for the entire chapel in the expiatory act intended to compensate for his father's usury, the source of his great wealth. The same scene shows the usurers hung by their purse strings in Hell. Although Giotto probably entrusted the execution of much of the Last Judgement to assistants, this is certainly by him.

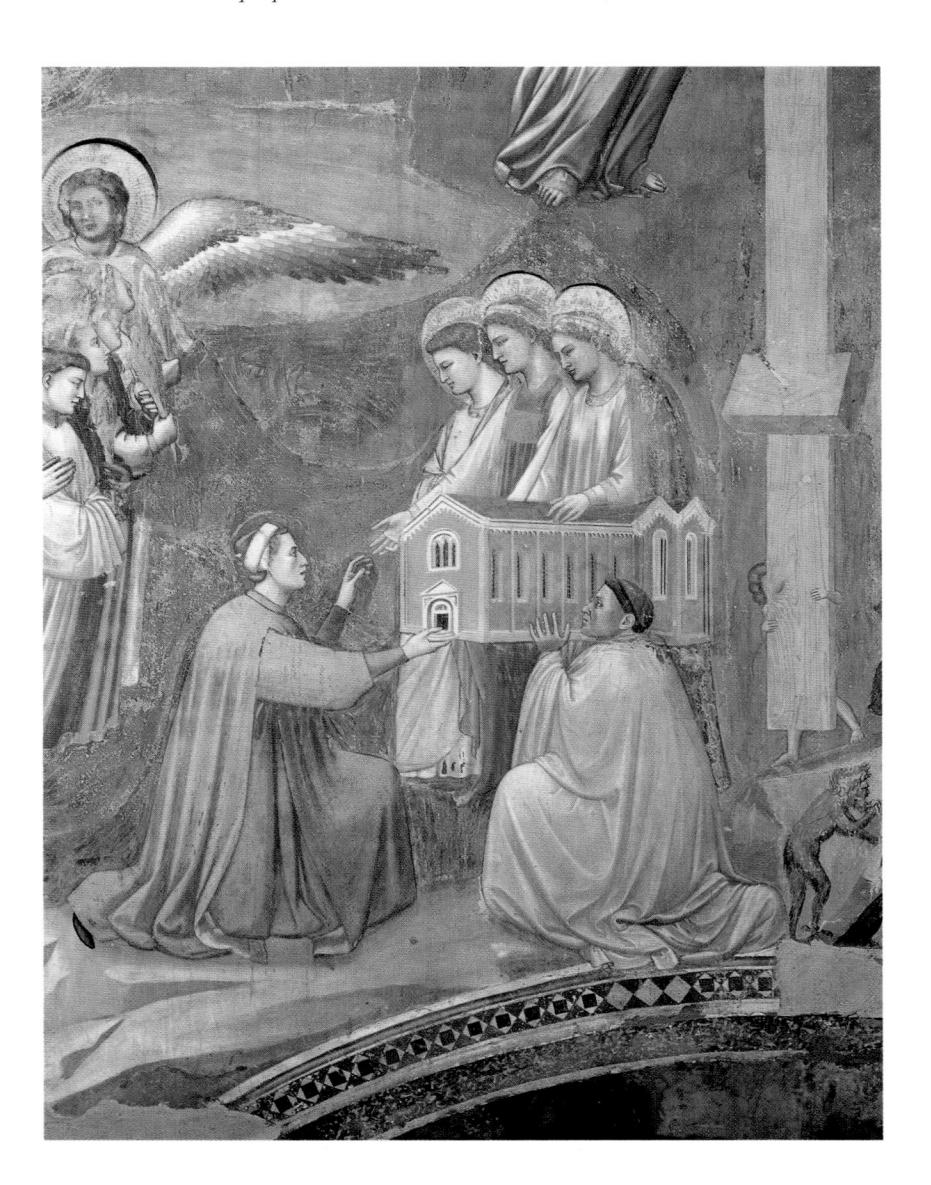

Giotto

It is perhaps indicative of the difficulty for Vasari in understanding this period, that he thought Cavallini was Giotto's pupil. On one thing, however, Vasari was clear – that Giotto (Giotto di Bondone, 1266/7-1337) was the most important artist of his age, having abandoned 'that clumsy Greek manner of painting and arrived at the modern and good way of painting, introducing the likenesses of living people'. Giotto's contemporaries had known this, from Dante and Boccaccio onwards, and their opinion was firmly backed by Cennini ('Giotto translated the art of painting from Greek to Latin'), the poet Angelo Poliziano and Leonardo da Vinci. The poet Petrarch (1303-74) owned a Virgin and Child by Giotto, and said that the ignorant would never appreciate its beauty, which would, however, amaze those who understood art. Giotto was even listed by the mid-century as the only artist among Florence's renowned citizens.

It is significant that Giotto attained considerable wealth through his work. Unlike Cimabue, whose status never seems to have risen much above that of a labourer, he owned houses in Florence and Rome as well as country estates. Giotto came into direct contact with Roman art in all its forms shortly after 1300, when he was employed in Old St Peter's to design the *Navicella* or Ship-of-the-Church mosaic above the cathedral entrance. Of this nothing remains.

Giotto was first documented in Florence in 1301, and his first securely dateable work is also his greatest – the frescoes of 1303–6 in the Arena (or Scrovegni) Chapel in Padua (see plates 47, 56). Fortunately, these are among the best preserved frescoes of the Trecento, and had they been the only example of Giotto's work to survive, would have ensured him a prime position in European painting. They are also clearly the work of a mature and self-confident artist, which assures us that Giotto had had considerable previous experience as a frescoist. Their whole approach is startlingly revolutionary, and their individual parts unrivalled for originality in their period.

Whatever Giotto's previous fresco experience may have been, it probably included work on some of the frescoes in the Upper Church of San Francesco at Assisi (see plate 48). Giotto's precise contribution there is much debated. Many critics insist that certain scenes reveal his beginnings, while others maintain that none of the painting is his. The chronicler Riccobaldo Ferrarese stated in 1312 that he painted there without specifying what, and by the mid-fifteenth century Ghiberti was asserting that he had painted almost all of the lower sections in the Upper Church. In any case, he would have

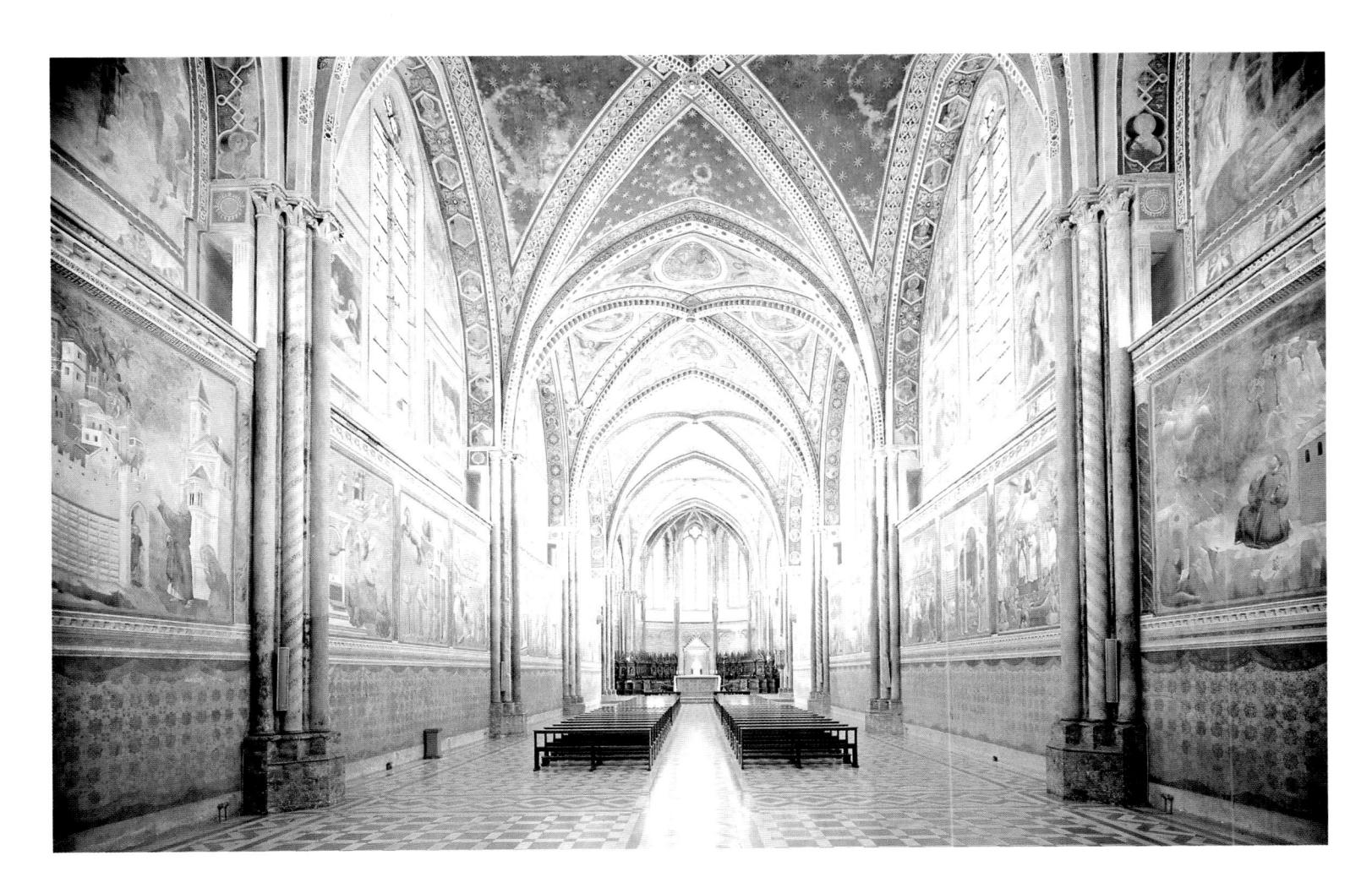

48 Assisi General view of the Upper Church c.1290—1307 The decoration of the single nave was begun c.1290. Vasari initially attributed the twenty-eight scenes from the life of St Francis on the first register to Giotto, and these were probably complete by 1307. It is likely that the decorations were a collaborative effort in which Giotto's naturalism was the most important influence. Four main artists have been suggested, including the St Francis Master and the St Cecilia Master. The saint's life is explored through his relationship with God, Man and Nature as illustrated by episodes from the Legend of Saint Francis by St Bonaventura.

been following directly in the footsteps of Cimabue, who probably worked there around 1280.

If Giotto's hand is still visible, it is in the Stories from the Old Testament on the right wall; The Doctors of the Church and Saints in a vault and arch; and Stories of the New Testament on the left wall and the entrance wall. More securely attributable are the Scenes from the Life of Saint Francis, twenty-eight episodes divided into groups of three corresponding with the church's bays. These contain in embryo much that Giotto later perfected in the Arena Chapel at Padua – individualized portraits, skilful use of space, careful architectural perspective and brilliant dramatic sense in figure composition and in the relationship of figures to their surroundings.

The most striking quality of Giotto's figures in the Arena Chapel in Padua is their convincing solidity – they

are subject to gravity, unlike the flattened, weightless forms of Byzantine painting. Giotto's gift for pictorial narrative in mural decoration is best seen in the Padua frescoes, which are set in sumptuous borders of *trompe-l'oeil* inlays of marble and semi-precious stones. Although Giotto retains some of the influences of Byzantine art, both in form and iconography, his new realism permeates each scene. His ability to reduce certain of the stories to the barest essentials, as in the *Pietà* with its chilling, rocky setting, arises from his genius for abstraction and from his study of Roman relief sculpture. Indeed, throughout the Trecento painters, like their sculptor colleagues, often turned to Roman statuary for direct inspiration.

Giotto's preoccupations were to be taken up by most representational painters in the West, and in this respect his work marks a major turning point. He was the first European painter to exploit the drama inherent in the three-dimensional human form. Examples in the Arena Chapel, such as the seated Saint Anne in the Annunciation to St Anne, are worthy of Masaccio. The Flight into Egypt, a masterpiece of composition uniting figures (and a donkey) in elegant motion against the landscape, forecasts the magical world of Fra Angelico by more than a century. He recreates the beauty of a Classical frieze in The Virgin's Return Home, while The Kiss of Judas concentrates dramatically on the central event through surrounding gesture and movement. Throughout the cycle, the subtly

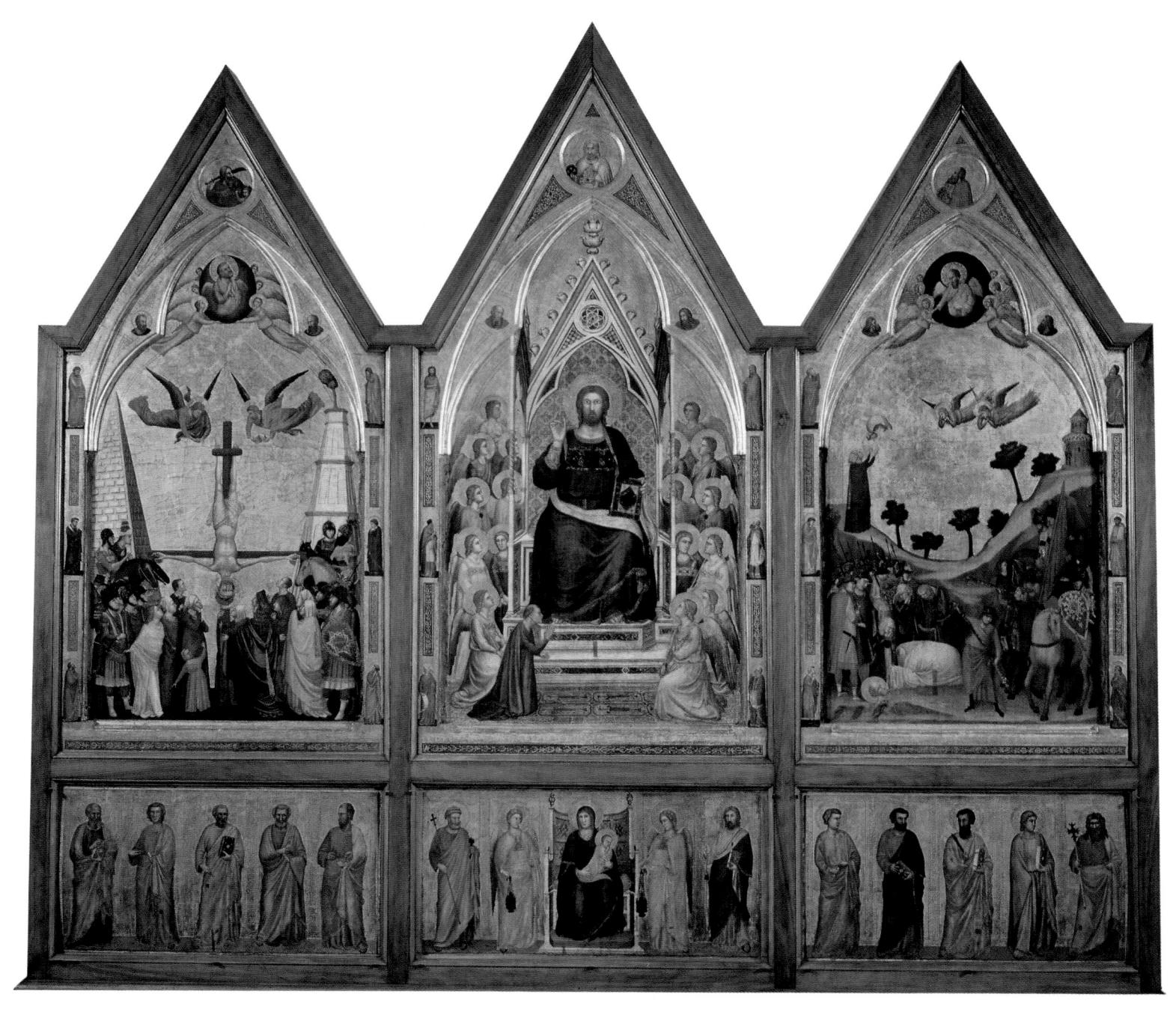

49 Gютто The Stefaneschi Altarpiece с.1300? Although this is one of several paintings bearing Giotto's signature, this may exist only as a guarantee that it came from his workshop. The altarpiece consists of three panels and a predella, and is painted on both sides. It is complete, apart from two of the rear predella panels, which are missing. A late work, it was probably commissioned by Jacopo Caetani Stefaneschi, cardinal deacon of San Giorgio al Valabro, to adorn the high altar of Old St Peter's in Rome. It has been argued that as no major paintings were commissioned during the absence of the Popes in Avignon (1308-77), this altarpiece must date from around 1300. The central panel shows Christ enthroned with angels and the donor, while flanking this are the Crucifixion of Saint Peter (including a view of the famous Pyramid of Cestius in Rome) and the Beheading of Saint Paul. Stefaneschi's portrait in the main panel is comparable in quality with Scrovegni's in the Arena chapel (see plate 47). The predella shows the Madonna at the centre with flanking saints. Cardinal Stefaneschi is shown in the central rear panel offering the entire painting and its elaborate frame to the enthroned St Peter. The altarpiece with predella remained popular until the late 15th century.

changing intensity in the Virgin's expression is carefully studied to accentuate her final sufferings.

Colour also plays a vital role in Giotto's dramas, whether used as a compositional link to lead the eye through a group, or as a highlight with symbolic overtones – Judas's cloak, for example, is yellow for evil. The unity achieved by Giotto within each scene and throughout the whole cycle was one of the elements which attracted later painters, prompting Van Gogh to note nostalgically that Giotto belonged to a balanced world, in contrast to the one in which he lived.

Giotto was the first painter in modern times to seek ways of giving the illusion of reality in paint. Conscious that in nature we see a sum of parts, he knew that each of these must be observed meticulously while never losing sight of the whole. Giotto's art was also revolutionary in exploiting the space in which his figures exist, allowing them to breathe as much as to move.

The chronology of Giotto's panels is hotly contested. His Stefaneschi Altarpiece (see plate 49), for example, is placed by some at the start of his career, by others at the end. He was also responsible for painting secular decorations, now destroyed, which included his *Allegory of Vainglory* of 1335 for a Visconti palace in Milan and his astrological themes in the Palazzo della Ragione at Padua.

After Giotto

Giotto's irresistible narrative, his psychological acuity of expression and gesture, and his conception of man as a being alive and vital in real space, found favour with painters seeking a new and expressive language. His followers in Florence were led by his son-in-law, assistant and pupil, Taddeo Gaddi (c.1300–c.1366). In 1347 Gaddi was described as the city's best painter. His masterpieces are the *Tree of Life* in Santa Croce's former refectory, the *Madonna* polyptych (San Giovanni Fuorcivitas, Pistoia, pre-1345) and the fresco cycle in the Baroncelli Chapel in Santa Croce (probably post 1328) (see plate 50), which

It is possible that Giotto made the layout designs for the frescoes showing the life of the virgin, which occupy the left wall of the Baroncelli Chapel in Santa Croce in Florence. Although they show the influence of Giotto's late style, as seen in the nearby Bardi Chapel, they also reveal a tendency towards a less down-to-earth rendering of their subjects, possibly under the impact of the influential writings of Gaddi's friend the Augustinian Fra Simone Fidati. The episode shown here is the meeting of the Virgin's parents, Joachim and Anne, at the Golden Gate, symbolising the conception of the Virgin. Gaddi's use of brilliant colour and his meticulous attention to detail are remarkable.

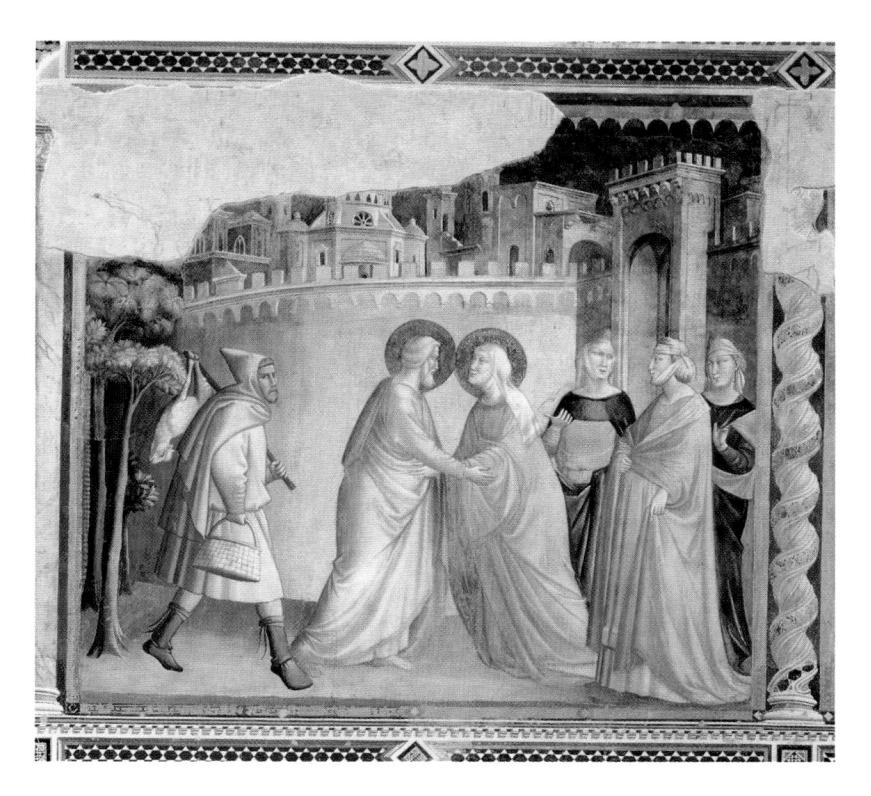

reveals both what he borrowed from his master and what he originated: the assertion that Gaddi did not advance Giotto's achievement is false. With tragic irony for a painter who used such memorable light effects, Gaddi's eyesight was badly damaged when he observed an eclipse of the sun.

Among Giotto's other Florentine pupils and contemporaries were Andrea Orcagna (Andrea di Cione, died 1368/9), a proficient architect, sculptor, painter and mosaicist; Bernardo Daddi (active 1290–c.1349?) (see plate 60); and Maso di Banco. Maso, who appears to have been active mainly in the second quarter of the fourteenth century, was ignored by Vasari, but accredited by Ghiberti with the frescoes of The Legend of Saint Sylvester in the Bardi Chapel at Santa Croce. On this basis other attributions have been made. Maso was documented as being in Florence in 1343-50 and probably drew his style from Giotto's Peruzzi Chapel work. Like Gaddi, Maso seems to indicate that the high drama of Giotto proved too much for the next generation, which, under the influence of a changing religious climate, preferred a more mystical interpretation of religious themes. Maso's masterpiece may be the delightful Saint Sylvester Quelling the Dragon, which already shows the new trends towards a more delicate interpretation of the human figure and its surroundings.

Sienese Art

From the mid-fourteenth until the mid-sixteenth century, Siena's history was deeply troubled, and Florence continually attempted to gain control of the city. In Siena, as in Florence between 1348 and 1380, the return of the plague led to a supreme consciousness of death, resulting principally in a greatly increased veneration of the plague saints, Sebastian and Roch (Rocco). The former took on this role through his failure to die when first shot with arrows; the latter was habitually depicted with his conspicuous plague 'bubo' on the inner thigh.

It was also the age of Saint Catherine of Siena (?1347–1380), whose intense involvement in religious and political affairs (she corresponded with the Popes and even the English adventurer, Sir John Hawkwood – see plate 75) reflected the extreme piety of her period in Siena. Partly under the impact of the Franciscans, Sienese veneration for the cult of the Blessed Virgin Mary visibly increased, and Siena became known as 'the ancient city of the Virgin'. Duccio's *Maestà* (see plate 59) is perhaps the supreme pictorial realization of the Virgin as 'Queen of Heaven'. On completion it was carried through the

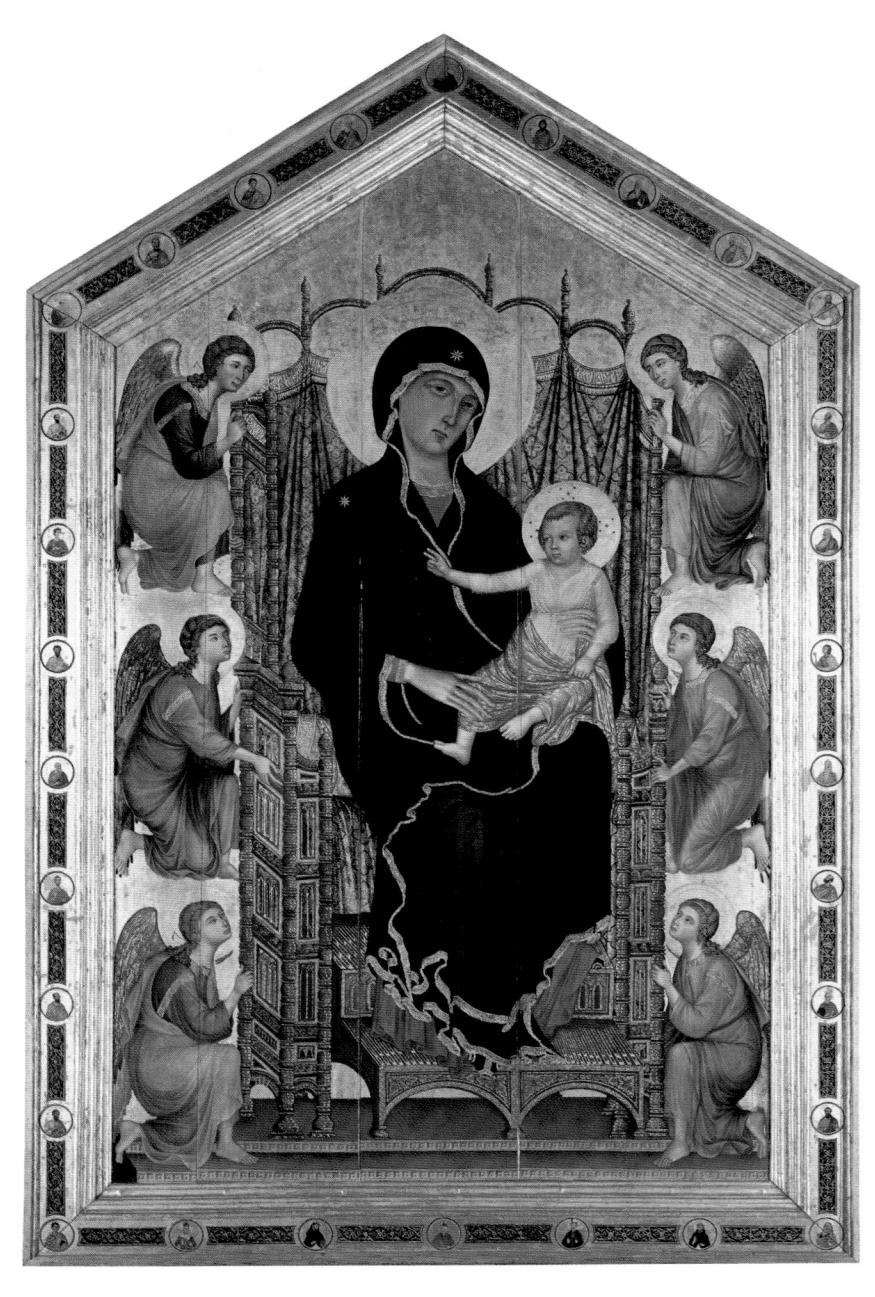

51 DUCCIO The Rucellai Madonna c.1285
Painted for the Rucellai Chapel in the great Florentine Dominican church of Santa Maria Novella, this painting, which is similar in style to Cimabue's work, illustrates the strong links between Florence and Siena in the late thirteenth century.

52 Duccio Christ's Entry into Jerusalem (detail of the Maestà) 1308–11

The Maestà (the Virgin in Majesty) was commissioned in October 1308 for the high altar of Siena Cathedral, and is the first altarpiece whose predella panels survive. In addition to the central panel of the Virgin and Child Enthroned with Saints and Angels, the predella shows seven scenes from Christ's early life flanked by figures of prophets, and scenes from the Virgin's last days in the pinnacles. The back panels depict the life of Christ, with scenes from His ministry in the predella and thirty-four scenes of the Passion behind the central panel.

streets of Siena to the ringing of church bells and triumphal music-making.

In its elegance, decorativeness and refined spirituality, Sienese art at this time reveals characteristics independent of painting in Florence, and it continued to maintain this separateness. For example, there is no Florentine equivalent in the sixteenth century to Domenico Beccafumi, whose peculiar form of religious intensity might be said to have originated in the fourteenth century.

Duccio

Duccio (Duccio di Buoninsegna, active 1278–1319) is the artist whose name dominates the Sienese Trecento and who parallels Giotto. However, unlike Giotto, he was not renowned as a frescoist, and is closer in many respects to

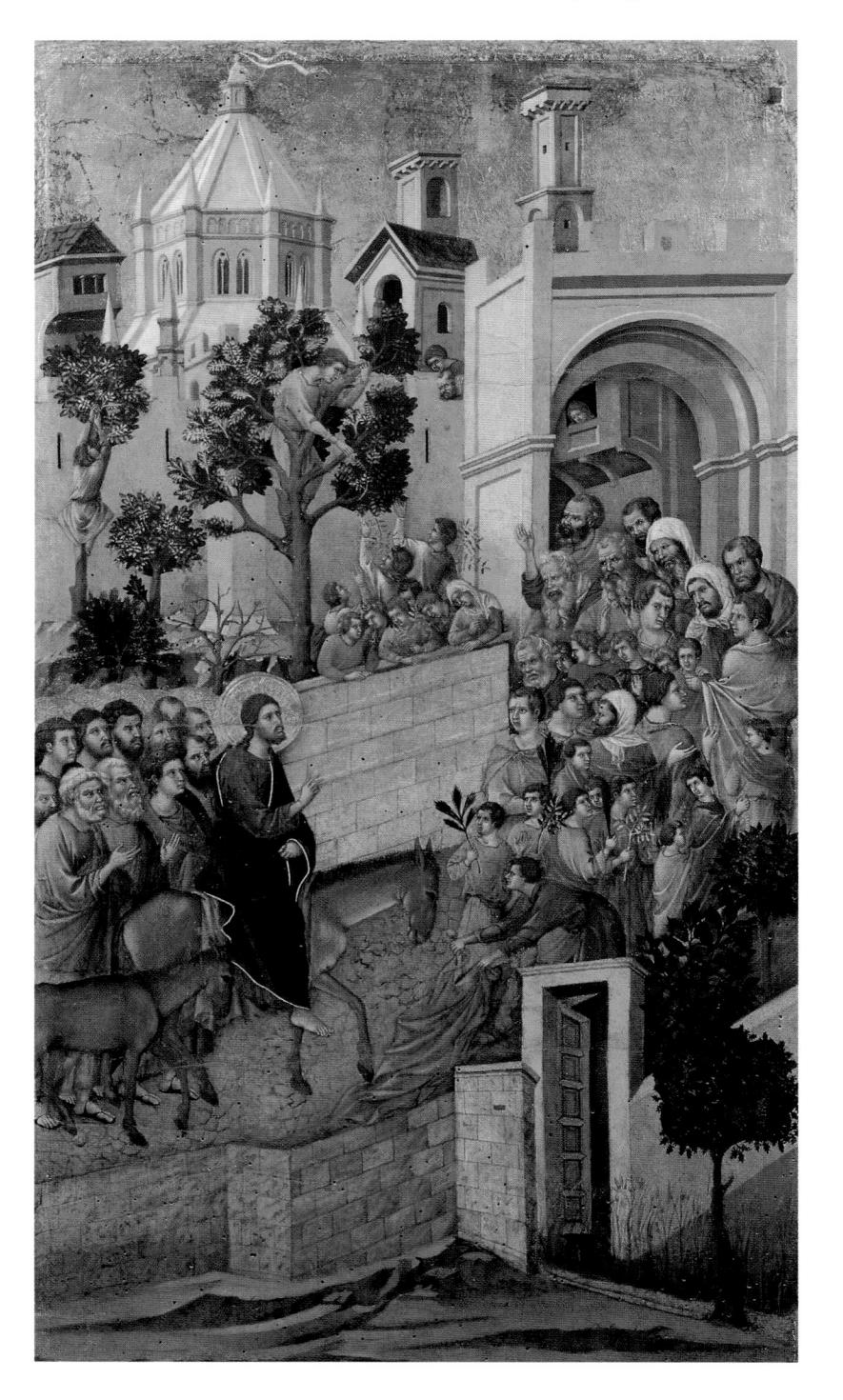

Cimabue. Although we know almost nothing of his life, it appears that he was convicted for several minor criminal offences, possibly including sorcery. Giovanni Pisano's sculpture exercised a strong influence on Duccio, whose only fully documented work is the *Maestà*. This spectacular achievement, so different from Giotto in its jewel-like conception of the world, demonstrates the continuing influence of Byzantine art. Duccio's vision – as if he is looking through the wrong end of a telescope – unifies his compositions, making the settings, particularly the interiors of rooms, as important as the figures. His approach is totally at variance with Giotto's more careful balance in favour of his figures.

However, Duccio's large Rucellai Madonna (see plate 51) and the central panel of the Maestà (see plate 59) show that he was capable of immense grandeur, created by large forms rather than the accumulation of brilliant small ones. The comparison of the Rucellai Madonna with Cimabue's Santa Trinità Madonna (see plate 58) shows similarities of intention, although Cimabue lacks Duccio's warmth, charm and love of decorative outline. Duccio was certainly alert to the sensuousness of French Gothic manuscript illuminations and even stained glass, and possibly the most enduring memory left by contemplation of the Maestà is its mixture of glowing and dazzling colours. In spite of his dependence on Byzantine forms, Duccio's passion for detail studied direct from nature, and for individual facial expression, place him firmly in the avantgarde alongside Giotto.

Simone Martini

Four years prior to Duccio's death, Simone Martini (c.1285–1344) dated his own *Maestà* (see plate 61), an immense wall fresco in the Great Council Chamber of Siena's Palazzo Pubblico. Simone represents the Sienese break with Florentine monumentality in favour of a sweeter, more delicate concept of line, colour and form. This had been incipient in Duccio, but under the impact of International Gothic sinuousness openly developed after him.

In 1317, King Robert of Anjou summoned Simone to his court at Naples. The artist was knighted, given a pension and commissioned to paint the *Saint Louis Altarpiece* (Museo di Capodimonte, Naples). Among the most striking images of kingship in Italian art, this commemorated the canonization of the King's brother, Louis of Anjou, bishop of Toulouse. Robert wished to promote this event to establish Angevin supremacy in central Italy and his own divine right. The regal splendour of the painting,

with its distinct flavour of international court life, finds further reflection in Simone's ten frescoes showing *The Story of Saint Martin*, in the Montefiore Chapel in the Lower Church of San Francesco at Assisi. *Saint Martin Renouncing the Sword* reveals his passion for sumptuous, overall decorative pattern in textiles and armour. This culminates in his famous Uffizi *Annunciation* of 1333, which Simone painted with his brother-in-law, Lippo Memmi (active 1317–47), who, like Simone, worked at the Papal court in Avignon. Only traces remain of Simone's grand Avignon frescoes, but they certainly had a massive impact on French art, notably that of the manuscript illuminator Jehan Pucelle (*c*.1300–*c*.1355) and on the development of the International Gothic style.

53 SIMONE MARTINI The Apotheosis of Virgil 1340
This formed the frontispiece to a manuscript commentary on Virgil owned by the poet Petrarch (1304–74), for whom Simone also painted a portrait of Petrarch's beloved Laura, now lost but recorded in his sonnet: 'it . . . can be imagined only in Heaven, not here among us, where the body is a veil to the soul . . .' Petrarch also owned a painting by Giotto.

In 1328 Simone painted one of the first equestrian portraits since antiquity in his fresco of the *condottiere* (mercenary leader) Guidoriccio da Fogliano, opposite the *Maestà* in Siena's Palazzo Pubblico. The towns of Montemassi and Sassoforte, liberated by Guidoriccio, appear in the background, the whole constituting a most satisfying combination of figures and landscape.

Pietro and Ambrogio Lorenzetti

It is thought that Simone's only rivals in quality, the Sienese brothers Pietro and Ambrogio Lorenzetti, both died in the Black Death of 1348, and often worked together on commissions. Vasari claims that Pietro was an even finer painter than Giotto. What is certain, however, is that the brothers had strong connections with Florence, and probably spread Sienese ideas there. Pietro was certainly immensely gifted, and a great colourist, as his Birth of the Virgin shows (see plate 62). But it was Ambrogio who left the most striking legacy in the form of the first pure landscape painting in European art, the huge frescoes of Good and Bad Government in Siena's Palazzo Pubblico (see plate 64). This immense achievement takes its inspiration from a surprising breadth of sources. From a Roman sarcophagus in the Palazzo Pubblico itself, Ambrogio borrowed a figure for his beautiful personification of Peace, and a flying figure of Security derives from a Classical Victory figure. Never again was Ambrogio able to unite such a variety of inspiration in any work of art, and his landscape achievement in these frescoes found no immediate following.

The Later Trecento

Tuscan painting during the second half of the century showed little indication of the immense flowering of talent that was to follow in the Quattrocento. The 1340s brought disaster after disaster to Italy, on an apocalyptic scale. Eight years before the Black Death, in 1340, more than 15,000 souls perished in an unidentified epidemic in Florence, which had been weakened by fire and seige earlier in the century. The failure of previously great banks in Siena and Florence (particularly the Peruzzi and Bardi in 1343 and 1345) led to economic disaster. The Church seized the opportunity to impose a sense of guilt on a populace already terrified by near-anarchy in many places, and to emphasize the need for repentance, restraint and a rethinking of priorities.

Giovanni Villani (c.1276–1348), who died in the

plague, wrote a highly esteemed *Chronicle*, which assembled facts scientifically. It presents with frightening clarity the prevailing atmosphere of dread of divine punishment ('because of our outrageous sins'). This partly accounts for the sudden popularity of *The Triumph of Death* theme in Italian art (see plate 63). It also lies behind the literal and graphic transcription of Dante's elaborate system of the nine circles of Hell in Nardo di Cione's *Inferno* fresco painted in the Strozzi Chapel in Santa Maria Novella, Florence.

The most important influence in later Trecento Florence was that of Andrea Orcagna and his brothers, Jacopo di Cione (active 1365–98) and Nardo di Cione (active 1343/6–65/6). Orcagna's style was reflected in the work of Taddeo Gaddi's son, Agnolo Gaddi, (died 1396), with its sharp outlines, flattened forms and hard, unrealistic rendering of texture. Agnolo Gaddi's pupils included Spinello Aretino (active 1373–1410/11) and Cennino Cennini, famous for his treatise on painting (see Chapter II).

The story of Trecento painting can be told largely in Tuscany, and where it flowered outside Tuscany, it was usually because of the travels of Tuscan painters such as Giotto or Simone Martini. Cavallini in Rome provided an exception, but it was Giotto's presence in Rimini some time before 1302 which directly affected painters in Emilia and the Romagna. Bologna, noted for its miniaturists, produced Vitale da Bologna (c.1309–61), while Tomaso da Modena (c.1325–pre-1379) appears to have been influential in transmitting Italian ideas to Northern Europe. In about 1360 he painted two Madonnas for the Emperor Charles IV at Karlstein near Prague, and these paintings in turn influenced Master Theodoric of Prague.

Petrarch regarded the Venetian Republic as a mundus alter - 'a world apart' - and, compared with the glittering array of talent produced there in the Quattrocento and Cinquecento, few names stand out in the Trecento. The exceptions include Paolo Veneziano (died c.1362), official Painter to the Venetian Republic, and Altichiero (c.1330-c.1395) from Zevio, near Verona. Altichiero is an underestimated artist capable of great charm (see plate 65), whose passion for botanical detail looks forward to the intricate world of Pisanello in the Quattrocento. Veneziano or 'Maestro Paolo' was influenced mainly by Paduan and Florentine painting including Giotto, although he retained many Byzantine features. These are most visible in the famous Pala d'Oro (see plate 67), whose preciosity was typical of much post-Giottesque painting, soon to be rejected in the first flush of the true Renaissance.

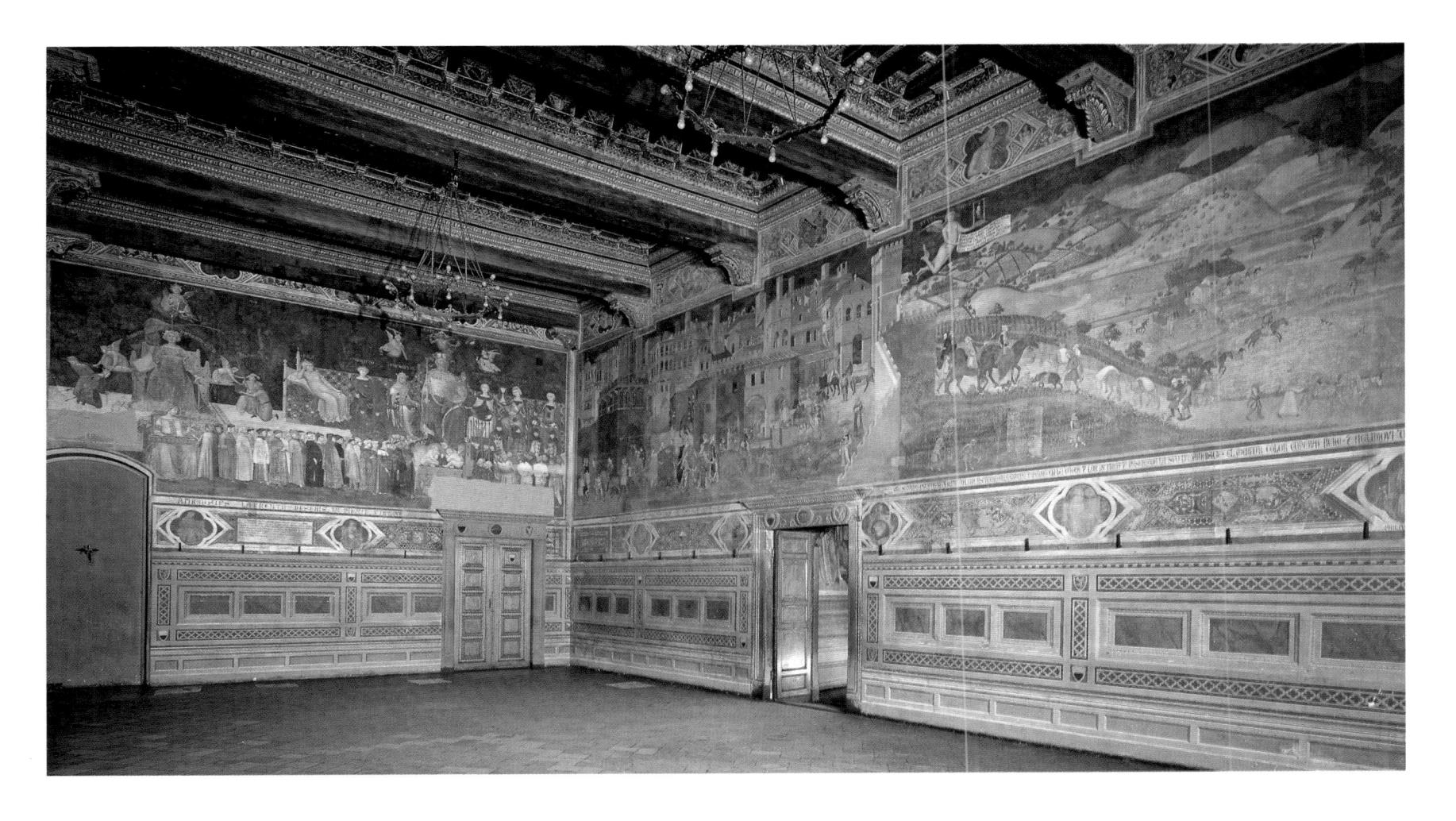

54 Ambrogio Lorenzetti Allegories of Good and Bad Government 1338–9

Lorenzetti's allegorical frescoes on the theme of good and bad government fill three of the walls in the Sala della Pace, or council room, in Siena's Palazzo Pubblico. The intention is clearly didactic. The Effects of Good Government in the Town and Country (see plate 64), which follows on from the Allegory of Good Government, includes a remarkable panorama of the city and landscape around Siena.

This sumptuous combination of picture and frame (formerly part of a triptych for Siena Cathedral) is one of the high points of Sienese Trecento painting. Its remarkable control of perspective seems almost a century in advance of its time: in the same year, Pietro was striving for similar effects of convincing depth in his Birth of the Virgin (see plate 62). Ambrogio, however, created a more highly controlled figure group perfectly related to its setting, whose simple monumentality is striking for its date and a foretaste of Quattrocento achievements.

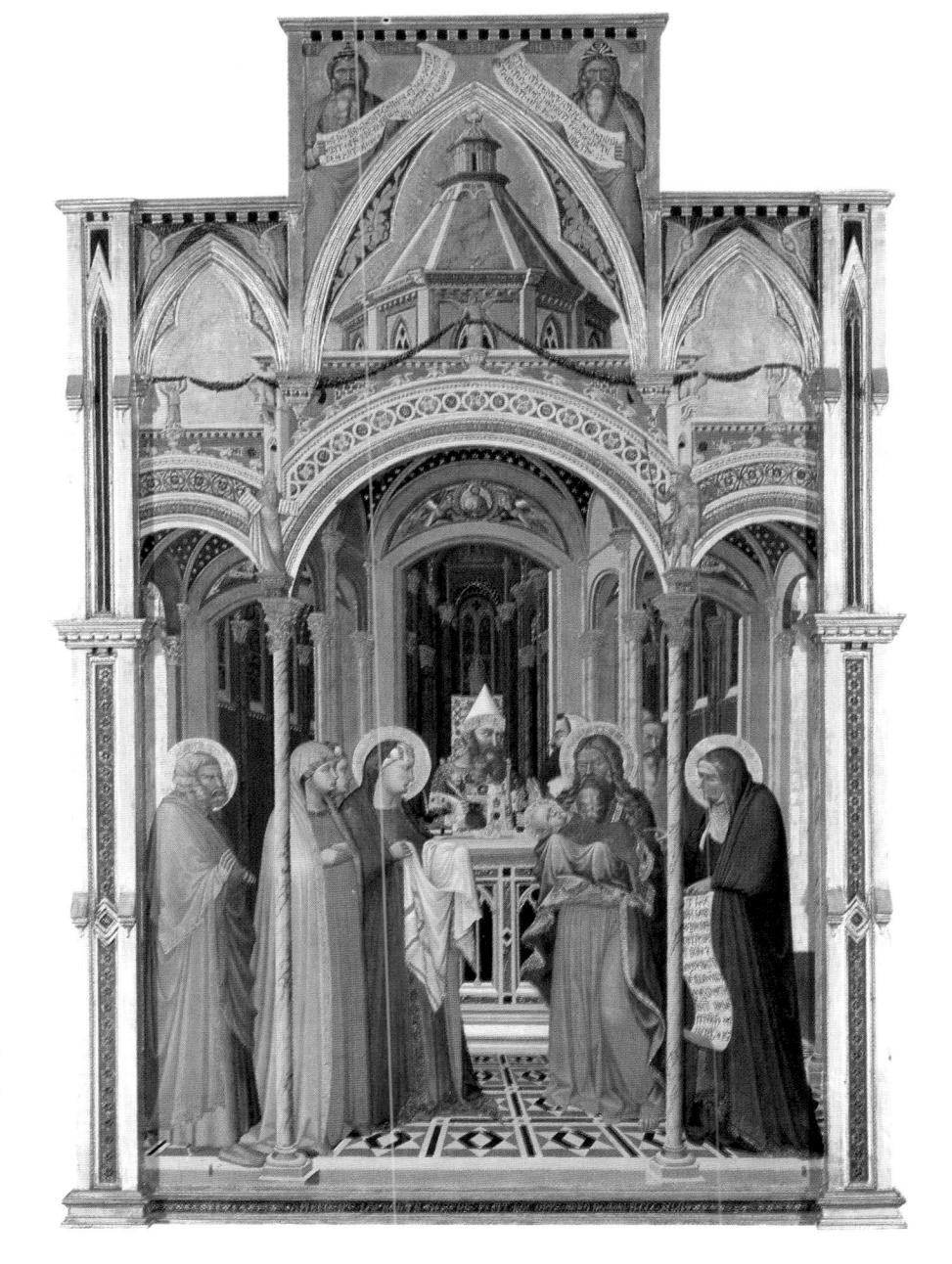

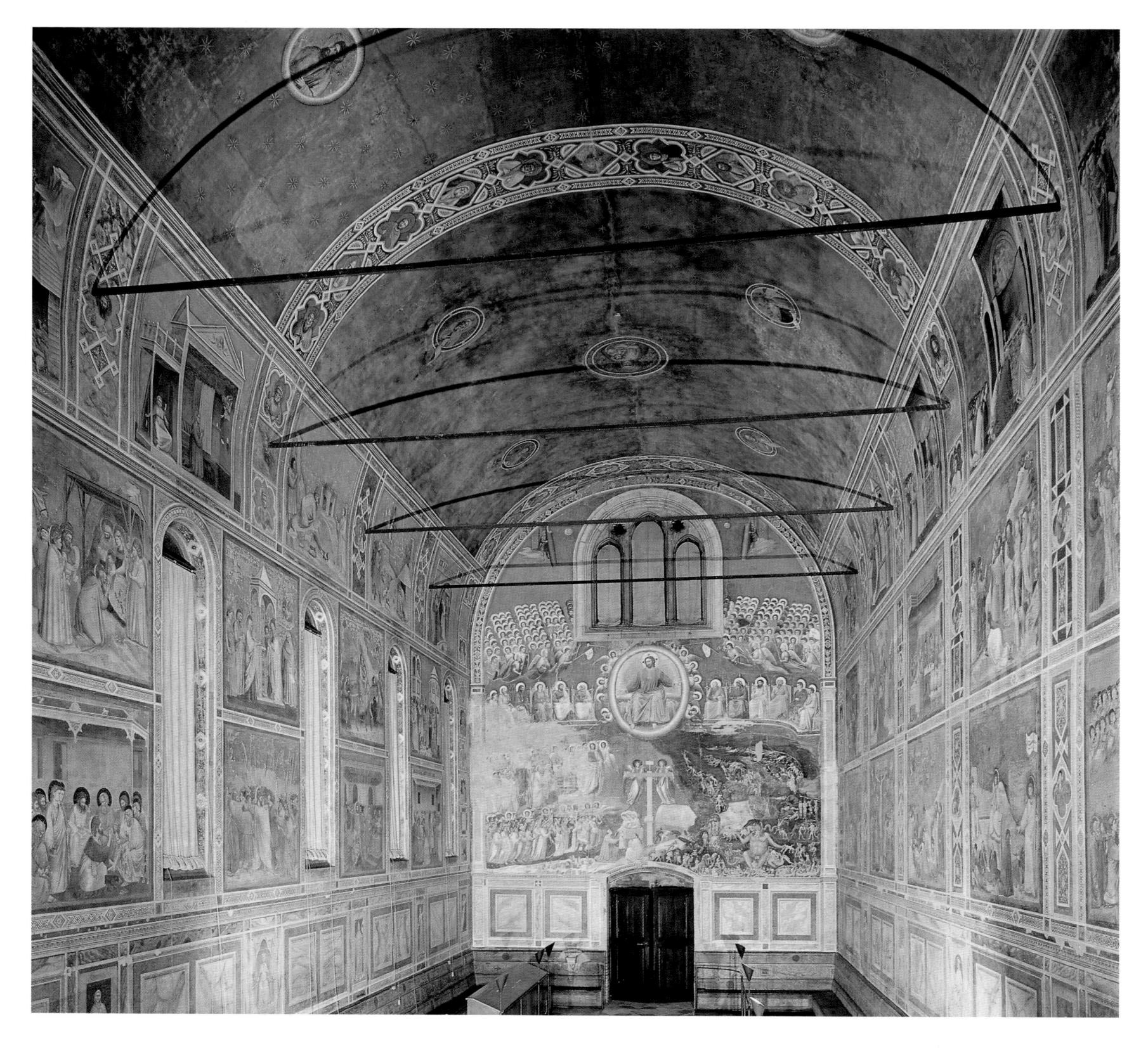

56 Giotto Arena Chapel, Padua 1303-6

Giotto may have actually designed the chapel, which has no distracting internal architectural features, and it seems that he had limited assistance in its decoration. The frescoes' iconography is new and very complex, referring to the reasons for the chapel's foundation and to an earlier church on the site dedicated to the Virgin Annunciate. It was probably influenced by the writings of Bishop Sicardo (c.1155–1215), who demanded that images in churches should show the laity 'things past (stories and visions) and direct their minds to the present (virtues and vices) and the future (punishments and rewards).' The stories, painted on three levels, portray the lives of the Virgin and Christ and preceding episodes. Above the tribuna arch is an Annunciation (including a debate in Heaven leading to Gabriel's announcement of the Incarnation), symbolizing the entry of Divine providence into human life.

57 Giotto Ognissanti Madonna c.1305–10

Neither signed nor documented, this is universally regarded as one of Giotto's unquestioned masterpieces, particularly for the grandiose sculptural concept of the seated Madonna. The only panel by Giotto of comparable quality and grandeur is his Crucifix in Santa Maria Novella, Florence. In this Madonna, the whole image is monumental in a way that would have been inconceivable if the painter had not been used to the scale and breadth of concept of fresco painting. In her scale, the Madonna suggests an overwhelming (and somewhat severe) presence, in deliberate contrast to the delicacy of the angels and the Gothic canopy of her throne.

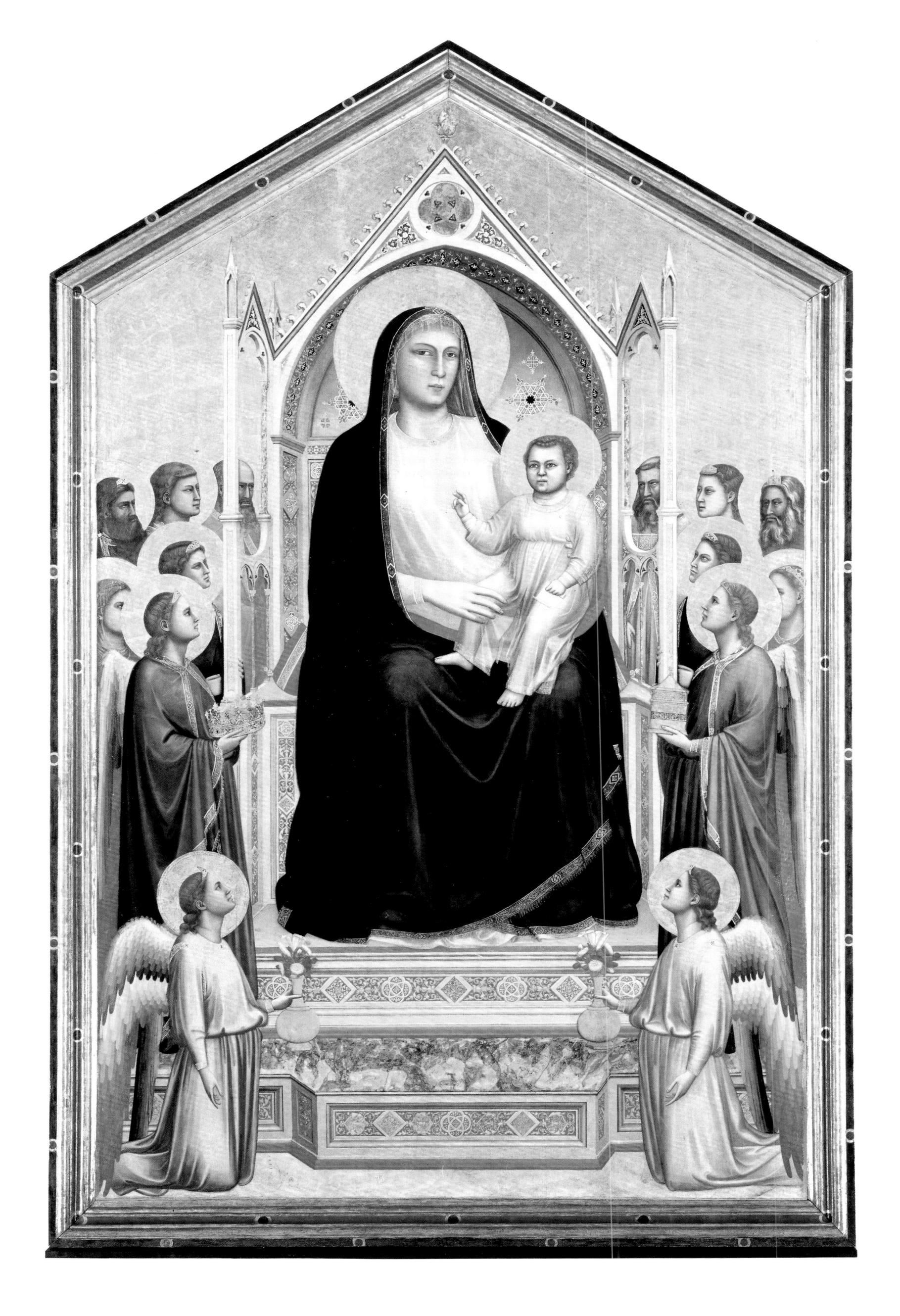

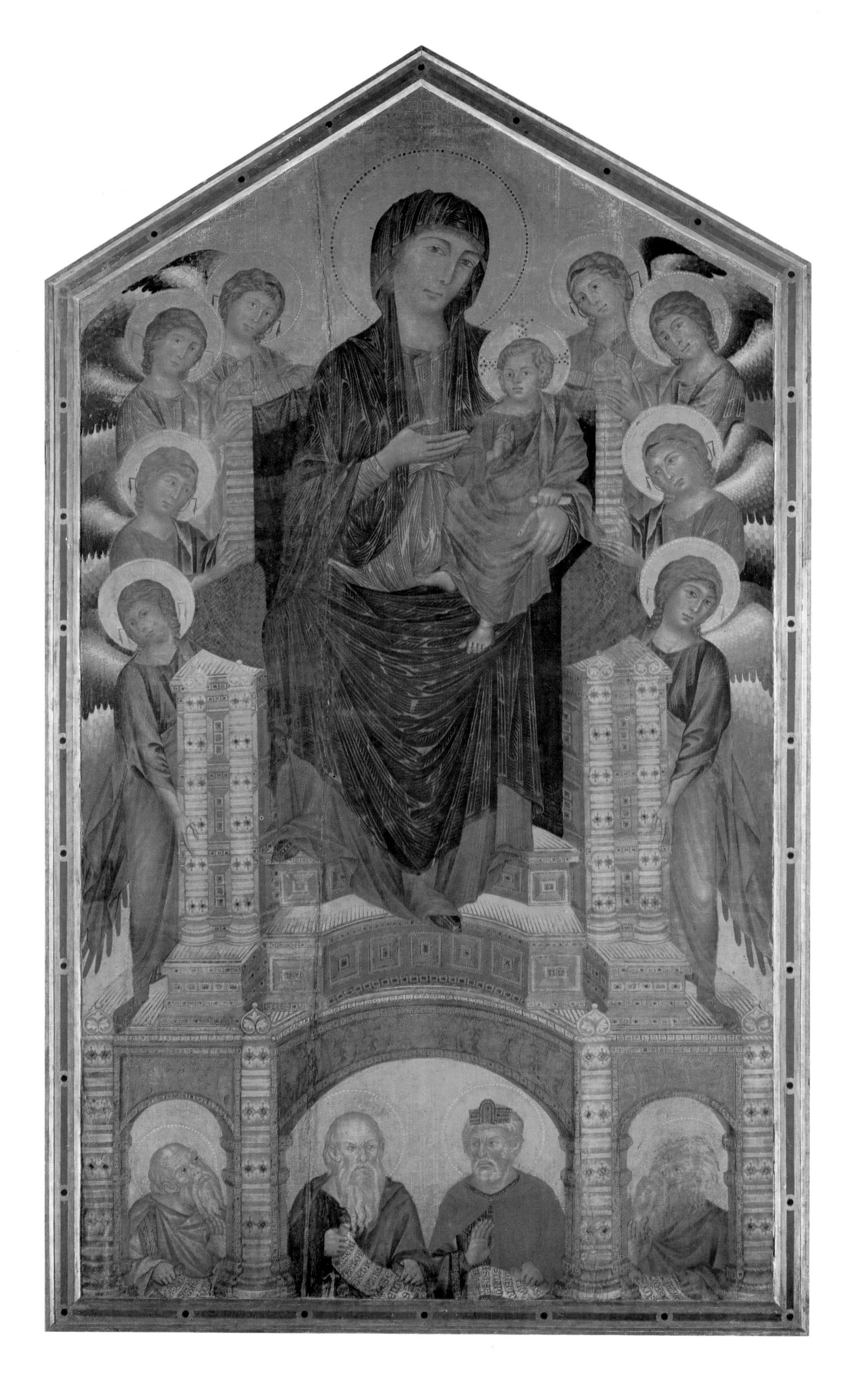

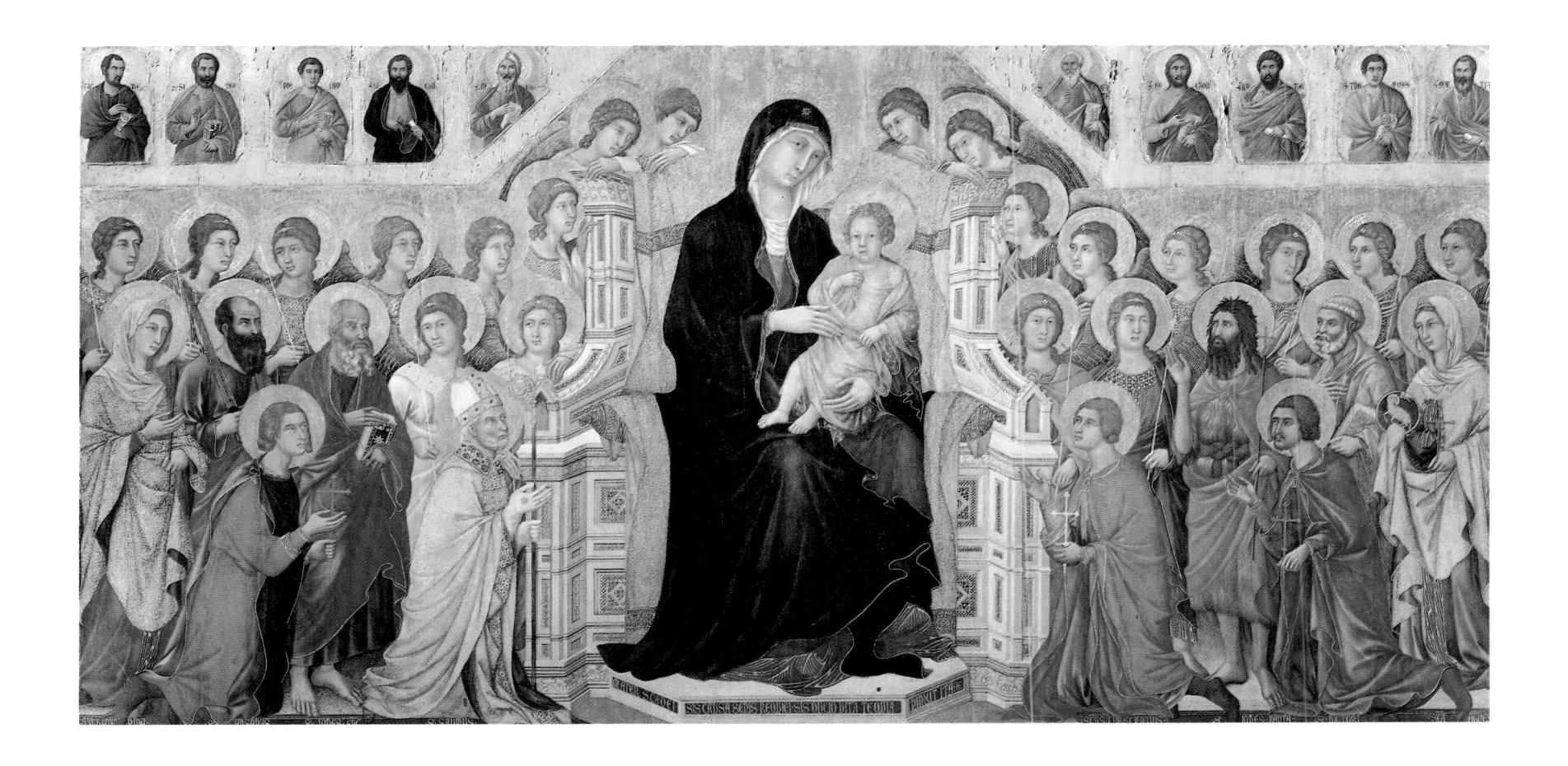

58 CIMABUE Santa Trinità Madonna early 1280s (Left) This was painted for the high altar of the Florentine church of Santa Trinità. With its elaborate gilt throne and stylized drapery folds, it conforms to the traditional Byzantine Madonna type and its composition strongly resembles Duccio's Rucellai Madonna. Below the throne are the prophets Jeremiah, Abraham, David and Isaiah.

59 Duccio Madonna and Child with Saints and Angels 1308–11

(Above) This is the front of Duccio's Maestà, commissioned in October 1308 for the high altar of Siena Cathedral. After the Sienese victory over the Florentines at the Battle of Montaperti, Siena had been placed under the Virgin's protection, with the implication that as 'Queen of Heaven' she was also Queen of Siena. The Maestà celebrates the Virgin in this role. As originally painted, the whole altarpiece included seven scenes from Christ's early life, flanked by the prophets who had foretold the events. In the pinnacles above were scenes of the Virgin's last days, probably culminating in her coronation. The scenes at the back of the altarpiece showed the Life of Christ in many panels.

60 Bernardo Daddi Madonna and Child 1346–7 (Right) Set in Andrea Orcagna's famous tabernacle of 1359, this eventually replaced a renowned miraculous image of the Virgin destroyed by fire in 1304. This Madonna, with her exquisite elegance and intimacy, is the finest example of Daddi's mature style. The painting rejects the grandeur of Giotto, and it shows that Daddi catered for the increasing demand for the private devotional paintings introduced by Duccio, in which details like the playful child play an important part.

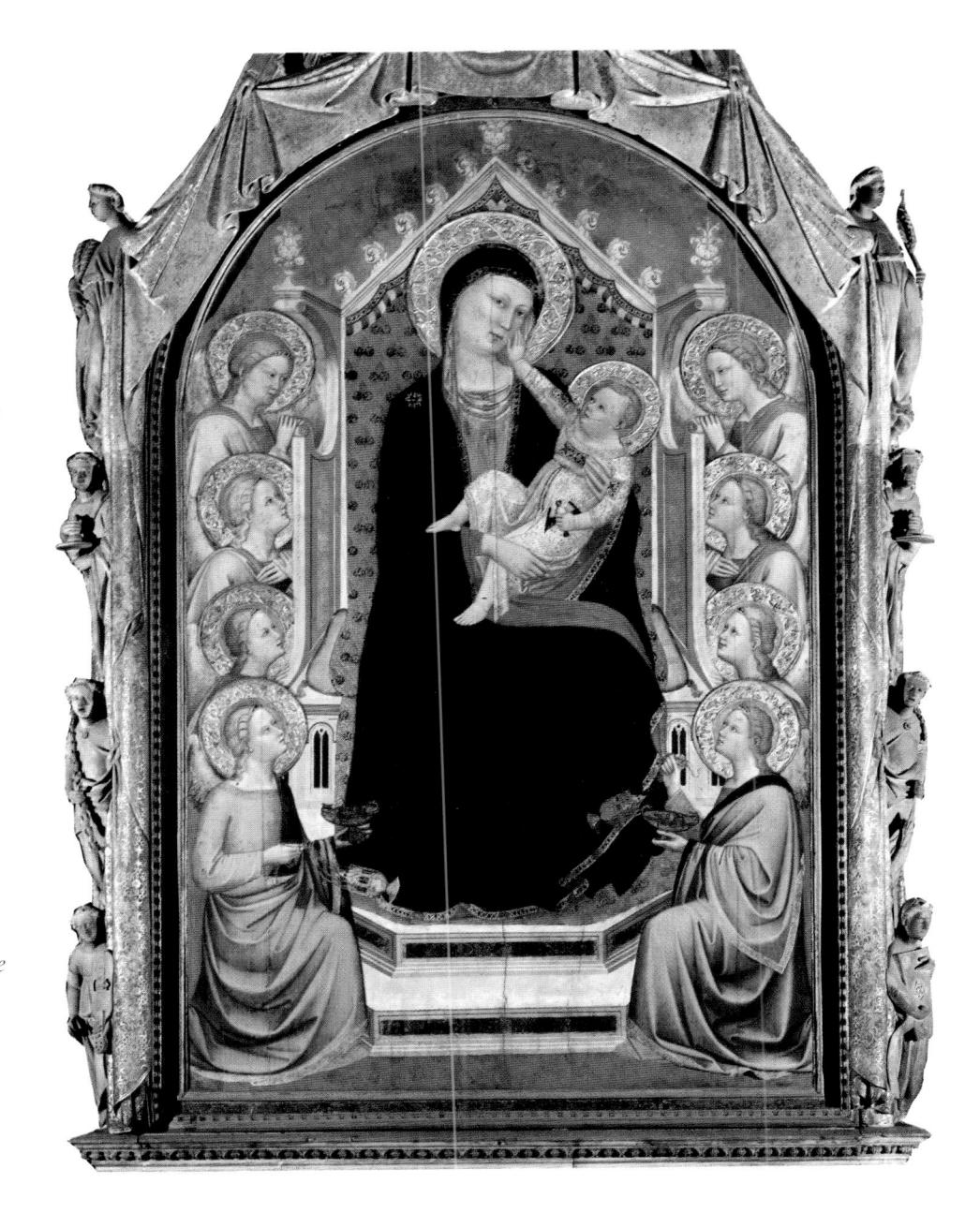

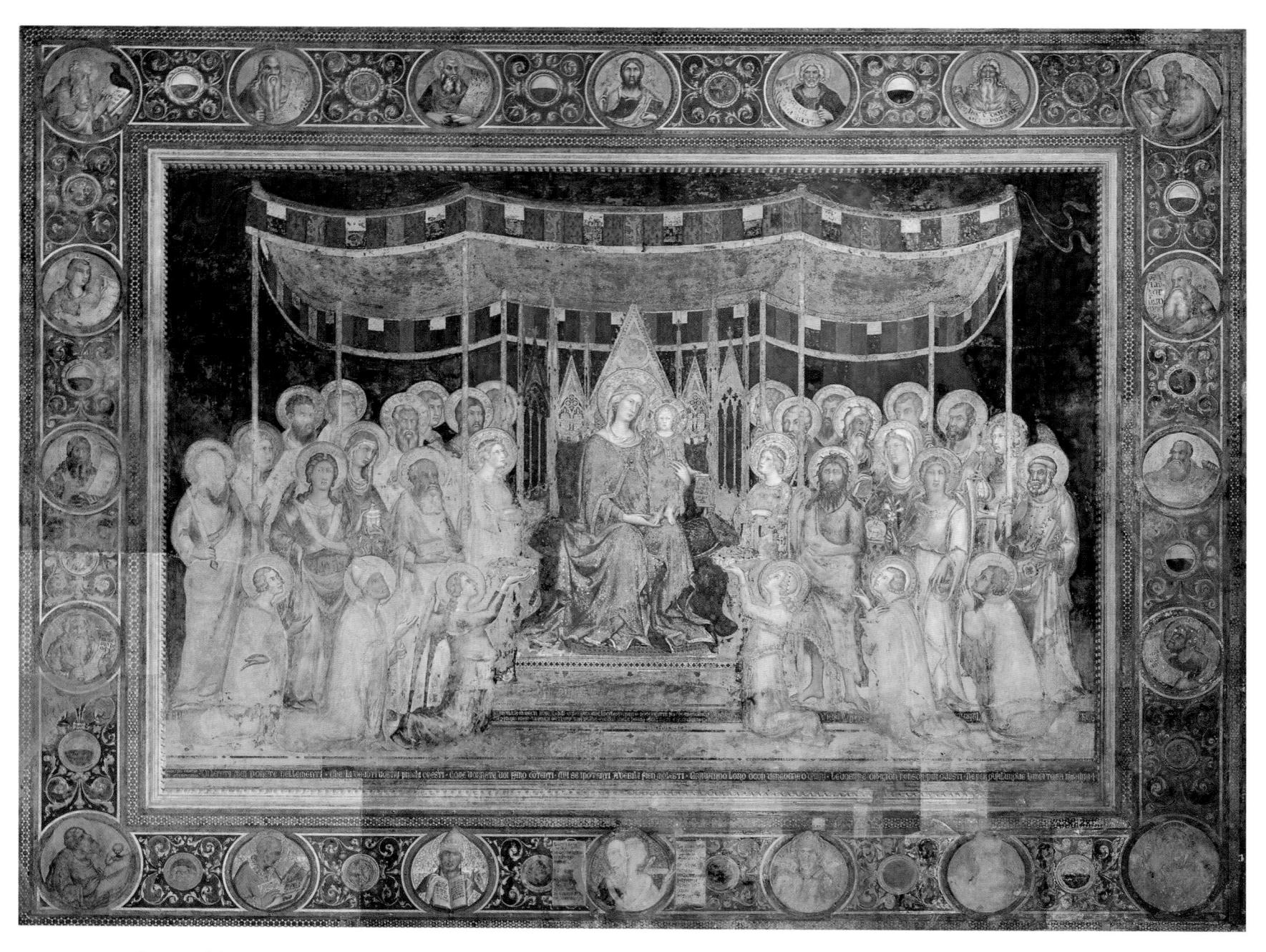

61 Simone Martini Maestà 1317

Simone's greatest work, this clearly shows the direction Sienese painting was to take after Duccio's death. The Virgin has a Byzantine remoteness, but this is coupled with monumentality, Gothic elegance and the desire – ultimately from Giotto – to render the scene tangible with a centralized architectural perspective and light. The consoles seen in perspective, and the lighting in the fresco 'deriving' from the actual windows all point to a desire to extend our experience with fictive space. The Virgin has a dual role as Queen of Heaven and Siena, and two verses beneath her throne plead that wisdom and justice should prevail in her city. They open with the words: 'The angelic flowers, the roses and lilies with which the celestial meadowland is adorned do not delight me more than good counsel. But I see those who for their own ends despise me and lead my country astray.'

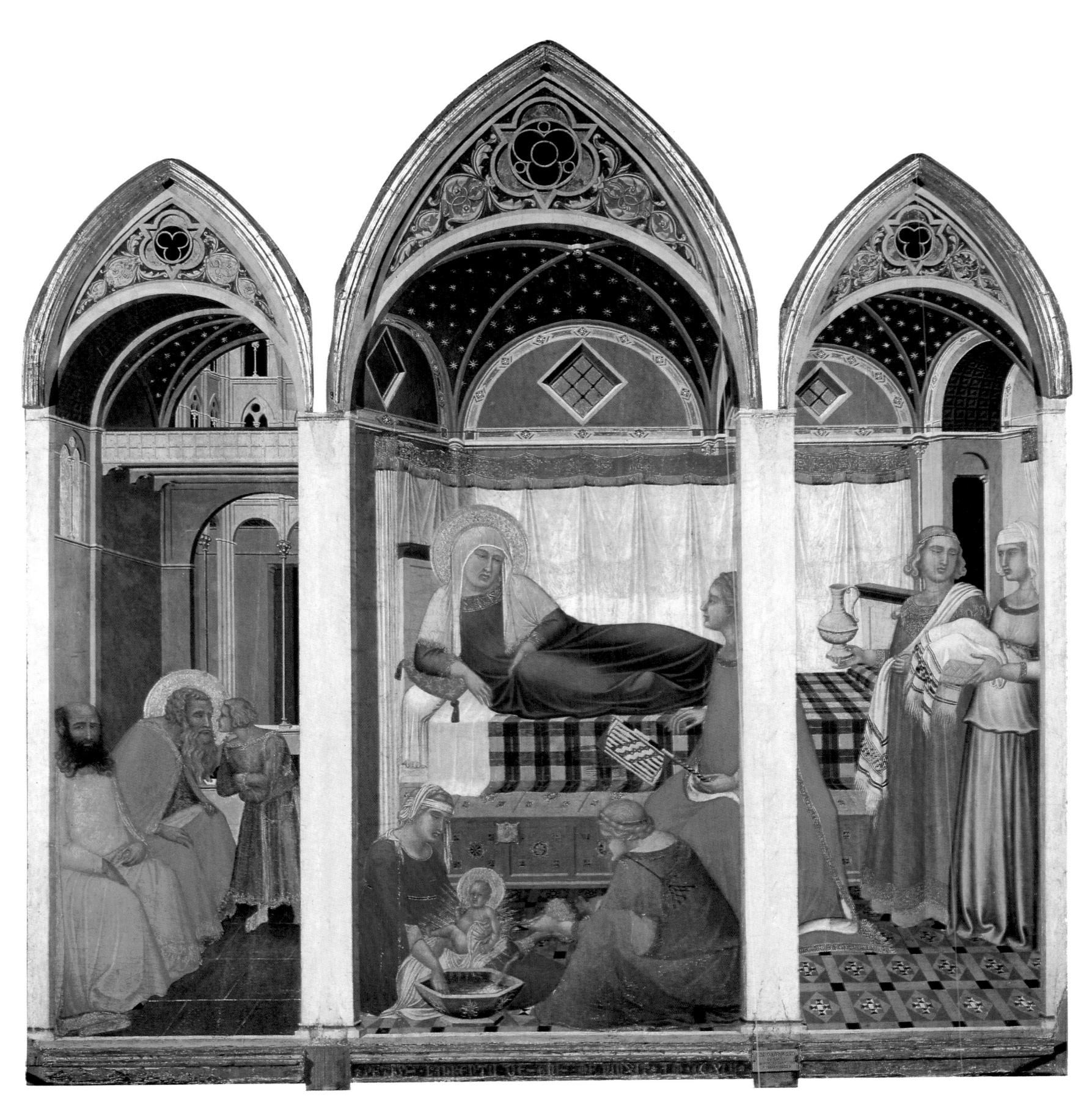

Pietro Lorenzetti Birth of the Virgin 1342

Painted for Siena Cathedral, this and Ambrogio's Presentation of the same year (see plate 55) stand as two of the period's most striking uses of perspective. Here, the principal interest is Pietro's evocation of a contemporary domestic interior, with lavish tiled floor, fabric-hung walls, and a bed characteristic of the period, raised on a decorated wooden base. The skilful continuation of space throughout the triptych, with the birth occupying two parts, and the anxiously awaiting male figures outside, creates a restrained drama in which detail plays an important role.

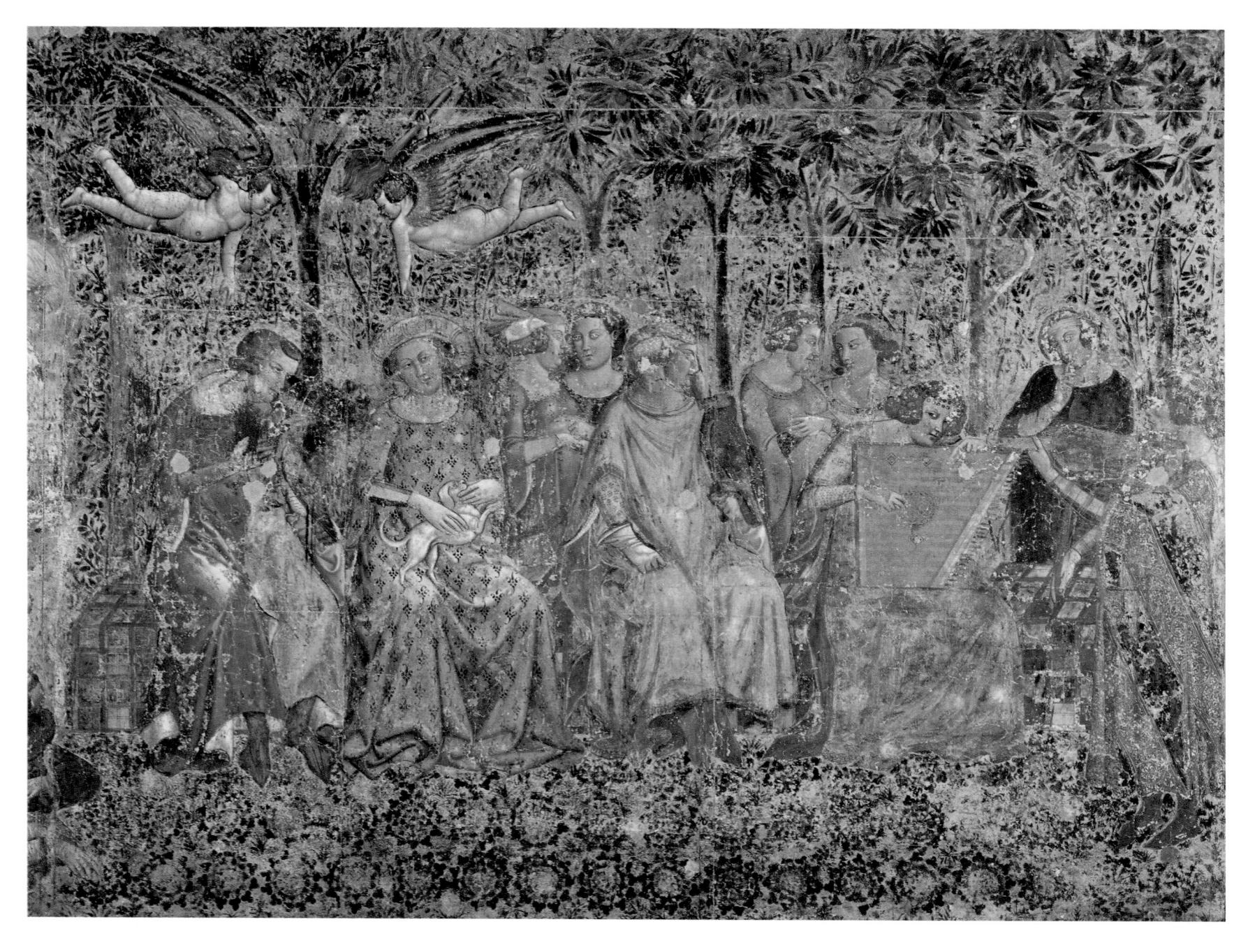

63 Master of the Triumph of Death Music-making in a Garden, pre-1348

The attribution of the Triumph of Death and its related frescoes remains uncertain, and its iconography is novel, particularly in the attention devoted to the scene of Hell. Once thought to refer to the major plague outbreak of 1348, the frescoes are now considered earlier. Here, a group of elegant young people evoking the atmosphere of the Decameron enjoy themselves in a garden, oblivious to the hideous fate awaiting them close at hand. Two flying amorini deriving from antique examples may allude to the transience of earthly love. The brevity of life at this time renders the scene all the more poignant.

64 Ambrogio Lorenzetti The Effects of Good Government in the City 1338–9

This view occupies the left-hand side of the composition, and the contrast with the famous view of the countryside around Siena could not be greater. The city and the country are also contrasted in the ruined frescoes on the facing wall showing an Allegory of Tyranny and Bad Government. The programme of the cycle is based on Thomist and Aristotelian theory, and several direct quotations from antique sculptures in Siena are included. Based on closely observed reality, the view shows a typically Italian combination of the towers which dominated medieval cityscapes and added wooden structures.

65 ALTICHIERO The Crucifixion c.1379

This forms the central panel of a tripartite Crucifixion scene. In works such as this Altichiero forms a link between the innovation of Giotto and the powerful drama of Masaccio: expression and gesture are rendered by drawing of a very high standard and the figure composition is among the most advanced of its period.

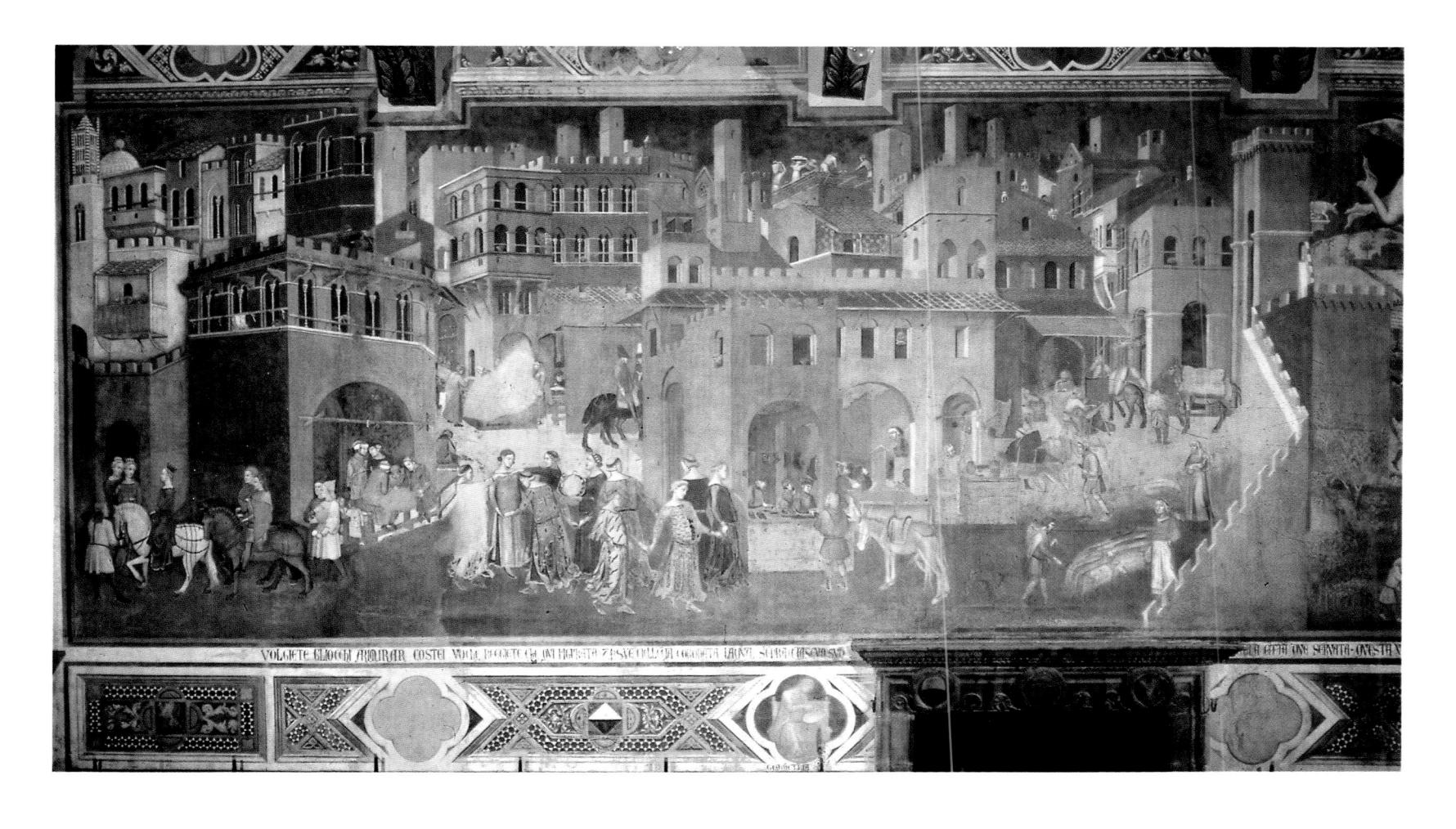

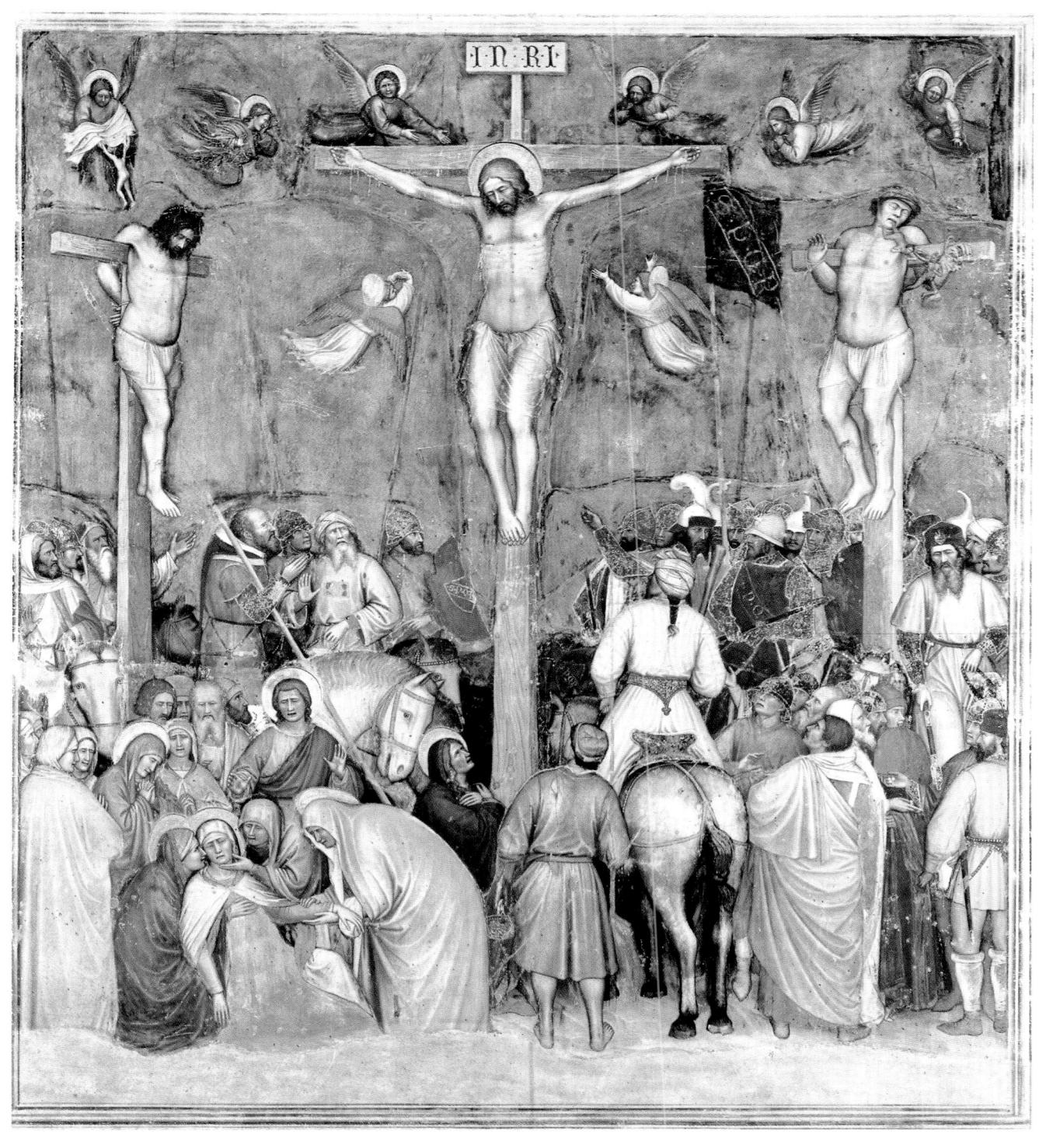

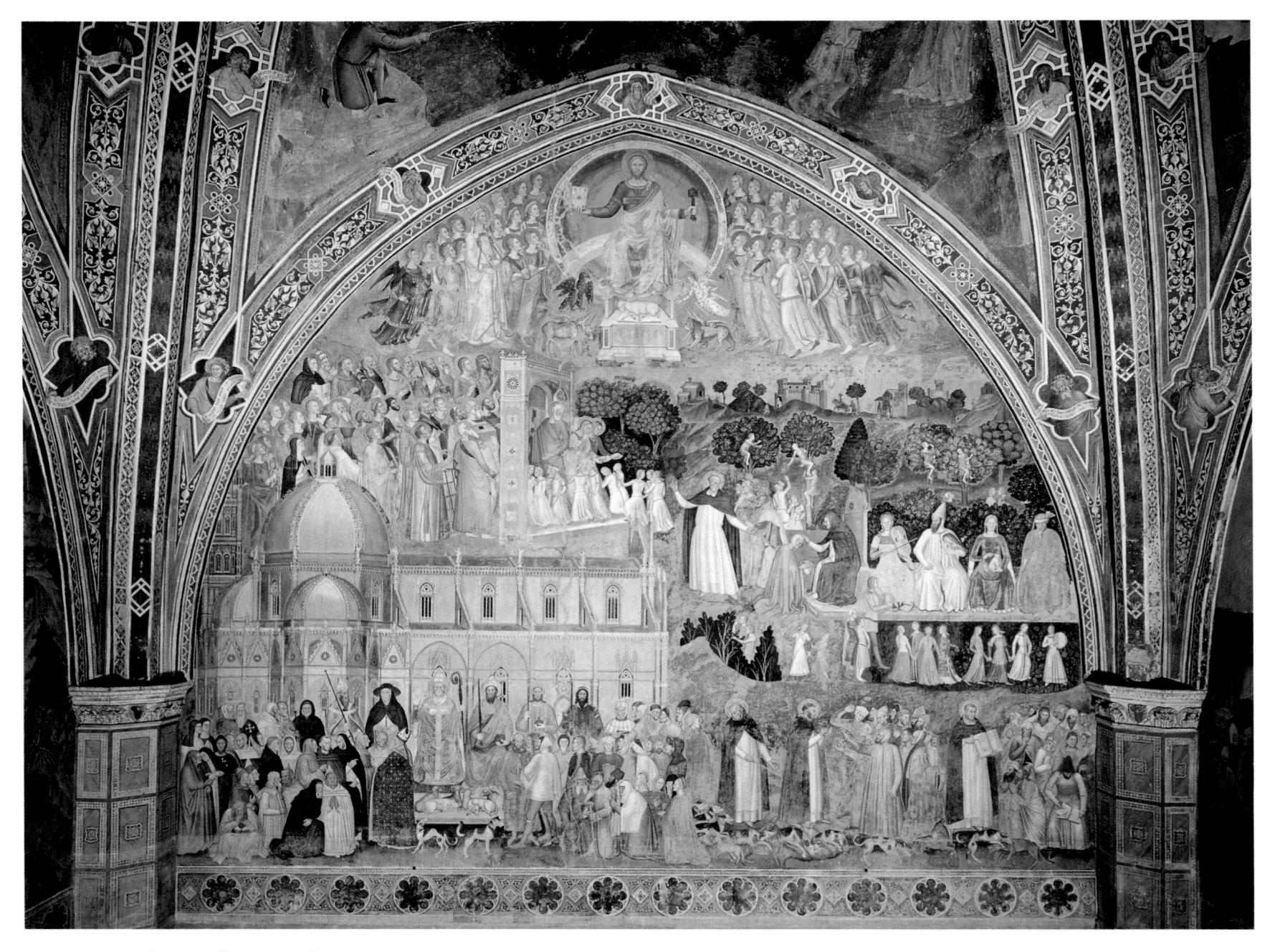

66 Andrea Bonaiuti (Andrea Da Firenze) Triumph of the Church 1365–7

Of all the frescoes in the Spanish Chapel in Santa Maria Novella this is the best-known; the chapel served as the council chamber for all the Dominicans of the province. The Church is represented by Florence Cathedral complete with a dome before Brunelleschi actually built it. The Pope and other ecclesiastics and laymen appear before the Cathedral, while before them black and white domini canes (a punning reference to the Dominicans as 'hounds of God') rescue lost sheep from wolves, while actual members of the Dominican Order dressed in black and white preach and lead people to the Gates of Paradise. The Redeemer appears above amid the heavenly host.

67 PAOLO VENEZIANO Saint Mark's Body Carried to Venice, undated

One of the panels making up the cover of the Pala d'Oro, the precious gold and enamel altarpiece which is still preserved on the high altar of San Marco in Venice, it was made during the reign of the learned humanist Doge Andrea Dandolo, and it may incorporate Classical references. This scene shows one of the most popular parts of the St Mark legend, when the saint's body was transported by sea to Venice. Veneziano has used warm colours richly combined with figures which recall Venice's Byzantine past.

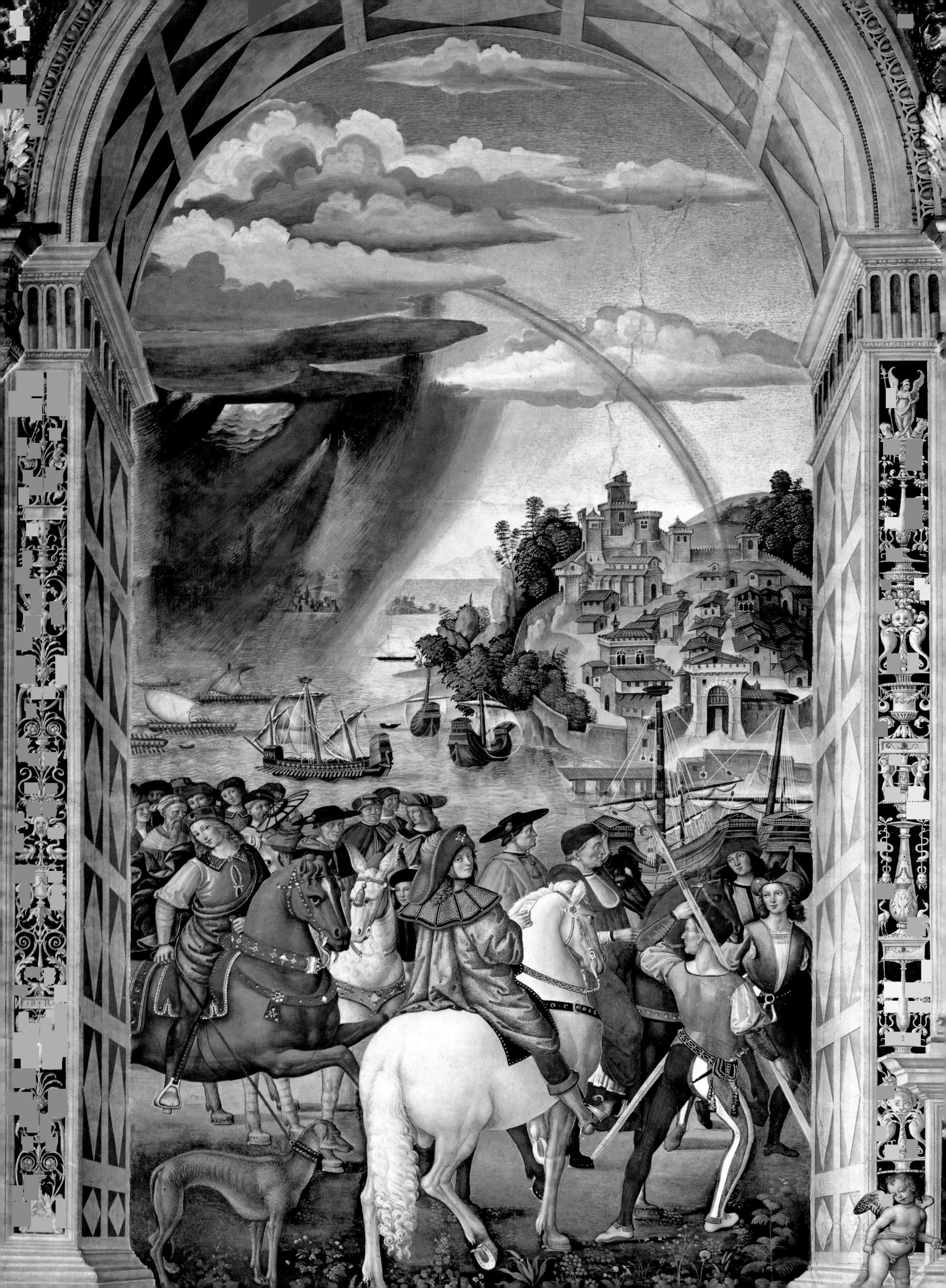

CHAPTER IV

Fifteenth-Century Italian Painting

The Italian fifteenth century – the Quattrocento – has come to be synonymous with the first achievement of the ideals of the Renaissance period. There have been many attempts in the history of European culture to revive the impetus which gave the ancient world and its art such force, but the Quattrocento's was the most complete and arguably the most successful. The major names in painting alone evoke its richness – Masaccio, Fra Angelico, Botticelli, Mantegna, Piero della Francesca, Giovanni Bellini and Leonardo da Vinci.

The Classical Legacy

Although Classical architecture and sculpture had never been wholly forgotten in Italy (it was impossible to ignore the visible evidence of Rome's past in its monuments and sculptural fragments) they began to exert the strongest fascination for fifteenth-century artists. This was true for painters as well as sculptors. During the High Renaissance in Rome, more knowledge of Roman painted decoration was acquired but at the beginning of the Quattrocento, ideas of ancient figurative depiction were based almost entirely on surviving sculptures. Indeed, the great archaeological rediscoveries, including Roman wall paintings (often by Greek artists), were not made until well into the

68 Bernardo Pintoricchio Scenes from the Life of Pius II 1502–9

The Piccolomini Library of Siena Cathedral was built in the 1490s by Francesco Todeschini Piccolomini, later Pope Pius III. It housed the manuscripts collected by Aeneas Sylvius Piccolomini (1405–64), Pope Pius II. Pintoricchio frescoed the ten compartments with scenes from his life both before and after his election as Pope. Vivid in incident, detail and colour, they continue the Quattrocento tradition of multi-figure scenes set in an extensive landscape.

eighteenth century: Herculaneum and Pompei were excavated in 1738 and 1748 respectively.

This period's understanding of antique painting was therefore vague and highly idealized, and produced results as widely different as Mantegna's Pallas (see plate 87) and Botticelli's Primavera (see plate 115). It derived much from the literary accounts of Classical writers, such as Pliny the Elder (AD 23-79) His 'breathtaking proto-encyclopedia', the Historia Naturis included, in his own words, '20,000 matters worthy of consideration', among them painting. The section devoted to art was translated into Italian in 1473. Quattrocento painters and theorists paid great attention to Pliny, while architects turned to Marcus Vitruvius's book De Architectura, which had been rediscovered during the first part of the century. Pliny summed up the basic requirement for a painter: to create an illusion of reality with the aid of proportion, harmony and above all, mathematics, without which 'art could not attain perfection'. Mathematics included that science intrinsic to Renaissance art, perspective.

Leon Battista Alberti (1404-72) may be said to have inherited the mantle of Pliny and Vitruvius, along with the practical approach of a more recent Italian, Cennino Cennini. This diversity, coupled with a highly enquiring mind, made Alberti the precursor of Leonardo da Vinci as a 'universal man' typical of this period. 'In what category of learned men shall I place him?' pondered one contemporary. Alberti's importance in the Quattrocento cannot be over-estimated, in terms of his architecture, his theories on art and the influence of his reliance on reason. His writings differ from Leonardo's in that they were published, circulated and discussed. Alberti was Genoese by birth, but his natural father belonged to a rich, exiled Florentine family. His education in classics, canon law and mathematics led him naturally to a career, from 1432-64, at the Papal Court in Rome, which enabled him to follow

his preferred intellectual and architectural aims. In 1428 he accompanied Pope Eugenius IV to Florence, a visit which enhanced his interest in the revival of Classical principles. After direct contact with the works of the Florentine architect Filippo Brunelleschi (1377–1446), Donatello and Masaccio, he wrote *De pictura* ('On Painting') in 1435, translating it from Latin into Italian (*Della pittura*) the following year.

Alberti's writings are important because they abandon the theological basis current in the Middle Ages for approaching questions of art. He defines painting as a window on the world, and proposes that man's highest aspiration should be for the public good. This early humanistic approach is fundamental to understanding the links between art and civic pride in the Quattrocento. For Alberti, the artist was no longer a craftsman in the service of the Church, but an independent and creative being free to depict the world as he saw it, whether in religious or secular terms. Alberti believed man's will could enable him to achieve anything he wished. Although links between such idealism and the breadth of Quattrocento painting are tenuous, the sense of liberation inherent in these new ideas spreads like oxygen through all aspects of the period's civilization. Alberti's other two principal treatises on the arts, De re aedificatoria (On Architecture) and De statua (On Sculpture), are also concerned with man's place in a perfect social structure. This rationality ultimately distinguishes him from the mystical aspects of contemporary Neoplatonism.

The question of Neoplatonism has puzzled many people in relation to Quattrocento art, and its impact must be accepted but not over-emphasized. The rebirth of Italian interest in the Greek philosopher, Plato, occurred in about 1400 with the arrival from Constantinople of manuscripts of his writings. By 1484 a complete Italian translation by Marsilio Ficino (1433–99) was available.

As one of the most important philosophers of ancient times, and the author of more than thirty works, Plato would naturally have interested any Classical revival. However, there was one aspect of his philosopy which drew the Renaissance to him, and which found ready reflection in the arts: his emphasis on the spiritual. In Plato, themes such as harmony and poetic inspiration are constantly present, and for him mathematics are the key to understanding nature. The latter struck a resonant chord with Quattrocento artists, with their love of perspective and proportion. It brings to mind at once a habit of thought dominant in Masaccio, Donatello and Brunelleschi.

The essence of Florentine Neoplatonism was its linking of Plato's philosophy with Christian thought, and in

this Ficino led the way, founding the Platonic Academy in the beautiful Medici villa at Careggi, above Florence. After 1462 he was helped in this by Cosimo de' Medici's generous patronage, followed by that of Lorenzo the Magnificent. In 1469-74 he produced Platonic Theology Concerning the Immortality of the Soul, in which he described the purpose of human life as freeing the soul from the constrictions of the body and bringing it as close as possible to God. His philosophies and those of his followers, notably Giovanni Pico della Mirandola (1469-1533), filtered into works of art through specially devised literary 'programmes' and through symbols which became pictorial currency in the second half of the century. The resulting marriage of such philosophies with Classical forms and imagery in painting could not have been more opportune or appropriate, and often enriched even traditional Christian themes with new possibilities.

Painting in Tuscany

In 1396 the Paduan humanist Pier Paolo Vergerio (1370–1444) noted that the only great example for his contemporaries among painters was Giotto, who had died about sixty years previously. Agnolo Gaddi died in 1396, leaving as a final heritage his famous frescoes in the Chapel of the Sacra Cintola in Prato Cathedral. Impressive as they are, they reveal that Florentine painting needed an injection of new vitality. It must have seemed impossible that any modern artist would ever equal or surpass Giotto, and indeed almost every painter of the intervening period owed him a debt, directly or indirectly. Many painters, however, turned away from Giotto's monumental example (see Chapter III).

The Quattrocento was, nevertheless, to prove the great age of fresco painting, with Masaccio, Uccello, Gozzoli, Castagno, Fra Filippo and Filippino Lippi, Piero della Francesca, Ghirlandaio and many others leaving an incomparable legacy in this field. Although not an age of technical innovation – Leonardo's attempts to emulate the secrets of antique mural painting in the *Last Supper* (see plate 41) failed dramatically – experiments in fresco occurred, notably in Tuscany. Thus, two of the most original works of art of the century, Masaccio's Brancacci Chapel and his *Trinity* (see plates 70, 93) are both frescoes. As fresco was notoriously difficult, it was regarded as the supreme proof of a painter's abilities.

Vasari has been accused of 'Tuscocentricity' (placing too much emphasis on developments in Tuscany), but it is undeniable that the greatest concentration of achievement is found in Florence and nearby towns and cities like

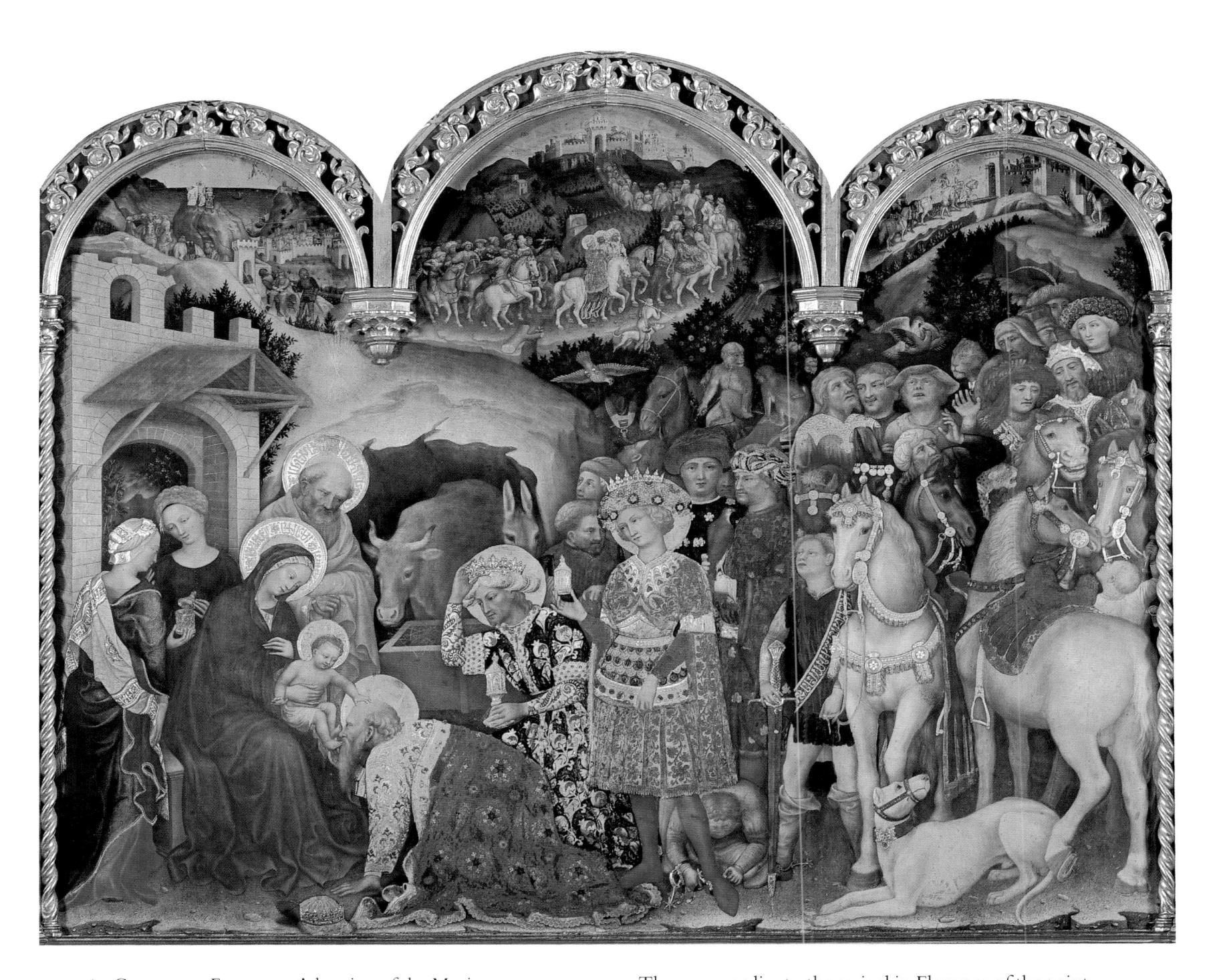

69 GENTILE DA FABRIANO Adoration of the Magi 1423 Painted for the Strozzi Chapel in Santa Trinità during Gentile's Florentine stay of 1420/22–5, this is the artist's major panel painting, and provides the main key to his style. Gentile's love of rich textures and decorative accessories derives from Venetian and Sienese art and harks back to the International Gothic style. The rich landscape here shows none of the contemporary Florentine rational approach, and is predominantly decorative.

Siena, Pisa and Arezzo. Florentine painters travelled regularly between these and other centres such as Rome, Venice and Urbino, resulting in a constant interchange of ideas which it is difficult to chart accurately. More accomplished painters were in demand for work in provincial centres, whose native artists eagerly adopted the latest fashion from Florence as best they could. Thus an isolated altarpiece by Masaccio or Fra Angelico in a provincial town could have the greatest effect on local style.

The same applies to the arrival in Florence of the paintings of contemporary Netherlandish and other artists. Sometimes foreign painters came in person, as did the Portuguese Alvaro Pirez, active in Pisa, Lucca and Volterra in 1410-35, and the Catalan painter Jacomart Baço, called to Naples by the King, Alfonso of Aragon. Flemish art quickly found its way into Italy. In 1437 Michele Giustiniani, a member of a leading Genoese family, commissioned a small triptych from Jan van Eyck. In Venice and the Veneto, the connoisseur Marcantonio Michiel recorded the presence of such Flemish pictures as the influential Crucifixion in the Ca d'Oro. Many commissions and purchases were made as a direct result of the intensive trading between the Netherlands and Italy, and the presence of Italian bankers in the North. Zanetto Bugatto was sent by Bianca Maria Sforza of Milan to the Brussels studio of Rogier van der Weyden from 1460 to 1463. It is probable that Van der Weyden visited the court of Ferrara in 1450 during his Italian journey of the Holy Year, and the French artist Jean Fouquet may have painted his delightful *Gonella* there (see plate 176).

Although the Renaissance in sculpture is usually dated from 1401, when the open competition for the bronze doors of the Florence Baptistery was announced, in paint-

70 MASACCIO, MASOLINO AND FILIPPINO LIPPI The Brancacci Chapel general view, 1425–7 and 1481–3 The Brancacci Chapel occupies the right transept of the Church of the Carmine, and was mainly frescoed by Masaccio in collaboration with Masolino. Filippino Lippi completed the frescoes in 1481–3. On the entrance arch, Masolino's Fall of Man faces Masaccio's Expulsion from Eden, clearly showing their different styles. The stories of St Peter symbolize salvation after The Fall. Centrally placed on the left wall is the famous Tribute Money, emphasizing Christ's delegation of the Church to St Peter (relegating the actual miracle of the money in the fish's mouth to the background).

ing the situation is less clear. In effect, Florentine painting did not begin its Quattrocento renewal until the 1420s. Siena produced a livelier painter in this period than Florence: Taddeo di Bartolo (1362/3–1422). Among those Florentines who were active in the intervening years before Masaccio's appearance were Antonio Veneziano whom we now believe may have lived until 1419; Lorenzo Monaco (1370/2–c.1425); Starnina (active c.1390–c.1314); and Giovanni del Ponte (c.1385–1437). Of these Lorenzo Monaco is possibly the most appealing.

Gentile da Fabriano

One of the most significant and attractive artists of his day, Gentile da Fabriano (c.1370–1427) probably arrived in Florence in 1420. He had already received extensive prestigious commissions elsewhere, including the Doge's

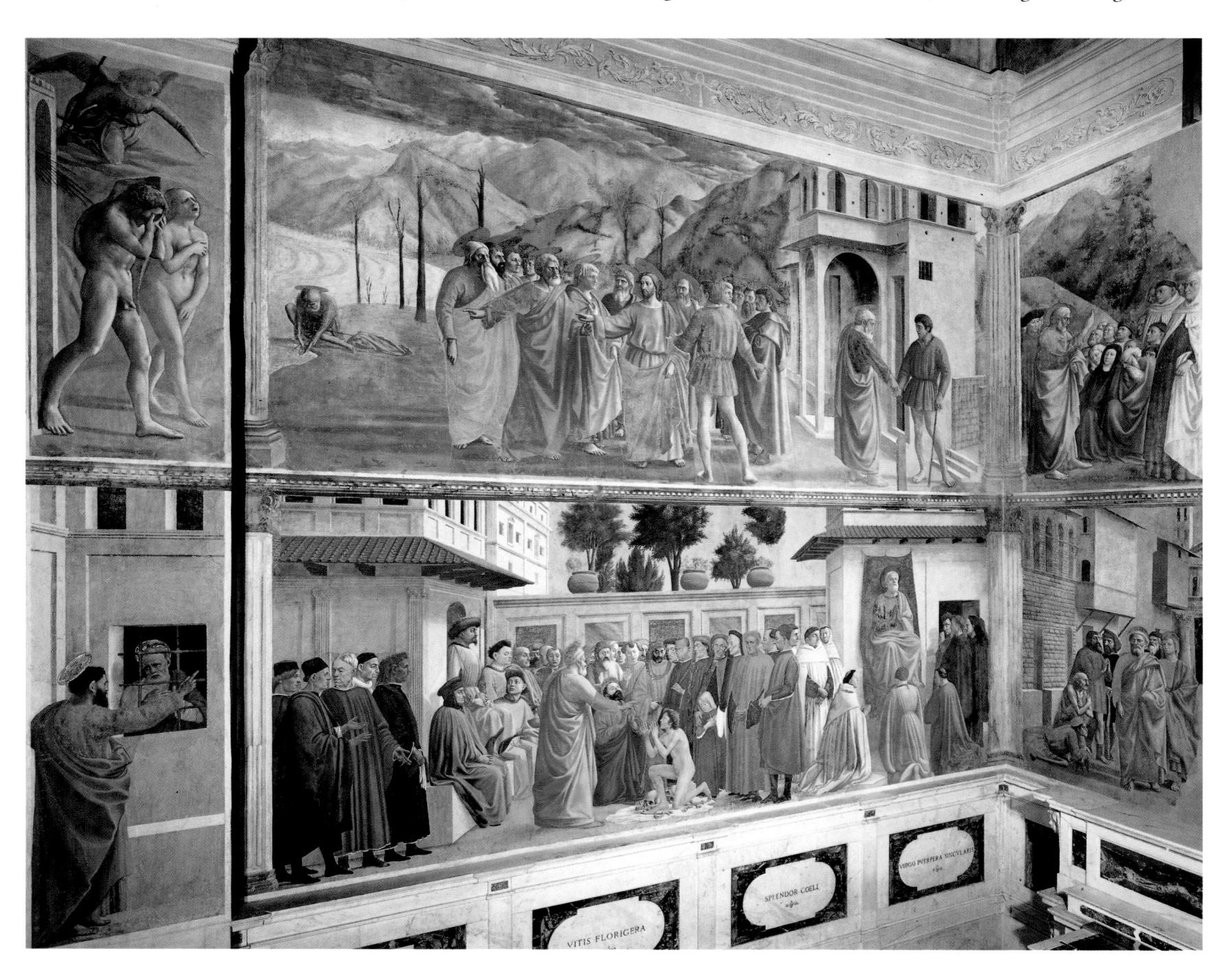

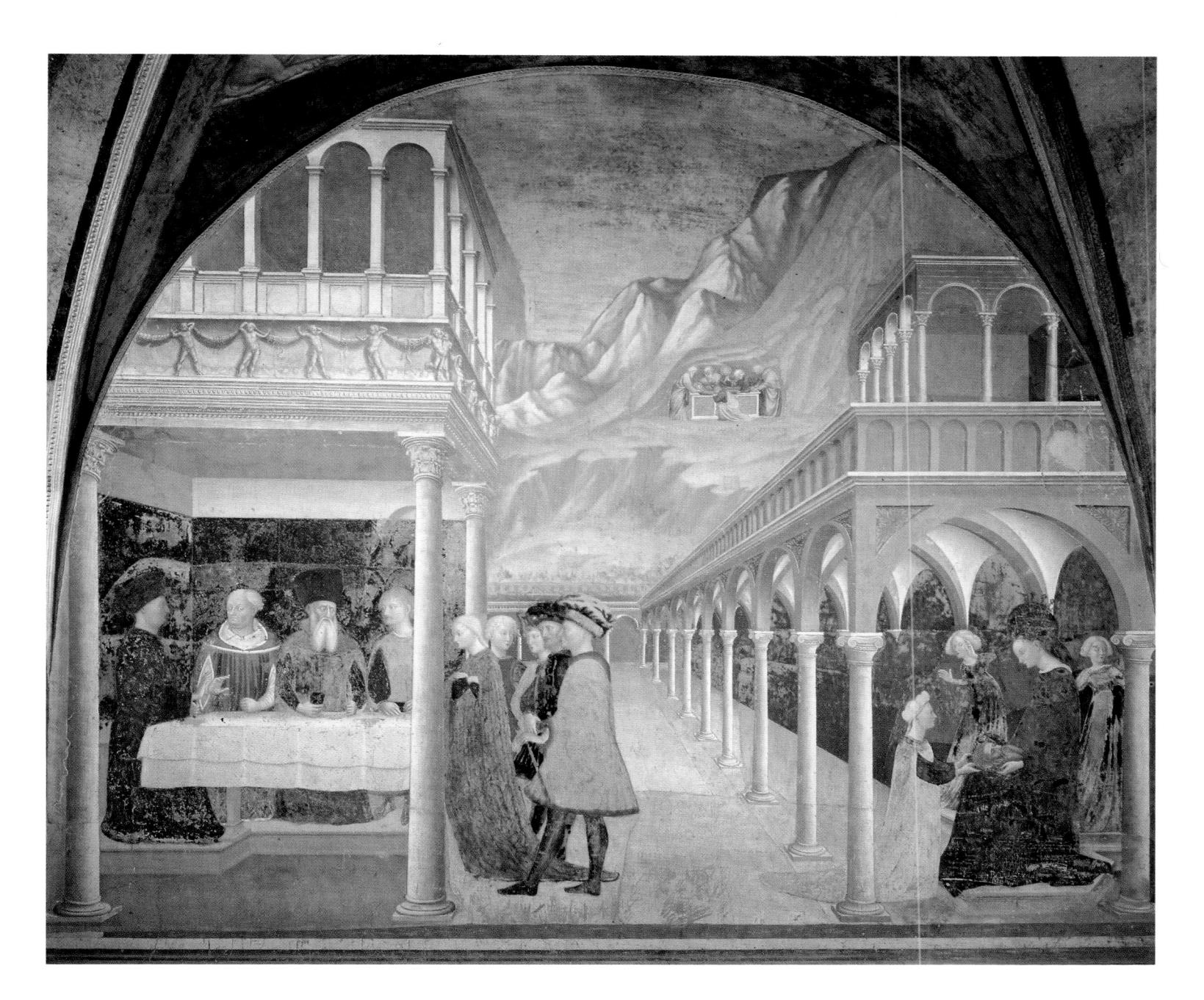

71 MASOLINO DA PANICALE Feast of Herod 1435
This forms part of Masolino's extensive fresco cycle showing The
Life of the Baptist, which he painted for Cardinal Branda in the
Baptistery at Castiglione Olona. It shows the moment when Salome
demands St John the Baptist's head. Many portraits have supposedly
been identified through the scene. Herod has been identified variously
as Cardinal Branda himself, the Emperor Sigismund or Niccolò
d'Este, with the young man on the right as Pippo Spano,
Masolino's Italian patron in Hungary. Masolino derived the
composition from Andrea Pisano's bronze relief version in the
Florence Baptistery.

Palace, Venice, in 1408 and was later to work at St John Lateran in Rome. He had worked in and around Venice after a training in the Marches, and his concerns overshadowed those of the Florentine painters he encountered. His love of magnificently textured fabric, striking effects of light on all surfaces and his romantic approach to nature contributed to his widespread contemporary influence. Gentile was one of the earliest Italian painters

to make a virtue of cast shadows, a seemingly obvious step, but one of great importance in the quest for natural representation. His masterpiece, the *Adoration of the Magi* (see plate 69), dates from his Florentine period, and shows why many artists there were more attracted to his sophisticated and decorative manner than to Masaccio's less approachable monumentality. Gentile's naturalism was developed after his death by his follower, Antonio Pisanello (c.1395–c.1455/6), who continued his work in Rome. Pisanello was an excellent portrait painter, and achieved great fame as a portrait medallist (see plate 92).

Gentile's style formed a precise parallel with the sculpture of Lorenzo Ghiberti (1378–1455). Just as the Trecento painters looked at sculpture, so the sculptor Lorenzo Ghiberti turned for inspiration to Northern art, which he discussed in his *Treatise*, through the work of one Cologne goldsmith, Master Gusmin. Ghiberti's new approach to voluminous draperies in his relief sculpture had a considerable impact on contemporary painters. This feature

remains constant in Florentine painting, along with Gentile's delicate traceries of decoration, well into the Quattrocento. Of much more fundamental importance, however, was the sculpture of Donatello (Donato di Niccolò, 1386–1466) and Nanni di Banco (c.1386–1421). Donatello's astonishing naturalism (he was accused of using casts), and the vitality and portrait realism he learned from Roman sculpture, proved irresistible to painters. In his incomparable marble relief, Saint George and the Dragon of 1417-20 (Museo Nazionale del Bargello, Florence), Donatello furthered the advances made by Brunelleschi, who had already discovered perspective. This relief is a milestone in art, for in it Donatello used orthogonals and a vanishing point to create the illusion that the figures exist in real depth. Masaccio was the first painter who followed in its footsteps.

Masolino and Masaccio

The lives of Tommaso di Cristofano called Masolino (c.1383–1447) and Masaccio (Tomasso di Ser Giovanni di Mone, 1401–c.1428) are closely linked, but Masaccio is credited with having left the more momentous impact on the art of painting. Masolino has long taken a poor second place to Masaccio, but was a painter of considerable merit. No document links their names or connects them with the patrons of their major works, but there is no doubt that they collaborated. Masolino may have been a pupil of Agnolo Gaddi, and Vasari says that he excelled in chasing and modelling in Ghiberti's workshop – an instance of the interdisciplinary training of many young artists in the Renaissance.

Vasari was confused by Masolino's collaborations with Masaccio, and believed paintings we now think are Masaccio's to have been his. The *Saint Anna Meterza* (Galleria degli Uffizi, Florence) of about 1424 is a good example of this joint authorship. Masolino spent just over one year in Hungary, working there for the Florentine soldier Pippo Spano, and returning to Florence late in 1427. The two painters then probably went together to Rome in May 1428, and it appears that Masaccio died there. On hearing of this, Brunelleschi supposedly said, 'We have sustained a great loss'.

Masaccio was probably already active as a painter by the age of seventeen. At twenty, in April 1422, when he dated the San Giovenale a Cascia Triptych (Pieve di San Pietro, Cascia di Regello), he was already an accomplished artist. On the basis of this, Masaccio's early career can be partly understood, since there is no proof of his having trained with Masolino as Vasari believed. He telescoped into a

period of about eight years one of the most innovative careers in European painting. Amazingly, there is little surviving documentation on his art, and even the great *Trinity* (see plate 93) and the Brancacci Chapel frescoes (see plate 70) are shrouded in mystery. He does not appear to have made much money, and may have allied himself with Masolino in late 1422 or early 1423 to further his career in Florence.

It is therefore possible that Masaccio was employed by Masolino, who, as an older, established painter received important commissions. Their first collaboration seems to have been on an altarpiece of 1423, once in Santa Maria Maggiore, Florence, now dismembered. The last was the great Brancacci Chapel. It was Masolino who received the Brancacci commission in 1424, but Masaccio who gave most of the scenes their monumental and heroic form, brilliant perspective and impressive humanity. For example, The Fall by Masolino has none of the dynamism of Masaccio's famous Expulsion from Paradise. Masolino may simply have lacked Masaccio's receptiveness to the great examples of contemporary sculpture, notably Donatello's John the Evangelist and Jeremiah. He may also have remained almost impervious to Masaccio's innovations, adjusting his style when they worked together in order to achieve visual unity, but reverting to his own more delicate manner elsewhere, notably after Masaccio's untimely death (see plate 71).

Fra Angelico

Had Masaccio lived, there can be no question that his influence would have been more immediate and lasting, but Gentile's highly ornate style of surface patterning found more eager followers in Florence. Among these, Fra Angelico was the greatest example in the Italian Renaissance of a painter uniting intensely personal religious feeling with the highest degree of artistic accomplishment. Angelico (Guido di Pietro, c.1400–55) entered the Observant Dominican convent of Fiesole, outside Florence, in 1418–21, and was elected prior in 1449. Vasari describes Angelico as 'a simple and most holy man' while John Ruskin went as far as to call him 'not an artist properly so-called but an inspired saint'. Although long known as 'Beato' (Blessed, one level below sainthood) he was only officially beatified in 1984.

From his beginnings in about 1417 in the studio of Lorenzo Monaco, Angelico's artistic life was extraordinarily productive. His earliest painting is likely to have been manuscript illustration, nurtured by the great influx into Florence of European manuscripts (of which the

Medici family were leading collectors). The International Gothic style of Gentile da Fabriano must have seemed simply a grand development of such minute work, and thus compatible with the Dominican desire to put art to the service of religion.

In addition to his work as a painter, Fra Angelico maintained an active involvement in the religious politics, movements and debates of his day. The two activities were probably related, as is suggested by the fact that he painted a chapel in the Vatican for Pope Nicholas V, whom he knew personally. In Florence, his closest involvement was with the much-revered Dominican, Saint Antonino, who in 1436 took over the friary of San Marco, which was remodelled by the architect Michelozzo (1396–1472), with financial assistance from Cosimo de' Medici.

At San Marco, Angelico and his assistants (particularly Zanobi Strozzi) created a group of forty-five frescoes (c.1438–45) and other paintings (see plates 72, 94, 95) unrivalled in the Renaissance for their devotional homogeneity. San Marco became a leading centre for the new humanism, which Angelico succeeded in reconciling with the intensity of residual medieval piety. This may be seen in his great *Last Judgement* of around 1431 (Museo di San Marco, Florence), showing the division between the elect and the damned. Here he imposed the most recent ideas about light, perspective and form on the iconographic tradition approved by his Order.

Angelico heads Vasari's long list of the painters who studied with Masaccio in the Santa Maria del Carmine in Florence. This became increasingly important in his later work, notably his fresco scenes from the *Lives of Saints Stephen and Lawrence* (1447–50) in the Vatican. These show his mature style, with solid, large-scale figures and a more dramatic intent, accentuated by a new realism of detail, more in tune with contemporary ideals than much of his earlier work. However, the innate sweetness of his art remained, and was to exert a considerable influence on painters such as Perugino.

The combined influence of Masaccio and Angelico on Italian Quattrocento painting was immense, and was immediately seen in the latter's pupil Benozzo Gozzoli (Benozzo di Lese, c.1421–97), who assisted Angelico in Orvieto and Rome. His most important undertaking was the 1459 fresco cycle in the Medici Palace Chapel showing the *Journey of the Magi* (see plate 114), where the two traditions are harmoniously united with his experience of the Franco-Flemish art of Jean Fouquet and Rogier van der Weyden. This cycle is noted for its inclusion of contemporary portraiture in the guise of religious imagery, and its wealth of minutely observed detail.

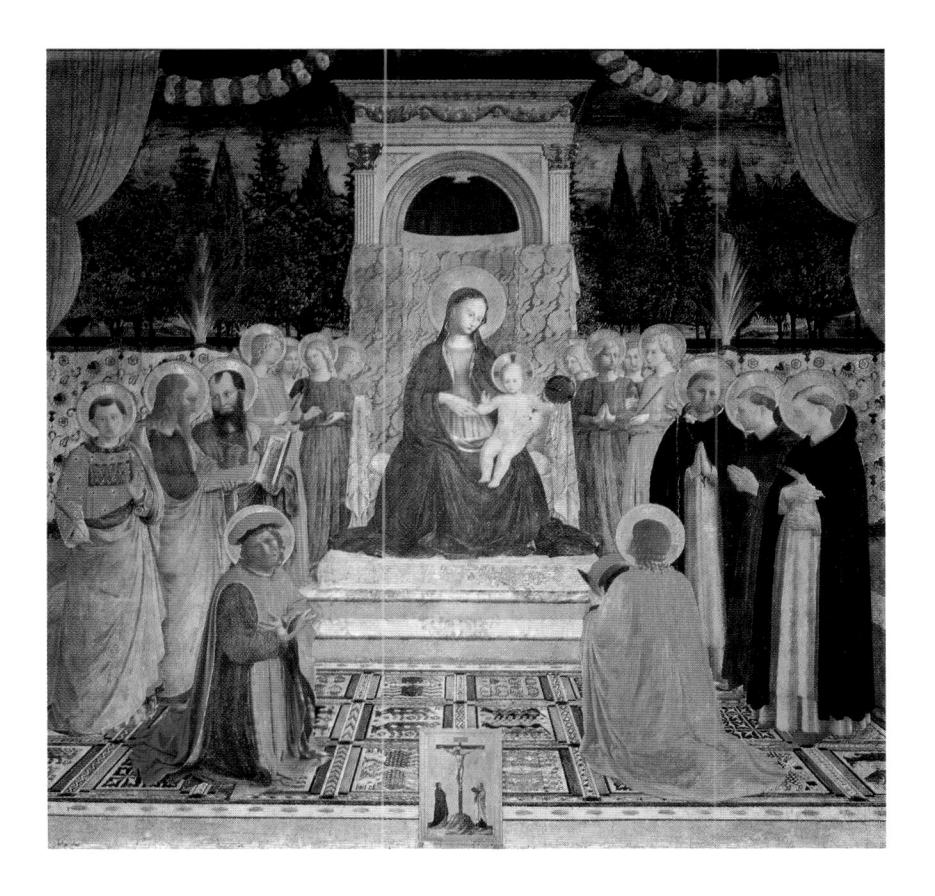

One of the grandest altarpieces of the Quattrocento, this was painted for the high altar of the conventual church of San Marco in Florence, dedicated to Sts Cosmas and Damian. It is the Virgin and Child Enthroned with Angels and Sts Cosmas and Damian, Lawrence, John the Evangelist, Mark, Dominic, Francis and Peter Martyr. It was always considered one of Angelico's masterpieces, and Vasari, noting its unique beauty, says that the Madonna 'moves to devotion those who look at her, by her simplicity . . . it is impossible to imagine ever being able to see anything more diligently made.' The predella was nonetheless dismantled and dispersed, and the altarpiece subject to drastic overcleaning. Cosimo de' Medici decided in 1438 to send a triptych by Lorenzo di Niccolo which was previously on the high altar, to Cortona, to be replaced by Angelico's picture; no record remains of the picture's commission.

The grandeur of its composition reflects Angelico's study of Masaccio, with the enthroned Virgin raised at the centre of a figure group of great solemnity against a simple background of cypress trees. The cypresses, palms and garlands of roses refer to the biblical passage comparing the Virgin to the cedar of Lebanon, the cypress of Mount Sion, the palm of Cades and the rose of Jericho. St Mark holds open the book at the passage from his Gospel describing Christ's teaching in the synagogue. The kneeling St Cosmas on the left may be a portrait of Cosimo de' Medici, and the kneeling St Damian may be a portrait of Lorenzo de' Medici, who died in September 1440.

Filippo Lippi

In contrast to the exemplary life of Fra Angelico, that of Fra Filippo Lippi (c.1406-69), as depicted so colourfully by Vasari, has intrigued posterity for its sheer irregularity. In 1421, he took his vows as a Carmelite friar at the Carmine convent where he had been raised as a foundling. This did not prevent him from conducting a celebrated affair (much to the mirth of his contemporaries) with the nun who was also his model, Lucrezia Buti. She bore him his painter son Filippino (see plate 73), and a daughter. Both were released from their vows and permitted to marry. Lippi was also tortured for embezzling money from an assistant, and made a rope from sheets to escape 'protective custody' in the Medici Palace! This waywardness is perhaps reflected in his paintings, produced over a career of more than thirty years, which glow with a spontaneity not too restricted by rules of perspective or humanist 'programmes', and it has been said that he undertook more complex and original subjects than any of his contemporaries.

Lippi's first dateable work is from the mid-late 1420s, the fresco of a *Scene from Carmelite History* in his own Carmine convent. Vasari tells us that Lippi had been inspired by watching Masaccio paint in the adjacent Brancacci Chapel. Of the same period, his *Madonna of Humility* (Fitzwilliam Museum, Cambridge) already shows the elements which he derived from Masaccio (particularly the sheer volume of the main figures) but with facial types which were to become very much his own, exemplified in the infant Christ with his chubby features and enquiring expression. By the time of the *Barbadori Altarpiece* (Musée du Louvre, Paris) about 1437, most of Lippi's characteristics were fully formed, and his preferred settings, amid marbled niches and arcades, well established.

His interest in architecture is also reflected in his love of Donatello, from whose Cavalcanti *Annunciation* in Santa Croce Lippi derived his own painting on the theme now in the National Gallery, Rome. It was ultimately his Madonnas, often in tondo form, which created posterity's image of him. Of these possibly the finest is the *Madonna and Child with the Birth of the Virgin and the Meeting of Joachim and Anna* dating from the 1460s (Pitti Palace, Florence).

In both of his great fresco cycles, in Spoleto Cathedral and Prato Cathedral (see plate 97), Lippi demonstrated his ability for subtle figure composition within grand architecture, and an agility of linear design different from the more solid approach of his pre-1440 works. This sinuous line was the mainspring of the art of Botticelli, who was

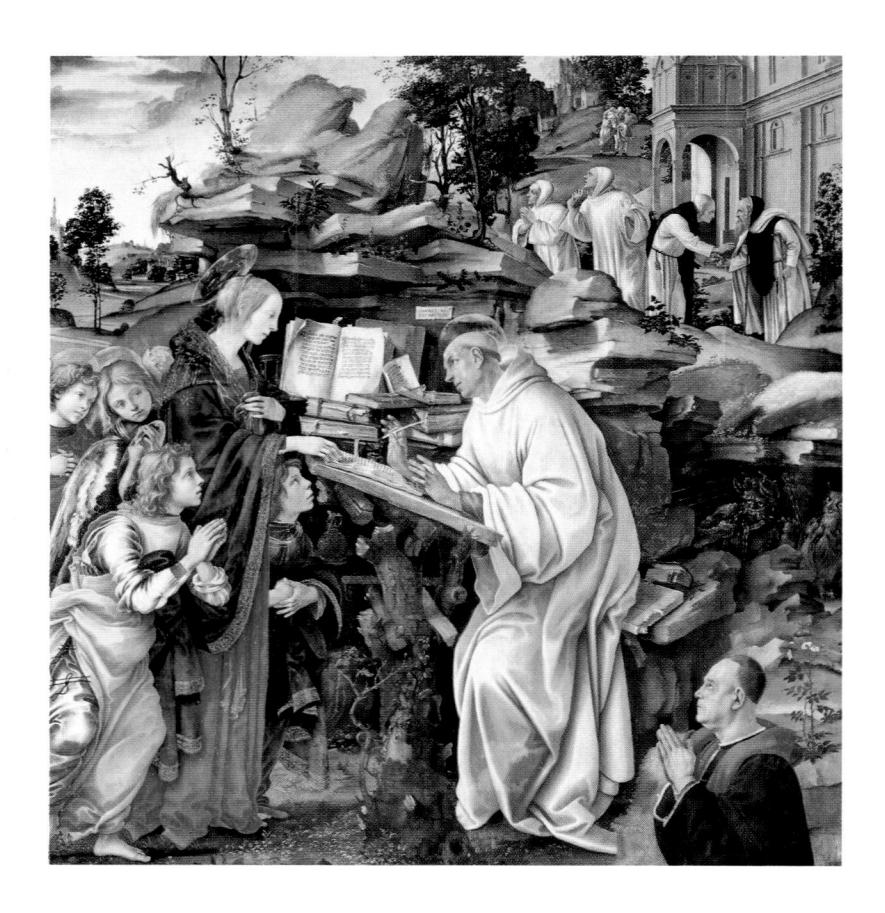

73 FILIPPINO LIPPI The Virgin Appearing to Saint Bernardo c.1482-6

Possibly Filippino Lippi's finest painting, this was commissioned by Piero di Francesco del Pugliese, and the donor is shown in profile with joined hands in the lower right, while tradition has it that the Virgin and angels portray his wife and children. Lippi unites an extraordinary chromatic richness with the most detailed description of every part of the picture, from the minute portraiture of the background friars to the striking still life of books, all of which are recognizable texts referring to the Mother of Christ.

probably Lippi's pupil and inherited much of the intensity of his last paintings, such as the *Dead Christ* (Musée Thomas Henry, Cherbourg). The critic Bernard Berenson once thought that this was by the young Botticelli. Overall, it is possible to follow his creative processes through the remarkable number of his surviving drawings, many of which are connected directly with known paintings.

Paolo Uccello

If Lippi represented a rational development from Masaccio, Paolo Uccello (Paolo di Dono, 1397–1475) was, like many great experimentalists, limited by his very adventurousness. 'He had no greater pleasure than to investigate certain areas of difficult and (indeed) impossible perspective,' says Vasari, while Ruskin concluded that 'he went off his head' with this obsession. Vasari also tells

the story of his wife urging him to come to bed when he was working late into the night, and Uccello's supposed reply, 'What a sweet mistress is this perspective'.

First documented as working in Ghiberti's studio in 1407, Uccello naturally learnt there the latest ideas on perspective. In 1425, he went to Venice and worked as a mosaicist (although none of his mosaics has been identified), returning to Florence in 1430. His first surviving dated work there is the immense fresco in Florence Cathedral of the English *condottiere* Sir John Hawkwood (see plate 75).

Uccello's major work in fresco was the series of Old Testament scenes in the Chiostro Verde ('Green Cloister') of Santa Maria Novella in Florence. Here, he adopted the 'perspective naturalis' advocated in ancient treatises, such as Euclid's. Like most painters of his day, Uccello would have turned to Ghiberti's Florence Cathedral's Baptistery doors for inspiration, and Ghiberti himself advocates this Classical type of perspective in his *Treatise*.

The cloister frescoes culminate in the famous *Flood* (see plate 74), where Uccello (as in the *Hawkwood*) reveals his flexible approach to perspective, and his desire to use it not merely for increased spatial realism but to exploit the inherent drama of the scene. In the *Flood*, for example, he selects two vanishing points whose lines cross, to maximize an impression of chaos appropriate to the subject.

From one point of view, Uccello's art could be regarded as a regression from Masaccio's in that, until his later years, he shows no interest in the evocation of atmosphere. Masaccio excelled at this, placing his figures in such a way that they seem to inhabit real space; and Masolino's broad treatment of colour also created such an impression, in a more contained manner. Uccello's figures are suspended unrealistically in space, and colour is often dissonant. However, it was precisely their atmosphere of unreality, coupled with their sense of volume, which must have attracted the young Piero della Francesca to Uccello's paintings.

Uccello's art found favour briefly with the Medici, and in the mid-1450s Cosimo de' Medici commissioned three panels from him showing *The Battle of San Romano*, to decorate a room in the Medici Palace. The *Battle* sequence has now been separated and distributed among London's National Gallery, the Louvre and the Uffizi. Drastic overcleaning has reduced the London picture to its bare bones, but has revealed Uccello's magnificent concept of large-scale form, which he blocked in prior to achieving his finish with careful paint glazes. From the London picture in particular, it is clear that Vasari did not exaggerate, and for Uccello, even round forms such as the horses' flanks, could be subjected to linear perspective.

The subtlety of such thinking is in contrast to the almost naive manner in which broken lances and corpses are somewhat startlingly foreshortened.

Uccello was one of the first Italian painters to use canvas as a support, in his later paintings such as Saint George and the Dragon (National Gallery, London). Among the most magical of his panels is The Hunt in the Forest (Ashmolean Museum, Oxford). This was painted in the 1470s, about the time of his enchanting Profanation of the Host (Galleria Nazionale, Urbino), which is also a wonderful record of a simple room of the period. The Hunt's night setting and the delicacy of its components show that Uccello was abandoning the strongly didactic use of perspective in his last years. Vasari's account of the artist's mental condition is touching, his obsession with perspective comparable in its effects to Parmigianino's with alchemy much later: 'Solitary, strange and melancholy. . . he came to live the life of a hermit, scarcely knowing anyone and shut away in his house for weeks and months at a time.' In a late tax return he claimed he was destitute.

Andrea del Castagno

In contrast to Uccello, Andrea del Castagno (Andrea di Bartolo di Bargilla, c.1421-57) achieved a monumental figure style with greater economy of means, and fits the mainstream of Florentine art in his period. Donatello's single sculpted figures are never far away, and the classical nobility of Castagno's figures looks forward to Mantegna. Like Uccello, Castagno visited Venice, returning to Florence in 1444 to create a pendant for Uccello's Hawkwood fresco, the equestrian figure of Niccolò da Tolentino. Castagno's masterpiece, the fresco cycle in Sant'Apollonia, Florence, notably the Last Supper (see plate 76), is at once more prosaic and less disturbing than Uccello's work, but more subtle in its use of perspective. Using a unified perspective system, he linked the Resurrection, Crucifixion and Deposition with the Last Supper, and coupled with a fine sense of colour, achieved a unique grandeur.

It may have been the convincing 'presence' of his figures which gained him the macabre commission to paint the rebels who rose up against Cosimo de' Medici. Their punishment was to be hanged by the heels, and Castagno rendered this in a fresco on the façade of the Palazzo del Podestà, as a grim warning to others. The painting no longer exists, but its startling realism may be imagined from the magnificent figures of *Famous Men and Women* in the Villa Carducci near Florence. The theme of exemplary historical figures (here including contemporary

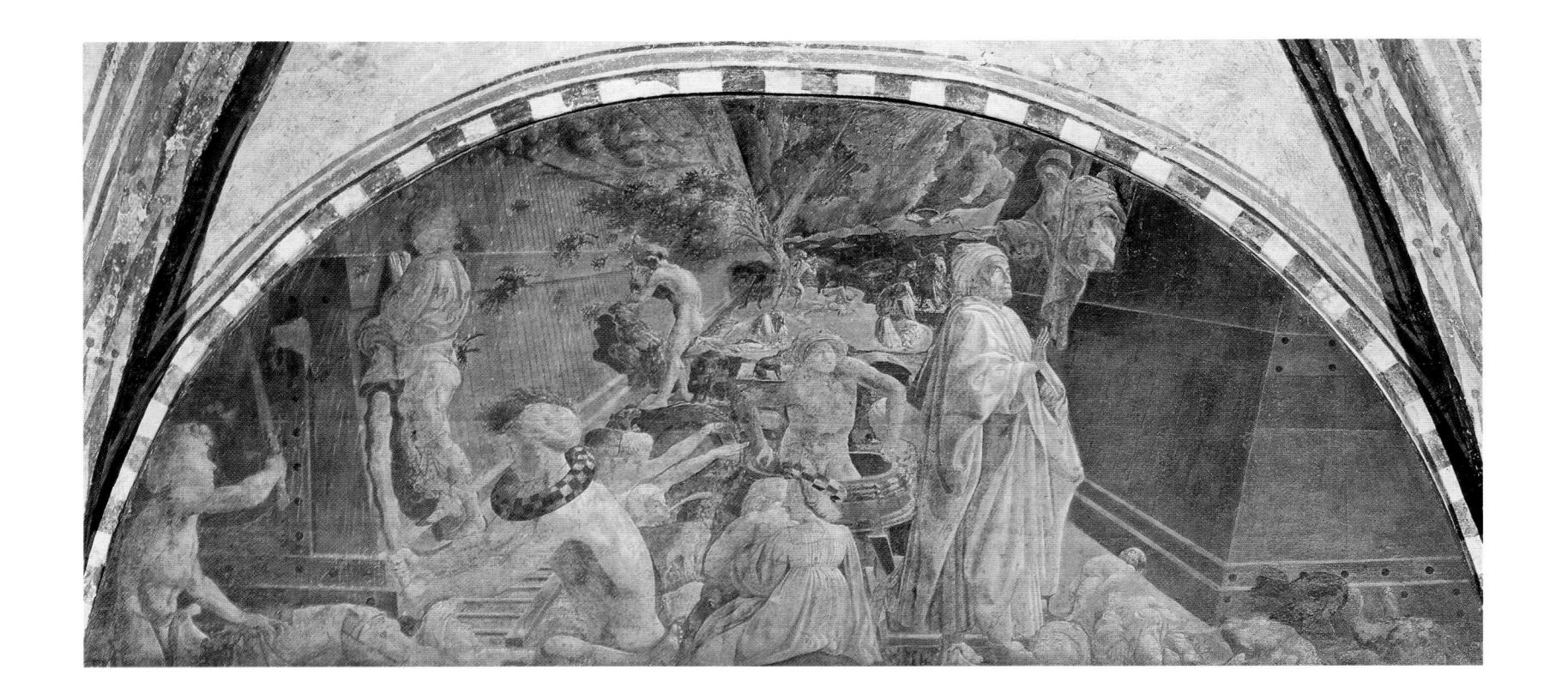

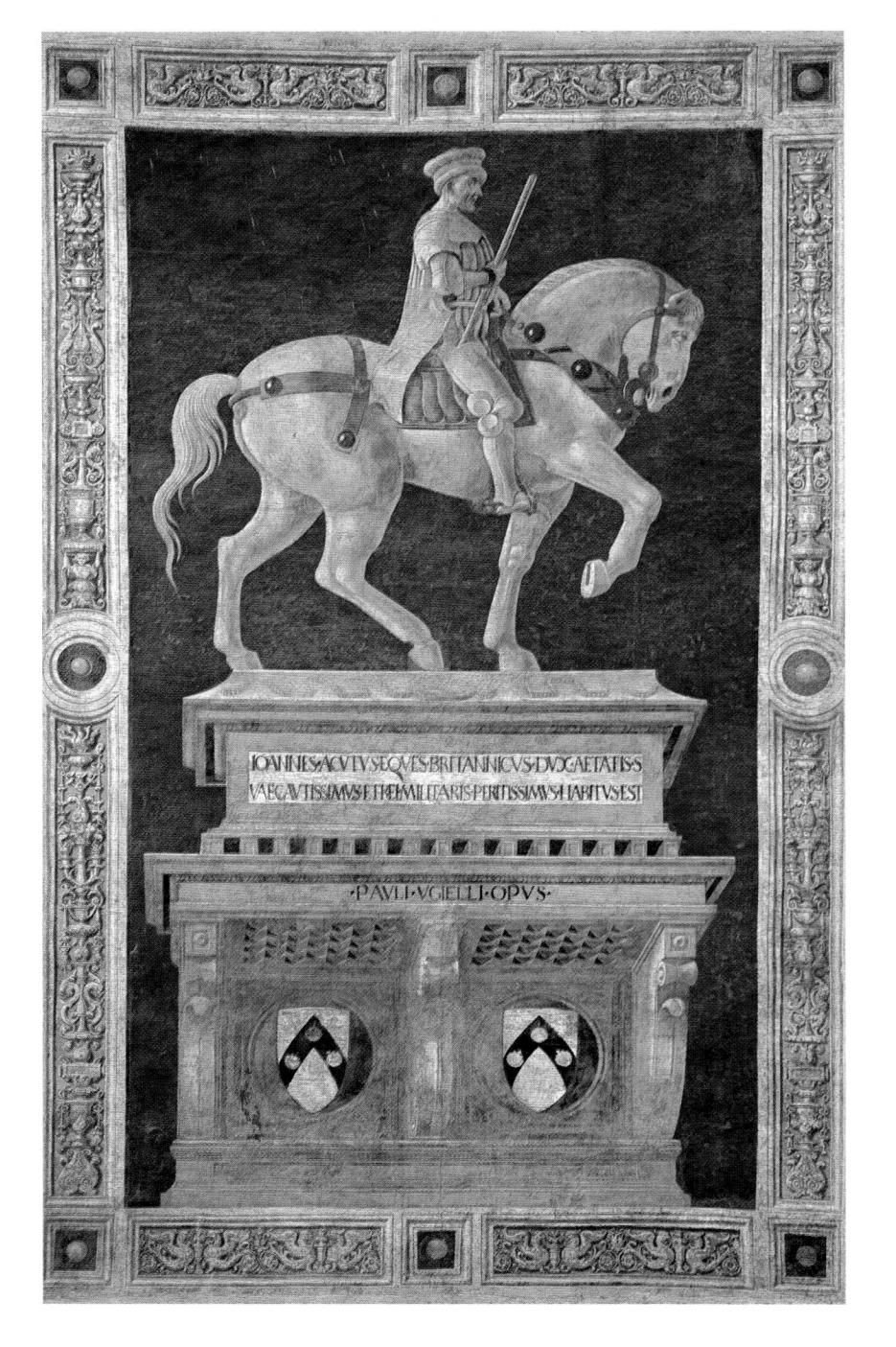

74 PAOLO UCCELLO The Flood and the Recession of the Waters 1446–8

One of the great undocumented works of Uccello's maturity, this comes from the Chiostro Verde of Santa Maria Novella, so-called because of the terra verde or predominant green used in the frescoes. Vasari's famous eulogy of the frescoes praises the rendering of the storm and its manifestations, and the fear shown by the figures. There is disagreement about the type of perspective employed by Uccello, but it is clear that he was deeply influenced by his friend Donatello's Paduan works which he saw on a visit sometime between 1443 and 1453. Thus he probably included different vanishing points to accentuate the scene's inherent drama, and may have been aware of earlier theories concerning the visual distortion experienced during violent storms. The Flood may have been painted on a single intonaco patch.

75 PAOLO UCCELLO Cenotaph to Sir John Hawkwood 1436 (Left) Hawkwood was an English mercenary who fought for the Pope and the Milanese and became Captain-General of the Florentine Republic. In the year before his death the Florentine Signoria voted to give him a memorial in the cathedral with no expense spared. The influences of the horses of St Mark's in Venice, Ghiberti and Luca della Robbia are combined to create one of the greatest equestrian images of the Quattrocento. Uccello's choice of simulated bronze influenced Donatello and later sculptors.

Florentines, thus linking past and present) was popular in Quattrocento Italy and seen as setting an elevated example. Vasari noted that Castagno 'excels in depicting movement in his figures and the disquieting expression of their faces. . .', emphasizing their gravity with vigorous drawing. Vasari believed that Castagno murdered the painter Domenico Veneziano (died 1461), but we now know that Castagno pre-deceased him, a victim to plague.

Antonio Pollaiuolo

Vasari also praised Castagno's interest in *scorti* (usually referred to by the French term *écorchés*) or dissections of corpses, and this links Castagno directly with one of the

76 Andrea Del Castagno Last Supper c.1447–50 The Last Supper had been the usual choice of subject for a refectory mural in Florence since the early fourteenth century and the theme is known as a cenacolo. Castagno painted this dramatic fresco as though it were illuminated by the real windows of the refectory, but apparently taking place in a separate spatial unit. The command of perspective is flawless.

Above the Last Supper he painted the Crucifixion, Entombment and Resurrection, the latter striking an optimistic note. Castagno has adopted vaguely Roman details in the fresco, such as pilasters and sphinxes, to harmonize with the period of the scene. Sphinxes, which usually guard the mysteries of religion, are probably included here as guardians of the mystery of the Institution of the Eucharist with the Last Supper. Castagno has used colour symbolically throughout, notably in the placing of the different coloured marble slabs behind the figures. It appears that each figure or small group had its own cartoon.

most influential figures active in the later decades of the century, Pollaiuolo (Antonio di Jacopo Benci, c.1432–98). Vasari says that he studied many dissections 'to see their underlying anatomy', which became for him what perspective had been for Uccello. Throughout Pollaiuolo's work, a new consciousness of the expressive force of the nude body in movement prevails, particularly in his most famous work, the *Battle of the Nude Men* (see plate 77). Pollaiuolo was equally gifted as a sculptor on a small scale, and as goldsmith, engraver and draughtsman and he frequently collaborated on projects with his less talented brother Piero.

Together with Piero, Antonio was commissioned by Piero de' Medici in about 1460 to paint *The Labours of Hercules* for the young Lorenzo de' Medici's bedchamber in the Medici Palace. Although lost, these are known from replicas by Pollaiuolo and other artists, and the almost frenzied vigour of the original can easily be imagined from the *Martyrdom of Saint Sebastian* (National Gallery, London). Its examination of the male figure both nude and dressed in a wide variety of poses (like the *Battle of the Nude Men*) prefigures Leonardo's and Michelangelo's battle scenes for the Palazzo Vecchio (see plate 208). Its Arno landscape background is equally forward-looking.

Like Castagno at Sant'Apollonia, Pollaiuolo exploited the painted illusion of space as an extension of 'real' space, in his altarpiece for the Chapel of the Cardinal of Portugal in San Miniato, Florence (the original is now in the Galleria degli Uffizi, a copy in the Chapel). In it, three saints are placed on a 'terrace' of coloured marble extending the lavish sculpture of the actual Chapel space and leading the eye on to a sweeping background landscape.

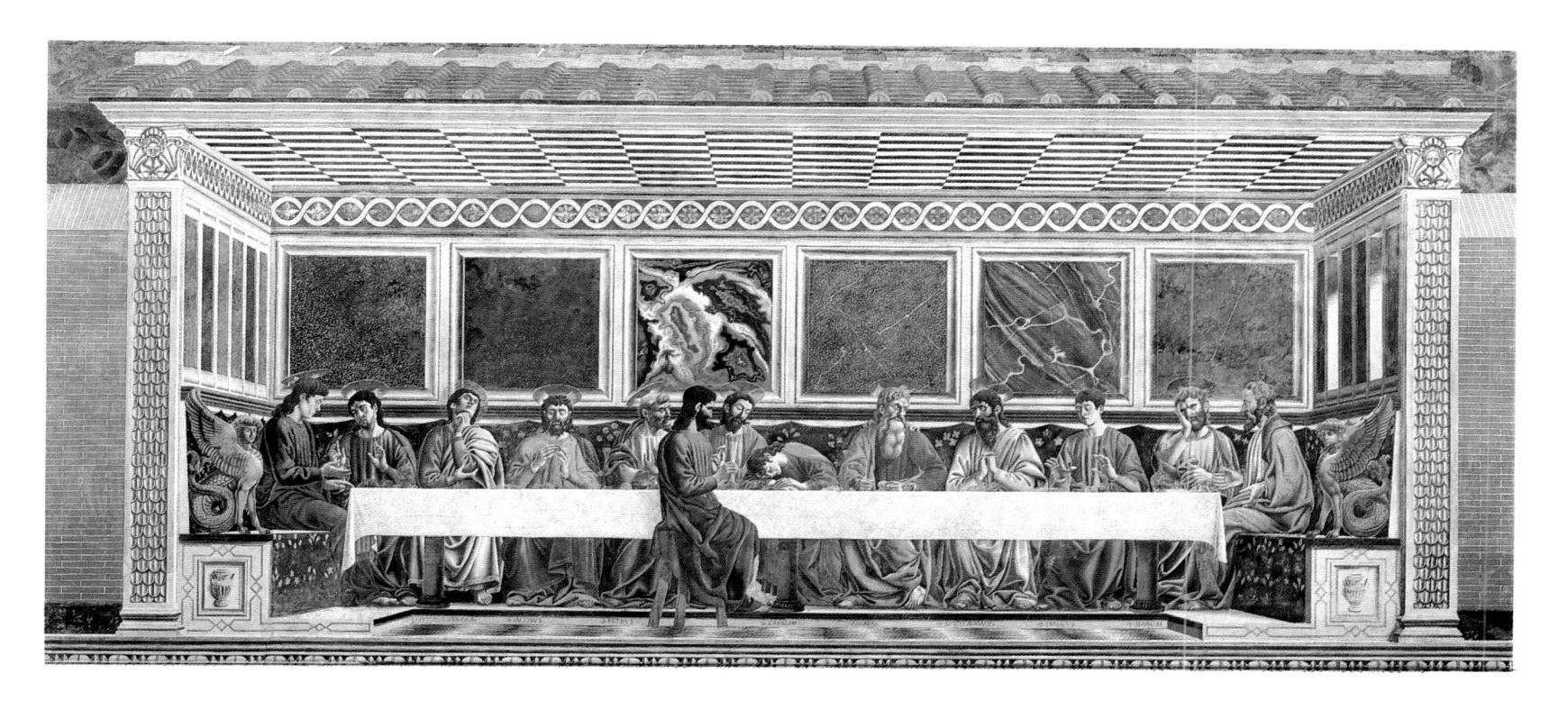

This altarpiece is the perfect illustration of Alberti's notion of the painting as a 'window' on the world, where real and imagined space intermingle. It was in his drawings and prints, however, that Pollaiuolo probably made his most important contribution to figurative art, notably in his use of the pen to create volume without internal shading in his drawings. It is not an exaggeration to suggest that Pollaiuolo exercised an influence only marginally less than Leonardo da Vinci's on the development of the High Renaissance.

77 Antonio del Pollaiuolo Battle of the Ten Nudes after 1483?

This engraving was probably conceived as reference material, to be used like a pattern book, rather than as illustrating a particular theme. Battle pieces were valued for their usefulness in demonstrating an artist's skill, and for the variety of poses they offered, and were taken to their conclusion in Michelangelo's and Leonardo's designs for the battle frescoes in the Palazzo Vecchio, Florence. The tradition of drawing from the nude dates back to the early Quattrocento, and the exaggerated musculature of these figures suggests that Pollainolo used one or more real models in its creation.

Domenico Ghirlandaio

The last of the true Florentine narrative painters of the Quattrocento was Domenico Ghirlandaio (1449–94), whose frescoes sum up the more worldly side of Tuscany under Lorenzo de' Medici, and include portraits of its protagonists. Usually underestimated because they lack vigorous innovation, his fresco cycles include some of the most pleasing images of the Quattrocento (see plate 98). His is a serene art, untroubled by the turbulent sense of anatomical discovery in Pollaiuolo or the neurotic elegance of Botticelli's symbol-laden images. The intellectual content of Botticelli's painting seems particularly remote from Ghirlandaio's more formal and aesthetic preoccupations, and apparently passive depiction of worldly imagery, centred on the Medici court and its rich banking community.

Ghirlandaio's first known painting, *Saints Julian*, *Barbara and Anthony Abbot* (Sant'Andrea, Cercina), has the calm monumentality of Castagno, although Vasari says he studied with Alessio Baldovinetti (*c.*1426–99). Baldovinetti's refined style, derived from Veneziano, Fra Angelico and Gozzoli, made him briefly one of Florence's

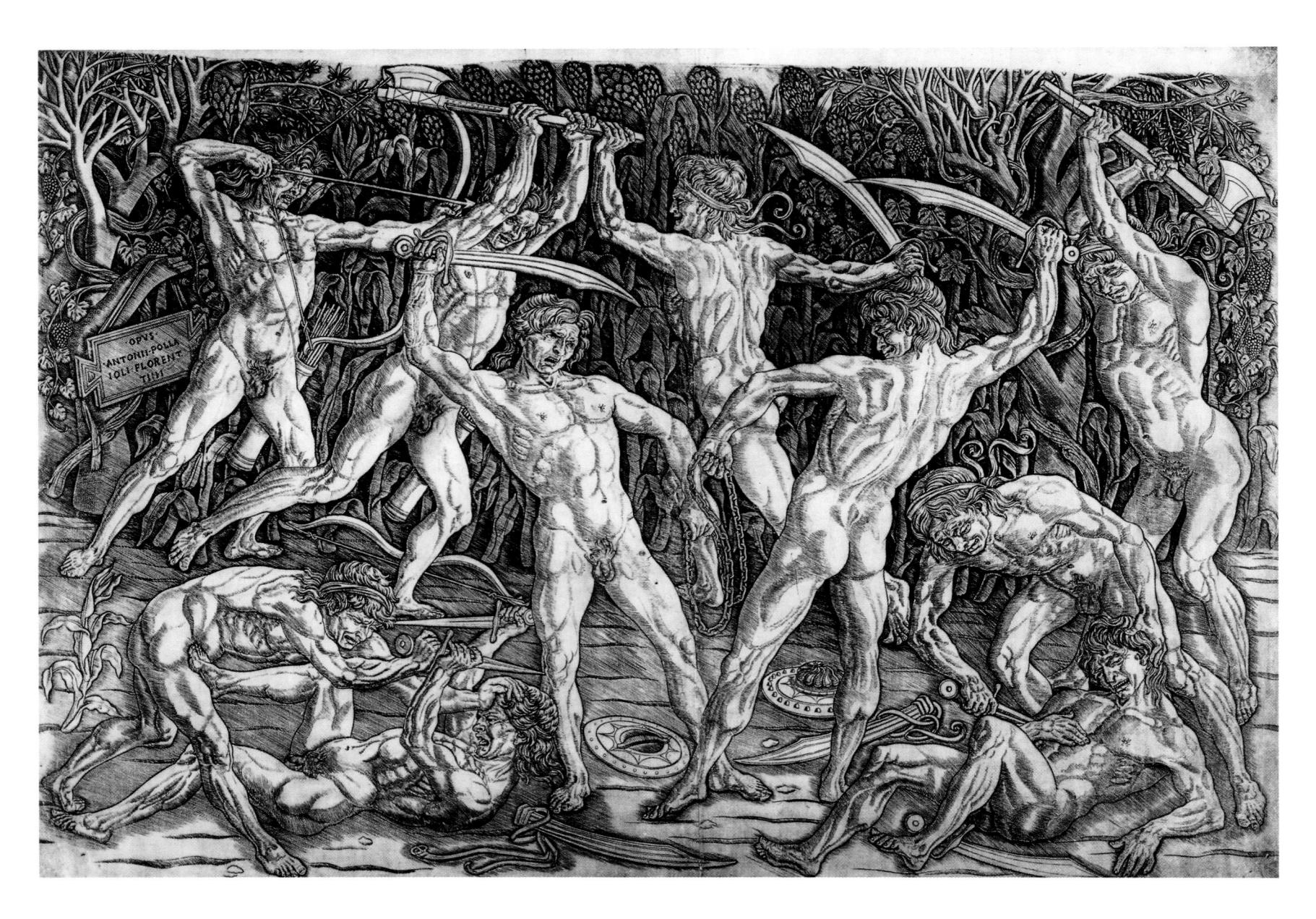

best painters in the 1460s. In 1481–2, Ghirlandaio worked with Perugino and Botticelli in the Sistine Chapel, and his reputation rests on his great fresco cycles.

Ghirlandaio was also a considerable portraitist, as the sympathetic rendering of human decay in his *Old Man with his Grandson* (see plate 103) shows. His son, Ridolfo (1483–1561), continued this aspect of his art with more than mere distinction. Domenico's most notable fresco cycles are in the Sassetti Chapel, Santa Trinità (1483–5) and in Santa Maria Novella in Florence (see plate 98). The most delightful lesser known cycle is that devoted to the *Life of Santa Fina* in the Collegiata at San Gimignano, where the grandeur of the Florentine frescoes gives way to a charming innocence. In all of these, Domenico made use of his highly successful studio, which he ran with his brothers Benedetto (1458–97) and Davide (1452–1525).

In 1483, the *Portinari Altarpiece* (see plate 151) arrived in Florence. It was commissioned by Tommaso Portinari, a Medici representative, from the Netherlandish painter, Hugo van der Goes, for the Church of Sant'Egidio, and represented the finest specimen of foreign painting in a Florentine collecting tradition that had begun fifty years earlier. Flemish painting is often reflected in the work of Lippi, Domenico Veneziano, Baldovinetti, Pollaiuolo and others, and Ghirlandaio borrowed an entire figure group from this latest arrival for his Sassetti Chapel altarpiece painted in 1485.

Through his painting, narrative is acted out by recognizably contemporary figures often in grand domestic interiors of the period, or in familiar Florentine settings such as the Piazza Signoria. The immediacy which this must have given these pictures (and which occurs in Botticelli and others) might appear almost shocking were it used today. It seems highly likely that Andrea del Sarto, Michelangelo and Raphael (a close friend of Ridolfo Ghirlandaio) all studied the frieze-like compositions of Domenico's work, which prefigure their own High Renaissance Classicism. A direct parallel might be seen between Ghirlandaio's Birth of the Virgin fresco in Santa Maria Novella and del Sarto's rendering of the theme in the Santissima Annunziata. It was no coincidence that Ghirlandaio's most famous pupil was to be Michelangelo as, like other restrained painters, he made an excellent teacher. Other pupils included Francesco Granacci (1469-1543), who briefly assisted on the Sistine Ceiling, and Giuliano Bugiardini (1475–1554). Michelangelo appears to have adopted from Ghirlandaio the system of cross-hatching seen in his early drawings, which he transferred directly into his sculpture in his use of the claw-chisel.

Luca Signorelli

The influence of Luca Signorelli (?1441–1523) emanates mainly from his great frescoes in Orvieto Cathedral (see plate 96). As in the case of Pollaiuolo, his work was seminal in the evolution of dramatic figure composition in Italy. Like Botticelli, Signorelli outlived his own age, although he seems to have been revered all his life. Vasari emphasized that he was 'always highly praised by Michelangelo', and it seems likely that one of Michelangelo's *ignudi* in the Sistine Chapel may derive from Signorelli's earlier frescoes there. He combined a genius for foreshortening with a passion for portraying the nude.

Born in Cortona, he worked throughout central Italy, in Rome, Florence, Arezzo, Perugia and elsewhere. According to Vasari, he was a pupil of Piero della Francesca, which seems plausible given his particular type of solidly modelled figures. Instead of Piero's mystical, other-worldly forms, however, Signorelli rendered the human figure as an arrestingly tangible object, its surface often given the hard gleam of metal sculpture – this is something he may have derived from Pollaiuolo's small-scale sculptures.

In 1483, he was commissioned to complete the Sistine work (principally the frieze scenes on the upper parts of the walls) unfinished by Perugino and others. Selection for this decorative scheme indicated a position of immense prestige in contemporary art, for it included Botticelli, contributions from Cosimo (1439-1507), Domenico Ghirlandaio and Perugino. When in 1499 Signorelli came to paint the Orvieto frescoes with scenes of the end of the world and the Last Judgement (see plate 96), he was probably the only painter in Italy capable of organizing such an immense number of figures with such splendour and force. Michelangelo was to have the opportunity a few years later, only on a much reduced scale, in his Bathers painting for the Palazzo Vecchio.

Signorelli was clearly an astute business man, since he arrived in Florence in the late 1480s with two paintings which he offered to Lorenzo the Magnificent: the superb *Education of Pan*, formerly in Berlin but destroyed in the Second World War, and a *Madonna and Child* now in the Uffizi. Both allude to the Medici's dynastic power. The *Pan* was an allegory of the reign of Lorenzo de' Medici, of the type dear to the Neoplatonists. It suggested the harmony of Lorenzo's age, which prized wisdom, chaste beauty (which inspired Platonic love), and music — the highest mental activity which many considered led to ultimate harmony with nature.
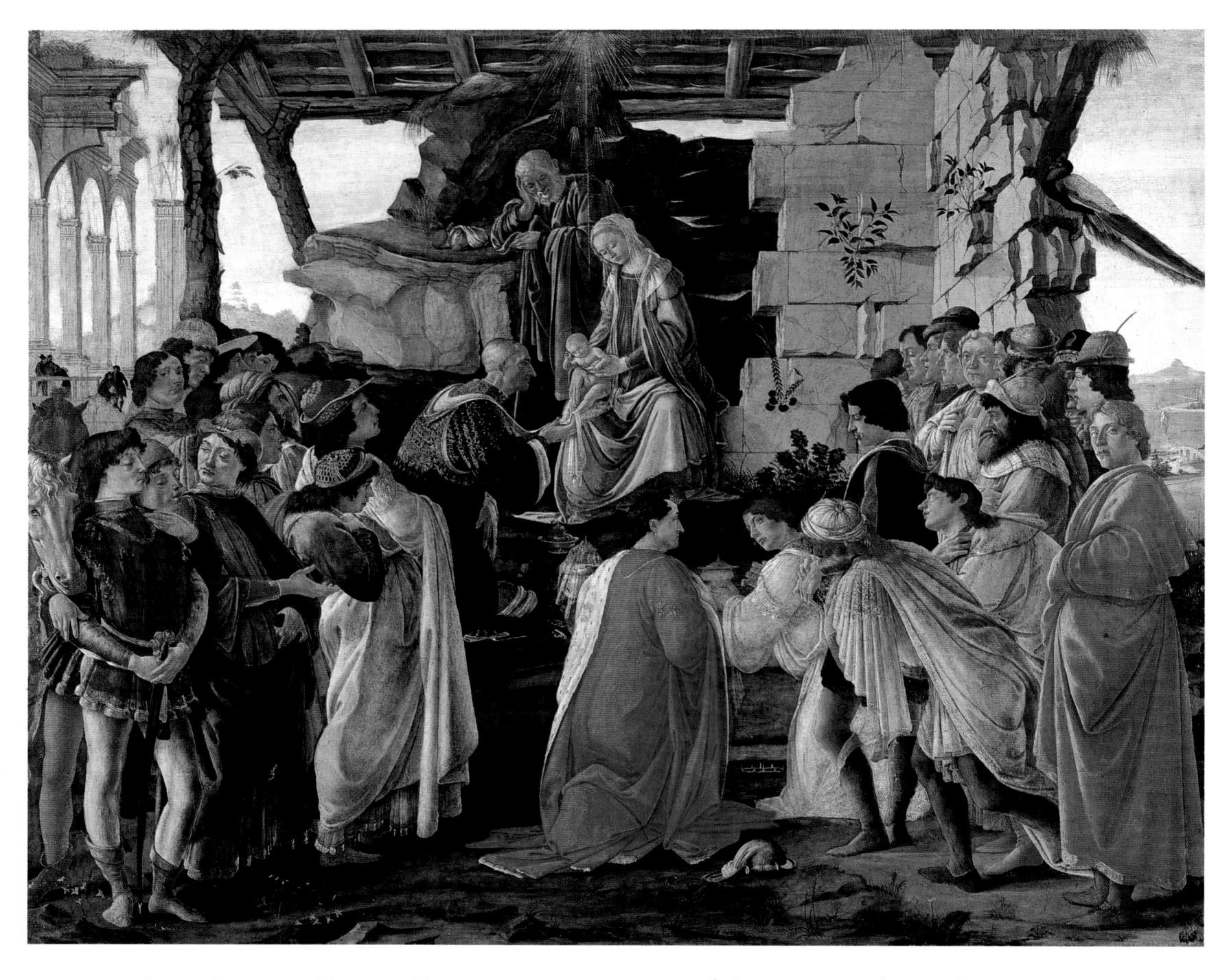

78 SANDRO BOTTICELLI Adoration of the Magi c.1475 Unlike most of Botticelli's pictures, the Adoration does not express some abstract philosophical or religious idea but the New Testament story. It is one of the major group portraits of the Renaissance, since it includes at least four likenesses of the Medici family. Botticelli portrays himself on the extreme right, Lorenzo the Magnificent stands in the left foreground, Cosimo the Elder kneels before the Virgin, while Piero the Gouty is shown from behind clad in scarlet and Giuliano stands at the front of the right-hand group.

Sandro Botticelli

The last quarter of the Quattrocento saw the emergence in Florence of three very different geniuses: Botticelli, Leonardo and Michelangelo. The latter two were to evolve the art which later emerged into the full High Renaissance, while Botticelli remained entirely a product of Quattrocento culture. Alessandro di Mariano Filipepi (1445–1510), known as Botticelli ('little barrel', a surname which was adopted by his family), was the only one of the three painters whose career was spent almost entirely in Florence, with the exception of work produced during a visit to Rome in 1481–2. His training in the studio of Filippo Lippi did not, as might have been expected, lead him to adopt the tradition of Masaccio. Instead, Botticelli stands outside the realist current of Lippi, Ghirlandaio and Cosimo Rosselli, whose pupils Fra Bartolommeo and Piero di Cosimo (see plates 81, 112 and 206) continued it. Piero di Cosimo (c.1462–1521) created highly original images, but apart from Vasari's spirited account of his life, regrettably little is known of him.

There is likewise little biographical information available on Botticelli, including his beliefs in Neoplatonism and other contemporary philosophies which play such a

vital role in his art. His image as a prim painter of Madonnas was cherished by the Victorians, but meant that he was largely ignored for almost the three preceding centuries. The reality, however, is very different. Botticelli's allegiances lay undoubtedly in the intellectual camp of the Lorenzo de' Medici circle. In 1475 he is known to have painted a banner (now lost) for Lorenzo to carry at a joust, with *The Triumph of Love*, described in detail by Poliziano, revealing Neoplatonic sources. The ideal of friendship among the Neoplatonists also found its expression in his small *Adoration of the Magi* (see plate 78). Botticelli painted it for a banker associate of the Medici,

Austere and harrowing, this is one of the most remarkable images of late Quattrocento art, and the most intense of Botticelli's later pictures. It is usually seen as reflecting the direct impression made on the artist by the sermons of Savonarola. Framed in the arch of the tomb, the group includes the figures of Sts Jerome and Paul, who both lived in a later period than the scene depicted and who could not have been present at the event. This may serve to emphasize the sense of the image being a vision rather than a direct representation of experience.

some of whose portraits he included as an apparent token of deep friendship.

While Leonardo was advancing the study of form in aerial perspective, Botticelli's preoccupation throughout his entire career was the exploitation of line, at which he excelled. The relationship of his drawings to his paintings remains unique, the use of line being virtually interchangeable between the two. His complete control of linear representation is best seen in his large drawings on white vellum which illustrate Dante's *Divine Comedy* (divided between the Vatican, Rome and the Staatliche Museen, Berlin).

In spite of his apparently deliberate detachment from many contemporary developments, Botticelli was fully aware of them. In his paintings of the *Adoration of the Magi* from the 1470s and early 1480s (particularly those in the National Gallery of Art, Washington and the Galleria degli Uffizi, Florence), he adopts the centralized composition and pyramidal forms of Leonardo. But he chose to evolve a style entirely his own, regardless of contemporary pressures for change. These years were the period in which much of his most potent imagery was created, such as the *Primavera* (see plate 83), the *Birth of Venus* (see plate

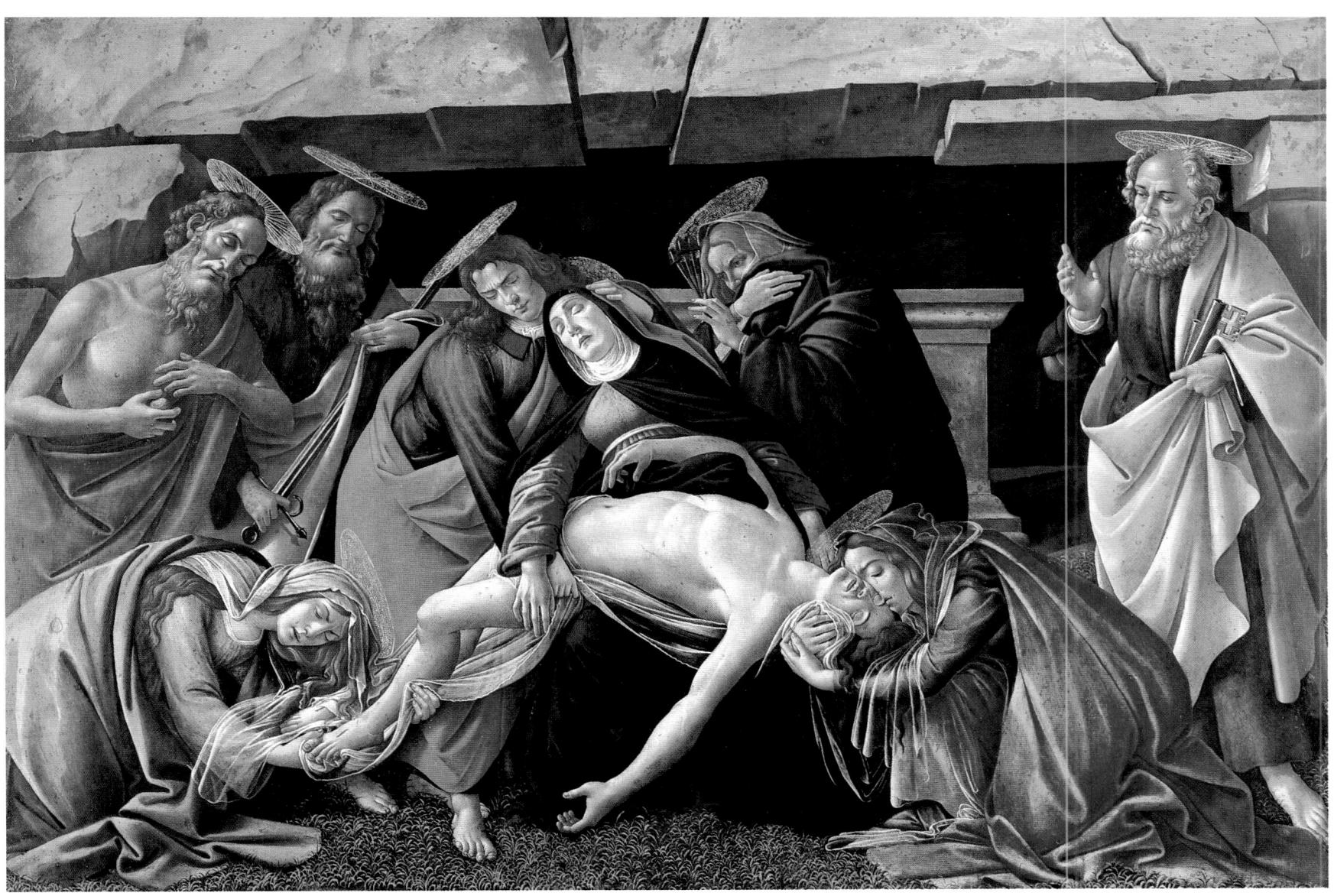

116) and *Minerva and the Centaur* (see plate 117). It is particularly apparent in the *Primavera* and *Birth of Venus* that Botticelli's treatment of outline owes rather more to Gothic art (such as miniatures or small sculptures) than it does to the Classical art which was to inspire Michelangelo.

Vasari says that Botticelli came under the influence of Savonarola (whom he probably knew well) and that, inspired by the priest's message of purification, he abandoned painting to atone for having depicted 'pagan' subjects. We know this to be untrue, as some of his finest paintings were made after Savonarola was burned at the stake. These include the much-discussed *Mystic Nativity* of 1500 (National Gallery, London), with its message referring to the end of the world and the dawn of the millenium, and the very late, intensely tragic *Lamentation of Christ* (see plate 79). It is clear, however, when these late

80 VITTORE CARPACCIO The Arrival of the Ambassadors 1490–4

This is the first picture of nine in the Saint Ursula cycle. In the scene at the left; the English ambassadors arrive at the Breton court. In the centre they present Prince Ereus's request for the hand of Ursula, and at the extreme right Ursula and her father discuss the matter. The Arrival is the most elaborate picture in the cycle, and many of the faces are probably portraits of members or patrons of the Scuola. Carpaccio's usual wealth of detail fills the scene, from the Perugino-inspired architectural background to the unforgettable seated figure of Ursula's nurse in the bottom right-hand corner. The gap at the bottom of the canvas corresponds to where a door was placed in the early sixteenth century.

81 PIERO DI COSIMO Cleopatra (so-called 'Simonetta Vespucci') c.1485–90

The identification of the sitter as Simonetta Vespucci, a celebrated beauty loved by Giuliano de' Medici, depends on the later inscription, and is only partly accepted. Simonetta died of tuberculosis at twenty three, and the snake could thus be a symbol of immortality or eternity. However, the contrast of the elaborate hairstyle with the exposed breasts creates an eroticism at variance with Simonetta's chaste reputation. Vasari's description of the picture as 'a very beautiful Cleopatra with an asp round her neck' seems to fit better than the traditional title.

paintings are compared with the decorative qualities of his earlier Madonnas, that Botticelli did undergo some profound spiritual maturing.

His large studio was very active (Lippi was his best pupil (see plate 97), and it seems clear that many assistants were trained specifically to repeat and vary his own successful compositions *ad infinitum*.

The Early Careers of Leonardo and Michelangelo

For Leonardo da Vinci (1452–1519), paintings pertained to philosophy, 'because they deal with the movement of bodies in the promptness of their actions just as philosophy extends itself into the world of movement'. This is conspicuous in every aspect of his intense and varied output, whether as painter, draughtsman, architect, sculptor, scientist, musician or philosopher.

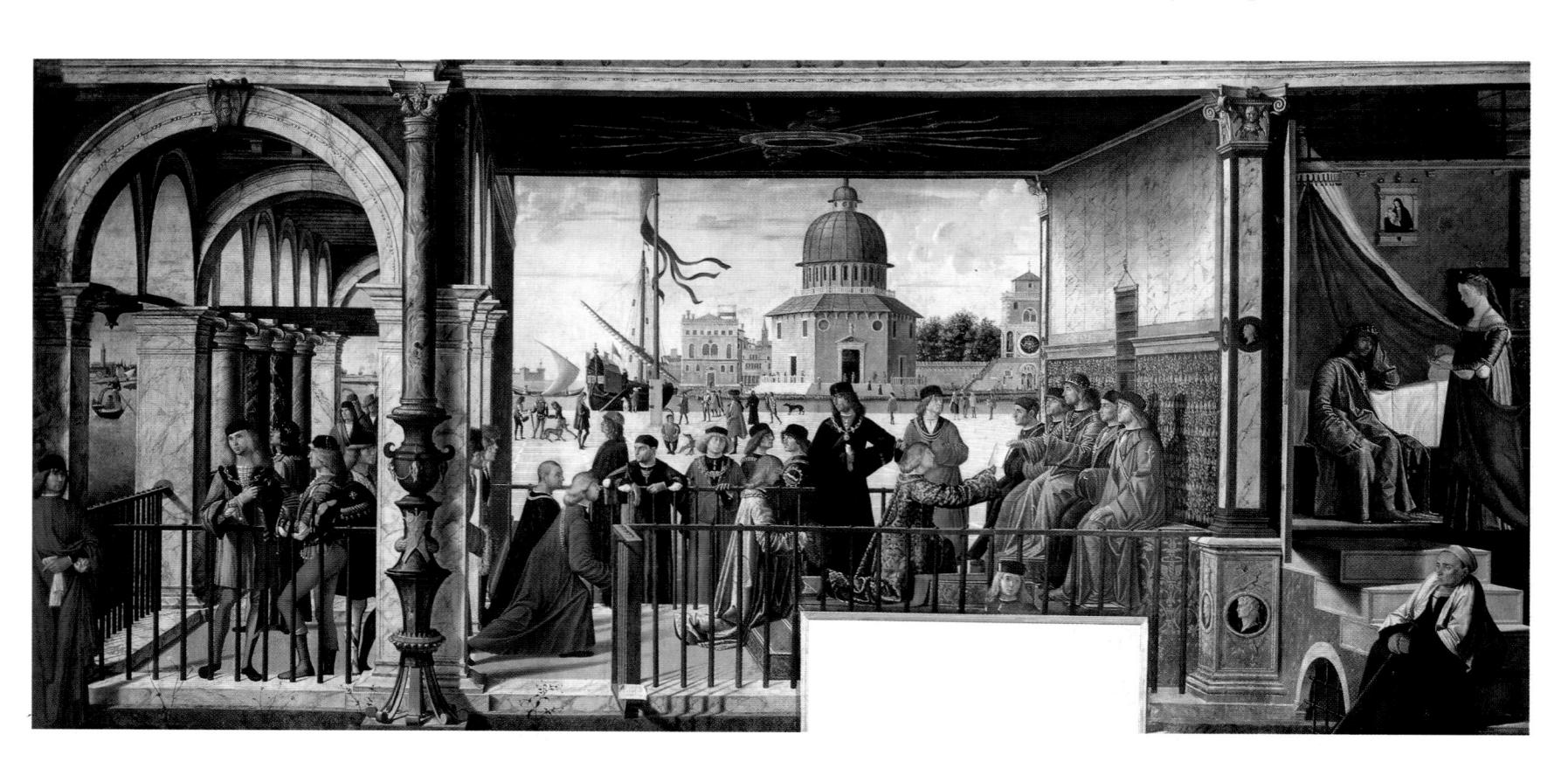

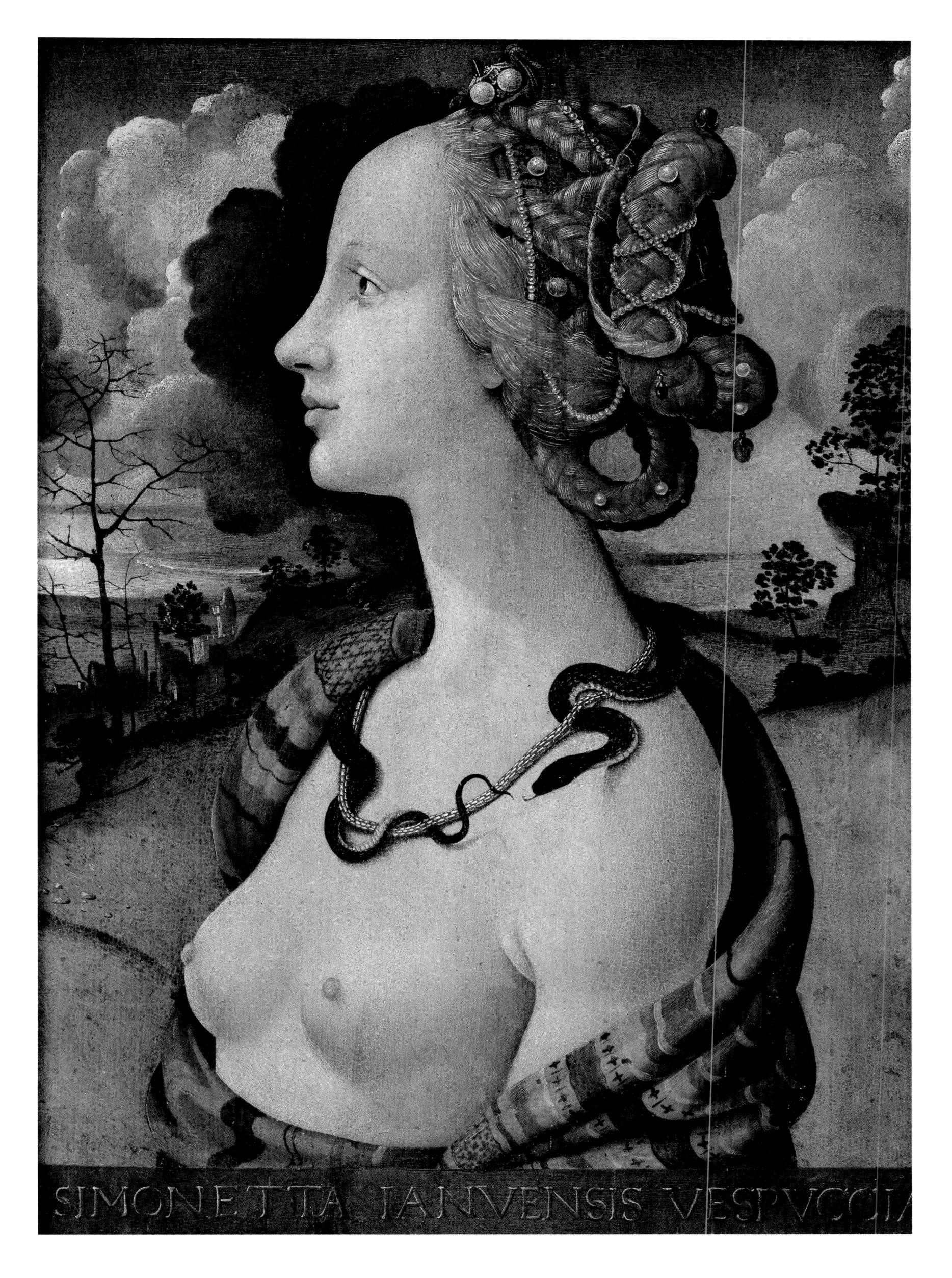

His birth as the illegitimate son of a Florentine notary and a peasant girl, Caterina, set the tone of mystery and romance which has always surrounded Leonardo. In 1472, he was enrolled as a painter in the Florentine fraternity of St Luke, and the fact that four years later he was living in the house of Andrea del Verrocchio (Andrea di Michele Cioni, c.1435–88) lends credence to the story that he studied with him. Leonardo's participation in Verrocchio's painting of the *Baptism of Christ* (see plate

82 LEONARDO DA VINCI Adoration of the Magi 1481-2 When he left for his first visit to Milan, Leonardo left this, his first major composition, unfinished in the house of Amerigo Benci (the father of Ginevra, whose presumed portrait by Leonardo is in the National Gallery of Art, Washington). By 1621 it was in the possession of Antonio de'Medici in the Casino Mediceo in Florence. The artist was originally commissioned to paint for the monks of San Donato a Scopeto, but after fifteen years they commissioned another from Filippino Lippi (now in the Uffizi), which appears to be based on Leonardo's preparatory drawings. What we see is really the underpainting for a finished picture in umber over a sand-coloured priming. It has been called 'the most revolutionary and anti-classical picture of the fifteenth century', and Vasari describes Raphael as standing speechless in front of it. A drawing in the Uffizi shows Leonardo working out the complex perspective, which he then altered considerably to concentrate attention on the central figure of the Virgin, on whom all elements converge. The composition and details prefigure many of the features of Leonardo's later painting, notably his fascination with psychology as seen in expression and gesture, his genius for placing figures in space, his use of sfumato and his sense of mystery.

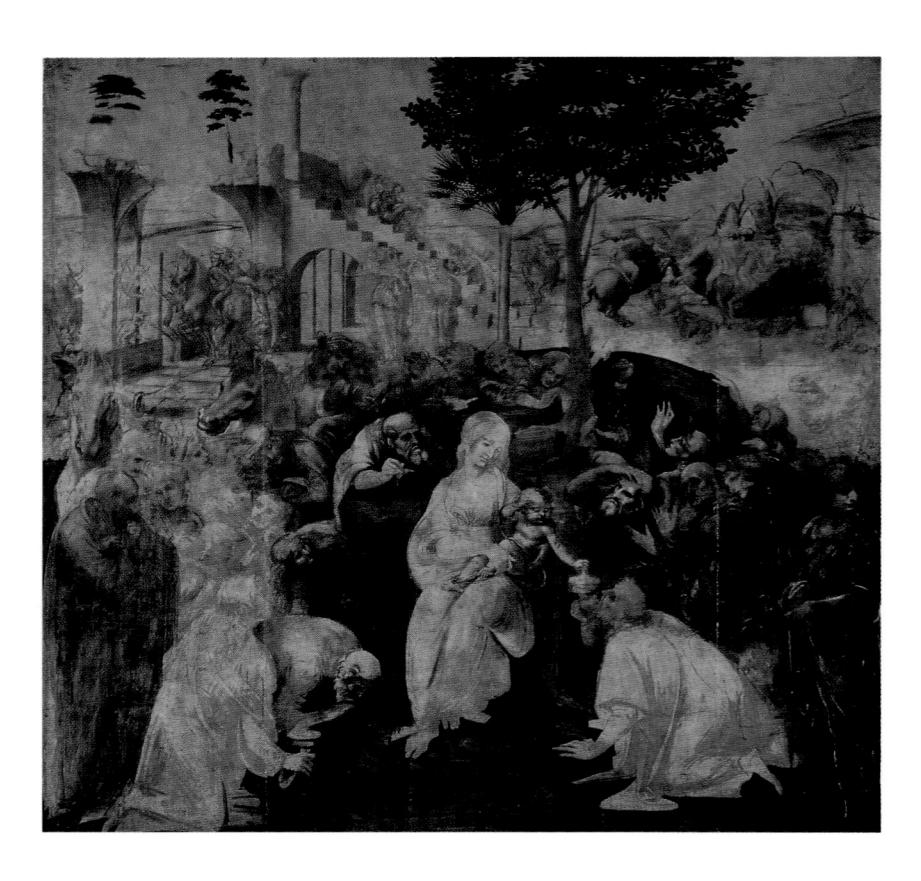

83), for which he contributed an angel's head, supposedly decided his master to abandon painting. In this head is crystallized all Leonardo's subsequent painting, with its exquisite realism in the painting of the curls and eyes, its disturbingly direct and yet remote gaze.

It may have been Leonardo's intensely practical emphasis in art that led him in 1482 to abandon the Florence of Lorenzo de' Medici and offer himself to Duke Lodivico Sforza ('il Moro') in Milan, primarily as a military architect and engineer. We know that Lorenzo sent Leonardo to Lodovico with a special lyre designed by the artist, much as he sent several important Florentine artists to other Italian courts as ambassadors of Florentine culture. Thus avant-garde Florentine ideas were transmitted overnight to Milan, where Leonardo was to leave his most striking image, the Last Supper (see plate 41). He had left incomplete in Florence his Adoration of the Magi (see plate 82), with its complex language of gestures and expressions, and its architectonic composition so at variance with the prevailing pictorial structures in Florentine painting.

Leonardo stayed twice in Milan: from 1482 until 1499 (the year of the French invasion under Louis XII), and from 1506 until 1513 (see Chapter VII). During his first stay, he painted numerous portraits, notably Portrait of a Musician (Pinacoteca Ambrosiana, Milan) and the Duke's mistress, Cecelia Gallerani (see plate 118), and experimented with one of his favourite themes, the Madonna with other figures. At opposite poles in this respect are The Virgin of the Rocks (see plate 191) and the intimate Madonna Litta (Hermitage Museum, Leningrad). In all of these panels, his painting technique attained a jewel-like transparency and perfection which cast its spell over Lombard artists. In March 1500, Leonardo was in Venice, and by August had arrived back in Florence, where the public exhibition of his celebrated cartoon, The Virgin and Child with Saint Anne (see plate 209), may be regarded as the real starting point of the High Renaissance.

The early Florentine career of Michelangelo Buonarroti (1475–1564) was primarily concerned with sculpture, and his first achievements in painting belong properly to the first years of the next century (see Chapter VII). Having moved with his family from Caprese to Settignano, outside Florence, Michelangelo was apprenticed to the Ghirlandaio studio in 1488. From 1489 to 1492 he studied the sculptures assembled by Lorenzo the Magnificent in the Medici Garden in Florence's Piazza San Marco. He was adopted by Lorenzo as his protégé, a protection continued by Lorenzo's successor, Piero. In 1496 another patron, Cardinal Riario, was his host during his first visit to Rome, and he did not return to Florence

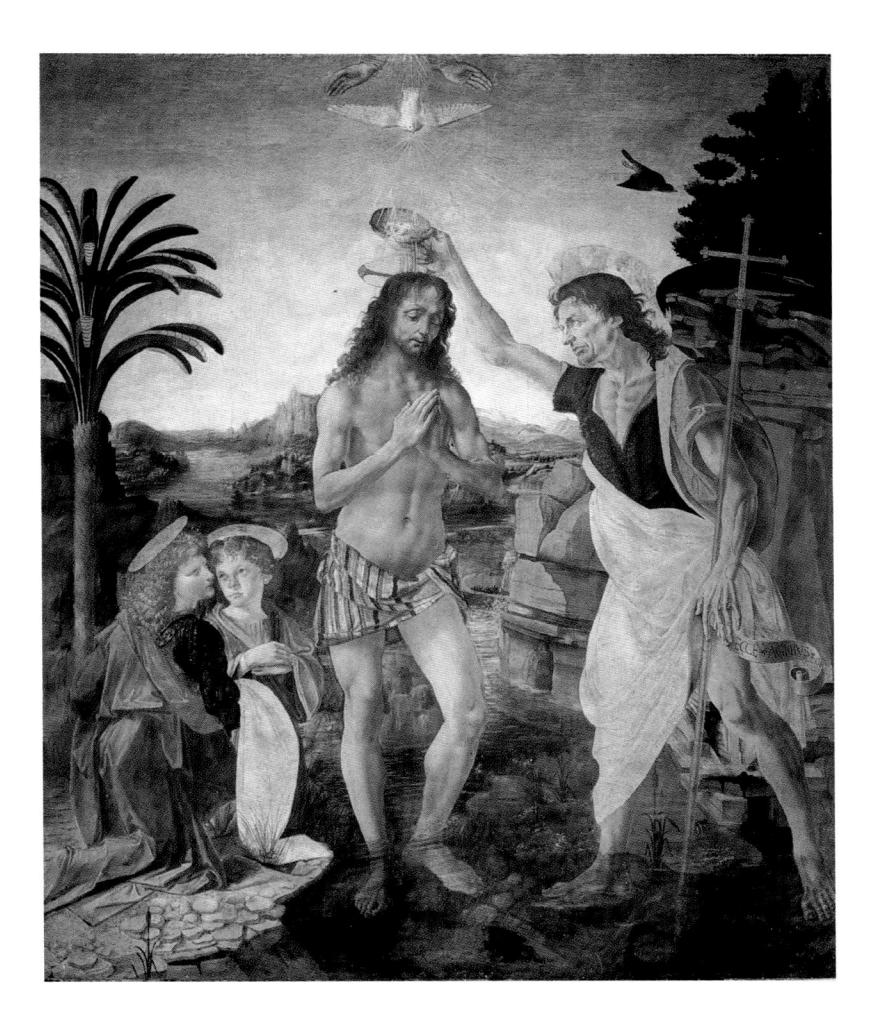

83 Andrea del Verrocchio Baptism of Christ 1472-5 (Above) Mainly active as a sculptor, Verrocchio was also a gifted painter, although he appears to have abandoned painting after 1472. His nickname means 'true eye'. This picture was painted for the church of San Salvi in Florence. The first reference to Leonardo's participation was in 1510, and it was repeated in Vasari. It is said that the angel at the extreme left and probably some of the landscape is by Leonardo who lived in Verrocchio's house for a while and probably studied with him. Vasari says that Verrocchio abandoned painting as a direct result of seeing Leonardo's angel in his picture, being more indignant that a boy should know more of the art than he did.' Whatever the truth of the story, the contrast between Verrocchio's patently Quattrocento treatment of the figure and Leonardo's more fluid style is particularly evident in the treatment of the angel's hair and facial expression. It anticipates similar heads of angels in Leonardo's subsequent paintings, notably the Virgin of the Rocks.

until 1501, leaving one great sculpture in the Papal city, the *Pietà* in St Peter's. He was poised to create a series of great sculptures and launch his career as a painter in the High Renaissance mould.

With the early careers of Leonardo and Michelangelo, Florentine painting moved decisively away from the Quattrocento, leaving a group of older painters, like Botticelli, as practitioners of a style which, although old-fashioned by comparison, continued to be generally popular.

Umbrian Painting

For the twentieth century, Piero della Francesca dominates Umbrian art in the Quattrocento, but Perugino's name would probably have sprung more readily to mind among their contemporaries. They represent the twin polarities of Umbrian art of the period. The most distinguished Umbrian painter in the first half of the Quattrocento is Ottaviano Nelli (c.1370–1444) from Gubbio. First documented in 1400, he worked in Rimini,

84 BARTOLOMMEO DELLA GATTA Stigmatization of Saint Francis 1486

(Below) Piero di Antonio Dei took the name Bartolommeo della Gatta when he became a Camaldolese monk. He was Piero della Francesca's greatest successor in the Arezzo area. One of the most striking and unusual pictures of the Italian Quattrocento, this work is also surprisingly little known. Its surface clarity and almost theatrical poise lend it a surreal air that owes much to Northern influences. The painting illustrates the story of St Francis's retreat to Mount La Verna where, while he was contemplating a vision of the crucified Christ, the marks of the stigmata appeared on his body.

Bartolommeo's last years were devoted almost exlusively to architecture; and he built the church of the Annunciata at Arezzo. This architectural interest is visible in the picture's ample expression of spatial effects.

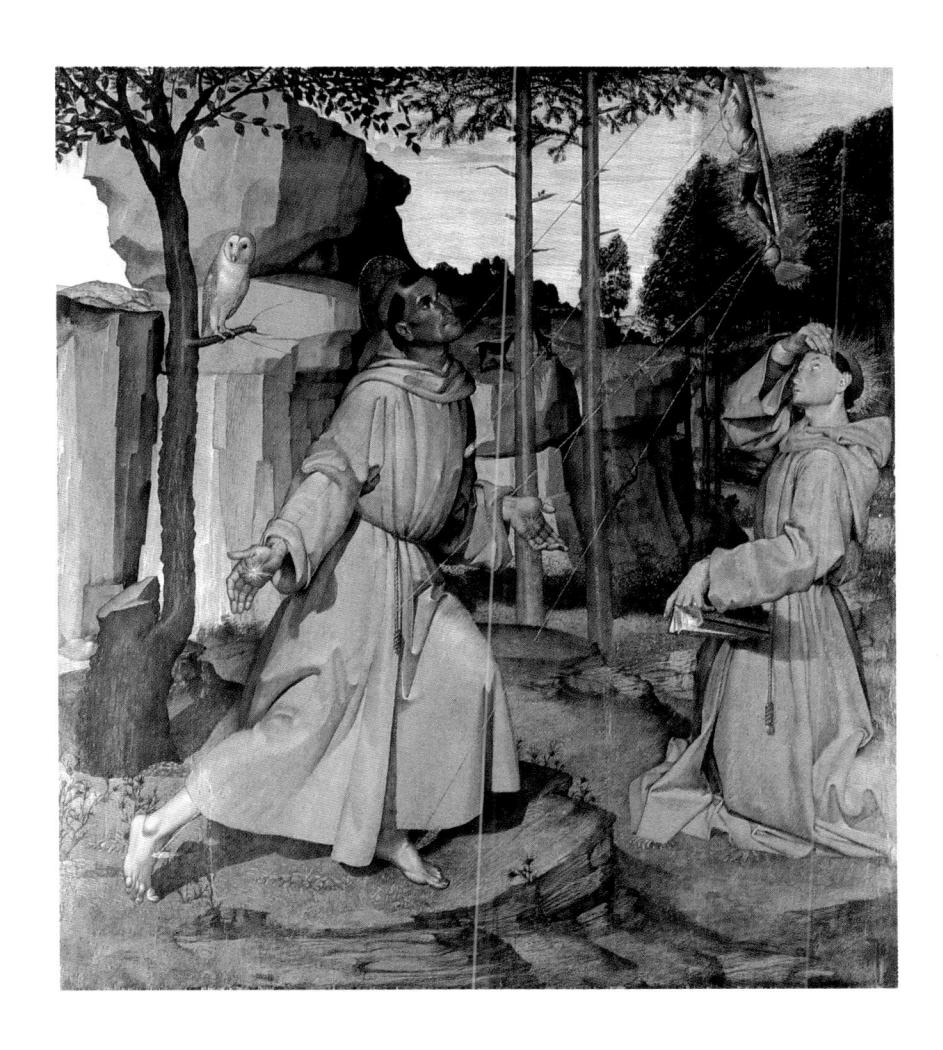

Foligno, Fano, Città di Castello, Urbino and elsewhere. His masterpiece, the fresco cycle showing the *Life of the Virgin* in Foligno's Palazzo Trinci, sums up his debt to late Trecento Florentine art. His courtly style is also reflected in the work of the so-called 'Palazzo Trinci Master', who was mainly active in the 1420s and 1430s, and whose charming frescoes were influenced by Pisanello and Gentile da Fabriano. Subsequent painters of interest include Bartolomeo Caporali and Matteo di Gualdo, who help to prepare the way for Perugino, with Piero the leading Umbrian master of the second half of the century.

Piero della Francesca

Piero della Francesca (Pietro di Benedetto dei Franceschi, 1416/7–92) is one of the major rediscoveries of modern art history, his imposing block-like forms perhaps being more to our post-Cubist taste than are Perugino's. Piero's formal language speaks of a magnificent detachment, accentuated by his palette of characteristically pale colours. His 'modernity' may have impressed his contemporaries more as the mathematical solution to formal representation, and what we find so hauntingly evocative

85 CIRCLE OF PIERO DELLA FRANCESCA View of an Ideal City c.1470

The latest developments in architecture play a fundamental role in many of Piero della Francesca's paintings. Although this may not be by Piero himself (it was attributed to him in the nineteenth century), its conception of the ideal urban landscape and its superb Classical detail and perspective owe their appearance entirely to him, to the Urbino court architect Laurana and to Francesco di Giorgio Martini. It has also been suggested that it may be a theatrical setting, an illustration to Alberti's De re aedificatoria or even Piero's own treatise De prospettiva pingendi. It may have formed the front of a cassone.

in his style probably meant something utterly different in his own times. Vasari had some difficulty in finding information about him for his compilation of artists' lives, yet most contemporary painters fell under his spell at some time or other, since he travelled to Rome, Florence, Ferrara, Rimini and Arezzo.

Piero always returned to his birthplace, Borgo San Sepolcro (today San Sepolcro), and it was there he painted his first documented work, the polyptych of the *Madonna della Misericordia* (Pinacoteca Communale, Sansepolcro), commissioned in 1445 and completed slowly over the next decade. This work charts the progress of his style in those years. Concurrently he was painting some of his best-known works, including the *Baptism of Christ* (National Gallery, London), and the *Flagellation of Christ* (see plate 100). In each of these, the essentials of his manner are visible. Although documented in Florence only in 1439, helping Domenico Veneziano, it is likely that he spent considerable time there in the 1430s.

In Florence, Piero absorbed most of the ingredients necessary to evolve his own style from studying the work of painters such as Masaccio, Uccello and Filippo Lippi, and also from sculptors such as Donatello. All displayed an interest in large-scale form described in general terms. Donatello's Classical references must also have attracted Piero, while Masolino's broad treatment of colour surely influenced his own.

Piero's painting illustrates perfectly his own theories concerning the mathematical nature of painting, as expressed in his two treatises, *De prospettiva pingendi (On Perspective in Painting)* and *Libellus de quinque corporibus regularibus (On the Five Regular Bodies)*. He demonstrates that, as in architecture, every part of the body can be subjected to the rules of mathematical perspective, and the result of this in his painting is its scale and deliberately simplified qualities. Because he believed, like Vitruvius, that architectural proportions must be based on the human body (the column in particular relating to the corresponding proportions of head, arms and legs), he achieved a unique

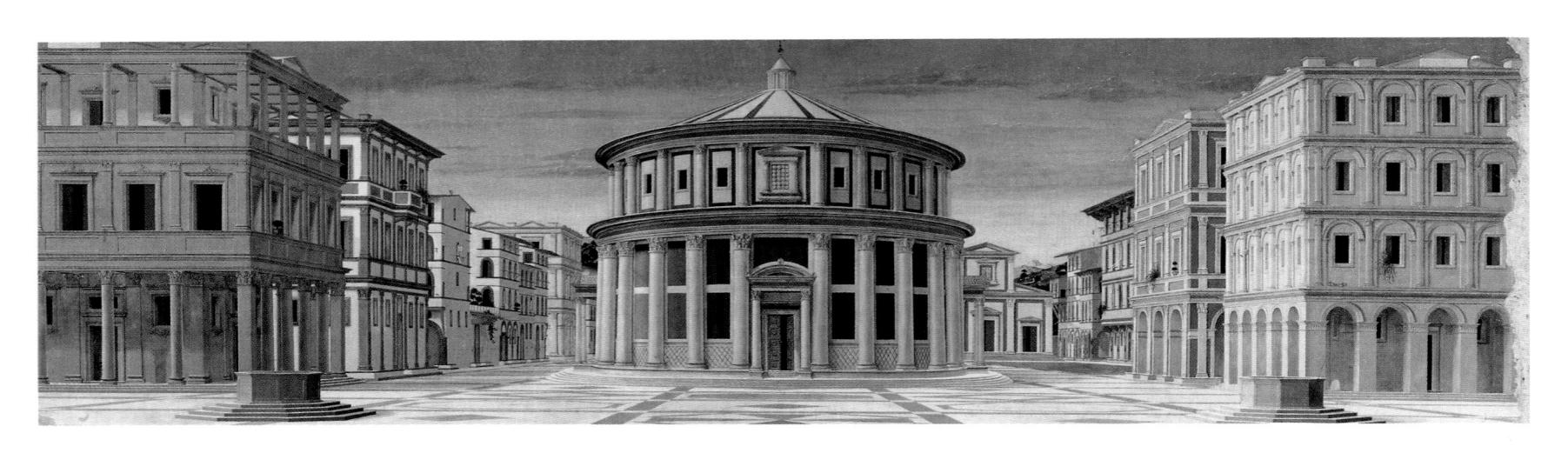

86 PIERO DELLA FRANCESCA Dream of Constantine 1455
The choir of San Francesco at Assisi is decorated with scenes from the
Legend of the True Cross. The Dream of Constantine is one
episode in the sequence, and it shows the Emperor asleep in his tent
guarded by soldiers. Above him an angel swoops down to foretell his
victory at the battle with Maxentius.

balance between man and architecture in his painting. *The View of an Ideal City*, attributed to his circle (see plate 85), is simply a depopulated version of Piero's figure paintings.

Piero's greatest statement of all his ideas is the fresco cycle showing the *Legend of the True Cross* in the choir of San Francesco at Arezzo, painted about 1452–65 (see plate 86). Here is concentrated his legacy from Masaccio's Brancacci Chapel, from Uccello's most experimental painting and from Lippi's feeling for space. All these elements are transformed into images of such momentous simplicity and stylized feeling that they have few equals in Western painting. Their light-filled spaces are no less mysterious for lack of shadow, and their timeless human gestures are inexplicably moving.

Some of these qualities were undoubtedly confirmed during Piero's Roman visit of 1458–9, when, besides Flemish and Spanish painters, he met Melozzo da Forlì (1438–94) and possibly even Antonello da Messina. Melozzo came from Forlì in the Romagna area, and evolved a softer version of Piero's style (see plate 120) together with a noted mastery of perspective. During these years Piero probably painted his unforgettable *Resurrection* (Pinacoteca Communale, Sansepolcro) with its pyramidal composition and hieratic figure of Christ. One of his more striking and original inventions of this time, formerly in Santa Maria di Momentana, at Monterchi, is the *Madonna del Parto* fresco, with its unusual iconography and severe beauty.

Piero's last years included much time spent at Urbino at the court of Federico da Montefeltro, whose portrait and that of his wife he painted (see plates 101 and 102). The humanist atmosphere there must have been entirely to Piero's liking, as much for its interest in architecture as painting, and the *Flagellation* may be a direct reflection of ideas current at court. Vasari's idea that Piero went blind seems to have been untrue. After his last works, the unfinished *Nativity* (National Gallery, London) and the Brera altarpiece (see plate 99) with their greatly increased atmospheric sense, it is likely that he devoted himself more to theory.

Piero's main successor in the Arezzo area was the Florentine Camaldolese monk, Bartolommeo della Gatta (1448–1502) who studied with Pollaiuolo and Verrocchio before entering Piero's studio. He was well acquainted

with Flemish art, as well as with Melozzo and the latest ideas in Urbino, and evolved a style of striking and unique realism (see plate 84).

Pietro Perugino

The art of Perugino (Pietro Vannucci, 1445/50–1523), with its easy formulae and often facile sentimentalism, could not be less like Piero's. He took his nickname from Perugia, his birthplace and the centre of his immense activity, which extended throughout Italy and was supported by a large workshop. This perhaps reflects Vasari's claim that Perugino 'would have gone to any lengths for

87 Andrea Mantegna Pallas Expelling the Vices from the Garden of Virtue c.1499–1502

This is the second of two pictures which Mantegna painted for the Studiolo of Isabella d'Este in the Ducal Palace in Mantua, the other being Parnassus (also in the Louvre). The programme was probably provided by Paride da Ceresara, Isabella's advisor, and is the major instance in Mantegna's work of his painting a complete illustration of a philosophical idea. The long inscription wound round the tree was to enable Isabella's visitors to read the picture like a narrative. Pallas Athene rushes into the Garden of Virtue from the left, raising her hand against a swarm of armed cupids; she scatters the other figures. The figure on the left being transformed into a bay tree symbolizes one of the four Cardinal Virtues deserting the garden. The Vices escape through the swamp, led by the figure of Avarice helped by Ingratitude to carry the fat Ignorance. They are followed by a grotesque satyr signifying Lust. The armless Idleness is led by the rope by Sloth. A hermaphrodite monkey stands for Immortal Hatred, Fraud and Malice, and has bags containing evil, worse evil and worst evil.

money'. By 1481, after studying with Verrocchio in Florence, and possibly with Piero della Francesca, he was sufficiently esteemed to join the team in the Sistine Chapel (see plate 114). The style he evolved there was to change little, and at its best combined elegant, simplified figures in rather conventional poses, occasionally reaching real pathos as in his *Pietà* (Palazzo Pitti, Florence).

Perugino's earliest style appears to combine the influences of Piero with Flemish art, as in the superb *Adoration of the Magi* (Galleria Nazionale dell' Umbria, Perugia). Considered of local importance in 1475, he was commissioned to fresco a room in the Palazzo de' Priori in Perugia (lost), and after his Sistine work he moved continuously between Perugia, Florence and Rome receiving prestigious commissions. The high point of his painting in these years is *The Vision of Saint Bernard* of 1489–90 (Alte Pinakothek, Munich), which achieves a purism resembling that of contemporary architecture in

Florence, totally at variance with the deliberate sophistication of Botticelli. In 1493, he settled in Florence on his marriage to the daughter of the architect, Luca Fancelli.

His decline in reputation was signalled in 1505 by Isabella d'Este's dissatisfaction with his *Love and Charity* (Musée du Louvre, Paris) painted for her *studiolo* (study), and in 1508 Julius II dismissed him from work on the Vatican *Stanze* (Papal Rooms). His last years were spent mainly working in Umbria, where he died of plague.

Pintoricchio (Bernadino di Betto, c.1454–1513) was probably Perugino's pupil, and evolved from him a decorative and alluring style with a profusion of colourful detail and costume. In 1492–5 he was employed in the Borgia Apartments of the Vatican, but his greatest achievement is the fresco cycle in the Libreria Piccolomini of Siena Cathedral (1503) showing the Life of Aeneas Sylvius Piccolomini (Pope Pius II) (see plate 68).

Mantegna in Padua and Mantua

Andrea Mantegna (1431–1506) grew up in Padua, which had a crucial influence on his art, not least in his obsessive love of sculpture and archaeology. With Giotto's Arena Chapel frescoes and Donatello's Paduan work in the background, Mantegna was trained by his adopted father Francesco Squarcione, whom he took to court for exploitation when he was seventeen. Squarcione's studio was the only one in Northern Italy claiming to teach 'in the modern manner', but Mantegna, who quickly developed a personal style, was the only major name to emerge from it. When he composed a shortlist of the leading artists of his day, the Urbino court painter Giovanni Santi (Raphael's father), put Mantegna in first place, even ahead of Leonardo. Vasari says of his first commission (at the age of sixteen) for an altarpiece (now destroyed), 'it seemed painted, not by a youth, but by an old man of long practice'.

Mantegna's first major commission was in 1448, for

88 Andrea Mantegna Man of Sorrows with Two Angels c.1500

This is the major religious work of Mantegna's last years, and is unusual in depicting Christ full length. It also includes some of Mantegna's most subtle observations of landscape. Christ is shown seated against a sarcophagus 'in the antique style' supported by two angels, one of whom has red wings and the robe of a seraph, the other of whom wears the blue associated with a cherub. On the left are two holy women walking towards the tomb on Easter morning, and Jerusalem appears in the background. The sarcophagus symbolizes the altar, with Christ as the Eucharist, while the left-hand landscape refers to Christ's death, the right to His Resurrection.

in the Ovetari Chapel in Padua's Eremitani Church. These were virtually destroyed in the Second World War, but are recorded in photographs. It remains clear that perspective, one of Mantegna's lifelong passions, was fully in his control, since the two lower scenes of the life of St James were realistically foreshortened as if viewed from beneath. Such perspectival realism was rare in the Quattrocento, and relates to his later work in Mantua (see plate 104), which in turn looks forward to Correggio's domes (see plate 222) and the dramatic foreshortenings, known as *sotto in sù* (from below upwards), of Baroque ceilings. Mantegna was one of the strongest influences on the young Correggio.

Many other features of his style were already present in the Eremitani frescoes. These include rigidly drawn outlines and a sculptural treatment of the human figure,

omnipresent Classical architecture and rocky landscape backgrounds where every stone is invested with precise geological importance. Mantegna is a painter who appears to make few concessions to any canon of beauty other than his own. This is all summed up in his spectacular San Zeno altarpiece of the late 1450s (San Zeno, Verona), which is based on Donatello's dispersed sculptural altarpiece for the Santo in Padua, of which it provides the best record. Mantegna's passion for the effects of marble and antique sculpture even led him to paint some of his pictures in *trompe-l'oeil*, using *grisaille* (monochrome) figures against coloured marble backgrounds, as in *The Introduction of the Cult of Cybele in Rome* of 1505–6 (National Gallery, London).

Mantegna was fortunate in finding a patron who shared his archaeological and antiquarian interests. From 1460 he was court painter to Lodovico Gonzaga, Marchese of Mantua. In 1474, he completed the decoration of the Camera degli Sposi (Bridal Chamber) in the Palazzo Ducale of the Gonzaga, which includes many outstanding portraits along with highly innovative spatial devices (see plate 104).

Mantegna was also involved in two other major secular undertakings in Mantua. The first was the series of nine canvases showing the Triumphs of Caesar (Hampton Court Palace). Painted about 1480-95, they are the most complete expression of Mantegna's nostalgia for ancient Rome, and are filled with every conceivable detail deriving from antique bas-reliefs and similar sources. Mantegna received the second commission in 1490, after two years' absence in Rome. This was to paint several pictures for the studiolo of Francesco Gonzaga's wife, Isabella d'Este. She aimed to obtain paintings from all the leading artists of the day, including Perugino and Giovanni Bellini. The most expressive of Mantegna's creations for the studiolo were the Parnassus (Musée du Louvre, Paris) and Pallas Expelling the Vices from the Garden of Virtue (see plate 87).

Mantegna's position in Mantua in his last years is comparable with Botticelli's in Florence, inasmuch as his late style made no concessions to contemporary changes. But as with Botticelli, his religious pictures achieved new intensity and pathos (see plate 88). Resisting the latest Venetian advances in colour and atmosphere, Mantegna preserved his hard outlines and coldly painted bright colour until his late years. His extensive activity as a printmaker is outside the scope of this book, but was intrinsic to his painting activities, and he was one of the first artists to publicise his compositions by this means. Albrecht Dürer copied his *Sea Gods* engraving and certainly knew many of his works.

89 Antonello da Messina Virgin Annunciate 1474
The visit to Sicily of the sculptor Francesco Laurana may have
inspired Antonello da Messina to simplify his forms, and the result is
evident not only in his fine portraits but also in this figure. The
Virgin's mantle appears to have been painted first in tempera, then
glazed in oil paint. This is one of the most original Quattrocento
depictions of the Virgin; the figure is made to appear to reach in to
our space over the table. The peasant face, and the extremely simple
contrast between her blue mantle and the dark background render the
atmosphere particularly intense. Antonello's many bust-length
portraits adopt the same direct, somewhat confrontational gaze.

Painting in Venice

While the Renaissance arrived early in Florence, it was only in the second half of the Quattrocento that Venice saw the beginnings of a comparable richness of talent, which flowered in the last years of the century and throughout the Cinquecento. Tuscany had the invaluable impetus of the 'proto-Renaissance' of Giotto and his school, and while he had left his masterpiece in the Arena Chapel at nearby Padua, Venice had not reacted to this as might have been expected. The first half of the Quattrocento saw Venice import outside talent – Gentile da Fabriano (in Venice 1408–14) and Pisanello were then

the principal decorators of the Doge's Palace. It was their followers, such as Giambono, Jacobello del Fiore and Jacopo Bellini, father of Gentile, who distinguished themselves among native Venetians.

The Vivarini family, notably Bartolomeo (c.1432–c.1499) and Alvise (c.1445–1503) worked mainly within the format of the Gothic gilt-framed polyptych, which can give an archaic impression to their painting. Although generally unadventurous and repetitive, paintings such as Bartolomeo's *Sacra Coversazione* (Museo di Capodimote, Naples) show his charming interpretation of Mantegna, while Alvise inclined more to Giovanni Bellini for inspiration.

Thus the advances made betwen 1450 and 1500 in Venice were all the more remarkable for their suddenness, and were largely due to one painter of genius and longevity, Giovanni Bellini. Paradoxically, the development in Venetian painting coincided with the city-state's economic decline, after it had reached the apogee of power and wealth in the mid-century. Its huge maritime empire in the Eastern Mediterranean was threatened by the fall of Constantinople in 1453. This empire had been a constant source of envy to other states, who formed the anti-Venetian league in 1483.

In 1475–6, a Sicilian painter, Antonello da Messina (c.1430–79), visited Venice and played a crucial part in the importation of the technique of painting in oils. He had almost certainly learned this from Flemish painting he had encountered in Naples or Milan, rather than from training with Jan van Eyck, as Vasari believed. His main Venetian work, the *San Cassiano Altarpiece* (fragments in the Kunsthistorisches Museum, Vienna) had a considerable influence on contemporary artists.

The Bellini Family

Born in about 1430, Giovanni Bellini survived until 1516; his lifetime spanned a transition from the residual late Gothic world to the High Renaissance. His father Jacopo (c.1400–1470/71), who ran a thriving workshop, visited Florence and saw all the most recent developments there. Later, in his frequent travels, he met Uccello, Donatello and Alberti, and in 1453 Mantegna married Nicolosia, Jacopo's daughter. If his painting reveals little of these influences, Jacopo's two sketchbooks (Musée du Louvre, Paris and British Museum, London), are important, containing as they do more than 230 drawings of landscape, architecture, (among them the first capricci, or architectural fantasies, using actual Venetian buildings) and experiments in perspective. This enthusiasm for the visible

world set the scene for Giovanni and his brother Gentile (c.1429-1507). It was principally Giovanni who first exploited colour and light in a Venetian manner distinctive from Tuscan, Roman and some central Italian art, which uses a predominantly linear description of form.

Vasari was clear about Giovanni's pre-eminence in the Venetian art of his day, and there are indeed few equals in the Quattrocento to his most dazzling paintings. But although Giovanni's career is well documented after 1500, his beginnings are obscure, and his relationship in age and status to Gentile is much debated. There are few dated early works, exceptions including the Portrait of Jörg Fugger (Norton Simon Museum, Pasadena) of 1474. Even the date of the celebrated San Giobbe Altarpiece (see plate 90) is uncertain, with a wide margin of 1477-87 given. His studio grew rapidly in size in the 1490s, testimony to his great success. This, however, makes precise attributions difficult, and they are further confused by the unusual length of his productive career. It is difficult to imagine that the same hand painted the early Madonnas and the late Woman at her Toilet (see plate 215), as much from the point of view of subject matter as technique, but Giovanni was as adventurous with iconography as he was

The influence of his brother-in-law, Mantegna, was predominant in his early years, yet a comparison of their versions of the Agony in the Garden, painted in about 1460 (both National Gallery, London) reveals Giovanni's independence of mind and his more atmospheric approach to landscape. From the same period, Giovanni's Davis Madonna (Metropolitan Museum of Art, New York) shows Donatello's influence, and indicates his future developments. Antonello da Messina's Venetian visit also brought changes to his style, notably in his abandoning tempera on panel in favour of oil on canvas and his softening of his outline. Giovanni's Doge Leonardo Loredan of c.1501 (National Gallery, London) is one of the first Venetian paintings to exploit the effects of paint impasto, further enriching the glowing palette he developed throughout his career. It belongs to a group of outstanding portraits (see plate 106).

Giovanni's late style, perhaps his most seductive, indicates his unique ability during the Quattrocento to evolve continuously. It opens with the pelucid *Baptism of Christ* of around 1502 (Santa Corona, Vicenza) and the *San Zaccaria Altarpiece* of 1505, by which time he had largely adapted to High Renaissance principles (see Chapter VIII).

Gentile's career is less well documented, but two important factors were his inheritance of Jacopo's sketchbooks and his period as painter at the court of

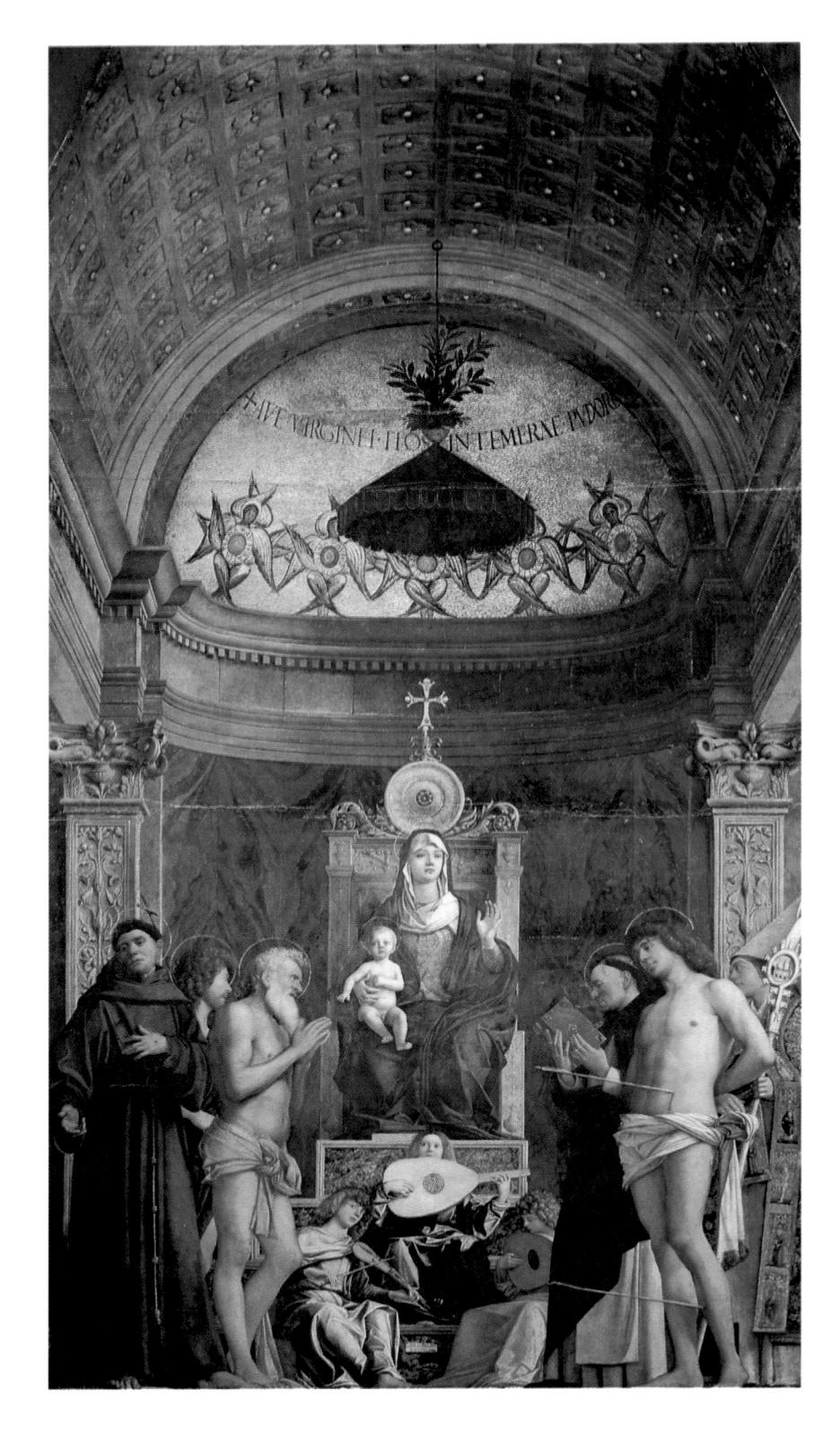

Constantinople from 1479 to 1481. This resulted in his exotic portrait of the *Sultan Mehmet II* (National Gallery, London). Gentile was also noted as a topographical painter, and in addition to a series of *Famous Cities* made for Francesco Gonzaga of Mantua after 1493, left numerous imposing views of the spectacular public life of Venice itself (see plate 121).

This aspect of Gentile's art seems to have been a main influence on one of the most charming of Venetian painters, Vittore Carpaccio (c.1450/60–1525/6), who is noted especially for his two painting cycles, *Scenes from the Life of Saint Ursula* of the 1490s (Accademia, Venice) and *Scenes from the Lives of Saint George and Saint Jerome* of 1502–7 (Scuola di San Giorgio degli Schiavoni, Venice).

90 GIOVANNI BELLINI The San Giobbe Altarpiece, before 1490

Commissioned for the Franciscan church of San Giobbe e
Bernardino, this is the major altarpiece of Bellini's maturity. The
saints shown are Francis, John the Baptist, Job, Dominic, Sebastian
and Louis, together with musical angels. It was already celebrated
during Bellini's lifetime, and was specified in contemporary lists of
notable works of art in Venice. Antonello da Messina's influence is
evident, and Vasari implies that it was this type of picture that
obtained Bellini the commission to decorate the Doge's Palace in
1479, with paintings that are now destroyed. The most notable
feature of the picture is its brilliant use of space, enclosed by
Lombard-style architecture, originally complemented by the frame
(still in San Giobbe) which echoes Classical forms. This and the
magical effects of light not only on the figures but also on the painted
mosaic in the apse, together with the figures' grandeur, look forward
to High Renaissance compositions.

Such narratives had a long Venetian history, dating back as far as the Byzantine mosaics in St Mark's. Carpaccio made them peculiarly his own, leaving an image of Quattrocento Venice which even Canaletto did not surpass in the eighteenth century. The range of Carpaccio's imagination was apparently unlimited, and both cycles combine magnificent architecture with richly dressed crowds filled with lovingly observed human detail. It was this apparent fidelity to nature which appealed to John Ruskin as Carpaccio's greatest literary devotee, and which made him a very distinguished and original portraitist (see plate 111). His celebrated *Two Women Seated on a Balcony* and *A Shooting Party on the Lagoon* (see plates 109 and 110), comparable to a detail from one of the cycles, show his powers of observation.

Another contemporary was Giovanni Battista Cima da Conegliano (1459/60–1517/18), who worked in the Giovanni Bellini manner (see plate 25). He created altarpieces of considerable beauty with particularly memorable landscape backgrounds, as in his *Baptism of Christ* (San Giovanni in Bragora, Venice).

Painting in Ferrara

Under the Este family, who became Dukes in 1471, Ferrara flourished for a further three centuries. Basing their power and wealth on a rich rural economy (reflected in Ferrarese painting), the Este made the city one of the leading cultural centres of Renaissance Italy. Such artists as Cosmè Tura, Francesco del Cossa, Ercole de'Roberti and later, the Dossi brothers (see Chapter VIII) painted alongside great men of letters like Ariosto.

91 Cosmè Tura Virgin and Child Enthroned c.1480 This formed the central panel of an altarpiece with eight parts formerly in San Giorgio fuori le Mura, Ferrara. The various parts are now separated and housed in various museums in the United States and Europe: the National Gallery, London; the Musée du Louvre, Paris; Galleria Colonna, Rome and the Museum of Fine Arts, San Diego. Since the inscription on the organ case refers to the Roverella family, it may be that the kneeling figures on the wings were members of that family. The throne has two tablets with words from the Ten Commandments in Hebrew and symbols of the four Evangelists: the eagle of St John; the ox of St Luke; the lion of St Mark and the man of St Mark. Although typically Ferrarese in its treatment of the figures, it reveals the strong influence of Mantegna. Characteristic of Tura are the elongated figures, with high fat foreheads and the elaborate, fantastic architecture. Tura's strange and original style was highly influential on other artists of the Ferrarese school

Cosmè Tura (c.1430–95) is one of the more eccentric painters of the period (see plate 91), using an astonishing array of aggressive pictorial devices, including clashing and often livid colour, bizarre architecture and grotesque facial features to create his unique world.

Francesco del Cossa (c.1435–c.1477) is less eccentric, but in comparison with his colleagues elsewhere, his art exudes a strange and sometimes disturbing aura. Influenced by Mantegna and Piero della Francesca, his activity as a distinguished portraitist is reflected in his most famous work, the frescoes in the Palazzo Schifanoia at Ferrara, painted for Borso d'Este. This delightful cycle, with its complicated but poignant intermingling of astrology, the Seasons and chivalry, and its dazzling array of decorative detail, holds a unique position in decorations of the time.

Lorenzo Costa (c.1460–1,535) was influenced by Tura and in 1506 succeeded Mantegna as Mantuan court painter and carried out work for Isabella d'Este. His style may have exerted a greater influence than has been thought, and his *Concert* (see plate 119) seems to be the first in a long tradition of such pictures in Italian art.

No century exists in a vacuum, and many of the Quattrocento's ideals formed the basis for the next century. The transitions which we now think we see clearly were much less obvious to the period, although by the end of the Quattrocento consciousness of the pattern of history was very high. Leonardo, so fundamental in the formation of the High Renaissance, was entirely a product of the Quattrocento, while Michelangelo belongs firmly in the Cinquecento in spite of being already twenty-five when it opened. Many painters whose careers were well underway in the Quattrocento lived into the

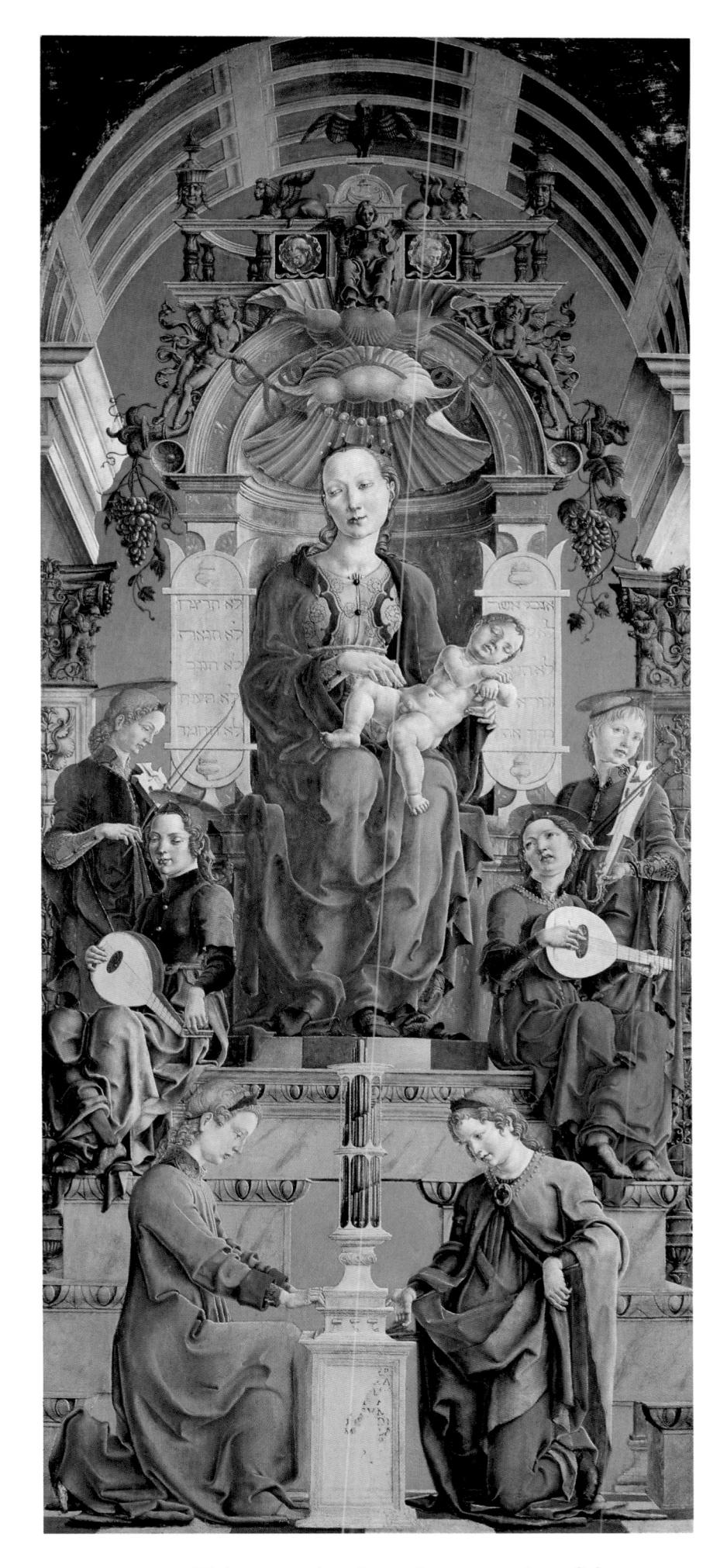

new century, which meant that the major innovations did not have the instant effect we imagine today, and that old ideas died hard, particularly when perpetuated away from the influences of the great centres.

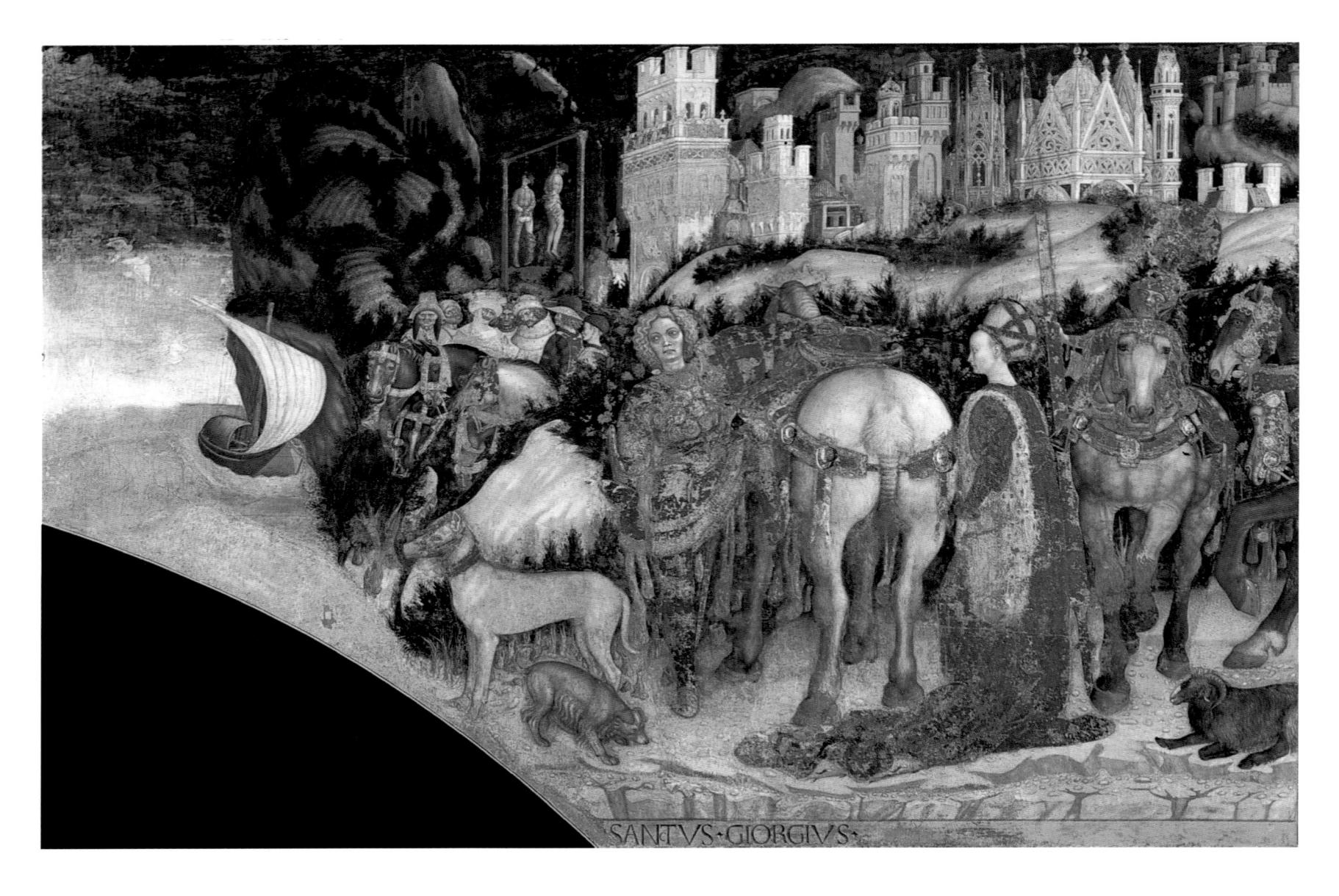

92 Antonio Pisanello Saint George and the Princess 1437–8

This is the only remaining fresco by Pisanello in the Pellegrini Chapel of Sant-Anastasia in Verona, and it documents his style after his Roman visit. The prevailing delicacy retains much of the International Gothic style as transmitted in the work of Pisanello's master, Gentile da Fabriano. The carefully observed horses and dogs and the towers and pinnacles of the city in the background create a masterpiece of north Italian naturalism.

93 Masaccio Trinity 1425-8

Masaccio's great fresco survives as only a shadow of its former self. It is very thinly painted; Vasari says that it was painted over other frescoes, which may have been partly visible from the beginning, and successive restorations have almost ruined it. The patron is uncertain, as is the identity of the donors in the fresco, and the iconography is unusual to the point of remaining a mystery. Masaccio merges the image of the Trinity with the idea of a Calvary indicated by the presence of Virgin and St John the Evangelist. Behind, the chapel painted in perspective may be a symbol of the Church as in Netherlandish paintings. Below, a skeleton lies on a sarcophagus; this may refer to Adam, whose skull is often placed below the cross in Crucifixion scenes, and this may be a reference to the hope of resurrection.

The fictive architecture is strongly influenced by Brunelleschi and Donatello, and reconstructions of the chapel's 'plan' suggest that the space would be square. The command of drawing, perspective and the depiction of the figures strongly suggest that Masaccio painted the Trinity after he had completed the Brancacci Chapel frescoes (see plate 70).

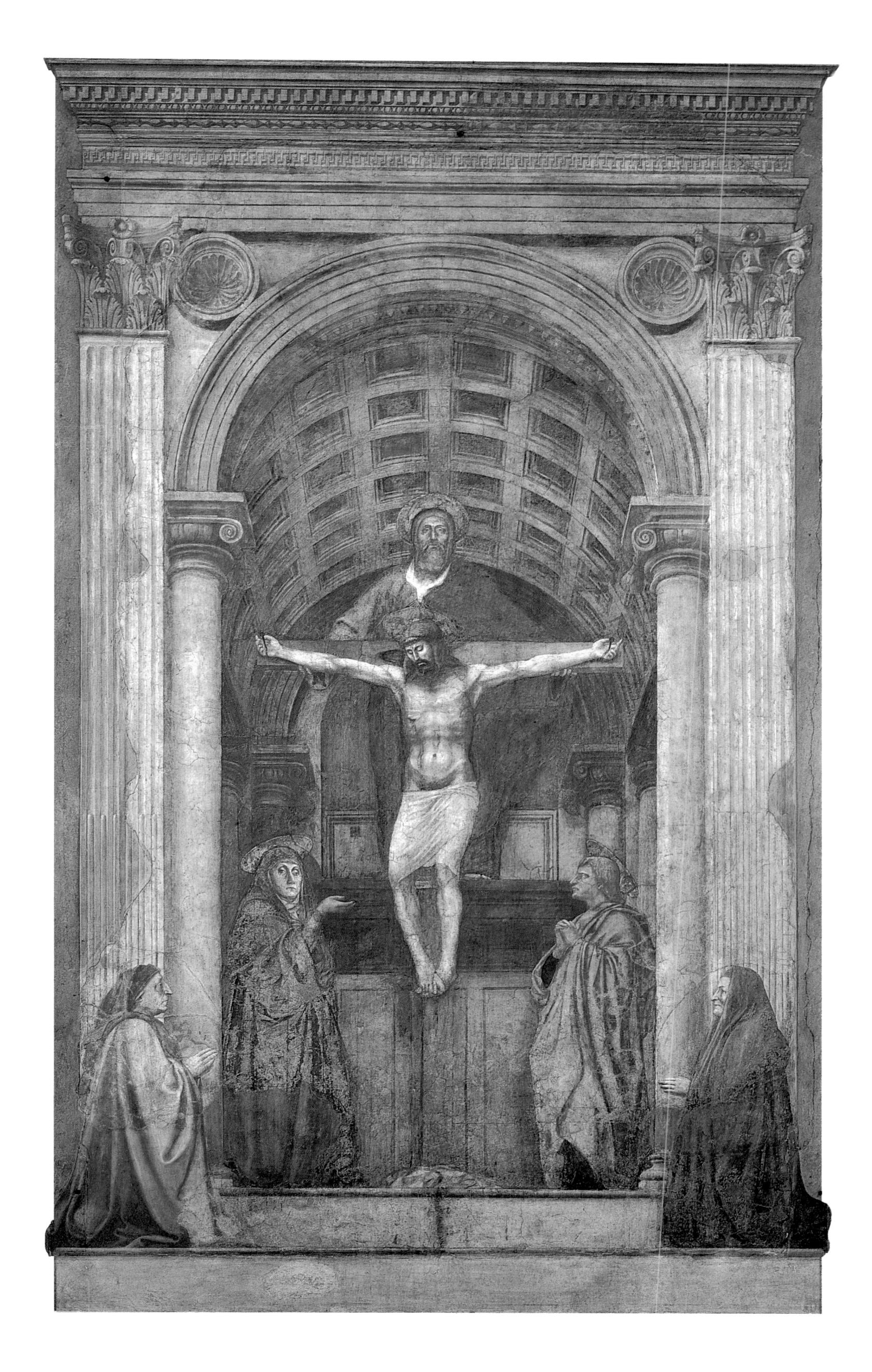

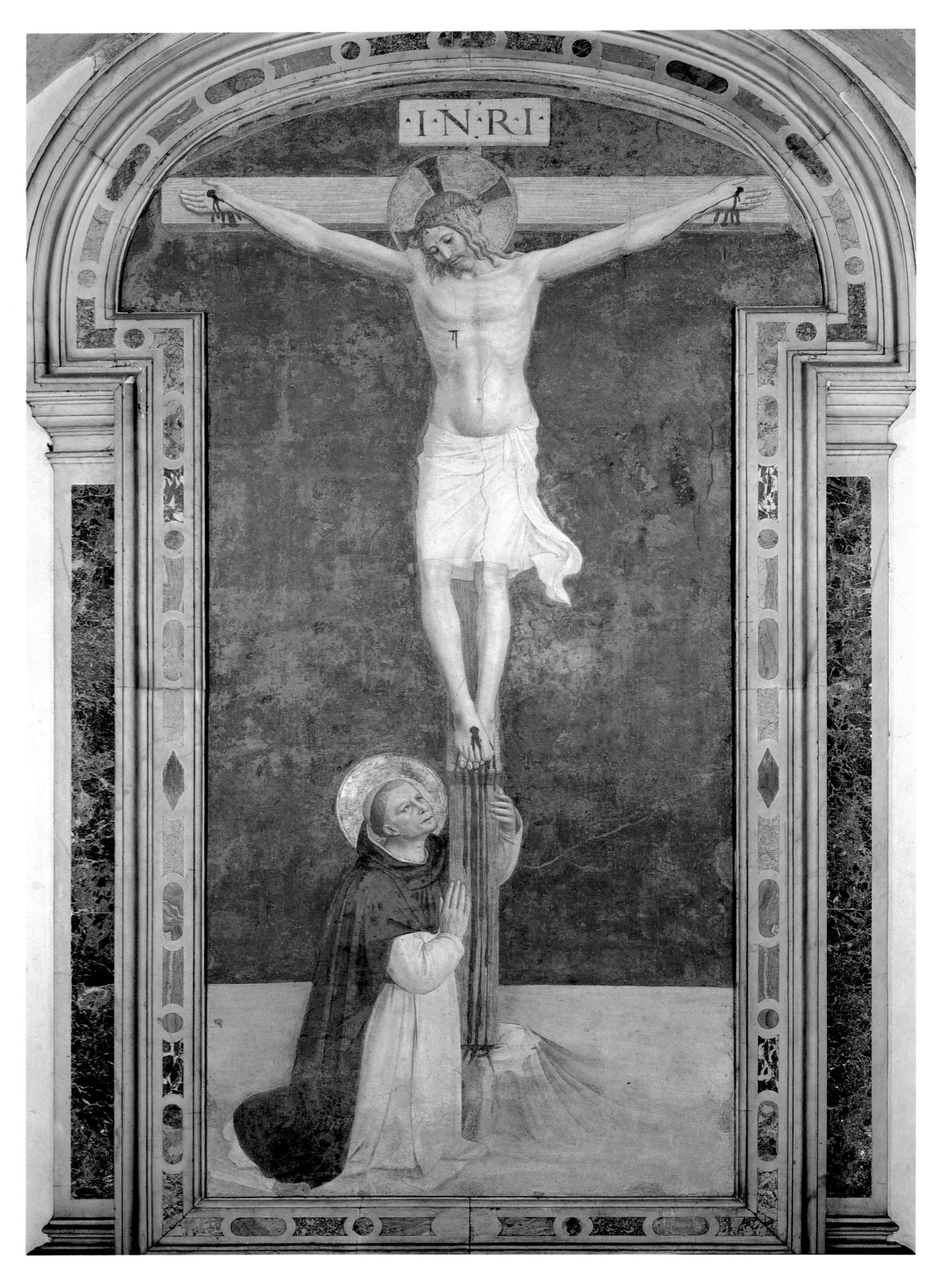

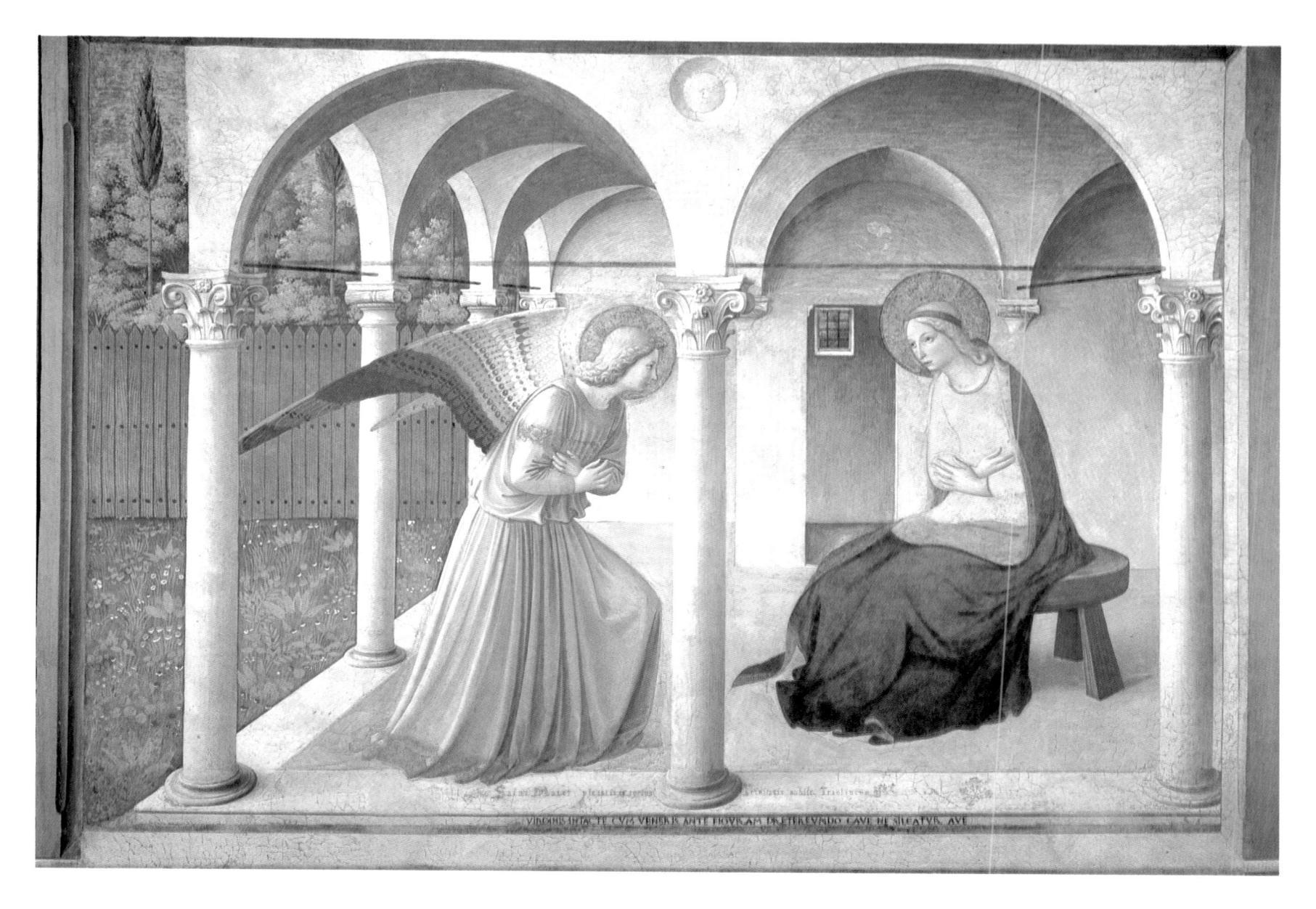

95 Fra Angelico Annunciation c.1450

This scene is set on the inner wall of the upper corridor facing the staircase in the convent of San Marco. It is set in a Classical loggia, clearly reflecting the architecture of Michelozzo's new convent of San Marco, and the Ionic and Corinthian capitals are derived from capitals by Michelozzo in the cloisters of the SS Annunziata and San Marco. One of the most satisfying of Angelico's compositions, the scene is flooded with miraculous light. Although the figures are still Gothic in their elongation, their simplicity and solidity reflect Masaccio's lesson. The brilliant colouring of the angel's wings strikes the main note in a harmony of soft pinks, beige, browns and greens.

94 Fra Angelico Saint Dominic Adoring the Crucifix, after 1442

This fresco greets the visitor on entering the cloister of the convent of San Marco, and is one of the most moving scenes in its simplicity and concentration. Although Angelico was assisted throughout the extensive work at San Marco, no documentary record of the artists involved is known. Certain scenes, such as this, have a good claim to being largely by his hand, but the attribution of the frescoes in the monks' cells remains the subject of debate.

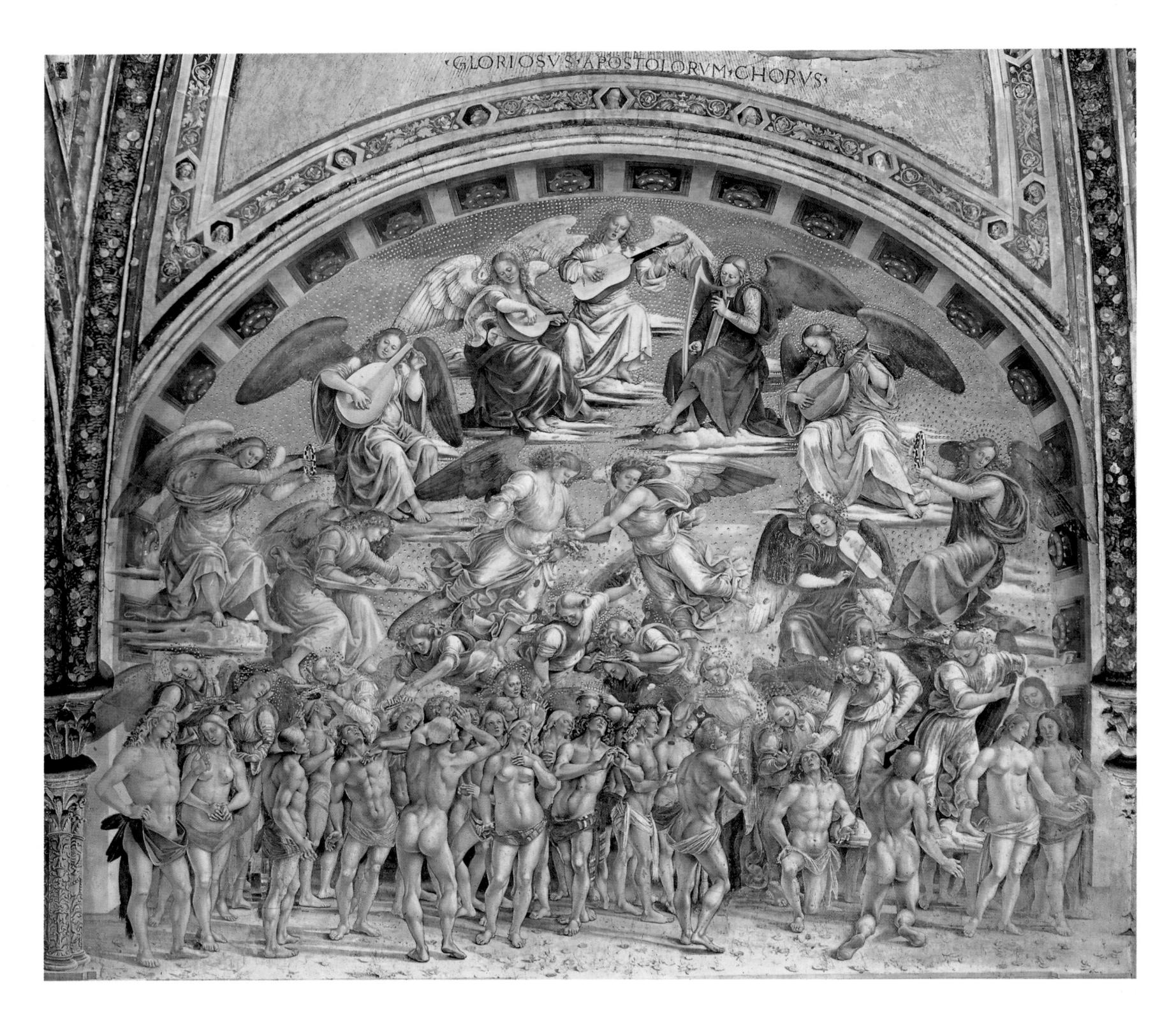

96 Luca Signorelli Calling of the Elect 1500–4 (Above) In 1447 Fra Angelico and Benozzo Gozzoli started the frescoes in Orvieto Cathedral, but only in 1499 was the completion of the chapel entrusted to Signorelli. In this scene of the Calling of the Elect the elect are crowned by angels while other angels scatter roses and make music. Throughout these frescoes, the dominant feature is the presence of many nude figures. This was without precedent in Italian painting, and it looks forward to Michelangelo, who admired these frescoes intensely.

98 Domenico Ghirlandaio The Birth of Saint John the Baptist 1485–90

(Right) Ghirlandaio's famous frescoes for the chancel of Santa Maria Novella in Florence were commissioned by Giovanni Tornabuoni. They were executed in collaboration with the painter's brother Davide, Sebastiano Mainardi and the youthful Michelangelo. On the left wall are scenes of the Life of the Virgin, and on the right is the Life of the Baptist. One of the highest achievements of Renaissance narrative painting, these frescoes combine a serene equilibrium with many contemporary portraits and other details from Florentine daily life, including costume and interiors.

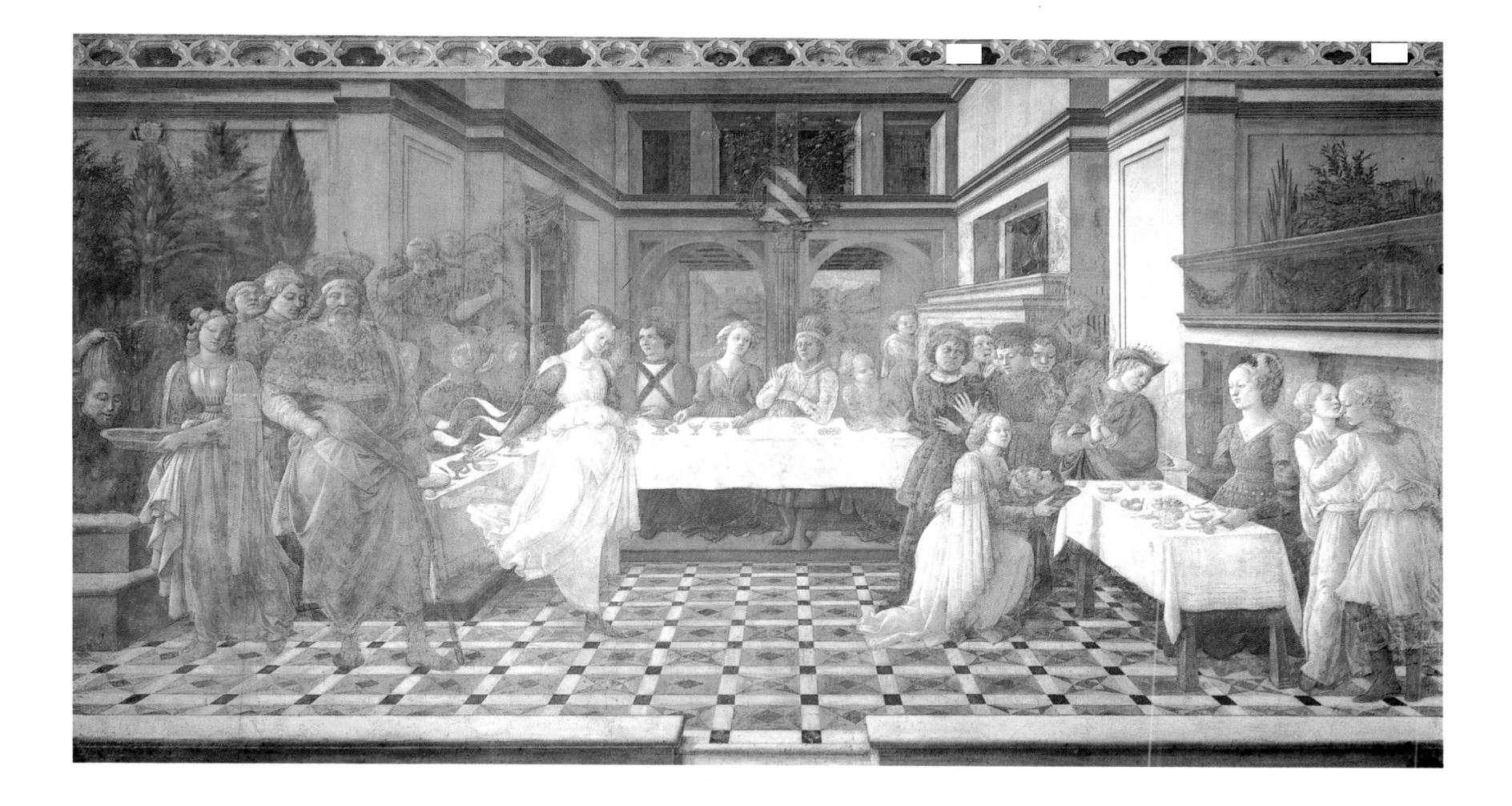

97 FILIPPO LIPPI Dance of Salome (Herod's Feast) 1452–66 (Above) This forms part of Lippi's fresco cycle in the main chapel of Prato Cathedral, which shows the lives of St John the Baptist and St Stephen, the patron saints of Prato. As many problems delayed the work, it took Lippi almost thirteen years to complete with the help of various assistants. Because Lippi worked over the fresco surface with

tempera, adding an incalculable wealth of detail and nuance, he achieved the elaboration and richness of surface normally associated with panel painting. Three events are included in one scene — Salome's dance, her reception of the Baptist's head, and her presentation of it to her mother, Herodias.

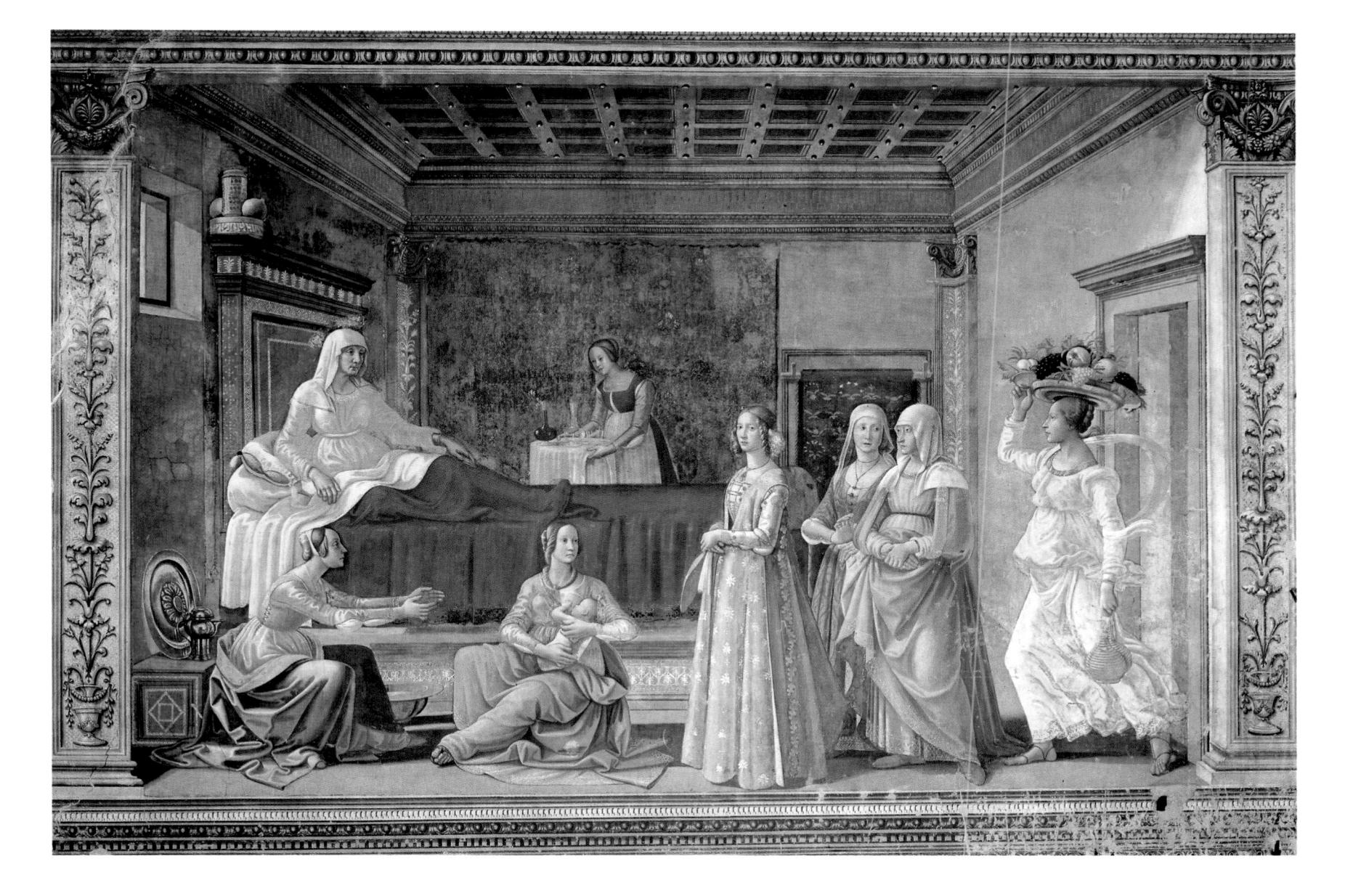

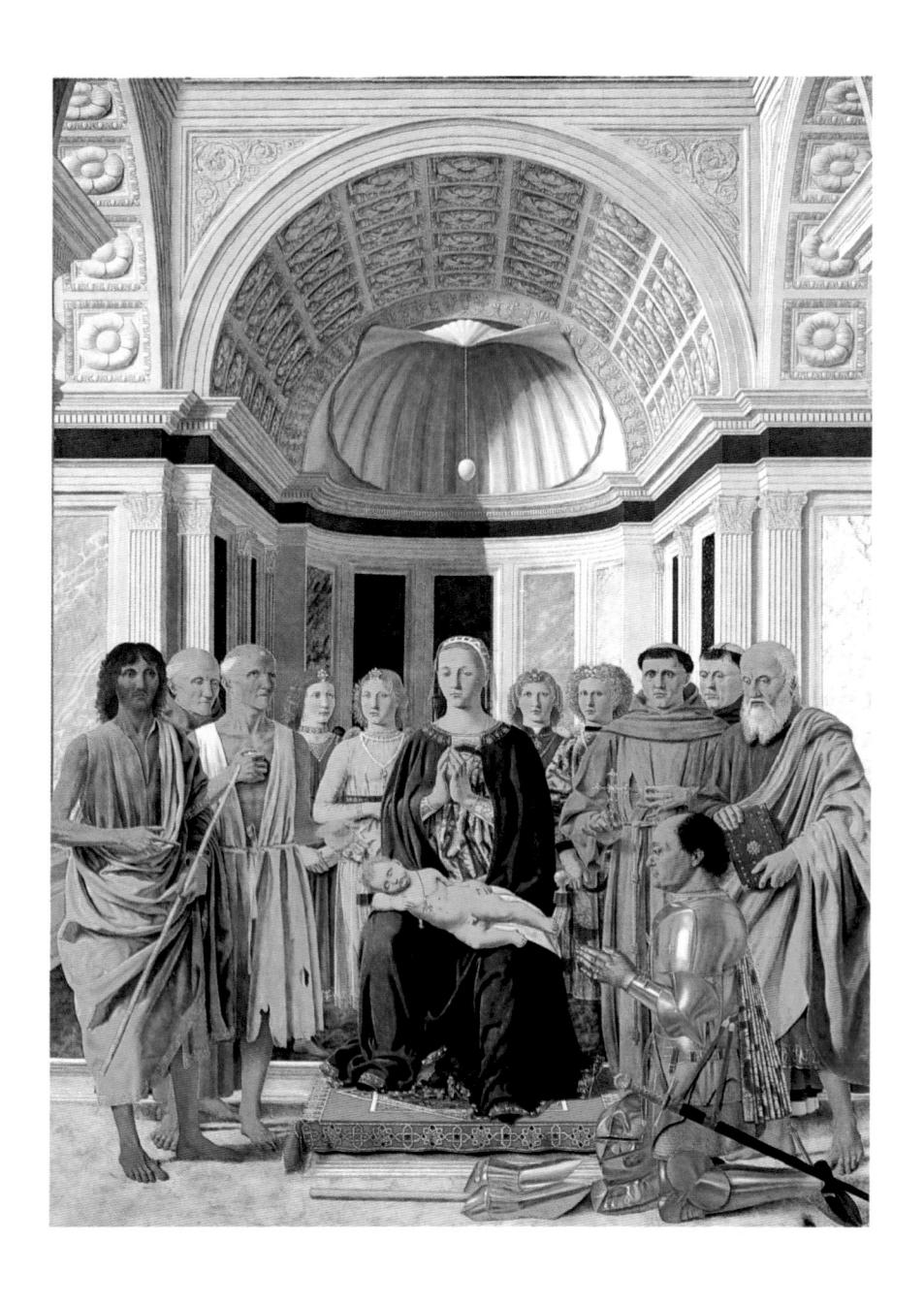

99 PIERO DELLA FRANCESCA The Brera Altarpiece 1472–4

(Left) This Madonna and Child with Six Saints, Angels and Duke Federico II da Montefeltro came from the church of San Bernardino in Urbino. It undoubtedly has a votive character, and may have been commissioned on the birth of Guidobaldo da Montefeltro in 1472. The suspended ostrich egg may be a Christian symbol for the four elements or a symbol of the creation – possibly a reference to Guidobaldo. The architecture was no doubt intended to relate to the original setting, and shows not merely an apse but also transepts and part of the walls of a nave. Like Van Eyck's painting of the Madonna in a Church (see plate 125), Piero's Madonna figure is disproportionately large, and a similar symbolic presentation of Mary as a temple may have been intended.

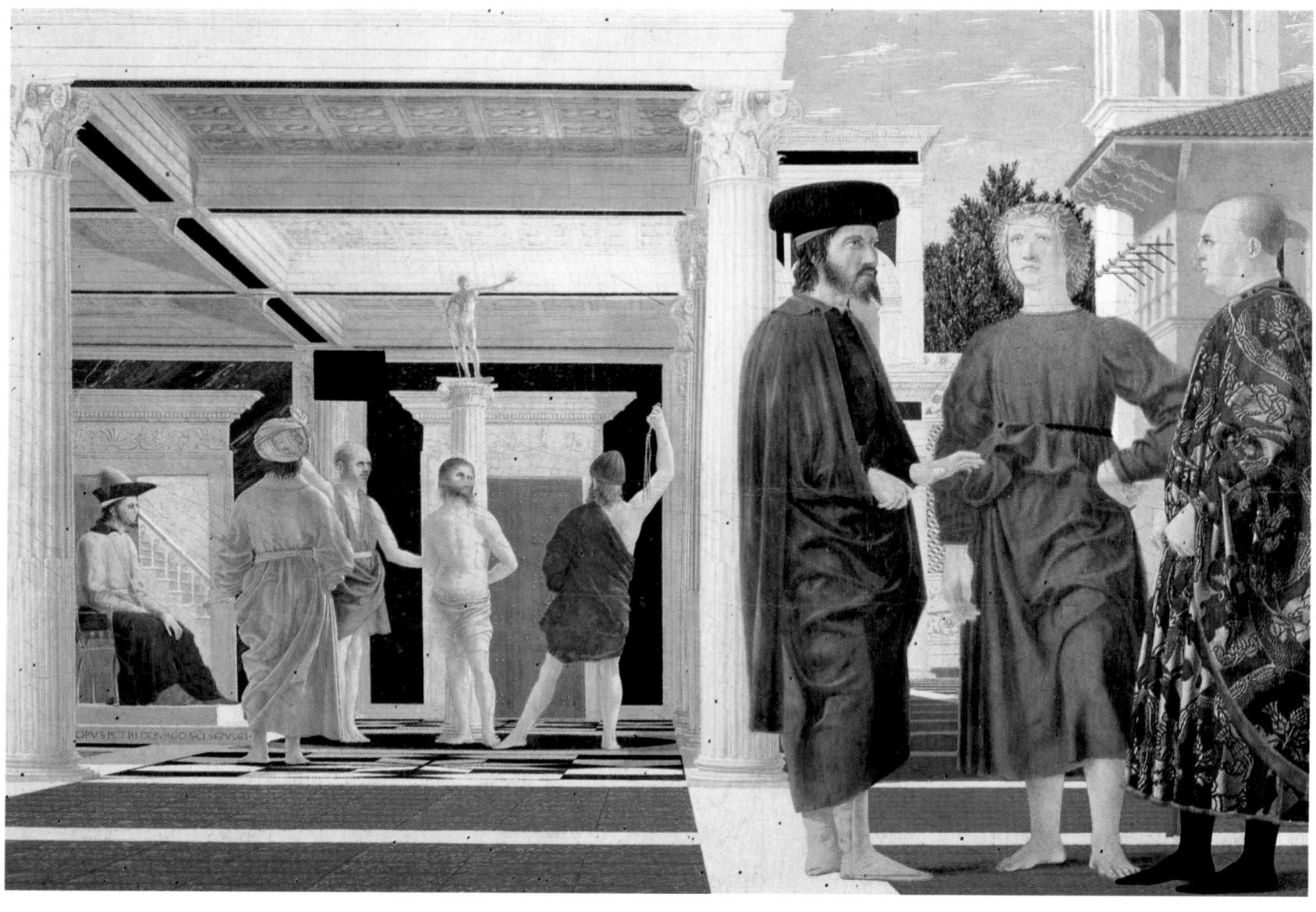

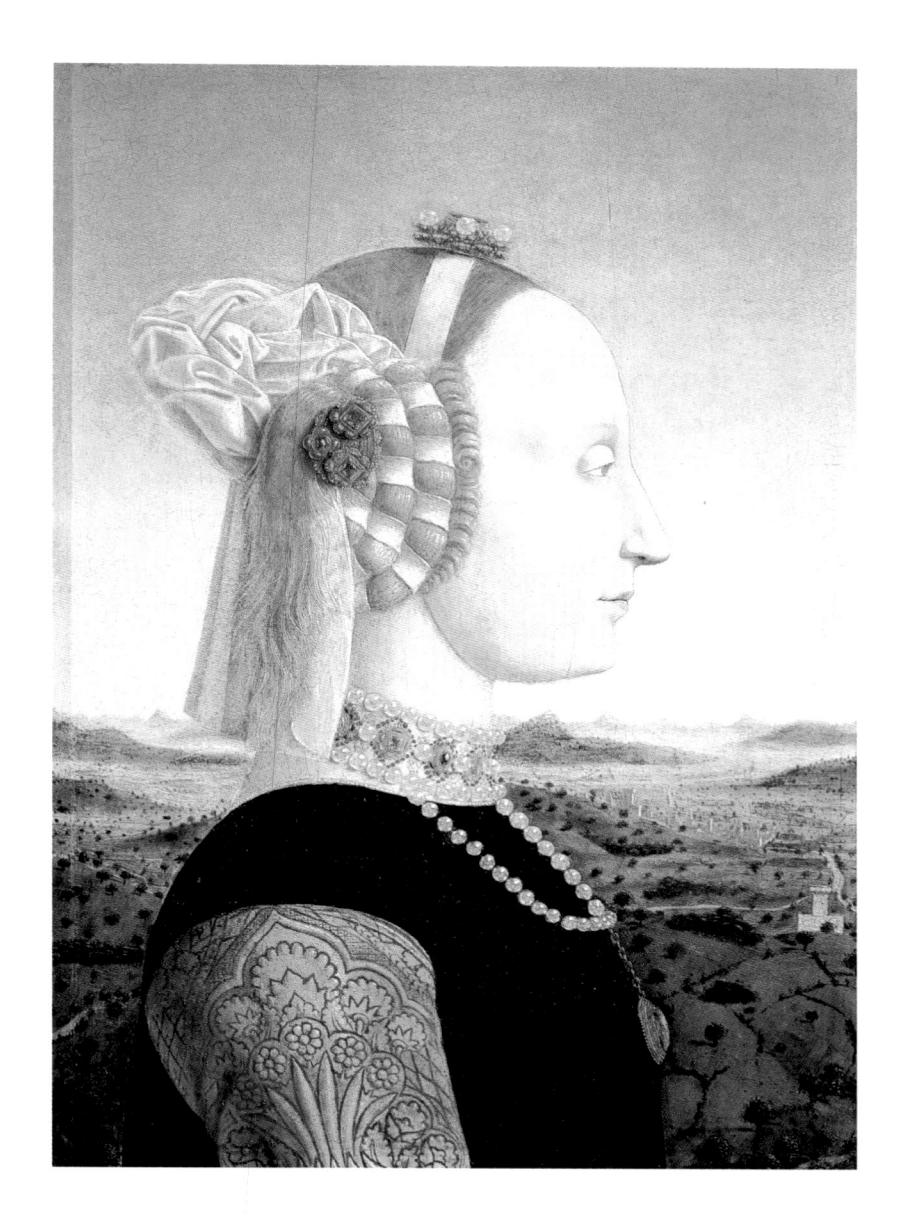

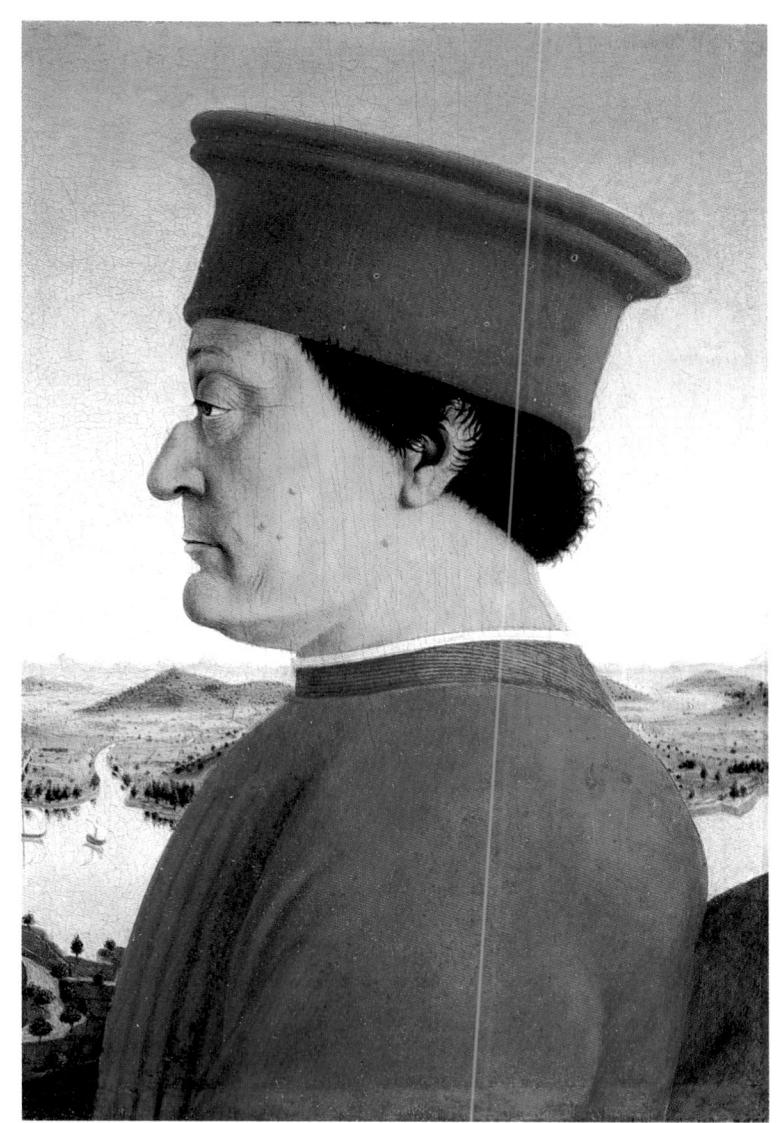

101 and 102 PIERO DELLA FRANCESCA Federico II da Montefeltro and Battista Sforza 1465

(Above left and Above) This diptych was probably originally in the audience chamber of the Ducal Palace at Urbino, moving to Florence in 1631 with the Della Rovere inheritance. Federico's nose was broken in a tournament, and Piero contrasts his hard outline with the soft one of his wife. The striking feature of the portraits is their close involvement with the background landscape, whose appearance recalls contemporary Florentine experiments by Pollaiuolo and others: there also appears to be a strong Flemish influence. On the reverse of the paintings is an allegorical triumph of the couple.

100 PIERO DELLA FRANCESCA Flagellation of Christ 1455 (Left) Traditionally the central figure of the right-hand group represents Oddantonio da Montefeltro with his ministers Manfredo dei Pio and Tommaso dell'Agnelo, ultimately responsible for the death of the young prince in 1444. Some critics have interpreted the picture as an allegory of the crisis in the Church which culminated in the Fall of Constantinople in 1453. The painting offers one of the most astonishing examples of 'pure' Renaissance architecture for its date, and the layout of the figures on the ground plan may have a precise mathematical symbolism.

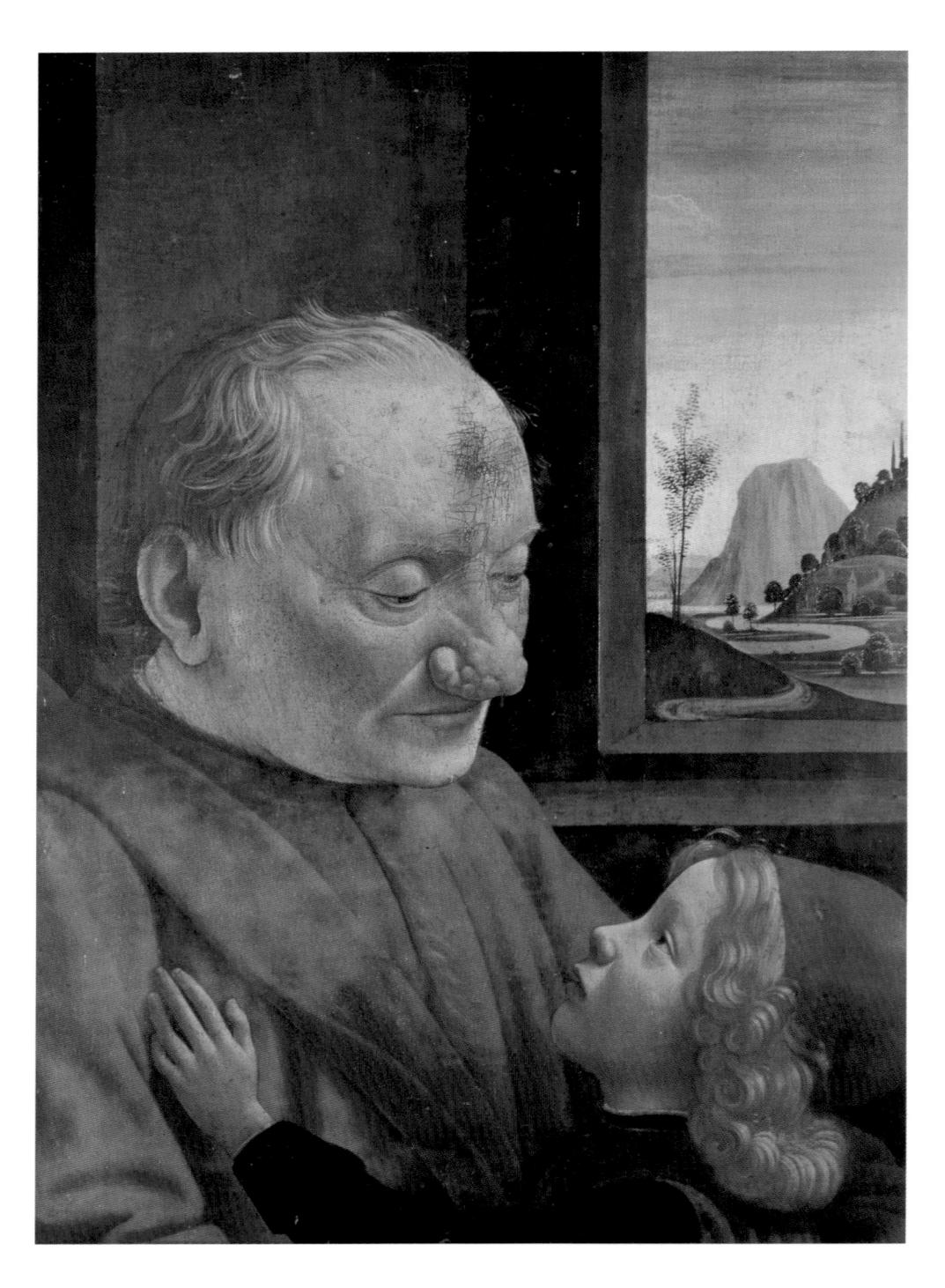

103 Domenico Ghirlandaio Old Man with a Young Boy c.1480

(Above) Unusual in its intimacy and realism, this apparently simple picture is an allegory on the cycle of life. Childhood stares in wonder at the decrepitude of old age, while the old man's gaze is full of understanding and compassion. The background view shows a path winding through hills leading to a high mountain, whose significance may also relate to the general theme.

104 Andrea Mantegna The Ceiling Oculus of the Camera degli Sposi, Palazzo Ducale, Mantua 1465–74

(Top right) The Camera degli Sposi in the Ducal Palace in Mantua was used to house precious objects and works of art. In the ceiling oculus, which is painted as though it were open to the sky, eight winged putti, two groups of women and a peacock are placed on or peeping through a balustrade, whose design recalls Donatello. This oculus is the first and most daring instance in Italian art of the use of the steep perspective known as 'sotto in su', where objects and figures are foreshortened to give the illusion of being seen from beneath.

105 Andrea Mantegna The Gonzaga Court 1465–74 (Bottom right) This fresco from the Camera degli Sposi is one of the few Renaissance representations of the assembled family of a specific court. It has been suggested that it shows the Mantuan court's reception for the Emperor Frederick III and the King of Denmark (although they do not appear) or the arrival of the news that Lodovico's second son Francesco had been made a cardinal. It does seem certain that the principal figure is that of Lodovico III Gonzaga, with his secretary Marsilio Andreasi, his wife Margaret of Bavaria and children, relatives and members of the court and household.

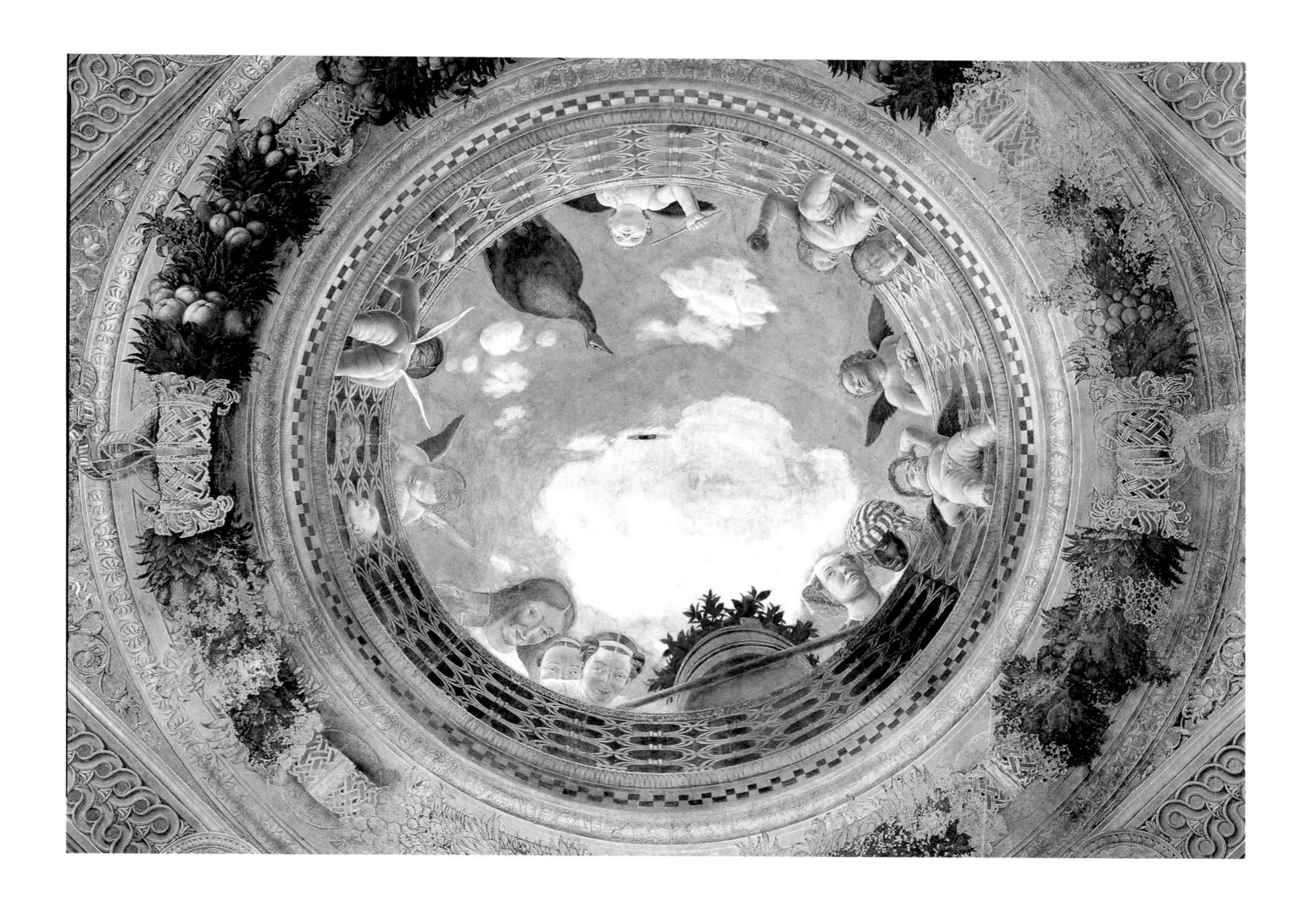

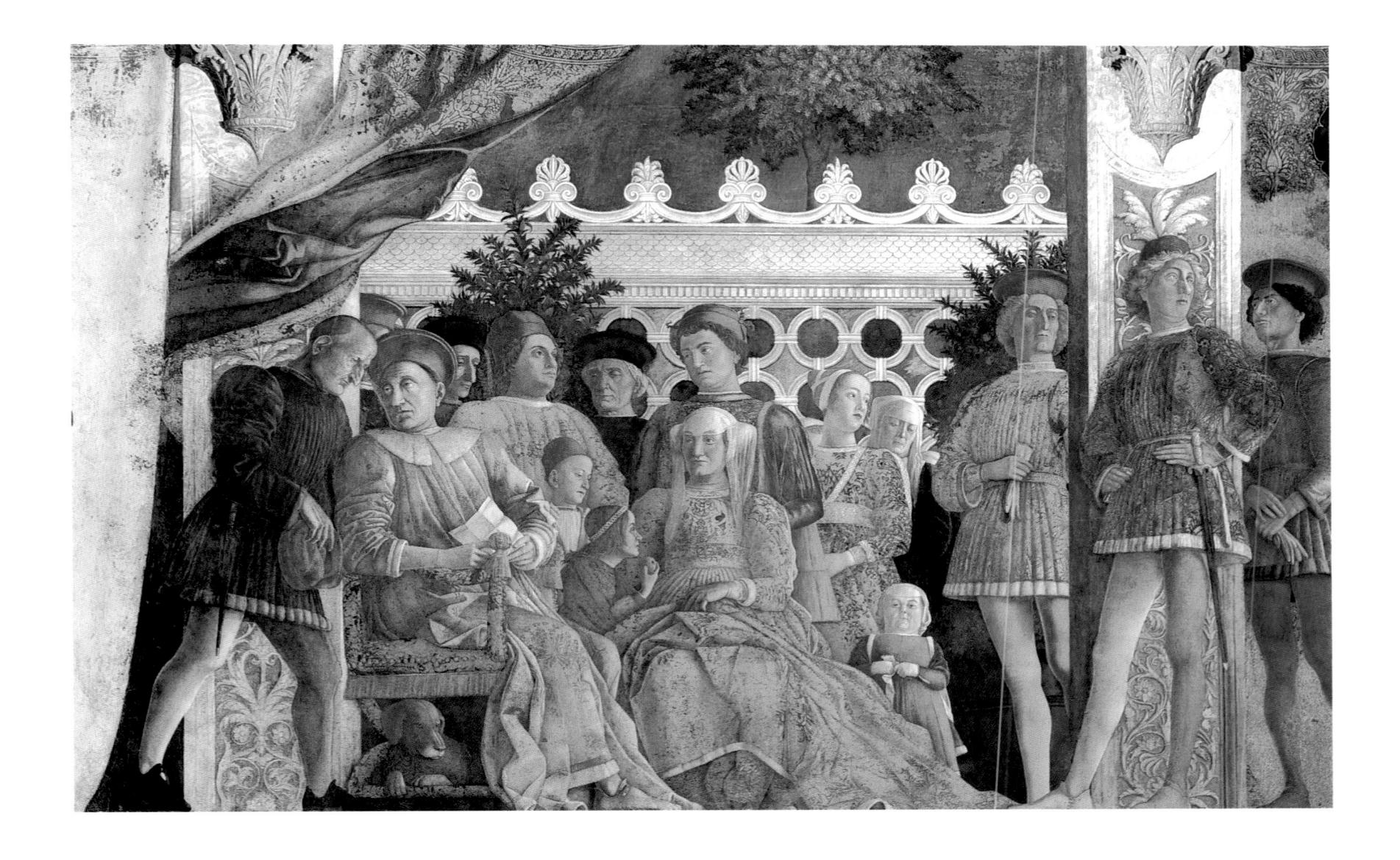

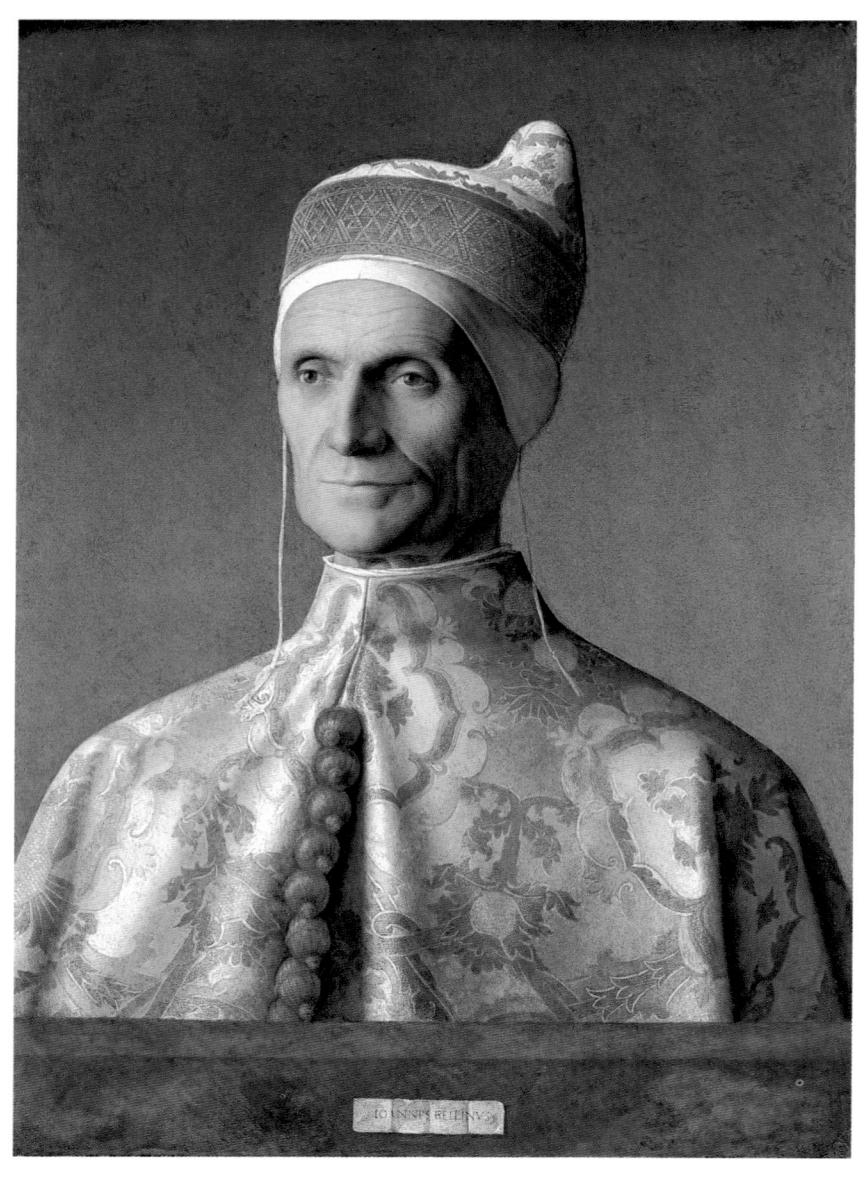

108 Antonello da Messina Saint Jerome in his Study 1474

(Right) Antonello was the greatest Sicilian painter of the Renaissance. Contrary to Vasari's belief that he studied with Van Eyck, he probably learned his oil painting technique from Netherlandish painters in Naples or Milan. This remarkable picture was painted immediately prior to Antonello's visit to Venice in 1475/6, where he influenced and was influenced by Giovanni Bellini. By 1529 it was in a Venetian collection, when it was suggested that it might be by a Flemish painter. It has been suggested that Antonello saw Van Eyck's lost Lomellino triptych, which was recorded in Naples in 1456. The background landscape is closely modelled on Flemish prototypes.

106 GIOVANNI BELLINI Doge Leonardo Loredan c.1501 (Above) Loredan was born in 1436 and was Doge from 1501 to 1521. It is likely that this portrait dates from immediately after his election as Doge. Once in the collection of the millionaire collector William Beckford at Fonthill Abbey, it represents the summit of Bellini's achievement as a portraitist. Bellini had used the device of a balustrade separating the sitter from the viewer in other portraits, and notably in many half-length Madonnas, but here it achieves a unique impression. The portrait's effect derives from its subtle palette of silver, gold, pale blue and the warm marble tones, together with an incisive likeness of the sitter. It was from works such as this that Titian's earliest experiments with portraiture derived.

The identity of the sitter is based on comparison with Emo's stone effigy by Antonio Rizzo in the Museo Civico, Vicenza, whose original polychromy may have inspired the colouring of Bellini's likeness. Emo (1425–83) was a Venetian Senator, sent as ambassador to Hungary in 1474 and to Constantinople in 1475. Although the influences of Antonello da Messina's portraits and Mantegna's treatment of detail are strong, the feeling of a sculpted bust is also striking.

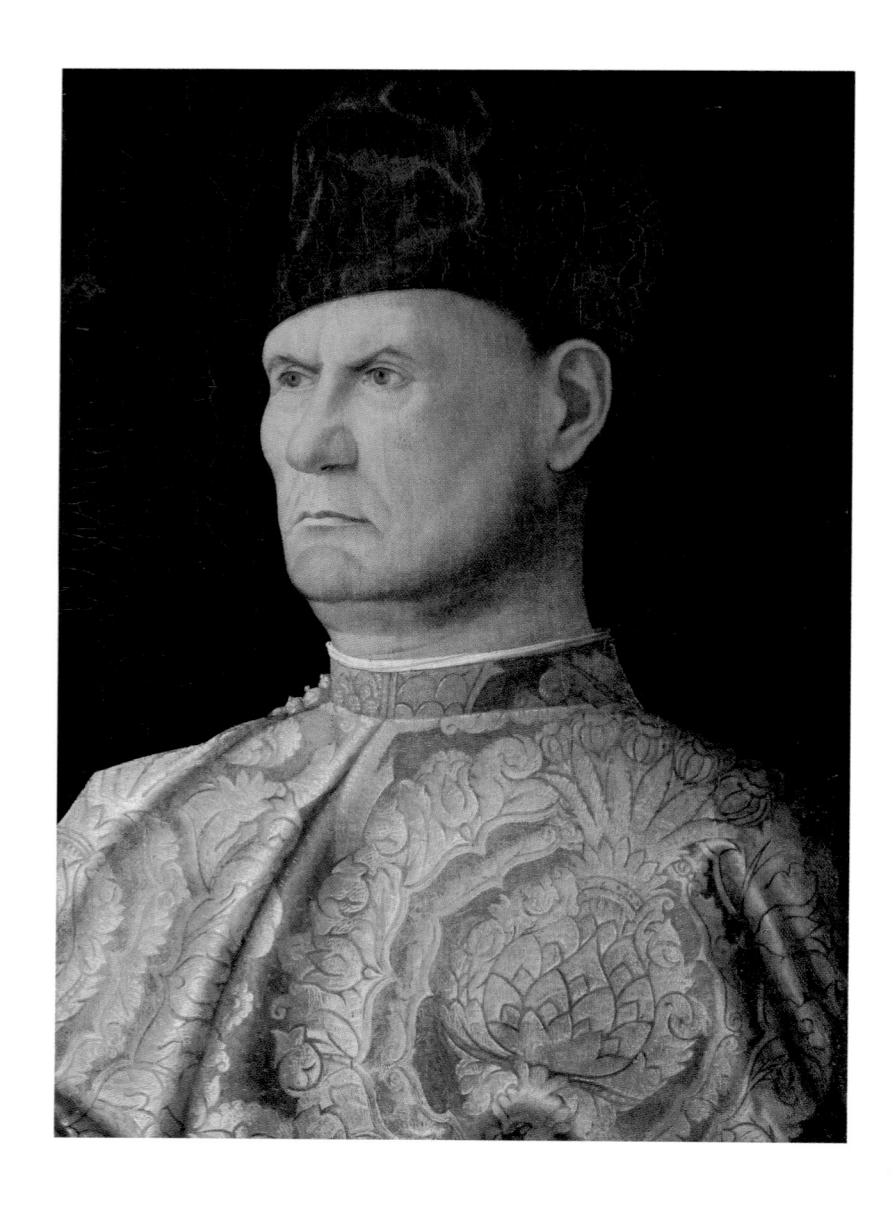

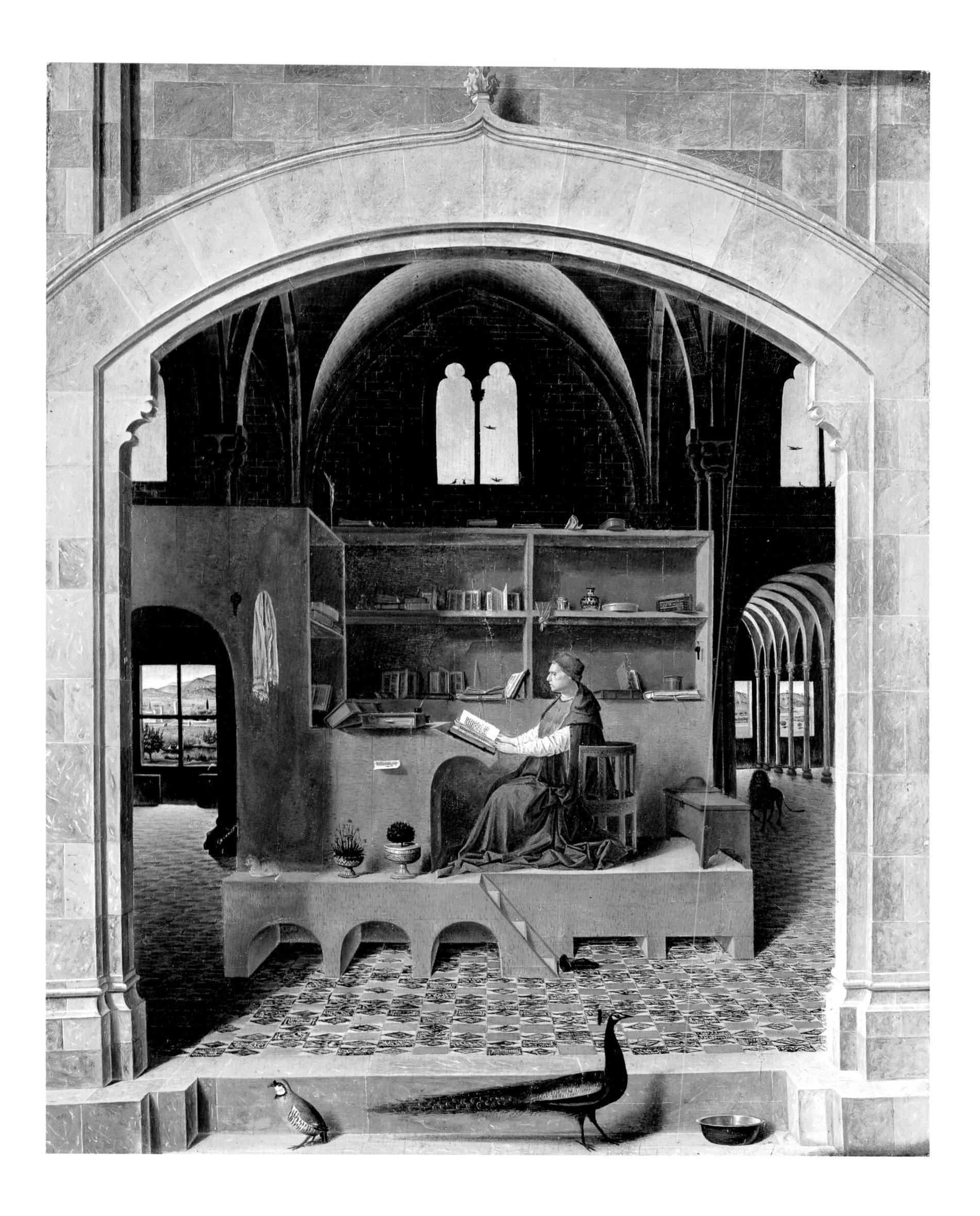

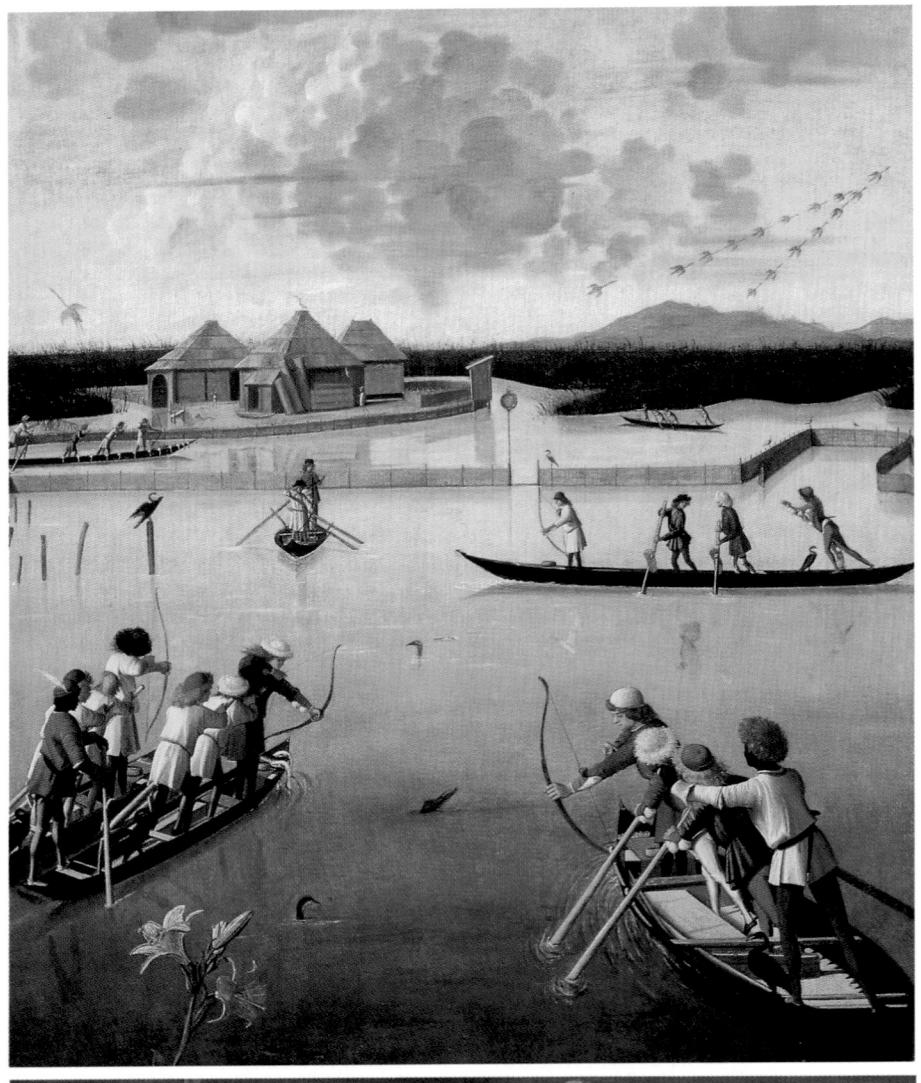

Lagoon and Two Women Seated on a Balcony 1490–6 (Left and Below Left) These two fragments clearly belong together. The lilies at the lower left of the Shooting Party correspond exactly with the vase on the lower balustrade. On the vase itself is the coat of arms of the noble Venetian Torella family, so it seems likely that the painting shows two ladies of the Torella family watching the hunt from their palace terrace, rather than two courtesans as was previously thought. It has been suggested that the painting might contain some reference to Circe, who had the power to transform men into animals, but it is not unlikely that it is simply a genre scene including two portraits.

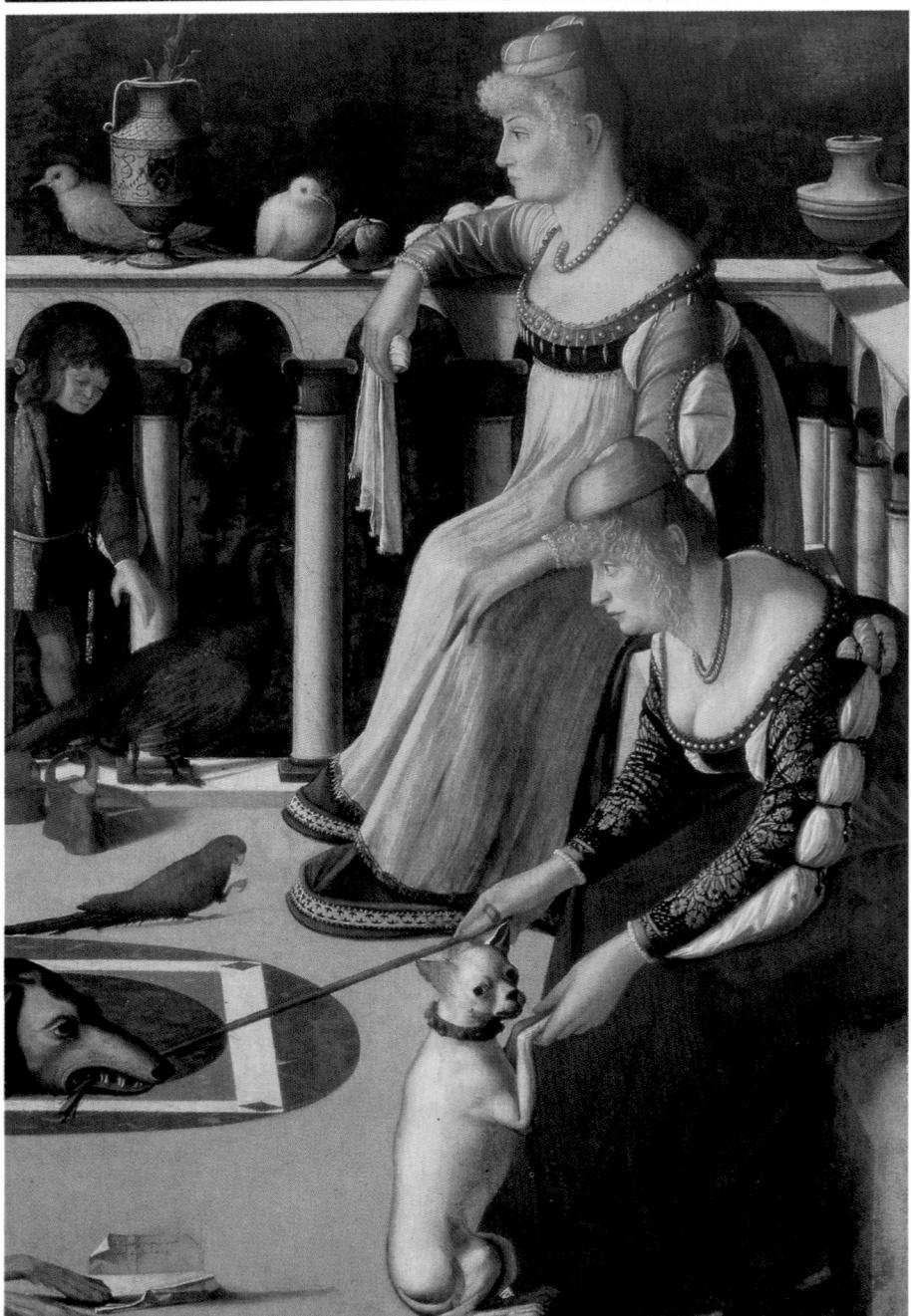

111 VITTORE CARPACCIO Young Knight in a Landscape (Francesco Maria della Rovere, Duke of Urbino) 1510 (Right) The subject is almost certainly the young Duke of Urbino (1490-1538), the son of Giuliano della Rovere and nephew of Pope Julius II. It once carried a false monogram to suggest that it was by Dürer, whose engraving of A Knight, Death and the Devil of 1504 (see plate 43) appears to be the source of the equestrian figure. Dürer's Venetian visit of 1505-7 did not go unnoticed by the city's artists. Full of direct and indirect references to the sitter and his family, this portrait typifies the Renaissance love of symbol and allegory. It is probably a knightly allegory of the Christian soul's struggle between good and evil, identifying the sitter with the characteristic strengths and weaknesses of the oak tree (rovere=oak). In the foreground are an ermine and a Latin inscription ('die painfully rather than be sullied'), both pertaining to the Neapolitan Order of the Ermine and also to the Dukes of Urbino. The mounted knight bears the black and gold colours of the Duke of Urbino. The foreground stump of oak and the background oak tree may suggest a gradual process of regeneration, probably referring to Francesco Maria's role in the family. He was christened Maria after his birth on the feast of the Annunciation, and the lilies and irises associated with the Virgin Annunciate are a further dual reference.

The picture's air of unreality is emphasized by the lack of aerial perspective and real shadows, and the way in which depth is arbitrarily suggested as if with stage wings. Detail is given equal scrutiny throughout the picture, contributing to the timeless, frozen atmosphere.

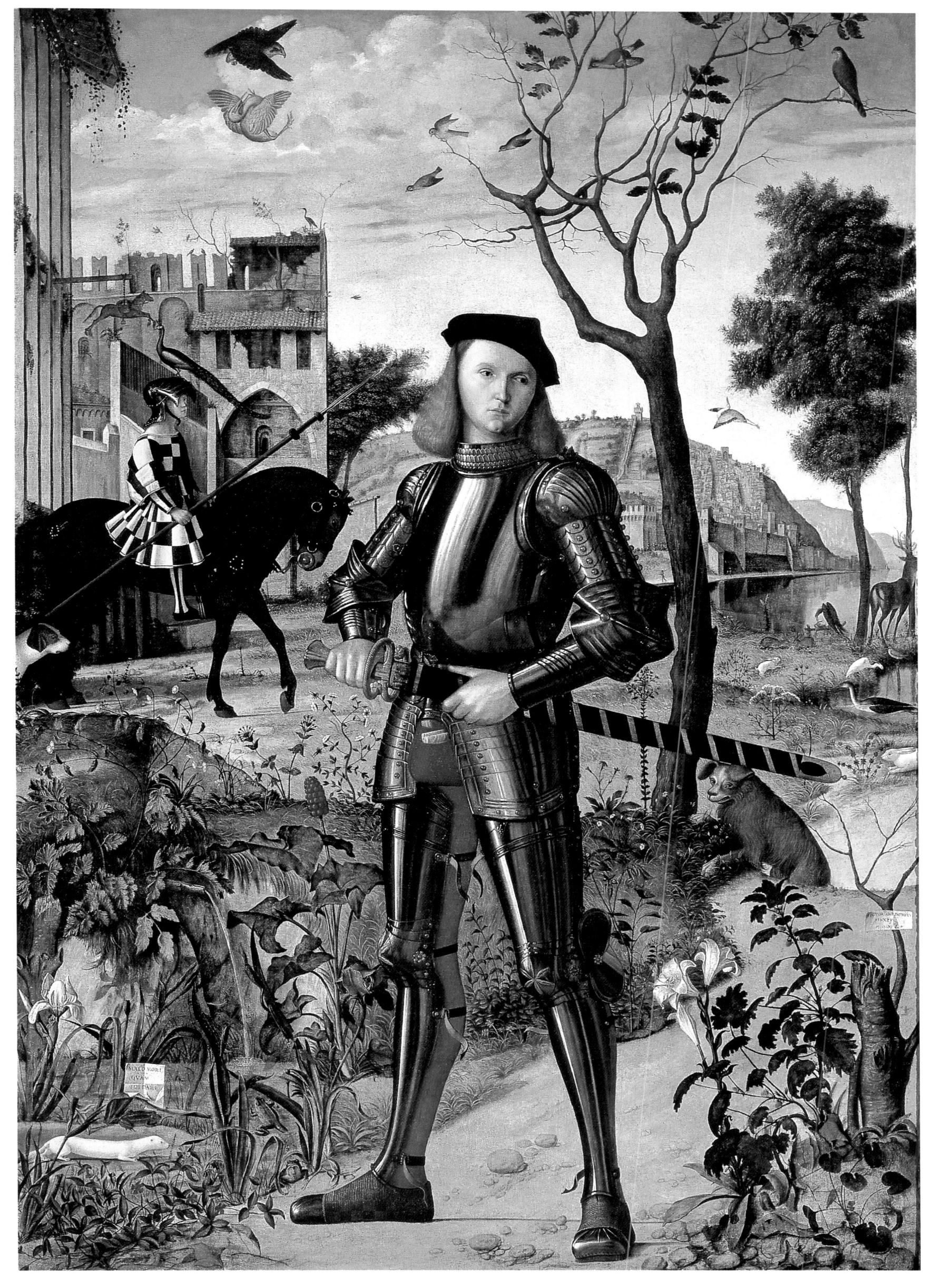

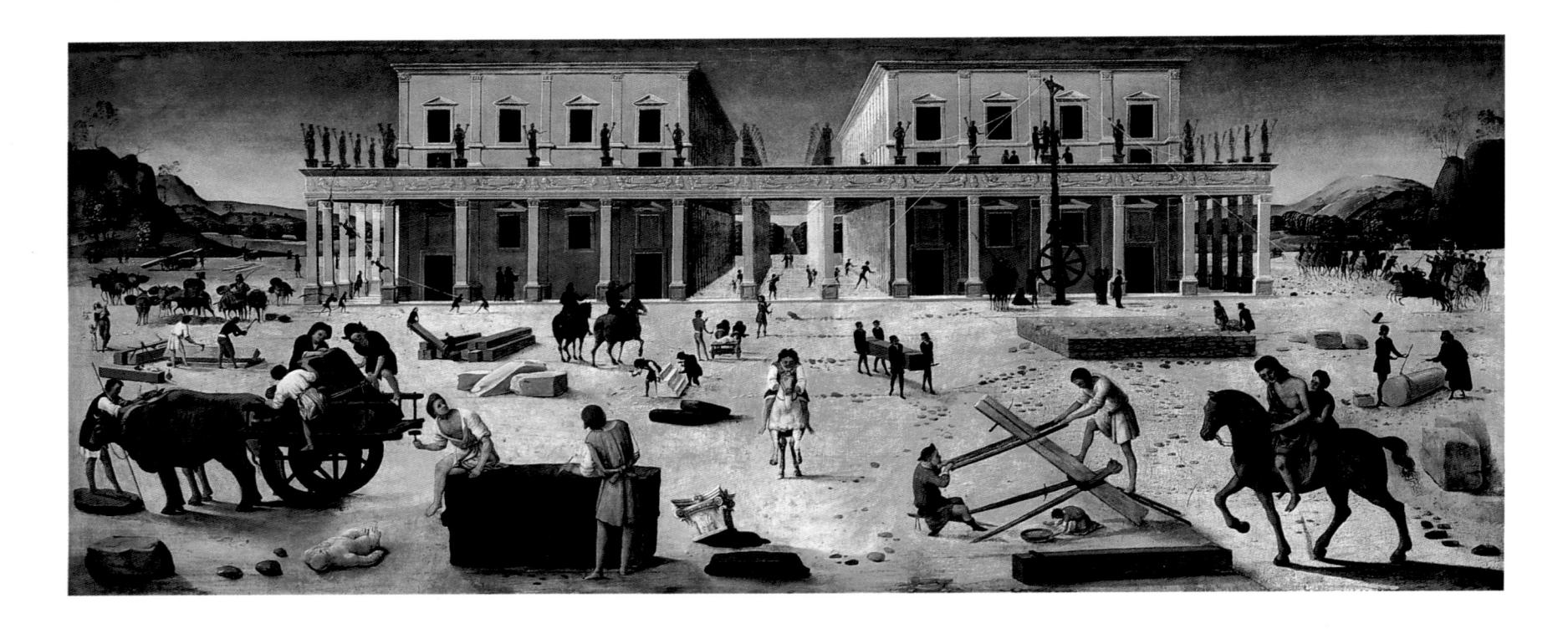

112 PIERO DI COSIMO The Building of a Palace c.1515–20 (Above) Although there is no specific key to this picture's meaning, it may be an allegory of The Triumph of Architecture, possibly partly in memoriam for the Sangallo family of architects. Piero knew the family, and painted a memorable portrait of Giuliano da Sangallo in c.1500–4 (Rijksmuseum, Amsterdam). The building is clearly in Giuliano's style, and its bipartite structure recalls the plan of the Villa Medici at Poggio a Caiano.

113 PIETRO PERUGINO Christ Handing the Keys to Saint Peter 1482

(Below) This fresco is part of the Sistine Chapel cycle commissioned in 1481. Its background architecture and formal disposition of the figures in a vast piazza give it a dignified monumentality. Many portraits of contemporaries are included.

(Right) These frescoes were commissioned by Piero de'Medici, son of Cosimo, for the tiny chapel of the family palace by Michelozzo in Florence. Piero's taste is important in understanding the fresco's dazzling display of colour and decorative detail; he was a highly refined collector of antique gems, tapestries, goldsmith's work and Flemish pictures in the tradition of the Duc de Berry and, among his contemporaries, Borso d'Este. Following a tradition dear to the Medici, the procession includes portraits of the family and their court set against a magnificent landscape. Recalling the glittering detail of Gentile da Fabriano's Strozzi Altarpiece, the procession is, however, rendered with the realism of an historic event to which it makes reference, the 1439 Council held in Florence. One of the three kings is Constantine XI Palaeologus, the last Roman Emperor, who died in 1453 defending Constantinople against the Turks.

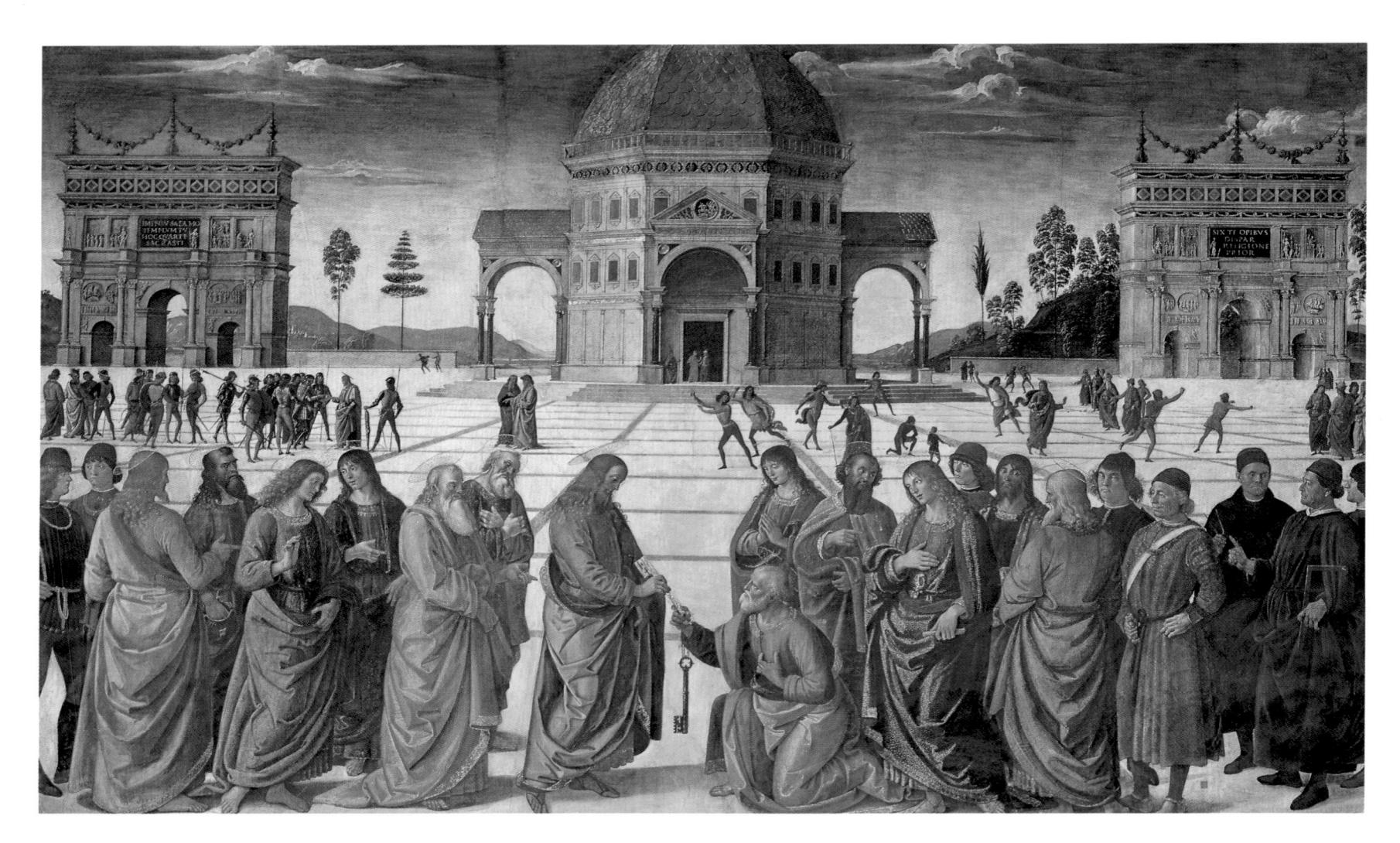

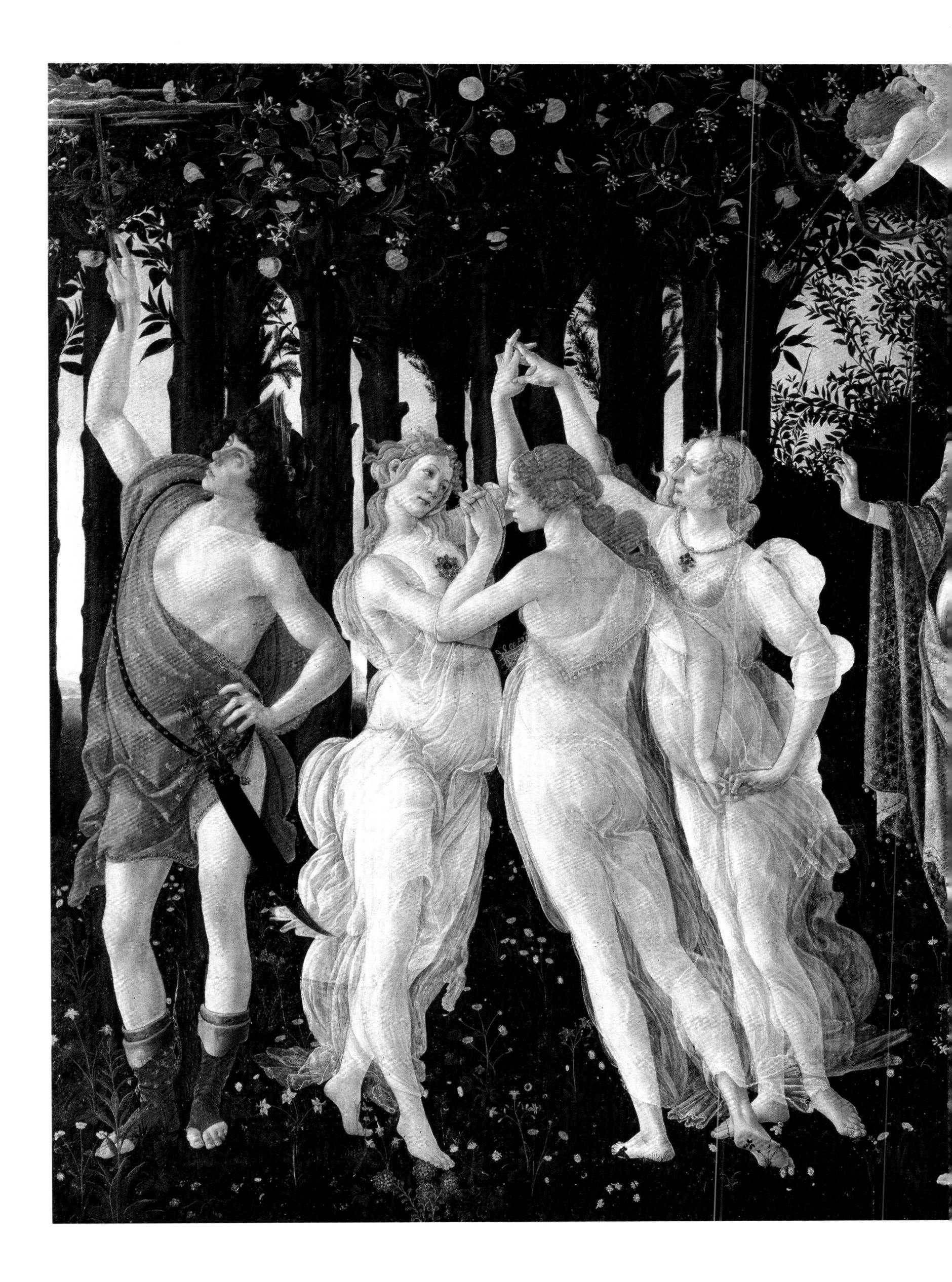

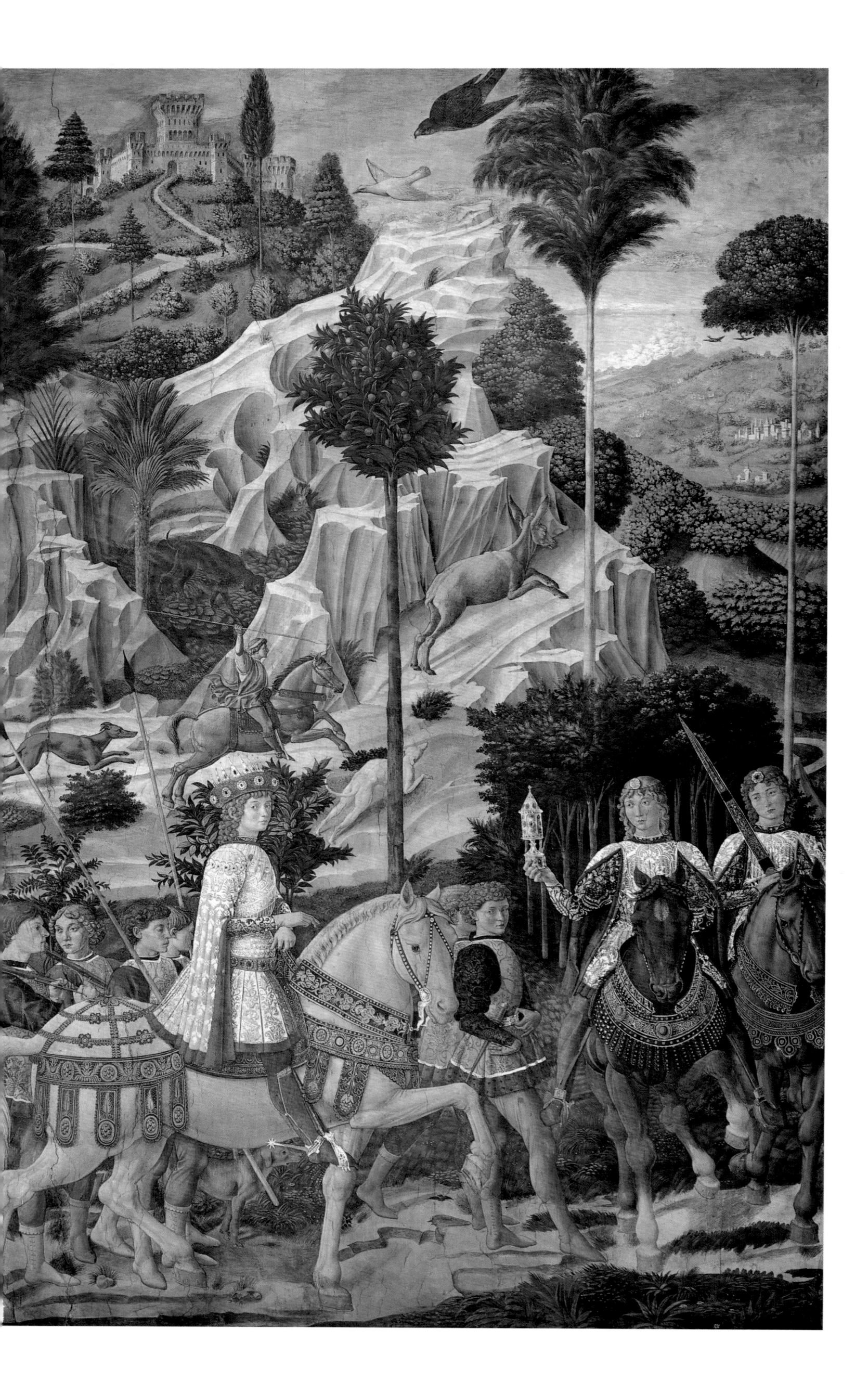

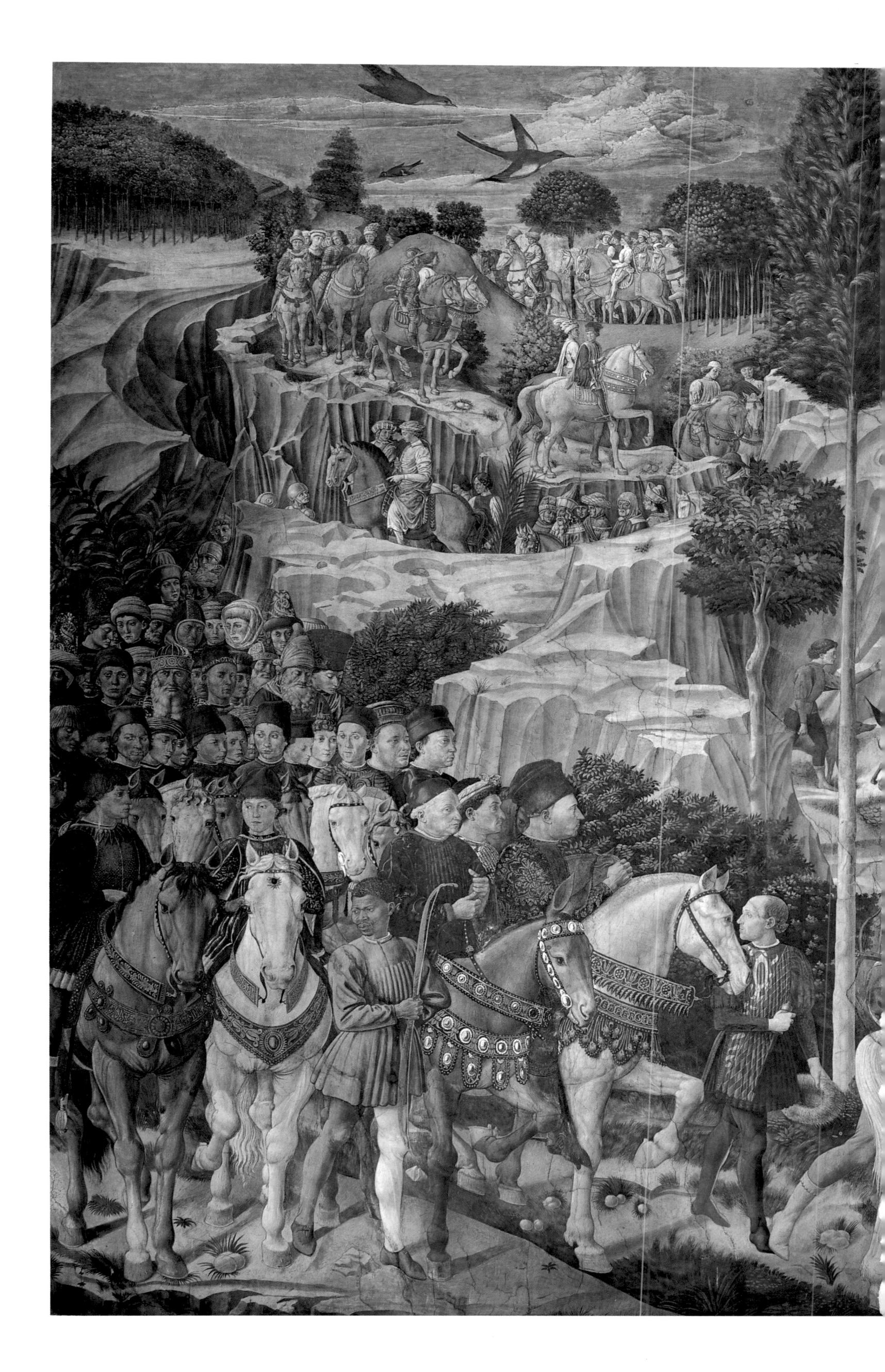

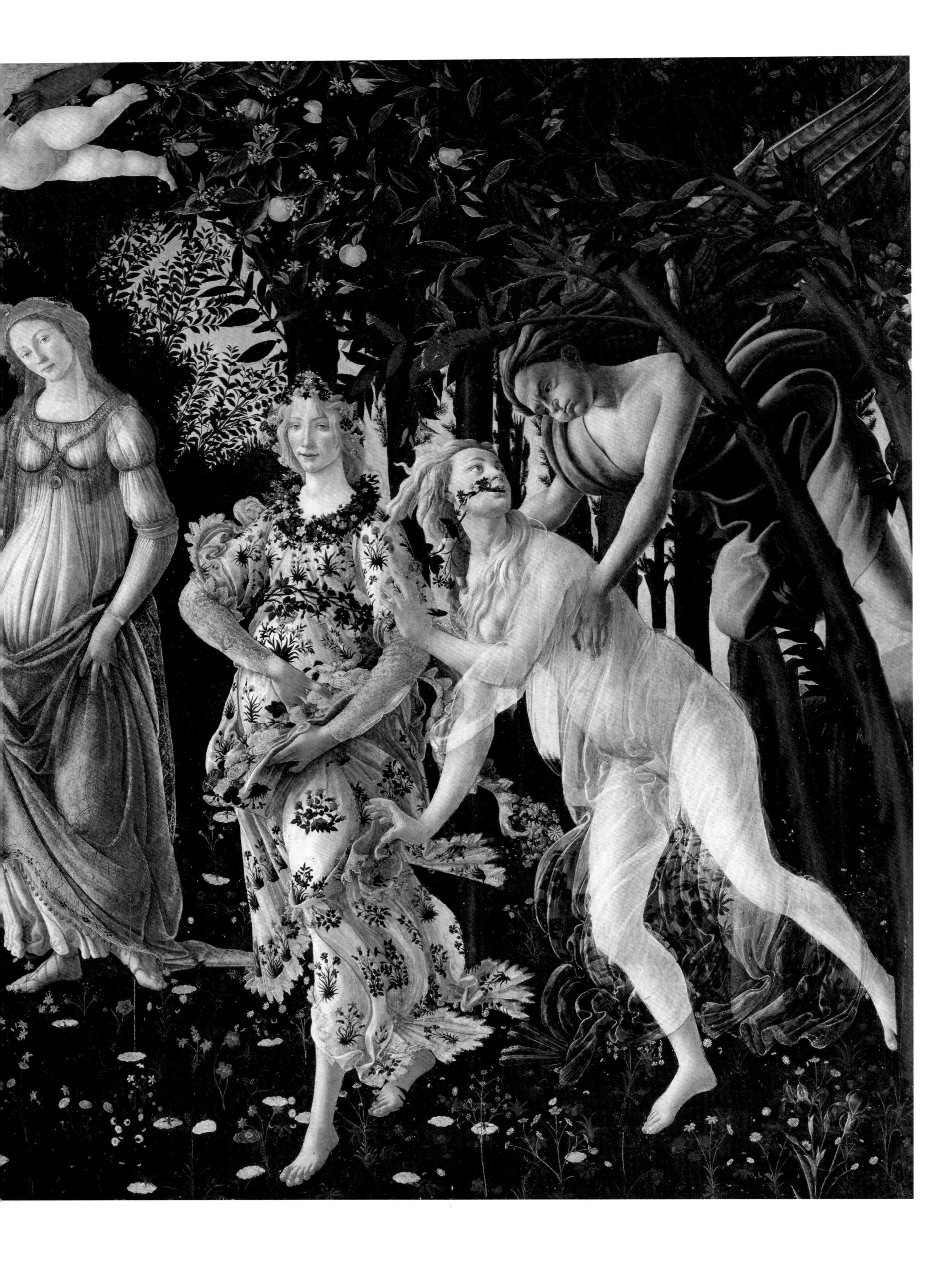

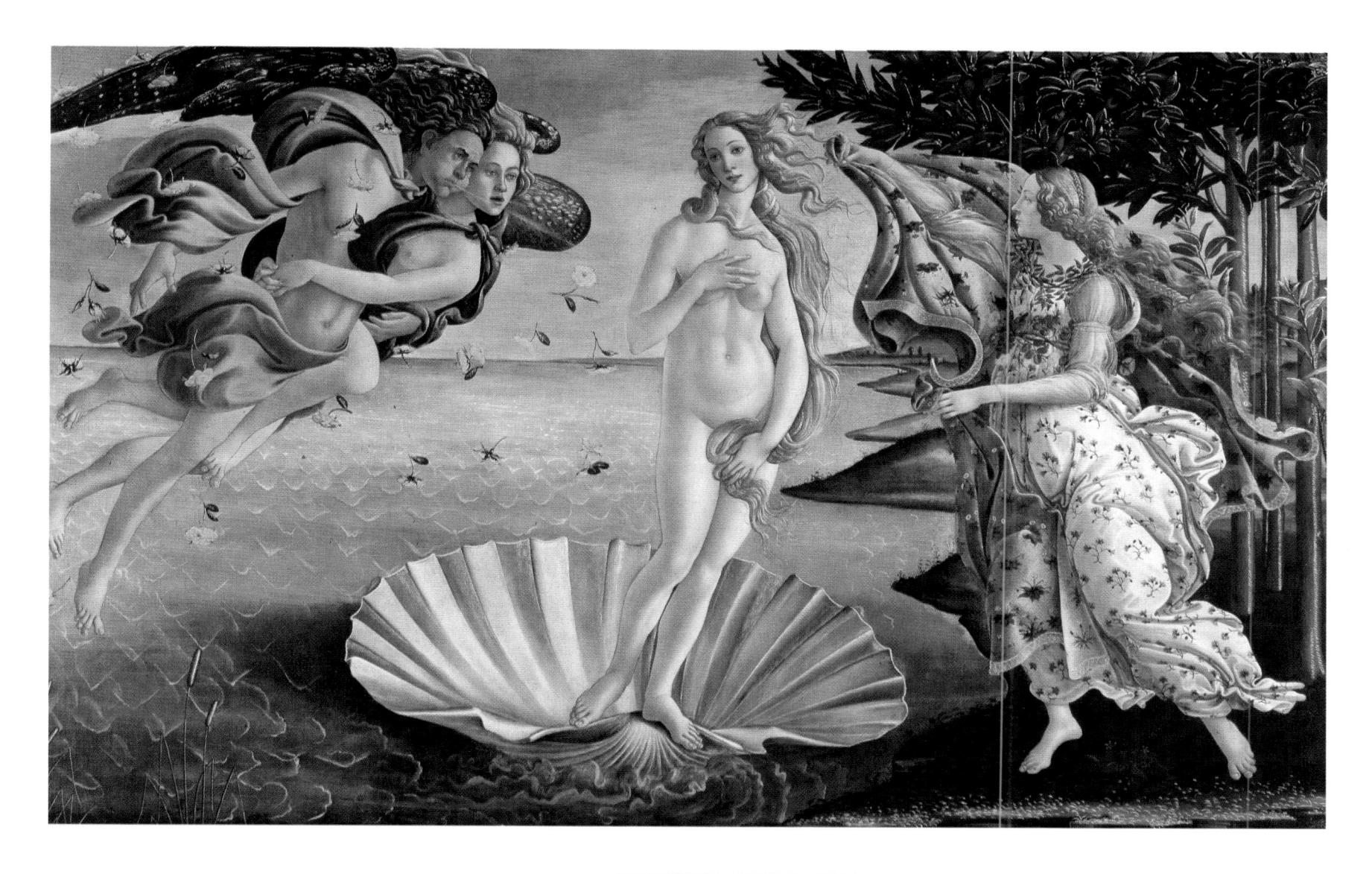

(Left) This painting forms part of a cycle including the Birth of Venus and Minerva and the Centaur, and all have a complex iconography. They offer a synthesis of Neo-Platonic doctrines. Zephyr (extreme right) personifies human love and nature's life-giving power. He seizes the nymph Chloris, who is transformed into Flora. Above, Cupid helps Venus to arouse this passionate love, but also to sublimate it through the intellect (the three Graces) towards an ideal contemplation of worlds beyond through the figure of Mercury (extreme left).

116 SANDRO BOTTICELLI Birth of Venus 1484–6 (Above) This picture was painted for Lorenzo de' Pierfrancesco de' Medici as the companion piece to Primavera, but has probably been cut at the top. The sources include Hesiod's Genealogy and Homer, as interpreted by the Neoplatonists.

117 SANDRO BOTTICELLI Minerva and the Centaur c.1480

(Right) Wrongly identified as Pallas and the Centaur on the basis of a misidentification with a painting described by Vasari, this picture shows Minerva as goddess of wisdom triumphing over the baser instincts symbolized by the satyr.

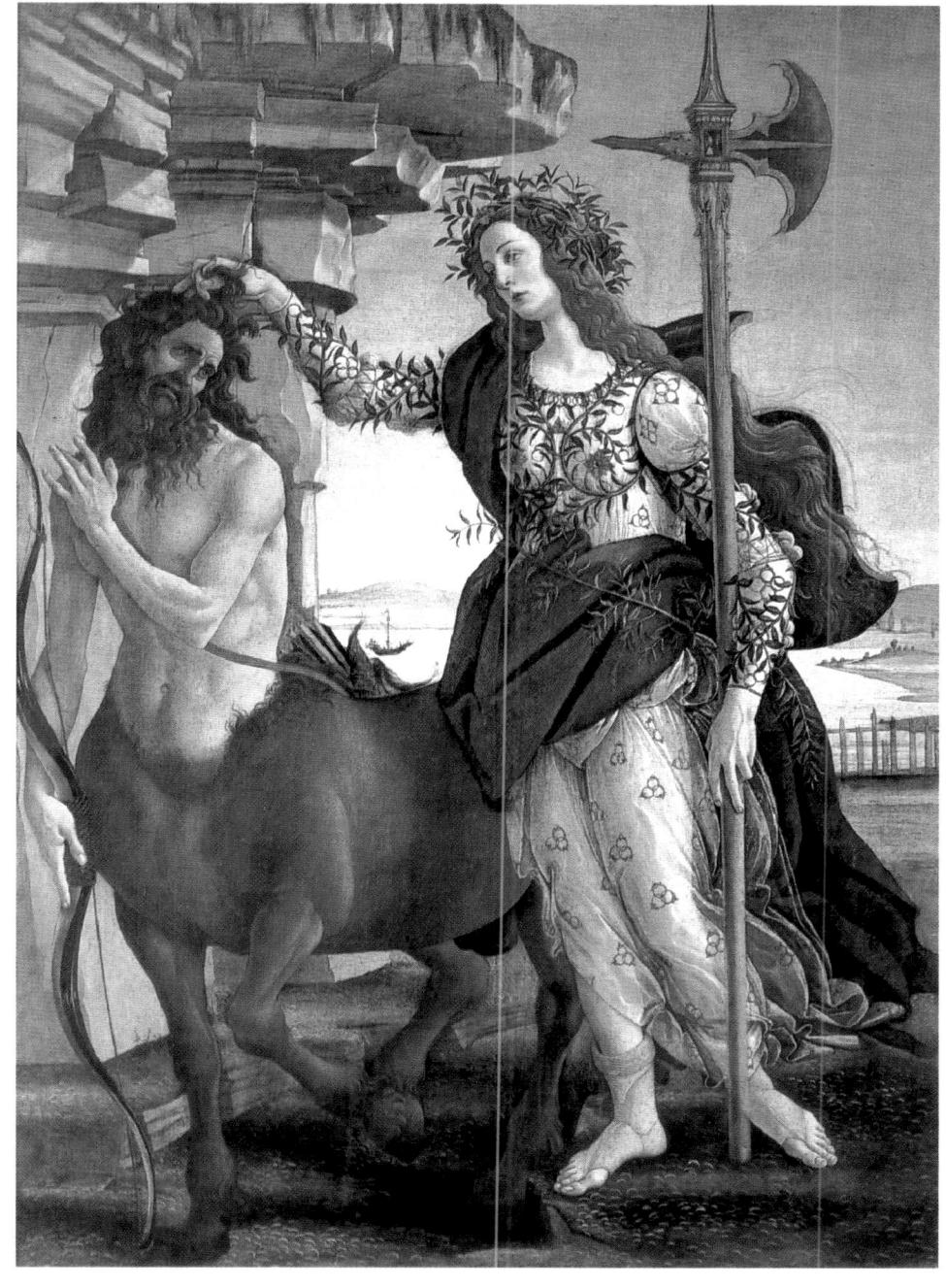

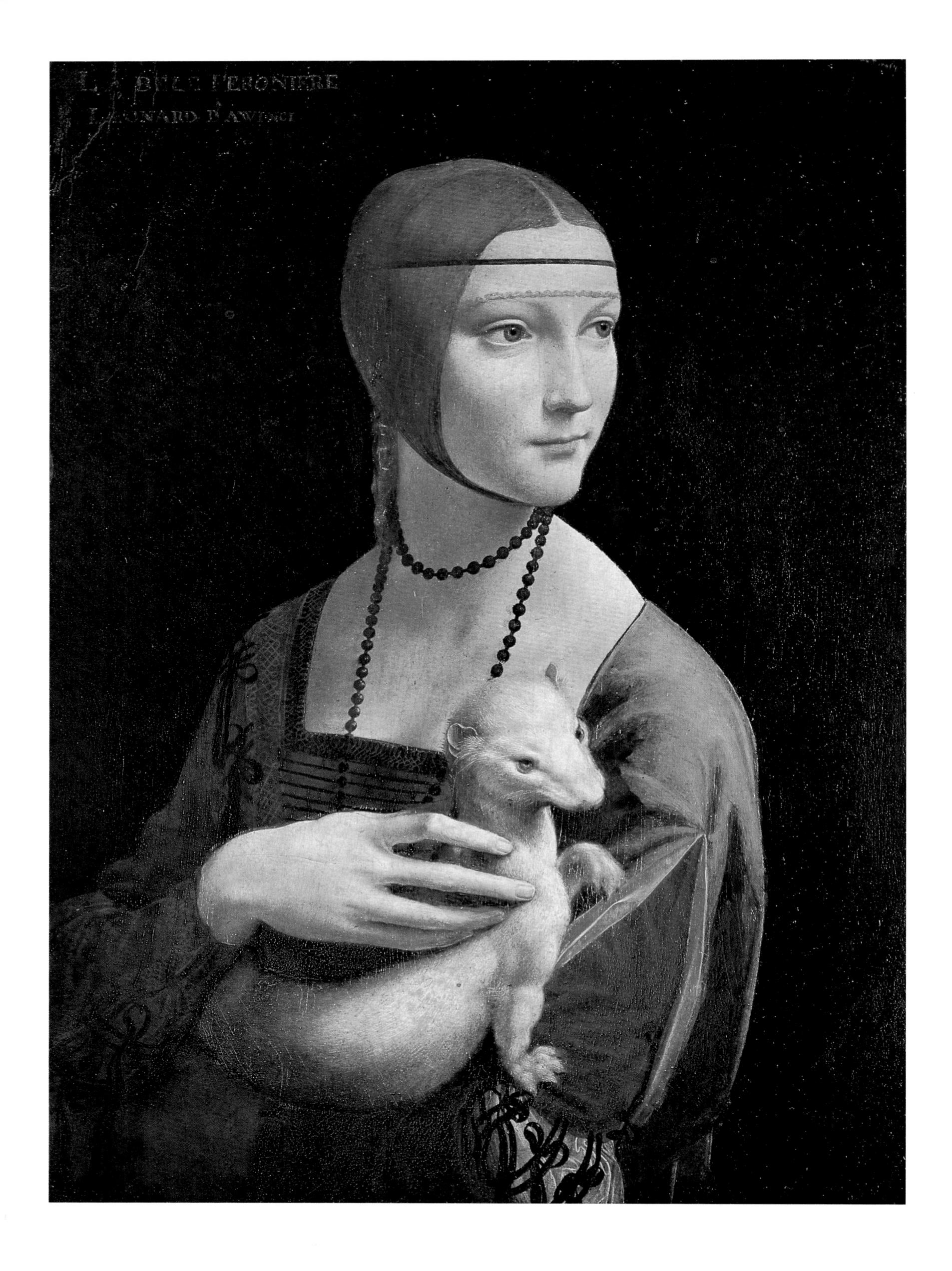

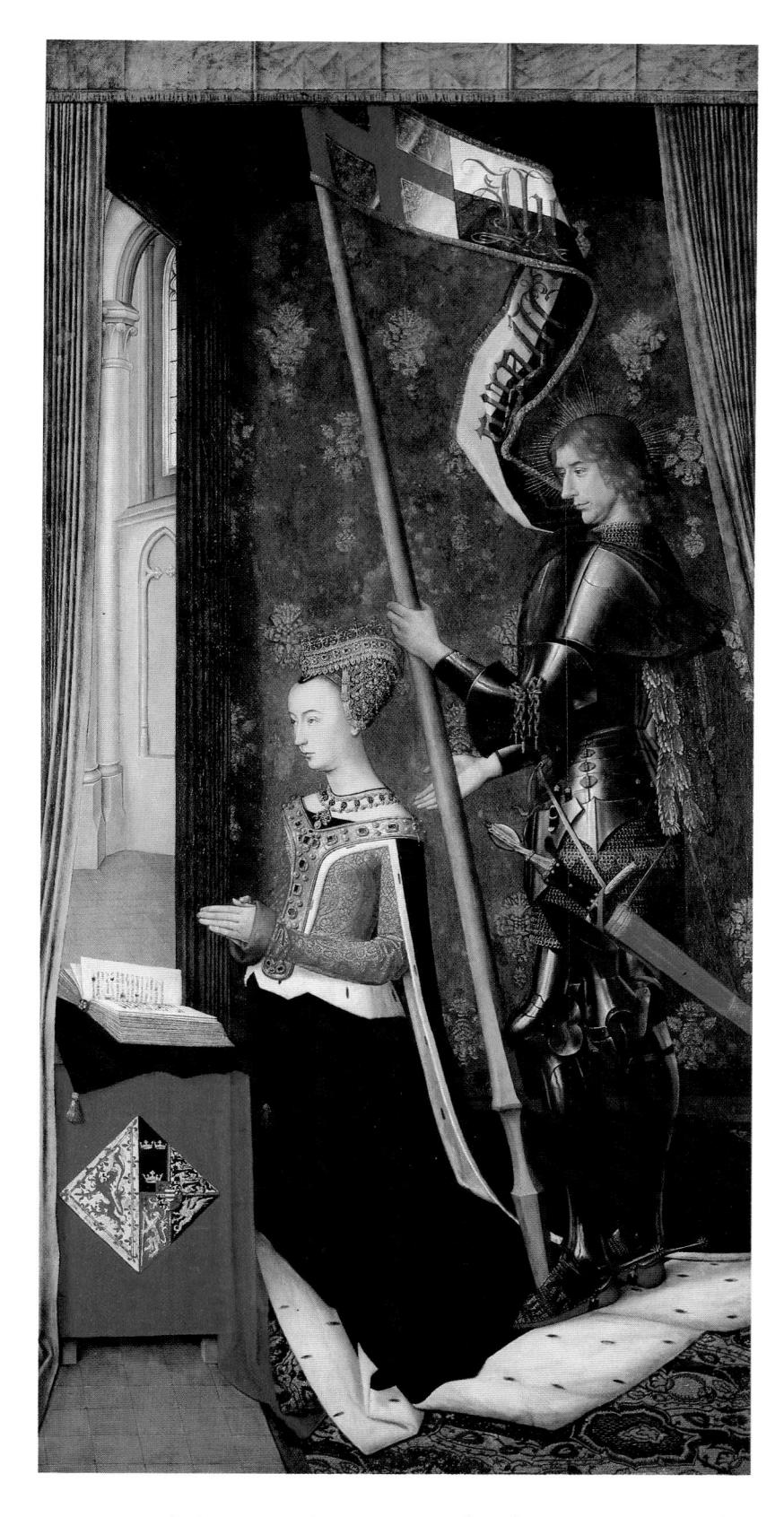

crowded composition not related to any particular Netherlands tradition. The possibility that he was a pupil of the Haarlem painter, Albert Van Ouwater, tells us little except that the latter's style also seems to belong to a seminaive tradition.

Related to Geertgen Tot Sint Jans is the 'Master of the Virgo inter Virgines' (active $\epsilon.1470-\epsilon.1500$) who is called after the picture on this theme in the Rijksmuseum, Amsterdam. He is known to have worked in Delft, and was also active as a designer of woodcuts for books. His other major work is the *Entombment* (Walker Art Gallery, Liverpool).

Hans Memlinc

More distinguished as a portraitist than as a painter of religious themes, Hans Memlinc (or Memling, c.1430–94) ran a large studio which perpetuated his ideas in this field. Although born near Frankfurt, he must have moved early in his life to the Netherlands since there is no indication of a German training. He was traditionally a pupil of Rogier van der Weyden, whose style appears in his precocious early work along with traces of Bouts' and Van der Goes' influences. The *Donne Triptych* of the early 1470s in the National Gallery, London, also quotes from Van Eyck.

Memlinc became the leading painter in Bruges, and according to tax records was among its richest citizens — so rich indeed that he had to pay the Emperor Maximilian's wealth tax levied as a result of the war with France. He seems to have moved from Brussels to Bruges after 1464, the year of Van der Weyden's death, and simply continued where his master had left off, but in a softer and less demonstrative style. Once evolved, this style showed little change, which complicates the dating of his work. Much has been made of Memlinc's apparent lack of strong religious convictions, but in effect the gentle melancholy of his work (particularly evident in the face of *Bathsheba* — see plate 154) may appear as restraint, and was probably one of the reasons for his immense success.

Like Bouts, Memlinc was fascinated by landscape, and his views, with their clever placing of architecture in the middle distance, are sometimes highly original. His landscape suggests tranquillity much as Perugino's simplified backgrounds did at the same time in Italy. Memlinc's, however, perhaps deliberately, do not relate to the mood of the subject, however intense that may be. In his Scenes of the Passion of about 1470 (Galleria Sabauda, Turin) fantastic architecture runs riot, rendering the figures subsidiary to a surreal forest of towers, turrets, windows and doorways. Something of this fantasy is also seen in the background of the Martyrdom of Saint Sebastian probably painted at the same period (Musées Royaux des Beaux-Arts, Brussels). Saint Sebastian illustrates the reticence with which the nude was still regarded in the North, whereas in Italy it had already become a proper and expressive subject. One major exception is his own extraordinary Bathsheba (see plate 154) – a rarity in this period.

Fantasy and reality meet in Memlinc's famous *Chasse of Saint Ursula* of 1489 (Hospital of St John, Bruges) – a richly carved and gilded wooden Gothic reliquary framing painted panels. The small size of these panels inspired in Memlinc a particularly concentrated version of his usual style, with generously scaled figures, colour in keeping
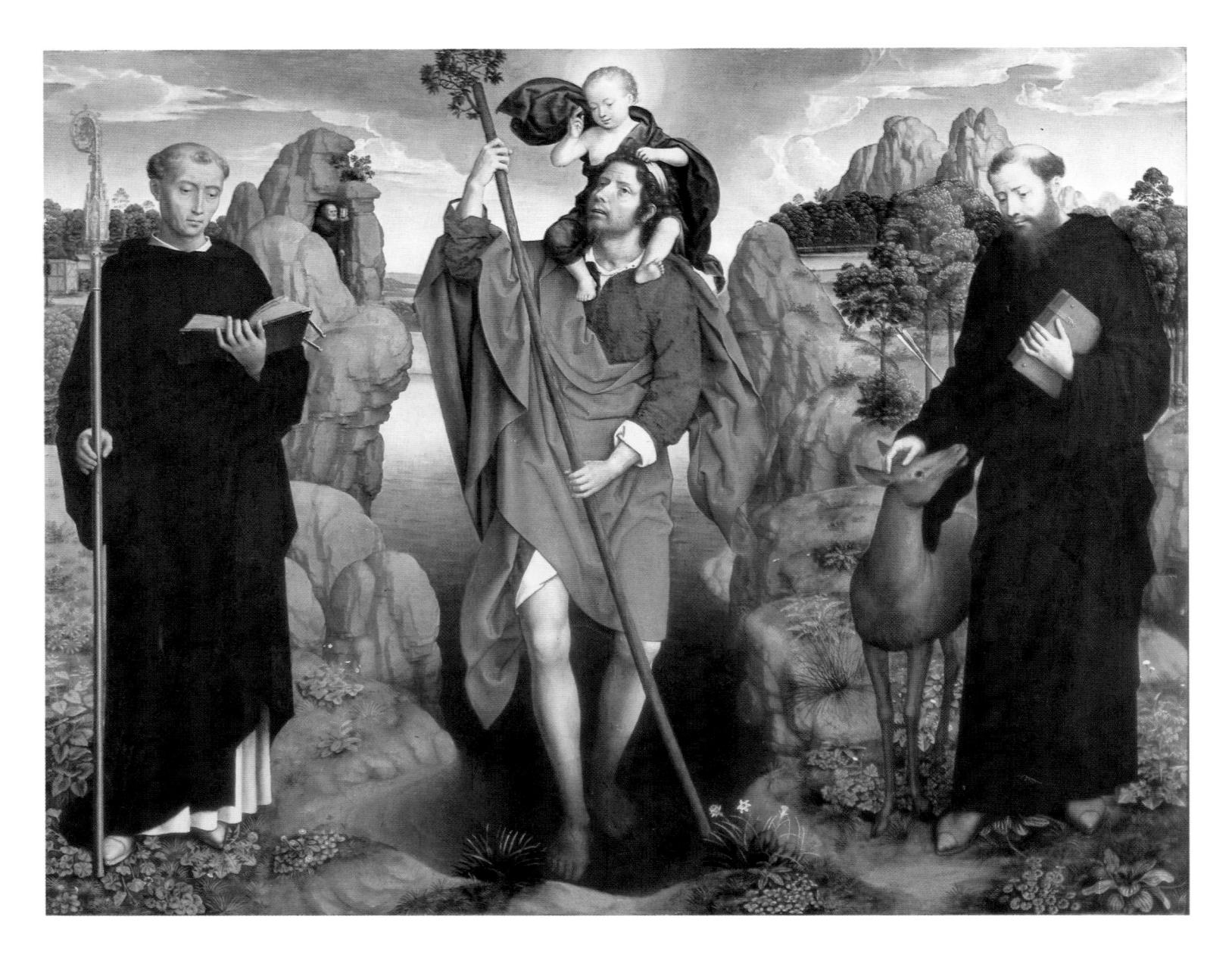

135 HANS MEMLINC Saint Christopher Altarpiece 1484
The left wing of this triptych shows the donor, William Moreel, with his sons, presented by his patron saint William of Maleval. On the right wing his wife Barbara van Vlaenderberghe appears with her patron saint and daughters. In the central panel, St Christopher is flanked by St Giles and St Maurus.

with the jewel-like object itself, and inventive back-ground views. The palette used is unlike what Friedländer characterized as Memlinc's 'cool, opaque colouring', and the style recalls miniature painting rather than Memlinc's grander panels. In its combination of sculpture with painting of the highest quality, the *Chasse* is one of the most beautiful objects of its kind to survive from this period. It is also one of the finest works in the Memlinc Museum, in the Hospital of St John in Bruges, one of the few places where sufficient work by a single painter of this period is collected, allowing a rounded view of his style.

The *Portinari Altarpiece* must have been well-known prior to its departure for Italy, but a comparison with Memlinc's *Floreins Triptych* (Hospital of St John, Bruges) reveals a common tendency of the end of the century, for

painters to hark back to Van Eyck and Van der Weyden; similarly the *Saint Christopher Altarpiece* (see plate 135) pays homage to Bouts.

The sheer number of portraits (around thirty) attributed to Memlinc indicates his popularity in this sphere, although there is no record of his reputation as a portraitist. He was probably much more inventive in portraiture than his contemporaries, and his range included the three-quarter length *Martin van Niuwenhove* (St John's Hospital, Bruges), a textural *tour-de-force* with evocative background details of windows, stained glass and shutters. The *Portrait of a Man with a Medal* (see plate 153), on the other hand, is Italianate in influence.

Memlinc is one of the most appealing artists of his age, and his style largely discards Late Gothic elements in favour of a contemplative art with, as one critic put it, 'the gift of inducing serene contemplation'. For the nineteenth century, he was the most important Netherlandish painter after Jan van Eyck. This judgement may have been based on the survival of a greater number of attributed paintings than is usual with his contemporaries. His lack of fanaticism also endeared him to the Victorians.

Gerard David

Like his contemporary Bosch, Gerard David, who died in 1523, was a transitional painter who carried fifteenth-century developments into the next century. David, however, remained much closer to those earlier traditions. He filled Memlinc's place in Bruges on his death, having probably arrived from Oudewater, near Gouda, between 1480 and 1484. David's career there saw the final decline of the city as an innovative centre, but he probably played a significant role in the developing export trade in pictures. And although Antwerp was already assuming its new importance through Metsys (see plate 275), in some ways David also achieved many of the aims of the northern High Renaissance in his later work. It is possible that he painted the first pure landscapes in Flemish painting, in his altarpiece wings in the Mauritshuis at The Hague.

With the exception of a possible visit to Genoa between 1510 and 1515 (where he may have painted the simple and extraordinary *Crucifixion* in the Palazzo Bianco), he remained in Bruges until a recorded visit of unknown duration to Antwerp in 1515. However, instead of becoming merely a provincial painter he

136 GERARD DAVID Christ Nailed to the Cross c.1480–5 This central panel from a triptych shows three separate scenes, and is unusual in its tightly packed and uptilted composition, which attempts to introduce a novel sense of immediacy and drama. Hugo van der Goes' influence can be seen in the realism of Christ's terrified expression. The wing panels, which are now in Antwerp, show mourning women and Roman soldiers with Jewish judges.

evolved a highly personal style in which Late Gothic elaboration is completely replaced by a human element of warm naturalism.

It seems likely that David arrived in Bruges as a master with an established reputation, since he obtained an important commission, now lost, from the city's magistrates in 1488 – the year he was elected a member of the painters' guild council. Three years later, he became its dean. *Christ Nailed to the Cross* (see plate 136) is probably one of his earliest works, painted on his arrival in Bruges, and it already indicates the essential elements of his style. Its realism is striking, and above all, he attempts to imbue the composition with its full drama by filling the entire centre stage with the cross, and focusing attention on Christ's subtly observed expression of fear. David's model at this point must have been Hugo van der Goes.

He reached his first maturity in the Judgement of Cambyses of 1498 (Groeningemuseum, Bruges), which is full of colourful incident, but also reveals a new energy in the composition of figure groups. This tendency is perfected in the early years of the new century with Canon Bernardinus de Salviatis and Three Saints (National Gallery, London). During that first decade he worked in a more grandiose manner than at any other time. Perhaps the most important example of this style is the Madonna and Child with Saints and Musical Angels of 1509 (Musée des Beaux-Arts, Rouen). The painting is unique in David's work for its combination of elegance and calm grandeur, and was important to the painter himself. It includes his own and his wife's portraits, and was given by him to the Carmelite Convent in Bruges.

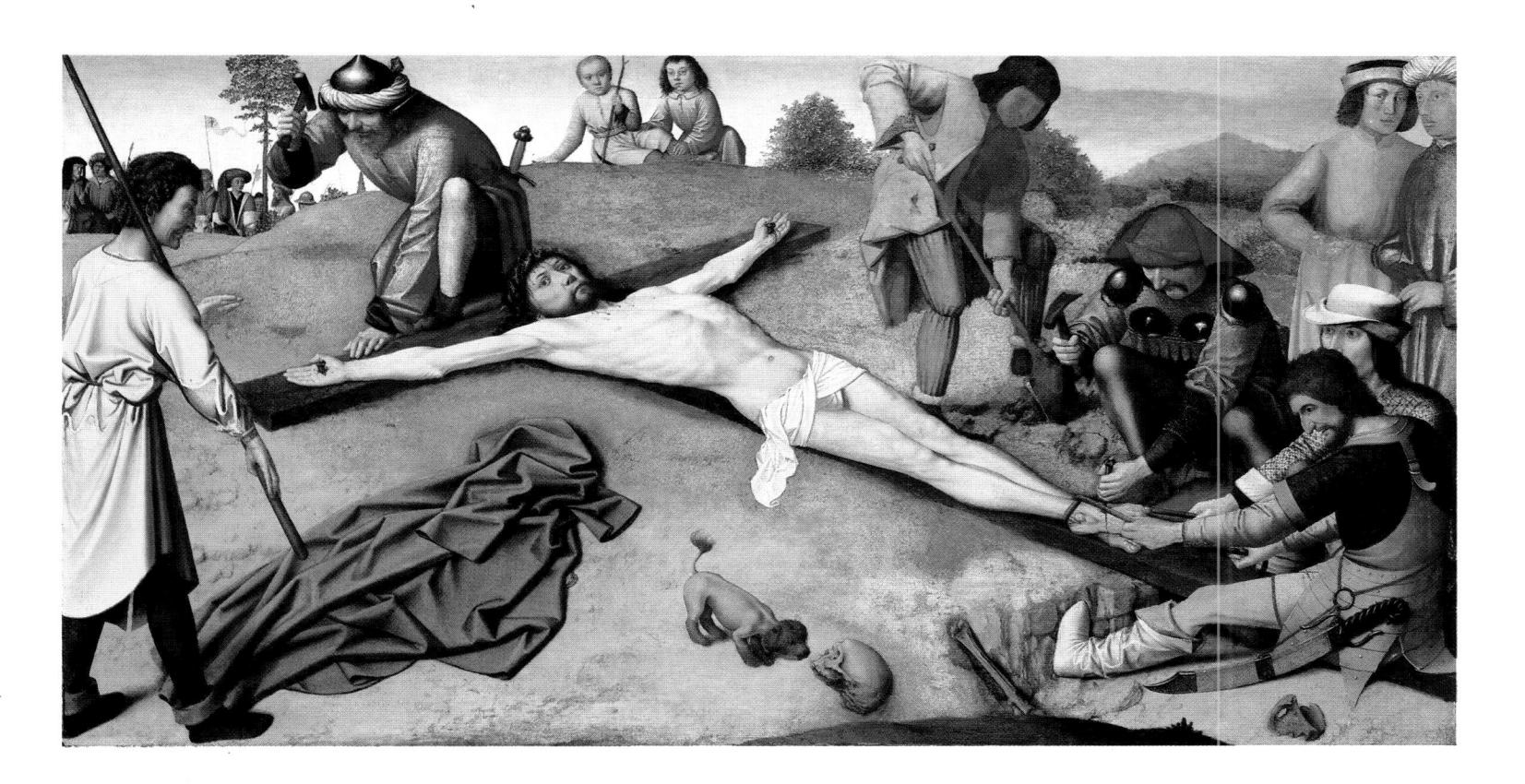

Contrary to what might be expected, David did not pursue this style, possibly because of the prevailing taste in Bruges rather than his own. The works of his last decade are marked by the intimate and simplified manner which many consider most characteristic of him. This style is ushered in, about 1510, by the delightful *Rest on the Flight into Egypt* (National Gallery of Art, Washington). Its lovingly depicted details of the donkey and the Virgin's basket, and the tiny figure of St Joseph knocking nuts from a tree, have a deeply appealing simplicity unequalled at this time. If his Genoese visit did occur, it would

137 HIERONYMUS BOSCH Christ Carrying the Cross c.1501–2 Among the cruellest images of human persecution in Western art, this panel compresses nineteen heads into an airless, spaceless setting, which concentrates on their nightmarish appearance. It may illustrate a Middle Dutch text of a verse from the Psalms: 'And in their fury they raged against you and gnashed their teeth like angry dogs.'

explain the Italianate character of David's various late renderings of the *Virgin and Child with a Bowl of Milk* (one version of which is in the Musées Royaux des Beaux-Arts, Brussels). Here the prototype may be Leonardo or his followers, but the feeling of intimacy and silvery light is entirely David's.

Hieronymus Bosch

The most enigmatic of all Netherlandish painters is Hieronymus Bosch (1453–1516). The contrast between his quiet provincial life and the bizarre imagery he painted could not be greater, while mainstream religious painting of the fifteenth century appears completely conventional beside Bosch's peculiar nightmare vision. He could conform when necessary however, as is demonstrated by his mundane *Crucifixion* of the later 1480s (Musées Royaux

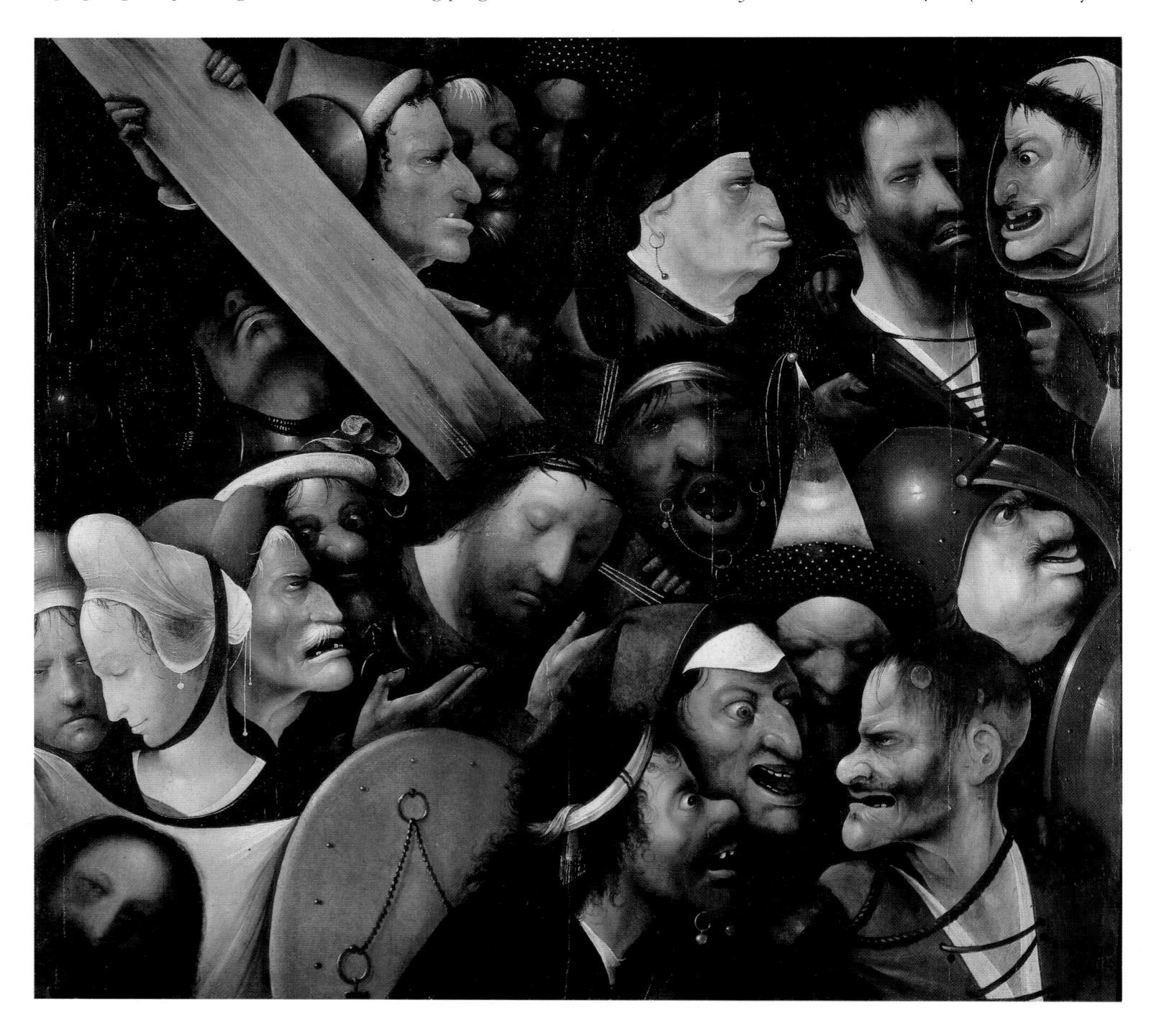

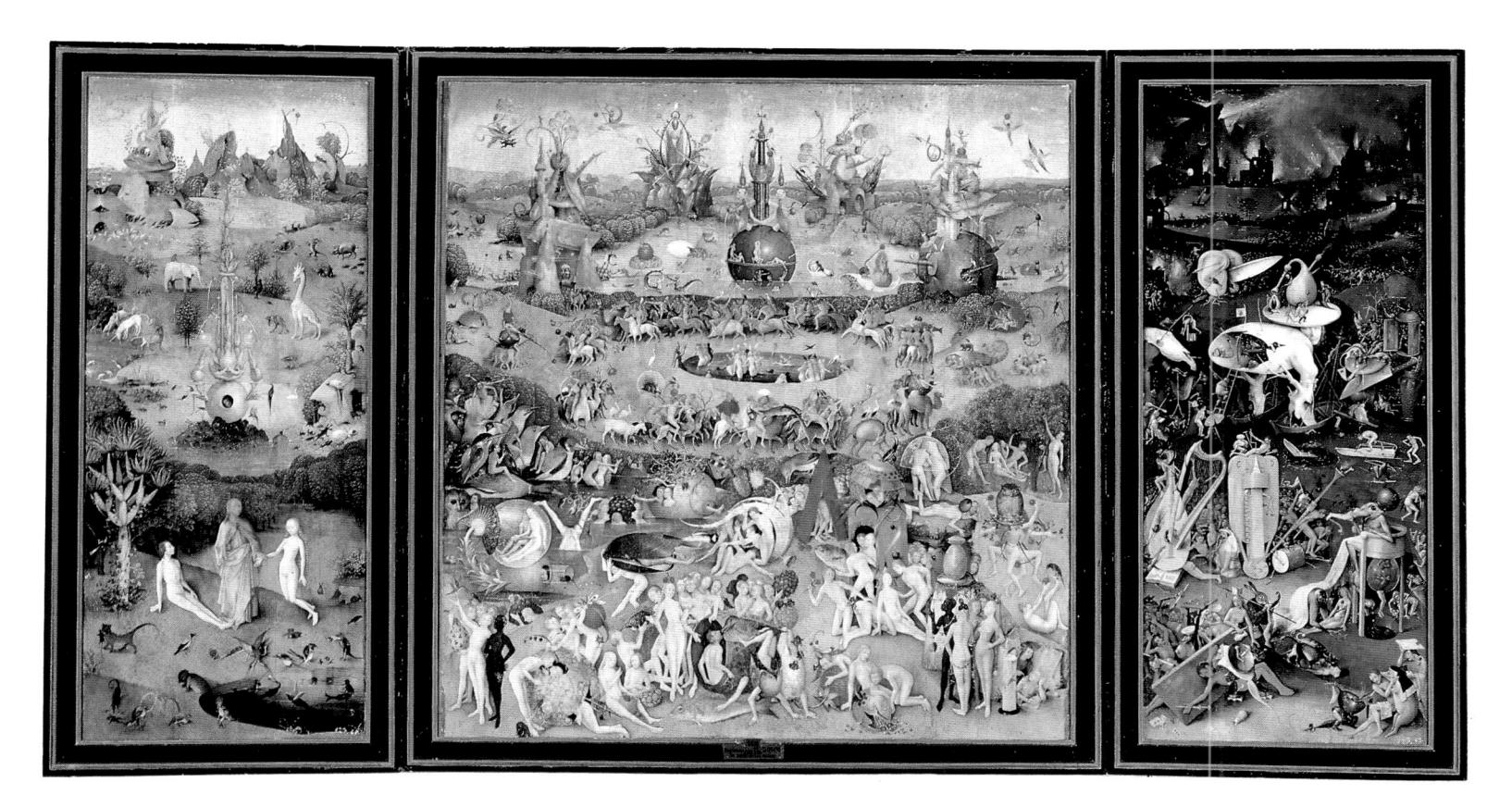

That Bosch's pictures were accepted in orthodox Catholic circles in the sixteenth century seems to discount implications of his heretical leanings. This triptych is probably Bosch's most complex image, offering for some a symbolic vision of man's sinfulness, for others an earthly paradise. The newly created world appears on the altarpiece's exterior, with the Garden of Eden in the left wing and Hell on the right. In the centre appears man's folly after the Fall. Astrological references are included, and there appear to be countless plays on words. Throughout the picture balance is always at risk, and souls are tortured by the ways in which they have sinned. It has also been suggested that there are references to the Inquisition. The text from Isaiah 40:6 – 'All flesh is grass, and all the goodliness thereof is as the flower of the fields' has been applied to this painting.

de Beaux-Arts, Brussels). But he also was capable of rendering ostensibly straightforward scenes with a macabre genius for the unexpected, as in his *Death of a Miser* of about 1500 (see plate 147). Bosch's iconography has inspired more conjecture than any other Netherlandish painter's. His orthodoxy as a Catholic is undoubted, however, and he worked for a local religious confraternity of which he was a member. The answer to his fantastic creations may simply lie in Bosch's overwhelming mission, as a didactic moral artist, to warn of the torments of Hell awaiting a sinful mankind.

How his style evolved is unclear, but Bosch came from a dynasty of painters. His grandfather had moved in the last years of the previous century from Aachen to s'Hertogenbosch in northern Brabant, now part of modern Holland. s'Hertogenbosch was a prosperous provincial town of little artistic importance, yet Bosch seems to have evinced no desire to move to any of the more active cultural centres. The immediacy of his technique – applying paint directly in glazes over underdrawing on a white ground – owed little to the complicated methods perfected by his predecessors. In his early twenties, Bosch painted a circular table top with the *Seven Deadly Sins* (Museo del Prado, Madrid) and a lost pendant showing the *Seven Sacraments*. These are thought to be his earliest works. The form used recalls the Wheel of Fortune, and most of the symbols conform to well-established Christian iconographies for death and its aftermath. Its claustrophobic scenes, in which figures exist in a vacuum, introduce that aspect of his art where even his extensive landscapes are hermetically sealed.

The novelty of Bosch's art, however, lies in the obvious delight he takes in inventing figures which best represent both human and non-human creatures, and in his complete disregard for fashionable style. Many of his paintings show subjects unique to him, such as his *Temptations* and allegories of the Last Things – Heaven, Hell, Death and Judgement.

Perhaps the most distinguishing feature of his art is its rejection of the importance of large-scale human figures in contemporary work. In Bosch, the human figure is nothing more than a formula for expressing his concepts in a recognizable way, and the kind of contemporary studies of anatomy that were undertaken in Italy were irrelevant to his perception of the nude. Thus his human figures belong to the same species as all the natural forms in his pictorial world. They are angular, uncomfortable,

sharp and suggestive not of the dignity sought by the High Renaissance but of the degradation of the flesh through inevitable suffering. This prevented him from producing that most admired of Flemish art forms, the portrait, since his interest in humanity is always general, not particular.

From his early pictures – such as Saint John on Patmos of the later 1480s (Gemäldegalerie, Berlin), to the famous Haywain triptych (see plate 146) of the following decade – the period of his first maturity – landscape is merely the means by which Bosch anchors events in this world. In the Haywain's right wing, Hell is made all too tangible by the graphic depiction of fire, while in subsequent paintings it is manifested in less obvious ways.

In his multi-figure paintings (such as the *Garden of Earthly Delights*, see plate 138), aesthetic considerations are subjected almost entirely to meaning and content. In this respect, such scenes represent the fullest expression of his didactic mission, and show his roots in the medieval rather than the Renaissance approach to imagery.

Christ Carrying the Cross (see plate 137) is now believed to be Bosch's last painting. He also portrayed himself in old age in the so-called 'Arras Sketchbook'. The Ghent painting is as cruel a testament as any from an artist's old age. Only a few years previously, Bosch had returned to a conventional pattern with his Epiphany Triptych (Museo del Prado, Madrid), which accentuates the horror of Christ Carrying the Cross. With the exception of Christ and Saint Veronica (both of whom have their eyes closed), all the figures have stepped out of nightmares, toothless, grimacing and wholly malevolent. Strikingly modern in concept, only the heads and a few shoulders appear, pressing in on Christ and suggesting little hope for humanity.

It is uncertain how Bosch's contemporaries received his anarchic style, although its popularity is shown by the engravings of his work made locally by Alart du Hameel, and the many copies of his paintings. His work was collected by Philip the Handsome and Margaret of Austria, and the fanatical Catholic, Philip II of Spain, attracted by Bosch's elaboration of simple themes with complex layers of meaning. Bosch's moralistic and ultimately pessimistic vision of man's inevitable sin and damnation may have conformed to Counter-Reformation taste in Spain.

Painting in Germany

Germany in the fifteenth century had little resemblance to the geographical area bearing that name today, being made up of many individual city states among which none dominated. The absence of aristocratic and court patronage and the presence of a rich mercantile class produced a specific provincial bourgeois art. A small number of painters attained more than merely local importance, preparing the way for major artists in the future like Schongauer and Dürer.

While Italian and Flemish painters explored many facets of the visible world, creating a modern art in which innovations such as perspective, atmospheric effects and an individualized portrayal of human physiognomy achieved a greater approximation to reality, artists in Germany remained more closely linked with miniature paintings and the International style. In interpreting such influences in their panel paintings however, a greater breadth and expression inevitably developed. The innovations of Flemish art were apparently known by the third or fourth decade, while advanced Italian ideas only became accepted in Germany much later in the century.

One of the most delightful German representatives of style was the Cologne 'Master of St Veronica', whose love of pale pastel colour and delicate figures was taken up by the leading master of the Cologne school, Stephan Lochner. Lochner, who seems to have been active from about the mid-1430s until 1451, came to Cologne from Meersberg near Lake Constance. He may have been trained in the Netherlands, or at least under a Netherlandish artist, since his work shows a much richer power of detailed observation than that of his German contemporaries. His career in Cologne was distinguished: he received a commission in 1442 on the Emperor Frederick III's visit to the city and served in the painters' guild.

His miniaturistic delicacy is best expressed in his female figures, such as the Madonna with the Violets of the mid-1430s (Erzbischöfliches Diözesan-Museum, Cologne) and the famous Madonna of the Rose Bower (see plate 156). He also painted multi-figure altarpieces like the Last Judgement Altarpiece (Wallraf-Richartz-Museum, Cologne) and the great Adoration of the Magi now in Cologne Cathedral but painted for the town hall; this was later much admired by Dürer. In it, although the figures are still miniaturistic, a feeling of monumentality is nonetheless present, and it seems clear that Lochner increasingly attempted the conscious inclusion of modern Flemish ideas while sometimes retaining an old-fashioned gold background. The so-called 'Cologne school' which was highly influenced by Netherlandish art, produced a surprisingly large number of painters during the second half of the fifteenth century, but many are not precisely identified.

Although he was born in Swabia, and was thus technically German, Konrad Witz (c.1400–44/6) is usually

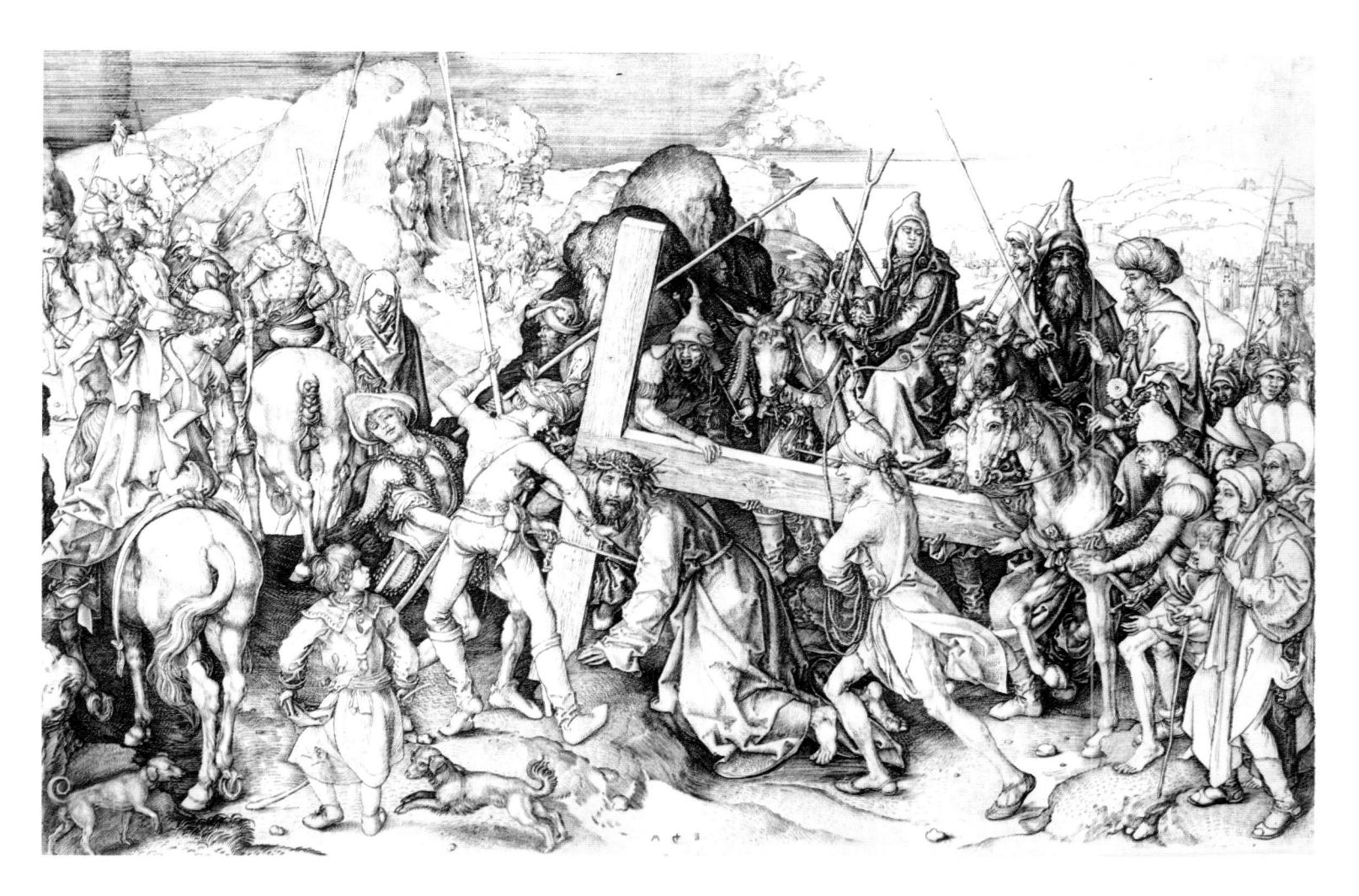

This rare engraving was Martin Schongauer's masterpiece, and among the largest and most impressive engravings ever made. Schongauer may have based the composition on a lost painting by Jan van Eyck, which is known from a copy in Budapest. Its rich texture results from its deliberate emulation of the complexity of oil painting, transcending the limitations of engraving. This novel feature and its combination of an elaborate composition with an extraordinary wealth of detail and landscape background must have particularly impressed Dürer.

associated with the Swiss school, as he became a citizen of Basle in 1435. He may have travelled in the Netherlands prior to this, as he seems to have known the style of Van Eyck and other Flemings. Although we know few pictures by him, these original works indicate his abilities. His figures are often rigid, as in the panels from his *Saint Peter Altarpiece* for Geneva Cathedral (Musée d'Art et d'Histoire, Geneva). This altarpiece also incorporated his famous *The Miraculous Draft of Fishes* (see plate 155), a masterpiece of landscape observation.

The work of one other artist of this time working in Ulm, Hans Multscher (documented 1427, died before 1467) should be mentioned. He typifies the German sculptor-painter, whose main activity was the production of the often immense multi-panelled altarpieces combining sculpted scenes with paintings, all set in elaborately

carved and gilded Gothic frames. Another artist of this type was Michael Pacher (active 1465?–98) who worked in the Tyrol.

It was in Colmar that the most important artist of the period prior to Dürer was active – Martin Schongauer, who died in 1491. Only one secure painting by him is known, the *Madonna in the Rose Garden* of 1473 (St Martin's, Colmar), although others are attributed to him. It was as the masterly engraver of about 115 plates that he earned his place in German art. He alone among his German contemporaries received favourable attention, and he exercised considerable influence outside his chosen workplace. What he was able to realize in his engravings was of profound importance to many other artists of all kinds, including Dürer.

Schongauer appears to have been in the Netherlands and certainly visited Leipzig, and the allure of his prints derives from their painterly approach, which gives them a higher degree of atmospheric expressiveness than those of his predecessors. From early works influenced by Rogier van der Weyden, he rapidly found his personal manner in images like the *Temptation of Saint Anthony* of *c.*1470–75. The immense variety of his style is impressive, ranging from individual figures such as his *Saint Michael* of the 1480s and the moving study of a *Censor* with all its elaborate Gothic metalwork detail, to the dramatic late multi-figure *Christ Carrying the Cross* (see plate 139).

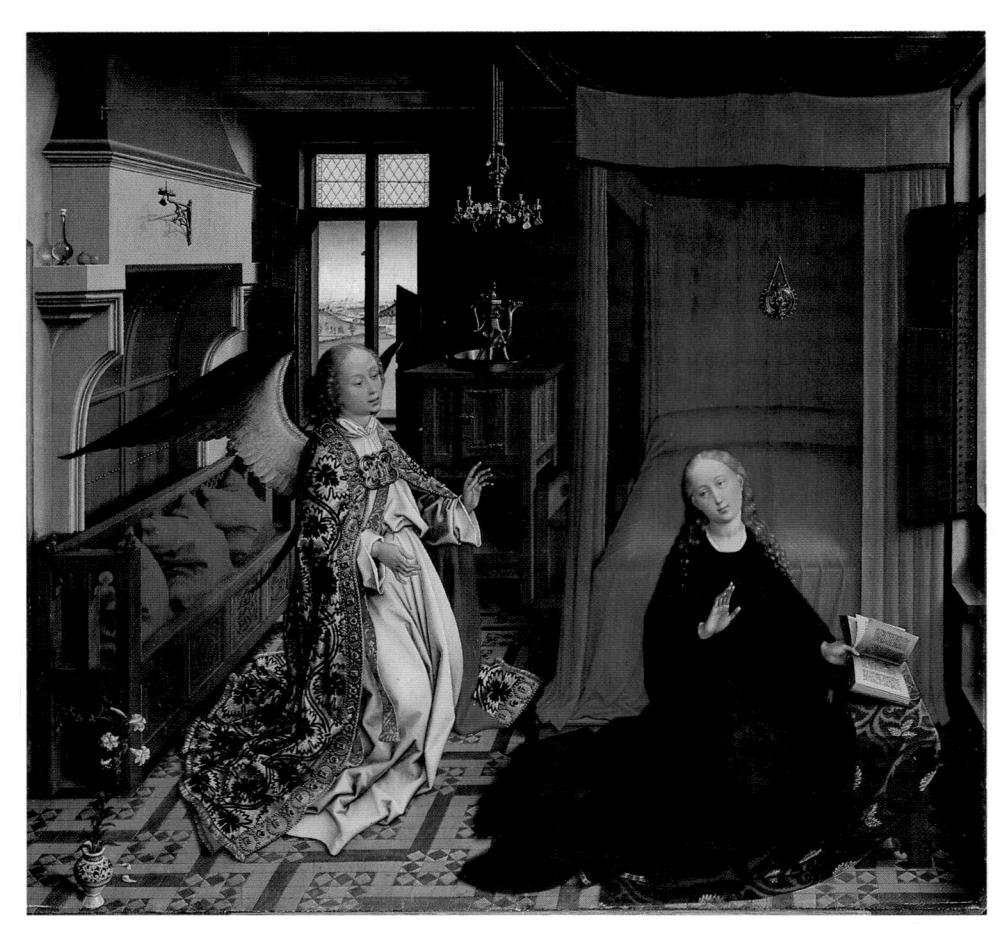

140 ROGIER VAN DER WEYDEN Annunciation c.1435

Now separated from its wings in the Galleria Sabauda in Turin, this panel clearly reveals the impact on Rogier's style of Van Eyck, both in form and colour. The vibrant scarlet bed, borrowed from Van Eyck's Arnolfini Marriage, the cupboard and the wooden settle, serve to compress the main scene on to a narrow foreground stage, where the earthbound figure of the Virgin accentuates the floating movement of the angel. This shows the relative discomfort of even a moderately grand room at this period. Of particular interest are the lavish floor tiles and hinged and bolted window shutters.

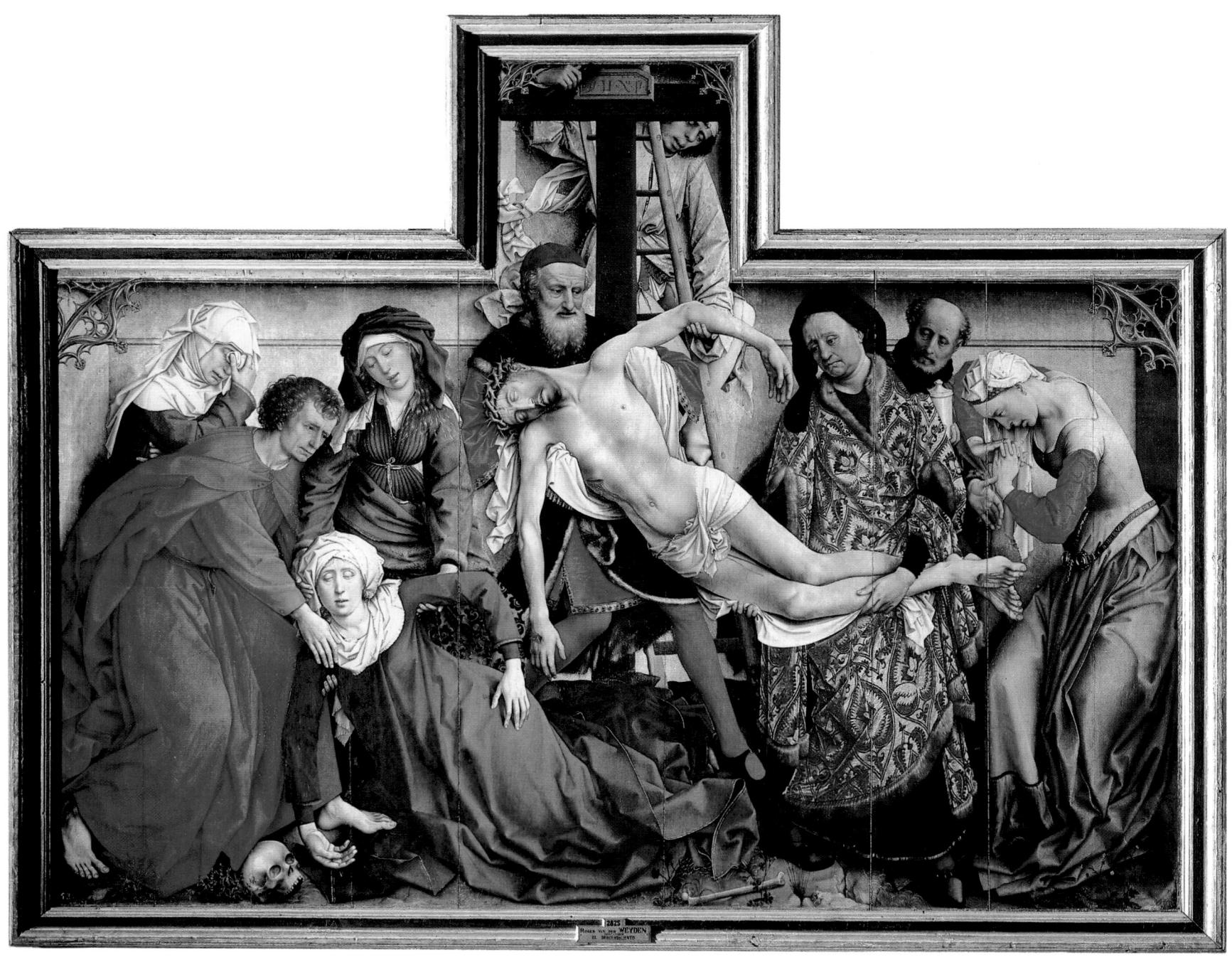

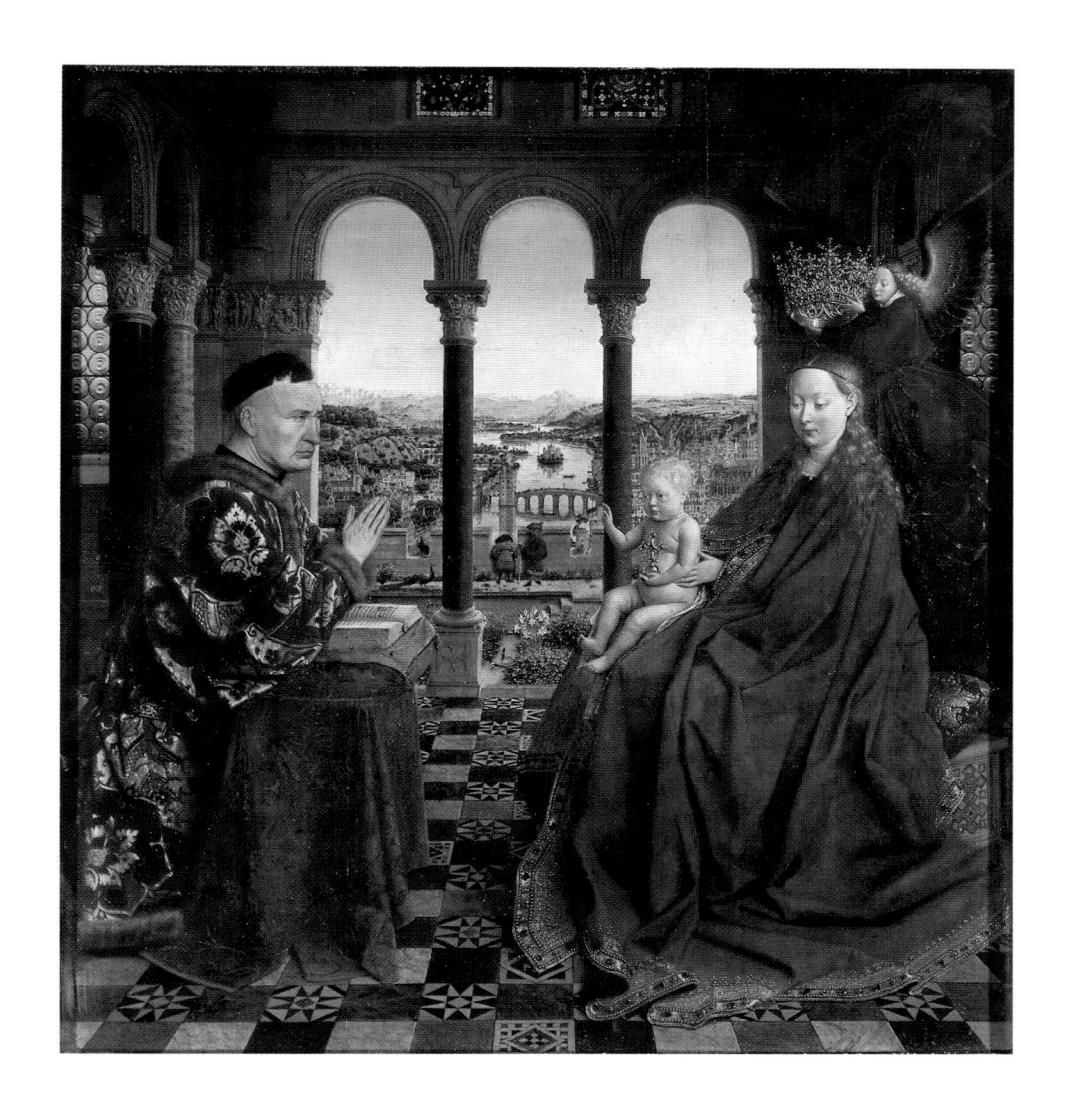

142 JAN VAN EYCK Madonna of the Chancellor Nicholas Rolin ('The Virgin of Autun') c.1434
This painting was probably presented to Autun
Cathedral in 1437 by the unscrupulous Chancellor of
Burgundy, Nicholas Rolin, when his son Jean was made
Bishop there. The idea of showing the donor in the
Virgin's presence without mediating saints was
innovative, and the sweeping background view enjoyed
by two tiny figures on the balcony outside is also novel.
Many suggested identifications for the town have been
made, including Bruges, Brussels and even Prague. The
triple Romanesque arched openings refer to the Trinity,
while in the garden are symbols of the Virgin - lilies,
irises and birds. Even the carved capitals to the left
contain symbolic Old Testament scenes.

141 ROGIER VAN DER WEYDEN Deposition c.1438

(Left) Possibly Rogier's best-known painting, this once formed the central panel of a triptych, and was commissioned by the Archers' Guild at Louvain for the church of Notre Dame hors-les-murs. Filling the entire picture space to bursting point, its unique combination of high drama with intensely wrought decorative surfaces and brilliant portraiture make it one of the most appealing Flemish paintings of its age. The swooning Magdalene is much more naturalistic than most of Rogier's figures, and the deliberate proximity of the figures to the picture surface renders the scene's pathos unavoidable.

143 ROGIER VAN DER WEYDEN Saint Luke Drawing the Virgin c.1435-7

(Right) This is probably the original of four versions of this picture. St Luke, patron saint of artists, is making a silverpoint drawing of the Virgin and Child, while glimpsed beyond in his tiny study is his symbol, the ox. The setting and much detail are borrowed from Van Eyck's Madonna of the Chancellor Rolin, but Rogier's originality lies in his splendid characterization of St Luke and the playful Christ child; his smaller-scale figures also lend greater intimacy.

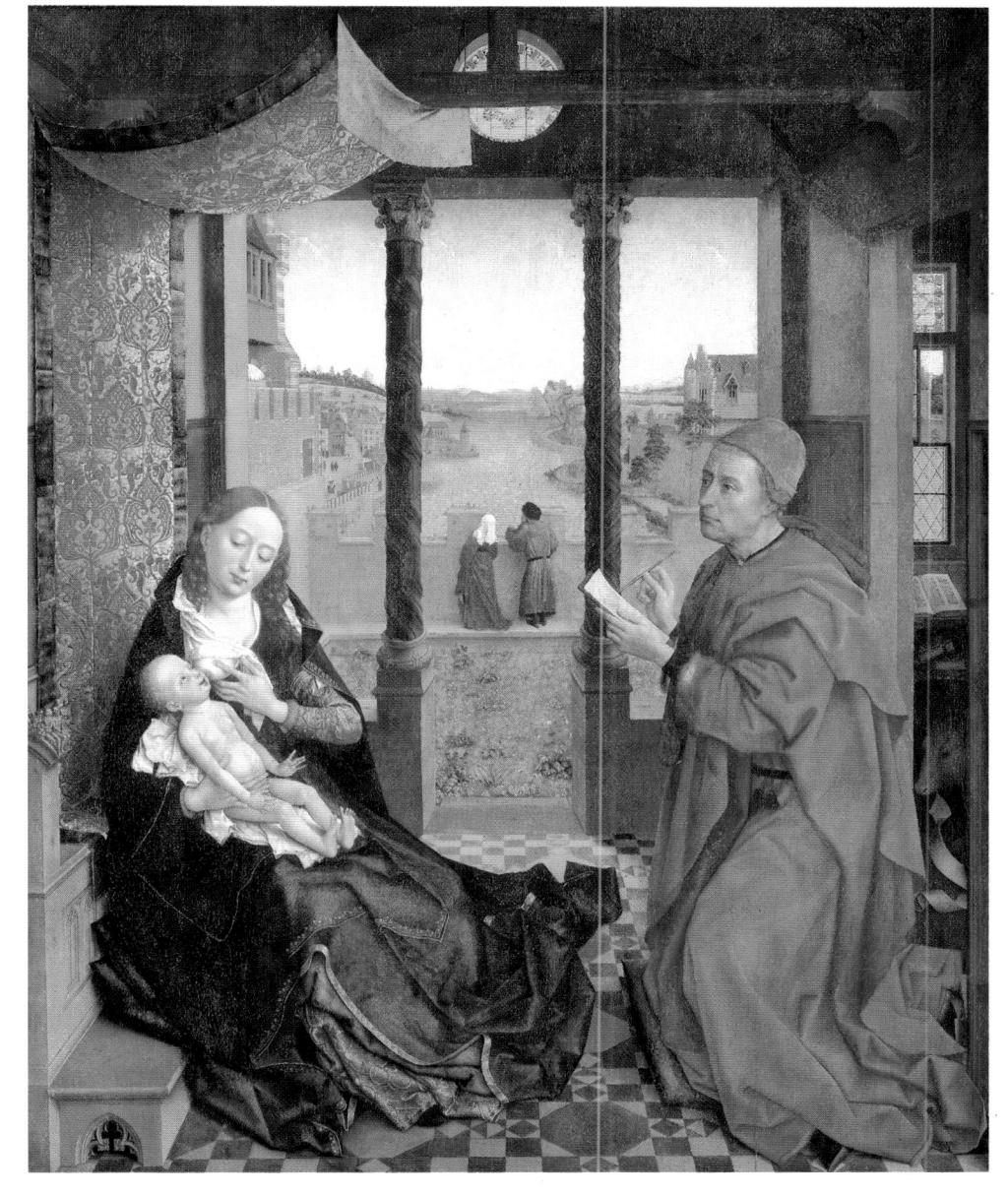

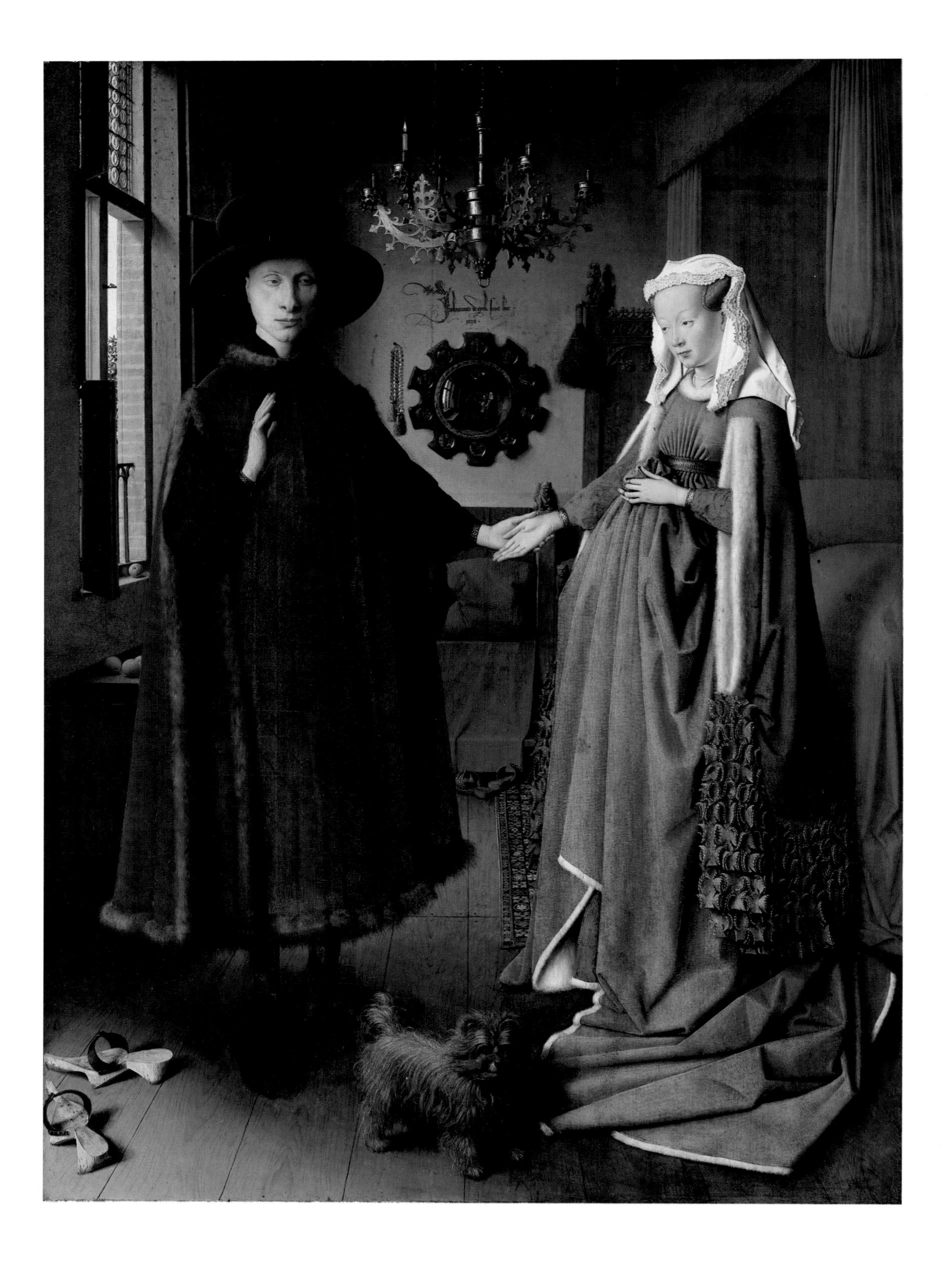

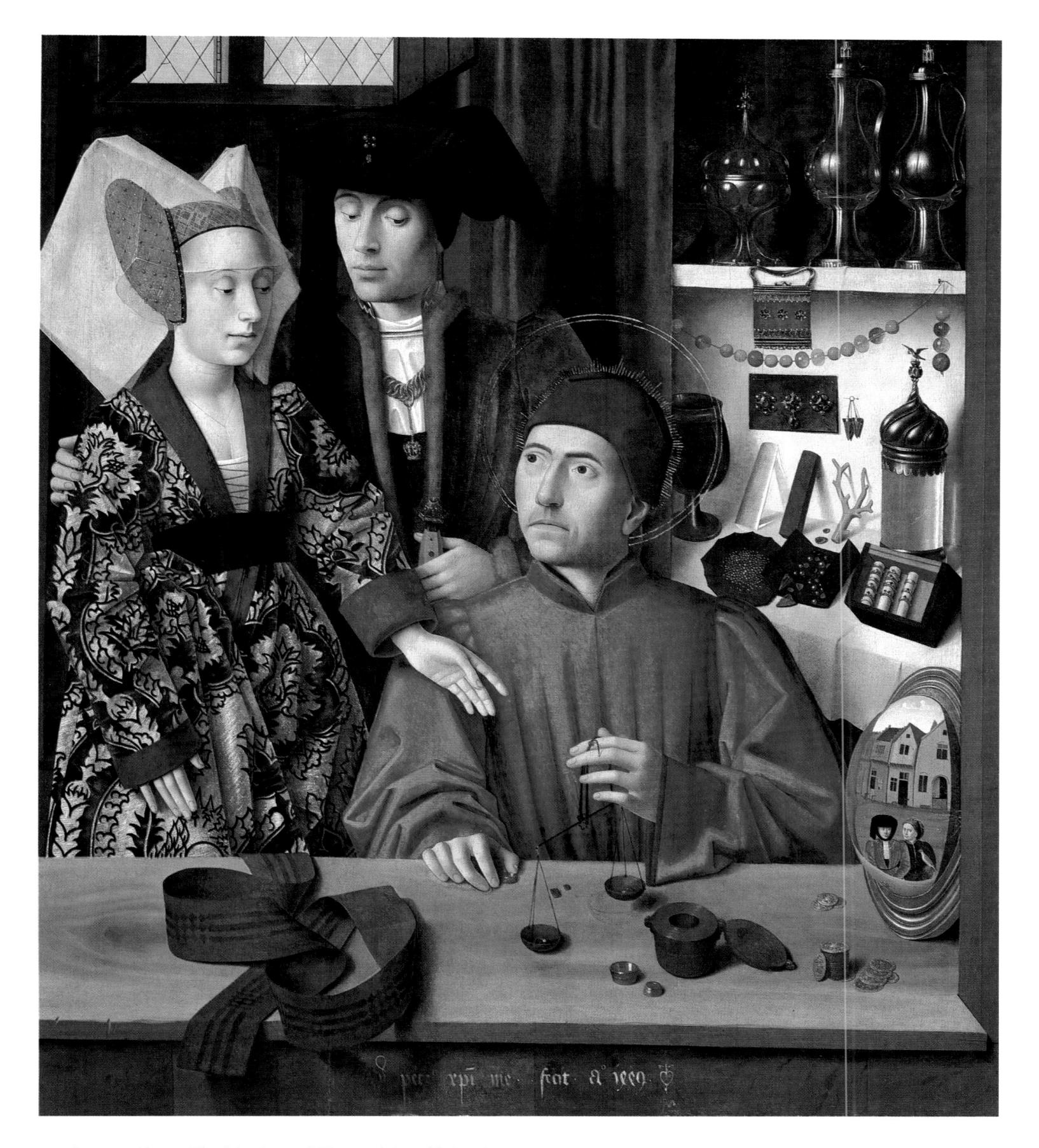

144 JAN VAN EYCK The Marriage of Giovanni Arnolfini and Giovanna Cenami 1434

(Left) Arnolfini was a merchant from Lucca who settled in Bruges. He and his wife here appear in a public bedroom to solemnize their marriage vows before two witnesses, one of whom is Van Eyck. The dog symbolizes marital fidelity, and the single burning candle which sometimes represents the all-seeing Christ was used when an oath was taken and also as the marriage candle of newly-weds. St Margaret is the patron saint of childbirth, while the crystal beads and the 'spotless mirror' are symbols of Marian purity. The fruit refers to man's innocence before the Fall. The painting thus symbolizes the state of marriage, referring through symbols to an ideal.

St Eligius is the patron saint of gold and silversmiths. Here he is shown in his workshop weighing a wedding ring for the young couple and surrounded by precious metals, crystal and coral. Christus succeeded Jan van Eyck as Bruges' leading painter, and he adopts Van Eyck's use of light on precious objects and textures: the convex mirror may even be a quotation from the Arnolfini Marriage. Much of the picture's charm derives from its awkward placing of the figures, in direct contrast to Van Eyck's sophisticated poses.

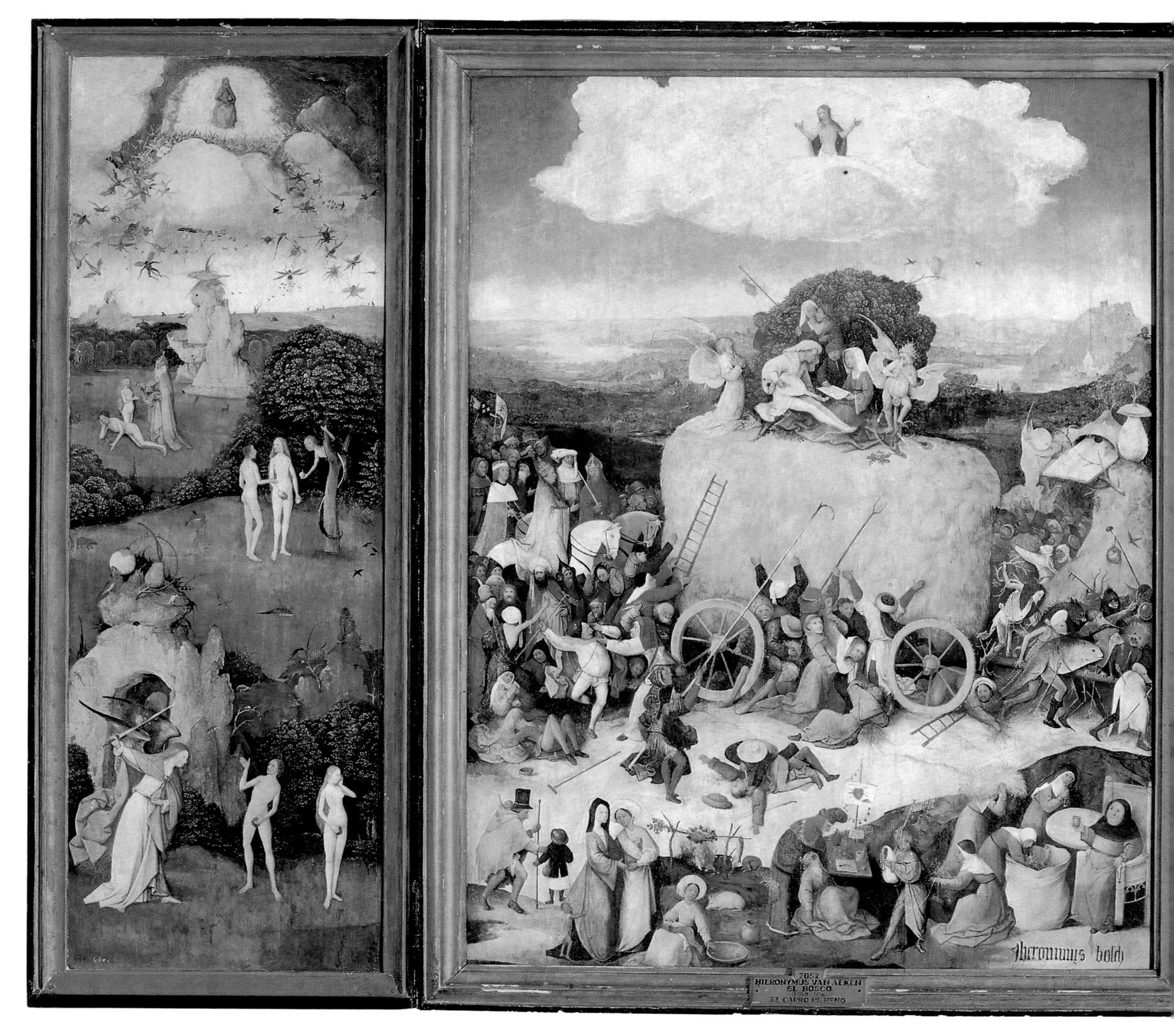

146 HIERONYMUS BOSCH Haywain 1495–1500

There seems to be greater agreement as to the possible meaning of this picture than many others by Bosch. It probably represents worldly vanity with overtones of the uselessness of human aspirations and greed for worthless values. It may illustrate a Flemish proverb about the haywain with the rabble snatching the hay, but it is also a moral lesson on the eternal curse of original sin, with Luxuria present as the principal sin. In the left panel there is a deliberate parallel drawn between the Fall of Adam and Eve and the Fall of the Rebel Angels.

147 HIERONYMUS BOSCH Death and the Miser c.1485–90

The shape of this panel indicates that it was a wing, possibly of a Seven Deadly Sins triptych. The dying man hesitates between the choice of a crucifix and the moneybag, but the certainty of death is indicated by his fixed gaze on Death's figure entering the room. It is probable that the picture illustrates medieval texts such as 'When the evil miser lies in his deathbed, he does not wish to be separated from his dishonest possessions. This is a true sign that he loves those possessions more than God, and more than his own soul.'

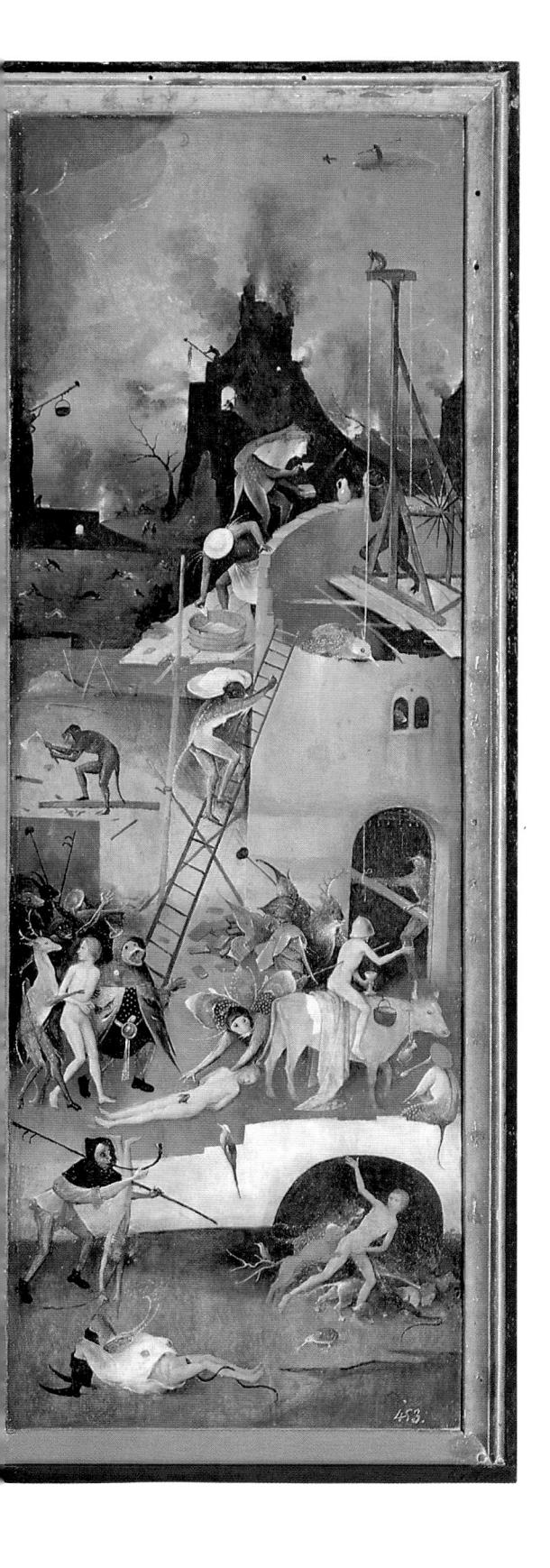

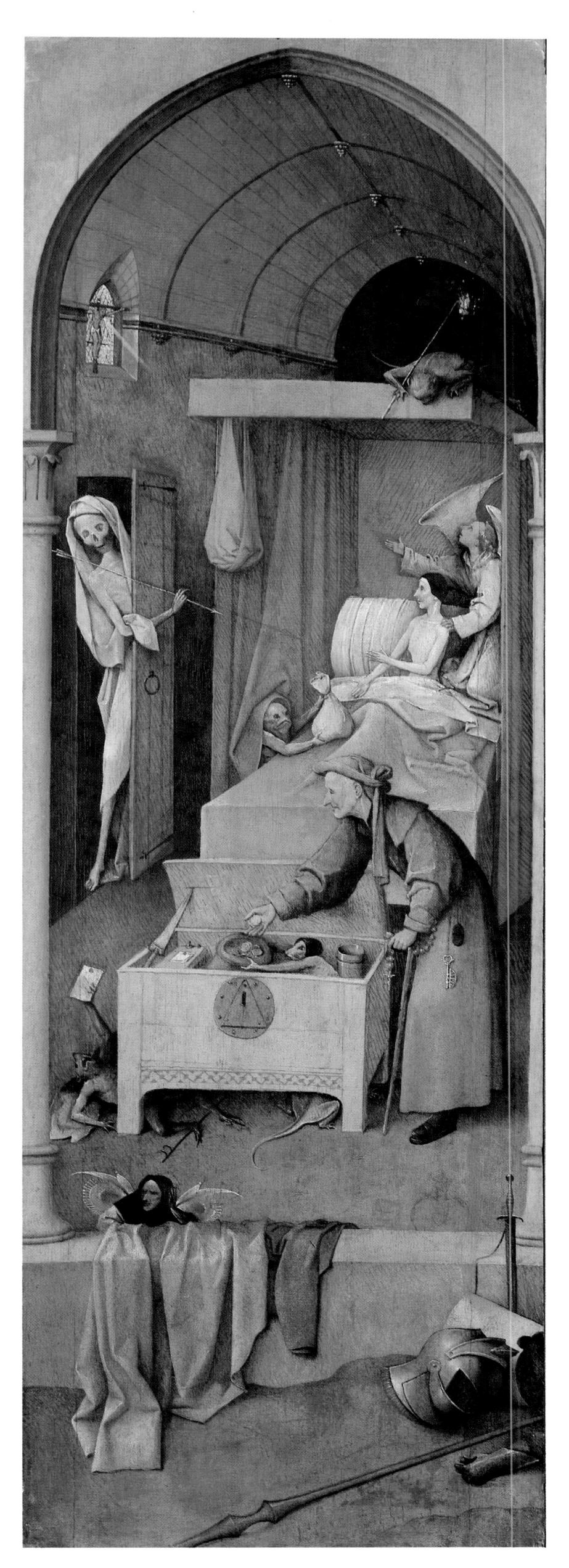

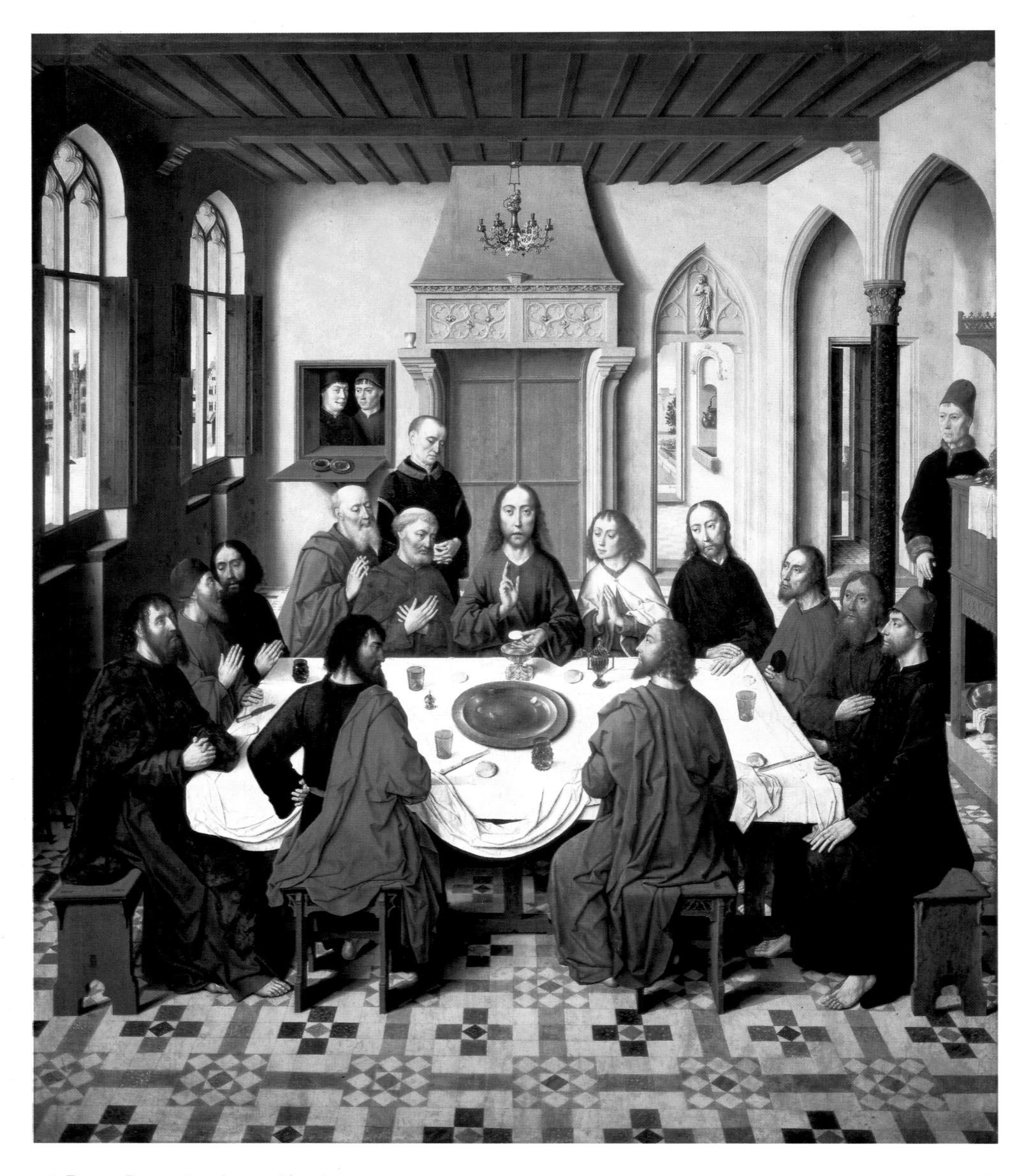

148 DIERIC BOUTS Last Supper Altarpiece 1464–7
The wings include four prefigurations of the main theme (The Institution of the Eucharist): Abraham's Meeting with Melchizedeck, The Sacrifice of the Pascal Lamb, The Gathering of Manna and Elijah and the Angel. The theme was prepared for the painter by two theology professors at Louvain University, and most of the participants appear to be portraits of known contemporaries. Following an established medieval tradition, the figure of Christ is disproportionately large.

(Right) This important painting has been extensively repainted, and the precise contributions of Jan and Hubert Van Eyck and their studio are still debated. A figure in a papal tiara (God the Father, Christ and the Holy Ghost) is the focus of the upper register, flanked by the Virgin and St John the Evangelist, musical angels and Adam and Eve. The outer right panels show holy hermits led by Sts Paul, Anthony Abbot, Mary Magdalene and Mary of Egypt, while the outermost panel shows St Christopher leading the pilgrims. On the left are the knights of Christ with Sts Martin, George and Sebastian, and the outermost panel shows the 'just judges'.

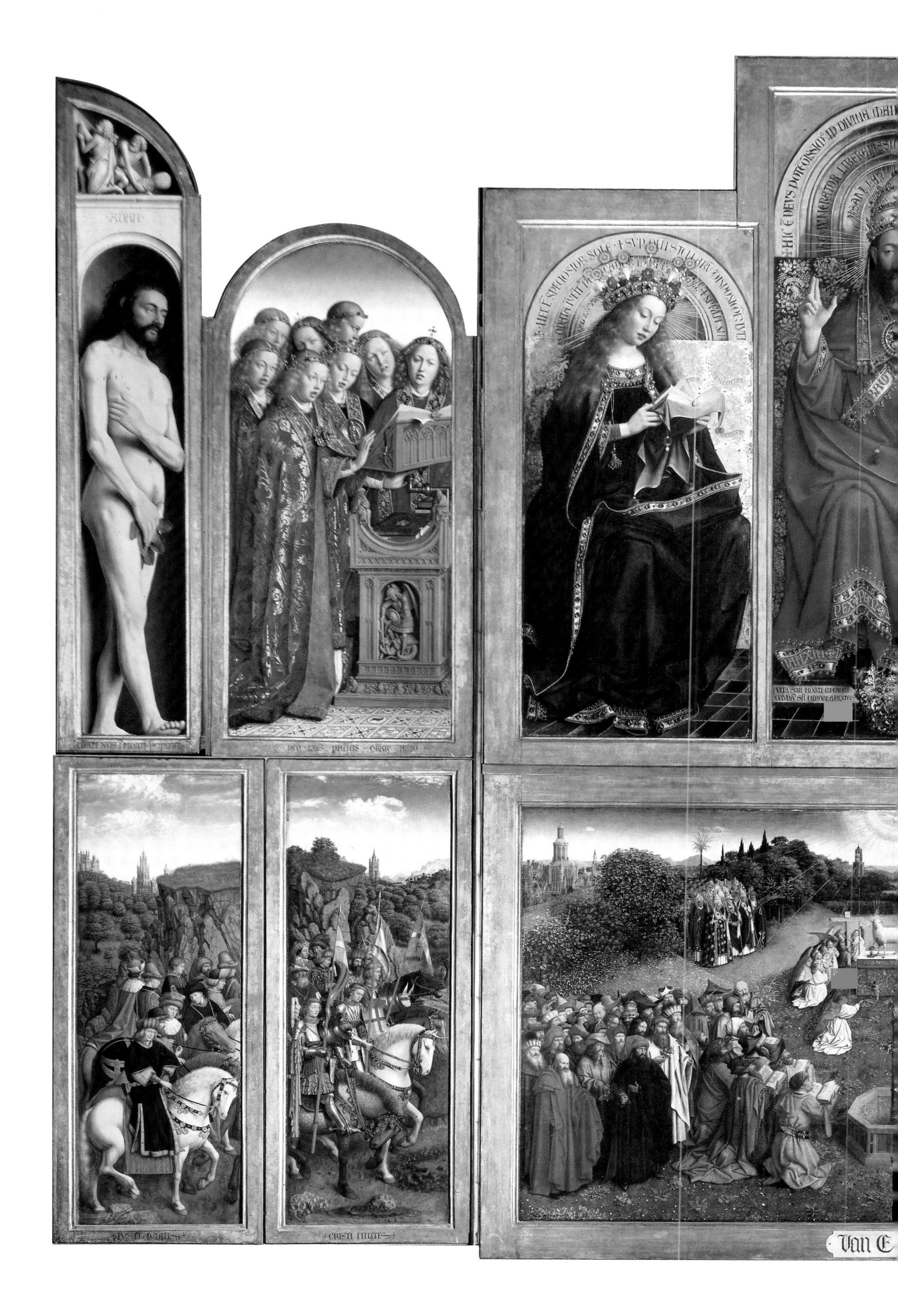

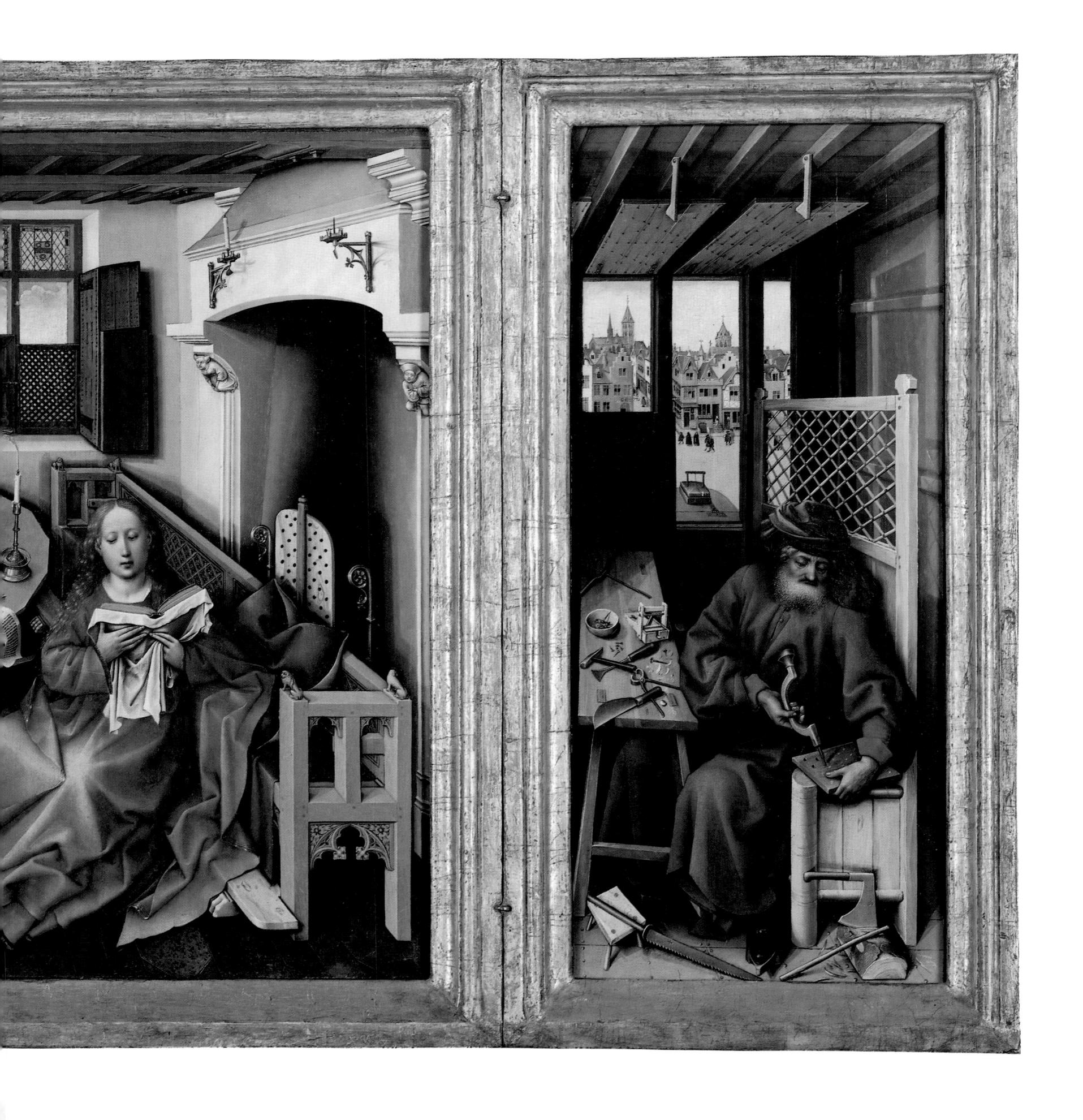

152 GERARD DAVID Annunciation, undated

(Right) By simplifying the event, and by using a surprising amount of black and other sombre colours in contrast with the bright robes of the angel, David creates here one of the most satisfying renderings of the theme found in this period. The marked lack of brilliant colour which he often favoured suggests that the limited colour may have formed a condition of the commission.

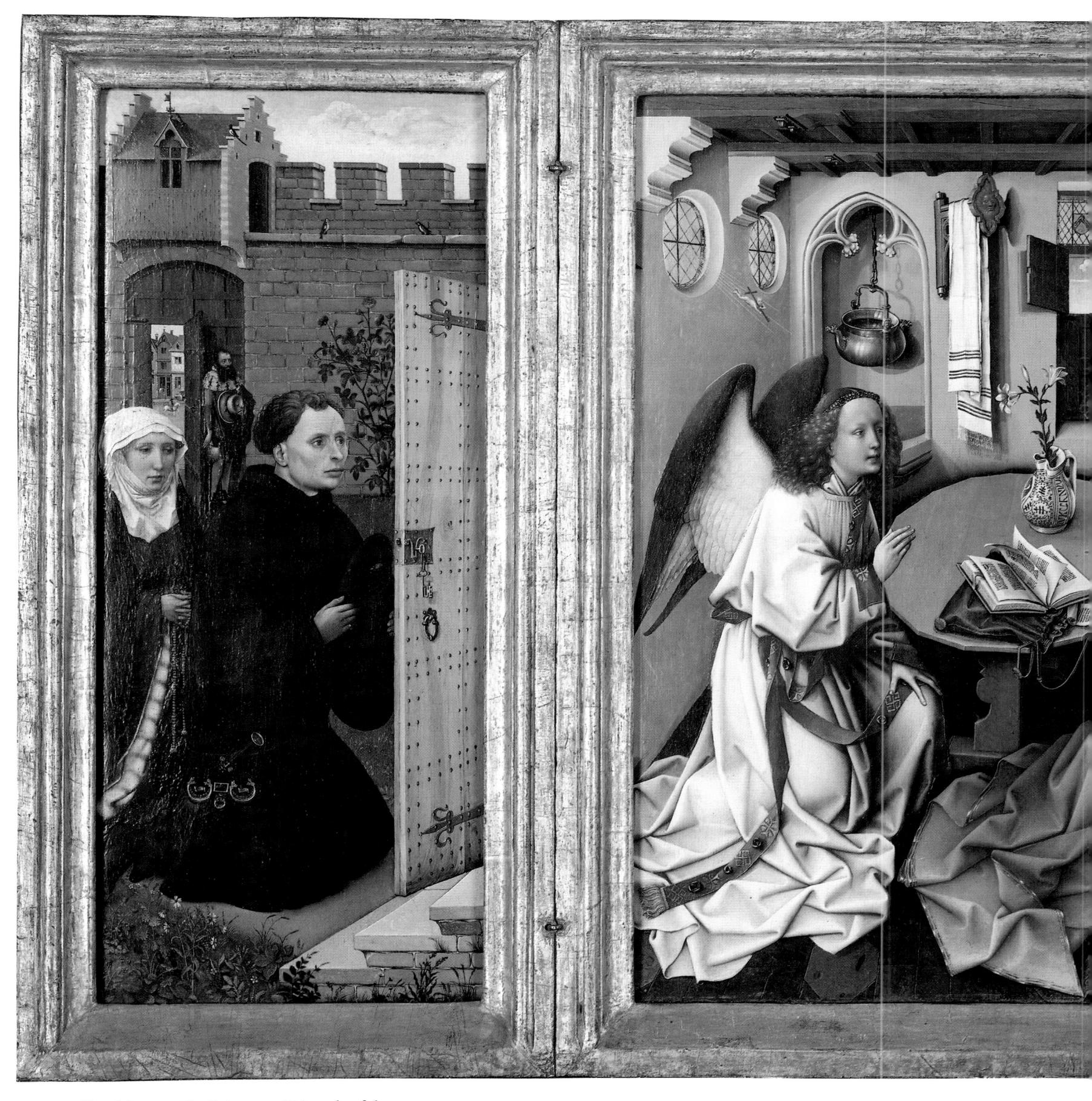

150 THE MASTER OF FLÉMALLE Triptych of the Annunciation c.1426

This altarpiece centres around the Annunciation, and has many Marian symbols such as the candle, jug and lilies. The donors of the Ingelbrechts (and possibly Calcum) families watch the main event through a door linking the central and side parts, and the evocative backgrounds of both wings look forward to the realistic interiors of seventeenth-century Holland. On the right, St Joseph is seen at work on his carpentry. Among his productions, the mousetrap refers to St Augustine's claim that the Incarnation was God's trap for the Devil. The picture is symbolically divided into three, but there is no real continuous spatial link between the scenes.

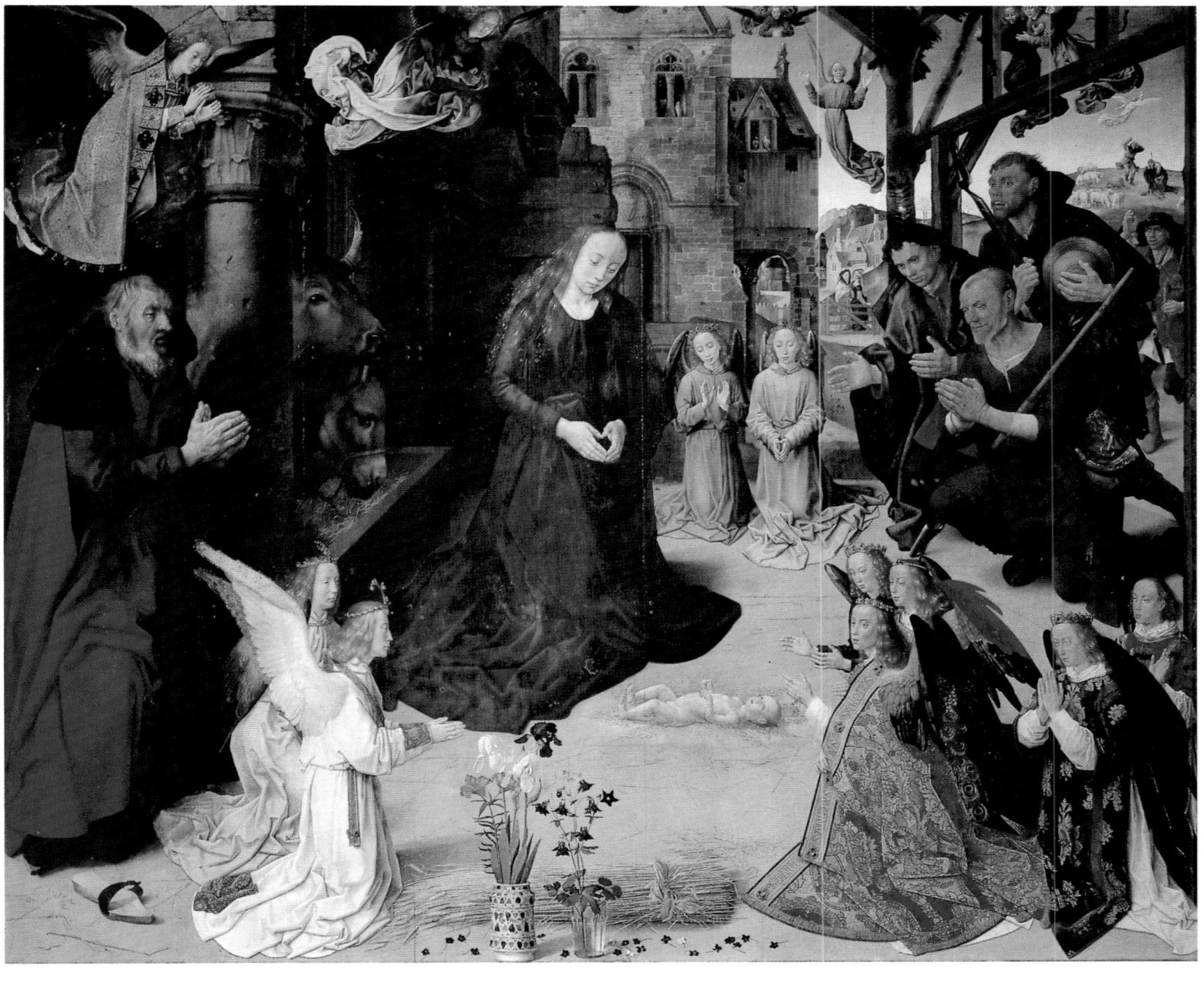

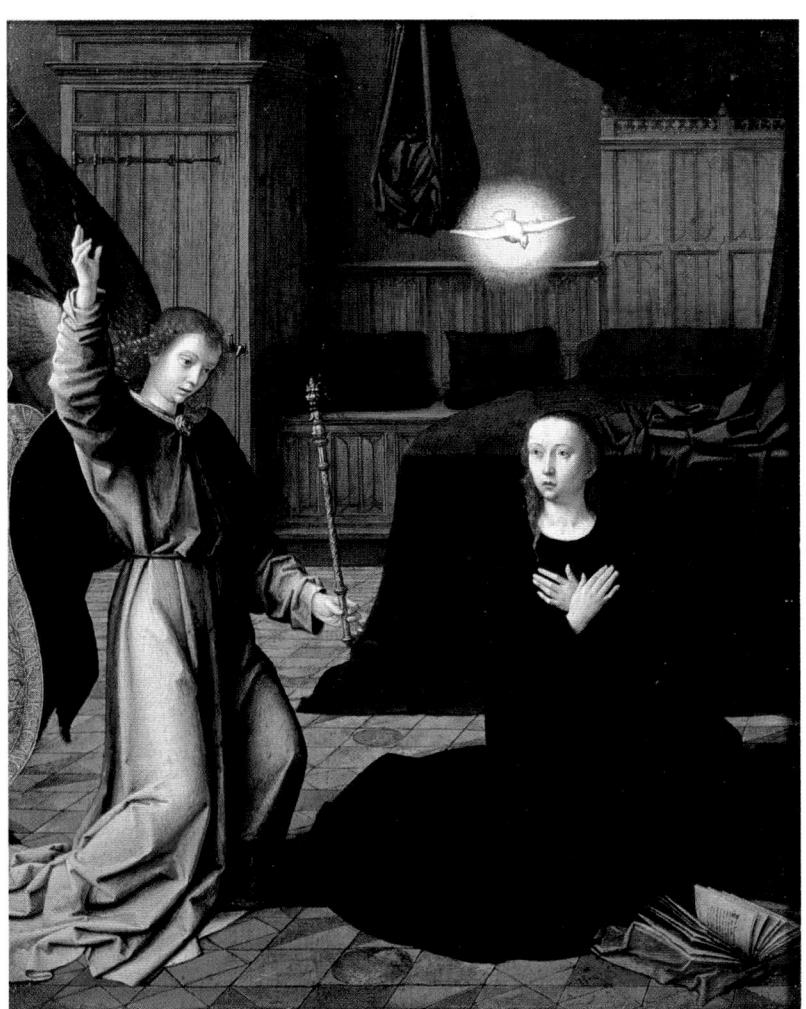

151 HUGO VAN DER GOES The Portinari Altarpiece 1474-6 (Above) This immense triptych was painted in Bruges for the Medici representative there, Tommaso Portinari, who appears in the wings with his family. On the left is Tommaso with his sons Antonio and Pigello, with Sts Anthony and Thomas, and on the right is his wife Maria Bonciani and their daughter Margherita with Sts Margaret and Mary Magdalene. In this central panel are both the Nativity and the Adoration of the Shepherds. The altarpiece was sent from Bruges to Italy, and installed on the altar of Sant' Egidio, under Portinari patronage, on 28 May 1483. In 1567 the altarpiece was dismembered, and following the destruction at the same time of frescoes by Domenico Veneziano and Andrea del Castagno, its panels were for a time thought to be by these two Italian painters. Its variations in scale and the high viewpoint were unusual, and the striking portraits not only of the Portinari but also of the shepherds profoundly appealed to Florentine painters.

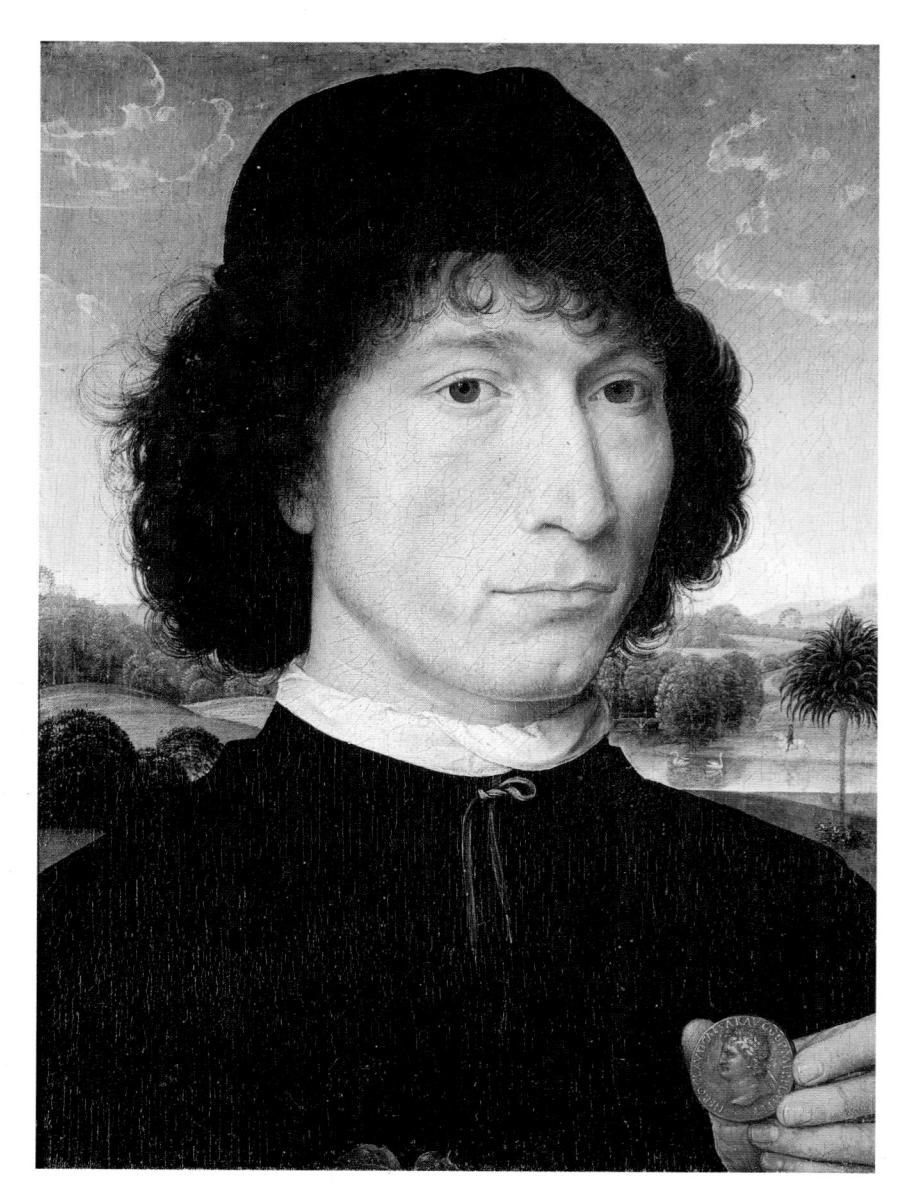

153 Hans Memlinc Portrait of a Man with a Medal c.1475-80

(Above) Memlinc appears to have been a prolific portraitist, and many of his portraits survive. It has been suggested that the sitter was one of the Italian medallists active in the Netherlands, Niccolò Spinelli or Giovanni di Candida, or he may be one of the many Italian merchants in Bruges who was also a collector. The medal shows the Emperor Nero, and the portrait evokes Italian prototypes.

154 HANS MEMLINC Bathsheba 1484

(Below) One of the finest examples of Memlinc's mature style, this may have been a diptych; a fragment in Chicago shows the figure of King David watching. This treatment of the nude is something of a rarity in Flemish art, and it may reflect a lost composition by Jan van Eyck. Devoid of erotic content, it concentrates on the moral aspects of the theme. As much attention is paid to the magnificent background architecture and still life details as to the main figure.

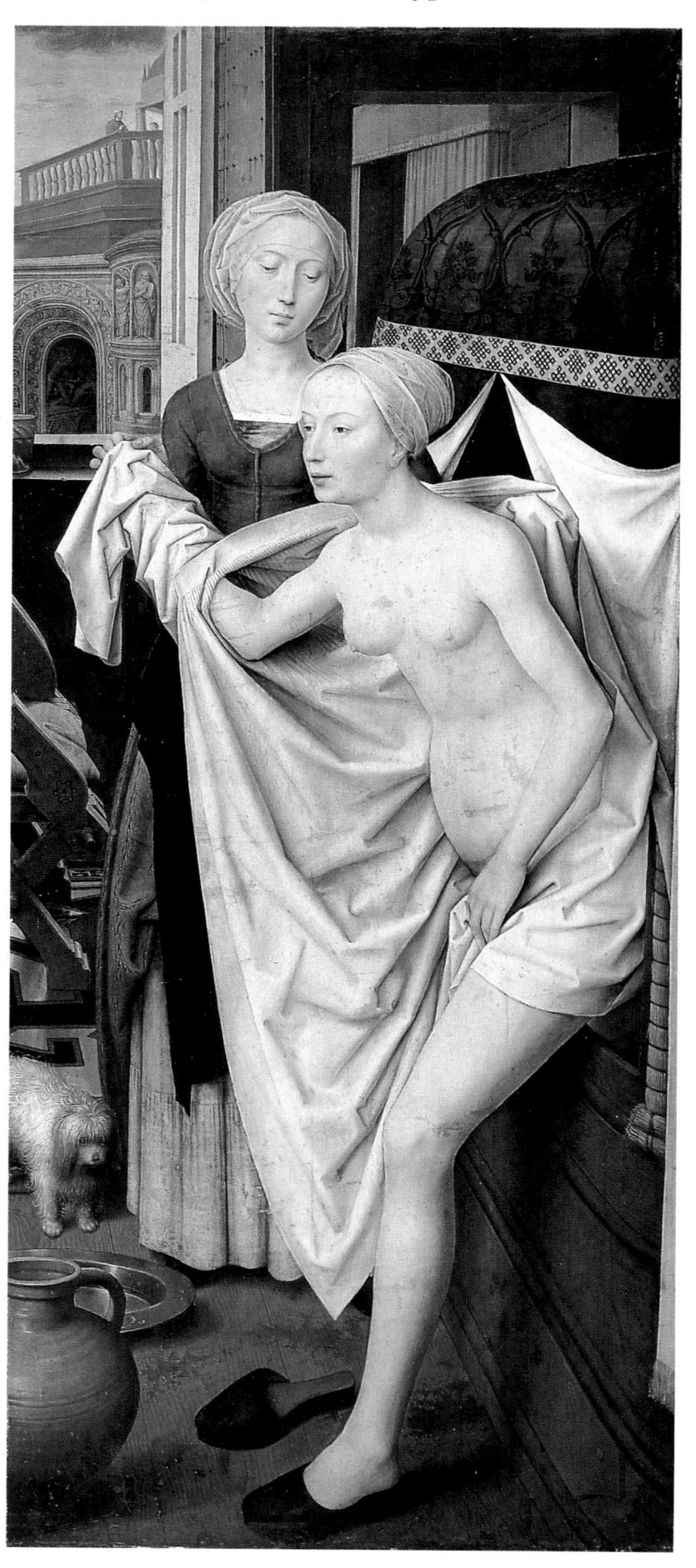

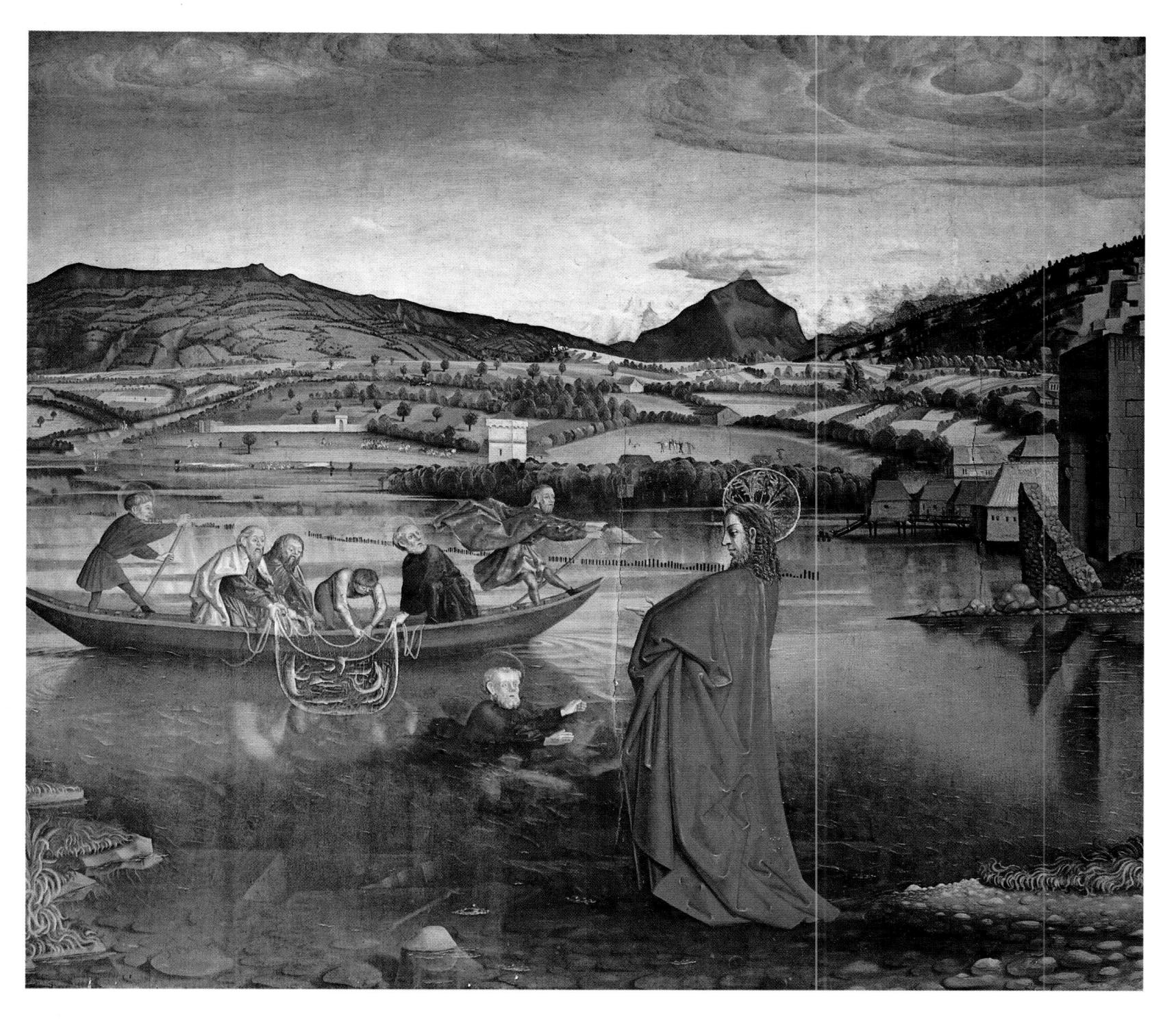

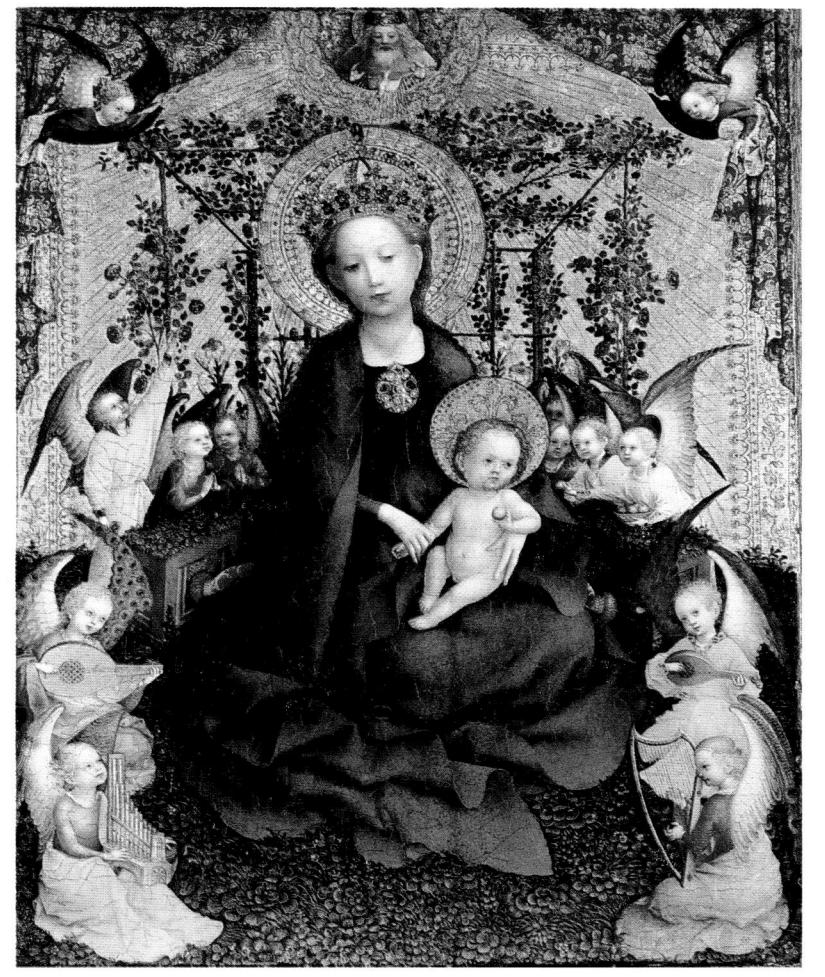

155 KONRAD WITZ Miraculous Draft of Fishes 1444 (Above) This forms part of Witz's last known painting, commissioned by Bishop François de Mies for the Chapel of Notre Dame des Maccabees in the Cathedral of Saint-Pierre in Geneva. It forms the rear of the left wing of the altar, whose central panel is lost; on its reverse is the Adoration of the Magi. The effects of light, both reflected and refracted, and the appearance of underwater phenomena make this one of the first real observations of water in European painting, and lends the figures a remarkable spatial realism.

156 STEPHAN LOCHNER Madonna of the Rose Bower

(Left) One of the most appealing paintings of the Cologne School, this picture relies on its contrasts of glowing, brilliantly coloured detail rendered with almost sculptural precision, and its flat gold background, accentuating the preciousness of the image. Its delicacy is still reminiscent of International Gothic, but it is coupled with more naturalistic expression.

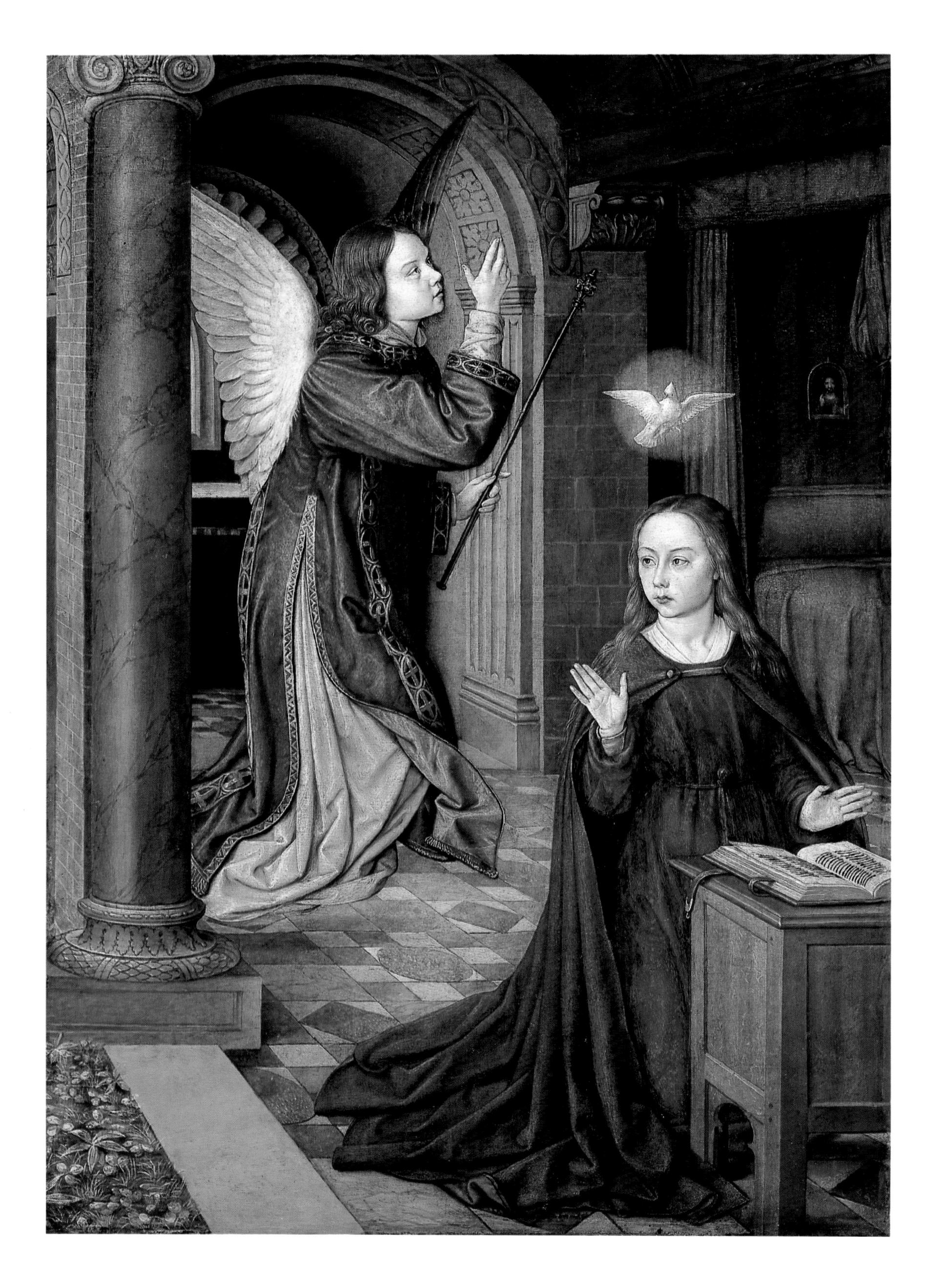

CHAPTER VI

The Renaissance Elsewhere in Europe

The degree to which Italian and Northern Renaissance principles were accepted or even known in other countries depended on a variety of conditions. France's proximity to Italy did not hasten her adoption of the Renaissance, which only reached maturity there in the sixteenth century. However, the presence of Masolino in Hungary for some time before 1422, and of other Florentine painters there during the 1420s – thanks to the encouragement of the Florentine condottiere Pippo Spano – shows a remarkable receptivity to new ideas in that country. And by about 1360, Tommaso da Modena had painted two Madonnas for Charles IV in Prague. Throughout the Renaissance works of art made the finest ambassadors, changing not only political destinies but also the course of local art.

Spain's close connections with Italy and Flanders resulted in somewhat confusing reactions to their different impetuses, while in England the Reformation scotched any real developments from the latest Italian ideas. Styles and fashions in painting also depended on political and religious movements, the presence of a court, and the strength of previous prevailing artistic movements, particularly the International Gothic style. The clear motivations and progression of the Italian Quattrocento provide the yardstick by which the spread of humanist and artistic ideas must be gauged.

157 THE MASTER OF MOULINS Annunciation c.1510
Probably originally part of a diptych, the interior in this painting is particularly satisfying, and shows an awareness of Italian architectural ideas in the Ionic column and coffered arch with a fluted pilaster.

Light effects are also notably subtle, and notwithstanding the overlarge angel, perspective is well handled in relation to the Virgin and the contents of the room. The Virgin's portrait-like appearance links the picture with others by the Master, notably the late Saint Maurice with a Donor and A Princess (see plate 175).

France

French art and architecture had reached a pitch of unrivalled perfection during the Middle Ages, and the transition to the Renaissance was slow and difficult in France. Even as late as the early sixteenth century, the French preferred the complex architectural decoration of Lombardy to Tuscan examples, possibly because of its resemblance to the most elaborate patterning of Flamboyant Gothic.

The immense production of illuminated manuscripts in France was one of the principal manifestations of International Gothic, with its overtones of courtly magnificence. Two of the greatest early manuscript illuminators were Master Honoré (probably died before 1318) and Jean (or Jehan) Pucelle (c.1300–c.1355). Appropriately named, the style flourished in most of Europe c.1375–1425. The artists it attracted travelled throughout western Europe, and it spread to Italy, Flanders, Brabant, the Rhineland, northern Germany and Spain.

The Wilton Diptych (see plate 186) is one of the most perfect but most problematic works of International Gothic. It was probably painted in Paris by an artist with a remarkable knowledge of international developments, not only in France, but in Italy and even Hungary. Although painted in the first years of the fifteenth century, it sums up all the characteristics of the preceding period in the most sumptuous manner, and shows the background against which Renaissance ideas were to filter into French art from Italy.

The Avignon papacy (1309–77) – during which all the popes and most of the cardinals were French – imported Italian painters, such as Simone Martini (who lived there from about 1335 until his death in 1344), to its rich court. A key figure in stimulating interest in the ancient Classical world, the Italian poet Petrarch (1304–74), lived for

158 LIMBOURG BROTHERS Month of February from the Très Riches Heures du Duc de Berry, begun c.1413

The Netherlandish illuminators Herman, Jean and Paul were among the most gifted of their age. When they died these Heures were completed by Jean Colombe. The atmosphere of deepest winter is captured in the details, such as the people by the fire.

fourteen years at Fontaine de Vaucluze, near Avignon, and owned work by Simone.

Avignon then belonged to the Angevin princes of Naples. Petrarch's contacts with the Papal court were very important in the growth of Humanism outside Italy, as visitors came from all over Europe. From Avignon the latest Sienese ideas travelled into France, the Netherlands, Austria and Bohemia. In addition to frescoes, panel paintings were produced by the Italianate painters at Avignon, and while their style remained Gothic, the contacts with Italy were of great importance.

The Valois dynasty ruled from 1328 until 1498, and included Charles V (1364-80) and his brothers, the dukes of Anjou, Berry, Burgundy and Orléans. Along with members of the court, they were important artistic patrons and particularly favoured luxurious and costly illuminated manuscripts. Of these brothers John, Duke of Berry, was the most important collector (see plate 158). This period firmly established the rich tradition of French royal patronage of painting which endured until the Revolution. Paris became the centre of the International Gothic style during the first quarter of the fifteenth century. The earliest independent easel paintings by Parisian artists were produced during the reign of Charles VI (1386-1422). These could not have been more at variance with contemporary developments in Florence, which appear to have had no impact whatever on French art.

The 'Second School of Avignon' produced the master-piece which signals the real end of medieval principles in French art: the *Pietà of Villeneuve-les-Avignons* (see plate 185) now attributed to Enguerrand Quarton or Charonton (c.1410–66). Under the Papal Legates, Cardinal della Rovere and Cardinal de Foix, patronage flourished in Provence. It emerges that a peculiarly intense religiosity prevailed among the painters of this school, seen in the anonymous, harrowing *Christ in the Tomb*, also known as the Boulbon altarpiece (Musée du Louvre, Paris).

Jean Fouquet

Although the seeds were sewn during the fourteenth century, and Italian ideas continued to filter into France, the Renaissance did not come to fruition there until the sixteenth century. Unlike Italy and the Netherlands, fifteenth-century France produced remarkably little talent in painting. The major exceptions were Jean Fouquet (c.1420-c.1481), who worked as a painter of easel pictures and miniatures, and the mysterious Master of Moulins.

Born in Tours, Fouquet, of whom we know little, appears to have had a more international vision than any of his contemporaries. Between 1443 and 1447 he was in Rome, where his prestige secured him a commission to paint Pope Eugenius IV's portrait, which is no longer traceable. It is tempting to think that he passed through Florence, since one of the principal effects of his Italian journey is a combined interest in Classical architecture and perspective. There are also indications that he knew the work of Florentine painters, including Fra Angelico.

The main surviving legacy of his journey is his remarkable portrait of *The Court Jester Gonella* (see plate 176) and

the extensive Italianate detail in his *Hours of Etienne Chevalier* (Musée Condé, Chantilly) painted between 1450 and 1460 for one of his most important French patrons. Fouquet may first have trained with miniature painters in Paris, such as the Boucicaut and Bedford Masters, and he perpetuated the miniature tradition through his influence on Jean Bourdichon and Jean Colombe.

His experience in Rome may have been instrumental in securing him court patronage on his return to Tours, although he was not made Painter to King Louis XI until 1475. Fouquet's memorable likeness of *Charles VII* (Musée du Louvre, Paris) typifies his combination of Northern and Italian styles, with his own sense of the monumental. This even informs his later work, exemplified by the superb illustrations to the *Antiquités Judaïques* manuscript (see plate 159), and his *Descent from the Cross* (Parish Church, Nouans). Throughout his career, Fouquet exhibited a gravity which gives his paintings a unique dignity, and imbues his incisive portraits with a

159 Jean Fouquet Fall of Jericho from the Antiquités Judaïques 1470–6

Dating from the later years of Fouquet's career, these miniatures illustrate a Josephus manuscript. Even on this scale, Fouquet achieves an astonishing monumentality comparable with the latest Italian achievements, and shows an ability to organise many-figure compositions that distinguishes him from his Northern contemporaries.

strong sense of introspection and remoteness unparalleled in Europe at this time.

Nicolas Froment (active c.1450–c.1490) from Uzès in Languedoc was instrumental together with Quarton (see plate 185) in introducing Flemish ideas of naturalism into French painting of the time. His masterpiece is the *Altarpiece of the Burning Bush* of 1476 (Cathedral of Saint-Saveur, Aix-en-Provence).

The Master of Moulins

All that is securely known of this anonymous, elusive but gifted painter is that, in about 1498, he painted a triptych showing the *Virgin and Child in Glory with Donors* in Moulins Cathedral. Its central panel is of an exquisite delicacy which has been compared to Ingres, with remarkable effects of light, and on the basis of its clear style a body of other works has been established. Since its commission came from the Bourbons (the donors are Pierre, Duc de Bourbon, his wife, Anne de Beaujeu, daughter of Louis XI, and their daughter Suzanne) it is clear that the Master of Moulins was favoured by an important circle of aristocratic patrons (see plate 175). It has also been suggested that he was another artist of the Bourbon court, Jean Hay from Brussels.

It is now believed that the Master was probably active from about 1480 to about 1520, not 1500 as has been previously thought. The earliest works attributed to him, such as Cardinal Charles II of Bourbon (Alte Pinakothek, Munich) and a Nativity of about 1480 (Musée Rolin, Autun) show Flemish influence, particularly that of Hugo van der Goes' Portinari Altarpiece (see plate 151). This seems to have been replaced by Fouquet's manner, and supposed later works show an elegant restraint still informed by his feeling for texture and light (see plate 157). Particularly reminiscent of Fouquet's grand conception of form is the Master's latest presumed work, the magnificent Saint Maurice with a Donor (Art Gallery and Museum, Glasgow) possibly dated about 1516. The handling of paint is, however, quite different from Fouquet's, as is the dynamic relationship between the two figures.

The Sixteenth Century

The Renaissance developed with astonishing suddenness in France during the first part of the sixteenth century. At this time, many vestiges of the Middle Ages were discarded and French politics and culture developed significantly towards the modern world. However, the importance of miniature painting appears to have been perpetuated. The two principal active painters of this period seem to have been Jean Perréal (died 1530) and Jean Bourdichon (c.1457–1521), but little is known of their careers.

Bourdichon was Fouquet's leading pupil, serving both Charles VIII and Louis XII at Tours. He certainly produced larger paintings, and may have visited Italy, but his principal known works are the miniatures in the *Hours of Anne of Brittany*, completed in 1508 (Bibliothèque Nationale, Paris). These show the influence of Italian decorative designs and an acquaintance with Italian painters, including Perugino. Such borrowings include little personal innovation, however.

Perréal appears to have been better known (Leonardo even mentions him) yet no paintings are securely attributed to him. Working as a sculptor, painter and court designer, he certainly made three Italian journeys, once in the company of Charles VIII and again with Louis XII. The portrait of *Louis XII* of about 1514 attributed to Perréal (Royal Collection, Windsor), shows why certain critics attempted to identify him with the Master of Moulins. It was against this background, where even important painters failed to make their mark on history as their Italian peers did, that the innovations of the reign of Francis I should be seen. At the same time, the status of the artist in French culture rose, and became an intrinsic part of court activity, as was the situation in Italy.

Francis I and the First School of Fontainebleau

Under Louis XII (1462-1515) taste had been led by a minister, Cardinal Amboise, but already Italian art was regarded as the measure for real developments. From the start of his reign in 1515, Francis I (1494-1547) made it clear that he intended to create a court to rival those of Italy. However, he was perhaps more attracted by the superficial glitter of Italian court life than by its underlying Humanism. To this end, he surrounded himself with men of learning and artists. He failed to bring Michelangelo to France, but obtained the services of Leonardo (1516-19) and Andrea del Sarto (1518-19), during which time the latter painted his magnificent Charity (Musée du Louvre, Paris), and Benvenuto Cellini (1540-45). The new style in French art inspired by the King was the work of a colony of imported Italian artists, but it soon evolved into a specifically French manner.

Francis' new building works at Blois and Chambord exemplified the grand scale of his ambitions, and his rebuilding and redecoration of the palace of

Fontainebleau after 1528 led Vasari to praise it as a 'new Rome'. The aristocracy and newly rich were also patrons of the arts, although cultural life was centred more in the châteaux of the Loire than in Paris at this time, initially because of the good hunting there.

Francis himself had visited Milan, Pavia and Bologna, and probably had a clear idea of what he wanted for his favourite residence, Fontainebleau. He was fortunate in attracting two of the leading Italian painters of the day, Rosso Fiorentino (see Chapter VIII) and Francesco Primaticcio (1504/5–70), who arrived in France in 1530 and 1532 respectively, together with their Italian assistants. The third member of the group, Niccolò dell'Abate (c.1512–71), arrived in about 1552, and it is revealing that Primaticcio admitted that his sole reason for inviting him was that 'in Paris . . . there was no one capable'.

Primaticcio came from Bologna and his painting, used in conjunction with elaborate plasterwork, proved of immense importance. He had been Giulio Romano's assistant in the complex decorations of the Palazzo del Tè in Mantua, and through Giulio knew Raphael's style. Vasari credited Primaticcio with introducing stucco decoration into France, and he travelled to Rome twice to buy antiquities and casts for the King. On Rosso's death in 1540, he assumed an unchallenged position of power. French assistants absorbed the new Italianate style, but few of their names are known and little of their work can be identified.

160 Francesco Primaticcio Ulysses shooting through the Rings c.1555–9

This is a highly finished preliminary study for the thirty-ninth of Primaticcio's fifty-eight fresco decorations in the Galerie d'Ulysse of the Palace of Fontainebleau. In the Iliad, Penelope had agreed to wed the suitor capable of bending Ulysses's great bow to shoot through twelve rings.

Rosso's cultivated tastes led Francis to appoint him his First Painter and canon of the Sainte-Chapelle, granting him many special privileges by letters patent. Mysteriously, little survives of Rosso's extensive French work, which included easel pictures, masquerade designs, goldsmiths' models and miniatures. Of his Fontainebleau decorations in the Pavillon de Pomone (with Primaticcio), the Pavillon des Poêles and the Galerie Basse almost nothing remains, and his major French pictures, including the Saint Michael and Leda, have vanished, leaving only his great Ecouen Pietà, now in the Musée du Louvre, Paris. The Pietà's dramatic and highly stylized pathos must have run somewhat contrary to French tastes, which tended to a more decorative manner. The most impressive interior in the palace initiated by Rosso was the Galerie François I (see plate 161). After his death in 1540, Charles Dorigny, Luca Penni and Antoine Caron carried the Rosso manner to Paris.

Primaticcio's more refined, less demanding style is best seen in the superb Chamber of the Duchesse d'Etampes and the somewhat unwieldy ballroom (1554). Sadly, Primaticcio's Galerie d'Ulysse (after 1556) was dismantled in the eighteenth century (see plate 160). Beneath the Galerie François I was the Appartement des Bains, with its decorations of a 'delicious indecency' summing up so much of the tone of the handsome King's court and private life. It is significant that a copy of Michelangelo's notorious Leda also hung there, and this picture, with Bronzino's Allegory of Venus (see plate 228), exercised considerable influence on the French approach to the nude. Francis's collection of contemporary Italian works was unequalled outside Italy, and included Leonardo's Virgin of the Rocks among other paintings by him, Raphael's La Belle Jardinière, a Titian Magdalen and the Bronzino Allegory. Cellini's superb sculpted Porte Dorée was among the palace's principal ornaments.

In spite of Primaticcio's apparent reservations, Niccolò dell'Abbate was already a highly talented and esteemed painter and frescoist in Italy. Vasari describes his synthesis of drawing and colour as *unione*, a term the critic also applied to Giorgione's 'fused' manner. Niccolò had had direct contact with two Italian artists of immense stature, Correggio and Parmigianino, and the latter's *Conversion of Saint Paul* (see plate 265) has sometimes been attributed to Niccolò. He thus introduced another phase of Italian Mannerist ideas to the court of Henry II (1519–59) who reigned from 1547, and whose marriage to Catherine de' Medici in 1533 increased the influx of Italian artistic ideas. Niccolò also received many commissions in Paris, Ecouen and elsewhere. He is one of the few Fontainebleau painters whose works survive in any quantity. His princi-

161 Rosso Fiorentino Venus c. 1534-40

The twelve frescoes in the Galerie François I are dedicated to Francis I and are set amid a wealth of richly ornamented stuccoes which relate to the fresco themes. Scibec de Carpi executed the elaborate carved wooden panelling below. The cuir or strapwork cartouche motif derived from leatherwork is often repeated in the decorative surrounds, and exercised international influence through adaptations in decorative engravings. The fresco subjects are taken from classical literature and mythology, but their precise iconography is unclear, some making general references, others precise ones to the King.

pal contribution to French painting lay in his exquisite landscapes, in which he specialized after 1556 (see plate 178). Despite their Mannerist artificiality, these introduced the taste for romantic, far-reaching views which culminated in the work of Claude Lorraine in the following century.

Because of the anonymity of many painters at Fontainebleau, a large number of works from there are regularly described as 'School of Fontainebleau' (see plate 189). This in no way denigrates their quality, and indeed many may be included among the finest artistic productions of the period.

Cousin and the Clouets

Fontainebleau did not exclusively dominate French painting at this time, although its influence was irresistible because of its prestige. Jean Cousin the Elder (c.1490–1560/61) moved to Paris from his native Sens in 1538, where he evidently enjoyed a successful career as a painter and a designer of stained glass. In Paris, he would have seen prints of Italian art, and even original paintings which developed his style. His *Eva Prima Pandora* (see plate 179) indicates how independent Cousin was from developments at Fontainebleau, but his only documented work is his designs for three tapestries showing the *Life of Saint*

162 JEAN CLOUET Guillaume Budé c.1535 Guillaume Budé (1467–1540) was the finest scholar of Greek in Northern Europe. Erasmus called him the 'marvel of France'. Painted in tempera and oil, the finishing glazes on the face have vanished, leaving a false impression of unusually thin paintwork. But the original intensity of the likeness remains, together with an austerity very different from the richly wrought surfaces of Holbein. The inscription was added later.

Mammès for the Cathedral of Langres. Two of the tapestries still hang in the Cathedral. His son, Jean the Younger (c.1522–c.1594), had a successful career between Sens and Paris mainly as a book illustrator.

The portraiture of the mid-century is dominated by Corneille de Lyon (active 1533–74) and François Clouet (c.1510–72). Confusingly, the latter often shared the nickname 'Janet' with his father, Jean Clouet (died 1540/1), who was probably the son of a Flemish painter, another Jean Clouet (or Jan Cloet), who arrived in France around 1460. François' father was an exceptionally gifted portrait draughtsman, whose softly hatched work suggests Italian influence. Although portraits can rarely be securely attributed to him, his appointment as court painter to Francis I and examples such as *Francis I* (see plate 16), *Mme de Canaples* (National Gallery of Scotland, Edinburgh) and *Guillaume Budé* (see plate 162) seem to justify a comparison with Holbein.

François succeeded him as court painter and valet de

chambre in 1541, and introduced a more superficially Italianate feeling to some of his portraits, notably in the superb *Pierre Quthe* of 1562 (see plate 163), one of the finest but less characteristic likenesses of the French Renaissance. He remains, however, quintessentially French in the character analysis of his portraits and in the mixture of Italianate and Northern inspiration in his approach to the female nude (see plate 181). Both tendencies appear in the *Bath of Diana* (Musée des Beaux-Arts, Rouen). Clouet's portraits belong to a sort of 'International Mannerist' style, represented by Jacob Seisenegger (1504/5–67) in Austria, Bronzino in Italy and Sanchez Coello in Spain (see plate 184).

His portrait drawings (mainly in the Musée Condé at Chantilly) are firmer and more meticulous in outline than his father's, and include such august sitters as Francis II (see plate 20) and his young widow, *Mary, Queen of Scots, in*

163 François Clouet Pierre Quthe 1562 Possibly the best example of the Mannerist portrait style in midcentury France, this is also one of the finest French portraits of the Renaissance. Quthe or Cutte was a noted apothecary, as is indicated by the open book of herbs. The combination of restrained dignity in the figure and sumptuous detail in the glowing green curtain and book indicates that Clouet was probably aware of the style of Bronzino.

White Mourning (Bibliothèque Nationale, Paris). In keeping with the striking attention to character in *Pierre Quthe*, these drawings reveal much more concern for surface realism than Jean's, and are among the highest achievements in French draughtsmanship.

In France, this was the period of 'portrait albums', in which were collected groups of portraits, usually executed in chalk, for reference for paintings, or records of important contemporary figures or families. It is thanks to these albums that numerous French drawings of this type have survived.

Corneille de Lyon came to Lyons from The Hague some time before 1534, and became a French citizen in 1547. He became Painter to the Dauphin (subsequently Henry II) in 1540, and later, to King Charles IX. He had a highly successful career, and was described by a contemporary as an 'incomparable' portraitist. Although his only secure portrait is that of *Pierre Aymeric* of 1553 (Musée du Louvre, Paris), his style is recognisably individual because of his preference for a small format, into which the bust-length portrait is fitted quite tightly, and for a highly characteristic green (occasionally blue) background (see plate 164). Corneille's was a gentle talent, often probing a sitter's character with great sensitivity and sympathy.

Henry IV and the Second School of Fontainebleau

Henry IV (1553-1610) was the first Bourbon king of France, and his second marriage, to Marie de' Medici in 1600, was the second of the century with a member of that powerful family. The artistic traditions established by Francis I, Henry II and Charles IX were largely perpetuated by Henry IV, through the so-called 'Second School of Fontainebleau'. Although the painters of the 'Second School' based their style on the innovations of Rosso, Primaticcio and dell'Abate, additional influences, especially from Northern painting, led them to evolve distinctive new contributions. The more important painters were Toussaint Dubreuil (1561-1602), Ambroise Dubois (1542/3–1614) and Martin Fréminet (1567–1619), followed by Guillaume Dumée and Gabriel Honnet, but little is known of their personalities. Antoine Caron (c.1520-c.1600) typifies one strand of French Mannerist fantasy painting. He was made court painter to Catherine de' Medici after studying with Primaticcio, and he specialized in brightly coloured many-figured scenes set against elaborate architecture, often drawn directly from ancient Roman examples.

The fascination with courtly, mythological and 'gallant'

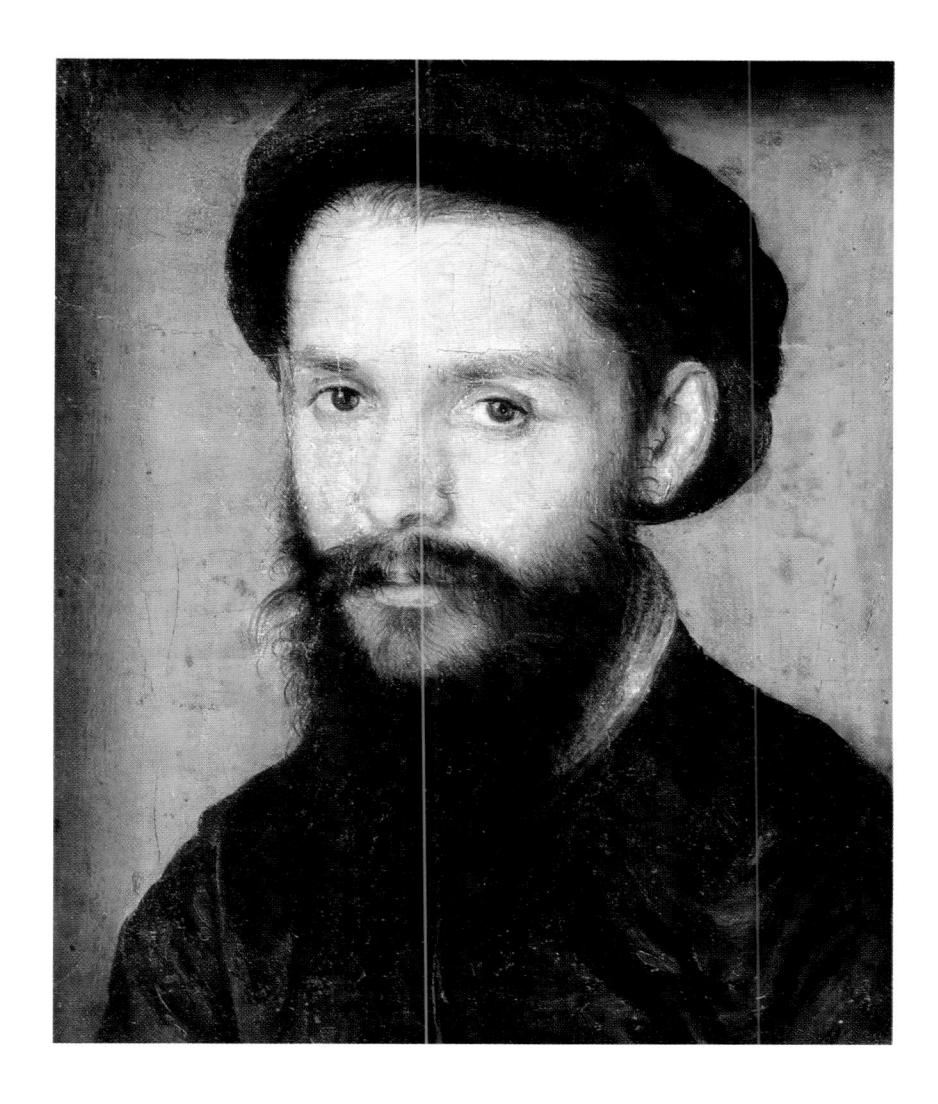

164 CORNEILLE DE LYON Clement Marot, undated This sensitively observed portrait shows Corneille de Lyon's almost miniaturistic style at its most refined. The artist has used thin paint and set a dark figure against the pale green background so favoured by many Mannerist painters. The picture shows strong affinities with the work of Netherlandish painters like Joos van Cleve, but its softness and delicacy is more typical of French portraiture at this time.

themes current among the First School painters continued with the Second School. Likewise, Henry IV perpetuated his predecessors' tradition of publicly flaunting his mistresses, including the most celebrated, Gabrielle d'Estrées (see plate 187).

The painters of Nancy, then the capital of the Duchy of Lorraine, maintained a flourishing school that lasted well beyond the sixteenth century. Mannerism found unreserved support there, although the two artists who best represent it lie somewhat outside the scope of this study. They are Jacques Callot (1592–1635) and Jacques Bellange (active 1600–17), both of whom had a genius for engraving. Callot's series, *Grandes Misères de la Guerre*, was inspired by the French invasion of Lorraine, and its brilliant detail and dramatic use of light and shade give it a unique place in the history of the art. Bellange's figures are among the most sophisticated, exaggerated and elegant of late Mannerism.

England

The Renaissance arrived late, abruptly and hesitantly in England, and the evolution of painting there offered no parallels with France's continual interest in Italian art and its gradual assimilation of Northern and Southern Renaissance ideas. It was conditioned and severely limited by the secularization of the church under Henry VIII (1491–1547). At a time when Italian Renaissance ideas might well have found fertile ground there were only intermittent signs of its arrival, such as the few works left

165 ROWLAND LOCKEY Sir Thomas More, his Household and Descendants ϵ .1595–1600

Rowland Lockey made three versions of the great More family portrait, which is now lost. This miniature was probably commissioned from him by Thomas More II after Lockey's 1593 version in the National Portrait Gallery, London. The impact of this composition showing a great intellectual 'at the centre of a family united in the common pursuit of piety and learning' must have been immense on English artists.

by the Florentine sculptor Pietro Torrigiano during his stay of c.1511-22. The major exponents of the new style in painting were all initially foreign immigrants, such as Hans Holbein and Hans Eworth.

The English Reformation involved devastating iconoclasm, thereby eradicating a long and rich artistic tradition. In 1559 (one year after the respite given by the Catholic reign of Mary Tudor), two particularly horrifying acts of barbaric destruction took place in London. These bonfires were recorded by a contemporary: 'of Mares (Virgin Maries) and Johns and odur images, there they wher bornyd (burned) with gret wondur'.

By such means, any expression of religion through art, particularly after 1535, was prevented. This spelt disaster for painting in all but the most limited secular forms. It was thus that portraiture began to assume an importance in England unparalleled elsewhere in Europe, mainly because of its propaganda possibilities. Allegory also came into its own under the Tudors, partly as a result of Italian Renaissance influence, and was to constitute an important part of painting in the Elizabethan era.

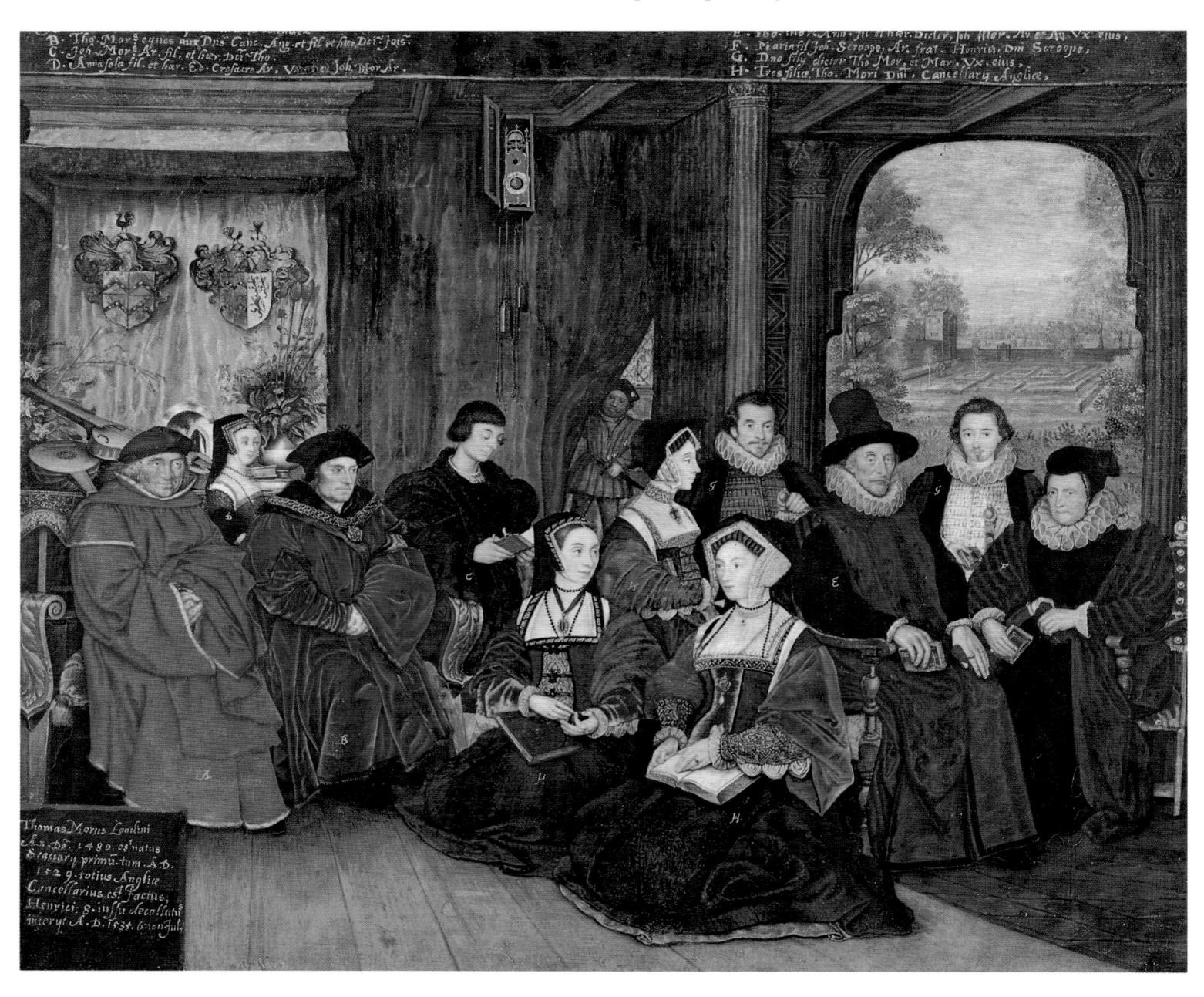

Henry VIII was quick to grasp the possibilities of Holbein's genius for portraiture, and the German artist remains the only painter of real importance in this period. The only likeness of Henry certainly by Holbein (Thyssen Collection, Madrid) depicts the cruel monarch with steely precision. From originals such as this, it was common practice throughout Europe for a painter or his studio to make any number of copies for use as diplomatic gifts, or reminders of the monarch's existence and power. Holbein's output in England was immense, with ninety portraits known from this period alone.

Hans Holbein the Younger in England

In spite of the efforts of Basle Town Council to deter their leading artist from leaving, Hans Holbein the Younger (1497/8–1543) moved to England after a visit in 1526, prompted by the loss of commissions in Basle as a result of the Reformation, when he had stayed for two years as the guest of Sir Thomas More. In 1527, he painted More's portrait (Frick Collection, New York) with a surface realism and grandeur which must have been astonishing in England. Even Erasmus continued to be amazed by Holbein's genius for creating a likeness and wrote of his *Sir Thomas More and his Family* (see plate 165), that it was 'so completely successful that I should scarcely be able to see you better if I were with you'. The highest compliment paid to portraitists during the Renaissance was to say that their likenesses were mistaken for real figures.

· In 1532 Holbein settled in England, where he died of the plague in 1543. His first London contacts came through his association with the German Steelyard Merchants, whereby he probably met Thomas Cromwell. Cromwell may have commissioned the celebrated *Ambassadors* of 1533 (see plate 180) with its atmosphere of intense intellectual life and international grandeur, its anamorphic image of a skull and complex symbolism. It has been interpreted as part of a conscious revival of Van Eyck's painting style, which in part explains the combination of austere outline with rich textures and glowing colour, characteristic of Holbein's finest work.

This combination endeared Holbein to the English aristocracy and intelligentsia (see plate 166), and led to his appointment as court painter in 1536. In the manner of his contemporaries elsewhere, Holbein was employed in a range of court activities, including portraiture (see plate 167), designs for costume, textiles, jewellery and court masques. The latter were to gain in importance under Elizabeth I. Holbein was also an engraver, exemplified in the *Dance of Death* published in 1538.

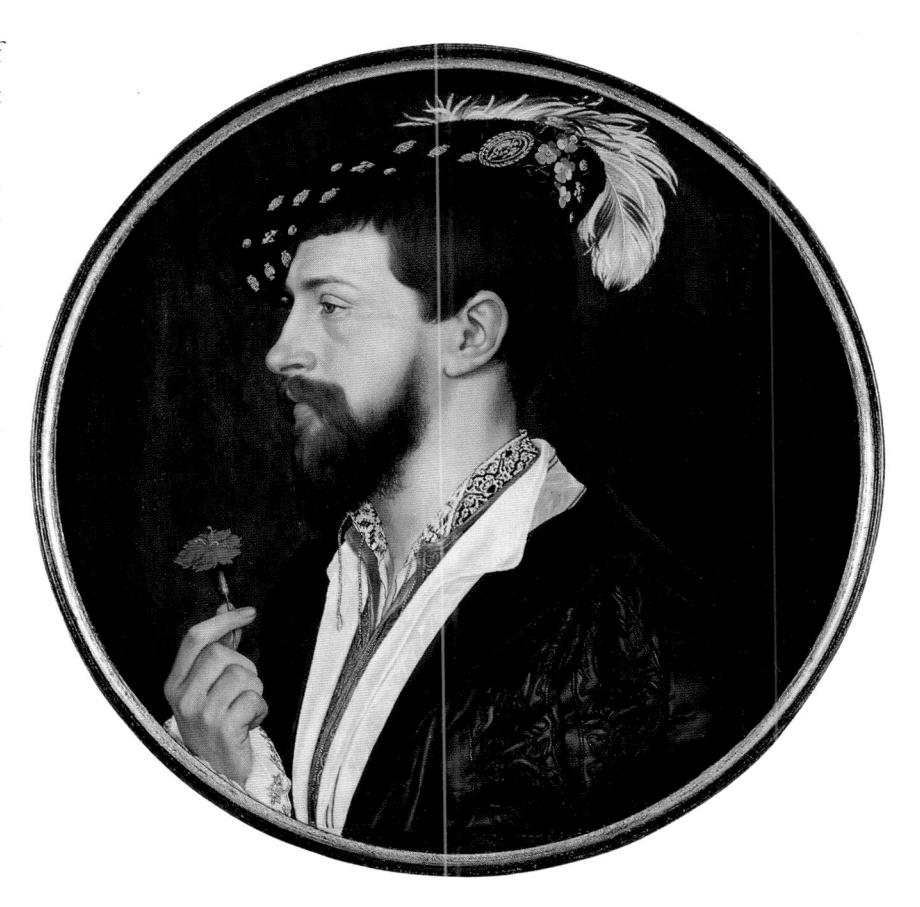

166 Hans Holbein the Younger Simon George of Cornwall 1535

The sitter is Simon George of Quocote, who became part of the Lanyon family of Cornwall by marriage. A strikingly modern preparatory drawing at Windsor shows him with a moustache and beard stubble, probably indicative of Henry VIII's order of 8 May 1535 that courtiers should cut their hair and no longer wear beards; radiographs reveal that originally the painting showed him with a shorter beard. The circular format and reflective pose reflect Holbein's activity as a miniaturist.

His major work for the court was a large mural portrait in the Privy Chamber of the New Palace of Whitehall. Henry, his third wife, Jane Seymour, and his parents, Henry VII and Elizabeth of York, were depicted against the background of the latest Italianate Renaissance architecture. Although later destroyed by fire, its appearance is recorded in Holbein's cartoon (National Portrait Gallery, London). Such a forcefully realistic celebration of a monarch was previously unknown in England, and exercised a strong fascination for successive artists.

Holbein transformed English art, and some native masters succeeded in emulating at least his style's externals, as in the fine, anonymous *Elizabeth I as a Princess* of the mid-1540s (Royal Collection, Windsor). Few European artists succeeded in achieving Holbein's balance of extreme sensitivity to his sitter and to his superb technique. His drawing technique was as refined as his painting, and the portraits in this medium (see plate 167) attain a perfection without contemporary equal.

167 Hans Holbein the Younger John More the Younger c.1527-8

John More (c.1509–47) was the fourth child and only son of Sir Thomas More. This is the largest study made for the More family group (see plate 165). It was made at the time of the sitter's betrothal to his father's ward, Anne Cresacre, whom he married two years later. The variety of chalk strokes indicates the breadth of expression the medium permits, from the delicacy of the facial treatment to the vigorous directness of the lower parts.

Almost every painter active in England between 1540 and 1570 hoped to emulate Holbein's style. His immediate followers included John Bettes the Elder (active c.1531-before 1576) and the Antwerp painter Hans Eworth (c.1520-after 1573), who worked in England from 1549 to 1573. Eworth's early travels resulted in a fusion of ideas from Netherlandish art and the Fointainbleau School with Holbein's style, as in his striking Mary Neville, Baroness Dacre of around 1555 (National Gallery of Canada, Ottawa). Its complex surface patterns contrast with Holbein's particular genius for simplified, large-scale figures against very simple backgrounds. Holbein's tendency to flatten his images was also reflected in the work of later followers like William Segar and George Gower (died 1596), who was appointed Serjeant-Painter to Elizabeth I (1533-1601) in 1581, and may have been the most significant English painter of the later

century. Holbein's methods were carried on into the next century by William Larkin (died 1619?) and Robert Peake.

Prior to Hilliard's emergence in the later 1560s, the most important artists were mainly Netherlandish or German, such as Gerlach Flick (died 1558) from Osnabruck. William Scrots (active 1537–53) painted in the International Mannerist style and became court painter to the Regent of the Netherlands, Mary of Hungary, in 1537, and to Henry VIII in 1546. He may have brought the fashion for full-length portraits to England, modelling them on the Austrian work of Jacob Seisenegger and the German Christoph Amberger, and he helped bring a more international outlook to English portraiture.

168 SIMON BENNINCK Self Portrait aged 75, 1558

With the replacement of the illustrated book by the woodcut, illuminators turned to other outlets, including miniature painting. Benninck was already painting detailed portrait miniatures in the 1520s. Here, he has begun the painting of a Virgin and Child on his easel, which is interesting for having racks for colours and brushes. Although a Netherlandish painting, its importance lies in the fact that it shows the style developed by Benninck's daughter, Lavinia Teerlinc (1510/20–76), who entered the service of Henry VIII in 1546, and it links the Ghent-Bruges school with Nicholas Hilliard.

169 NICHOLAS HILLIARD Man Clasping a Hand from a Cloud, perhaps Lord Thomas Howard 1588

Howard served in the fleet sent against the Armada, and was a distinguished naval commander. Clasped hands were a common emblem of Concord and plighted faith in Elizabethan art and literature, but the motto remains untranslated and unexplained, suggesting a recondite complexity of meaning and purpose for the portrait typical of such miniatures. Since Howard was a courtier, he may have been involved in theatrical performances, and the miniature may refer to one of these.

Nicholas Hilliard and the 'Art of Limning'

England's greatest miniaturist or 'limner', Nicholas Hilliard (1547–1619) was the first English-born painter whose talent was recognized by his contemporaries, and indeed the first native artist of the English Renaissance.

His immediate predecessor was Lucas Hornebolte (c.1490/5–1544) from Ghent, active at Henry VIII's court along with Holbein, and an exceptionally gifted miniaturist. Hilliard's training as a goldsmith with his father led to his continued activity in this sphere, and he probably made the *Armada Jewel* (Victoria and Albert Museum, London). In 1570 Elizabeth I made him her Court Miniaturist and Goldsmith, and he clearly enjoyed her favour since she later decreed that no painter should paint her portrait 'excepting only one Nicholas Hilliard'. Hilliard's miniature of the Queen painted in 1572 (National Portrait Gallery, London) assumed a status

comparable to Holbein's *Henry VIII*, and was reproduced on different scales. Hilliard expressed his debt to Holbein as follows: 'Holbeans maner of limning I have ever imitated and howld it for the best' (regard it as the finest).

Hilliard was known in France, which he visited about 1577 and where he probably saw the lavish art of the Valois court, including François Clouet's miniatures. His *Treatise Concerning the Art of Limning* was not published in his lifetime. In spite of his talent and success, he was frequently in financial difficulty, and was even involved in speculative gold mining in Scotland!

170 NICHOLAS HILLIARD Young Man Leaning against a Tree 1588

Hilliard's most famous miniature seems to show a young lover encouraged by the roses of love but pricked by their thorns, but the motto Dat poenas laudata fides comes from Lucan's Pharsalia, urging the assassination of Pompey. This does not tally with a proposed identification as Robert Devereux, Earl of Essex.

171 NICHOLAS HILLIARD AND ASSISTANTS The Mildmay Charter 1584

This is the charter authorizing Sir Walter Mildmay to found Emmanuel College, Cambridge. Hilliard designed the whole composition, painted the figure of the Queen, and then presumably delegated the border to an assistant. The grotesques reflect Italian prototypes, and probably derive from those decorating Nonesuch Palace, by Toto del Nunziata. The charter is basic to any understanding of Hilliard's work as a graphic artist, and shows how he tried to keep up with the latest Italian ideas.

The close relationship between miniature painting and precious metalworking are obvious, although Hilliard's freedom of technique and command of brilliant colour within his chosen limitations of scale are never finicking. Elizabeth I kept her miniatures in her bedroom, individually wrapped and labelled with the sitter's name, and in general miniatures were carefully hidden from light and dust in boxes of ivory or other valuable materials.

The intensely private nature of the portrait miniature lent it a unique position in European Renaissance art, a position somewhat comparable to the portrait drawings of Clouet and his circle in France. Like these, miniature portraiture was quintessentially a royal art, and remained exclusive for the first half-century of its existence. Its evolution resulted directly from the removal of Italianate

inspirations with the Reformation, a fact proven by the changes which affected the miniature when strong links were again forged with Italian culture under Charles I.

One of the aspects of Renaissance thinking which directly influenced the miniature from the 1580s was the employment of emblems and *imprese* (mottoes). Thus symbols began to play an increasing part in miniature imagery. Flames could symbolize the passion of love, while a black background could indicate constancy. As they were often gifts between lovers (or a highly prized gift from the Queen herself), these hidden meanings satisfied the Tudor and Jacobean love of the esoteric. As Elizabeth's reign closed, her miniaturists delighted in portraying her as eternally young and beautiful, embellished with luxurious jewellery and clothes, while clearly his next patron, James I, failed to inspire Hilliard or indeed any of the other painters who had produced such images of the Virgin Queen.

Hilliard's studio was probably extensive (see plate 171). Rowland Lockey (c.1565–1616) became his apprentice in 1581, working for Bess of Hardwick and learning from Hilliard the crafts of goldsmith, miniaturist and painter on canvas. His record copy of Holbein's *Sir Thomas More and his Family* (see plate 165) is an important document. In the hands of the mysterious Isaac Oliver (1560–1617), late Elizabethan and Jacobean miniature painting entered a new and different phase, with the inclusion of intensely religious works like the *Lamentation over the Dead Christ* of 1586 (Fitzwilliam Museum, Cambridge). Most closely related to European Renaissance ideas are his portraits of sitters in masque costume (see plate 304).

Renaissance Painting in Spain

The immense *Retable of Saint George* begun by Marzal de Sax (active 1394–1405) about 1400 (Victoria and Albert Museum, London) typifies Spanish painting at the dawn of the fifteenth century. It consists of principal scenes and over thirty subsidiary scenes and figures, contained in a carved and gilded Gothic framework. Astonishingly, two thousand retables have survived in varying degrees from the fourteenth and fifteenth centuries, and constitute a heritage we associate particularly with Spain. Luis Borrassá (c.1360–c.1425) who was active in Barcelona probably painted a large number of these complex and demanding works, in a combination of French and Sienese styles. About twenty have survived.

It is impossible to present a simplified picture of the complex changes in Spanish late medieval art under the impact of Flemish, French and Italian ideas. The character of Spanish paintings was always different from the rest of Europe, often dominated by fervent religiosity which evolved and intensified through El Greco into the Baroque era. The International Gothic style survived in Spain well into the fifteenth century. Gradually, however, the influence of Sienese painting displaced the Gothic idiom, and religious imagery of sometimes shocking directness was combined with strong narrative. Illumination remained one of the principal areas of production. The Florentine Gherardo di Jacopo called Starnina (active *c*.1390–died *c*.1413) had a long stay in Spain until 1403, and his delightful version of late International Gothic must have been influential. No other Italian painter is recorded there in the fourteenth century.

Bernardo Martorell (active 1427-52) was the leading Barcelona painter after Borrassá, although only his Altarpiece of Saint Peter of Púbol of 1437 (Gerona Museum) is documented. He combined Flemish and French ideas in a uniquely forceful version of International Gothic. Within his lifetime, however, the so-called Hispano-Flemish style, with its strong echoes of Jan van Eyck, made its appearance in Barcelona and rapidly began to replace International Gothic. This must have been directly reinforced by Van Eyck's presence in Spain on a diplomatic mission in 1427 and 1428. The direct result of his visit was a superb painting by Luis Dalmau (active 1428-60): the Virgin of the Councillors of 1445 (Museo de Arte the Cataluña, Barcelona). Jaime Huguet (active c.1448–92) became the leading Catalan painter of the later fifteenth century, although his influence extended to Aragon, where the Gothic style was strongly entrenched.

Fernando Gallego (c.1440–after 1507) is the first relatively well-documented Castilian painter, and may have visited the Netherlands. He evolved a recognizably personal style, with distinctive slim figures rather different from any other contemporary work. This greatly facilitates attributions to him in a period when these are often problematic. One of the principal sources for his life is the book *Museo Pictórico y Escala Optica* by Antonio Palomino y Velasco (1655–1726), 'the Spanish Vasari', which provides invaluable biographies of sixteenth-century artists. Gallego's first dated painting is the *Retable of Saint Ildefonso* (Zamora Cathedral), which shows the influence of German prints but also considerable expressiveness in the figures.

Gallego's major contemporary was the Master of Ildefonso (active 1470s). This generic name derives from his key work, the *Investiture of Saint Ildefonso* (see plate 182) of the later 1470s, a colourful work which is evidence not only of Flemish influences, but of a growing knowledge and understanding of Italian painting. Gallego is at the centre of a group of painters whose work illustrates the

sudden flowering of the last years of the century, also seen in the highly independent painter Bartolomé Bermejo, born in Cordova but active in Aragon and Barcelona between 1474 and 1498. His *Saint Michael* of 1468 (see plate 172) and his haunting *Pietà* of 1490 (Barcelona Cathedral) both mark him as an original master, and show

172 Bartolomé Bermejo Saint Michael and the Dragon 1468

This, probably an early painting by the master, suggests he may have experienced Flemish painting at first hand. Its combination of Flemish and Spanish elements resulted in an intense, personal style. Characteristic is the highly stylized tight drapery.

173 PEDRO BERRUGUETE King David, after 1483
This is one of the six predella paintings of Kings and Prophets of
Israel from the Retable of St Eulalia, and it shows Berruguete's
Italian experience, notably at the court of Urbino in 1477 under Joos
van Ghent. It was he who introduced the larger concept of form,
gesture, colour and pattern into Spanish painting.

the progression from an angular Flemish imagery to an Italianate manner in which atmospheric landscape plays an important role.

Ferdinand and Isabella expressed considerable favour for Italianate painters. The Flemish Juan de Flandes (died c.1519) was Isabella's court painter from 1496 until her death in 1504. Although he worked on a smaller scale than the major retable painters, his refined painting grafts Italianate detail on to the style he had learnt in Antwerp. The Castilian Pedro Berruguete, who also died in 1504, was court painter to both monarchs, and he demonstrates the fullest understanding of Italian Quattrocento ideas. Within Spain he was probably unique in his direct experience of the finest Italian art of the day. He seems to have worked for Federico da Montefeltro at the Court of Urbino, in the company of Melozzo da Forlì and Joos van Ghent. Although his early work was probably influenced by Gallego, he evolved a grandeur based on large forms, rich detail and colour, and expressive faces and gesture (see plate 173).

The Sixteenth Century in Spain

Towards the end of the sixteenth century, Spanish art was dominated by El Greco, who settled in Toledo in 1577. Although painting flourished between the two powerful polarities of court and Church, a distinct lack of fine painters is evident at this time particularly when compared with the seventeenth century. The High Renaissance produced as its leading painter the somewhat dull Fernando Yáñez de la Almedina (active 1506–c.1531), who may have assisted Leonardo in Florence on the *Battle of Anghiari* in 1505. Alonso Burruguete (c.1488–1561) also spent time in Florence from 1504 to 1518, after which Charles V made him court painter.

Philip II imported a group of significant Italian artists to decorate his Escorial Palace, including the painters Pellegrino Tibaldi (1527–96), Luca Cambiaso (1527–85) and Federico Zuccaro (1540/41–1609). They introduced Spain to the latest developments in Italian Mannerist painting, leaving many important examples of the style in the Escorial. Philip's tastes were eclectic, and in addition to commissioning some of Titian's most sumptuous later works, he included in his collections many paintings by Hieronymus Bosch.

Two other painters can be said to have achieved much more than local status: Alonso Sánchez Coello (1531/2–1588) and Luis de Morales (c.1520/25–86). Coello was, with Titian and Anthonis Mor (see plate 297), Philip II's court portraitist. He was sent as a child to Portugal, whose king, John III, made him study under Mor in Flanders. By about 1550 he had returned to Portugal and five years later was in Philip II's court, a royal favourite. The king was godfather to his daughters, and Coello evolved the perfect painted equivalent to the rigid etiquette of the time. Within the confines of the International Mannerist portrait style, his balanced, restrained likenesses allow no elaborate detail to dominate, but sumptuousness is everywhere implied (see plate 184).

Morales was Spain's greatest native Mannerist painter, principally of religious themes. He owed his occasional use of monumental scale to Portuguese art (he lived in Badajoz, a border town), and after 1558 he painted numerous large altars. Leonardo inspired his compositions, and his love of romantic, rocky scenes and mysterious *sfumato* effects, which were also practised in Spain by the Dutch painter Hernando Sturmio. Best known for his small, half-length Madonnas (see plate 183) and Pietàs, which earned him the nickname 'El Divino', Morales sums up one side of Spanish Counter-Reformation provincial piety – sweet, intimate and introspective.

Painting in Spanish America was by definition colonial

and usually provincial, dependent on prints or imported paintings from Europe. But it included many examples of interest and beauty. In Bolivia, paintings from the workshop of Quentin Metsys and others were known, and before 1550 the influence of Antwerp combined with that of Italian Mannerism. The latter prevailed from the midsixteenth century, lasting well into the eighteenth century throughout Spanish America. Under Philip II, painting in Mexico suffered a setback when many Flemish, French and even Italian artists were imprisoned, falsely accused of Lutheranism. The Inquisition was even more rigid in Spanish America, thereby limiting subject matter.

Prague Mannerism

One of the last and greatest outposts of Renaissance ideals was at the Prague court of the Emperor Rudolph II (1552–1612). He modelled it on the refined style of the later Medici, such as Cosimo I and his son Francesco I, who favoured an opulent mixture of the fine and decorative arts, mingled with the extravagant and bizarre. Elsewhere it was matched by the courts of Francis I at Fontainebleau, Philip II at Madrid and Albrecht V in Munich. While Bronzino and Vasari dominated a host of lesser artists in Florence, and Frederick Sustris and Pieter Candid excelled in Munich, the leading painters in Prague were Bartholomeus Spranger (1552–1615), Hans von Aachen (1552–1615) and Josef Heintz (1564–1609). Of these, Spranger was certainly supreme.

Spranger was born in Antwerp, trained there, and was strongly influenced by Franz Floris (c.1517-70). He achieved a sophisticated international style thanks to his travels. In 1565 he visited Paris and then Italy, at a time when Italian Mannerism had created its major masterpieces. His involvement in the great fresco cycles by the Zuccari at the Villa Farnese in Caprarola was fundamental to his development, as was the art of Parmigianino. After a stay in Vienna, Spranger settled in Prague to become court painter to Rudolph in 1581. As at Fontainebleau, the taste of Rudolph's court tended to a strong interest in the erotic, including its most perverse forms. All subjects, whether religious or mythological, were permeated with this eroticism, so that both Susanna and the Elders (Schleissheim Schloss) and the magnificent Triumph of Wisdom (see plate 189) have a similarity of intent. This, together with extrovert distortions of the human figure (and face), enamel-like paint surface and the rich vocabulary of jewels, armour and complex dress, which Spranger had learned in Italy, resulted in one of the last great examples of true court art before the advent of the Rococo.

174 Attributed to Alonso Sanchez Coello View of Seville, undated

The rarity of urban views in European painting of the sixteenth century makes this particularly interesting: the best-known example is El Greco's famous if more idiosyncratic View of Toledo.

Carefully observed landscapes appear in the backgrounds of some Coello portraits.

175 THE MASTER OF MOULINS Young Princess c.1498 (Left) Two possible identifications for this unusual portrait have been proposed; Suzanne of Bourbon and Marguerite of Austria. Its jewel-like colour and intensely concentrated expression, together with the positioning of the figure apparently on a high columned terrace, lend it a remoteness at variance with the sitter's proximity to the viewer. The luminous landscape and jewels are beautifully painted.

Once attributed to Bruegel the Elder, then to Jan van Eyck (whose treatment of physiognomy it recalls), this unique portrait is almost certainly Fouquet's work. It shows the famous court jester of the court of Niccolò III d'Este. It is likely that the portrait was painted for Niccolò's son, Lionello d'Este, a well-known amateur of Flemish art. The device of representing figures tightly enclosed in the frame with their arms folded in this way appears in miniatures by Fouquet and his successor Jean Colombe. Particularly striking is the direct gaze, engaging the sitter with irresistible intimacy. Compared with Fouquet's portrait of Charles VII (see plate 8) this shows a complete liberation from late medieval conventions, and may have been painted in France after the artist's return.

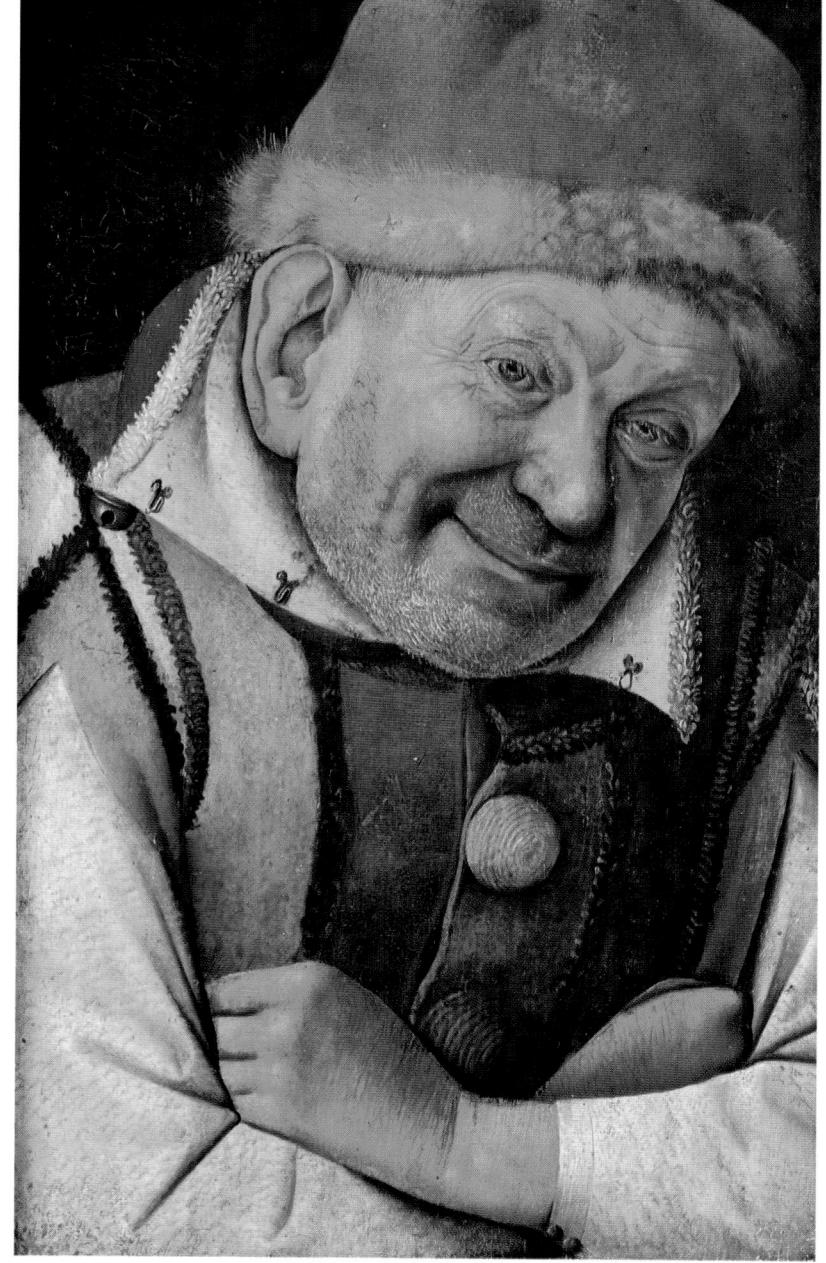

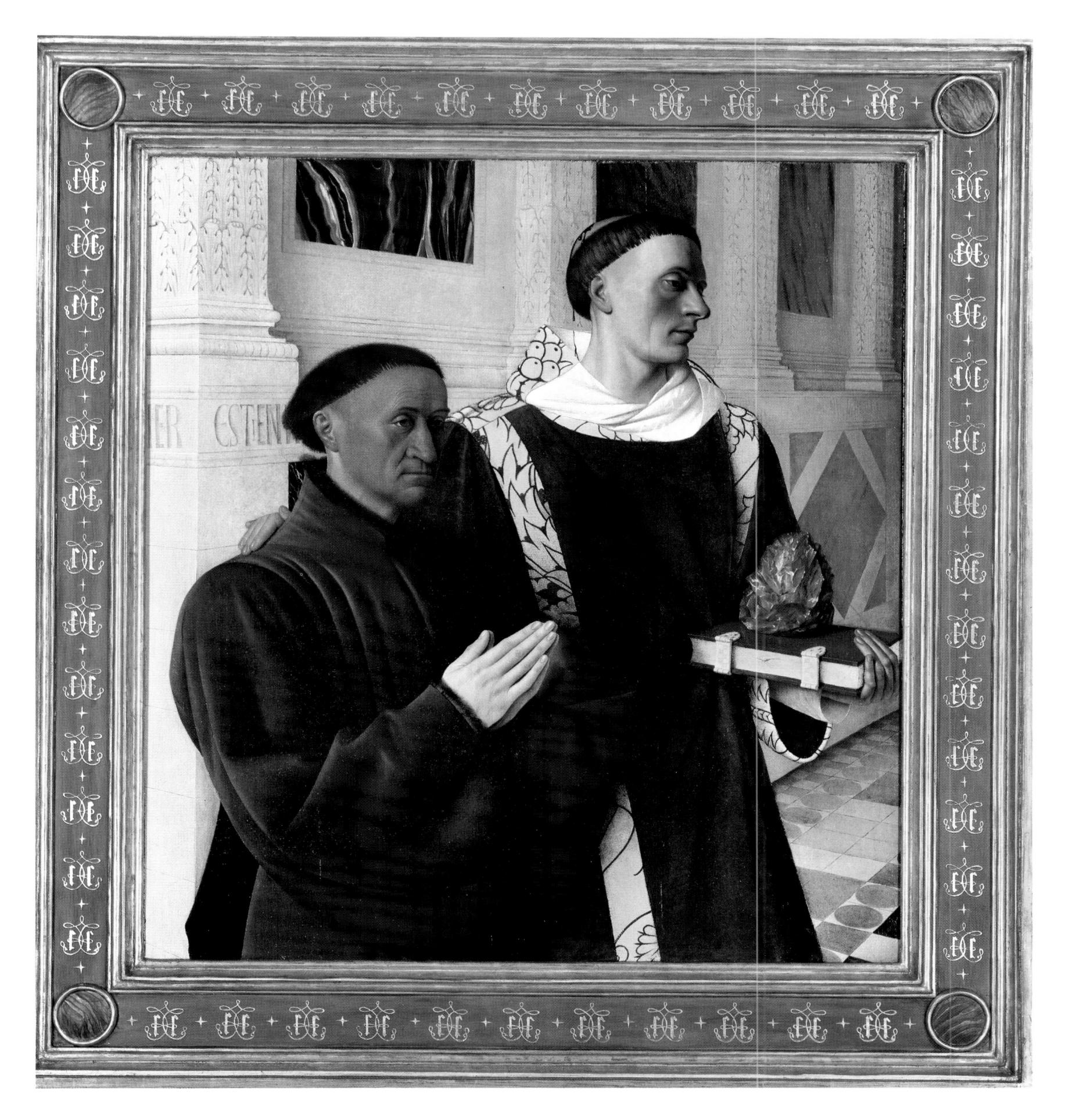

177 JEAN FOUQUET Etienne Chevalier with Saint Stephen, 1477

The diptych of which this is half was located above the tomb of Etienne Chevalier in Melun Cathedral until 1775. Its right wing, showing the Madonna and Child with Angels, is in the Musée Royal des Beaux-Arts, Antwerp. Here, the saint wears a deacon's robe and carries a book and stone referring to his martyrdom. Chevalier's name is repeated several times along the base moulding of the background architecture. Chevalier, who died in 1474, was the

son of a secretary to Charles VII, and became Treasurer of France in 1451. Fouquet also made other portraits of Chevalier in Chevalier's Book of Hours: most of these miniatures are in the Musée Condé at Chantilly. The crystalline clarity of form and colour in both figures and background, and the intensely observed character of the two faces, mark this out as Fouquet's masterpiece.

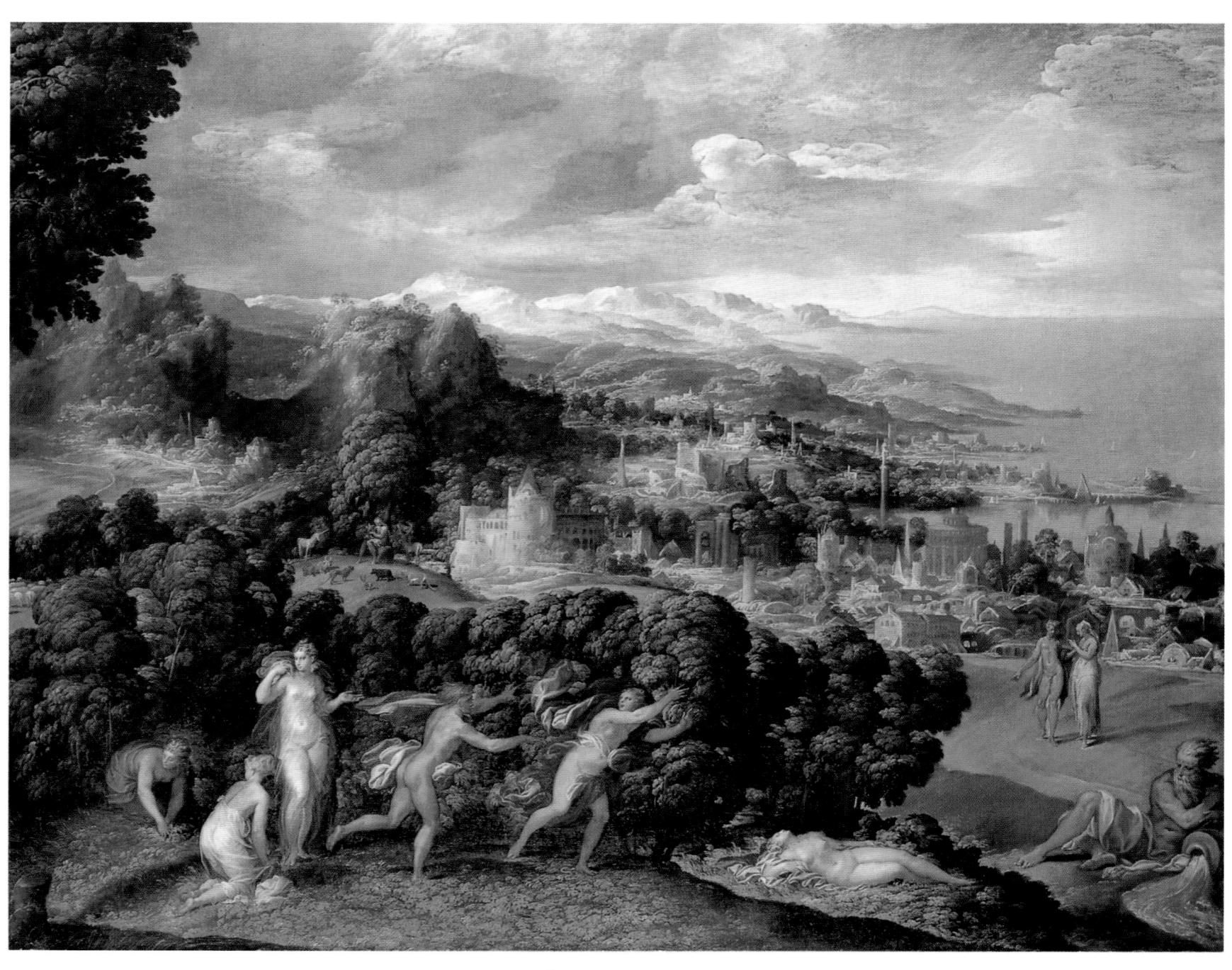

178 Attributed to NICCOLÒ DELL'ABATE Landscape with Euridice and Aristarchus c.1558-59

Drawing on a variety of sources, this landscape typifies dell'Abate's approach to the romanticized landscape which he introduced at Fontainebleau. Its high viewpoint, permitting the depiction of foreground, middle ground and horizon in equal detail, is typical of Northern Mannerist art and was used by Bruegel the Elder, among many others. The elegant figures, notably the broad-hipped, small-headed women, recall the painter's Bolognese training.

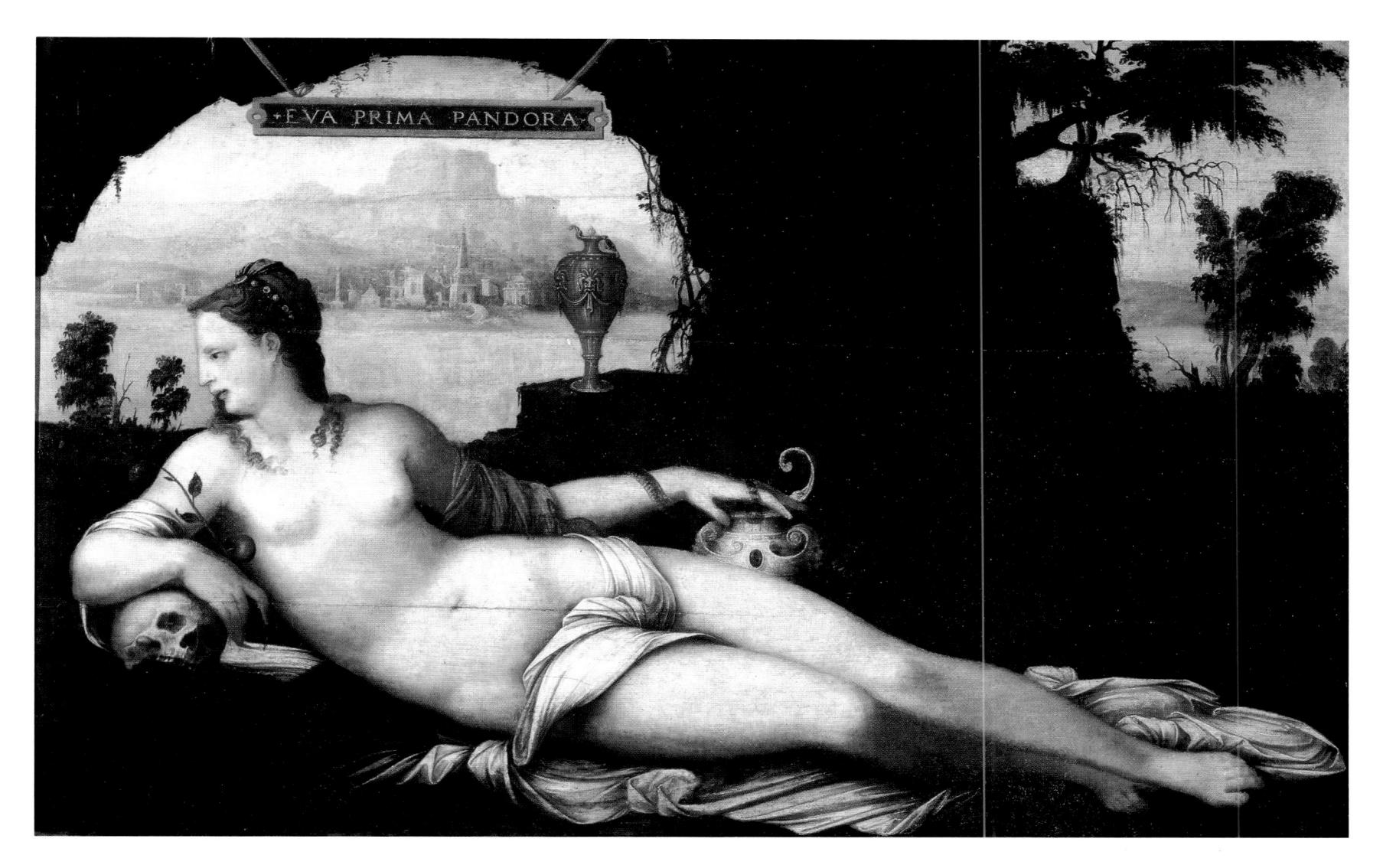

In Greek myth Pandora was created with earth and water by Prometheus, and originated illness and vice on earth by opening a forbidden box. This painting was already attributed to Cousin within his lifetime, and is the best-known interpretation from the French Renaissance of Pandora as a pagan Eve who, like Pandora, released evil by biting the forbidden apple. Vasari much admired Cousin, and his Italianate rendering of the nude reflects the concerns with idealized Mannerist form of the artists active at Fontainebleau, notably Niccolò dell'Abate and Francesco Primaticcio.

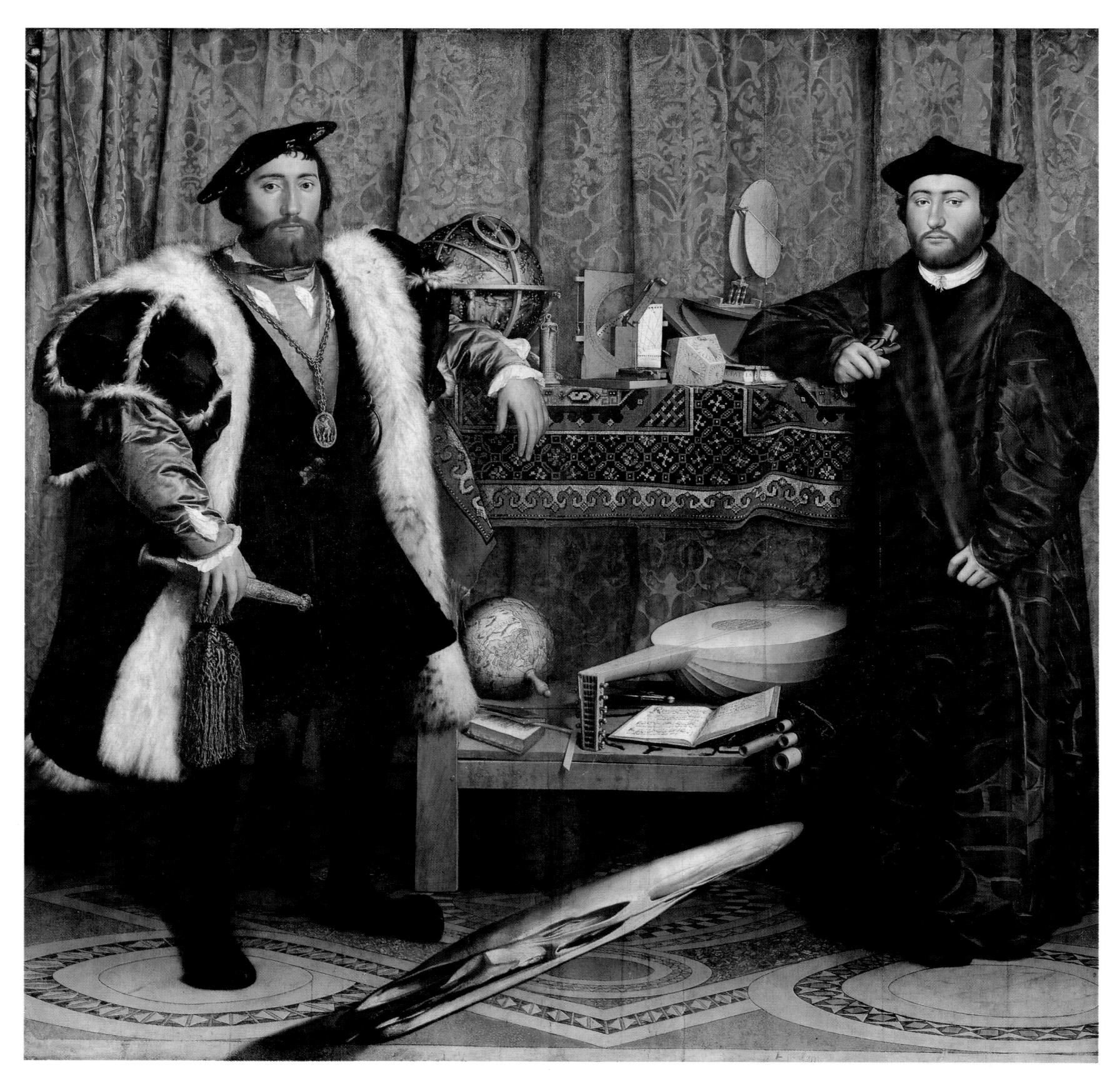

At the left is Jean de Dinteville, who was ambassador or diplomatic envoy to England on five occasions. He is shown wearing the Order of St Michael. At the left is his friend George de Selve, who visited him in London April—May 1533, and who was several times ambassador to the Emperor, the Venetian Republic and the Holy See. This picture's extremely complex symbolism still eludes complete explanation. A skull appears on de Dinteville's cap and in perspective across the mosaic floor, which is an almost exact copy of Abbot Ware's in Westminster Abbey. The skull seems to indicate that the picture is a sort of memento mori: the broken lute signifies a vanitas theme. The inclusion of so much still life is unique in Holbein's painting.

181 François Clouet A Lady in her Bath c.1571 Clouet signed two paintings, this and Pierre Quthe (see plate 163). This portrait has sometimes been identified as Henry II's mistress, Diane de Poitiers. It is a remarkable amalgam of influences, notably that of Leonardo da Vinci's lost nude Mona Lisa – which exercised a considerable fascination for French painters – and undeniably Flemish features, notably in the nurse and the child in the middle distance. With the exception of the nude, the rest of the painting

suggests the influence of Peter Aertsen in its combination of realistic figures, closely observed interior and still life. The nude's artificiality is typical of refined court taste, probably created in part by the presence there of Bronzino's Allegory of Venus (see plate 228). Many variants on this half-length type were produced in France at the time.

explosion of inner forces, while Michelangelo's composition was more expansive. Michelangelo's choice was arguably more subtle, depicting a moment when bathing Florentine soldiers are surprised by imminent Pisan attack. This permitted the display not only of every conceivable anatomical contortion but also of differing psychological reactions. Michelangelo's conception was destined to exert far greater influence through his cartoon, described by Vasari as a 'school for artists' (among whom he lists many early Mannerists including Rosso Fiorentino, Pontormo and Perino del Vaga), and so much copied by leading painters of the day that it had already disintegrated by 1516. Its importance can be gauged by comparison with a contemporary painting by Botticelli, his *Mystic Nativity*, which already belongs to a past age.

Leonardo appears to have begun his most celebrated picture, the Mona Lisa or La Gioconda (see plate 194) at the same time as the Battle of Anghiari, and probably completed it about three years later. It is hard for us now to see the incalculable significance of this, the most overexposed painting in history. It represents the conclusion in Leonardo's portraiture of his attempts to explore the mysteries of sexuality, both male and female, a fact which has led to countless untenable interpretations of its meaning. The challenging yet withdrawn gaze of La Belle Ferronnière (Musée du Louvre, Paris), painted in 1490-95, already contains the germ of the Mona Lisa's enigma. Michelangelo's attitude to women was also novel in Renaissance painting. Whereas Leonardo preferred to concentrate on the female characteristics of both sexes (as in his late Saint John the Baptist in the Louvre), Michelangelo invested his women with male physical characteristics. Such subtle nuances of psychology characterize much of Italian High Renaissance art, and appear in different ways in the contemporary Venetian works of Giorgione and his followers. It may be said that the tendency culminates in Correggio, but often assumes sinister implications in the work of Mannerists such as Rosso Fiorentino.

Leonardo returned to Milan in 1506 to complete the Louvre *Virgin of the Rocks*, and he later became Painter and Engineer to Francis I of France. The previous year Michelangelo had left Florence for Rome, in response to an offer from Julius II to create the architecture and sculpture for his immense mausoleum in St Peter's. But in the brief period they shared in Florence, both artists created work of outstanding importance, news of which lured other artists to the city.

Leonardo and Michelangelo both pushed the technical possibilities of art to the extreme in this period. Leonardo had opened the way, particularly in his private drawings,

which explored in great depth every conceivable facet of the world. Michelangelo continued the process later with his marble Pietà in St Peter's and accelerated it throughout the first decade of the new century. Their experiments were conceived to imbue art with a greater degree of naturalness, or at least the illusion of a closer approximation to the visible world. Vasari started his serious assessment of this period in the 1530s. He saw 'Nature' as the cornerstone of art, but knew that his contemporaries, and in particular his artistic god, Michelangelo, had done more than merely recreate it in paint or marble. He therefore perceived a definite change taking place about 1500, for although Quattrocento artists succeeded in rendering the external appearance of their world, they could not achieve the illusions given by such devices as the sfumato effects in Leonardo and Giorgione.

193 LEONARDO DA VINCI Saint John the Baptist 1513–16 This is Leonardo's last major work, and opinion has been sharply divided as to its intentions, quality and authorship. Leonardo has here carried to their conclusion his earlier experiments with sfumato and the virtual exclusion of colour. The result can be interpreted either as a suave rendering of psychological ambiguity, or as a slightly ludicrous failure to capture a transient expression.

194 LEONARDO DA VINCI Mona Lisa 1503–5
This portrait shows Lisa Gherardini, who was born in 1479 and in 1495 married Francesco del Giocondo (which is why the picture is sometimes known as La Gioconda). Vasari says that Leondardo painted 'for Francesco Giocondo the portrait of monna Lisa his wife . . . now in the possession of King Francis of France at Fontainebleau.' The picture is now one of the chief attractions of the Musée du Louvre in Paris.

The mystery surrounding the painting's origins is accentuated by the sitter's ambiguous expression, the disparity of the two parts of the landscape background and the lack of any directly related preparatory drawings. Its greatest influence was, not surprisingly, on painting in France, where it is assumed Leonardo's original cartoon showing the model nude was widely known.

Vasari's description emphasizes the picture's naturalism, now difficult to assess under discoloured varnish. He commented that: 'the eyes had that lustre and watery sheen which is always seen in real life . . . the nose, with its beautiful nostrils, rosy and tender, seemed to be alive. The opening of the mouth . . . seemed not to be coloured but to be living flesh.'

Michelangelo and the Sistine Chapel

Michelangelo Buonarroti (1475–1564) contributed directly to High Renaissance painting through very few works, of which the ceiling of the Sistine Chapel overshadows all others. The impact of his sculpture on contemporary painting was, however, immeasurable. Having quarrelled with the Pope about his mausoleum project and fled to Florence, Michelangelo agreed to undertake the Sistine frescoes only under duress. The chapel, built by Sixtus IV from 1477 to 1481, already had wall frescoes illustrating the Old and New Testaments, by Ghirlandaio, Perugino, Botticelli, Signorelli and others.

Michelangelo conceived a novel form of illusionistic architectural framework for his combination of single figures and groups. 'Stone' ribs, like the supports for a gigantic vault, span the whole space, as if some of the infilling masonry has been removed to hold the important scenes. The ceiling is divided into three zones, with Man, before divine light penetrated his state of unconsciousness. placed symbolically in the lowest one. Moving upwards to the middle zone, we find the Seers (alternating prophets and Classical sybils), whose vision of the divine (the coming of Christ) foretells the awakening of Man to God. The culmination comes in the uppermost area of divine revelation, with God separating light from darkness, creating the world and Adam and Eve, until the three scenes depicting Noah show his continuation of the human race. Against the ribs are seated the Ignudi (nude youths), whose meaning has been ceaselessly debated. It seems remarkable that, in an age increasingly concerned with 'programmes' in art, no contemporary attempt at a written explanation of Michelangelo's intentions has been found. If it is accepted that Michelangelo was not required to work to pre-existing specifications, his freedom to create directly from the urgings of his spirit was unprecedented - and never equalled again.

The unimaginable task of painting more than 300 figures in an immense space exceeding 1000 square metres frequently led Michelangelo to despair. Apart from the physical toll, the artist's biographer, Ascanio Condivi, recounts technical difficulties such as the appearance of mould. Furthermore, there was no precedent for such a complex iconographic scheme on this scale, the technique of fresco was new to the artist, and the Pope was negligent in paying him. In 1509, Michelangelo wrote '...I am uselessly wasting my time', and he lost a year's work through shortage of money.

When the ceiling was eventually completed in 1512, Michelangelo was hailed as the greatest artist of his age. The forms, colours and mood he had created were to transform Italian art. Since the vault's recent cleaning, we know that the sharp colours preferred by so many Mannerist painters derived directly from it, while its figure and facial types, anatomy and poses at once spoke a new and hypnotic language.

Michelangelo retreated to Florence, and with the exception of the unfinished *Entombment* (National Gallery, London), whose dating is uncertain, he concentrated almost entirely on sculpture and architecture. Only in his later years did he return to monumental fresco in the *Last Judgement* and the Cappella Paolina (see Chapter VIII).

Raphael

Raphael (Raffaello Sanzio, 1483-1520) remains one of the best-known but least understood of Renaissance artists. His importance is universally acknowledged, and his Madonnas have entered popular consciousness to a degree only paralleled by the Mona Lisa. But not even his secular paintings have made him a popular artist. Vasari's summing up of his art, full of unstinting praise as it is, contains the germ of an explanation. 'In truth, we have from him art, colouring, and invention harmonized and brought to such a pitch of perfection as could scarcely be hoped for.' It may be this perfection which has so alienated our age from the Madonnas and sweet-faced youths once so beloved of nineteenth-century amateurs: Somerset Maugham already saw in Raphael 'the vapidity of Bouguereau', the nineteenth-century French academic artist. It is easy to overlook the strength underlying Raphael's supremely controlled art, a strength not manifested with the shock effects of Michelangelo's terribilità (awesomeness), but in a refined sensibility, a highly developed sense of colour and flawless drawing.

Raphael was born in 1483 in Urbino. The town was far from provincial: Raphael's painter father, Giovanni, lived at the centre of the Montefeltro court's intellectual pursuits, and wrote a *Chronicle* of the reign of Federico, Duke of Urbino. The young Raphael spent eleven years in such an atmosphere – which was equivalent to the youthful Michelangelo's experiences in the intellectual circles of Lorenzo the Magnificent. He absorbed not only painting techniques from his father but also the love of literature and the arts which informs all his work, particularly after his move to Rome in 1508.

His early style depends entirely on Pietro Perugino (c.1445–1523), and there is no reason to doubt Vasari's claim that he was Raphael's master. Like Perugino, Raphael was peripatetic, travelling continuously throughout Tuscany and Umbria until he settled in Rome in 1508.

The year 1504 marks the turning point of his career, when he painted the Brera Marriage of the Virgin, taking Perugino's style to its conclusion. On I October, the Duke of Urbino's sister, Giovanna della Rovere, wrote to the Republic of Florence's Gonfaloniere (Governor) Piero Soderini, saying that Raphael has 'much talent in his vocation, and wishes to spend some time in Florence to study.' The youthful artist's sketchbooks reveal that he did study avidly, concentrating on two very Florentine preoccupations: the male nude and the Madonna. In addition to famous sculpture, such as Donatello's Saint George, he copied Pollaiuolo's engraving, the Battle of the Ten Nudes (see plate 77). It was clear from the beginning that his aspirations led him away from the static art of Perugino towards the dynamism of the Leonardo and Michelangelo Battles for the Palazzo della Signoria. The Battle of Cascina's grandiose nudes remained a formative influence on him throughout his career.

To his own gentle synthesis of Perugino, Raphael now added Leonardo and other Florentines, such as Ghirlandaio, whose earliest Madonnas, such as the Madonna Terranuova (Gemäldegalerie, Berlin), borrow exactly the Virgin's pose from Leonardo's Virgin of the Rocks. It also uses the favourite Florentine tondo or circular form, which Raphael was to perfect later in the Madonna Alba (see plate 211) and the Madonna della Sedia Palace, Florence). While Leonardo Michelangelo produced very few works in Florence, Raphael was prolific, each new painting charting his rapidly increasing originality, inventiveness and his evident excitement at his progress. From the uncertain steps of the early Madonnas, his increasing liberation is evident through the Madonna del Granduca (Palazzo Pitti, Florence), the Small Cowper Madonna (National Gallery of Art, Washington), the Bridgewater and Colonna Madonnas (Edinburgh, National Gallery of Scotland and Staatliche Museen, Berlin). By the time of one of the last Florentine Madonnas, the Tempi (Alte Pinakothek, Munich), he had achieved that illusion of naturalness coupled with the most subtle formal arrangement which characterized his subsequent Roman Madonnas. Another important aspect of Raphael's Florentine experiments in this area was his use of Leonardo's full-length seated Madonna compositions based on the pyramid form in The Madonna and the Goldfinch (Uffizi, Florence), The Madonna of the Meadow (Kunsthistorisches Museum, Vienna) and La Belle Jardinière (Musée du Louvre, Paris).

Raphael is recorded as being in Rome in the autumn of 1508, and his first documented payment followed in January 1509. This was for the room subsequently known as the Stanza della Segnatura, commissioned by Julius II as

part of the redecoration of his Vatican apartment. There seems little doubt that Raphael had already visited Rome before he settled there, which, according to Vasari, was at the instigation of his uncle, Bramante. Elements of Classicism suggesting he already knew Roman art are evident in his works of the Florentine period, such as the *Madonna Esterhazy* (Szépművészeti Museum, Budapest) and the *Deposition* (Borghese Gallery, Rome). Bramante himself had arrived in Rome in 1499, escaping from Milan after the French invasion of Lombardy.

By the time Raphael settled in Rome, Bramante had already evolved his Roman Classical style, the effects of

195 RAPHAEL Detail of the mural grotesques from the Vatican Loggie 1518–19

The Loggie were erected by Bramante for Pope Julius II but completed under Leo X. Raphael decorated them in a mixture of stucco and fresco, in imitation of ancient Roman grotesques named after the grotte or underground chambers in which they were excavated. Raphael's designs inspired countless designers in the seventeenth and eighteenth centuries, and grotesques were metamorphosed into arabesques and other similar motifs. Their form is primarily vegetal and floral, but they also incorporate imaginative painted and stucco relief roundels, shields, lozenges and rectangles bearing figures, birds and animals, usually in tall, narrow vertical strips.

whose massive grandeur were to extend beyond the boundaries of architecture; Raphael worked daily in the shadow of Bramante's Vatican work, notably on the Cortile del Belvedere, and its innovations are reflected in his own architecture and paintings. His passion for the new domed, centralized architectural ideals is clear from the elegant background temple in his *Marriage of the Virgin* of 1504. Bramante gave Raphael a love for everything Roman, which not only helped to perfect his Classical figure style, but led to his epoch-making interior decoration using *grotesques* based on Roman mural designs in the Vatican Loggie and the Bathroom of Cardinal Bibbiena (see plate 195), and the Villa Madama in Rome.

The Stanze – Julius II's suite of personal, although not necessarily private, rooms – comprised his study (Segnatura), audience chamber (Eliodoro) and the meeting room of the Church's supreme court (Incendio). Only Perugino's ceiling in the Incendio remains of the earlier decorations, and by the end of 1508 Julius's select team of painters was ready to redecorate completely. The Segnatura's iconography reflects all aspects of intellectual exercise, its ceiling roundels in simulated mosaic showing Theology, Philosophy, Jurisprudence and Poetry.

Raphael's striking depiction of space in the first fresco in the Stanza della Segnatura (the *Disputà*) is already present in his lesser known fresco, in San Severo, Perugia, painted in 1505, the *Holy Trinity with Saints*. This stems directly from his experience in Florence of Fra Bartolommeo, who remained a close friend of Raphael's until the former's death in 1517.

The Disputà's composition shows the lingering influence of Fra Bartolommeo, but is filled with Raphael's new Roman gravitas, and his increasing awareness of the power of ancient art to transform his conception of the human form. This consciousness culminates in the same room in the celebrated School of Athens (see plate 196). The equilibrium achieved by Raphael in these works was, however, short-lived, as is seen from the rapid increase in visual drama, rich colour and other eye-catching effects found in the later frescoes of the Stanze. Already in the Expulsion of Heliodorus of 1513-14 (notwithstanding the thematic need for dramatic movement) the exquisite balance of the School of Athens has gone, to be replaced by something of that richness of surface pattern which evolved later in Mannerism. By the time of the Fire in the Borgo (1514) a new awareness of the possibilities of figure painting has swept away the freshness of the first frescoes in the series, replacing it with sophistication and the grazia, or gracefulness, so admired by Vasari. This grazia was already present in Fra Bartolommeo (see plate 206) but the addition of Classical Roman grandeur directs it

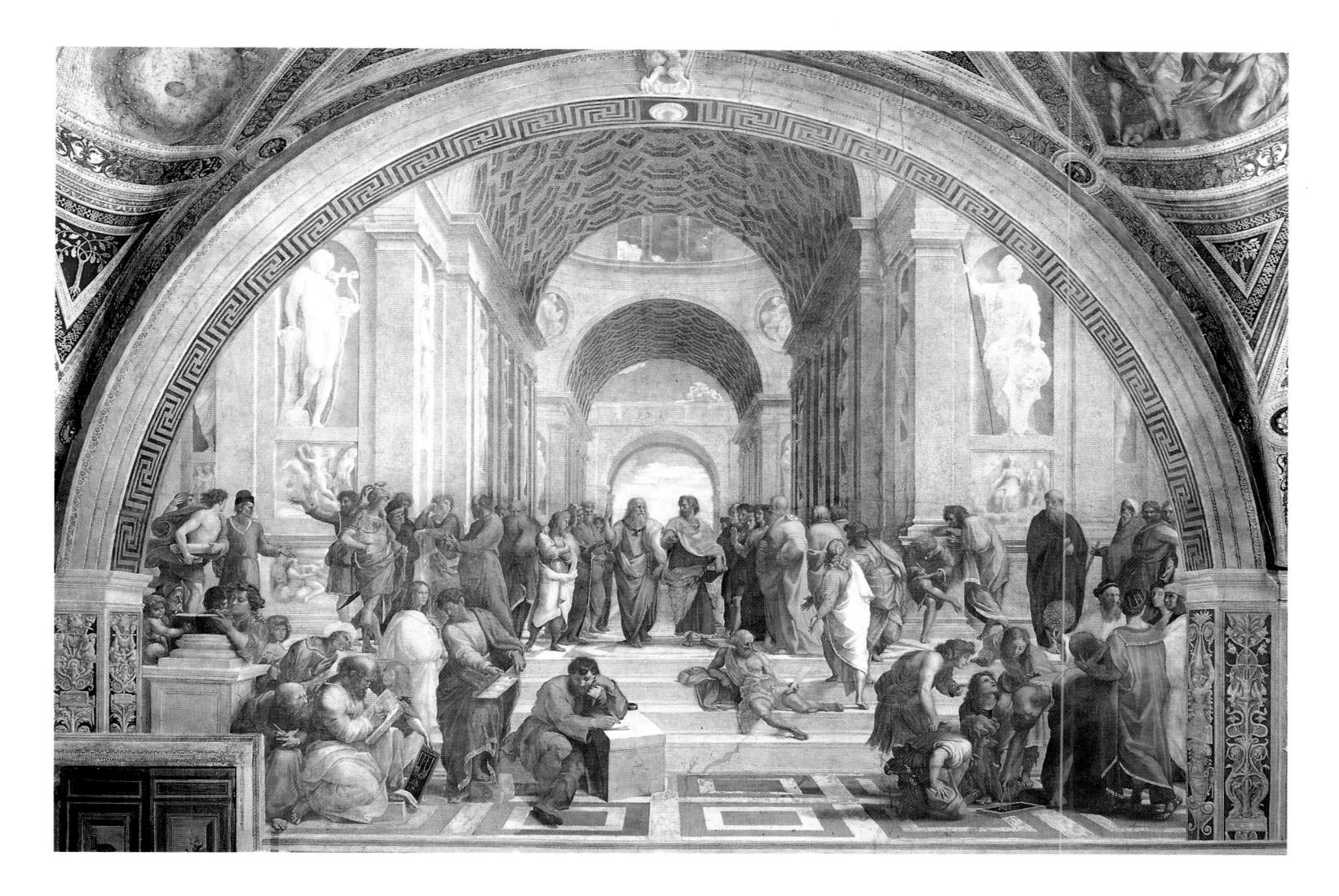

In this large fresco lunette in the Stanza della Segnatura of the Vatican, commissioned by Pope Julius II, Raphael achieved the total mastery of his individual style, not least in posing over fifty figures to create vitality and to relate each figure to its group, each group to the whole. With the Sistine ceiling it may be seen as the quintessential painting of the High Renaissance. Plato and Aristotle are dramatically placed at the centre of the composition, and every aspect of the philosophical life is represented, appropriate to a Pope's study-library.

While the Disputà opposite still suggests a certain striving on Raphael's part for a classic solution, in the School of Athens his delight in placing his dramatis personae against sublime architecture, probably based on Bramante, renders a potentially pedantic theme human and approachable.

towards magnificence. An increasingly dark palette already looks forward to Raphael's late work and Giulio Romano's version of it.

Raphael never experienced the psychological crises recurrent in Michelangelo's life, and which inspired the unique form of his art. As with all artists of his generation, however, he looked in awe at the external evidence of Michelangelo's style, already formed in the *Cascina* cartoon and brought to perfection on the Sistine vault. But Raphael did not become in any sense a 'Michelangelo

follower' and was gifted enough to assimilate the elements that attracted him. Thus, while his cartoons of 1515 for the Sistine Chapel's tapestries depicting the Acts of the Apostles (see plate 205) are inconceivable without Michelangelo's influence, they demonstrate how he pursued his own ends relentlessly.

The cartoons (now in the Victoria and Albert Museum, London), have been called the Parthenon sculptures of modern art. Raphael's portraiture during the reign of Leo X also reached new heights of individuality, and remains possibly the most accessible aspect of his later work. Under Venetian influence (and that of the Mona Lisa, brought by Leonardo to Rome in 1513), he evolved half-length portraits of men and women combining unique psychological insight with painterly sensuousness. From La Donna Velata (Pitti Palace, Florence) to Baldassare Castiglione (see plate 12) he rendered his sitters more approachable even than Titian's. His portraits of ecclesiastics such as A Cardinal (Museo del Prado, Madrid) or the celebrated Leo X with Cardinals Giulio de' Medici and Luigi Rossi (Uffizi, Florence) set the standard for unflattering likenesses nevertheless imbued with great dignity.

It is tempting to speculate how Raphael's style would have developed had he not died young (at the age of thirtyseven). Raphael was then at the height of his productivity,

Listed as being at Fontainebleau in the early seventeenth century, this picture may have belonged to Francis I. The left-hand figure is certainly Raphael, but the identity of his companion remains uncertain. Among the many names suggested have been Pintoricchio, Giulio Romano, Pietro Aretino and Giovanni Battista Branconio dell'Acquila, a close friend of the artist during his last years and the executor of his will. Raphael himself appears prematurely aged, possibly by his heavy workload in this later period, as architect of St Peter's and Director of Antiquities in Rome.

Along with Baldassare Castiglione (see plate 12) and Navagero and de Beazzano (Doria Gallery, Rome), this portrait reveals Raphael as the supreme master in the Renaissance of the 'speaking likeness', where sitters seem to communicate directly with the viewer. There seems little doubt that a precise symbolism was intended, and Raphael may have intended a veiled reference to Christ with one of His disciples. More than any other of his portraits, this painting recalls the sombre grandeur of the work of Sebastiano del Piombo.

and with him, stylistic changes happened very rapidly. The transformation from the three differing interpretations of Classicism as seen in *Galatea* (see plate 214), the *Sistine Madonna* of 1513–14 and *Saint Cecelia* of 1514 to the high drama – both in content and form – of the *Transfiguration* (see plate 248) indicate that Raphael would probably have developed into a sophisticated Mannerist.

Painting in Rome and Florence

During his own lifetime, Raphael's fame and influence spread through the engravings of his work made by Marcantonio Raimondi. But it was from Raphael's late style as seen in the *Transfiguration* that his pupils Giulio Romano (1499–1546) and Gianfrancesco Penni (c.1488–c.1528) developed. Romano was by far the more original. Not only did he evolve aspects of Raphael's style in new ways, but he also invented a rich new language in his Mantuan frescoes (see plate 263).

An idea of how inimitable were the contributions of Raphael and Michelangelo to Roman High Renaissance painting may be seen in the Roman work of the Piedmontese artist, Sodoma (Giovanni Antonio Bazzi, 1477–1549). He was influenced by Leonardo, and worked in Siena before being commissioned by the Sienese banker Agostino Chigi. In 1516 Sodoma decorated Chigi's bedroom in the Villa Farnesina in Rome (see plate 227), alongside Baldassare Peruzzi (1491–1536), who was then at work on the villa's Sala delle Prospettive. The travels of such a painter as Sodoma (who returned to Siena) were important in carrying the latest news of Roman art to the provinces.

Meanwhile, Florence must have regretted the departure of the great triumvirate who had revitalized its painting. In spite of a handful of masterpieces from the second decade, there is a provincial aura about its art until Pontormo emerges as the Florentine genius of the 1520s. However, Baccio della Porta, called Fra Bartolommeo (1472/5–1517), not only painted some of the most memorable images of the period, but also exercised a wide influence on his contemporaries and partly filled the place left by Leonardo, Michelangelo and Raphael.

Like Fra Angelico before him, Fra Bartolommeo became a monk in the convent of San Marco. His training with Cosimo Rosselli provides little clue to the peculiarly monumental style which he created after 1504, when he painted his Vision of Saint Bernard (Galleria dell'Accademia, Florence). His two versions of the Marriage of Saint Catherine, 1511 and 1512 (Musée du Louvre, Paris and Galleria dell'Accademia, Florence), show the influence of his brief visit to Venice in 1508. In them he evolved a static grandeur after seeing Venetian altarpieces by Bellini and others. As with Andrea del Sarto, there is a sense – for reasons which are not easy to define – that his imagery falls short of the painters whom he sought to emulate. Fra Bartolommeo's masterpiece is the Carondolet Altarpiece (see plate 206); had he permitted himself more of its effortless elegance in his other work, his achievement might have been greater. His partner

from 1509 to 1512, Martiotta Albertinelli (1474–1515), used pronounced *chiaroscuro* to re-interpret Fra Bartolommeo's inventions.

If Fra Bartolommeo sometimes verges on the academic, this is never sensed in his countless beautiful drawings, including landscapes and urban scenes. Andrea del Sarto (Andrea d'Agnolo di Francesco, 1486–1530) was also a great draughtsman in the Florentine tradition, but his variety and inventiveness placed him in the avant-garde of the city's artists, at least during the second decade. While his colleague, Francesco Franciabigio (1482/3–1525) represented the Florentine attempt to emulate Raphael directly, Sarto absorbed much from Leonardo. It was to Leonardo's *sfumato* that Sarto owed the softness of his modelling, if not the models themselves.

198 RIDOLFO GHIRLANDAIO A Man of the Capponi Family, undated

Ghirlandaio is perhaps the most underestimated portraitist of the Florentine Cinquecento. His psychological insights were usually rendered in images of considerable restraint, but his innovations of form were of the greatest importance for artists such as Sarto, Pontormo and Bronzino. This portrait also shows Ghirlandaio's outstanding technical ability.

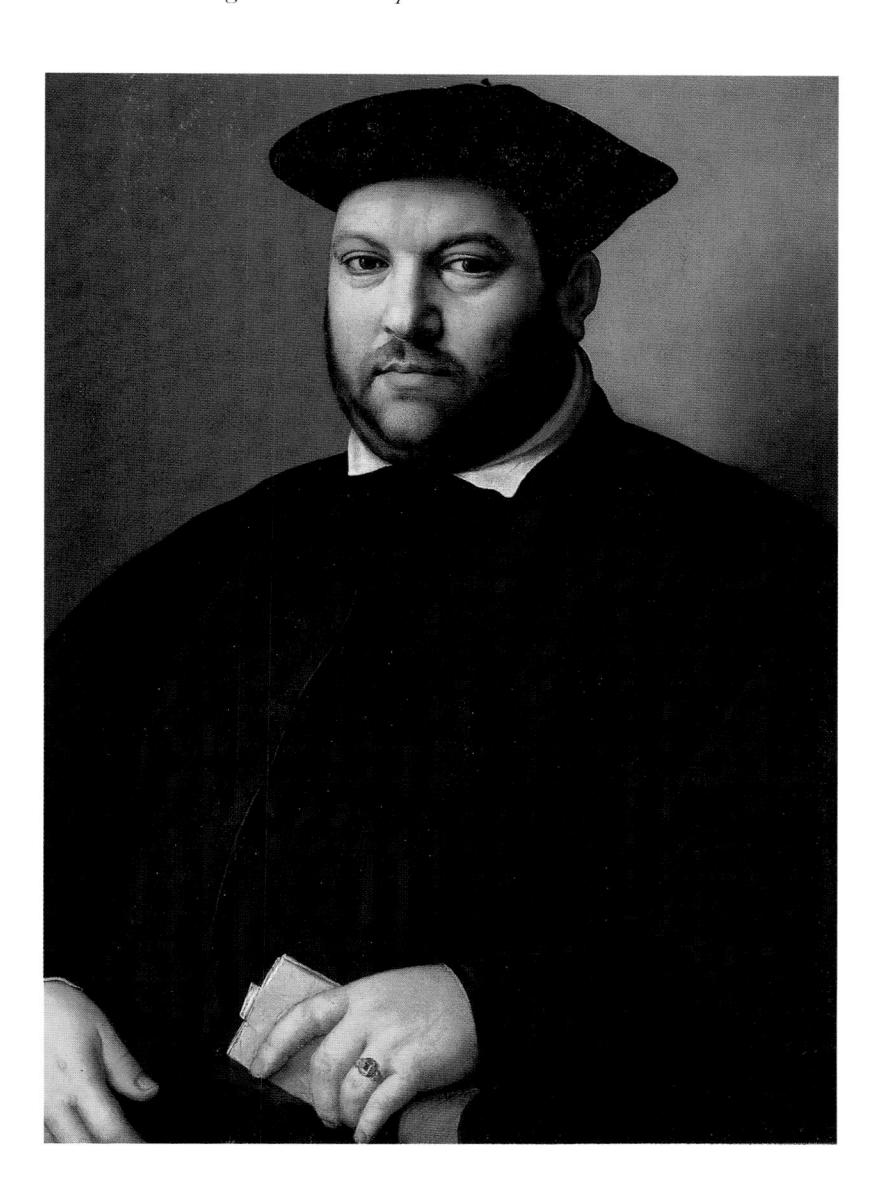

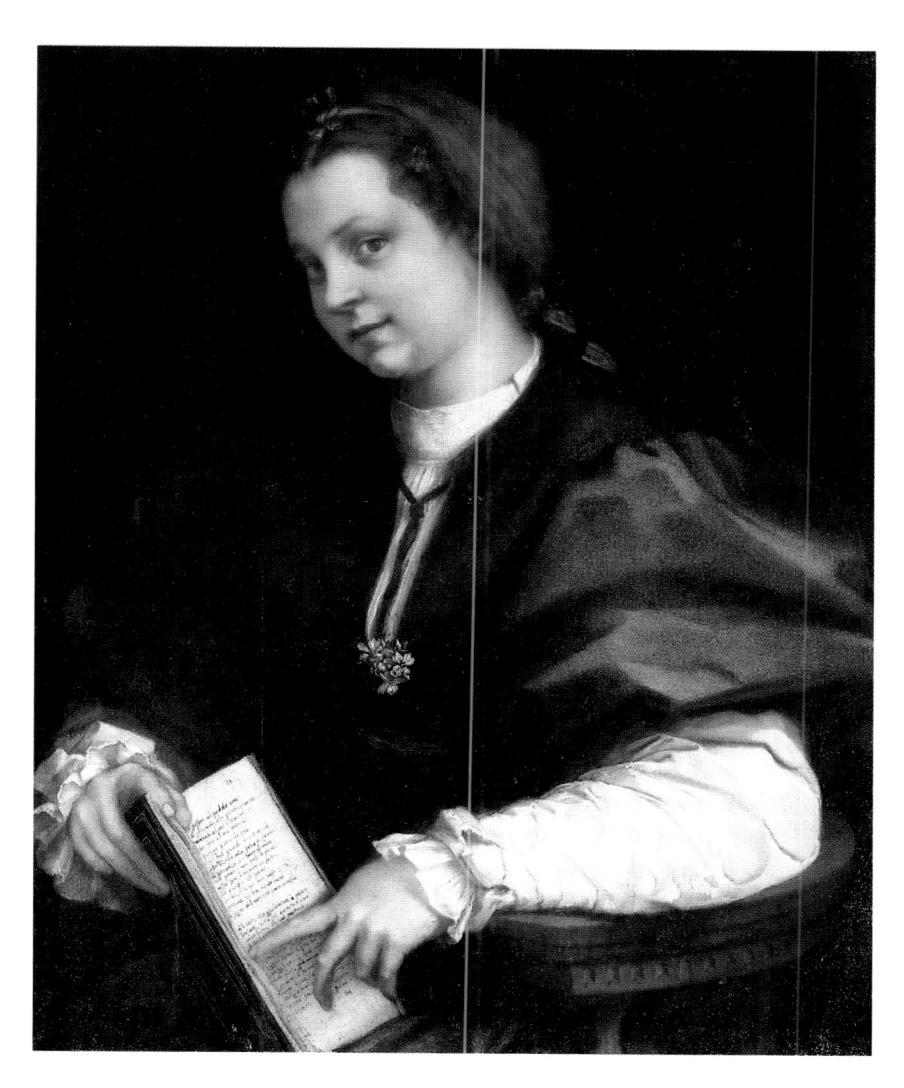

199 Andrea del Sarto A Lady with Petrarch's Sonnets 1528–9

This is one of the most mysteriously fascinating portraits of its period. It seems safe to discount the old idea that it represents the artist's wife. The first sonnet refers to the lover's faith in Love's power in spite of uncertainties, while the second speaks of the sublimation of the baser desires to higher planes. The subject's glance at the painter is clearly not that of a distant aristocratic sitter. Recent cleaning has revealed the most subtle palette of colours and a delicate sfumato technique, in which Sarto had few rivals at this time.

His first important frescoes, completed in 1510 at the Santissima Annunziata, show the *Life of Saint Philip Benizzi* and recall Quattrocento art and his studies with Piero di Cosimo (c.1462–1521?). By 1514, when he completed another fresco in the same location, the *Birth of the Virgin*, he had fully entered the monumental spirit of the High Renaissance imported by Fra Bartolommeo. This grandiose scene is Florence's closest approximation to Raphael's Roman style of the same years, but is imbued with the late Quattrocento tradition of domestic intimacy best seen in Ghirlandaio.

In the steps of Leonardo, Sarto worked briefly for Francis I of France in 1518–19, having in the previous year completed his *Madonna of the Harpies* (Galleria degli Uffizi, Florence). This showed his closeness to the

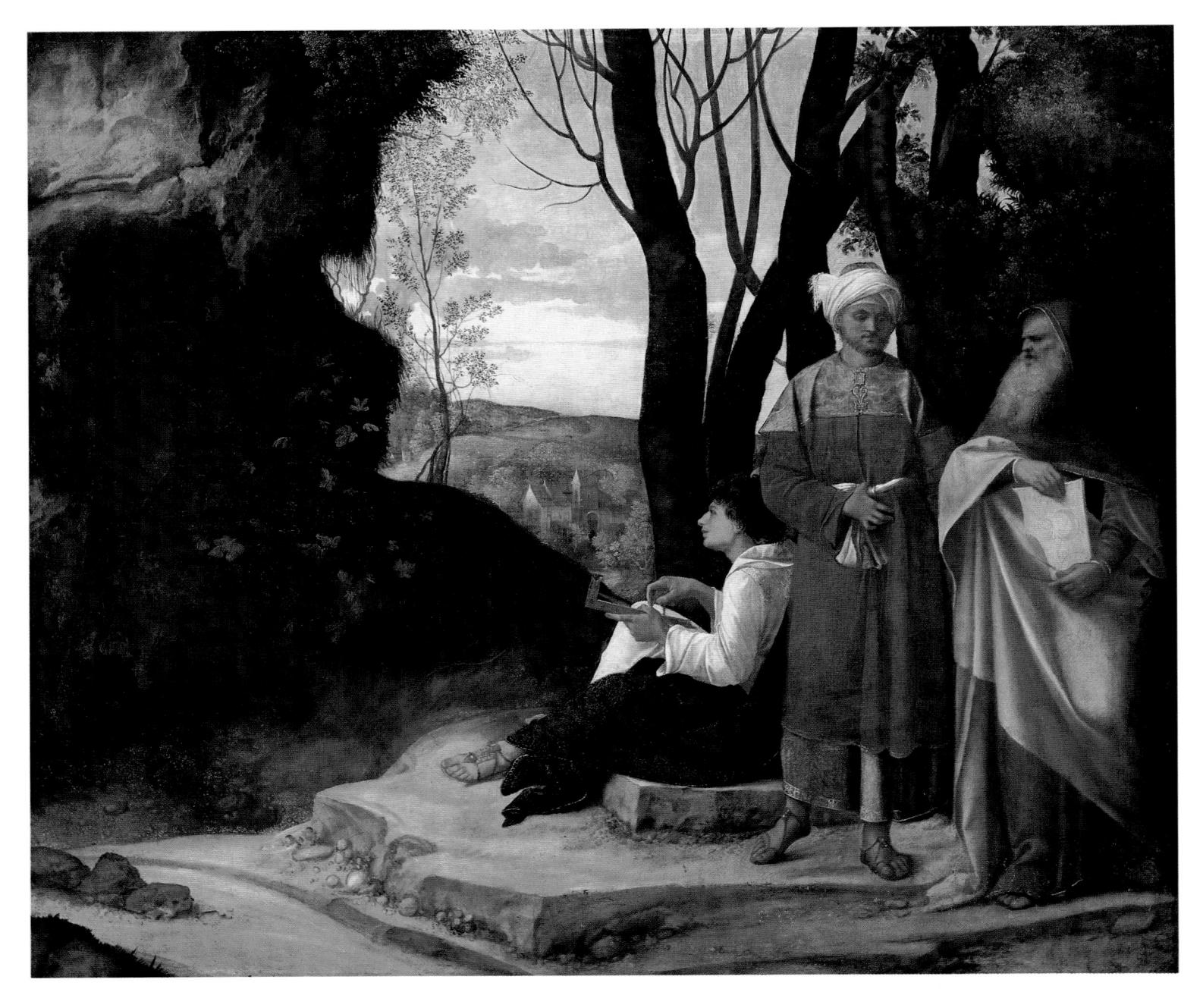

These figures have been variously interpreted as the three Magi, symbols of the ancient, medieval and modern worlds, and representatives of Arabic, medieval and Renaissance philosophies. A copy by Teniers the Younger shows the picture was cut at the left and originally gave greater emphasis to a cave there. It is clear that three different ages of man and, probably, three nationalities, are represented; this and their differing gestures clearly indicate a specific meaning for each one, probably unified by their relationship with the mysterious cave and the brilliantly painted sunset background.

Raphael of the *Sistine Madonna*. His French journey appears to have altered Sarto's approach, however, and on his return the first elements appeared which would soon lead to parallels with the early Mannerism of Pontormo, his former assistant.

The vigour of Raphael's classicism is absent from Sarto, whose imagery often appears passive, even in potentially dynamic themes. His real magic lies in the ethereal quality which his use of *sfumato* gives his faces. This works

particularly well in his portraits, whose restraint lends them an elusive and enigmatic quality (see plate 199). Together with Ghirlandaio's underestimated likenesses (see plate 198), Sarto's original conception of portraiture was fundamental to the work of the Mannerist artists Pontormo and Bronzino.

Painting in Venice

Like Florence, and in contrast with Rome or Milan, High Renaissance Venice was to build on the achievements of its native painters during the Quattrocento. Giovanni Bellini, who may have been almost ninety at his death, retained his facility for adaptation, which enabled him even in later life to create novel imagery of startling beauty (see plates 212, 215). But in spite of his dominant presence at the turn of the century (and his importance as a teacher), the changes in Venetian art were almost entirely due to one remarkable painter, Giorgione.

In addition, the emergence of so great a genius as Titian from Giorgione's studio also created a situation unique to Venice, in that Giorgione's style was not merely continued by imitators, but evolved by a pupil of equal standing. No parallel exists for this in the High Renaissance, and it partly accounts for the undiminishing strength of Venetian art through almost an entire century. While there is a continuous ebb and flow of talent around Florence and Rome, Venice appears to go only from strength to strength: Titian, Veronese and Tintoretto were surrounded by a galaxy of lesser, but nevertheless talented painters.

The innovation of painting in oils on canvas proved crucial for Venice, and was generally adopted by the beginning of the sixteenth century. The new medium gave an infinitely greater richness of tone and depth of colour than tempera. Indeed, it is with sixteenth-century Venetian painting that we associate the first use of the canvas's texture to augment that of the paint laid on it. Giorgione's achievement is inconceivable without the aid of oil paint on canvas.

Painters in Venice generally used the same pigments as elsewhere, but its trade with the East led to the introduction of certain novelties. Orange, previously rare in Quattrocento painting, began to appear in the work of Carpaccio and his contemporaries, and was later adopted by Titian. The light effects, atmosphere and texture associated with Venetian art owe their existence to these artists' abilities to maximize the potential of canvas.

The impetus to employ such effects came from Giorgione (Giorgo Barbarelli or Giorgio del Castelfranco, 1476/8–1510), and the important innovations of early Venetian Cinquecento painting stem from the few pictures certainly by him. These are the *Castelfranco Altarpiece* (although even this has recently been doubted), *The Tempest* (see plate 190), *An Old Woman ('Col Tempo')* (see plate 201), *The Three Philosophers* (see plate 200), *Judith* (Hermitage Museum, Leningrad) *Laura* (Kunsthistorisches Museum, Vienna), and the Dresden *Sleeping Venus* (see plate 220). The attribution of others oscillates between Giorgione and his followers.

Giorgione was a nickname meaning 'great George', explained by Vasari as relating to 'the stature and the greatness of his mind'. Given that our knowledge of him comes from some contemporary references of 1506–10 and very few accepted paintings, his importance is all the more surprising. The uncertainty of attributions to him also indicates how great and immediate his influence was.

Vasari relates that Giorgione began his career as a purveyor of small devotional Madonnas. Cabinet pictures designed for private settings remained his preference and

the Castelfranco Altarpiece is in many ways unsatisfactory by comparison. Giorgione's fascination for us lies in the dichotomy between his surface realism and the indefinable magic of his images. A comparison with another sort of contemporary Venetian realism in Jacopo de' Barbari (active c.1497, died 1516?, see plate 202) shows how unfactual Giorgione was. Even his contemporaries seemed at a loss to ascertain the precise subject of many of his paintings. Michiel, the informed connoisseur, resorted to generalized descriptions of pictures such as The Three Philosophers (see plate 200), leaving their detailed interpretation to the twentieth century. However, none of his followers succeeded in capturing the intense, reflective and self-absorbed quality of his pictures. For example, Lorenzo Lotto and Dosso Dossi tended to create their individual styles from selected aspects of Giorgione's (see plates 246, 266).

Vasari attached great importance to Leonardo's Venetian visit of 1500. He saw Giorgione's *sfumato* as resulting from it, and placed him alongside Leonardo for his innovations. It is likely that Giorgione also studied in Giovanni Bellini's studio in the early or mid-1490s with

201 GIORGIONE An Old Woman 1508—10
The old woman holds a piece of paper bearing the motto 'col tempo' referring, together with her decrepitude, to the effects of time's passage. It is unlike any other painting attributed to Giorgione, particularly in the directness of its unambiguous message and its paint handling, although the figure's scale relative to the picture shape relates to several other works by or attributed to him.

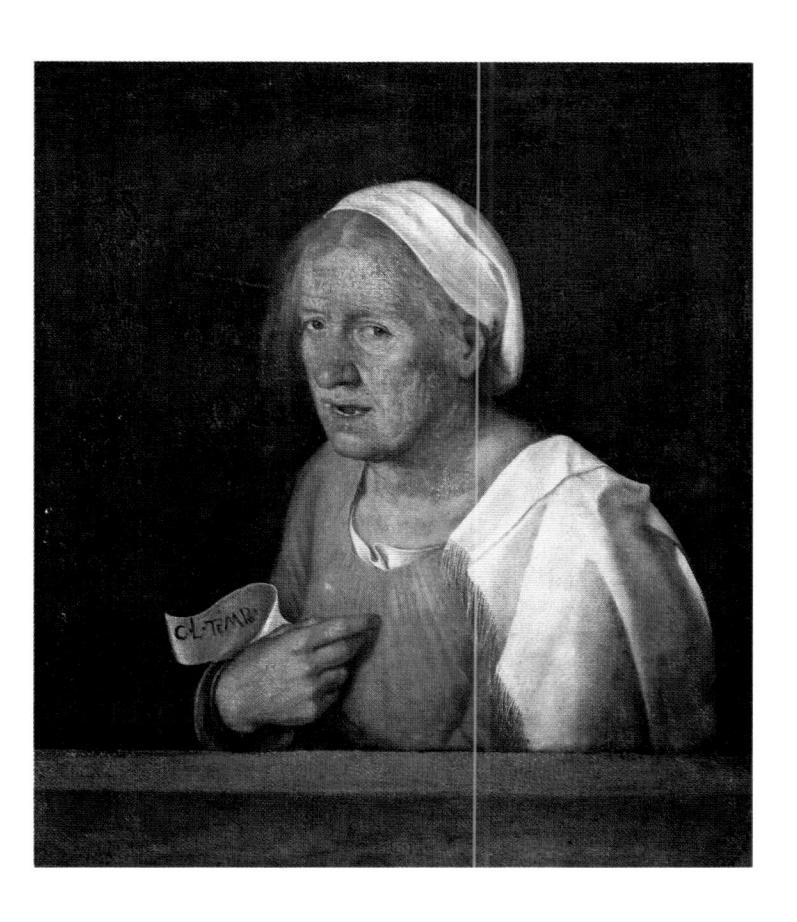

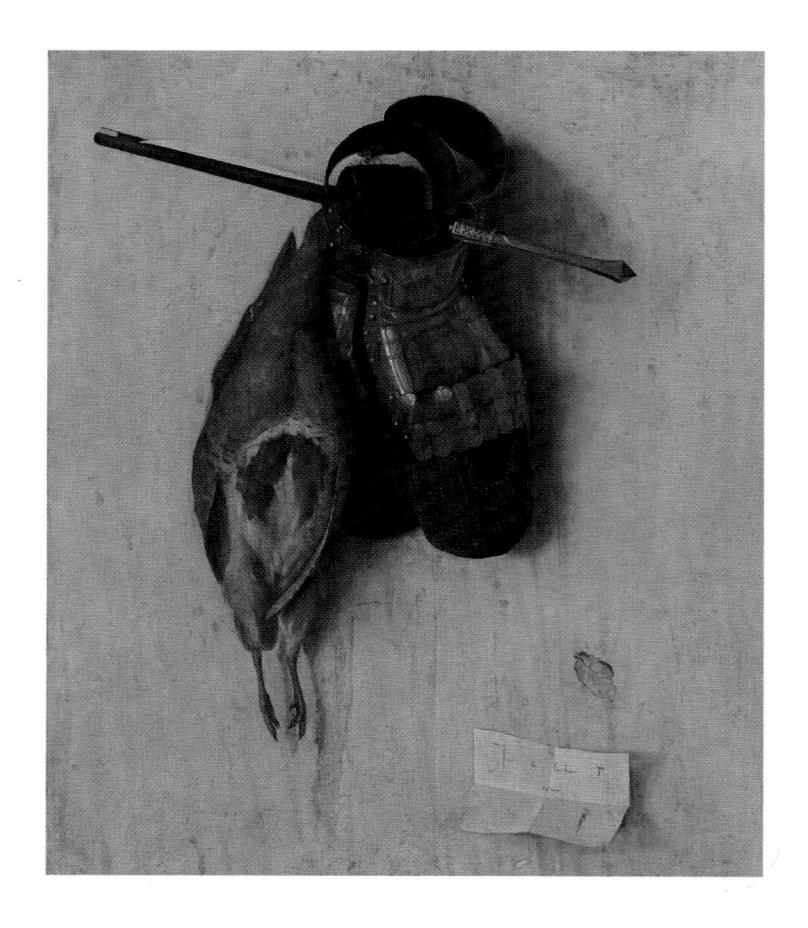

202 JACOPO DE' BARBARI Still Life 1504

This may have formed the cover or reverse part of a portrait, in which case it would have had less importance as an autonomous still life.

The influence of miniature painting is clear, probably along with that of Dürer and Antonello da Messina.

Lorenzo Lotto and Palma Vecchio. But unlike them he appears to have had sufficient knowledge of central Italian painting, including Perugino, to evolve in a very different way. If any development can be traced in Giorgione, it is in the accelerated progress from slight hesitancy in The Tempest of 1503/4, through a more classical assurance in Judith (The Hermitage, St Petersburg) of 1504/5, to a style comparable with High Renaissance monumentality in The Three Philosophers of about 1506 (see plate 200). In other hands, these paintings might well have been produced at intervals of ten years. In his last great image, the Sleeping Venus of 1507-8, the sensuality which lightly surfaces in his earlier work triumphs completely (see plate 220). This quality, which Giorgione accentuated with vibrating light and the liquid handling of paint, most fascinated Titian and his other followers.

Giorgione's premature death from plague in 1510, followed by Bellini's in 1516, left the centre stage open for Titian's all-conquering genius. The other major Giorgione follower, Sebastiano del Piombo (c. 1485–1547), made his career in Rome from 1511, and would probably not have posed a serious threat to Titian.

Of Titian (Titiano Vecellio, c.1485-1576), Vasari says

that he '... imitated Giorgione so well that in a short time his works were taken for Giorgione's'. For a long time many eluded precise attribution (among them, the Louvre Concert Champêtre, the Pitti Concert and the Glasgow Woman taken in Adultery). His personal language was formed by 1511 when he frescoed Padua's Scuola del Santo. Already Titian showed more flexibility in his handling of outline than his master, and this became one of the important factors in his treatment of the human form. By the 1550s, when he painted Diana and Actaeon (see plate 238), the outlines had become absorbed into their surroundings.

Titian's feeling for figure composition, and his increasingly rich colour, gained momentum after Giorgione's death, and during the second decade of the sixteenth century he produced a number of innovative paintings, including *The Three Ages of Man* (see plate 221) and *Sacred and Profane Love* (see plate 219). His passion for brilliant, saturated colour developed rapidly, culminating in the series he painted in 1518–23 for his new patron, Alfonso d'Este (see Chapter VIII).

Titian expanded his circle of patrons at this time, but always resisted attempts to lure him away from his beloved Venice. His status as the city's foremost artist was crowned by one of the most important commissions of his lifetime, and one of the major achievements of High Renaissance art: the Assumption of the Virgin (see plate 254). Like the Vatican works of Raphael and Michelangelo, this transcended its period to express aspirations which could only be fully realized during the Baroque age. With the Assumption, and his other masterpiece in the Frari Church in Venice, the Pesaro Madonna (1519-26), Titian moved into a new dynamic phase in the 1520s. Such wealth of inspiration and energy also characterizes the Parmese dome frescoes of Correggio, which may be indebted to his knowledge of the Assumption through prints (see plate 222).

Like Raphael, Titian achieved social success equal to his attainments in painting, and on an even greater international scale. Vasari speaks of his 'power of attaching himself and making himself dear to men of quality'. His connections with the Emperor Charles V (see plate 7) and his son Philip II brought him a knighthood, and the unbroken momentum of his career ensured him personal wealth. Together with his friends, the sculptor Jacopo Sansovino (1486–1570) and the poet Pietro Aretino (1492–1556), Titian ruled the artistic life of Venice for more than sixty years.

Titian's social mobility is clear from the immense range of his portraits: of the Imperial family and European monarchs; of the Italian aristocracy, Venetian doges and popes,

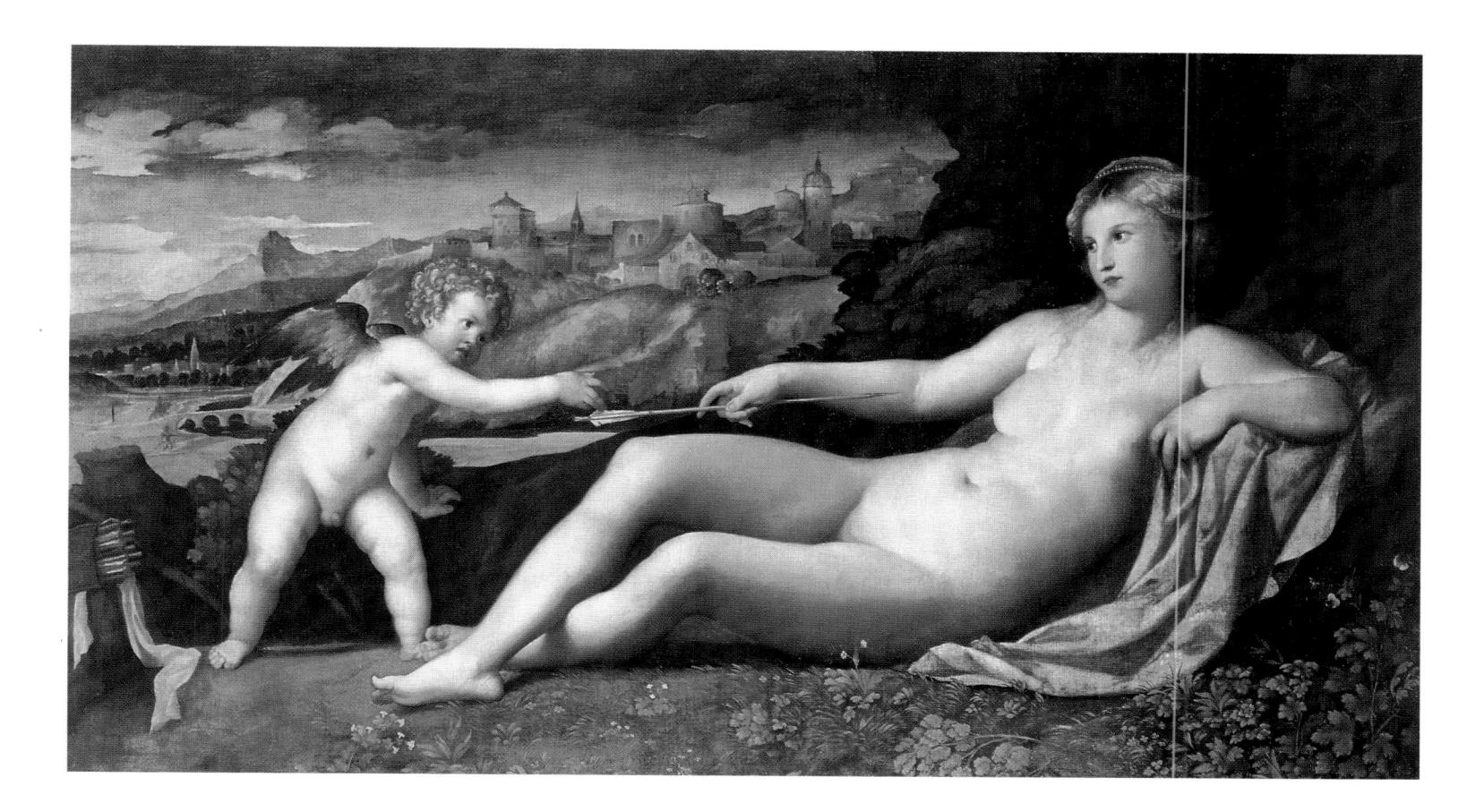

203 PALMA VECCHIO Venus and Cupid in a Landscape 1522–4 The subject appears to come from Ovid's Metamorphoses; Venus was accidentally scratched by one of Cupid's arrows, leading to her tragic love for Adonis. Venus is surprisingly monumental, and her elongated limbs and Cupid's contrapposto are both Mannerist elements, but the effect is one of elegant naturalism.

and of the leading intellectuals of the day. From his first portraits (such as the London Ariosto), to the last (such as the Vienna Jacopo Strada), he excelled in the half- and three-quarter-length formats, suggesting the status and character of his sitters with an economy of means which continued to influence portraiture long after his death. The portraits of Moretto da Brescia (Alessandro Bonvicino, c.1498–1554), who may have trained with Titian, are indebted to him. Another Brescian artist, Girolamo Savoldo (active 1508-after 1548) also came under his sway (see plate 226). The dividing line between Titian's female portraits and mythological paintings of women is often fine, as in the famous Venus of Urbino (Uffizi, Florence). With Palma Vecchio (see plate 203) and Paolo Veronese, Titian created absolutes for feminine beauty which far outlasted their period.

Correggio

The brief career of Correggio (Antonio Allegri, 1494–1534) overlaps the High Renaissance and early Mannerist periods. His development parallels that of

Raphael in his rapid absorption of Quattrocento influences before launching a new and unique style. That style remained faithful to High Renaissance ideals, never entering the realms of physical distortion which characterize his follower Parmigianino. Nonetheless, it contains many elements related to Mannerism.

The name of Correggio's master is unknown, but in the decade from 1510 he showed the influence of both Andrea Mantegna and Lorenzo Costa, who succeeded Mantegna as court painter at Mantua. These influences were rapidly superseded by Roman art and the work of Raphael. Maintaining that Correggio had never visited Rome (much of his early knowledge of Raphael came from Marcantonio Raimondi's prints), Vasari believed that it was 'La gran madre Natura' rather than Classical influences which transformed the youthful painter's delicate, almost feminine manner, derived from Mantegna and Leonardo, into major art. The leap from Correggio's earliest paintings (such as the Detroit Marriage of Saint Catherine) to the grandeur of his two Parmese dome frescoes and the great altarpieces is, however, inconceivable without any experience of the avant-garde in Rome. The new spatial ideas found in Florentine and Roman painting around 1505-15, coupled with his inheritance of Mantegna's fascination with perspective, quickly changed Correggio's approach. It is now generally thought that he visited Rome in 1513, after Pope Leo X's election. Thus, not only could he have met Leonardo (and presumably have seen the Mona Lisa) but he also probably observed Raphael's latest style at first hand in the Stanza della

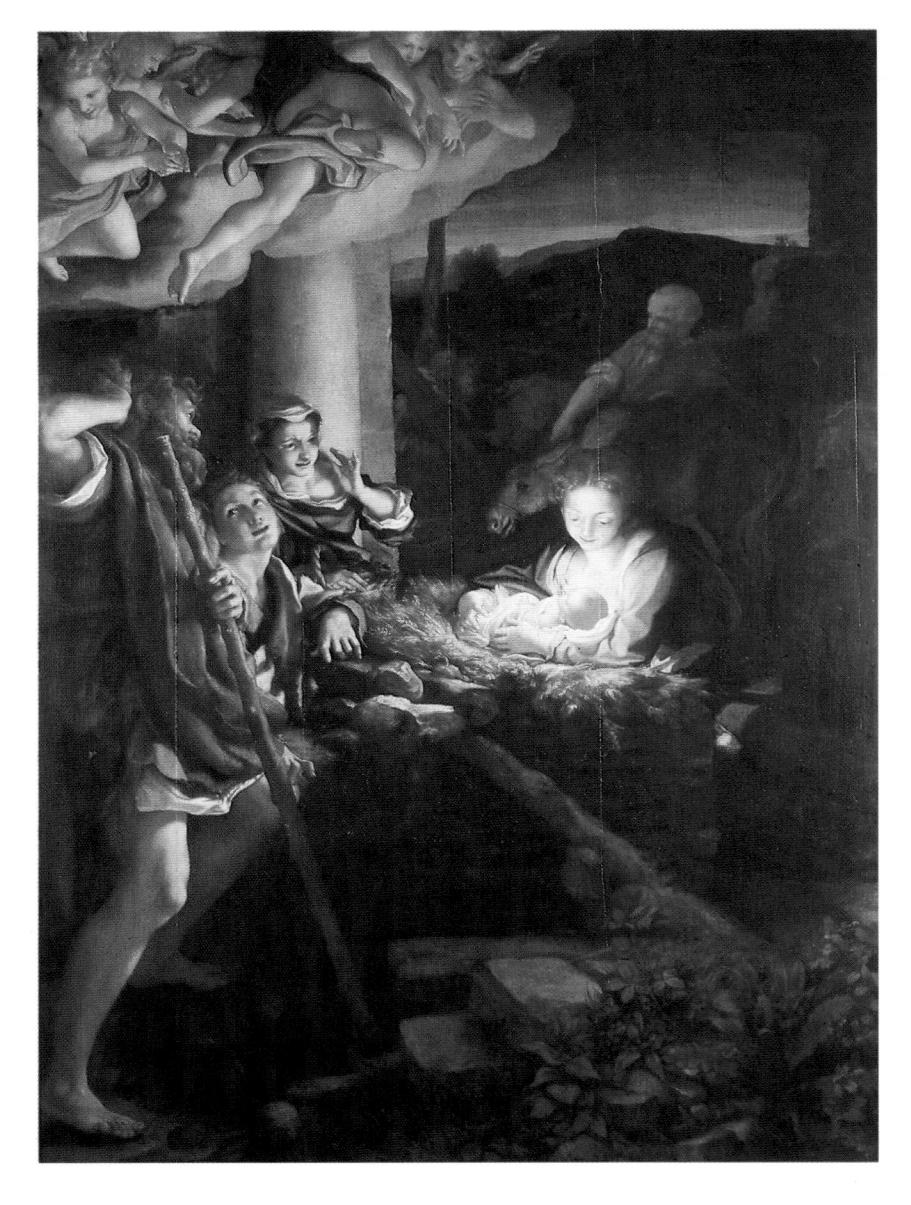

204 CORREGGIO Nativity 1529–30

This picture hung in the Pratonero Chapel in San Prospero at Reggio Emilia until Duke Francesco I d'Este stole it for his collection in 1640. The remarkable light effects and the dynamic composition predict the pictorial devices of the Baroque. In Italian the Nativity scene was often described as a 'notte', or night.

Segnatura, the frescoes in Santa Maria della Pace and the early Roman altarpieces.

Both Raphael and Correggio shared a passion for the spatial effects so vital to High Renaissance art (Raphael's was also expressed through buildings such as the Chigi Chapel in Santa Maria del Popolo in Rome). In Correggio it led to proto-Baroque illusionism, in Raphael to the grandeur of formal inter-relationships found in the *School of Athens* or the *Sistine Madonna*. Both artists maintained a lifelong eclecticism, perhaps even more pronounced in Correggio's case than Raphael's, since he assimilated the work of painters as diverse as Leonardo, Mantegna, Lotto, Raphael and even late Gothic artists.

Correggio's career has been described as 'a struggle to master every technical device a painter could imagine, followed by another, less evident, struggle to prevent such mastery from mastering him.' This emphasis on virtuosity is inevitable in today's assessment of Correggio, since, as with Raphael, it seems to mitigate other characteristics less palatable to the twentieth century, such as ecstasy and sweetness of expression.

Correggio created his most characteristic paintings after settling in Parma in 1519, two years before Leo X reclaimed the city from the French. His style after this date is notable for its unique sensuousness, whether the theme is religious (see plate 222) or mythological (see plate 224). For Correggio, soft, yielding flesh and voluptuous expressions were common to both saints and nymphs. Correggio's saints display an aura of receptivity to divine intervention, his female mythological figures an air of total abandon.

Unlike Giorgione or Titian, Correggio prepared his compositions in countless drawings, in the manner of the Florentines. This gave his figures a deliberate, forceful presence despite their *sfumato* outlines, accentuated by the way he expanded them to the edge of the canvas, even beyond it into the spectator's space. Such dynamism led to his invention of the illusionist dome with many figures seen in foreshortening from beneath (*sotto in sù*).

A pattern emerges in Italian painting of the early sixteenth century which in many ways justifies Vasari's notion of progress. With the exception of Leonardo, the key figure in the development of the High Renaissance, the major artists involved in its creation were born around 1480 and all came to artistic maturity between 1500 and 1510. Regardless of their places of birth, they display characteristics which evolved simultaneously.

This is evident at the end of the first decade in the similarities between Giorgione's *The Three Philosophers*, the figures of Plato and Aristotle in Raphael's *School of Athens*, and the saints in Fra Bartolommeo's *Carondolet Altarpiece*. The parallel evolutionary processes continue, with the stylistic changes in Raphael's *Transfiguration* comparable to those in Titian's *Assumption* – and this is not only due to direct traceable links between works of art.

This artistic unity, which makes sense of the term High Renaissance, began to disappear after the second decade. With Leonardo's death in 1519 and Raphael's in 1520, followed by the Sack of Rome in 1527 and the dispersal of the School of Rome, an era ended. Michelangelo was not to return permanently to Rome until 1534, by which time Mannerism was firmly entrenched (if not given that name) as the prevailing style in the arts. An age of optimism seems also to have ended, soon to be replaced in Italy with an ever-increasing steely professionalism best represented by Vasari's career. Vasari believed that his own age had achieved perfection. It may have been this illusion that led to the end of the Renaissance.

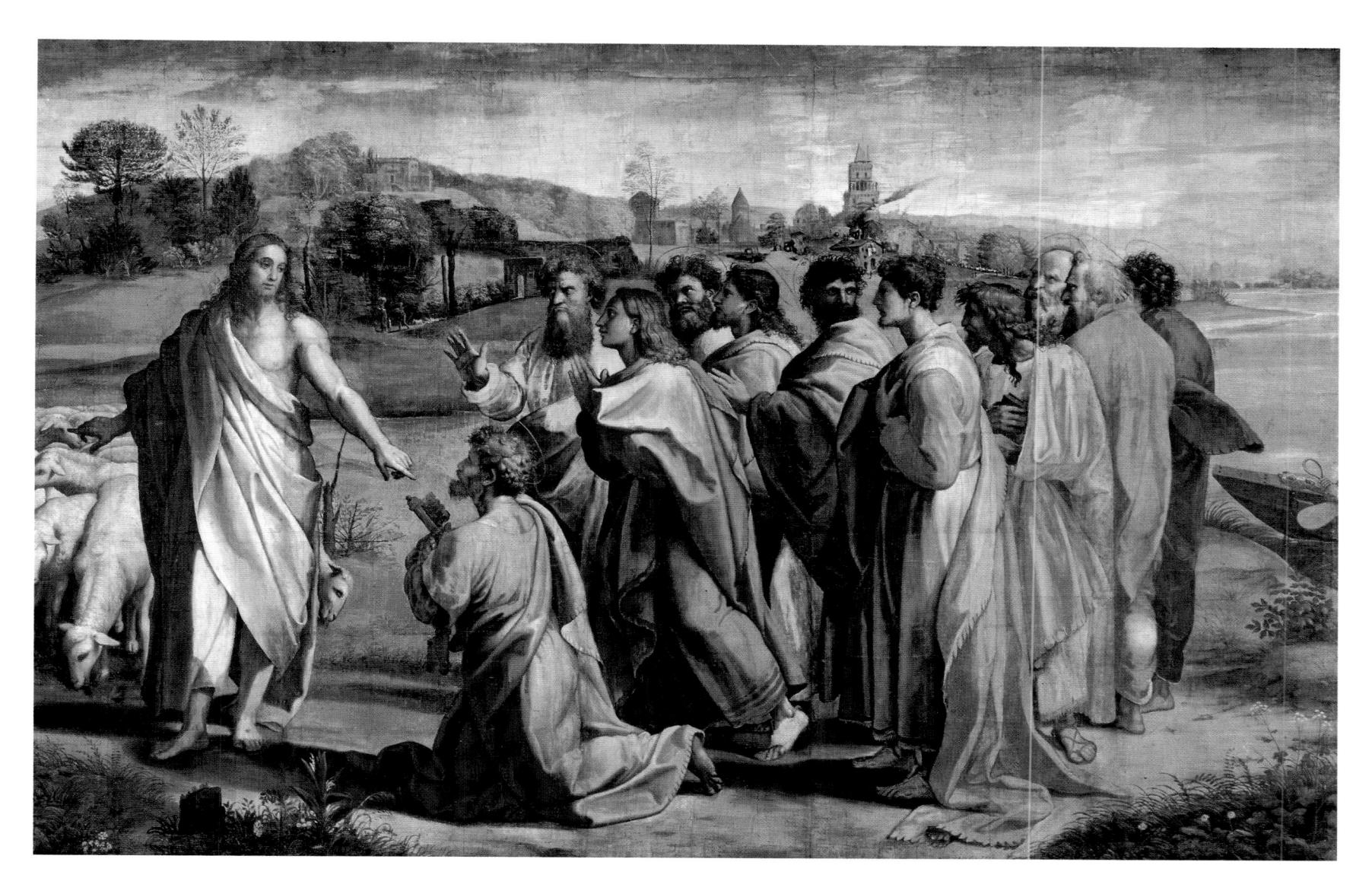

205 RAPHAEL Christ's Charge to Saint Peter 1515–16 (Above) The ten cartoons commissioned by Pope Leo X from Raphael have always been regarded as among the most important examples of the classic art of their period. The cartoons were probably painted between June 1515 and December 1516, and by late 1519 seven of the tapestries were in place in the Sistine Chapel. Vasari says of them: 'This work was executed so marvellously that it arouses astonishment in whoever beholds it wondering how it could have been possible to weave the hair and beard in such detail and to give softness to the flesh with mere thread.' In style the cartoons come between Galatea of 1514 (see plate 214) and the Transfiguration begun in 1517 (see plate 248).

206 Fra Bartolommeo Carandolet Altarpiece c.1511

(Right) One of the major altarpieces of the High Renaissance, this was commissioned by Ferry Carandolet, Archdeacon of Besançon and Ambassador to Rome. He is kneeling at the right. The Virgin is supported by putti against a background of magnificent Classical architecture, framing a view which recalls the artist's many landscape drawings. Its symmetrical composition and the effortless elegance of the figures make it one of Fra Bartolommeo's finest paintings.

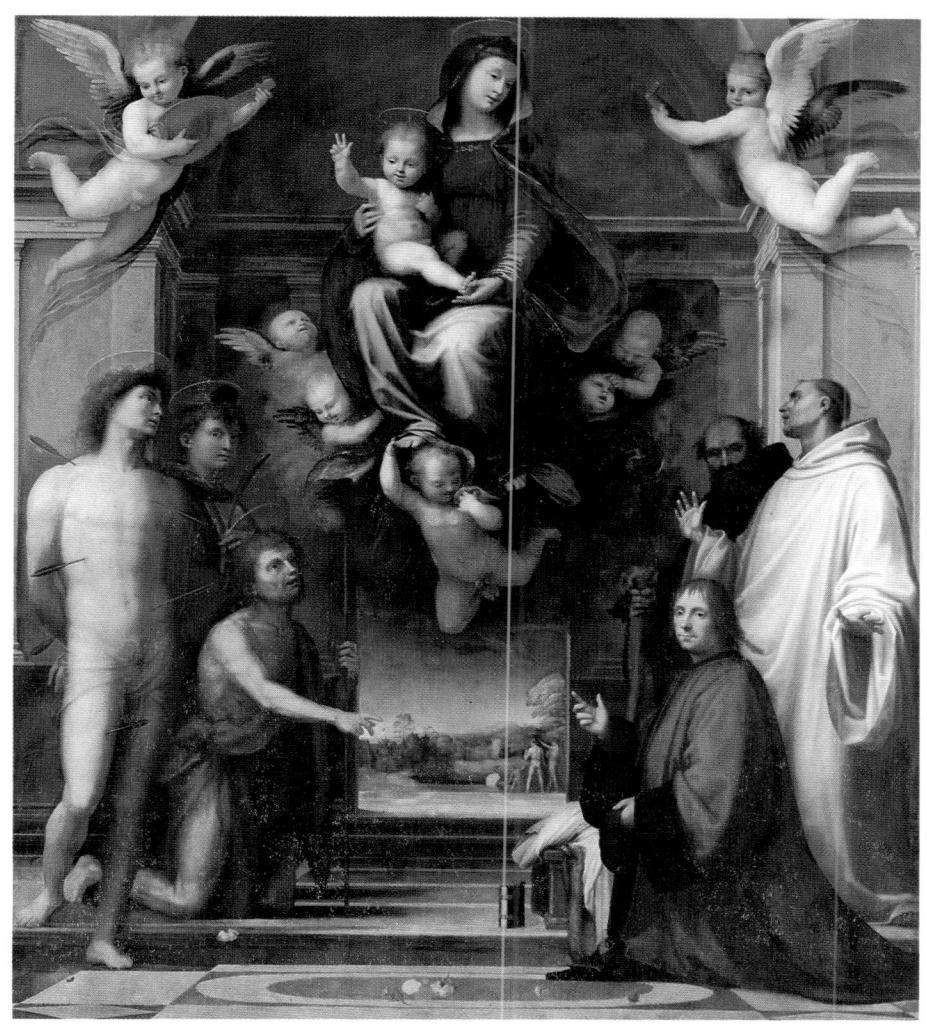

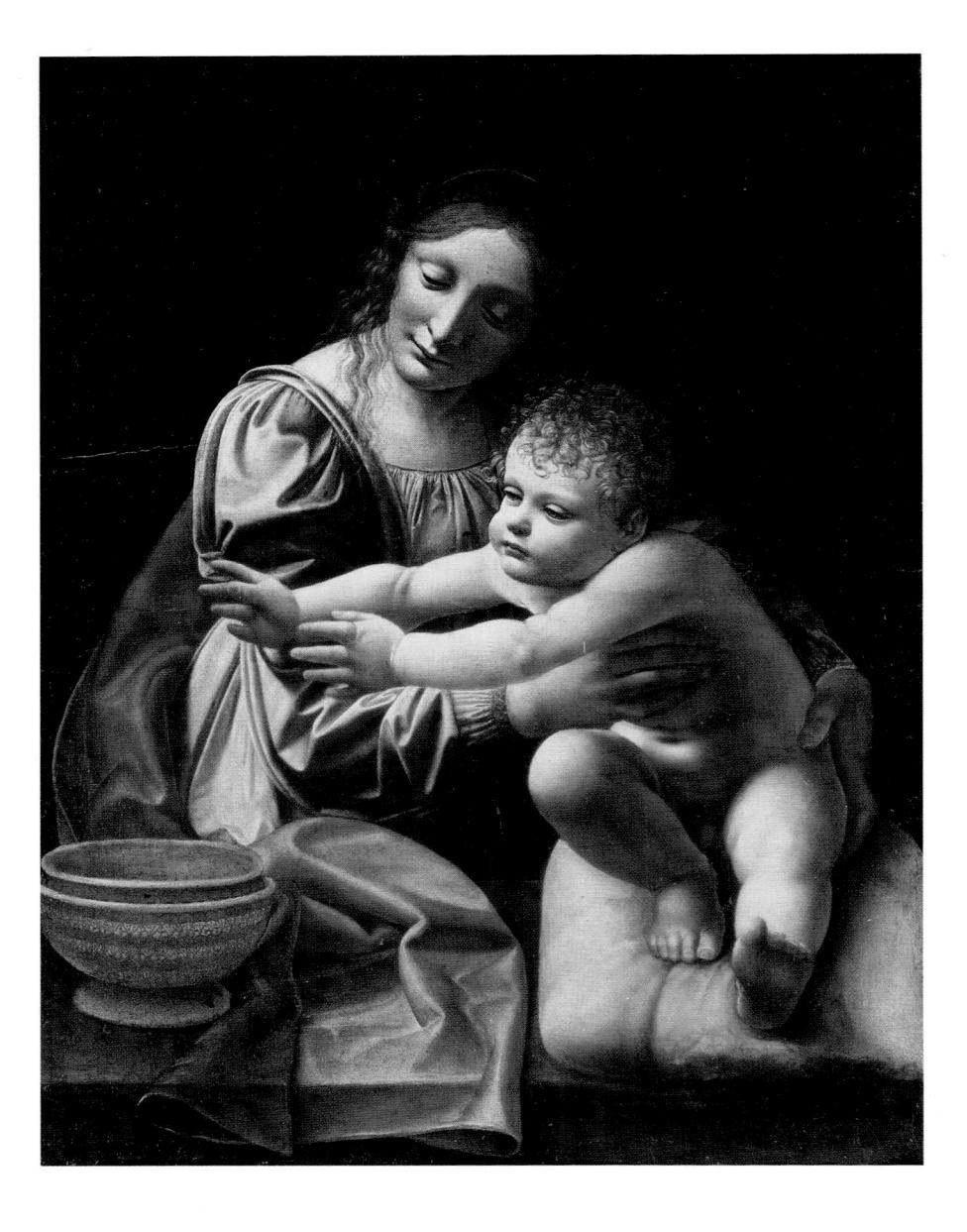

207 GIOVANNI ANTONIO BOLTRAFFIO Virgin and Child, late 1490s

(Left) This picture is of such high quality that the involvement of Leonardo has been suggested. Both facial types show his influence, as does the meticulous handling of the hair and other details. In this Boltraffio reveals himself a greater master of composition, colour and psychology than other Leonardo pupils, such as Luini.

208 Leonardo da Vinci Virgin and Child with Saint Anne and Saint John the Baptist ϵ .1498

(Right) The origin of this cartoon is unclear, although Louis XII of France ordered a painting of the theme from Leonardo in Milan before 1500. The grandeur of the composition led Berenson to compare its drapery folds with those of the goddesses of the Elgin Marbles. Its design had a considerable influence on Milanese painters like Luini.

209 ARISTOTILE DA SANGALLO after MICHELANGELO Battle of Cascina *c.*1542

Vasari described Michelangelo's conception thus: 'one saw there muscles and nerves in their entirety . . . incredible positions: standing, kneeling, bending, lying, getting up, with skilful foreshortening' and it was at his instigation that Sangallo made a partial copy of it. Michelangelo began the cartoon in December 1504, making changes in 1506. It was probably dismembered and destroyed by repeated copying.

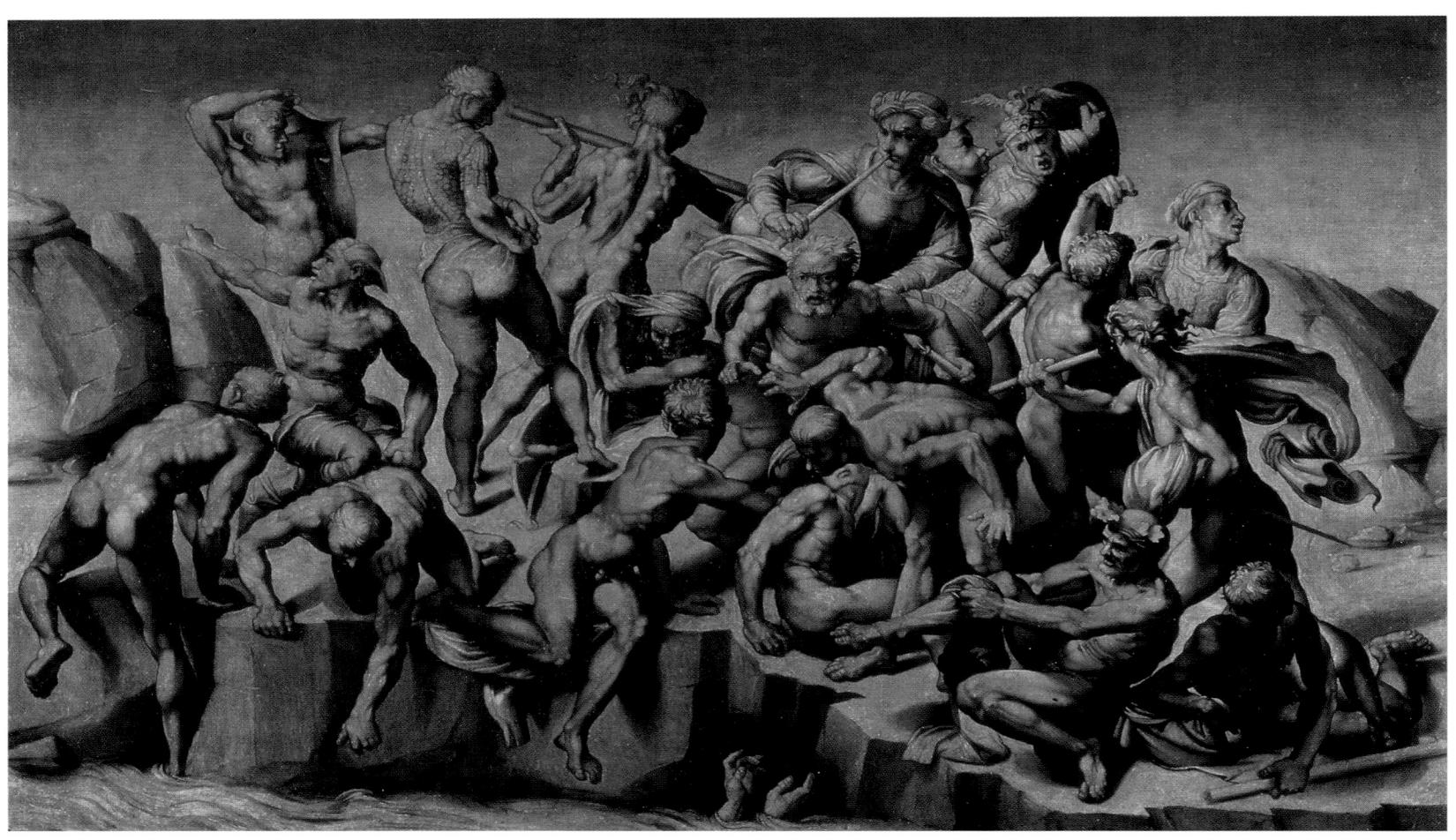

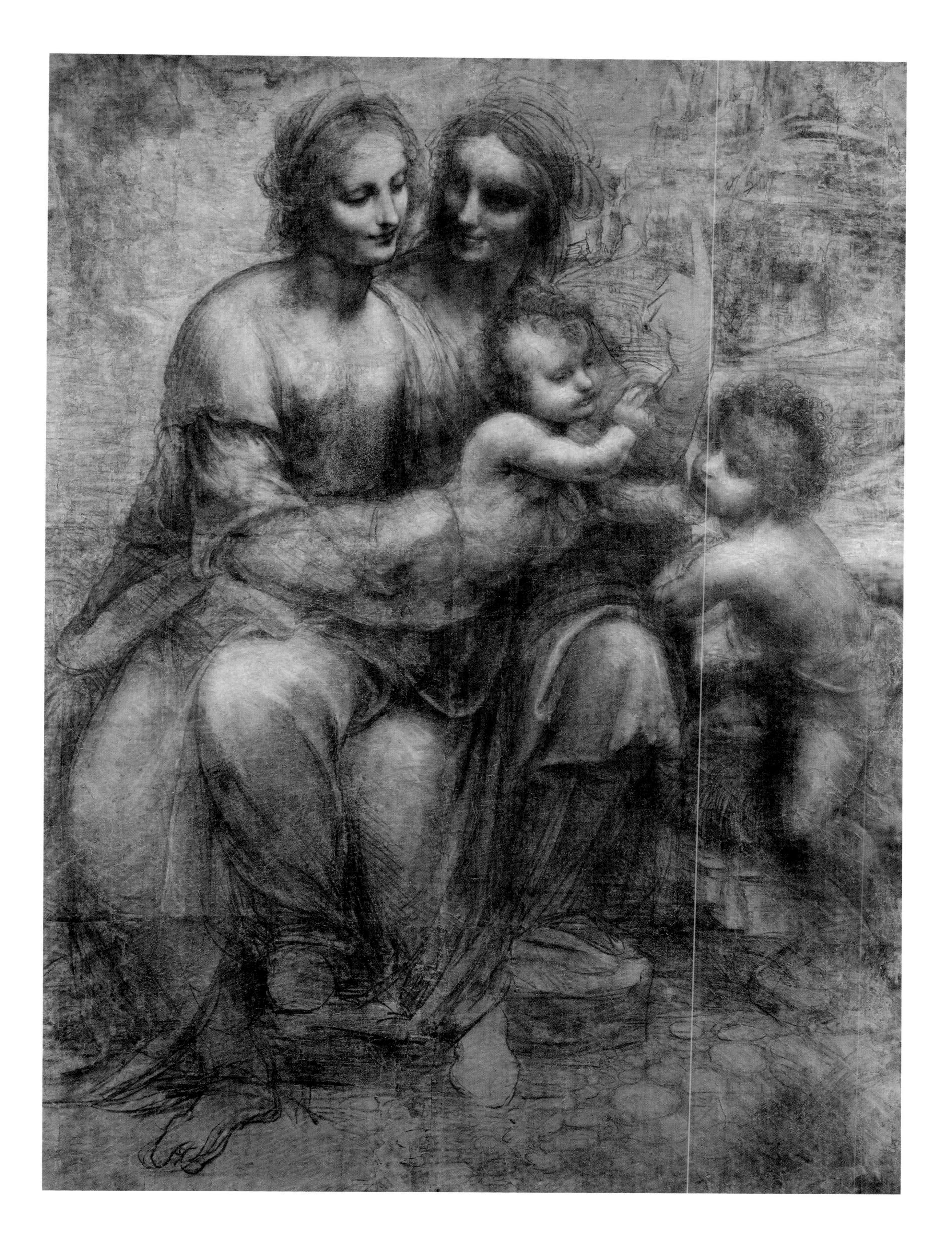

210 MICHELANGELO Holy Family with Saint John the Baptist (Doni Tondo) 1504 Vasari records the commissioning of this panel by Michelangelo's friend Agnolo Doni for his wedding to Maddalena Strozzi. The magnificent carved and gilded frame bears her arms. This is the only securely documented painting (as opposed to fresco) by Michelangelo. The Virgin's sculptural, monumental figure looks forward to the Sistine sybils, and her contrapposto and modelling of cool, acid colour without chiaroscuro provide the starting point for the Florentine Mannerists Pontormo and Bronzino.

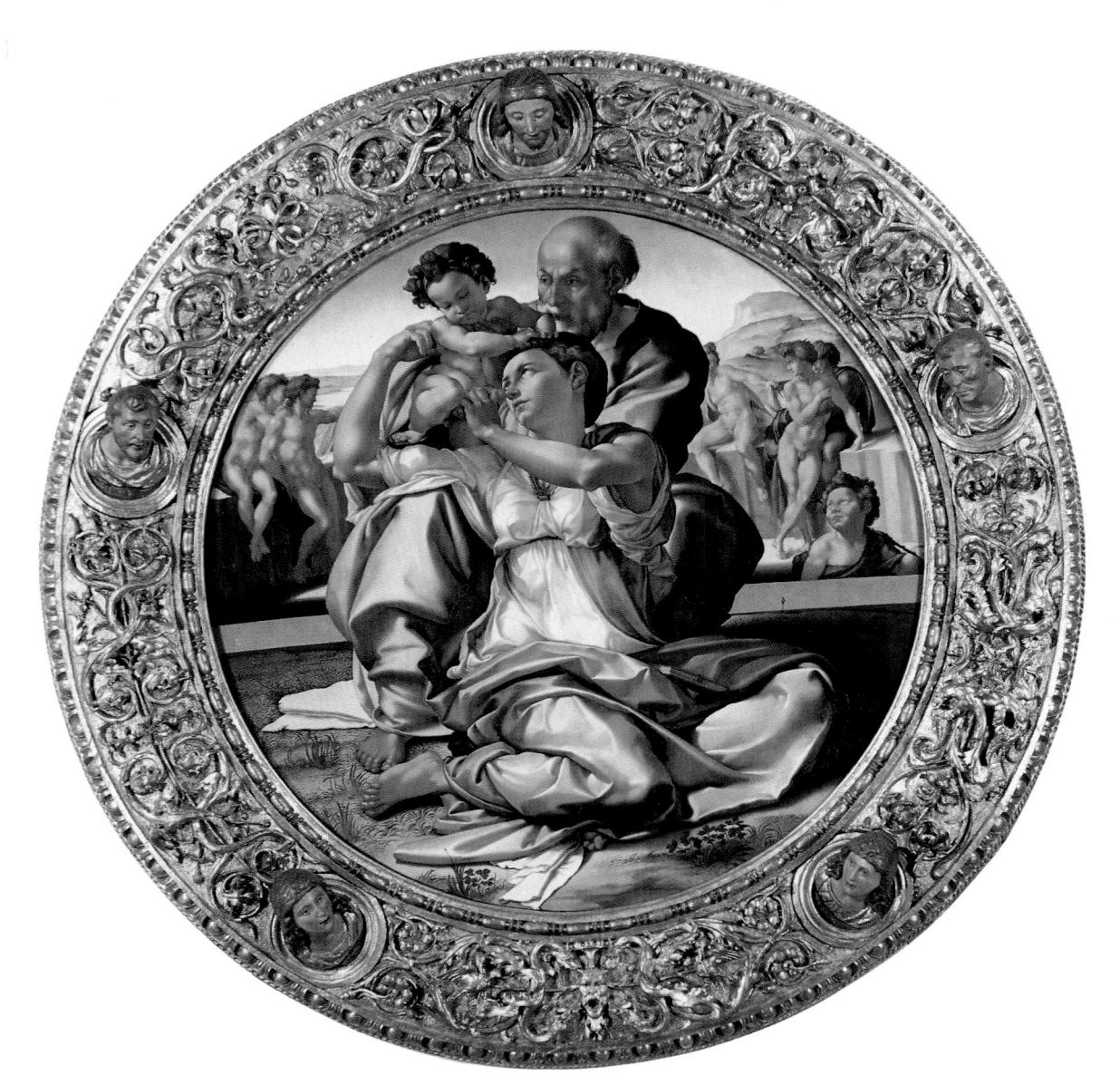

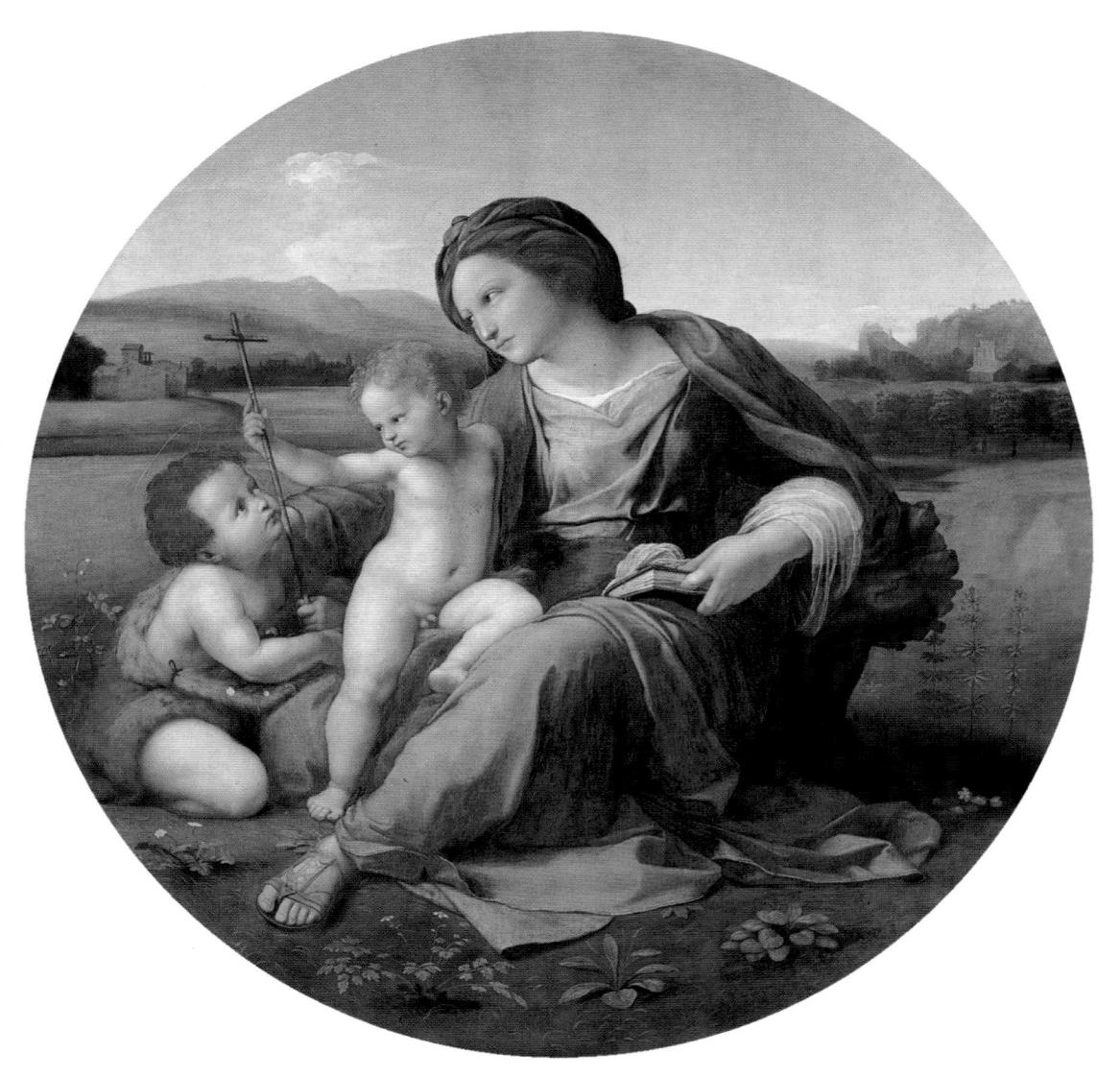

Although the details of its commission are unknown, this painting belonged among others to the Duke of Alba and Czar Nicholas I of Russia. It shows how rapidly Raphael evolved the tondo form, with which he had experimented in Florence, to the highest degree of sophistication. Basing the Madonna's pose on a particularly beautiful red chalk study of a male model, he achieved a sense of natural movement, suggesting a deceptive simplicity by the most complicated compositional means. The subtle use of contrapposto is close to that in the contemporary Triumph of Galatea (see plate 214), and both reveal Raphael at the height of his powers in integrating form with content.

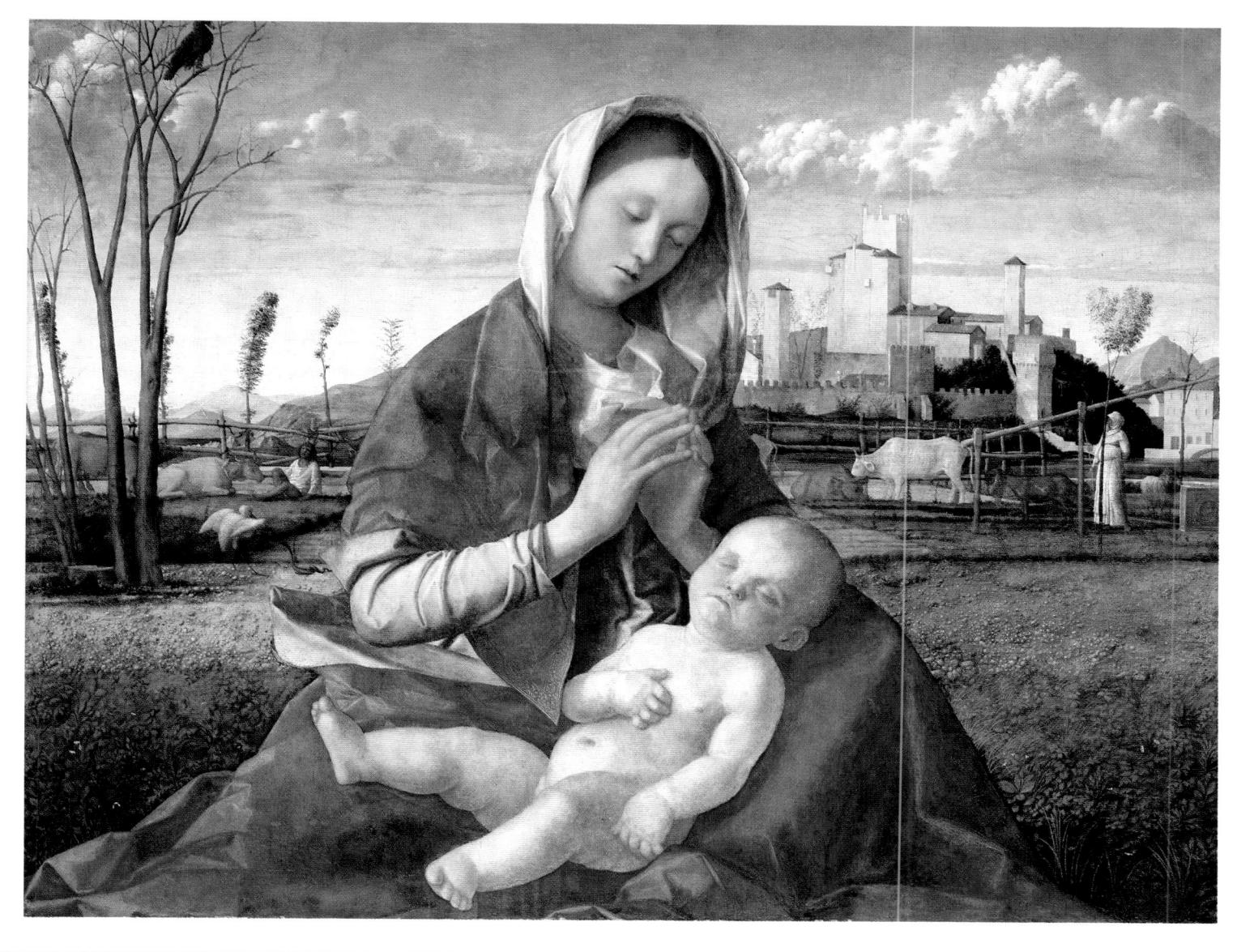

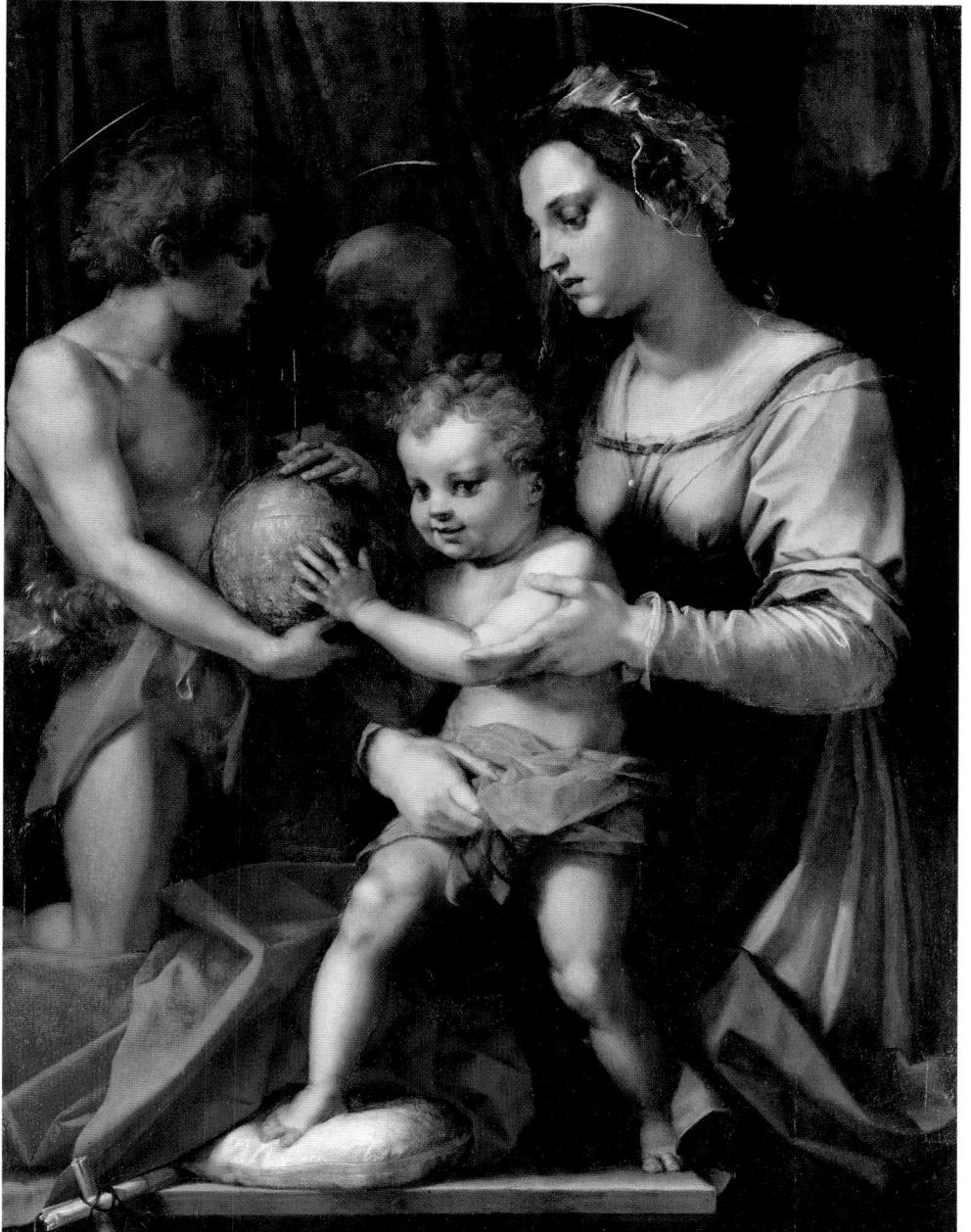

212 GIOVANNI BELLINI Madonna in the Meadow c.1505 This painting is among Bellini's late masterpieces, achieving a perfect synthesis of the figures with a sensitively observed landscape background. The detail of the fighting snake and white bird has been connected with Virgil's Georgics.

213 Andrea del Sarto Holy Family with the Youthful Saint John $\it c.1530$

This is among Sarto's latest works, and one of his most monumental renderings of this theme. It is probably the version recorded by Vasari as painted for Giovanni Borgherini. The globe singles out Christ as Salvator Mundi, and the St Joseph may be a modified self portrait. Less evidently mannered than some other later works, it relies for its effect on magnificent colour, crisp detail and the close proximity of the figures to the framing edge.

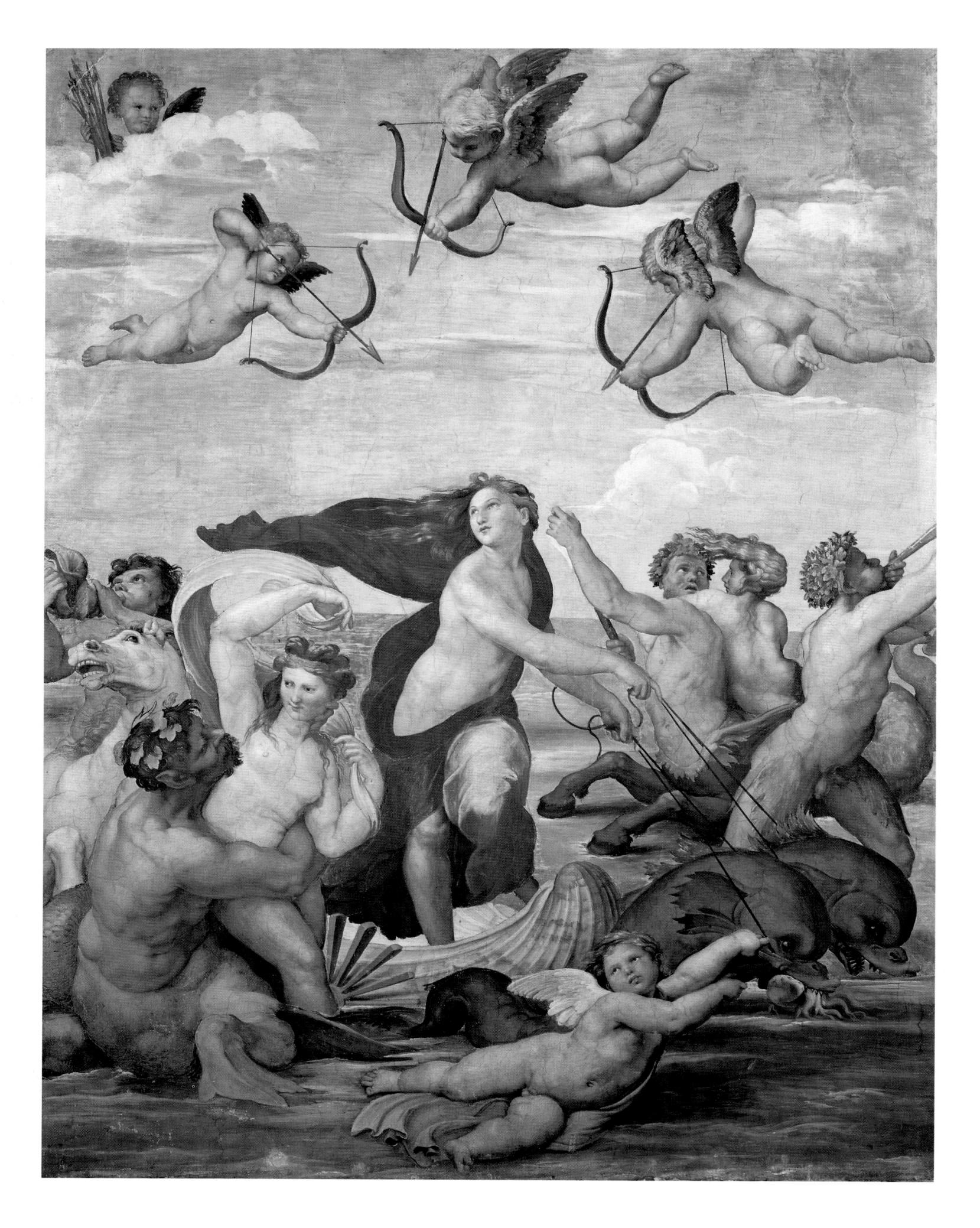

214 RAPHAEL Triumph of Galatea 1511
Raphael painted this fresco for the villa built by Baldassare Peruzzi
for the Sienese Papal banker Agostini Chigi on the banks of the
Tiber at the edge of Rome. The story of Galatea, a beautiful seanymph loved by the cyclops Polyphemus, comes from Ovid and

Theocritus. Raphael shows her skimming over the water in a huge shell equipped with paddles and drawn by dolphins. This is Raphael's major tribute to Classical painting and sculpture.

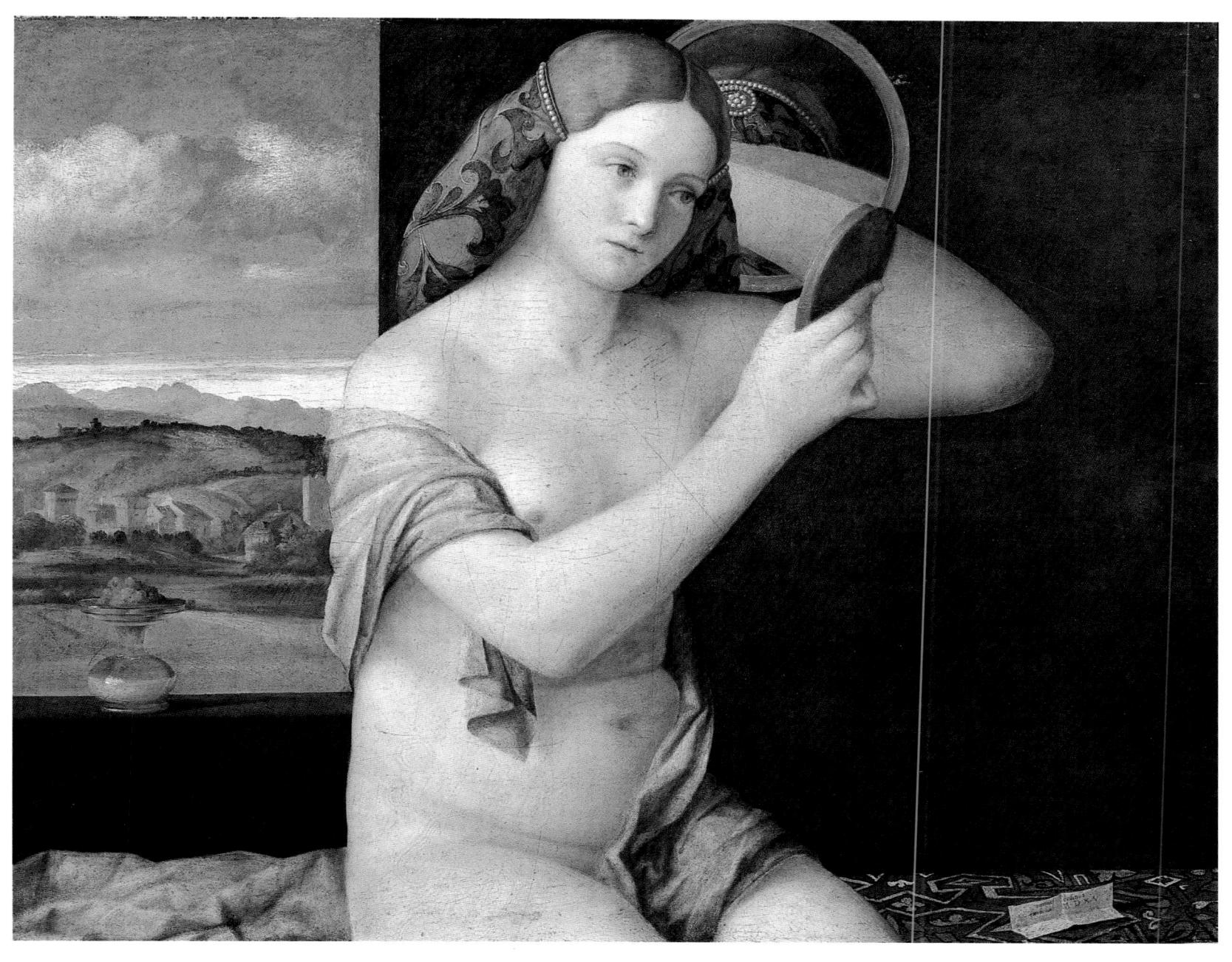

One of Bellini's most lyrical paintings, this was made when he was seventy-five and inspired by Giorgione and the young Titian. The figure's silent self-absorption is accentuated by the translucency of her pale skin, brilliantly offset by the dark background, the play on the idea of reflections seen and unseen, and the delicate balance of colours. The glass vase on the window sill against the Alpine foothill landscape encapsulates the picture's clarity and purity.

216 SEBASTIANO DEL PIOMBO Death of Adonis c.1512 (Below) Although it was probably painted just after Sebastiano transferred to Rome from Venice, this large picture clearly demonstrates his debt to Giorgione and early Cinquecento painting in Venice. The influence of Roman High Renaissance art is evident in some of the poses, but there is none of the sharper outline and forceful colour areas which Sebastiano was to adopt in Rome. The background view of the Venetian Ducal Palace strikes an odd note.

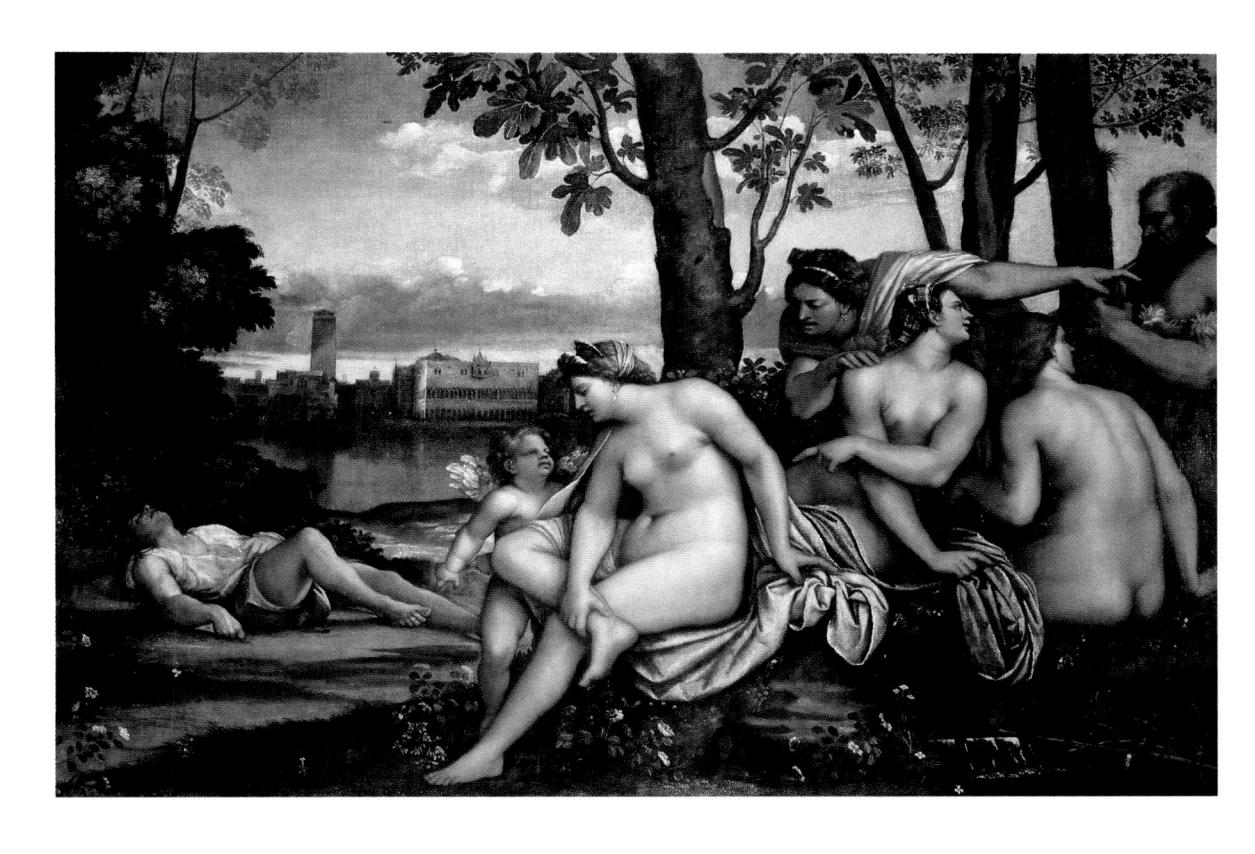

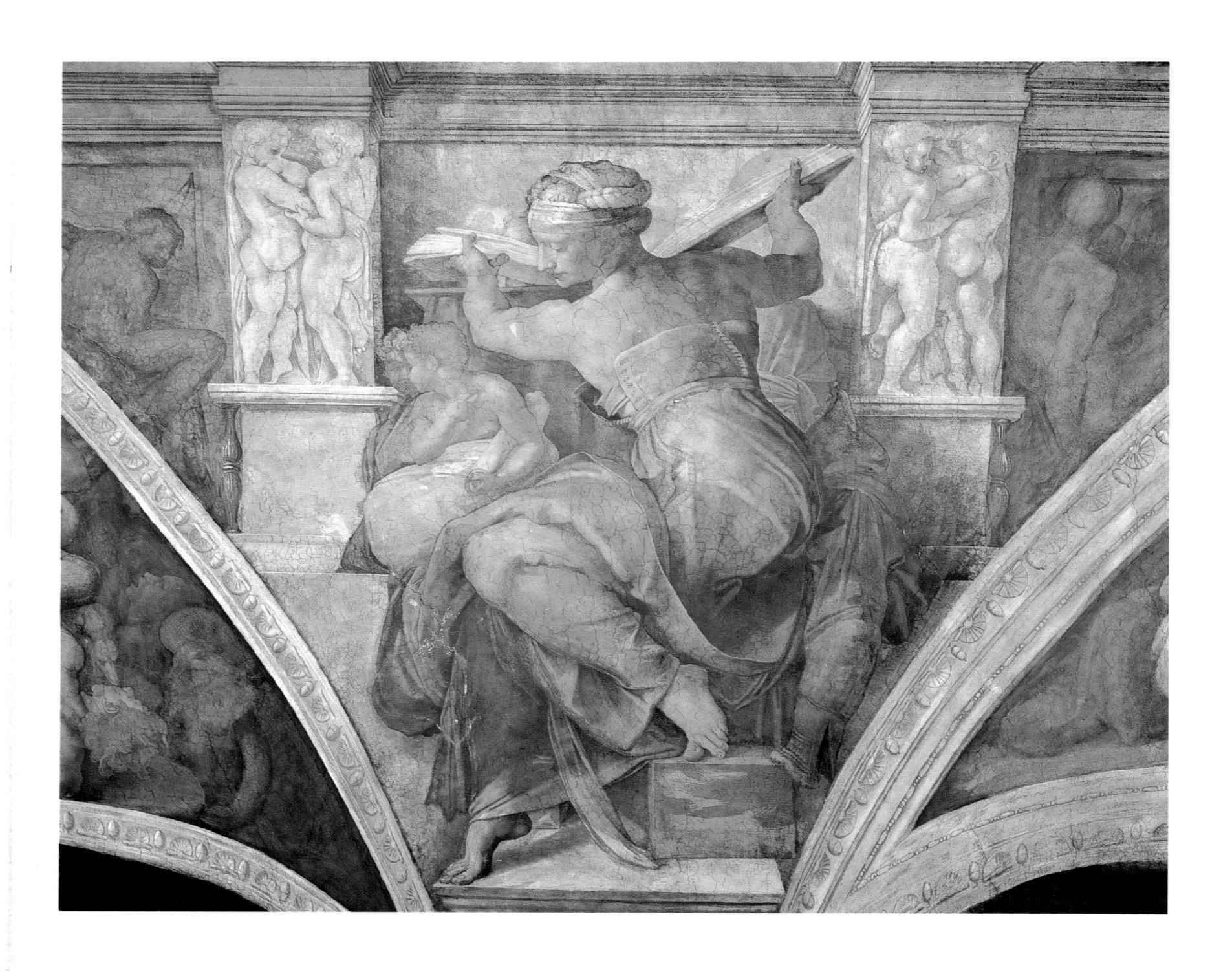

217 MICHELANGELO Lybian Sybil 1511

This is one of the figures in the final section of the vault, and shows Michelangelo's complete command of his medium by this point. Particularly striking is the modelling of the flesh and face by very fine hatched strokes. The precise meaning of the Sybil's gesture to the book is unclear. Vasari believed she is symbolically closing it, but she is probably simply taking hold of it to write in it. Her contrapposto turning of the upper torso, elaborate headdress and the colours and forms of her garments all had immense influence on later artists. The fresco is shown here before its recent cleaning.

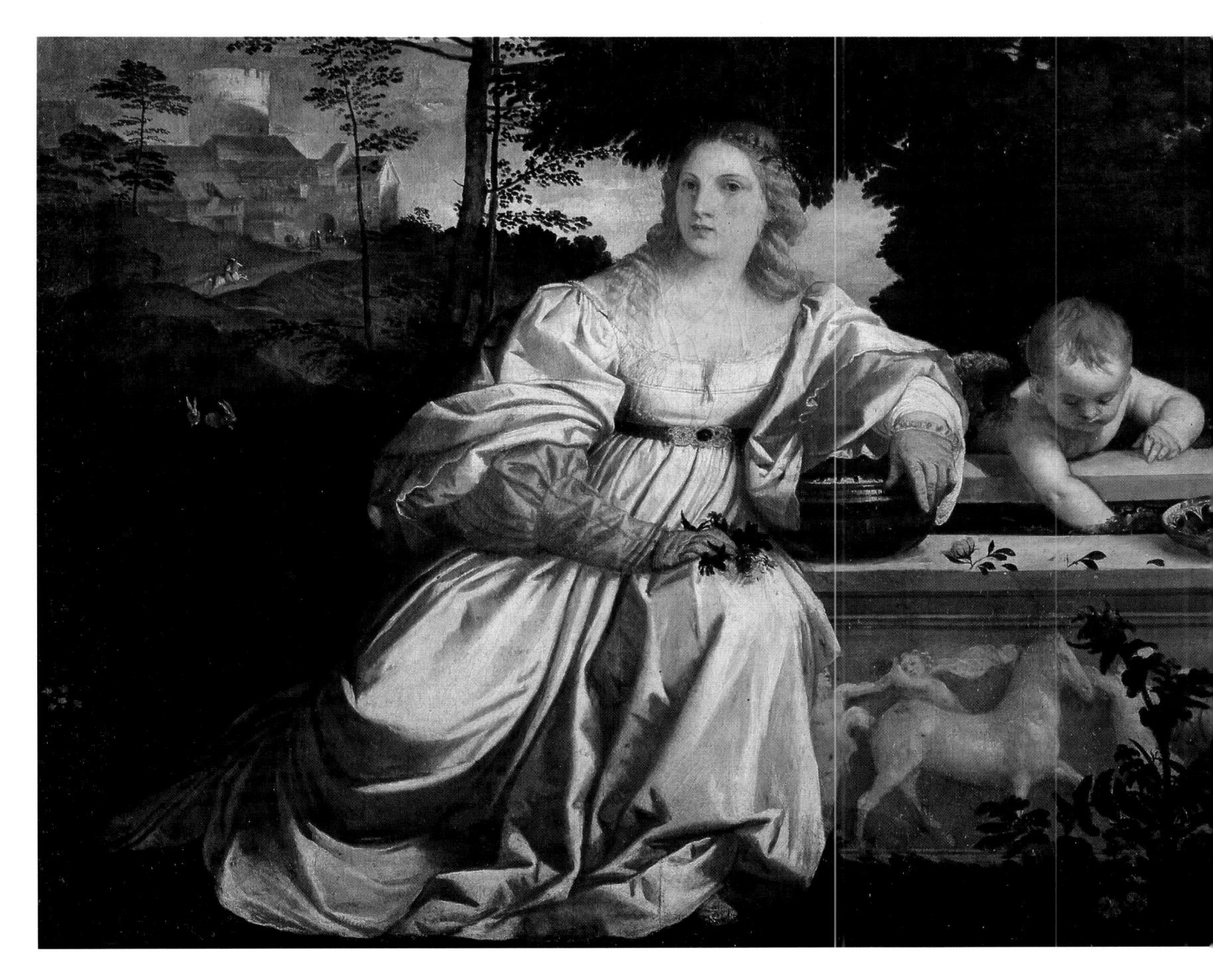

219 TITIAN Sacred and Profane Love c.1514

The precise meaning of this picture is uncertain. It was Titian's final painting in the Giorgione manner, and is one of the most beautiful allegories of the Renaissance. The only certain identifications are those of Venus, seated at right, and Cupid, stirring the water in the sarcophagus. It may represent the Neo-Platonic concept of the Terrestrial Venus (clothed) and the Celestial Venus, or Polia Recounting her Adventures to Venus from the influential Hypnerotomachia Poliphili published in Venice in 1499. The escutcheon on the frieze bears the arms of Niccolò Aurelio, one of Venice's most important civil servants, and his wife appears on the silver dish. It seems likely therefore that the painting's real subject may be The Bride of Niccolò Aurelio at the Fountain of Venus. As deities were sometimes understood to be invisible to mortals, the bride seems unaware of Venus.

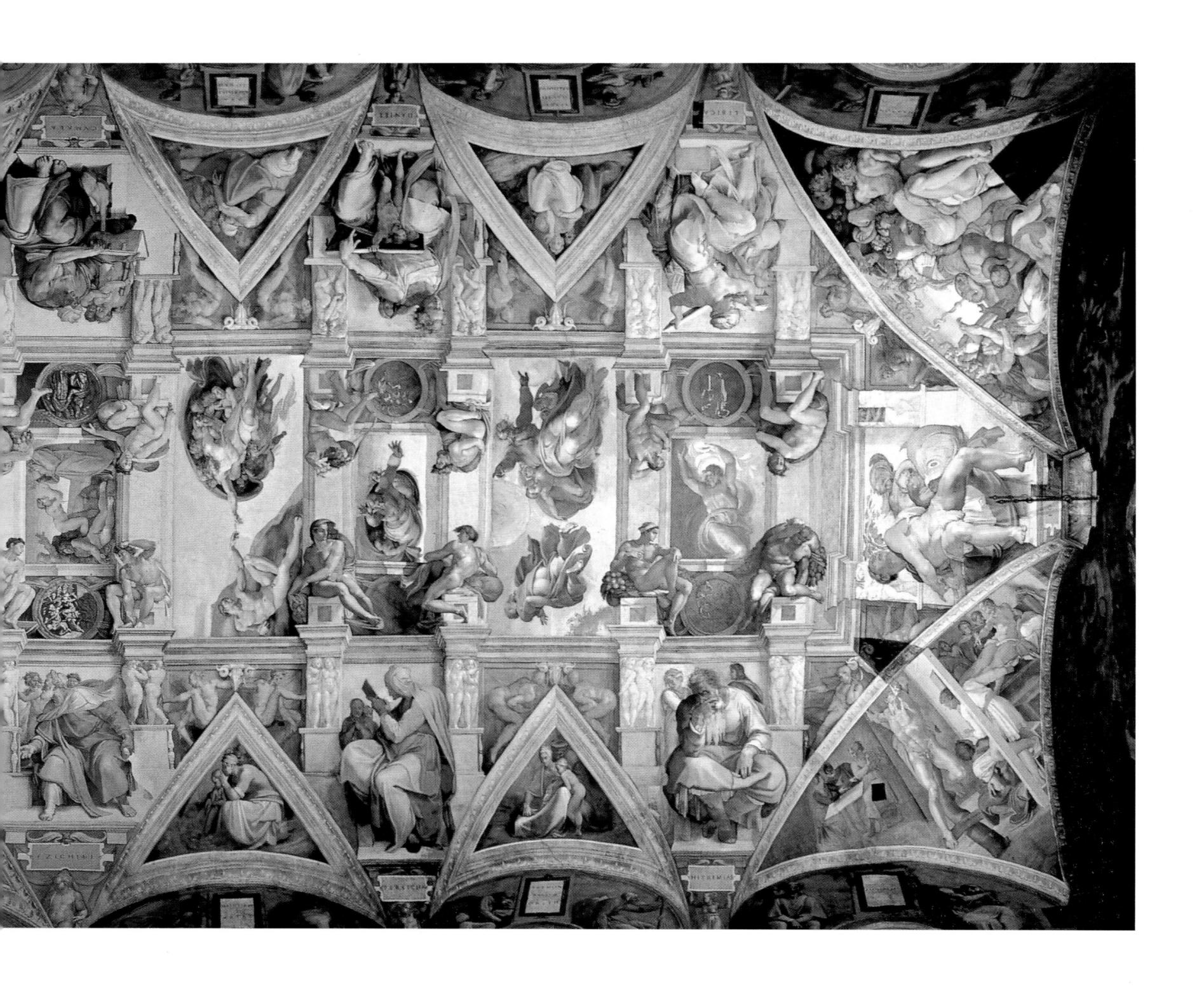

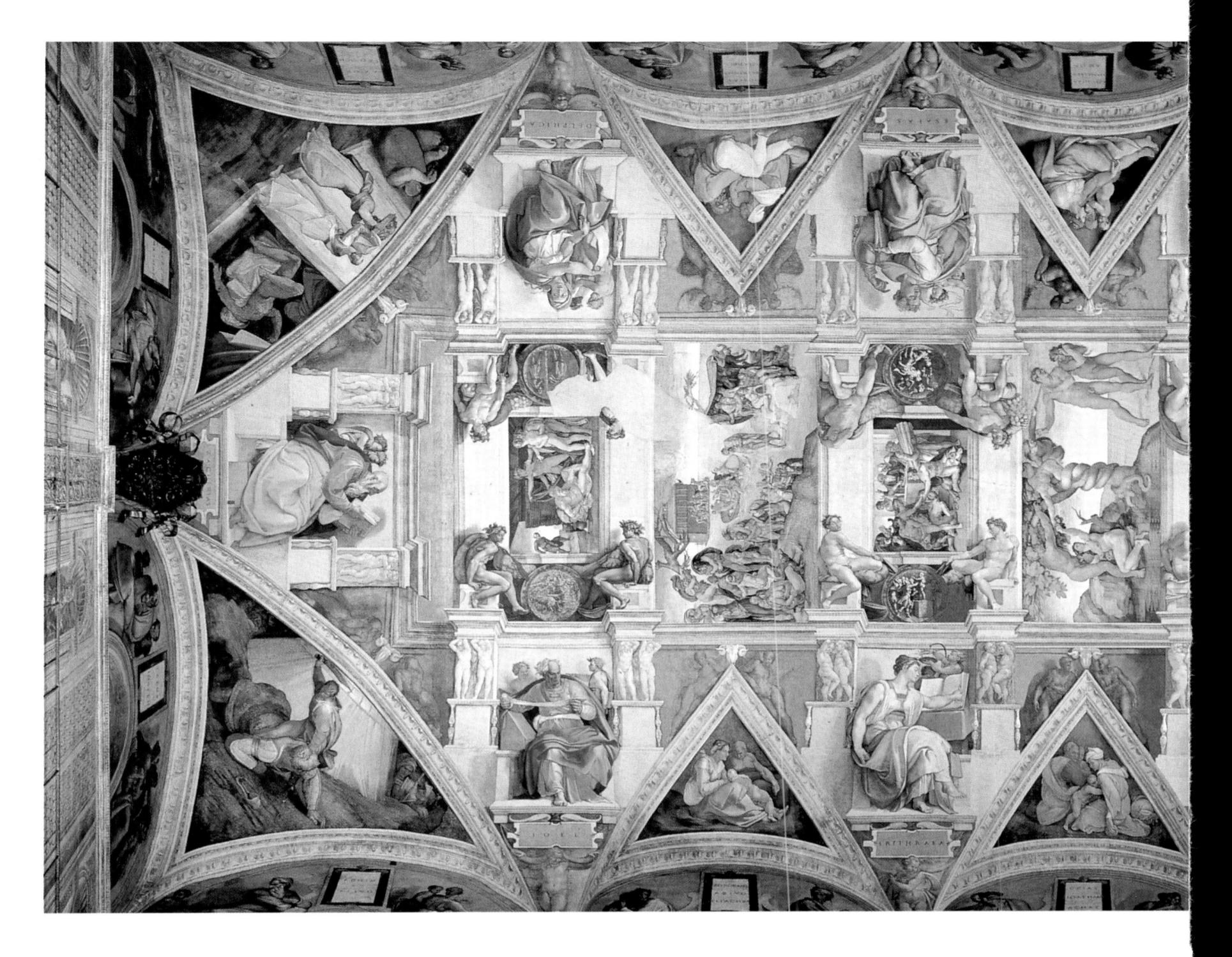

218 MICHELANGELO Sistine Chapel Ceiling 1508–12
The contract for the decoration of the great vault of the Sistine
Chapel was signed on 10 May 1508. As originally planned it would
have had far fewer figures (the twelve Apostles) to replace the original
gold stars on a blue ground which surmounted mural frescoes by
Perugino, Botticelli, Ghirlandaio, Signorelli and others. The plan
was gradually modified, until about 300 figures were included in a
highly complex scheme. Its forms and colours were to alter the course
of Italian art.

The huge scale and awkward position of the work caused Michelangelo immense physical and psychological problems, coupled with difficulties in 1509, a year's cessation in 1510 and continuous pressure from Pope Julius II to complete the work quickly. The artist's many red chalk drawings reveal his working processes using the nude model.

The vault is divided into three levels, separated by fictive painted architecture: lunettes over the windows show the Ancestors of

Christ, above these are the pendentives with the Prophets and Sybils, and nine rectangular panels depict biblical stories at the vault's centre. The smaller panels are framed by four of the famous Ignudi or nude youths, whose energy remains unique in Western painting.

There are three zones: in the lowest man is in a state of unconsciousness before divine revelation through light; in the middle the Seers foresee this revelation. God then intervenes, culminating in the celebrated scene of his dividing light from darkness. The Creation of Eve inaugurates the vault's second part, and shows the artist experimenting with colour harmonies. By the Creation of Adam he had totally mastered the fresco technique.

It was not only the scale and dynamism of the figures which affected contemporaries; the startling juxtapositions of colour altered the perception of colour for the next generation of Mannerists. Recent cleaning has restored these.

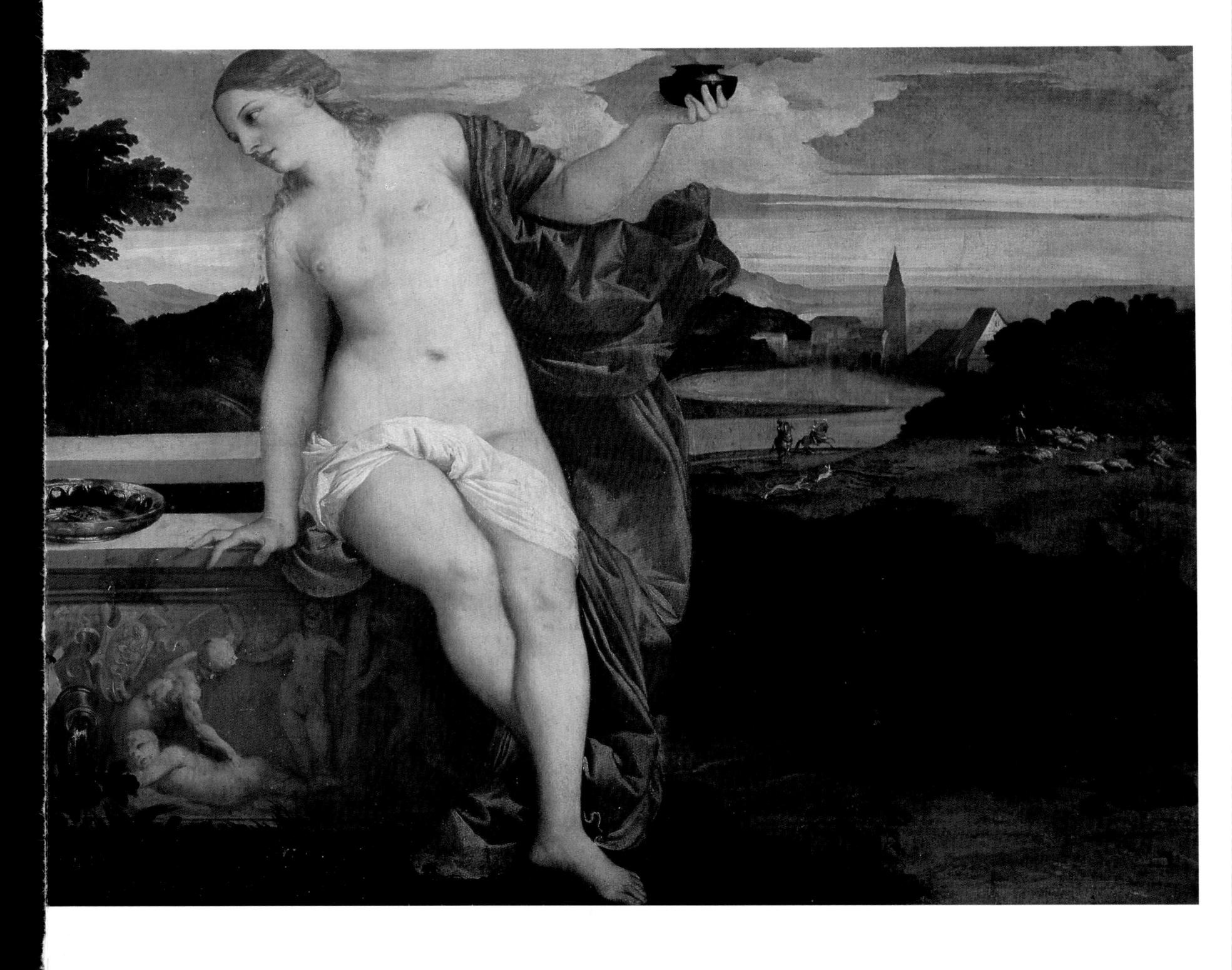

220 GIORGIONE Sleeping Venus c.1510

(Top right) A figure of Cupid was painted out at some time, almost certainly confirming that this was the picture described by the writer Michiel in 1525: he also stated that the landscape and Cupid had been painted by Titian. The contemplative, passive nature of the sleeping woman is wholly in character with Giorgione's vision of nature, totally transformed by Titian in his later variant, the Venus of Urbino, into a sophisticated, worldly figure.

221 TITIAN The Three Ages of Man 1516

(Bottom right) By the time he painted this, Titian had reached his first maturity and could combine restrained but potent allegory with images of unique poetic beauty and technical skill. In spite of an underlying melancholy (the inevitable passage of all living things towards decay and death), Titian's emphasis is optimistically on the youthful lovers. The girl is crowned with the flower associated with Venus, myrtle. The intensity of the lovers' gaze isolates them in space and time, suspends the girl's music-making and results in one of the most subtle and delicately erotic images in Western art. Only in the figures of the lovers is no obvious symbol of transience included: the putti cluster around a dead tree and the old man contemplates two skulls, while the distant church symbolizes Christian hope beyond death.

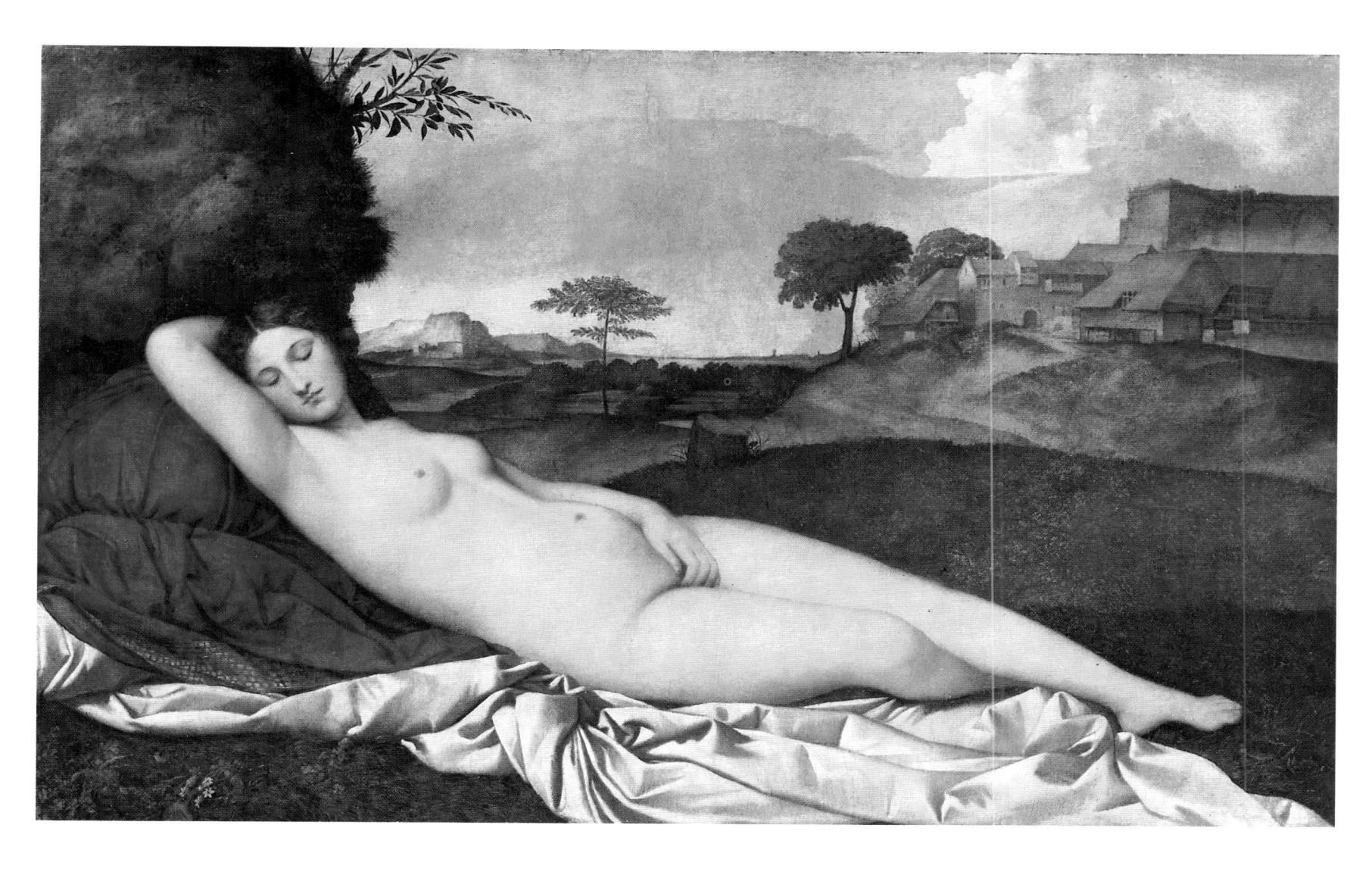

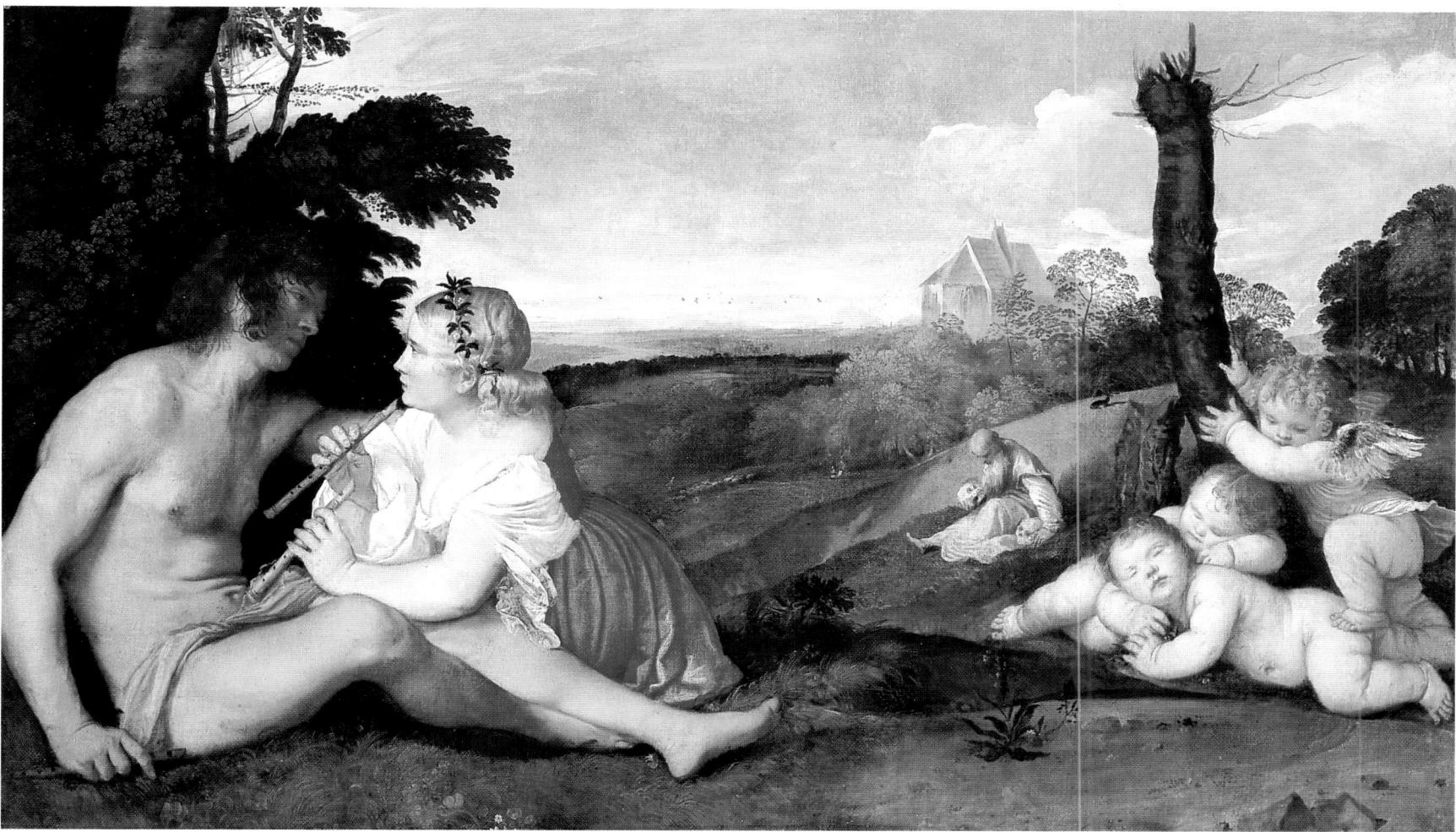

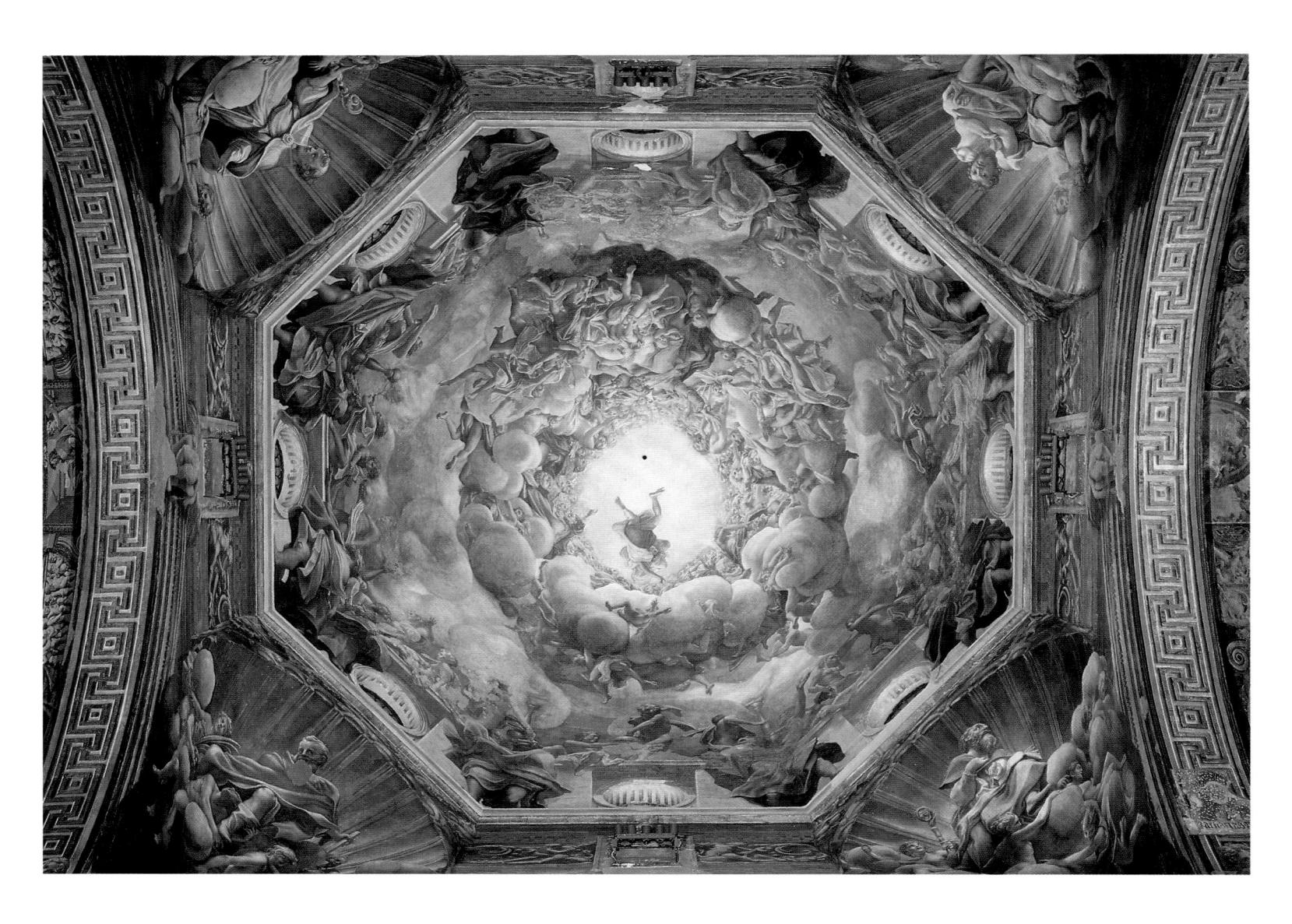

222 Correggio Assumption of the Virgin 1526–8

(Top left) This dome fresco in Parma Cathedral is unusual in continuing down from the cupola area to surround the circular windows of the zone equivalent of the drum of the dome. At the centre of the composition is the figure of Christ surrounded by more than fifty heads of the blessed, with the Virgin below surrounded by thirty or forty angels. Further down are twenty-nine youths holding torches, and at the base huge figures of the Apostles. The perspective is so steep that in many cases the faces are invisible, and the effect was once compared to a 'hash of frogs' legs'. It is this daring exploitation of spatial effects which made this work so influential on Baroque ceiling decoration.

223 CORREGGIO Martyrdom of Four Saints 1524–6

(Bottom left) This martyrdom is somewhat obscure, and took place at Messina on the orders of a pirate in 541 or 542. Central to the drama are Sts Placido and Flavia, the others being the child martyrs Eutychius and Victorinus. Together with the Lamentation it was painted for the Del Bono Chapel in San Giovanni Evangelista in Parma. Correggio uses an intensity deriving from Beccafumi to create a novel type of religious painting, in which ecstatic expression plays a fundamental role. The central saints' raised eyes and hand gestures, the emotive use of drapery and the flying angel all introduce ideas later consciously adopted by the Baroque style. Such sweetness of expression was brought by Correggio to much of his religious painting.

224 CORREGGIO IO 1531

(Right) This small canvas belongs to a series of pictures illustrating the Loves of Jupiter, commissioned by Duke Federico II Gonzaga as a gift for the Emperor Charles V for his coronation in Bologna. The story is rare in Renaissance art. Jupiter embraced the nymph Io in the guise of a cloud and she was transformed into a white heifer. The extreme refinement of eroticism in this image makes it one of the most memorable nudes in Western painting. Its blond tonalities, Io's pose and her facial expression are all foretastes of the French Rococo style.

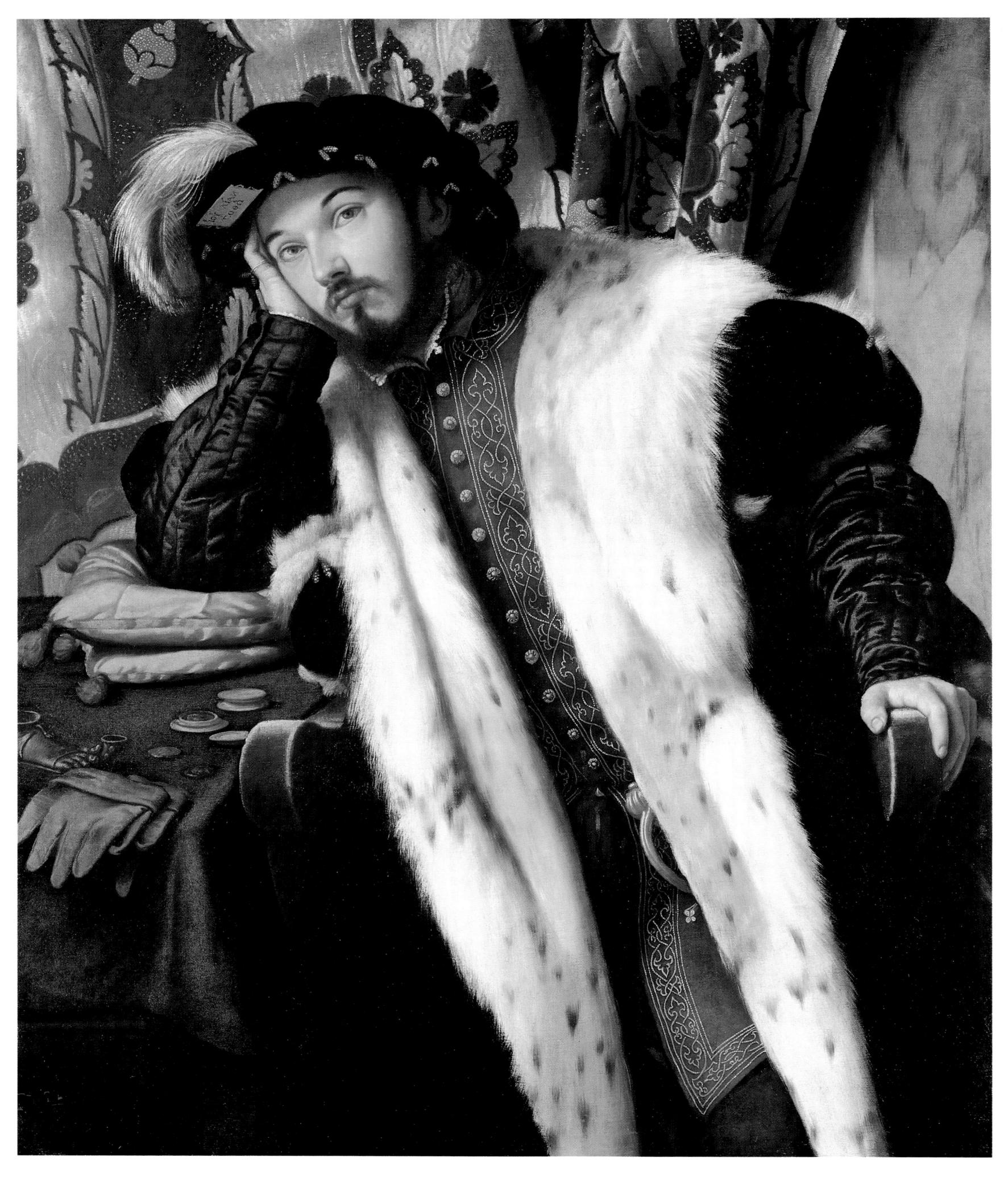

225 Alessandro Moretto, called Moretto da Brescia Presumed Portrait of Count Sciarra Martinengo Cesaresco ϵ .1545–50

If the identification of the sitter is correct, he was page to Henry II of France, who created him a knight of St Michael at the age of eighteen. The precision of handling, vivid colour and the unusual pose combine to give the sitter striking presence, and suggest the influence of Lorenzo Lotto.

226 GIAN GIROLAMO SAVOLDO Saint Mary Magdalene Approaching the Sepulchre *c*.1528–30

One of Savoldo's most striking images, this shows his fascination with light effects and light on fabrics. Although ultimately deriving from Giorgione, Savoldo's intentions are more decorative. It seems likely that the background shows a view of Venice. Caravaggio was certainly influenced by Savoldo.

227 SODOMA Marriage of Alexander with Roxana 1516–17

(Below) The little-known group of frescoes of which this is the most appealing is among the most delightful of the Roman High Renaissance period. Sodoma painted them in the bedchamber of the suburban Roman Villa Farnesina belonging to the rich banker Agostino Chigi, where his compatriot Baldassare Peruzzi was also painting. By comparison with Raphael's suave classicism of these years their style may seem old fashioned and fussy, but they are full of delightful detail and incident.

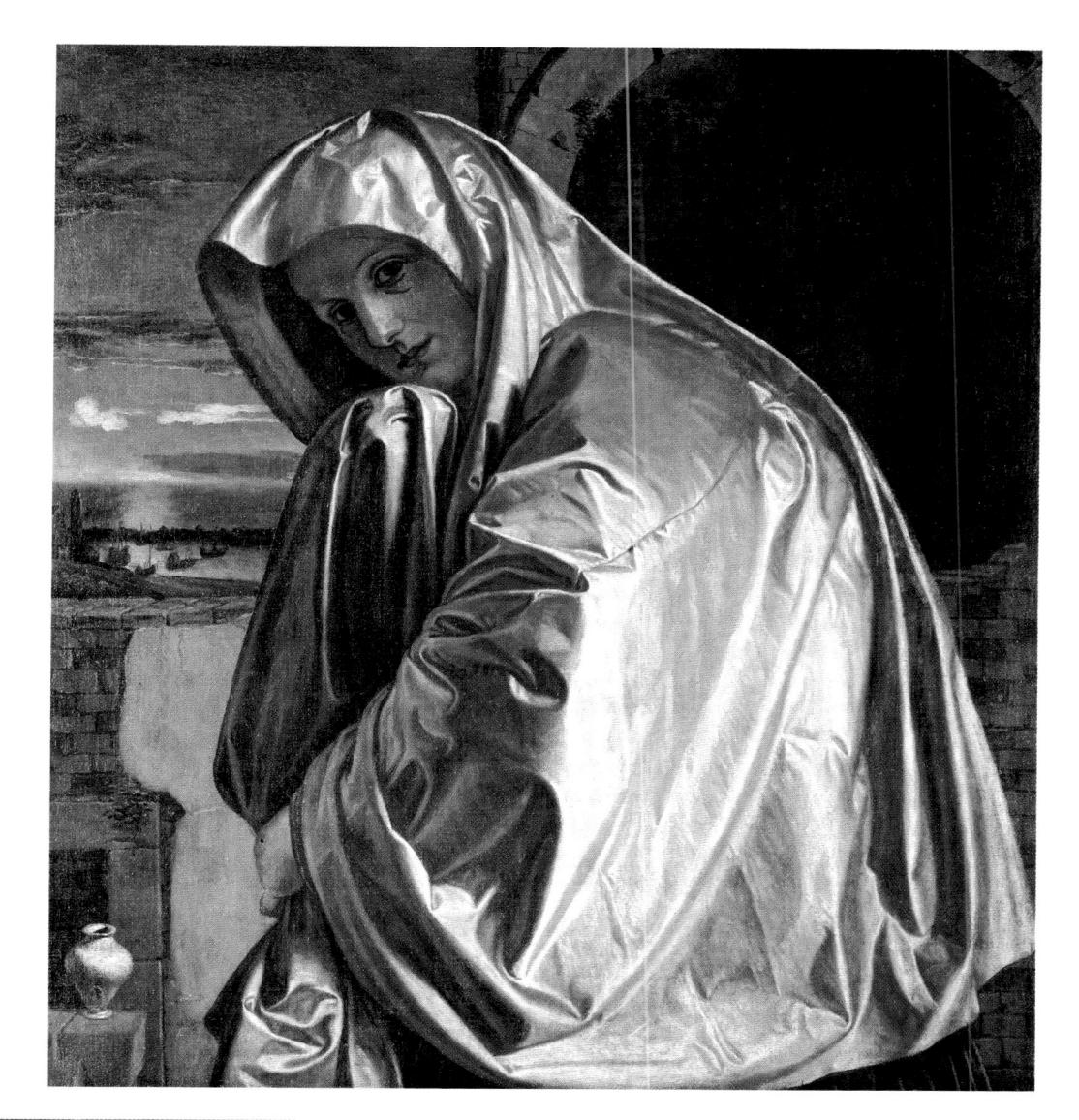

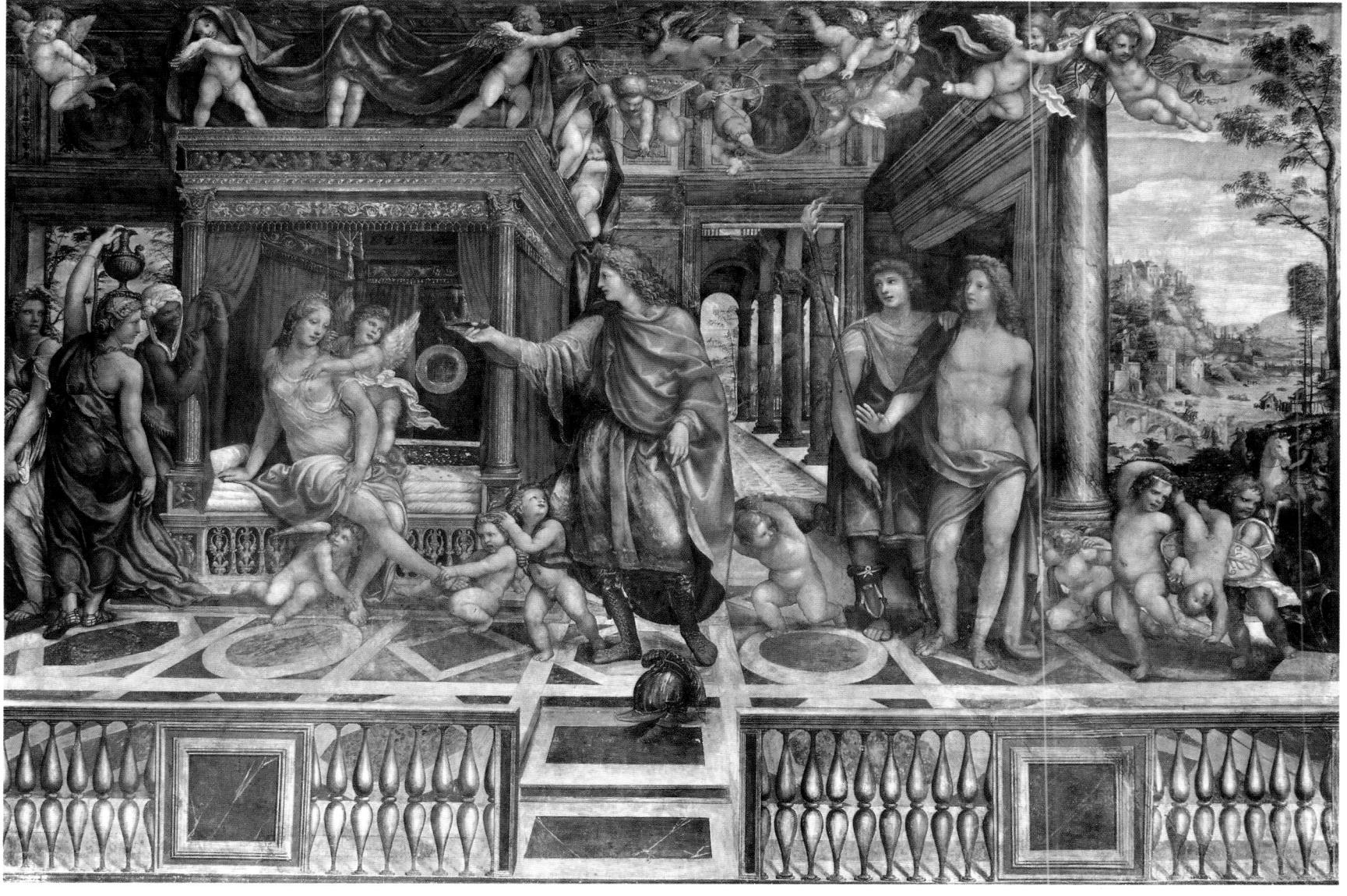

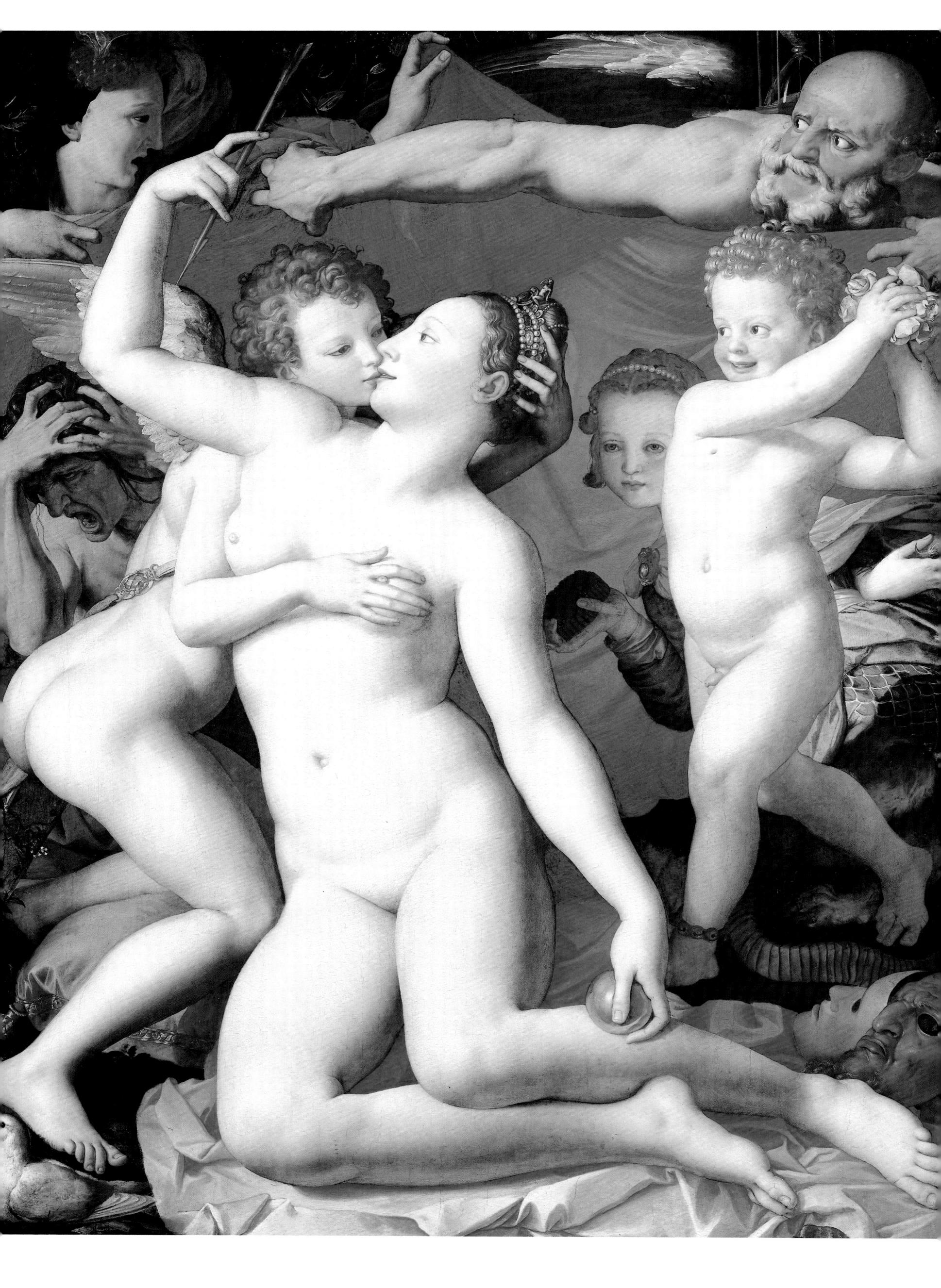
CHAPTER VIII

The Later Renaissance and Mannerism in Italy

The Counter-Reformation

A fter the richly creative and optimistic period leading up to the Sack of Rome in 1527, there followed a time of questioning in both society and the arts. The Papacy remained the most powerful single Italian state, but omnipresent in Rome at this time was the shadow of the Protestant threat to the Catholic Church. Pope Paul III was intent on introducing Catholic reformers in influential positions in Rome, to stamp out the heresies of the Protestant Reformation.

In 1540, the Society of Jesus (the Jesuits) was founded by the Spanish priest, Ignatius Loyola, with Paul III's approval. It was destined to be the strong right arm of the Counter-Reformation or 'Catholic Reformation'. Two years later, Giampetro Carafa (later Paul IV) had organized the Holy Office (the Inquisition) in Rome with Dominicans and Franciscans as Inquisitors. Only Venice was outside its jurisdiction, having set up its own tribunals in 1540. By 1547, the Jesuits' programme of education in universities and schools was launched, and their missionary activities began to spread through the world.

There was resistance to the Holy Office and the Jesuits in certain parts of Italy. But by 1551, in spite of Cosimo I de' Medici's opposition, they had founded a college in

228 AGNOLO BRONZINO Allegory of Venus, Folly and Time c.1545

This, one of the principal achievements of Italian Mannerist allegory, shows Bronzino's virtuoso technique in using startling colour to unique effect in creating icy eroticism. Venus engages in an incestuous embrace with her son Cupid, who tramples underfoot the doves of marital fidelity. Folly almost succeeds in concealing the fact that Pleasure not only offers a honeycomb but also has a hidden reptile's tail. Only Time, in drawing aside his curtain, will reveal what Folly hides from us, that illicit pleasure leads only to unhappiness.

Florence with the support of the Duchess, Eleonora of Toledo. Loyola's *Spiritual Exercises* was published in 1548; its rigorous self-examination, using every means to scrutinize the soul, had a great influence on the arts. Ignatius set an example of moderation and charity 'without hard words or contempt for people's errors'.

Meanwhile, the Holy Roman Emperor, Charles V, had been urging the Papacy since the late 1520s to call a council on Imperial territory, to placate the German cities and princes who had taken up the Reformation cause. Paul III promised this in 1536 – the year in which Michelangelo began work on his Last Judgement. The Council first met in Trent, an Italian city under the jurisdiction of the Emperor. Under the powerful leadership of the Pope, the Council dealt less with matters of reform (as Charles V wanted) and more with redefining Catholic orthodoxy. This made possible the enforcement of a new uniformity, and was summed up in one Act of the Council: 'No image shall be set up which is suggestive of false doctrine or which may furnish an occasion of dangerous error to the uneducated.' Although the atmosphere of religious change was already present in earlier painting, the effects of such explicit demands appeared increasingly in different ways as the century progressed. It was only a matter of time before the Church (like many Renaissance princes) saw art as a useful tool for propaganda.

Vasari and Contemporary Commentators

The key contemporary figure in understanding the art of the Cinquecento is Giorgio Vasari (1511–74), on whose writings we still depend for much information. More than any of his contemporaries, Vasari was in a position to know what he was talking about. Painter, architect, decorator, collector, historian, he was acquainted with

most of the leading men of his day. In an age which saw a huge increase in writings about art and the world of art, he had no rivals. The peripatetic sculptor Benvenuto Cellini (1500-71) in his Autobiography, written in 1558-62, also provides a vivid picture of contemporary art and life. The Milanese painter, Giovanni Paolo Lomazzo (1538–1600), wrote two treatises on art, the Trattato dell' Arte (1584) and the Idea del Tempio della Pittura (1591). Cellini catches the romantic imagination, putting flesh (often ugly) on the bones of his period, while Lomazzo gives us real insight into the Mannerist point of view. A lengthy dialogue published in 1584, Raffaele Borghini's Il Riposo, provides our best account of the Florentine art scene in the Mannerist period, although its theorizing is borrowed directly from Vasari. In 1547, another Florentine intellectual, Benedetto Varchi, had the idea of asking various living artists for their ideas on the paragone, or relative merits of the arts, on which Leonardo had previously commented in his treatise. In Venice, Marcantonio Michiel's plans to write a history of art appear to have been scotched by Vasari's progress with his, but Michiel's notes survived and are particularly useful in their descriptions of collections and connoisseurship. Even Castiglione's Book of the Courtier (1518) offers a discussion of art. None matched Vasari's encyclopaedic vision, however, which formed posterity's image of the period and how to understand it.

Vasari began planning his Lives of the Most Excellent Painters, Sculptors and Architects about 1543, just as Italian Mannerism was reaching maturity. First published in 1550, a second and heavily revised edition appeared in 1568. It still strikes us as a remarkably modern work, with its sound introduction on the technical aspects of art followed by the biographical and analytical studies of past and present artists. Central to its aims was the desire to improve standards by example, a method fundamental to the practice of Florentine historians such as Guicciardini, and found in Machiavelli's The Prince (1513) and Castiglione's Book of the Courtier (1528). It also lay behind the academic ideal, best represented in the fine arts by the foundation under Cosimo I of the Accademia del Disegno in 1563 in Florence.

Vasari had gathered his material with a scientific method characteristic of the Renaissance, from interviews, correspondence and the works of art themselves. In spite of a much greater subjectivity than would be considered balanced today, we still return to the *Lives* not only for factual guidance on the period, but also for the general mood in the arts. This is qualified wherever possible by subsequent documentation and a greatly increased knowledge of the existence of works of art.

The sixteenth century's obsession with defining and writing about the perfection it sought in art and society has proved enormously helpful in seeing the period in its own terms. It also helps us to understand why certain artists adopted Mannerist styles while others (such as Veronese) remained almost impervious to them, in the same way that the French academic tradition continued to run in parallel with the development of Impressionism.

Vasari was born in Arezzo, which was then subject to Florence, where he was educated with Ippolito and Alessandro de' Medici, thanks to their guardian, Cardinal Silvio Passerini. Vasari therefore had the necessary contacts to launch his career on an Italian rather than a local scale. His artistic training was completed in the studio of Andrea del Sarto, but as a painter he was most influenced by early Florentine Mannerism and Michelangelo. With essential patronage from the Grand Duke of Tuscany, Cosimo I, Vasari built an enviable circle of patrons, including the Papacy and many religious bodies and private individuals. In order to respond adequately (and often little more than adequately) to his numerous commissions, he ran a large studio with exemplary efficiency. No one could claim that Vasari painted many pictures whose appeal lies outside a small circle of specialists, and his most attractive scheme was certainly the tiny studiolo of Francesco I de' Medici in Florence's Palazzo Vecchio (1570-73). His large decorative complexes, such as the Salone dei Cinquecento in the same palace (begun 1563), and the 'Room of a Hundred Days' in the Palazzo della Cancelleria, Rome, of the late 1540s contain admirable parts but are visually confusing and doctrinaire. Vasari is perhaps the proof that the gifted theorist may not be the finest practitioner.

Michelangelo's Later Years

Michelangelo (1475–1564) is the *eminence grise* behind all Italian Cinquecento painting and sculpture. During the last thirty years of his life, which he spent in voluntary exile from Medici Florence in Rome, he created three monolithic masterpieces of painting. One of these was the *Last Judgement* (see plate 229) in the Sistine Chapel. Pope Paul III, who succeeded Clement VII, appointed Michelangelo 'Supreme Architect, Sculptor and Painter to the Apostolic Palace', and this new commission took over from the tortured project of completing Julius II's tomb.

Begun in 1535, the *Last Judgement* occupied Michelangelo for the next six years. The decision to cover the entire altar wall of the Sistine Chapel with the fresco meant losing earlier work by Perugino, in addition to two

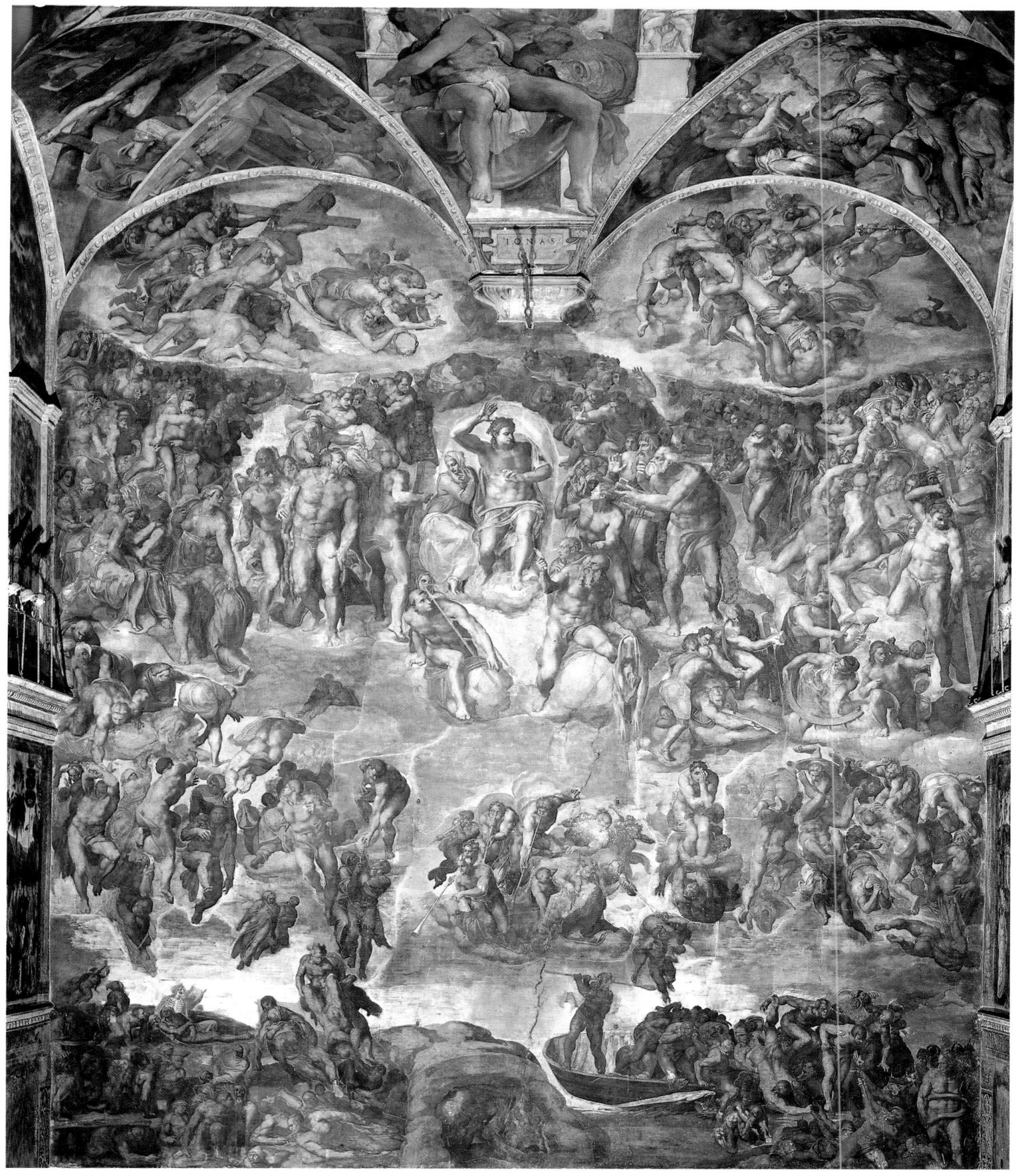

229 MICHELANGELO Last Judgement 1535–41

Although originally commissioned by Pope Clement VII, it was
Pope Paul III who instigated the execution of this fresco in the
Sistine Chapel. An existing altarpiece and other decoration by
Perugino were removed to give Michelangelo the entire wall surface.
The immense scale and freedom of composition this allowed him were
unprecedented, and the resulting arrangement of figures was all the
more original. A gigantic Christ in an unforgettable attitude of
judgement is the focus of the whole, and His pose and gesture are

echoed throughout the movement of the entire figure group. The Virgin as intercessor for the resurrected is pressed close to his side. Michelangelo arranged the groups in a rotational pattern, with the figures at the left ascending at the Resurrection, while those at the right fall to damnation. Originally the nudity, which shocked many at the unveiling, gave an impression of even greater vigour, recorded in a copy made by Marcello Venusti in 1549. This photograph was taken before the recent cleaning of the fresco.

230 MICHELANGELO Conversion of Saint Paul 1542–5
On completion of the Last Judgement Pope Paul III commissioned
Michelangelo to paint two frescoes in the Vatican's Pauline Chapel.
Their themes are complementary, as the other shows the crucifixion of
St Peter, the other founder saint of the Catholic Church. The figures
recall those of the Last Judgement, their grandeur and contrapposto
accentuated by the up-tilted, simplified landscape setting.

of his own *Ancestor* lunettes from the ceiling. This greatly extended the space, however, and permitted Michelangelo to create the most complex yet the most rational large-scale arrangement of figures in the Renaissance. In spite of the density and complexity of the groupings, all the figures are dependent on Christ's unforgettable gesture of condemnation, sending the Damned downwards while raising the Blessed upwards to Heaven.

The Last Judgement must have puzzled Michelangelo's artist contemporaries. In spite of its mass of writhing figures, it cannot be classified as a work of Mannerism, which it transcends by its sheer force. It does not display grazia and maniera — gracefulness and stylishness. The beautiful forms of the Sistine ceiling have been replaced by figures expressing a far greater urgency. Any sense of real space has been abandoned for an abstraction, and the muscularity of the ceiling's figures appears more self-conscious beside these massively formed creatures. More than the ceiling or any of Michelangelo's earlier works, it defies categorization. Like the later Cappella Paolina frescoes, it speaks a new language of total independence from all other current art trends. There can be no denying also that the mood of the Last Judgement stands for some of the dra-

matic changes which had occurred since the creation of the ceiling. Its completion in 1541 coincided with the arrival of the Counter-Reformation in Rome.

There was to be no respite for Michelangelo, as Paul III then ordered him to paint two frescoes in the Vatican's Pauline Chapel (see plate 230) recently built by Antonio da Sangallo the Younger. Only after the Pope had arranged for the ageing artist to be released from the contract for Julius II's tomb, could he start these frescoes in late 1542. They were finished in 1549 and unveiled the following year to little critical interest. Only Vasari and Condivi tried to understand them. 'These were his last paintings produced at the age of seventy-five', says Vasari, 'He spoke to me one day of fatigue: one discovers at a certain age that painting, particularly fresco, is not an art for old age.' These frescoes have never received the attention lavished on the artist's other works, and are certainly not easy to understand or appreciate. Vasari noted that Michelangelo "... dreamed only of perfection; he eliminated landscapes, trees, buildings, and all the various embellishments of art, refusing to stoop to them, to let his genius stoop to such things'. The style of these last frescoes provided no inspiration for contemporary painters chained to the embarras de richesse of Mannerist imagery, and remained largely without apologists until the present day.

Vasari's feeling that there could be no further progress in painting after the achievement of Michelangelo may well have been more prevalent in the mid-sixteenth century than is generally supposed. If so, it would have been another uncertainty added to those already perplexing many painters nearing the end of the Renaissance tradition. Indeed, self-confidence expressed in Vasari's historical and theoretical writing was probably based on what he hoped for his own age rather than what he actually saw in its art. It might have dismayed him to know that the twentieth-century art historian, Walter Friedlaender, would classify painting in his age as 'The Anticlassical Style'. Vasari saw contemporary painting (including his own) as the continuation of the Classical ideas of the High Renaissance period. But the very existence of Michelangelo's Doni Tondo and the Sistine vault at its heart suggests the tenuous nature of Classicism, even then.

The Mannerist Style

The Mannerist period in Italian art offers a bewildering assortment of styles. But the term 'Classical' does not describe the majority of painters included in this chapter – Giulio Romano, Pontormo, Rosso Fiorentino, Parmigianino, Perino del Vaga, Bronzino, Allori, Salviati

or Vasari himself. The term does, however, have relevance for painters who made their debuts at the peak of the High Renaissance, such as Titian and Correggio, or those whose styles offer a late version of High Renaissance ideas, such as Veronese. Paradoxically, however, even in the most extreme manifestations of Mannerist physical distortion while the language may not appear Classical, the details and underlying inspiration often are. The sixteenth century's obsession with style blinds us to this fact. Even where it is least obvious, the moving force behind many Mannerist works of art remains the antique.

'Mannerism' is related to the word 'manners', implying an acquired code of behaviour which will bring its adherents close to a specific norm. More exactly, it derives from the Italian word *maniera* – manner or style – a word current with Vasari and his contemporaries. In an age like ours, which claims to value practicality and 'naturalness', something 'stylized' may tend to be dismissed as insincere, while something 'stylish' appears praiseworthy.

In its application to art, Mannerism may be said to incorporate both terms, since the later Renaissance valued any conspicuously stylized artefact (because it represented the triumph of art over nature). At the same time it demanded that art be stylish and polished, not rozza (coarse) as Vasari categorized the medieval period. Such stylishness depended on ceaseless refinement, whether in the deportment of a courtier, the turn of a literary or musical phrase, or the depiction of nature in art. The result, if successful, was seen as displaying maniera or being manieroso (mannered), or artifizioso (artificial, in a complimentary sense). All art is by definition artificial, but the Florentine man of letters, Benedetto Varchi, wrote in 1548 that it had to be 'an artificial imitation of nature'.

Two terms illustrate particularly well the source of much of the elegance achieved in Mannerist art - contrapposto and the figura serpentinata. While contrapposto, the turning of the different parts of the body to achieve compositional balance, had long been an essential constituent of variety, notably in sculpture, its exaggeration in Mannerism produced different results. Michelangelo's Doni Madonna is depicted in extreme and unnatural contrapposto, as are the men in the Battle of Cascina (see plates 210, 209). In his treatise, Lomazzo says that any figure with the form of a flame will be beautiful, going on to praise the 'Serpentinata, like the twisting of a live snake in motion, which is also the form of a waving flame . . . '. The serpentine figure came to be increasingly regarded as the ideal of beauty, even in its most extreme and bizarre forms.

In spite of the elegance of much Mannerist painting, the style is often aggressive in a way whose only parallel

231 JACOPO PONTORMO Pietà c.1526-8

This altarpiece is at the centre of the Capponi Chapel, which Vasari says Pontormo spent three years decorating in such secrecy that even the patron Lodovico Capponi could not follow its progress. Its now destroyed cuppola contained a fresco of God the Father by Pontormo, who looked down past four tondi in oil of the Evangelists (two of which were by Bronzino) to the Deposition and the frescoed Annunciation, thus making a unified dramatic entity that looked forward to Baroque schemes. The chapel is Pontormo's only surviving decorative scheme.

The Deposition was painted in Pontormo's first mature style. It is partly based on an antique sarcophagus, and comparison with the surviving modello drawing shows that Pontormo pared the final composition down to its essentials. Its perspective, colour (deriving in part from Michelangelo) and costume are equally ambiguous, but all accentuate the intensity of feeling in the Virgin's gesture of farewell to the body of her son; the sense of frozen unreality and the illusion that the group is illuminated by a sudden flash of light underline the pathos of the theme.

232 PARMIGIANINO Madonna of the Long Neck c.1535
This painting was commissioned by Elena Baiardi for her chapel in
Santa Maria dei Servi at Parma. Both the columns and the Virgin's
long neck may be references to a medieval hymn relating the Virgin
to a column, and not merely stylistic exaggerations like the elongated
limbs and small heads. Nonetheless, the painting remains one of the
highest points of Mannerist stylization, with an ideal of feminine
beauty refined from Correggio's.

in previous European art is late Gothic. Both present their characteristic features in a way which appears to make them the *raison d'être* of the work of art. Distortion appears in every phase of Mannerism, with a preference for attenuated limbs and extremities, small heads and pronounced musculature. A rejection of the canons of 'realistic' space achieved with such effort during the Quattrocento and High Renaissance is one of Mannerism's most striking features, from Pontormo's *Pietà* (see plate 231) to Parmigianino's *Madonna of the*

Long Neck (see plate 232) to Tintoretto in the Scuola di San Rocco.

The theories of the mid-century bore out what had already started to appear in painting thirty years earlier. Raphael's real legacy to the next generation was not his gentle Madonnas, but his darker, vigorous and assertively stylish later work, such as *Saint Cecilia* (Pinacoteca, Bologna), *Lo Spasimo di Sicilia* (see plate 250) and the *Transfiguration* (see plate 248). Here, the composition of the lower zone includes some of the most felicitous combinations of pose, gesture and facial expression in Western art, while the foreground figure of the mother is one of the clearest prototypes for Mannerist elegance.

Raphael was evolving towards *maniera* and *grazia*, prime requirements of Vasari's and documented by Raphael himself as vital to art. In his famous letter of 1519, written with Castiglione to Pope Leo X, he condemns Gothic architecture as *privi di ogni gratia*, *senza maniera alcuna* (devoid of all grace and entirely without style).

However, the assumption that all the seeds of Mannerism are visible in one Raphael figure is of course erroneous. Unlike High Renaissance style, most of whose manifestations tend to share the desire for rational balance, Mannerism divides into quite different currents. These have been simplified, not misleadingly, as 'neurotic mannerism' and 'courtly mannerism', and the distinction is borne out by an examination of many paintings made between 1520 and 1550. The appearance of this greatly heightened *grazia* in late Raphael coincides with an intensely sybaritic period in Roman life which ended abruptly with the Sack of Rome in 1527.

Raphael falls into the category of 'courtly', exemplified in his Transfiguration figures, as do painters who turned to his work for inspiration, particularly Perino del Vaga (see plate 233) and Parmigianino (see plates 232, 245). It could be argued that the Ignudi on the Sistine Ceiling, where effortless beauty predominated, even belong to this category. Bronzino, as the supreme 'courtly' Mannerist, while deriving from Pontormo, occupies a unique position. Prime among the 'neurotic' mannerists are Pontormo (see plates 231, 249) and Rosso Florentino (see plates 234, 251), neither of whom shows the ostensibly rational motivation of their 'courtly' peers. The situation is further complicated by the emergence in Vasari, late Bronzino and others, of what might be termed 'academic Mannerism'. Such a late permutation of the style undoubtedly resulted from the exhaustion felt by many painters in working and reworking a style fundamentally based on formulae (i.e. Michelangelism). It was against this that the reaction occurred in the Bolognese Carracci family and Florentine painters like Santi di Tito.

Mannerism in Florence and Rome

There is disagreement as to whether the first real development of Mannerism occurred in Florence or Rome. Pontormo painted *Joseph in Egypt* (see plate 249) in Florence, probably in 1515, and while its figure style still belongs to the world of Sarto and Franciabigio, its bizarre conception of space and other unreal elements link it firmly to early Mannerism. But it still shows none of the distortions present in his fresco lunettes (1523–5) at the Certosa di Galluzzo (the Carthusian monastery outside Florence). These derive so much from Dürer's prints, which, according to Vasari, had flooded into Italy. Sarto, Pontormo and Bronzino were only a tew of the Italians who studied them, along with those of Schongauer (see plate 139), Lucas van Leyden and others.

Incipient Florentine Mannerism, therefore, emerged in early Pontormo, and like much contemporary Tuscan work, required only the injection of Roman ideas to set it in independent motion. It seems reasonable to accept that the most direct current of influence did indeed come from Raphael to his Roman followers: Guilio Romano, Giovanni da Udine (1487–1564), Polidoro da Caravaggio (1500–43?) and Perino del Vaga. Without exception, their work was heavily influenced by Raphael's antique interests, whether in the extreme elegance of Polidoro's monochrome friezes on palace façades (such as Palazzo

233 Perino del Vaga Martyrdom of the Ten Thousand 1522–3 This, the modello for a lost cartoon for an unexecuted fresco, brought the latest Roman ideas to Tuscany. Its balletic movement and wealth of decorative detail had an immense influence on the next generation of Florentine painters, notably Bronzino.

Ricci, Rome), da Udine's grotesques or Giulio's Classical themes at Mantua's Palazzo del Tè (see plate 263).

It was Perino del Vaga (1501-47) who created one of the first Tuscan monuments of the Roman Mannerist style, in his cartoon showing the Martyrdom of the Ten Thousand (see plate 233). Vasari describes the cartoon as 'a divine object' and praises Perino's success in expressing psychological states through pose and expression, thus relating directly back to Alberti's ideas of decorum in Della Pittura. It is significant that Vasari applauded the 'wealth of most beautiful ornament that one could possibly create, both imitating and supplanting the antique, drawn with that devotion and artifice which reaches the very heights of art'. He singles out precisely the type of decorative detail which proliferates in later Mannerism -"... cuirasses in the antique style and most ornate and bizarre costumes; and the leg-pieces, boots, helmets, shields and the rest of the armour . . .'. A similar, almost fetishistic interest in super-ornate costume, armour and hairstyles finds a direct expression in Michelangelo's drawings of Divine Heads, including the famous Cleopatra (see plate 32), which he may have based on Piero di Cosimo's Cleopatra or Simonetta Vespucci (see plate 81).

Leonardo, in his treatise on painting, cautions the artist: 'As far as possible avoid the costumes of your own day, unless they belong to the religious group. . . Costumes of our own period should not be depicted unless it is on tombstones in churches, so that we may be spared being laughed at by our successors for the mad fashions of men and leave behind only things that may be admired for their dignity and beauty'. The concept of achieving greater timelessness through idealized or fantastic dress distinguishes much Mannerist art, and the idea was everpresent in Michelangelo. Even cross-dressing was considered a means of removing figures from any toorecognizable context. In Pontormo's Pietà (see plate 231), for example, this is carried to the extent of creating deliberate ambiguity between flesh and clothing. In this fantasy world, Italy led the way, although Northern mannerists such as Spranger (see plate 189) and artists of the School of Fontainebleau eagerly borrowed such ideas.

Pontormo

The Florentine Pontormo (Jacopo Carucci, 1491–1557) moved rapidly from early work in the manner of Sarto, with whom he studied after a period with Piero di Cosimo and possibly Leonardo. The leap from his *Visitation* fresco, begun in 1514 (Santissima Annunziata, Florence), to the Pucci altarpiece of 1518 in San Michele

Visdomini is immense, the latter showing all the irrational elements so characteristic of his subsequent style. Instead of the compositional balance found in the great Florentine High Renaissance altarpieces, figures are spread out in unstable poses and with little apparent relationship.

Pontormo's paranoid nature, often manifested in hypochondria, led him to flee to the Certosa during the plague of 1523. He took as his assistant the youthful Bronzino, whom he had depicted in *Joseph in Egypt*. Portrayed so well in Vasari's account, his character can also be glimpsed in his diary fragment from the years 1554–6. His main preoccupation is with his health, but the diary also reveals his exceptionally close relationship with Bronzino. At this time he was decorating the Choir

234 Rosso Fiorentino Dead Christ supported by Angels c.1525–6

This shows something of the secularizing tendency in many Mannerist images, since the way in which Rosso depicts Christ might equally be applied to a Classical figure such as Adonis. The influence of Michelangelo is also very evident in Christ's pose, but the stylized angels, with the 'shot' coloured garments are wholly Rosso's. Like Bronzino's in his Deposition (see plate 235), Rosso's Christ illustrates a dogma important to the Church in its fight against heresy — exposed as the Eucharist miracle of the real presence.

of the Medici church of San Lorenzo with frescoes (now lost) aimed at surpassing his idol Michelangelo. Their appearance can be gauged from the artist's surviving drawings. The monumental language of his work from the 1520s with its echoes of High Renaissance calm (see plate 231) has given way to a neurotic and tortured atmosphere – by then rare in central Italian Mannerism.

Rosso Fiorentino

Pontormo's evolution is parallelled in the work of his near-contemporary, Rosso Fiorentino (Giovanni Battista di Jacopo, 1495-1540). He also came from the Sarto studio (although Vasari stated that no master could satisfy him). While Pontormo's career was entirely Florentine, Rosso's became more international, his last decade being spent at Fontainebleau (see Chapter VI). From the outset, Rosso's figures have a caricatural expressiveness deriving from certain Sarto types, with dissonant colour and juxtapositions. There can be no doubt that such experiments with 'shot' colour (cangianti) in early Mannerism derive directly from the Sistine ceiling. Like Pontormo's Visdomini altar, Rosso's first Mannerist painting dates from 1518 (it is thus contemporary with Raphael's Transfiguration and Titian's Assumption) - a Madonna with Saints for Santa Maria Nuova (Uffizi, Florence). Skeletal, angular figures announce a principal feature of Rosso's subsequent work, continued in the great Deposition of 1521 (Museum, Volterra) and culminating in the Città di Castello Resurrection which enters the realm of nightmare.

In his Florentine paintings of the early 1520s, notably his Marriage of the Virgin (San Lorenzo, Florence), Rosso retains an element of that Classical equilibrium which reappears in Pontormo only after 1525. He moved to Rome in 1524, lured by the election of a Medici Pope, Clement VII, and the impact of Michelangelo and Raphael was crucial in his development. This is evident in his Dead Christ supported by Angels (see plate 234), painted before he escaped from the Sack of Rome in 1527. Among others leaving the city at that time were Sansovino, Sebastiano del Piombo and Aretino, who all went to Venice.

In tracing the origins of the next phase of Mannerism and Vasari's painting style, Rosso's arrival in Arezzo is fundamental. His *Dead Christ* exhibits *maniera* and *grazia* in the highest degree of self-conscious concentration, but after the Sack the qualities give way to pessimism. Rosso befriended and advised the youthful Vasari in 1528, after his move north from Rome, and Vasari became heir to the multitude of influences which had shaped Rosso.

Bronzino

The interlocking of influences is also seen in Bronzino (Agnolo di Cosimo, 1503-72), who emerged with Titian as the greatest portraitist of the mid-century. So he must have appeared to his contemporaries. Bronzino's beginnings in Raffaellino del Garbo's studio and as Pontormo's assistant were feeble. However, he inherited the achievements in portraiture of Sarto and Ghirlandaio, and it is likely that he was an accomplished portraitist (Portrait of a Lady, Stadelsches Kunstinstitut, Frankfurt) well before he was called to the summer residence of the Dukes of Urbino at the Villa Imperiale near Pesaro (1530-2). The direct outcome of this was his masterly essay in the Titian manner, Guidobaldo della Rovere (Palazzo Pitti, Florence), but its soft focus was soon abandoned by Bronzino on his return to Florence in favour of sharper outline and strong colour and lighting.

Unlike Titian, Bronzino's success depended largely on one court only, that of Duke Cosimo I de' Medici (see plate 2), for whom he painted portraits, religious and allegorical subjects (see plates 252, 228), tapestry cartoons and theatrical designs. Bronzino's further ability as a poet must have increased his success at court. Competition was, however, fierce, given the range of artists available to Cosimo - Pontormo (whose character prevented him from becoming an artist-courtier), Vasari, Francesco Salviati (1510-63) and a range of outstanding sculptors including Benvenuto Cellini and Baccio Bandinelli (1493-1560). For almost four decades, Cosimo (Duke of Florence 1537-69, Grand Duke of Tuscany 1569-74) led the most glittering of all Italian courts of the mid-century. Only Venice rivalled its quality and quantity of artistic patronage in this period.

At an early stage, Bronzino rejected Pontormo's transparent, elusive use of colour in favour of solid blocks of dense and opaque paint, frequently deliberately evoking the resilient surface of marble for his flesh areas. In his portraits, ambiguities are sometimes created by his sitters' apparent remoteness.

From the early 1530s, Bronzino's preferred portrait format was the three-quarter length, usually with one shoulder turned away from the spectator in a *contrapposto* deriving directly from Michelangelo's marble figure of *Giuliano de' Medici* in San Lorenzo. This was nearing completion when Bronzino first borrowed the pose, so its impact must have been doubly strong for his Florentine public. The Uffizi Gallery's *Young Man with a Lute* and Berlin's *Ugolino Martelli* are the finest examples of its influence. The latter show Bronzino's ability to suggest, through pose and composition, the social and intellectual

235 AGNOLO BRONZINO Deposition 1545 Bronzino frescoed the vault and walls of the tiny chapel of the Duchess Eleonora of Toledo in the Palazzo Vecchio, Florence, providing this panel as its altarpiece. It is one of the major altarpieces of the later Italian Renaissance. The central figures derive from Michelangelo's 1499 Pietà in St Peter's. Eleonora's husband, Duke Cosimo I de'Medici, gave it as a diplomatic gift to the Emperor Charles V's Keeper of the Seals, Cardinal Granvelle, to be replaced in the chapel by a later copy by Bronzino. The highly ordered elegance hides a spirituality as deep as that of its prototype, Pontormo's Deposition (see plate 231). Bronzino himself referred to this painting as a Deposition, not a Pietà, and intended the elegantly disposed figure of Christ to symbolize the Eucharist, contemplated by a chorus of other figures who display differing reactions. Since the event symbolized is ultimately a joyous one, tragedy would be out of place; colour glitters like jewellery, as befits a celebration, and chiaroscuro is virtually absent. The hard glittering surfaces render the forms arrestingly tangible, while the flawless condition of the paint permits a greater understanding of Bronzino's unique technical accomplishments.

standing of his sitters. His faces already adopt that mask-like appearance which approaches surrealism in Rosso Fiorentino.

From the 1540s, Bronzino's new post as court painter resulted not only in the famous portraits of the Duke and his Duchess, Eleonora of Toledo, (see plates 2, 11), but in two major essays in interpreting the Michelangelesque nude: the London Allegory of Venus (see plate 228) and the frescoes in the Duchess's Chapel in the Palazzo Vecchio. The former has all the jewel-like colour and artificiality of high Mannerist ideals, and is based on the most elaborate use of extreme contrapposto, which also plays a large part in the chapel frescoes. In the altarpiece for the chapel Bronzino achieved a synthesis of all his mature ideals, and it is one of the key works of the period. His work for the Medici court included tapestry design (the late 1540s Story of Joseph, woven in Cosimo's tapestry manufactory, and now divided between Florence and Rome), and the large Martyrdom of St Lawrence fresco of 1569 in San Lorenzo. Notwithstanding the fact that it includes many fine portraits, this fresco illustrates with alarming clarity the vacuity of later Mannerism's narrative methods, and its impossibility of further evolution from Michelangelo's approach to anatomy and composition.

Bronzino's genius for portraiture only increased with age, and was particularly pronounced when he painted friends. As late as 1560, he created one of the most memorable 'homages' of one artist to another in his *Laura Battiferri* (see plate 253), where the figure is seen almost as a sculpted relief. Little of this picture's intensity occurs in his other late work. This may be partly explained by his sense of increasing isolation on the deaths of his closest friends and patrons, including Pontormo, Eleonora of Toledo and Michelangelo, all of which inspired tragic sonnets from the ageing painter.

The tired uncertainty evident in his late work was also partly occasioned by the confusion resulting from the impact of Counter-Reformation ideas on Florentine art, and the convulsive conscience-searching of artists, such as the sculptor Bartolommeo Ammanati (1511–92).

Venetian Painting After 1520

Whereas in Florence and Rome the linear preferences of the Quattrocento persisted, Venetian painting continued where Leonardo's experiments had left off. His *sfumato* approach was diametrically opposed to the method defined by Cennini and current through most of the Quattrocento, where vividly coloured areas of paint defined form. In exploring aerial perspective, which requires the viewer's imagination to complete the relationship of forms to space, Leonardo prepared the way for the daring later experiments of Titian and Tintoretto. The rigid depiction of form through outline was being replaced already in Giorgione's work with the interaction of colour, light and atmosphere. In Giorgione's paintings, consequently, it is more often the impression of the whole canvas rather than individual detail that remains in the mind.

In Florentine and Roman painting, however, exactly the opposite prevailed, and the supremacy of traditional disegno, so much vaunted by Vasari, won the day. Even a thoroughly Venetian painter like Sebastiano del Piombo, trained in Giorgionismo, converted in Rome to local methods and Michelangelo's influence, as is seen in his Raising of Lazarus (National Gallery, London) painted with Michelangelo's help in direct competition with Raphael's Transfiguration. Ever since twentieth-century art history initiated the study of Italian Mannerism, the precise degree to which central Italian Mannerism influenced Venetian art has been much debated. From one point of view there can be little doubt that Venetian painting remained remarkably independent, since central Italian Mannerism depended on certain instantly recognizable features. These included a heightened concentration on individual human forms (even in making up the largest, most convoluted compositions) as vehicles for the display of anatomy and elaborate poses, costumes, accessories and colour. Mannerism's primary emphasis was on the artificial, often leading to accusations of its overriding concern with form at the expense of content.

Instances in Venetian painting where such criticisms can be made are rare. When the Holy Office accused Veronese in 1573 of introducing extraneous elements into a painting for a Venetian convent, the artist might well have cited any contemporary Florentine picture to demonstrate how ill-founded the accusation was. The work he actually used was Michelangelo's *Last Judgement*.

Opportunities for painters abounded in Cinquecento Venice more than any other Italian city, and both in quantity and quality their response was unique. Much importance was attached to working in the Palazzo Ducale (the Doge's Palace), where two disastrous fires in 1574 and 1577 led to considerable scope for redecoration. In addition, the city's unique *scuole* or religious societies were lavish patrons of the arts (see Chapter 1). There were two distinct groups, the *Scuole Grande* and the *Scuole Piccole*. The former had come into being to assert the pious, devotional life, but were predominantly lay, self-governing institutions which by the mid-sixteenth century wielded considerable power. The *Scuole Piccole*

were smaller variations on this, and were often related to a trade or expatriate minority. Competition between the scuole for the most splendid buildings and works of art naturally benefited Venetian painters and architects.

Titian's Later Career

We rightly think of Titian (Tiziano Vecellio, died 1576) as a High Renaissance painter. It is thus sometimes easy to overlook the fact that most of his career coincides with Mannerism elsewhere. What Titian substituted for Mannerist tendencies was a unique dynamism, seen first in the awe-inspiring Assumption of the Virgin (see plate 254). He proved that huge scale was not necessary to achieve this, in his Annunciation in Treviso Cathedral completed in late 1522, and the contemporary polyptych with the Resurrection, Annunciation and Saints (Santi Nazaro e Celso, Brescia). In the first, drama is created by 'continuing' the real architecture of its setting, while the polyptych quoted directly from the Laocoön and two of Michelangelo's slaves for Julius II's tomb in Saint Peter's. Titian was not alone in the early 1520s in Venice in seeking a dynamic figure style, and even Palma Vecchio achieved an approximation to Roman grandeur and grazia with his Saint Barbara in Santa Maria Formosa.

The most sumptuous of Titian's paintings at this time were commissioned for the Camerino d'Alabastro (Alabaster Chamber) of his new patron, Alfonso d'Este of Ferrara. The room contained some of the best north Italian art of the day – Bellini's Feast of the Gods, (National Gallery of Art, Washington), Dosso Dossi's Feast of Cybele (National Gallery, London), Titian's the Garden of Love (Museo del Prado, Madrid), Bacchus and Ariadne (National Gallery, London), and Bacchanal of the Andrians (see plate 236). Titian's robustness must have made the Bellini and Dosso pictures appear very old fashioned. His paintings show his mastery of colour at its most seductive, exercising a spell on all subsequent colourists, notably Rubens.

It was also hoped that Michelangelo, Fra Bartolommeo and Raphael would contribute to the Camerino d'Alabastro scheme. Interiors of such lavishness were not common, and usually their cost could only be borne by public bodies, as in Venice. Its subsequent dismantling meant the disappearance of one of the greatest humanist painting schemes of the Renaissance.

The energy of these paintings culminated in an altarpiece whose commission Titian won in competition with Palma Vecchio and Pordenone (Giovanni Antonio de Sacchis, 1483/4–1539). This showed the *Death of Saint Peter Martyr*, and was completed in 1530 for Santi

Giovanni e Paolo, Venice. It was later destroyed but is known from engravings and copies. Contemporary with Correggio's largest dome fresco - the Assumption - in Parma Cathedral (see plate 222), it shared the same elements which were later utilized by Baroque artists. Although both works depend for their effect on dynamic figure poses (in Correggio's they are suspended in space, so enhancing their drama), that effect remains primarily natural. The three protagonists in the Titian are shown in contrapposto, but to heighten tension and not for stylistic reasons. Titian was aware of Michelangelo, Raphael and Roman prototypes but he deliberately chose an independent path. This allowed him to give colour, light and movement first place in his art, without attempting, as Sebastiano del Piombo was said to have done (unsuccessfully), 'to unite the drawing of Michelangelo with the colour of Giorgione'.

Only rarely did Titian later permit himself the drama of the early decades, most notably in the lost *Battle of Cadore* of 1537–8 for the Palazzo Ducale in Venice. In late works, such as *Tarquin and Lucretia* of 1571 (Fitzwilliam Museum, Cambridge), style has overtaken drama to create elegant surface pattern. Even in his last, intense *Pietà* (Accademia,

This formed part of a group of four paintings in the studiolo of Alfonso I d'Este in the castle of Ferrara. The others were Titian's Bacchus and Ariadne and the Worship of Venus, and Bellini and Titian's Feast of the Gods. The theme of this picture comes from Philostratus the Elder's Imagines, and shows the inhabitants of the island of Andros drunk from the stream of wine created by Dionysus. Ariadne lies asleep at the right.

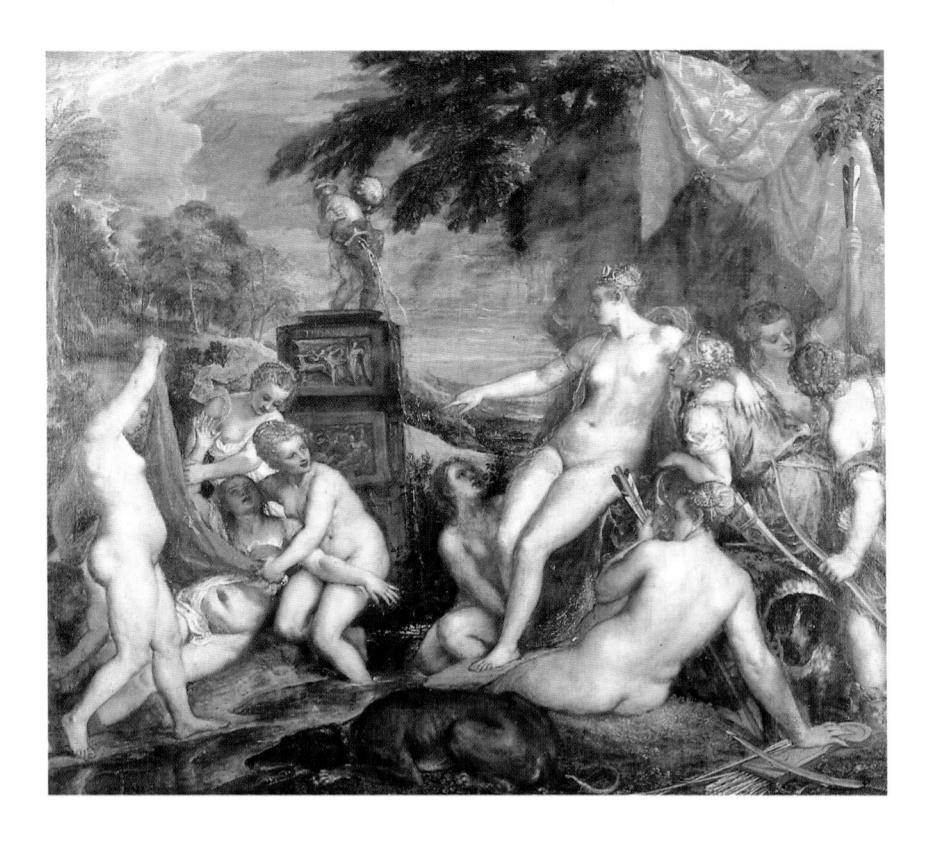

237 TITIAN Diana and Callisto 1556–9
As with its pendant, Diana and Actaeon, the source of the story is
Ovid's Metamorphoses. Diana discovers the pregnancy of her
nymph Callisto, who has been seduced by Jupiter. Both pictures were
painted for King Philip II and despatched to Madrid in 1559.

Venice) there is a sense of the figures being frozen in their dramatic poses.

Vasari defined Titian's position in Venice up until the 1540s and 1550s, saying that he 'had in Venice some competitors but not of much worth, so that he has surpassed them easily with the excellence of his art'. This is nowhere more evident than in his portraits (see plate 255). Lavish dress (including armour) had to play a part in presenting a sitter's character, and Titian had no equal in achieving a perfect balance between the sitter's face and his clothing, particularly during the 1530s. The portraits of Cardinal Ippolito de' Rovere and his Duchess, Eleonora Gonzaga (both Uffizi, Florence) exemplify the unique combination, implied and visible, of richness with aristocratic restraint, which made Titian the model for so many subsequent court portraits.

The measure of his genius was that he could transform the prototype of Giorgione's Dresden *Venus* into the *Venus of Urbino* of about 1538 (Uffizi, Florence) by giving the generalized nude the particular quality of portraiture. This painting is in many ways the artist's final farewell to the quieter world of Giorgione and, in about 1540, he experimented tentatively with central Italian Mannerism introduced into Venice by Francesco Salviati (1510–63) and others. Combined with the pose and scale of Michelangelo's figure of *Dawn* in the New Sacristy of San

Lorenzo in Florence, the subtle Urbino *Venus* later emerged as the majestic and voluptuous versions of *Danaë* for Ottavio Farnese and King Philip II of Spain (Museo di Capodimonte, Naples and Museo del Prado, Madrid).

In the decade between these two versions (Philip II's painting dated from 1553–4), Titian's brushwork progressed towards greater looseness and fluidity. This is seen to perfection in two of his finest *poesie* (poems, as Titian liked to describe them) for Philip II illustrating the story of Diana (see plates 237, 238). It is also the secret of *The Death of Actaeon* (National Gallery, London), where colour is minimal and a total harmony is achieved between the human figure and surrounding nature. Such a feeling of resolution pervades many of Titian's late paintings, from his moving *Self Portrait* (Staatliche Museen, Berlin) of the early 1560s to his final testament, the *Pietà* (see plate 256).

Titian's only real competition before 1550 in Venice came from Palma Vecchio and Il Pordenone. After this, the rise of Tintoretto, and then of Veronese, while in no way diminishing Titian's stellar position in Europe, certainly provided viable alternatives.

238 TITIAN Diana and Actaeon 1556-9

Ovid describes how Prince Actaeon came across the pool where Diana and her nymphs were bathing one day while he was out hunting in the forest. Titian's painting is charged with mixed reactions to the erotic encounter. He creates highly concentrated drama by the simplest of means, using a V-like recession into depth and two monumental figures (Diana and Actaeon) at either side, in a manner that prefigures Baroque compositional methods. His colour is at its most sumptuous, notably in the brilliant rose drapery set against a deep blue sky and the powder blue cloth of the seated nymph.

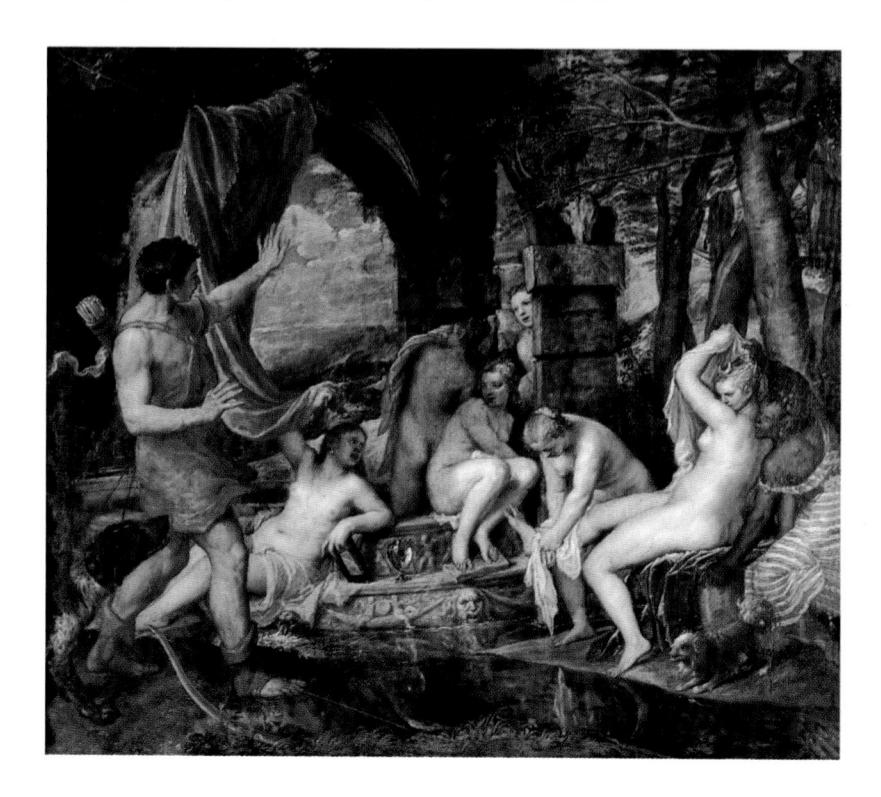

Tintoretto

Tintoretto (Jacopo Robusti, 1518–94) is already recorded as an independent painter in 1539, at which time he appears to have produced mainly *Sacre Conversazioni*. Even in these it is clear that Tintoretto, who was largely self-taught, was not content to purvey weak derivations of the established Titian style. Always original and immensely productive, Tintoretto possessed a boundless energy greater even than Titian's. His assimilation of ideas, from both outside Venice and within, meant that he was much more open to Mannerist concepts at a time when Titian continued largely to reject or ignore them. Tintoretto never became a Mannerist painter, although he made use of some Mannerist devices. It was left to lesser painters such as Andrea Schiavone (c. 1510/15–63) and Paris Bordone (1500–71) to attempt the style in Venice.

Among the central Italian and Emilian Mannerists he could have studied in Venice was Lorenzo Lotto (see plate 246, 247, 264), although Lotto's precise position is not easy to classify. It is possible that Tintoretto travelled to Florence and Rome in about 1540, when he would have seen Florentine Mannerism at its height and the work of Michelangelo. Throughout his life, Michelangelo's terribilità and dramatic distortion of the human figure seem to have remained in his mind, and different as the end results are, the explosive dynamism of Tintoretto's best pictures can have no other underlying inspiration. Tintoretto's excitement at the new narrative possibilities offered by many-figured, even slightly confused compositions, is evident in Christ in the Temple of the early 1540s (Museo del Duomo, Milan). Yet had Titian known these early efforts, he would rightly have detected little hint of a future rivalry, except perhaps in the untrammelled energy of the images.

Already by the mid-1540s, Tintoretto was experimenting with portraiture, which he later perfected with a unique sobriety very different from Titian's sparkling international manner. His late portraits are most memorable, including his haggard Self Portrait in the Louvre. He had also attracted sufficient attention for Pietro Aretino to commission two mythological ceilings from him. In 1548 he painted the Miracle of the Slave for the Scuola Grande di San Marco, which launched his reputation, and must have seemed to the Venetian public to offer a totally new alternative to Titian. In fact, when compared with a multi-figure Titian composition painted only five years earlier, Ecce Homo (Kunsthistorisches Museum, Vienna), it is clear that Tintoretto was giving a massive injection of new ideas to Venetian painting. Its colour is far from the suffused softness of Titian, using a colder and more metallic glitter to highlight a palette of sharper greens, orange and steely blue. Its scale and exuberance, and the dramatic use of foreshortening and theatrical figure groupings also single it out as a turning point in Venetian art.

From the start, Tintoretto painted with what Aretino called his prestezza del fatto (immediacy), which the influential writer (who specifically favoured Titian and furthered his career) suggested might be replaced by la pazienza del fare (patient application). Tintoretto's 'immediacy' produced results very different from those of Titian's increasingly rapid working methods. Tintoretto exploited flickering light and tone, often with less colour, achieving a dryer effect for all his rich paint application. This is seen in Saint Mary of Egypt in Meditation in the Scuola di San Rocco and in the magical light effects in the Last Supper.

It was not only in visual dynamics, however, that Tintoretto now excelled. In *Susanna and the Elders* of the mid-1550s (see plate 262), Tintoretto avoids a classical grouping and, with characteristic invention, takes the viewer right to the core of the subject, bringing Susanna

239 Jacopo Tintoretto Miracle of Saint Mark 1548
This story comes from Jacopo da Voragine's Golden Legend.
Tintoretto shows the moment when St Mark miraculously intervenes to save a servant who wished to venerate his relics, but was condemned to torture and death. Tintoretto chooses the high point of the drama, when the saint swoops down to save the servant surrounded by breaking instruments of torture, and accentuates the movement by extreme foreshortening. Serene Palladian architecture contrasts with the foreground violence. This picture launched Tintoretto with the Venetian public, demonstrating his ability to depict large crowds of figures in dramatic action. Portraits of the artist (with beard, at left), Aretino and others have supposedly been identified in the crowd.

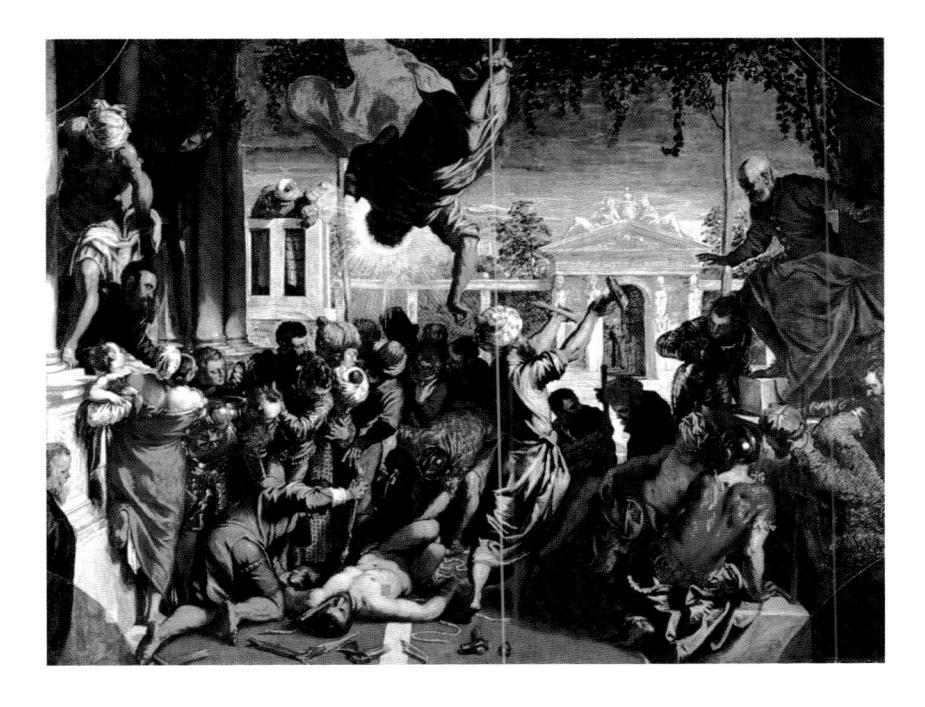

dramatically to the foreground and creating a screen of greenery in the centre which accentuates the tension of Susanna's surprise. Such devices and his brilliant ability to unify many figures in tightly-knit compositions distinguish his methods from those of central Italian Mannerists with their build-up of disparate units in a 'sum of the parts' approach.

In contrast to Titian's glamorous career; Tintoretto's was uneventfully confined to Venice, its principal milestones being his marriage and the births of his children. His major recognition outside the city came in 1566, when he was invited to join the Florentine Accademia di Pittura, together with Titian, Salviati and Andrea Palladio. This was the year that Vasari went to Venice, and noted that every visiting gentleman, man of letters or prince wished to meet Titian.

One year previously Tintoretto had initiated his lifelong involvement with the Scuola di San Rocco by painting the huge *Crucifixion* there, which remains one of his greatest achievements. It upsets all the perspective concepts established by previous Renaissance practice, using ladders, rising crosses and their complex interaction with elaborate figure groups to suggest the horror of the scene. Unity is imposed by Tintoretto's mastery of intensely dramatic lighting, difficult to control over so many figures and separate scenes. An illusion of our own presence at the scene is completed by the brilliant device of suggesting that we are not on the hill, but below it. The scale of Tintoretto's contribution to the Scuola decorations has no rival in European art.

Between 1581, when he completed the Temptation of Christ for the Sala Grande of the Scuola di San Rocco and his Last Supper of 1592–4 (San Giorgio Maggiore, Venice), Tintoretto was much more consistently a civic and ecclesiastical painter than Titian had ever been. His extensive works for the Palazzo Ducale and churches such as Santo Stefano and San Moisè, were undertaken simultaneously with major aristocratic commissions including the eight Fasti Gonzagheschi (scenes from the lives of the Gonzaga family of Mantua), now in the Alte Pinakothek, Munich. In these years, Tintoretto was tackling compositions on a scale equalled by few, such as the Paradise (1588) for the Sala del Gran Consiglio in the Doge's Palace. This was the result of a competition to redecorate some of the rooms after the fire of 1577: among other competitors were Veronese and Francesco Bassano, to whom the commission was originally given.

If Tintoretto cannot be termed a Mannerist, his expressive, sometimes even expressionistic, style generated an impulse among some of his Venetian contemporaries to experiment with Mannerism. Perhaps the most unex-

pected product of Tintoretto's influence was El Greco. Although supposedly a pupil of Titian's, he formed his style on the basis of Tintoretto's expressionism before moving to Rome in about 1570. There he painted the last great Italian miniaturist of the Renaissance, Guilio Clovio (see plate 258), and *Christ driving the Money-Changers from the Temple* (Institute of Art, Minneapolis), before settling in Toledo in 1577 for the remainder of his life.

Veronese

One painter who resolutely avoided any concessions to mainstream Mannerism after his tentative beginnings was Veronese (Paolo Caliari, 1528-88). He represents the serenity and resolution of an elegant and optimistic style which could well stand as a symbol for the close of the Italian Renaissance. While there are fleeting reflections of his contemporaries' influence, Veronese rapidly established his personal manner and varied it little throughout a career lasting more than forty years. Unlike Titian or Tintoretto, Veronese worked with equal success in oil and fresco, and two of his most beautiful decorative schemes, at the Villa Barbaro, Maser (see plate 240) and the Venetian church of San Sebastiano are in fresco. His early style reflected Giulio Romano, probably because Verona, his birthplace, was always more interested in Mantuan cultural developments than Venetian. Veronese also visited Mantua in 1552. Giulio's elaborate version of Raphaelesque Classicism with all its rich trappings must have opened Veronese's eyes to new and extravagant decorative possibilities. In many ways, it is through the sheer opulence of Veronese's paintings that we choose to visualize the Venice of the Cinquecento. This ability to reflect the ethos of an entire city's culture may come from a certain detachment from real drama which makes his pictures so easy on the eye.

In 1553 Veronese settled in Venice, where Titian dominated his attentions. With prestigious commissions from Cardinal Gonzaga and others behind him, he at once received work in the Palazzo Ducale. Veronese's interests must never have clashed with those of Titian, as may be deduced from ceiling panels showing the *Story of Esther* in San Sebastiano. In essence, these contain the germ of Veronese's subsequent work, and single him out as the most able illusionist ceiling decorator in the city. They show him breaking with the Giorgione traditions of fused outline and patches of colour, and substituting a vigorous clarity quite at variance with the prevailing taste in Venice. It is a mark of his sophistication that he chose paler colours than most Venetians, which ultimately led to

the palette adopted by Tiepolo in the eighteenth century. The ceiling also affirms Veronese's love of illusionistic figure painting using the oblique perspective preferred in Venice to Correggio's sotto in sù. Although he loved the softness of Correggio's style, and the yielding allure of his female models, none of their subtly implied sexuality enlivens Veronese's women, for all their beauty. Illusionism recurs throughout his work, perhaps most successfully in the incomparable *Triumph of Venice* (see plate 241) with its strong foretaste of Baroque ideas.

The fertility of Veronese's visual imagination exceeds any of his contemporaries', and was praised by Vasari as his invenzione. Inventive he certainly was, and there is rarely any sense of the repetition of established formulae in his painting. The superabundance of realistic detail links him to the central Italian Mannerists, but his intention is to seduce the eye, rather than impress with erudition. This he achieved with a decorative use of colour, and with models of an idealized beauty which nonetheless often give an impression of portraiture. But while Titian or Tintoretto's figures suggest that their poses and gestures spring from their emotions, Veronese's often appear to offer only superbly elegant mime. This links him with the intentions of Mannerists like Bronzino in his greatest subject pictures. Veronese is at his most theatrical - indeed operatic - in Alexander and the Family of Darius (National Gallery, London).

According to Ridolfi's Meraviglie dell'Arte (Marvels of Art), Veronese visited Rome in 1560, and the effect of this

240 PAOLO VERONESE View of the Villa Barbaro, Maser 1561 Veronese frescoed the central block of Palladio's great villa in the Veneto, built for the brothers Marcantonio and Daniele Barbaro. The themes include Classical mythology, genre and landscape, and the whole ensemble is Veronese's greatest single achievement in fresco. Set in painted architecture are portraits, nudes, lavishly draped figures, animals, statuary, garden pergolas and a wealth of visual devices. Just visible on one wall is the famous scene of a carriage approaching a villa in a landscape, and many other naturalistic observations are included.

journey can be seen in his superb frescoes at Maser (see plate 240). He appears to have studied Raphael, not only in the Stanze, but also the more sensuous moments in his Farnesina *Story of Psyche*. Possibly more than any other painter, Veronese transmits the mood of mid-century Venice (without literally portraying it) in his unique inclusion of grandiose Classical architecture, which reflects the latest ideas of his younger contemporary, Palladio (see plate 261).

Even Veronese, however, seems to have felt the new currents of the Counter-Reformation's demands for seriousness by the 1570s. This is particularly evident in several renderings of the *Crucifixion* (Musée du Louvre, Paris; Gemäldegalerie, Dresden and Szépmüvészeti Muzeum, Budapest), where he can be seen struggling to transcend the mere beauty of his technique. Depth of feeling certainly increases during his last years, when some of his religious themes almost assume the intensity

241 PAOLO VERONESE Triumph of Venice 1583

After a fire in 1577 the redecoration of the Sala del Maggior

Consiglio was entrusted to Veronese, Tintoretto and Palma il

Giovane. Veronese's great oval, the central feature of the ceiling,
shows his considerable ability to organize forms in space. Its
illusionism is different from that of Correggio and typically Venetian;
although seen from beneath, the composition is only tilted at an angle
and not seen 'di sotto in sù'. Nonetheless its overwhelming impact
of form, rich colour and movement had a considerable influence on
Baroque ceiling decoration.

242 JACOPO BASSANO Adoration of the Magi, early 1540s This is among Bassano's finest compositions. The ruined building on the left derives from Dürer's woodcut of the Holy Family's Sojourn in Egypt. The inclusion of contemporary dress is typical of Bassano's innovative approach to genre, of which he was one of the first practitioners.

of such reforming painters of the period as Annibale Carracci in Bologna. Veronese's ability as a portraitist never deserted him, from the poignant beauty of *La Bella Nani* (Musée de Louvre, Paris) through the vivacious full-length *Family Portrait* (Palace of the Legion of Honour, San Francisco) to his *Portrait of a Man* in the Galleria Colonna, Rome, which prefigures Van Dyck's insouciant elegance. The only painter comparable with Veronese was the celebrated frescoist Giovanni Battista Zelotti (1526–78), who collaborated with him.

Bassano

Veronese considered Jacopo Bassano the only painter to whom he would entrust his youngest son, Carletto. Bassano (Jacopo da Ponte, c. 1510–92) and his four sons represent a trend in painting in the Veneto outside the 'official' mainstream of Titian, Tintoretto and Veronese. Vasari was impressed by Bassano's painting of animals, whose inclusion in many of his religious pictures lends them a naturalism of detail without parallel in Venetian painting of the period. It is sometimes difficult to tell whether his subject is religious or genre (see plate 242), and this was to have considerable influence on Italian art. Like many of his contemporaries, including Veronese, Bassano ran an extensive 'shop', assisted by his sons.

Bassano was deeply influenced by prints, particularly those of Parmigianino and after Raphael, notably his *Lo Spasimo di Sicilia*. Thus there are more overtly Mannerist features in his mature painting, not only in poses and compositions but also in his frequent use of cold, brilliant colours. Tintoretto's skill at highlighting forms against dark backgrounds also influenced Bassano, as in his *Entombment* of 1574 (Santa Maria in Vanzo, Padua).

Painting in Emilia and Northern Italy

Even outside the main centres, the wealth of creative talent throughout Italy in this period was prodigious, and the interaction of ideas virtually impossible to outline in simplified terms. In Milan and Piedmont, the Leonardo tradition flowered into a variety of forms, for example Gaudenzio Ferrari (c.1475/80–1546) created haunting images, not least in the Sacro Monte at Varallo. Bologna produced a wealth of lesser talents, such as Girolamo da Carpi (1501–56), Niccolò dell'Abbate (c.1509–71, see plate 243), Francesco Primaticcio (1504–70) whose principal achievements affected France (see plate 160), and Pellegrino Tibaldi (1527–96, see plate 244). The Zuccaro brothers, Taddeo (1529–66) and Federico (c.1542–1609)

244 Pellegrino Tibaldi Adoration of the Shepherds 1548–9

Tibaldi was born in the Duchy of Milan and seems to have trained in Bologna and Rome. During the 1550s he decorated the Palazzo Poggi with a fresco cycle of the Story of Ulysses. In 1586–94 he painted for Philip II of Spain at the Escorial. This is his first documented work, and shows the influence of both Michelangelo and Raphael, with strongly lit, statuesque forms.

243 NICCOLÒ DELL' ABATE A Concert 1548–52 The artist's Bolognese sojourn saw him painting mainly palace decorations such as this fresco, one of the most delightful interpretations of Northern genre prototypes.

were born near Urbino, but made highly successful careers in Rome. After Titian's death, Federico Zuccaro can claim to have been the most famous painter in Europe, travelling to the Netherlands and England, where he was chosen to paint Queen Elizabeth I. Taddeo created one of the most important decorative schemes of the Cinquecento, the frescoes at the Farnese villa of Caprarola, culminating in the 'sala dei fasti Farnese' of 1565, whose combination of illusionism with trompe-l'oeil pictures 'hung' on walls looks forward to the developments of the early Baroque. In Venice, Jacopo Palma il Giovane (1544–1628), grand-nephew of Palma Vecchio, carried on the Cinquecento ideas into the new century, but saw the demise of the city as a leading artistic force. In Florence, Bronzino adopted as his son Alessandro Allori (1535–1607), whose late *maniera* style (see plate 267) dominated the latter part of the century, until it was supplanted by the reforms of Jacopo da Empoli and others.

Painting in mid-late sixteenth-century Emilia produced many individual talents, ranging from Correggio to the Carracci. Emilia's position midway between the central Italian states and Venice and the North made it accessible to a wide range of influences. In 1521 Michelangelo Anselmi arrived in Parma, and introduced the ideas of the leading Sienese Mannerist, Domenico Beccafumi (1485/6–1551). Beccafumi's elegant and elongated, flame-like figures with their small heads and curious simplified faces were thus indirectly responsible for some of Parmigianino's evolution, as seen in his early frescoes at Fontanellato; this gives an idea of the rapid movement of ideas in Italy at this time.

Parmigianino

One of the most fascinating figures of the period, Parmigianino (Girolamo Francesco Maria Mazzola, 1503–40) was also one of the most characteristic and original Mannerist painters. Vasari devotes much attention to his obsession with alchemy and eventual madness. He visited Rome in 1524–7 where he found favour with Pope Clement VII, who introduced him to Perino del Vaga and Rosso Fiorentino, and thereby Correggio's influence was transformed into one of Mannerism's most sensuous styles. While at work in Rome on the *Vision of Saint Jerome* (National Gallery, London) he was captured during the Sack of 1527, but he escaped to Bologna.

Parmigianino's use of elongated, curving forms and exceptionally elegant detail makes his work the finest example of *grazia* in Cinquecento art. This is undoubtedly

245 PARMIGIANINO A Lady 'The Turkish Slave' c.1522 This is one of the high points in Parmigianino's portraiture. The unusual headdress, assumed to be a turban, led to the mistaken identification 'the Turkish slave'. Although stylized to conform to Parmigianino's ideal of female beauty, it is definitely a likeness of an individual sitter. The suavity of its rounded forms, turn of the head and remarkable variety of textures accentuate her enigmatic beauty.

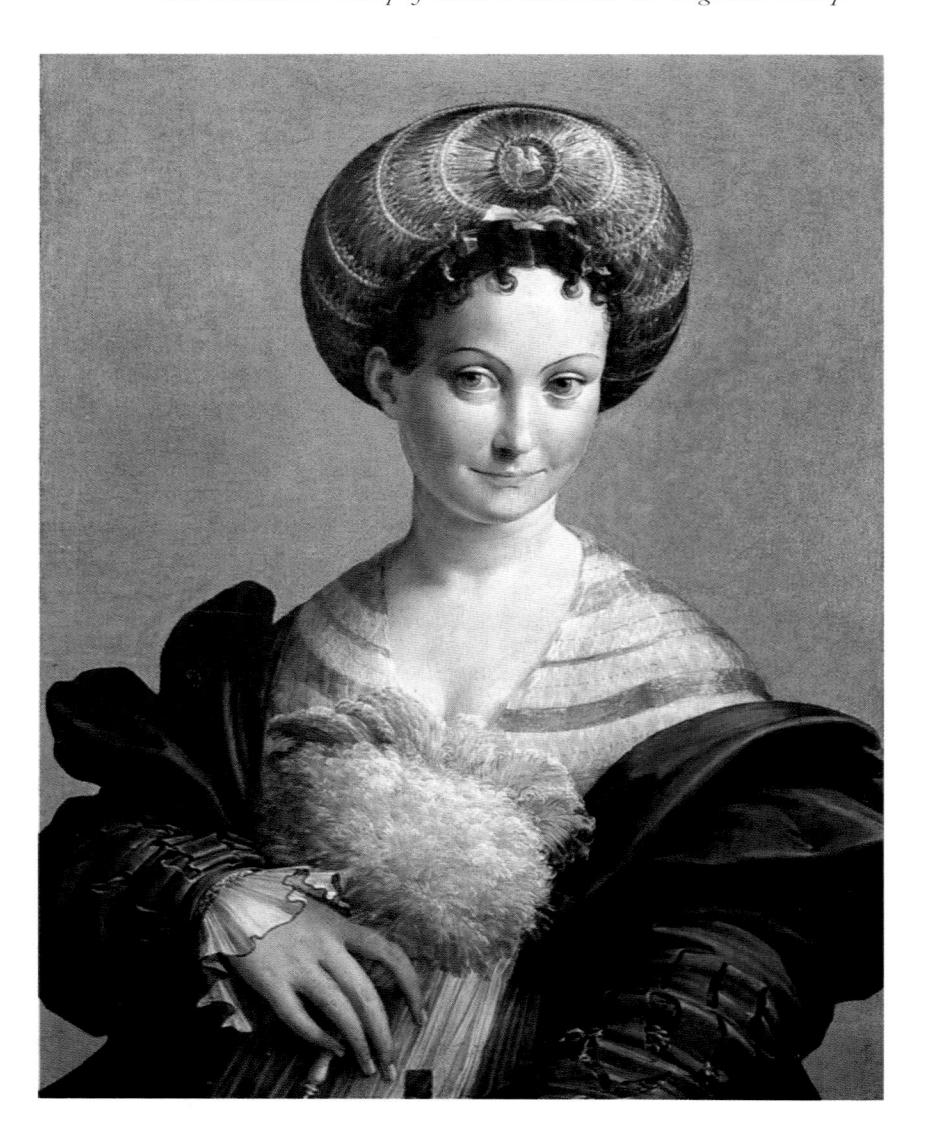

best expressed in the Madonna of the Long Neck (see plate 232). His influence was incalculable, mainly through his superb etchings which were imitated by Ugo de Carpi, and reached courts as disparate as Fontainebleau and Prague. His painting and drawing breathe a rarefied atmosphere of extreme refinement, which as much as Correggio's was to fascinate the painters of the Rococo style. In some ways, Parmigianino can be seen to have used decorative devices later found in Veronese, but instead of Veronese's ostensibly 'natural' approach to anatomy and composition, he achieved a highly romantic and perverse atmosphere. Apparently resolved and selfconfident, his figures are really symptomatic of a profound unease, expressed in a way comparable to Bronzino's enamelled figures. Unlike Bronzino's portraits, however, Parmigianino's (such as A Man with a Book, in the City Art Gallery, York, or the mysterious Antea in the Museo di Capodimonte, Naples) suggest a deceptive intimacy with the spectator, while in fact being even more perversely withdrawn and inward-looking. In the late Portrait of a Man (Kunsthistorisches Museum, Vienna) - contemporary with his last great fresco work in Santa Maria della Steccata (completed 1539) - he adopts an architectural background device such as Bronzino exploited in the same years. The almost effete quality of some of these late works finds further expression in the work of Parmigianino's cousin by marriage, Girolamo Bedoli (c.1500?-69) who took the name Mazzola Bedoli.

Dosso Dossi

At Ferrara, Dosso Dossi (Giovanni di Niccolò de Lutero, 1490–1542) also created a very different, but equally romantic vision of both nature and man. Dosso was court painter under two successive Este dukes, Alfonso I (1503–34) and Ercole II (1534–59), who, at the apogee of the court's brilliance, aimed to employ painters of the stature of Raphael and Titian. Dosso's legacy was very rich, for he and his brother Battista worked in every facet of the luxury arts, including festival and theatre decorations in palaces and villas. Tragically, much of this vanished when the Papacy seized Ferrara at the end of the century and much of its culture was destroyed.

Dosso was in Mantua in 1512, after studying Giorgione and early Titian in Venice. He also visited Rome where Raphael most impressed him. It was his highly original distillations of such a variety of sources which produced his distinctive, vigorous style – at the very opposite polarity from an artist like Parmigianino. From the off-beat art of the Ferrarese court, with its interest in astrology and

alchemy, may derive some of Dosso's highly unconventional iconography. Dosso's bucolic, earthy (and sometimes highly erotic) images are distinguished by their brilliant lighting, vivid colour and verdant landscape backgrounds. His *Melissa* of c.1523 (Galleria Borghese, Rome) shows his unique mixture of Classical grandeur, esoteric iconography, opulent texture and colour, landscape and even humour, all within a deceptively downto-earth form. In his last years, he even permitted satire to appear, as in *A Scene of Witchcraft* (Uffizi, Florence).

Lorenzo Lotto

Like Dosso, Lorenzo Lotto (c.1480–1556/57) stands somewhat apart from mainstream trends. He worked mainly in the provinces (Treviso, Recanati and elsewhere) in spite of being Venetian by birth. His beginnings belong properly to the High Renaissance, since Vasari says that he studied alongside Giorgione and Titian in Bellini's studio. Lotto combined the clarity of Bellini and Antonello de Messina with an astonishing repertoire of sources including the Florentine High Renaissance masters and Leonardo. The results in his mature works are expected, both in his portraiture and religious and allegorical themes (see plates 246, 247 and 264). His dramatic sense is best seen in the *Annunciation* (Santa Maria sopra

246 LORENZO LOTTO Portrait of Andrea Odoni 1527
This picture perfectly illustrates the collector's passion in the later
Renaissance. Odoni was a wealthy Venetian merchant, who clearly
had a passion for the Antique. Titian, Parmigianino and Palma il
Giovane were all influenced by the picture's original and pleasing
composition.

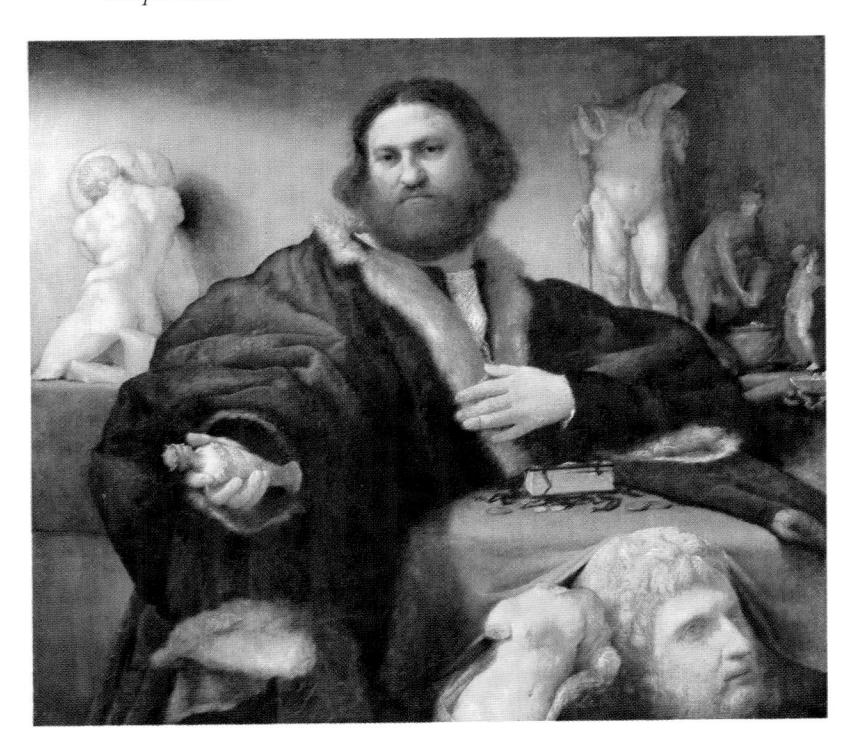

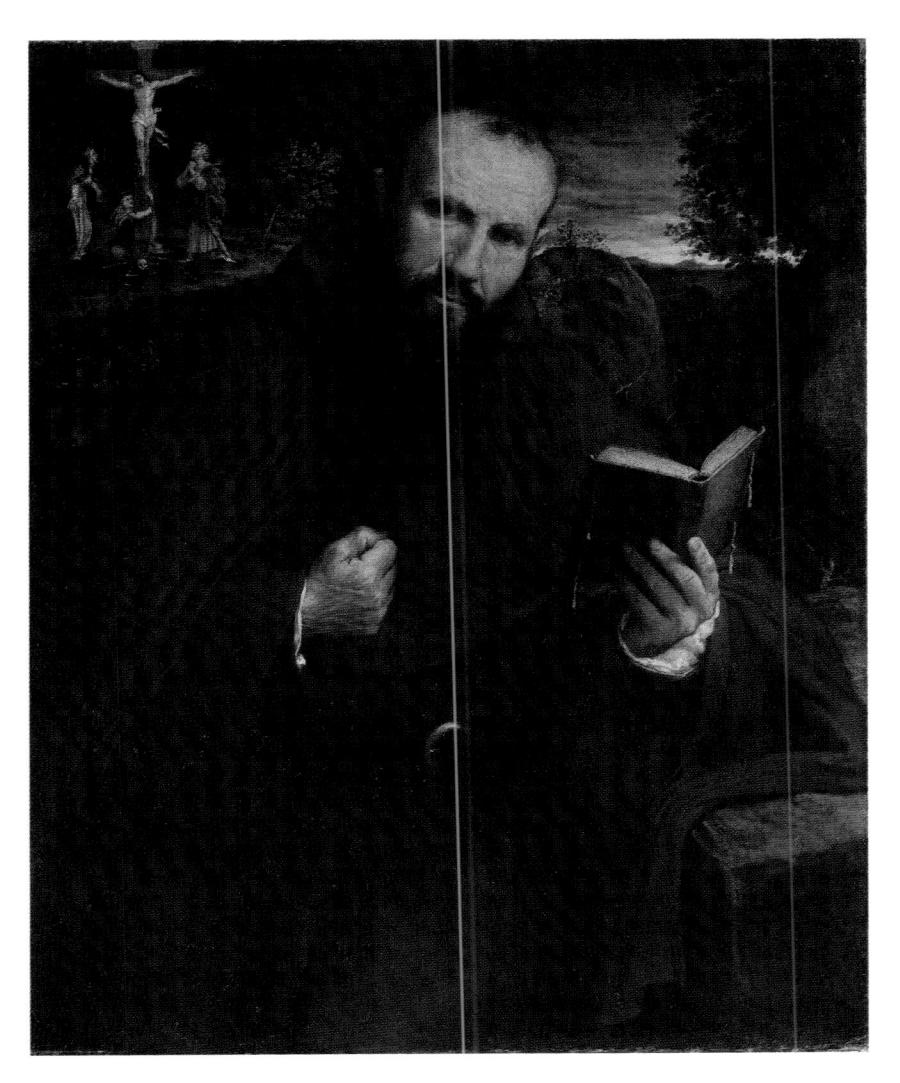

247 LORENZO LOTTO Brother Gregorio Belo of Vicenza 1547

This portrait shows early evidence of Counter-Reformation fanaticism, in the striking pose, with its clenched, almost threatening fist, the fierce expression and background Crucifixion. It is as though Belo were actually present. The fist evokes the iconography of the patron of the order of St Jerome, to which the friar belonged. Lotto painted another picture with comparable religious fervour in the same year — St Peter Martyr (Fogg Art Museum, Cambridge).

Minerva, Recanati) and the *Saint Lucy Altar* of 1532 (Biblioteca Communale, Jesi) where light and shade create an eerie world midway between reality and dream.

By the time of the deaths of Michelangelo, Titian and Veronese, a new spirit was emerging in Italian painting, partly under the influence of the Counter-Reformation, but also partly in reaction to the 'de-humanizing' elitist tendencies in Mannerist art. The ideals of Mannerism and its offshoots still belonged to the world of nostalgia for an imagined Classical and pagan past, which was the mainspring of the first Renaissance. The sixteenth century had contributed a new breadth of vision to the Quattrocento's dream of antiquity, aided by new concepts of scale and, in the case of such a painter as Titian, new technical means. Many of the painters discussed in this chapter represent the countless aspects of the end of this epoch.

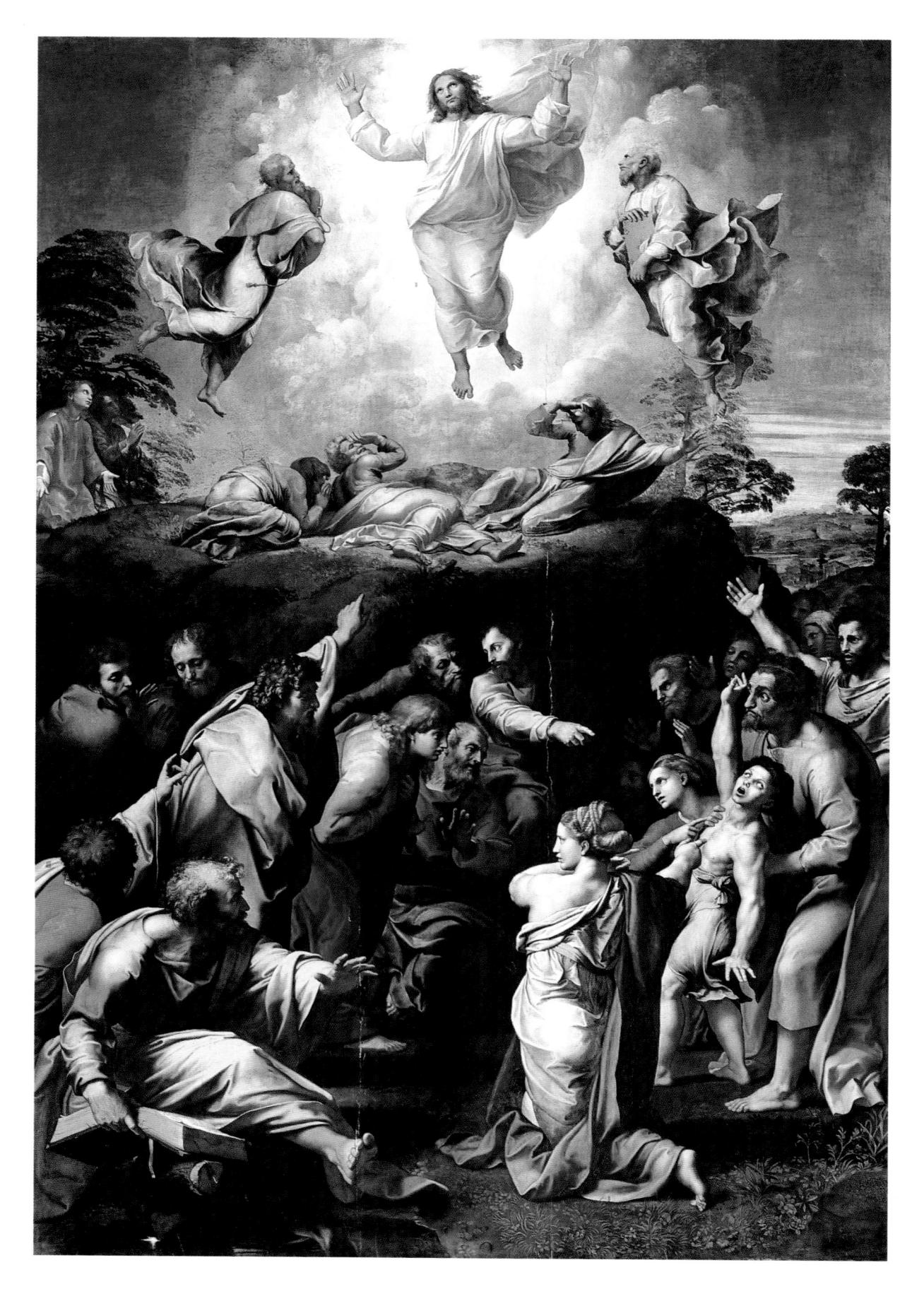

248 RAPHAEL Transfiguration 1518-20

The painting depicts the moment when Christ revealed His divine nature to His disciples on the top of a high mountain: Moses and Elijah appeared and Christ's face and garments became radiant with light, while the voice of God proclaimed: 'This is my son'. In the bottom half is the subsequent healing by Christ of a demoniac boy. In late 1516 Cardinal Giulio de'Medici ordered this altarpiece for the Cathedral of Narbonne; it was never sent. He then commissioned Sebastiano del Piombo to paint a Raising of Lazarus (National Gallery, London), to the design of Michelangelo, on the assumption that the competition between him and Raphael would stimulate

better results. In July 1518 Sebastiano wrote to Michelangelo suggesting that Raphael had still not begun the painting. By September 1519 he was devoting most of his time to it.

Both Sebastiano and Vasari were sure that Raphael had personally completed the altarpiece, and the suggestion that Giulio Romano or Penni finished it has been largely discredited. Battista Dossi, sent to Venice to obtain the necessary colours for the Transfiguration, saw Titian's newly unveiled Assumption in the Frari (see plate 254); its revolutionary composition may have led Raphael to alter his design.

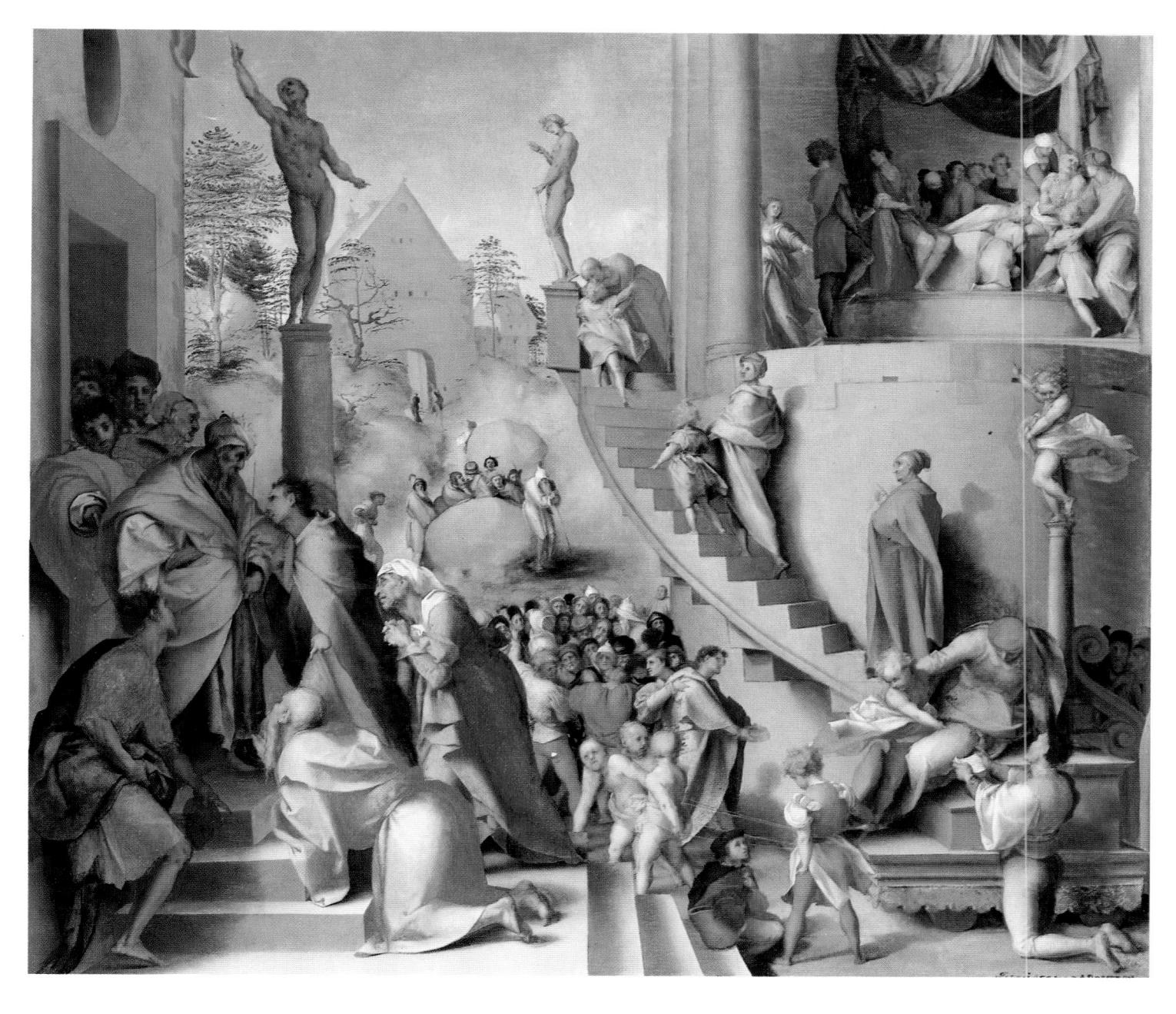

249 Jacopo Pontormo Joseph in Egypt 1517–18

A number of Florence's leading painters — Andrea del Sarto,
Granacci, Bachiacca and Pontormo — collaborated on the decoration
of the nuptial chamber of Pier Francesco Borgherini's Florentine
palace. The theme chosen was the story of Joseph, and Pontormo's
Joseph in Egypt is the most grand and complex of the paintings,
notwithstanding its small scale, which recalls the small scenes in
predella panels and cassoni. Influenced by prints by Northern artists
such as Lucas van Leyden (notably in the landscape and background
architecture), it deliberately combines disparate chronological scenes in
one picture. The statuary seems ambigious as are various spatial
devices. Vasari says that the seated boy in the foreground represents
Bronzino, who had just entered Pontormo's studio as a pupil.

250 Raphael The Road to Calvary (Lo Spasimo di Sicilia) c.1517

Although much of the painting may be by Giulio Romano, the design is Raphael's and shows his latest style at its most dramatic. A vigour and a greatly increased forcefulness of gesture replace the sweetness of his earlier style. The design is based on Dürer's woodcut of Christ carrying the Cross, and in its turn Veneziano's engraving after the Raphael exercised considerable influence.

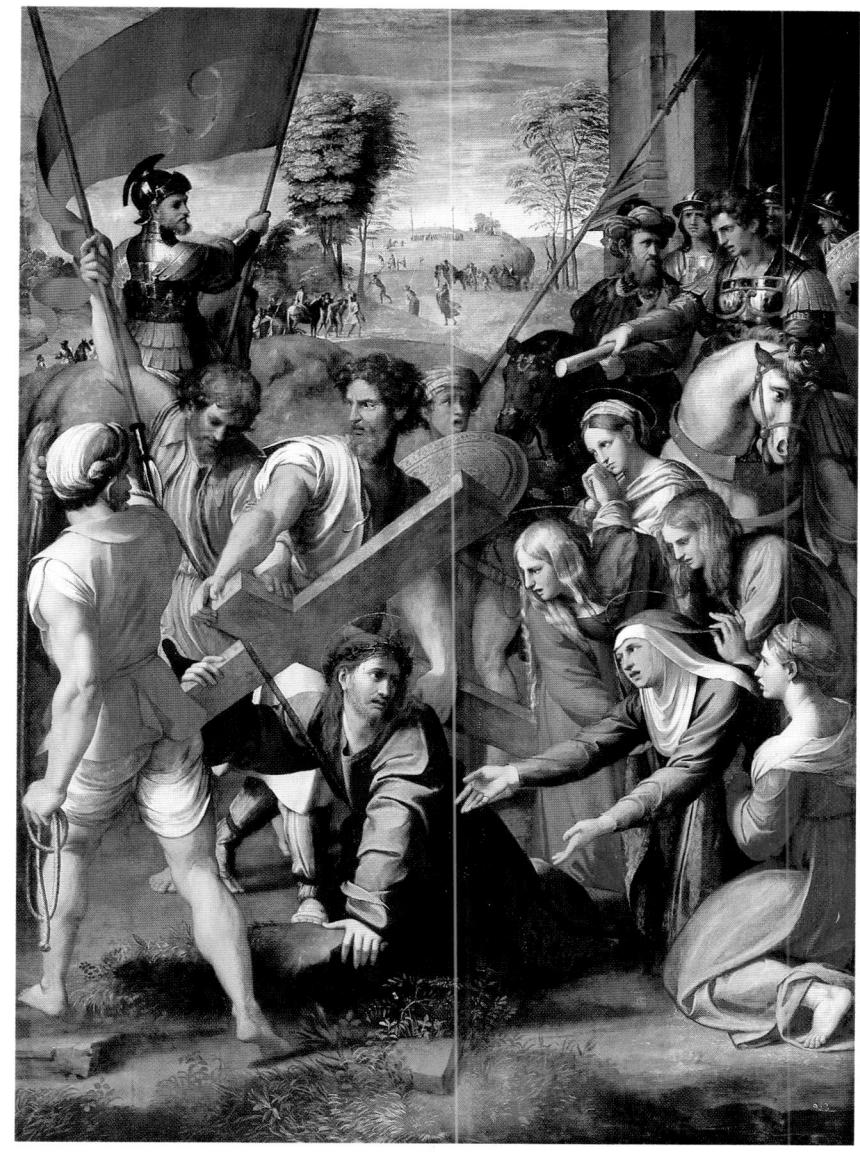

251 Rosso Fiorentino Portrait of a Young Man c.1528 This is one of the classic portraits of Mannerism. The self-conscious pose and remote gaze of the sitter recall effects sought by Bronzino, but with a more elusive character. Its sharper features and elongated forms are far from the courtly aims of Bronzino, creating a more expressive and disturbing atmosphere.

252 AGNOLO BRONZINO Portrait of Giovanni de'Medici as a Baby 1545

This was once thought to represent Garcia, son of Cosimo I and Eleonora di Toledo, but is now known to depict his elder brother Giovanni, aged eighteen months. Astonishingly vivacious, it shows a very different side of Bronzino's portrait painting, reflecting his recorded personal devotion to the Medici children.

253 AGNOLO BRONZINO Portrait of Laura Battiferi, late 1550s (Right) One of the most original and striking portraits of the Mannerist period, this shows Bronzino's close friend, the poetess Laura Battiferi (1523–89), wife of the sculptor Ammanati. Her two marriages were childless and she called herself 'a sterile tree'. She was a close friend of Eleonora of Toledo and, like her, deeply religious and involved with the Jesuits. She corresponded with many of the leading men of her day, including Cellini and Torquato Tasso, and published her first book of poems in 1560. Bronzino and she exchanged Petrarchian sonnets (she is shown holding Petrarch's Sonnets), and in Bronzino's sonnet dedicated to her, the artist describes her as 'inside all iron, externally of ice.'

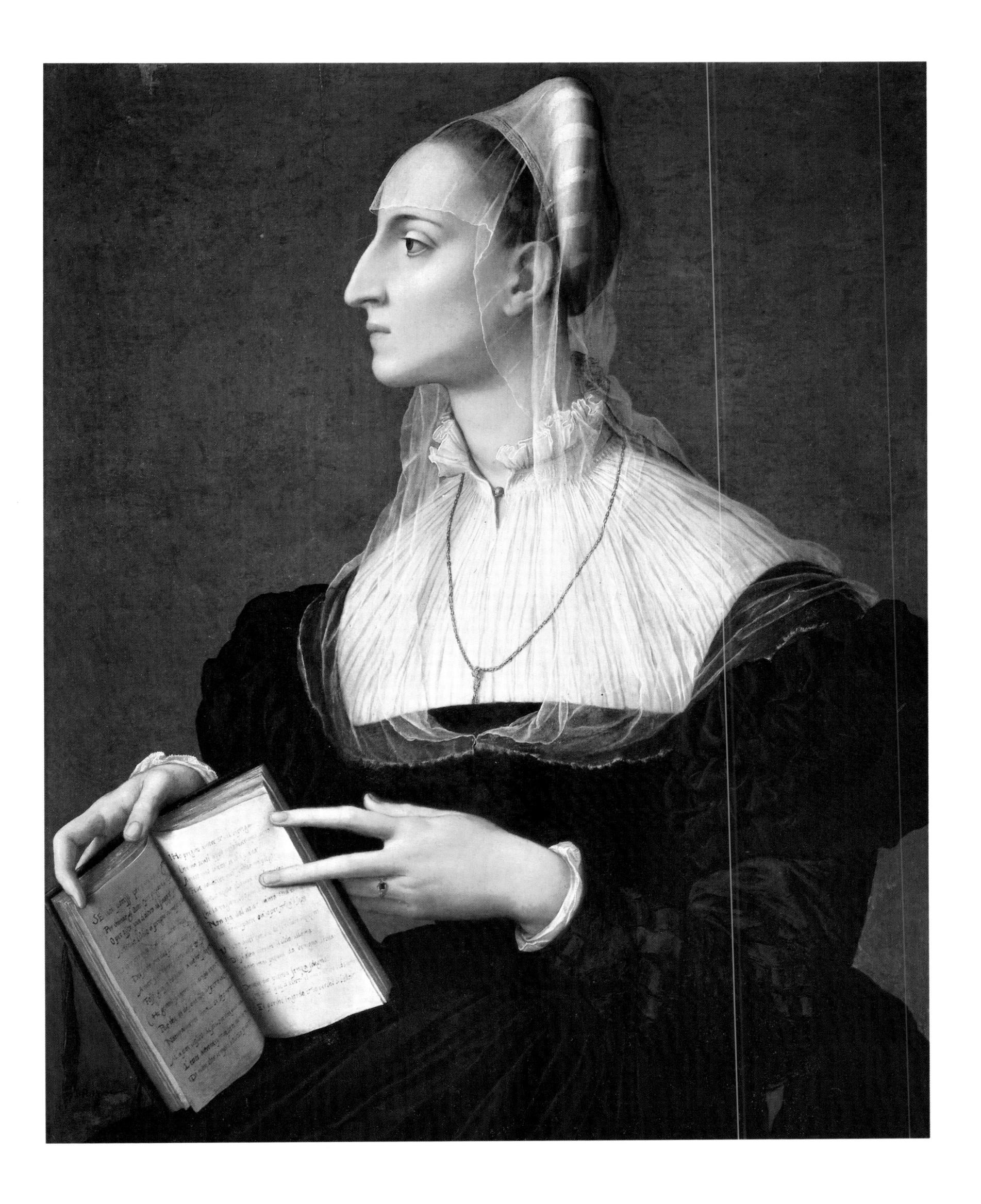

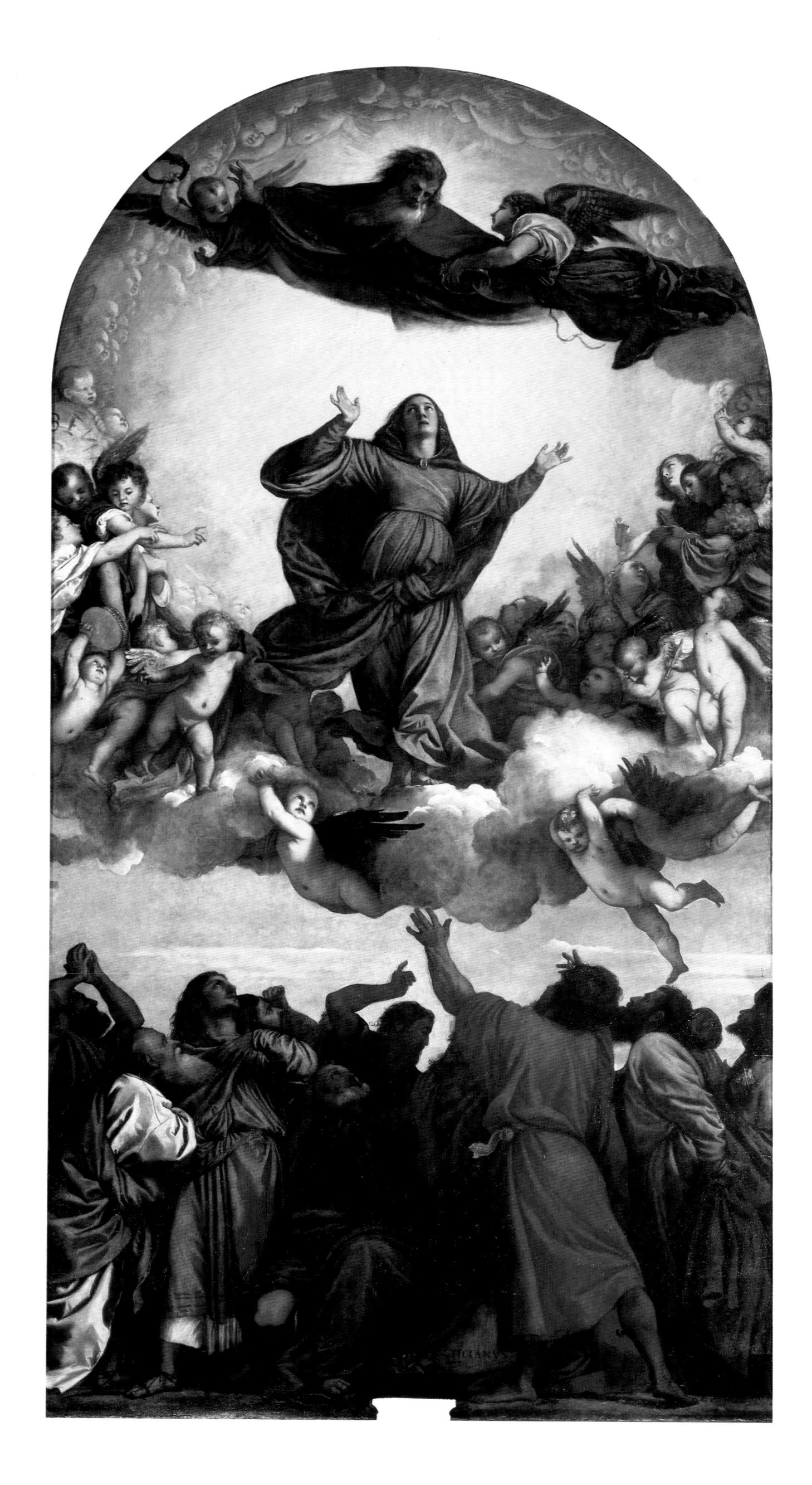

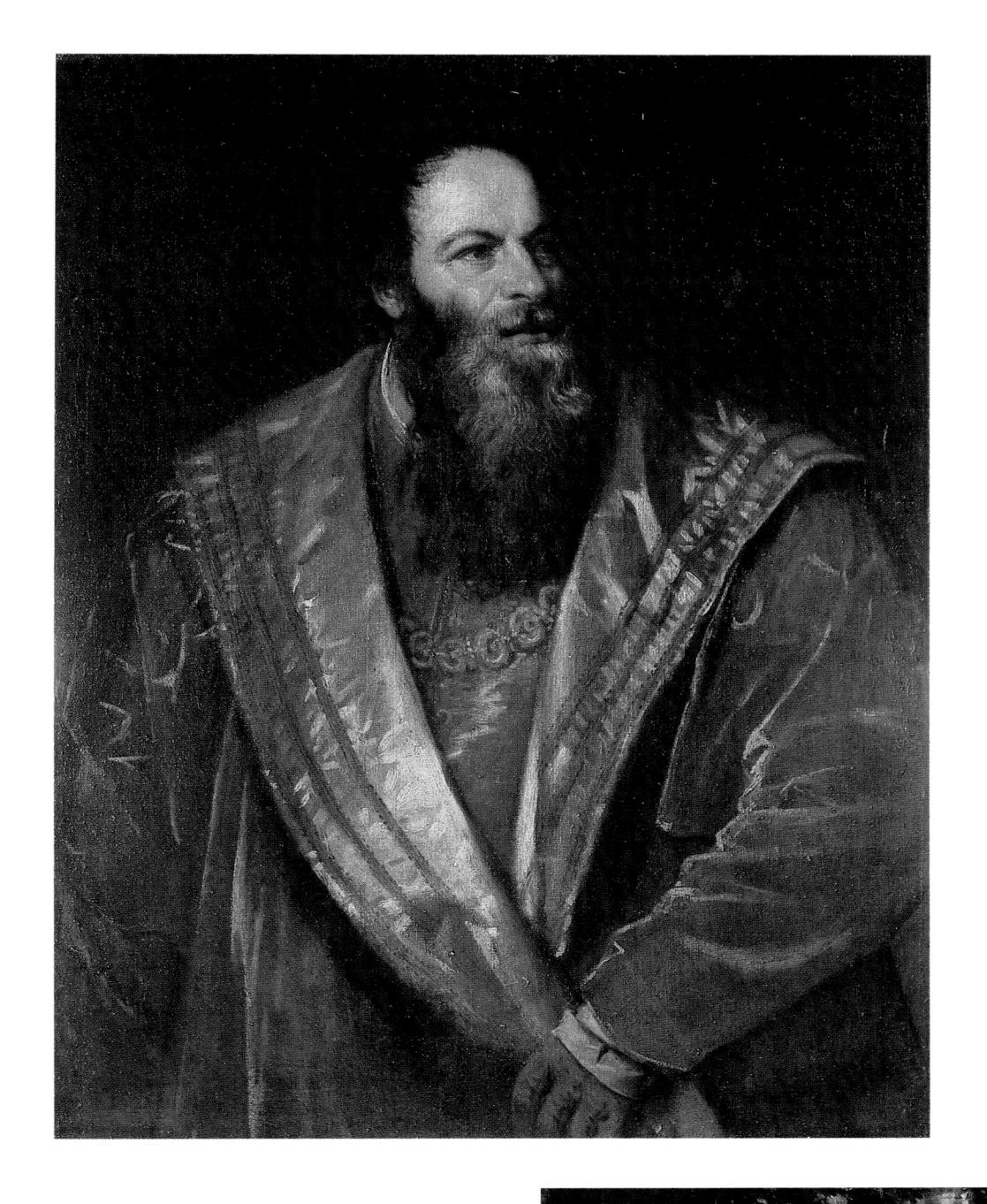

255 TITIAN Portrait of Pietro Aretino 1545
Aretino from Arezzo was one of the leading
intellectuals of his period. After 1522 he was
active at several Italian courts, particularly
Mantua under Federigo II Gonzaga. Of humble
origins, his character was coarse and his sonnets
included the pornographic ones graphically
illustrated by Giulio Romano. Aretino thought
this portrait a mere sketch, but this did not
prevent him from giving it to Cosimo de'Medici.

256 TITIAN Pietà 1576

Palma il Giovane painted the inscription on the central pedestal recording his completion of Titian's unfinished picture. Titian had intended this moving image to be placed over his own tomb in the Cappella del Crocefisso in the church of the Frari, Venice, but possibly on account of its being incomplete at his death it was placed elsewhere. Titian shows himself as St Jerome, at right; the Hellespontic Sybil with cross and crown of thorns prophesies Christ's death, while Moses appears at left, with the Magdalene and the Madonna. The setting reveals Titian's fami 'iarity with the architectural ideas of Serlio and others, and the loose paint handling typifies his own latest manner.

254 TITIAN Assumption of the Virgin 1516–18

(Left) This was Titian's first important religious commission and the culmination of his early career, and is one of the major monuments of High Renaissance art. It was conceived for its setting, so its strata correspond with the great Gothic windows of the Frari's apse. The painting's striking novelty, in contrast to the prevailing taste of Bellini's altarpieces, almost led to its refusal by the church authorities. Titian probably drew inspiration from Raphael's Disputà in the Vatican, known to him through drawings by other artists. An elongated triangle is created against the predominantly gold background by three dominant areas of red drapery, accentuating the Virgin's upward movement towards God the Father. The painting's scale and drama exerted considerable influence on Baroque painters.

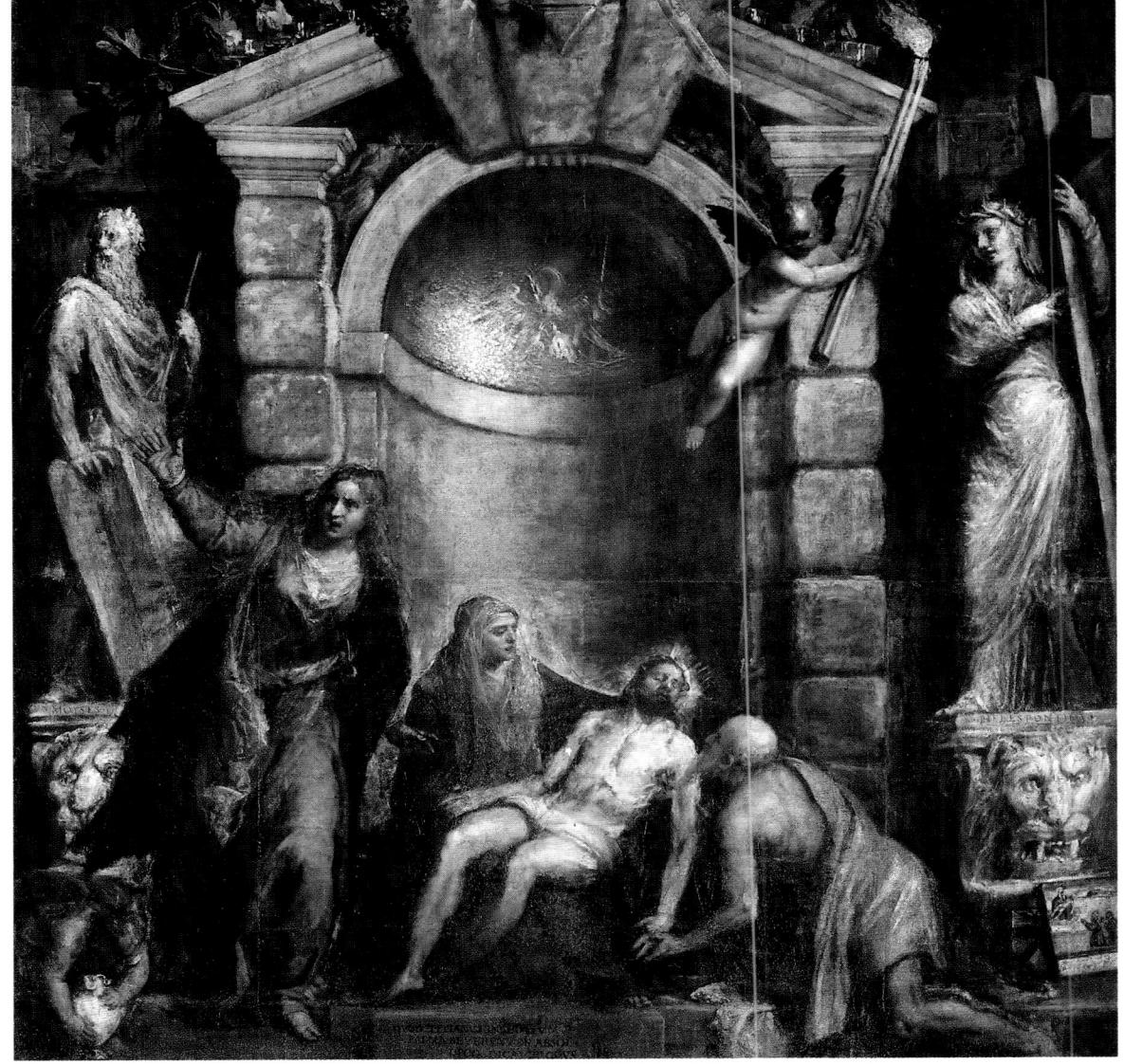

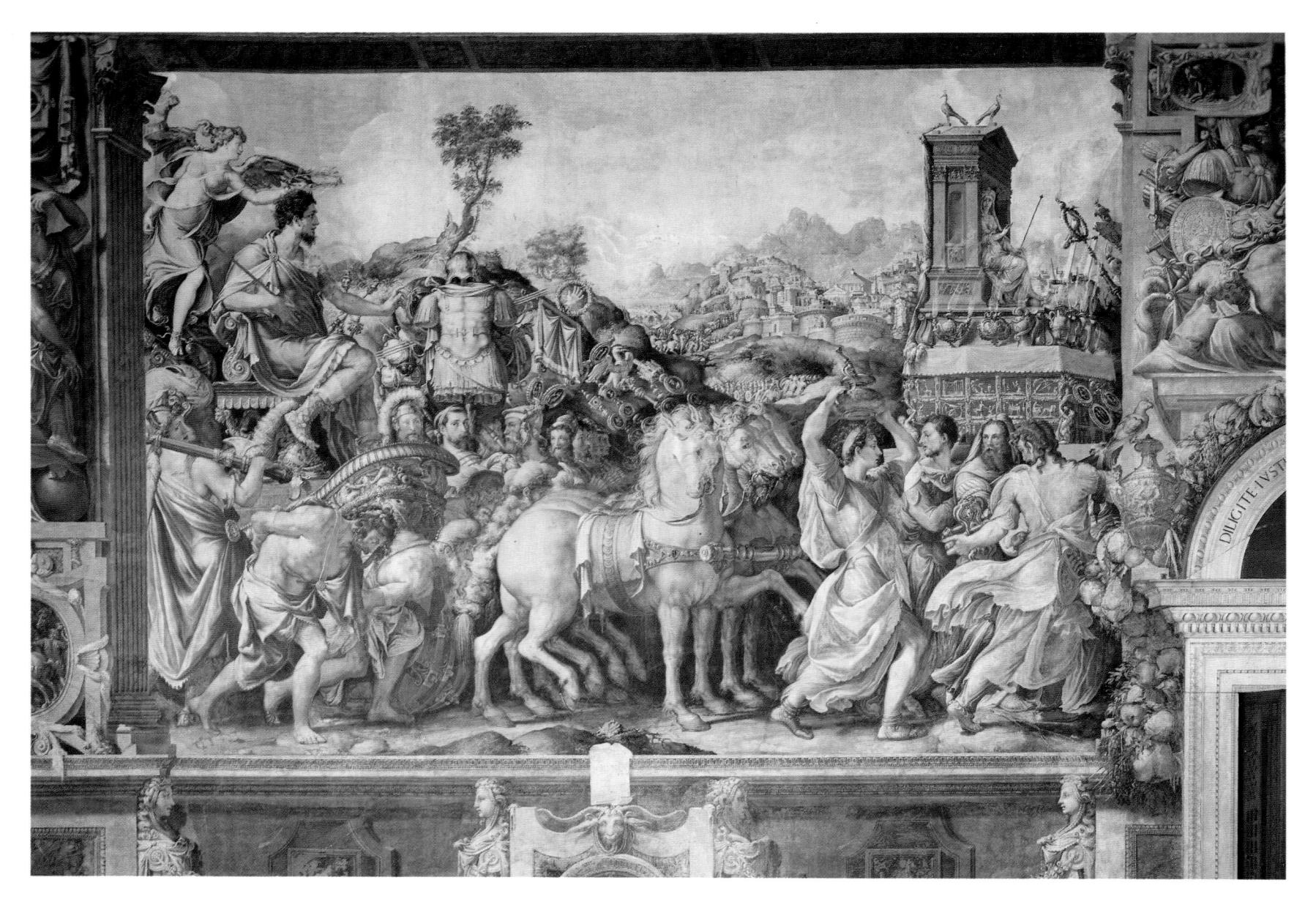

257 Francesco Salviati Triumph of Camillus 1543–5
Salviati hoped for extensive Medici patronage while in Florence, but although he worked for the court tapestry manufactory his failure to obtain the San Lorenzo commission won by Pontormo and Bronzino made him return to Rome. He was Bronzino's major rival at court in the 1540s. These frescoes in the Audience Chamber of the Palazzo Vecchio show the peculiarly Roman combination of elements from both Raphael and Michelangelo found in mid-sixteenth century painting there. Extensive Classical detail, vibrant colour and elaborate compositions produce a somewhat overcrowded effect.

258 EL Greco Giulio Clovio Holding the Farnese Hours 1570–2

(Top right) Clovio was a Croatian miniaturist, who worked continuously for Cardinal Alessandro Farnese over some forty years after he entered the Cardinal's service around 1537. The last great European miniaturist, he lived first in the Cancelleria Palace, then in the Farnese Palace after Alessandro inherited it in 1565, where he died aged almost one hundred in 1578. He accompanied Alessandro into exile at the Medici court 1551–c.1553. He also designed livery for a carnival ball for the Cardinal, and acted as his artistic adviser. Clovio and El Greco became close friends.

259 GIULIO CLOVIO Pages from the Farnese Hours, completed 1546

(Bottom right) Clovio painted twenty-six paired miniatures, his masterpiece, for Cardinal Alessandro Farnese, one of the greatest patrons of the mid-century, over a nine year period. The Hours are perhaps the finest production of Italian Renaissance miniature painting, and by 1577 were included among the major sights of Rome. Vasari thought they were 'something divine, not human'. The whole set was given a silver-gilt binding by the master craftsman Antonio Gentili. Clovio set the brilliantly coloured scenes in bronze frames, including imitation antique cameos (Alessandro was an avid collector of engraved rock crystals) and simulated marble figures, possibly influenced by Salviati's work for the Farnese.

260 Sebastiano del Piombo Portrait of Ferry Carandolet and his Secretaries 1511–12

Ferry Carandolet was a figure of great importance in his period, Archdeacon of Besançon, adviser to the Emperor and Ambassador to Rome. This portrait was painted in Rome: Sebastiano had arrived from Venice in 1511 to fresco a room in the Villa Farnesina. Until the nineteenth century it was believed to be by Raphael, the intense characterization of whose Roman portraits it reflects. It is certainly one of the most imposing portraits of the Roman High Renaissance.

261 PAOLO VERONESE Marriage Feast at Cana 1562–3 (Right) This immense canvas was painted for the refectory of the Benedictine convent of San Giorgio Maggiore, from where it was looted by Napoleon. Its sense of space and grandeur have long been praised, together with the variety and richness of the figures. This, and its use of colour and lavish detail, contribute to a sense of festivity without equal in Renaissance painting. There are many portraits of notable contemporaries, including Titian (playing the viol) and Veronese himself (playing the violin). The Palladian architectural setting was painted by other specialist artists.

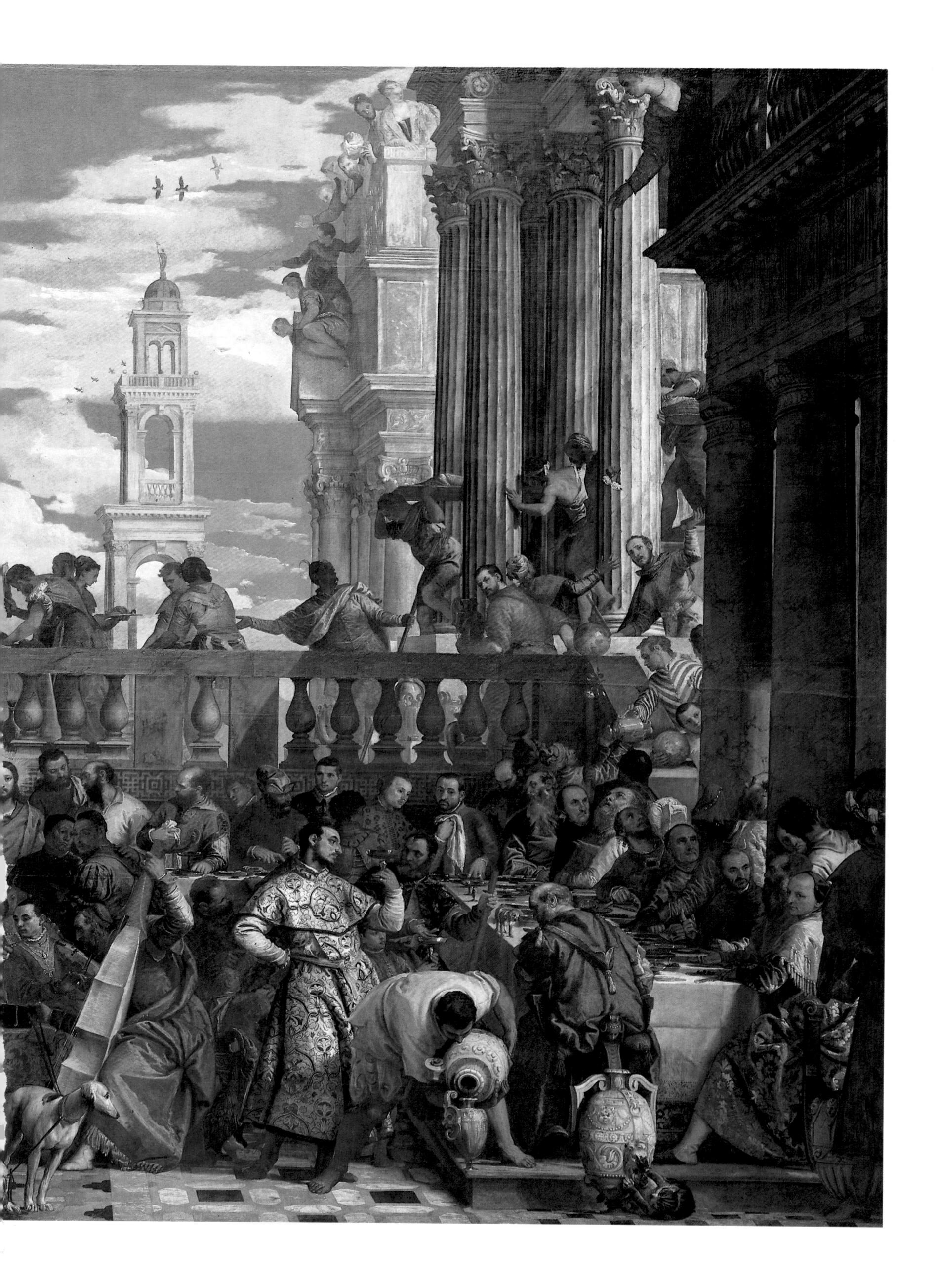

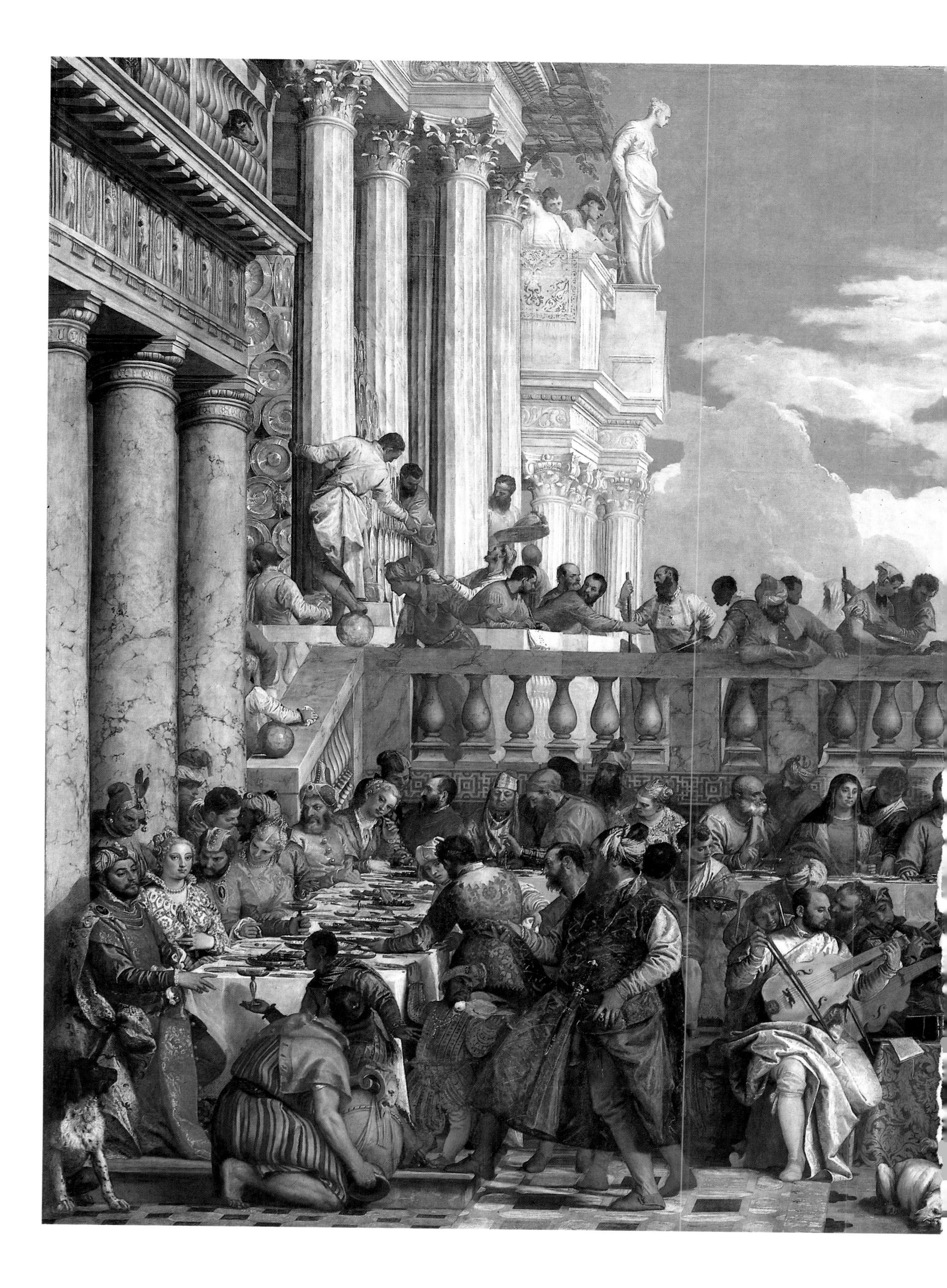

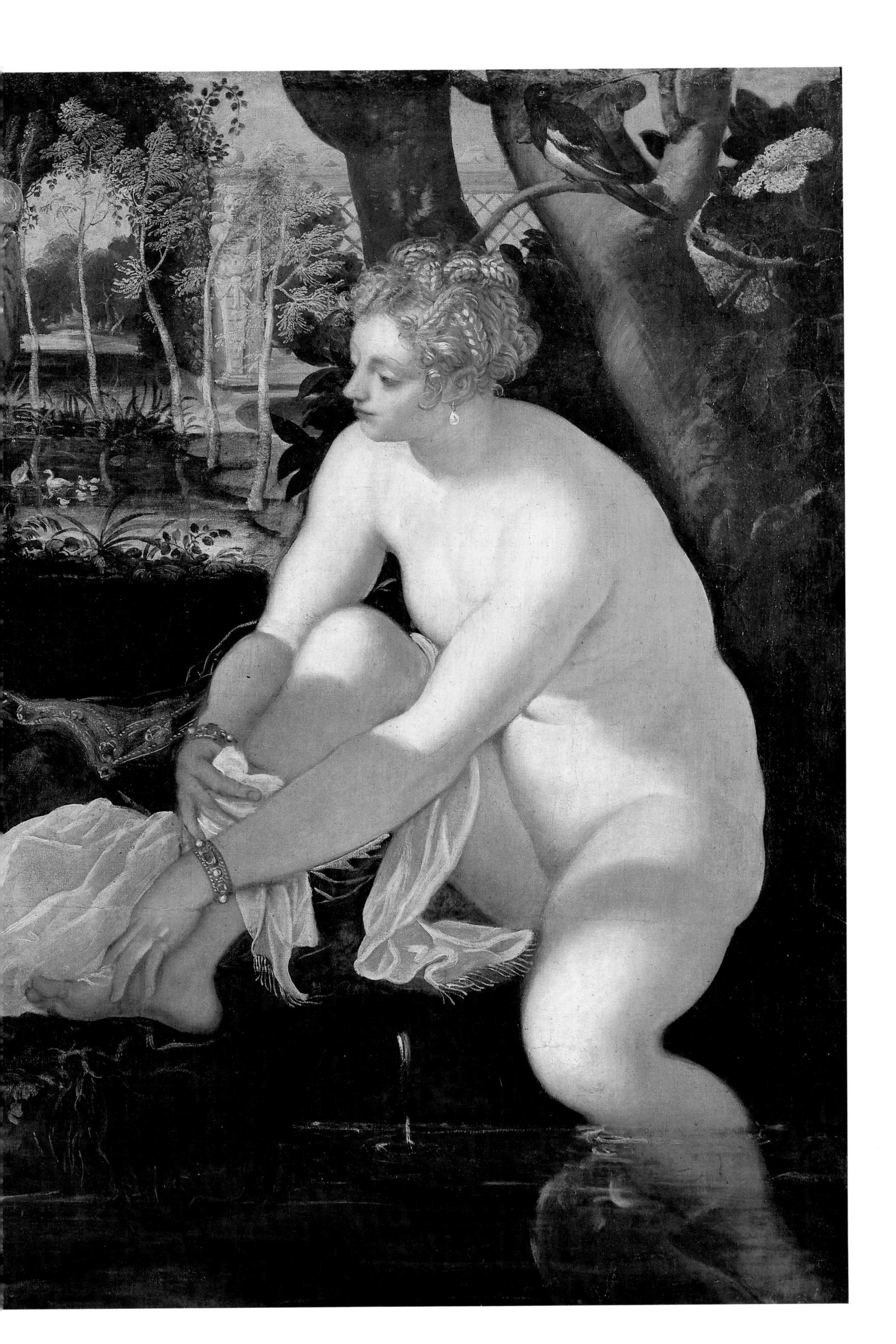

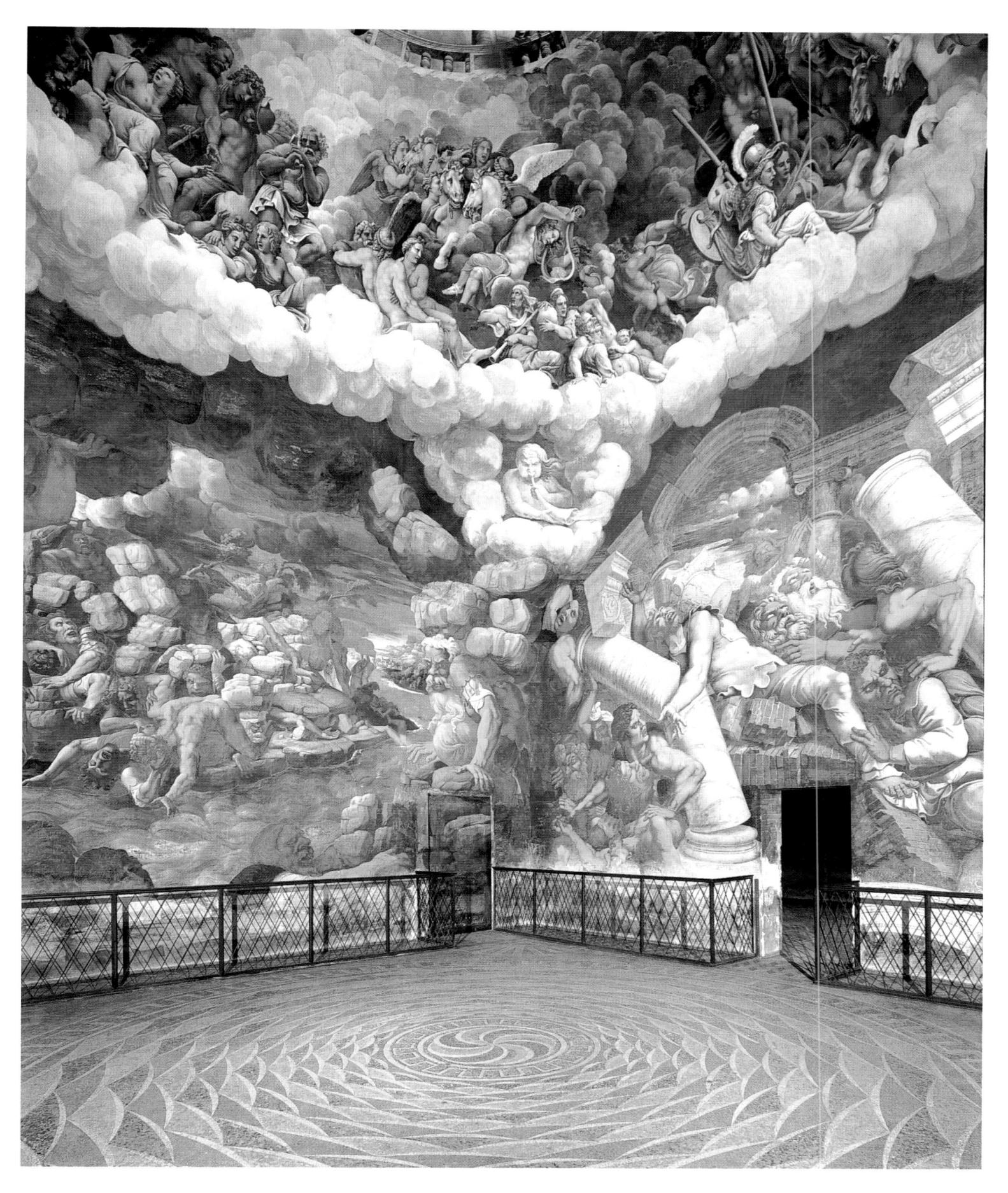

262 JACOPO TINTORETTO Susanna and the Elders 1557 (Left) Identified with the picture recorded by Ridolfi in the house of the painter Niccolò Renieri, this is perhaps Tintoretto's most sensual rendering of the female nude. Instead of the more usual episode when the elders surprise Susanna, Tintoretto has chosen the much more erotic, voyeuristic moment when she is still unconscious of their presence, and gazes unperturbed at her reflection in the mirror. Notable are the daring device of dividing the picture with the hedge, which recalls Mannerist visual tricks, and the limpid painting of flesh and the delicate still life and water.

263 GIULIO ROMANO The Sala dei Giganti, Palazzo del Tè, Mantua 1532–4

(Above) Giulio Romano moved in 1524 from Rome to Mantua, where he reinvigorated Mantuan painting under Marchese Federigo Gonzaga and created some of the greatest interiors of the period. His rooms in the Palazzo del Tè include vigorous frescoes and elaborate stuccoes in a variety of styles. The Sala dei Giganti is unique there, with its deliberately disturbing illusionism showing the destruction of the Giants by the Gods, in a 'conceit' designed to disturb the viewer in a witty fashion typical of Mannerist artifice.

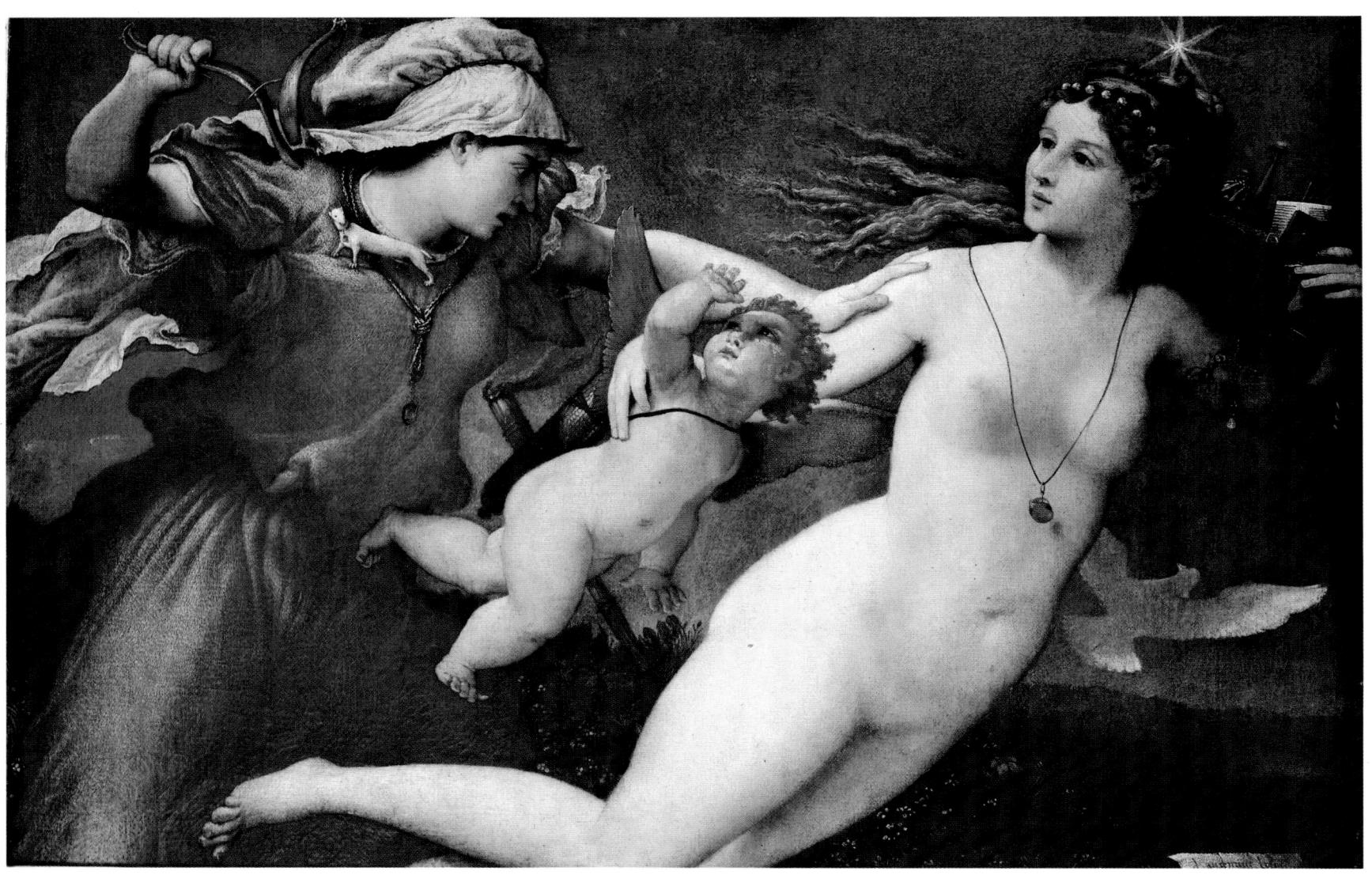

264 LORENZO LOTTO Triumph of Chastity c.1531

It is likely that this was a marriage picture. Its marble-like flesh and acid palette belong to an intensely Mannerist phase in Lotto's career. Chastity, fully dressed at the left, chases the lascivious Venus and frightened Cupid in a friezelike composition. The figure of Chastity is probably based on a Roman sarcophagus in the Vatican. The picture's iconography may be compared with that of Titian's Sacred and Profane Love (see plate 219), also a marriage picture, with clothed and unclothed figures.

265 PARMIGIANINO Conversion of Saint Paul 1527–8

Recent cleaning has revealed this as a painting of astonishingly brilliant colour and dynamic effect. Its attribution to Parmigianino is recent (1950), and a preparatory drawing seems to prove this. Close in style to Parmigianino's later Roman works, it derives from Raphael's Heliodorus fresco in the Vatican, with the addition of the elongated limbs and superbly elegant composition so typical of the painter's best work. Virtuoso painting makes it one of Mannerism's most characteristically stylish images.

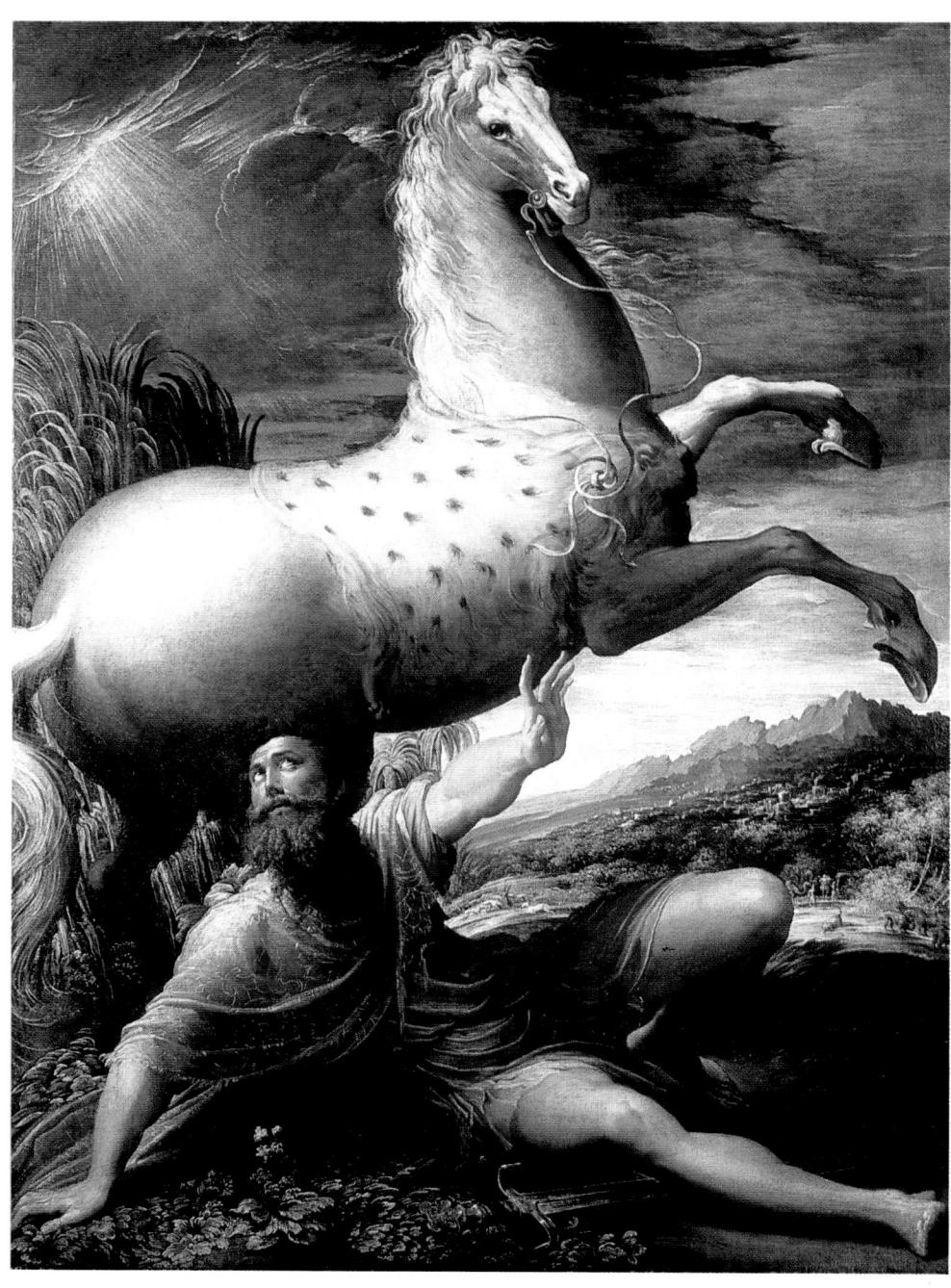

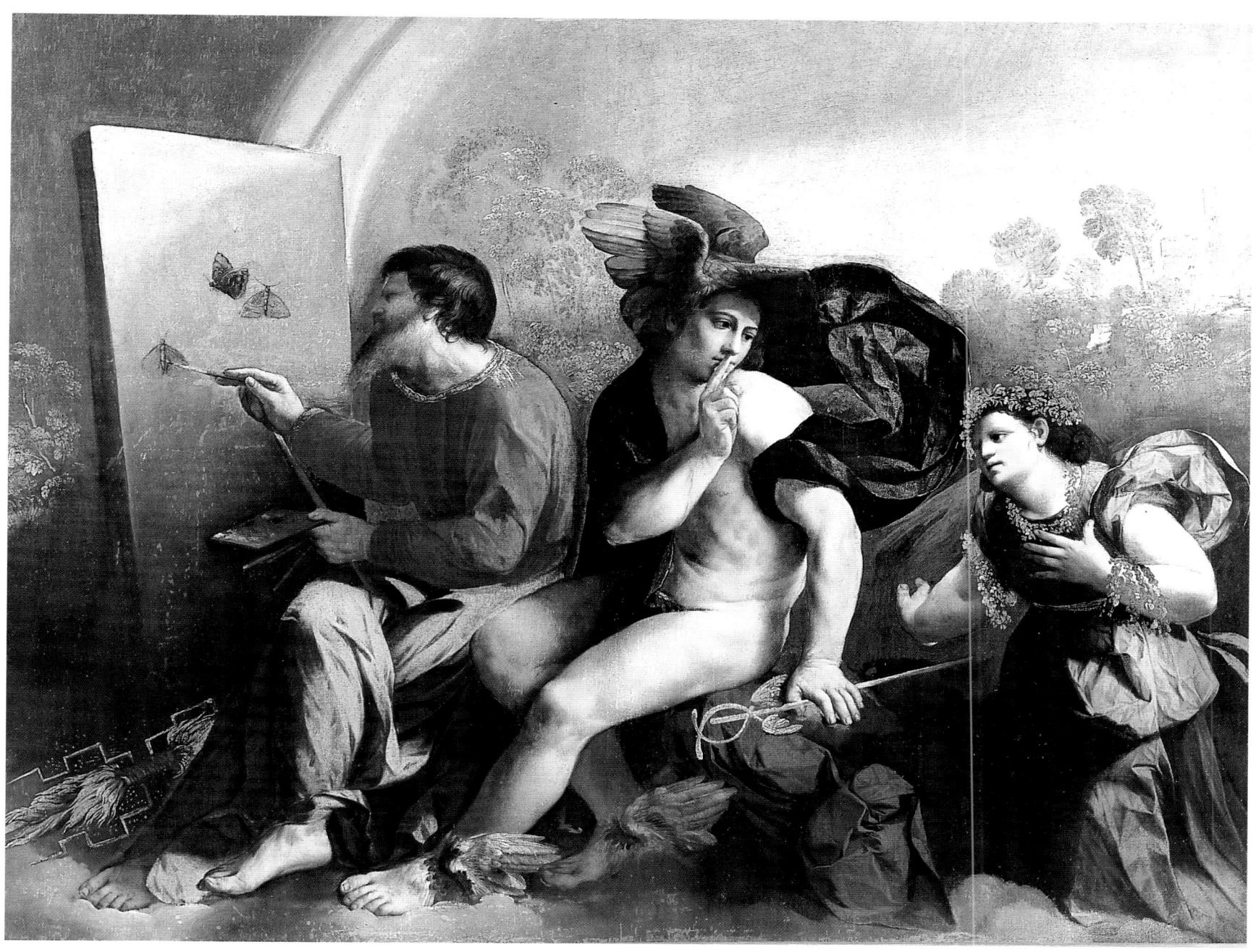

266 Dosso Dossi Jupiter, Mercury and 'Virtue' ϵ .1529

Based on a fable by the Hellenic poet Lucian, the picture shows Virtue pursued by Fortune, appealing to Jupiter for protection. Mercury bids her to be quiet as Jupiter paints butterflies, symbolic of souls. It uses a typical Dosso combination of landscape, evocative figures and strong colour.

267 Alessandro Allori The Pearl Fishers 1570–2

This, possibly Allori's best known picture, forms part of the decoration of the studiolo of Francesco I in the Palazzo Vecchio. The inventor of the tiny room's literary programme, Borghini, drew his inspiration for this scene from Pliny, and the subject alludes to the room's precious contents. The painting's style encapsulates the most important aspects of Florentine painting at this time — admiration for Michelangelo's nudes, Bronzino's finesse, and an interest in Flemish art in the depiction of the pearls, shells and other natural objects.

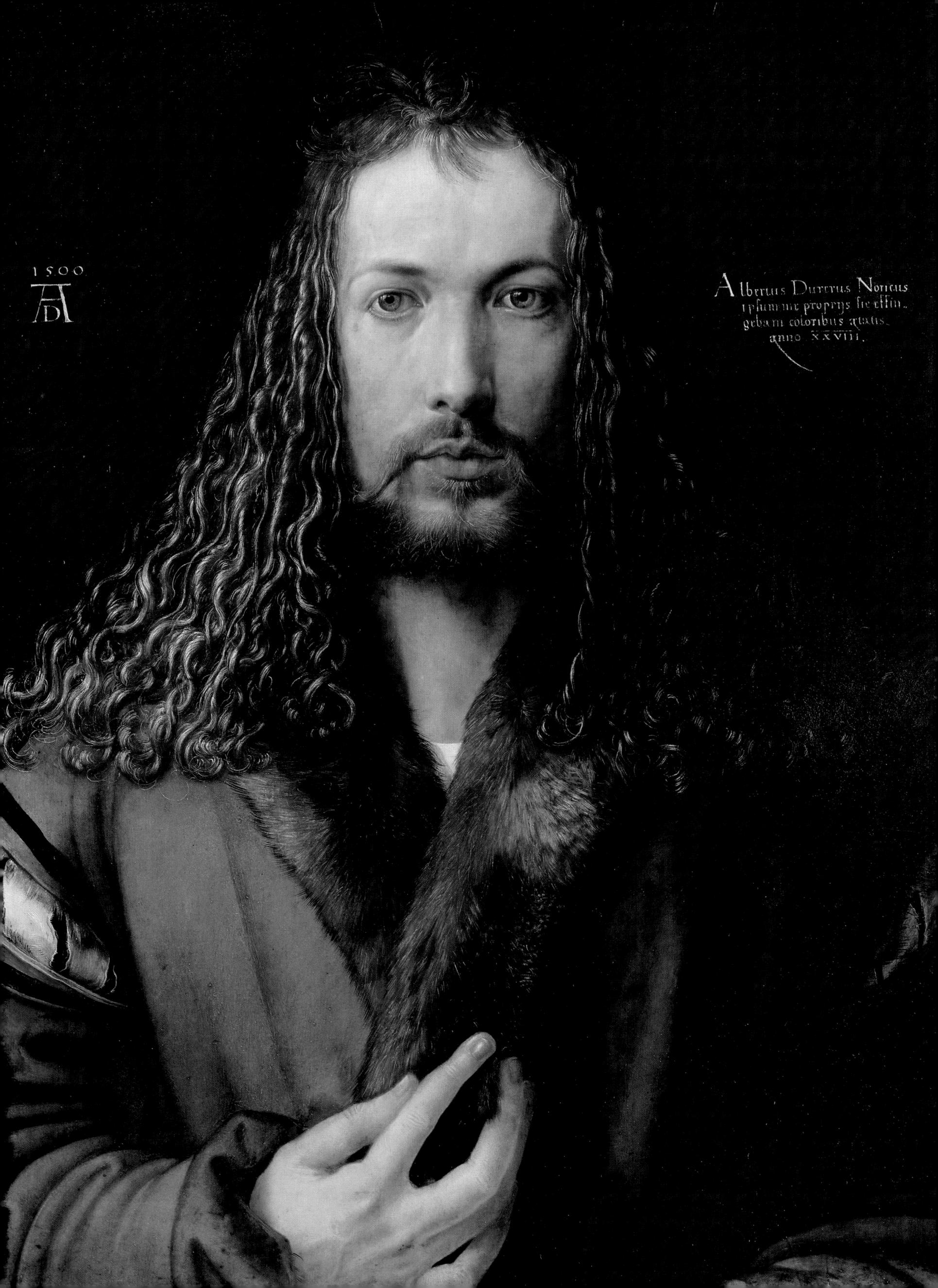
CHAPTER IX

Painting in Germany and the Netherlands in the Sixteenth Century

The sixteenth century in Northern Europe has left us some of the most memorable and diverse images in Western art, whether in Dürer's Adoration of the Magi (see plate 287), Altdorfer's Battle of Issus (see plate 289) or Bruegel's Hunters in the Snow (see plate 284). Each of these represents a different current in Northern European painting. While Dürer stands for the German equivalent of the Italian grand manner of the High Renaissance, Altdorfer represents the magical landscapes of the 'Danube School', and Bruegel's peasant scenes express one side of Netherlandish national feeling.

The first thirty years of the century saw an unprecedented flowering in German painting; Dürer, Altdorfer, Cranach, Grünewald and Hans Holbein the Younger were all active at this time, as were an unprecedented number of less well-known artists. Most of them worked at some time in the medium of engraving, and in Dürer's case this constituted much of his finest achievement.

Humanism in Italy had evolved during the early fifteenth century, and produced a very different sort of art from that of the Netherlands or Germany in the same years. With the achievements of the great Florentines of the 1420s, any remaining shadows of the Gothic world had been rapidly dispersed. Its vestiges lingered on much

268 Albrecht Dürer Self Portrait with a Fur-Trimmed Robe 1500

This is one of the greatest of Dürer's self portraits, and the culmination of his early development. Its rigid verticality seems almost medieval, with the hieratic feeling of a religious painting recalling Byzantine renderings of Christ. The intense expression and strong individuality of the face and hand gesture in addition to the virtuoso technique are, however, indicative of his complete confidence both as an artist and as a technician. The inscription reads 'Thus I painted myself, Albrecht Dürer of Nuremberg, using lasting colour, at the age of twenty-eight.'

longer in the North, however, and it was only towards the end of the fifteenth century that humanism filtered in; it was not fully embraced there, however, until the mid-sixteenth century.

Germany

While major centres such as Wittenburg, Regensburg, Ulm and Freiburg provided many ecclesiastical and court commissions, it was perhaps natural that painting flour-ished best in the wealthy city-republics of south Germany: Augsburg and Nuremberg. Munich grew into a great Catholic Renaissance city in this period, and Stuttgart and Landshut followed its example. The principal Protestant cities were Basle, Brunswick, Bern and Lübeck, while Catholic strongholds, such as Freiburg or Münster, remained within Protestant territories, and were sought out by painters for their lucrative altarpiece commissions. There can be no question that the Reformation dramatically reduced the possibilities for artists throughout the Protestant lands, making it necessary for them to travel in search of work.

Dürer and his Pupils

The greatest German artist of the period, Albrecht Dürer (1471–1528) was also the first to embody all the ideals of the Renaissance as expressed in Italian art and humanism. He and Raphael exchanged examples of their work, and Dürer was familiar with the writings of Vitruvius and Alberti, as well as the ideas of Leonardo (see Chapter VII). His travels and contacts were among the most stimulating of any painter in the Renaissance, and his sympathy for Luther's writings proved important in his spiritual

Always the most celebrated of Dürer's virtuoso watercolours, even good copies of it were treasured by other artists. The warmth of this study liberates it from the realm of pure scientific observation. It was painted entirely with the brush; the painter first outlined the general form with broad strokes, and then filled in the detail of the fur with a very fine brush, further highlighting this with white body colour.

very fine brush, further highlighting this with white body colour.

During Dürer's second Venetian visit, Giovanni Bellini asked him for one of the special brushes with which he obtained such miraculous effects, and was surprised to receive an ordinary brush.

growth. He towered above his northern contemporaries and, through his prints, exerted a remarkable influence in Germany, the Netherlands and Italy. Indeed, his contemporaries probably remembered him more as a printmaker than a painter (he collaborated on a triumphal arch for the Emperor Maximilian, which was made up of hundreds of separate woodcuts), and his genius with line is already visible in his silverpoint *Self Portrait* of 1484 (Albertina, Vienna). The great humanist Erasmus (1466–1536), whose portrait Dürer engraved, called him 'the Apelles of black lines'. (The Greek painter Apelles was considered the greatest in antiquity.)

The vigour of Dürer's personality and art still strike us as unique in his period, and the passion with which he pursued his ideals throughout his life, even in enfeebled old age, remains deeply moving. The new insight which he brought to his experiments in a wide range of themes from landscape watercolours to portraiture and religious painting (see plate 270) compares with the breadth of vision we usually attribute only to Leonardo. His life could not have been more different from that of Leonardo, or any of his Italian contemporaries, and was intimately involved with the events of his time.

Dürer was born in Nuremberg, the son of a Hungarian goldsmith who had settled there in 1455. His education at a Latin school was enough to set him apart from most contemporary painters, and typified the beneficial effects of German humanism. Dürer was exceptionally fortunate in having as his godfather a leading printer and publisher, Anthony Koberger (c.1445–1513). This association shaped his enduring interest in graphic art and printing, which was furthered by his apprenticeship, at the age of fifteen, to the important Nuremberg painter and book illustrator Michael Wolgemut (1434–1519). It was he who gave the woodcut its independent status in German art. Dürer's lifelong friendship with the humanist poet, Willibald Pirckheimer (1470–1530), was only one of several associations with leading men of his day. It was Pirckheimer who opened the artist's mind to the idea of Italy, which he was to visit in 1494-5 and 1505-7.

In 1490, at the end of his apprenticeship, Dürer travelled by way of Mainz and Frankfurt to study with Martin Schongauer in Colmar on the Upper Rhine. Schongauer, then Germany's leading painter-engraver (see Chapter V), died before Dürer arrived in 1492, leaving a rich legacy of about 115 of his elegant and influential prints, but only one painting securely his, the *Madonna in the Rose Garden* (see plate 156).

In 1494 Dürer made an arranged marriage, having returned to Nuremberg after brief periods in Basle and Strasburg. Four years later, he produced his large woodcut series of the *Apocalypse*, to be followed by the *Great Passion* and the *Life of the Virgin* (1510), *The Knight, Death and the Devil* of 1513 (see plate 43) and the celebrated *Melancholia I* (1514). Through his engravings, Dürer developed the art to unforseen heights, achieving effects previously thought possible only in painting.

His Paumgärtner Altar of 1504 (Alte Pinakothek, Munich) and the Adoration of the Magi (see plate 287) show his early style in religious painting, before the crisis of the Reformation affected him. Soon after completing them, Dürer left for Italy – an unusual decision for a German artist at the time – and probably went to Venice, Padua, Mantua and Cremona. His next visit was to last two years, possibly taking in Florence and Rome as well as Venice and Bologna, where he hoped to learn perspective. The Venetian painter, Jacopo de'Barbari, seems to have shown him how to construct human figures on geometrical principles.

Giovanni Bellini's compositions and luminosity of colour influenced Dürer, who painted the *Feast of the Rose Garlands* (National Gallery, Prague) while in Venice, as both a tribute and a challenge to painters there. It was not until 1526, however, that Dürer made his most complete tribute to Italian High Renaissance ideals, with the monumentally conceived figures of the *Four Apostles*, (Alte Pinakothek, Munich). These reveal the artist's self-confessed obsession with proportion more than any of his other paintings, and relate to his two treatises on measurement and human proportions. His genius for portraiture (see plate 270) is an extension of his interest in every aspect of the natural world, as expressed in his famous watercolour *The Hare* (see plate 269), painted in 1502.

Profoundly influenced by Mantegna, Dürer was mainly active as an engraver in this period, but his paintings reveal his exceptional insight, as in the disturbingly penetrating gaze of his Self Portrait of 1500 (see plate 268). In publishing his own prints, Dürer was independent and invented a new form for the illustrated book - the album. This, together with his superiority over other artists in formal education and experience brought him many illustrious commissions, notably from the Emperor Maximilian, who became his most important patron after about 1512, and later from Charles V. During a journey to the Netherlands in 1520-21 Dürer met many important painters, recording events in his diary, and was hailed as the leading artist of the day. His influence can clearly be seen on the Flemish artist Marinus van Reymerswaele, whose Saint Jerome takes Dürer's 1521 version of the subject as its point of departure (see plate 298). German Renaissance art is inconceivable without Dürer's presence, but his universality is missing from his pupils and followers, who tended to concentrate rather on his style and detail. Altdorfer and, to a lesser extent, Baldung Grien are the only real exceptions.

Already during the 1490s Dürer's influence was producing a following among southern German painters. Among his most talented pupils were Hans Suss or Suess, known as Hans von Kulmbach (c.1480–1522), who was also influenced by Jacopo de'Barbari. Hans Schaufelein (1480/85–1538/40) studied with Dürer and worked in Augsburg and elsewhere, while the Beham brothers, Hans Sebald (1500–50) and Bartel (1502–40), were principally engravers, but worked in stained glass and other media. Bartel's painted portrait of 1529, *The Umpire* (Kunsthistorisches Museum, Vienna), reflects recent Italianate trends comparable with Amberger in Augsburg (see plate 9). The distinctive portraiture of Georg Pencz (c.1500–50) reflects his experience gained on two Italian

270 Albrecht Dürer A Young Woman 1506
The sitter appears to be in Venetian costume, and its style indicates that it was painted during the artist's second Venetian journey, towards the end of 1506 when he would have seen Bellini's portraiture. This is not the painter's wife as was once thought.

The softness of outline and modelling strongly reflects what Dürer saw in Venetian painting, but he did not explore this new style after leaving Venice. The simplified background might suggest sky and sea.

visits, when Bronzino certainly influenced him. He was expelled from Nuremberg with the Beham brothers for holding extreme Protestant views.

Altdorfer and the Danube School

Dürer's near contemporary, Albrecht Altdorfer (c.1480–1538), a citizen of Regensburg from 1505, is best remembered for his remarkable landscapes (see plate 271), although he was primarily a painter of religious themes. His landscapes suggest a pantheistic belief in nature, whose exuberance he interprets with unique power. He also painted erotic works in the Cranach manner. Altdorfer was the leading painter of the so-called 'Danube School', a term which describes a number of artists

271 Albrecht Altdorfer Landscape with a Footbridge c.1518–20

This is among the earliest examples of pure landscape. It probably predates Altdorfer's only other landscape without figures, which is now in Munich.

Like Altdorfer's mature woodcuts, these landscapes derive much of their impact from the intensely concentrated forms, which crowd together to create the stifling effect observed in coniferous forests. They give the impression that they are closely based on natural observation. The same densely packed composition can be seen in the artist's Battle of Issus (see plate 289) which depicts the battle between Alexander and Darius which took place in 333 B.C.

working independently of each other in the Danube Valley. These included Lucas Cranach the Elder and Wolfgang (or Wolf) Huber (c.1490–1553), painter-architect to the prince-bishop of Passau. Huber possessed an inventive and spirited talent, and was innovative in the use of colour and light. The sources of his images are not easy to identify, but landscape dominates many of his paintings.

The origins of the Danube School lie in late Gothic painters such as Jan Polack in Munich and the Austrian painter and sculptor, Michael Pacher (active 1465?–98), whose masterpiece is his *Saint Wolfgang Altarpiece* of the 1470s (St Wolfgang, Abersee). Pacher introduced many Italian ideas into Germany, which were carried on by his follower Max Reichlich.

Until 1505, there is no documentation of Altdorfer's activity. After this, he appears to have been successful as a painter, and he died a moderately rich man, having refused to become mayor of Regensburg but accepted the post of city architect, apparently designing only somewhat mundane structures. Such an official image is perhaps difficult to reconcile with his sometimes eccentric art. Early graphic work by him is known, but his first signed painting is the tiny Satyr Family of 1507 (Gemäldegalerie, Dresden), an image full of nostalgic poetry which uses landscape to create a mood more intense than any others in contemporary painting. It is tempting to think that Altdorfer might have seen Venetian paintings such as Giorgione's, and he almost certainly knew Mantegna's work. It cannot be coincidence that such apparently Venetian elements also occur in Cranach the Elder's landscapes. Moreover, the Venetian Jacopo de'Barbari (see plate 202) worked for a series of Northern patrons including the Emperor Maximilian and Frederick the Wise of Saxony, to whom he was court painter prior to Cranach the Elder. Only in the 1520s did Altdorfer dare to eliminate figures completely from nature in his Danube Landscape near Regensburg (Alte Pinakothek, Munich), frequently achieving a pathos which was not recaptured in landscape painting until Caspar David Friedrich in the Romantic period.

The architecture in Altdorfer's pictures (such as *The Finding of the Body of Saint Florian* in the St Florian Monastery near Linz) is sometimes Italianate, and he explored architecture in his drawings of around 1520. Altdorfer remained unrivalled in his evocations of the grandeur of nature, and was often 'Gothick' in his effects (see plate 271). This experimental aspect was extended in his *Holy Night* of 1512 (Gemäldegalerie, Berlin) to include novel light experiments, which were to be a feature of much of his later painting.

Altdorfer worked for the Emperor Maximilian, and his connections with Austria appear to have been strong since his probably visited Vienna twice. In 1518 he worked at the monastery of St Florian, where he exploited astonishing colour and light effects in his *Christ on the Mount of Olives*, which echoes Dürer's *Passion* series. A quasi-Surrealism appears in the figures in other painting there. During the 1520s, Altdorfer perfected both an intimate landscape style and a monumental one, first seen in the delightful and highly original *Birth of the Virgin* (see plate 288) and culminating in the grandiloquent *Battle of Issus* painted for the Duke of Bavaria (see plate 289). Altdorfer's followers in landscape, however, failed to realize a comparable degree of high drama, preferring a less demanding form of imagery.

Lucas Cranach the Elder

Lucas Cranach the Elder (1472–1553), whose name derives from his birthplace Kronach, in southern Germany, appears to have lived in Vienna for about three years until 1504. He moved in the type of humanist circles to which Dürer was accustomed, and painted one of the most moving and sensitive images of that world (see plate 272). Perhaps the remarkable diversity of his work also comes from his Viennese experience. It ranges from landscapes – which relate him to Altdorfer and the Danube School – to magnificent altarpieces, celebrated nudes, forceful portraits and distinguished graphic work.

272 Lucas Cranach the Elder Johannes Cuspinian c.1502 This picture, together with its companion showing Cuspinian's wife Anna, is one of the most magnificent portraits of the German Renaissance. The pair are probably wedding portraits, as they include the couple's astrological birds, the owl and the parrot. Cuspinian, a noted and precocious humanist, was poet laureate to the Emperor, and his major work on the Roman Caesars and Emperors glorified the German Imperial ideal. Cuspinian is shown aged twenty-nine, as 'rector magnificus' of Vienna University. A typically rough Danube School landscape contrasts with the refined sitter.

While influenced by Dürer, Cranach's portraits seem to make a subtle progression in crystallizing the atmosphere of a world still changing from Gothic ideas to the Renaissance. Cranach's remarkable adaptability, however, is displayed by his complete adoption of mid-century means of expression in his powerful Self Portrait of 1550 (Uffizi, Florence). This portrait marked the end of his career as court painter at Wittenberg, first to Frederick the Wise, Elector of Saxony. Having served there for fortyfive years, Cranach followed the last Saxon Elector of that line - John Frederick - into exile at Augsburg. His most innovative portraits are full-length, and lovingly delineate costume, as in Henry the Pious of 1514 (Gemäldegalerie, Dresden). The sitters included a remarkable cross-section of the German aristocracy and intelligentsia (see plate 272). Cranach was the archetypal court artist of his period in Germany, creating images of aristocratic elegance even within biblical themes. This ensured a high demand for his work, of which the many contemporary copies and versions are an indication. Something of the nervous elegance of Mannerism pervades Cranach's figures, and this was exploited by his son Lucas the Younger (1515-86) who led the Cranach workshop and completed his father's last painting, the moving Allegory of Redemption (Stadtkirche, Weimar).

Highly honoured in Wittenberg, (Luther was godfather to one of his children), Cranach evolved a sophisticated and witty visual language, especially in paintings of the nude. He appears to have kept himself informed on painting elsewhere, travelling in 1509 to the Netherlands and adopting some Flemish ideas in his *Holy Kinship Altarpiece* (Stadelsches Kunstinstitut, Frankfurt), with its striking floor tiles, contemporary fashion and anecdotal detail. His woodcuts are influenced by both Dürer and Flemish artists and include secular and religious themes.

Mathis Grünewald

A court painter of a very different stamp from Cranach was Mathis Gothardt or Neithart (c.1470/80–1528). He was mistakenly called Grünewald by his first biographer, Joachim Sandrart, in his study of German art, the *Teutsche Akademie*, published in 1675. Grünewald is, however, a rediscovery of the twentieth century, and has proved very much to its taste. German Expressionist painters strongly identified with his angst. His long neglect seems surprising when we now rank him second only to Dürer, but his melancholy nature and unapproachable painting may explain it to some extent. Like Dürer, he is mentioned by only one contemporary, Melanchthon, after his death.

Grünewald's particular strength lies in his marriage of the spiritual world of the Middle Ages with new and unique imagery, colour and drama.

His departure from Albrecht von Brandenburg's service because of his sympathies with the Peasants' War, the loss of a major altarpiece at sea, the romance of his rediscovery and his painting style itself combine to create a fascinating figure. A further oddity is that he was documented as a waterwork designer in 1510. Grünewald, a convinced Lutheran, seems to have studied in Nuremberg in the early years of the century, where Dürer's influence was unavoidable. He moved to Mainz where he worked for Archbishop Uriel von Gemmingen from 1508–14, and for his successor, Albrecht von Brandenburg. Grünewald met Dürer in 1520 when he accompanied Albrecht to Aix-la-Chapelle for Charles V's coronation.

His first known work is the *Lindenhardt Altarpiece* of 1503 (Lindenhardt Parish Church) whose mixture of disturbing, angular figures meticulously rendered in strong contrasts of light and dark, looks forward to his major work, the *Isenheim Altarpiece* (see plate 282). There is none of Dürer's optimism here, and already in a slightly later chalk drawing, *Christ on the Cross* (Staatliche Kunsthalle, Karlsruhe) the agonized angularity of the Christ and a realism of detail appear that characterizes subsequent works, such as the *Small Crucifixion* (see plate 281). The multiple visual and psychological possibilities of the Crucifixion scene repeatedly drew Grünewald to express himself most fully with this theme.

Working independently, Grünewald painted the four healing saints for the (now lost) central panel of the *Heller Altarpiece* of 1508–10 (Städelsches Kunstinstitut, Frankfurt and Fürstenber Collection, Donaueschingen). Costume dominates these slightly contorted figures, with heavy, tangible drapery. The whole effect is somewhat eerie, suggesting the mystical world they inhabit.

The Isenheim Altarpiece (see plate 282) contains all the artist's most important statements, and although it was followed immediately by a painting of real charm, the heavily symbolic Virgin in the Garden (Stuppach Parish Church), his later work reveals the desire for increasing profundity. This did not exclude, however, an apparent concession to High Renaissance principles of proportion and composition in the Meeting of Saints Erasmus and Maurice of the early 1520s (Alte Pinakothek, Munich). He then reverted to an intense, pessimistic world in his later works. His last years seem to have been spent in penury in Frankfurt. He apparently suffered from paranoia, and in 1527 he fled to Halle where he died of plague. Of the few artists attracted to him, Baldung Grien derived superficial elements from his style.

Hans Baldung Grien

The extensive output of Hans Baldung Grien (1484/5–1545) included religious and mythological paintings, tapestry, stained glass, book illustration and drawings. There is a strongly erotic (sometimes obscene) element in his renderings of women and death, and in woodcuts like the *Fall*. The epicene contrasts between voluptuous female figures and voracious skeletons are particularly memorable. These were made as a result of his training with Dürer, but early in his career he manifested

273 Hans Baldung Grien The Three Ages of Woman and Death 1509-11

This allegory of earthly vanity may have been part of a series of the Dance of Death. While the Düreresque woman admires herself unknowingly in the mirror, Death waves an hourglass above her and traps her by her veil. Below, a child also plays with a veil - probably a reference to the medieval idea of a veiled cupid symbolizing lust. The old woman at the left attempts to forestall Death's action. Typical of Germanic humanist taste, such allegories were virtually unknown in Italy at this time.

a love of the grotesque, supernatural or gruesome (see plate 273). Born in Schwäbisch-Tremünd in southern Germany, of an academic family, he studied in Strasburg at the turn of the century before entering Dürer's studio about 1503. His *Adoration of the Magi Altarpiece* of 1507 (Gemäldegalerie, Berlin) clearly shows Dürer's influence. Strasburg was later to be Baldung's adopted city.

An interest in witchcraft and the supernatural emerged throughout European art in the later Renaissance (for example, in Rosso Fiorentino) and Baldung's *chiaroscuro* woodcut, *The Witches* (1510), shows superficial similarities to figures in Altdorfer. Although not obviously connected with such themes, his later woodcuts, such as *Wild Horses* (1534) and *The Bewitched Groom* (1544), possibly an allegory of lust, often suggest sinister overtones, which were taken up with some relish by the eighteenth-century Swiss artist Fuseli. Baldung borrows from the medieval Dance of Death, but combines it with the more contemporary Italianate theme of *vanitas*.

Baldung's masterpiece was the high altar (1512–16) for Freiburg Minster. The central panel, showing the *Coronation of the Virgin*, radiates colour and light, and its crowded composition placed closely parallel to the picture plane recalls that he was working at the same time on the Emperor Maximilian's prayer book. It is one of the rare works reflecting aspects of Grünewald's *Isenheim Altarpiece* and its *Nativity* is one of the finest night-pieces of the period.

His portraiture is distinguished, the most famous example being his 1521 woodcut of Luther, shown in the light of the Holy Ghost, with distinctly Gothic drapery folds to his monk's habit. The likenesses of his Freiburg period are possibly his most penetrating, the best example showing *Count Palatine Philip the Warlike* in 1517 (Alte Pinakothek, Munich) with an acuity worthy of Holbein.

A postscript on Swiss painting, closely linked with German developments, must include Urs Graf (c.1485–1527/8), who spent time as a mercenary in Italy and is best known for his engravings, and many drawings of soldiers and fashionably attired prostitutes.

Painting in Augsburg: the Holbeins, Burgkmair and Amberger

Much grandeur remains today to show how wealthy was the city-republic of Augsburg, Nuremberg's principal Renaissance rival. The great banking and merchant families, such as the Fuggers, Peutingers and Welsers, not only built lavishly but were important patrons of painting and sculpture. This flourishing culture was furthered by

the Emperor Maximilian, whose favourite city Augsburg became. Here Italianate ideas were encouraged, culminating in the distinguished portraits of Christoph Amberger. Its most famous citizens were the Holbeins, father and son, followed by Hans Burgkmair. Hans Holbein the Elder (c.1465-1524) attained considerable fame in Germany, while his son became one of Europe's greatest portraitists. Holbein the Elder probably went to the Netherlands before establishing himself in Augsburg, since he shows the influence of Van der Weyden and Gerard David in his elongated figures and certain poses. This can all be seen in his Saint Sebastian Altarpiece of 1515-17 (Alte Pinakothek, Munich) one of his most elegant mature works. His accomplished and sensitive portraiture and drawings must have been immensely influential on his son.

Hans Holbein the Younger (1497/8-1543) matured into a completely different world from that of his father, and proved to be Germany's last major Renaissance painter. He trained with his father, and this, coupled with his father's reputation, certainly furthered his career. Holbein belongs to the reign of Charles V, whose court painter he might easily have become. Perhaps fortunately for posterity, instead of the religious commissions which had occupied his father and his workshop, the Reformation forced Holbein to specialize almost exclusively in portraiture. He went with his brother Ambrosius to Basle in 1514-15, where he worked mainly in graphics and printing, but was in Lucerne in 1517-18, collaborating with his father on the decoration (now destroyed) of a house belonging to the Von Hertenstein family. In 1516 he painted a diptych showing the mayor of Basle, Jakob Meyer and his Wife, set against a Renaissance arch (Öffentliche Kunstsammlung, Basle). In using tempera and oil on lindenwood for these, he established the technique he preferred throughout his portraits.

His superbly dramatic – and suddenly mature – portrait of *Bonifacius Amerbach* of 1519 (see plate 290) suggests that he had travelled to Italy, for it already has the breadth of vision and softer style of his best later work. He was certainly in France in 1524, where he saw the work of Raphael in the royal collection. This is probably reflected in his *Madonna of Burgomaster Meyer* of 1526 (Schlossmuseum, Darmstadt) and in his *Dance of Death* series of prints, which were not published until 1538 in Lyons because of their Reformation ideas.

It was obvious by now that Holbein was drawn to portraiture, since even his bust-length *Adam and Eve* of 1517 (Öffentliche Kunstsammlung, Basle) is clearly based on actual people influenced by figures in Dürer and Baldung Grien. Italy is also recalled by his *Christ in the*

Sepulchre (see plate 274). In addition Holbein made nearly 1200 woodcut and metalcut engravings, stained glass designs and painted house façade decorations.

In 1520, Holbein became a citizen of Basle and married the widow Elsbeth Schmid, by whom he had four children. At this time, he painted the impressive Oberreid Altarpiece in Freiburg Minster followed by a portrait of Erasmus (see plate 14), for whom he also provided marginal illustrations to In Praise of Folly. He went to England in 1526, having been recommended by Erasmus to Thomas More. After returning to Basle, he witnessed the iconoclasm unleashed there, and in spite of considerable official patronage, may have decided to seek work elsewhere. Finally, in 1532, he left to work permanently in England (see Chapter VI). Germany had lost its greatest portraitist to a foreign court. His magnificent likeness of Georg Gisze (see plate 291) spans the transition from his old to his new life, looking forward to the richness of his English style.

The third artist of note in Augsburg in this period was Hans Burgkmair the Elder (1473–1531), who trained with Schongauer at Colmar and probably visited Milan and Venice, prior to establishing himself in his native town by 1498. He married Holbein the Elder's sister in that year. A second visit to Italy is possible since echoes of Leonardo and even Michelangelo's influence are perceptible in his work. He also went to Bruges, which gave him a wider vision than his brother-in-law, and, like Dürer, he collaborated on Maximilian's triumphal arch. His finest (and most Italianate) work is the *Saint John Altarpiece*, and it was he rather than Holbein the Elder who made significant steps forward in Augsburg's adoption of Italian colour and sensuousness.

274 Hans Holbein the Younger Christ in the Sepulchre 1521–2

This probably formed an unusual predella to the two wings of Holbein's Oberreid Altar, saved from iconoclastic destruction in 1529 and now in Freiburg Cathedral. It may refer to sculpted figures of this type which were only exposed during Holy Week, and shows the deep religious feeling which the Reformation forced painters like Holbein to stifle. The harrowing intensity of the image remains unique in his work.

Innovations in Italian Mannerist court portraiture were certainly becoming known in northern Europe, and Charles V's employment of Titian as a portraitist must have spurred on German painters to update their styles. In Augsburg, which was so in touch with Imperial tastes, the one portraitist who achieved something of the international court style of the mid-century was a pupil of Burgkmair, Christoph Amberger (c.1505–61). Amberger had met Titian in Augsburg in 1548, and consciously aimed for Venetian grandeur of form, which he achieved in his *Charles V* (Staatliche Museen, Berlin) and *Christoph Fugger* of 1541 (see plate 9), which resembles Bronzino. There is little of Holbein's directness in his stylized depiction of his sitters.

The Netherlands

Through the Empire the artistic fortunes of the Netherlands and Germany in the sixteenth century were interlinked and painters from both areas knew their contemporaries' work. Moderately peaceful conditions during the first half of the century favoured the arts, but this situation did not continue. Philip II was brutal in his repression of Protestantism in the Netherlands, and the more the Netherlands rebelled, the harsher he became. His main tool was the Inquisition, which butchered thousands of people. In 1566, a decision was taken among Netherlandish rebels to rid themselves of the dreaded Inquisition, and destroy Catholic works of art throughout their country. The so-called 'Spanish Fury' followed, in which Philip violently quelled the uprising. Bruegel may have painted the Crippled Beggars of 1568 (Musée du Louvre, Paris) as a direct result of this.

Antwerp, which had been of slight artistic importance in the fifteenth century, supplanted Bruges (whose estuary had silted up) as a trading centre and became a leading international port. Many of the great Flemish paintings now in Spain and Portugal were collected by Iberian merchants in Antwerp at this time. Such collectors may also have developed a sophisticated taste for much earlier painting, which resulted in a revival of elements of Van Eyck's style: even Holbein partook of

this. Antwerp's growing artistic and economic reputation attracted increasing numbers of painters. Painters' guild records are an important source of dates, and we owe a great debt to the writings of the Netherlandish painter Karel van Mander (1548–1606), who worked mainly in Haarlem. His three-part *Het schilderboeck* (The Book of Painters) published in 1604, provides over 170 biographies of German and Netherlandish artists since Van Eyck, lives of Italian painters since Cimabue (derived from Vasari) and practical advice on technique and theory. Van Mander came to be known as the 'Dutch Vasari'.

Metsys, Patinir, Joos van Cleve and Mabuse all distinguished the first decades of the century in the Netherlands. Flemish painting did not, however, attain the greatness of the fifteenth century, and with the exception of Pieter Bruegel, failed to produce a genius of Dürer's standing. Gradually, various cities became known as centres in which accomplished painters could be found: Antwerp, Haarlem, Leiden, Bruges and Strasburg. Court art was centred in Brussels and Malines, where the Emperor's regent was based.

The most remarkable single feature of Netherlandish painting in this period was its interest in Italy and eager adoption of Italianate ideas, which eventually culminated in the Northern Caravaggesque artists in the next century. One of the most important events in the early years of the century was the presence, until 1519, of Raphael's Sistine Chapel tapestry cartoons in the Brussels weaving studios (see plate 205). This major masterpiece suddenly exposed painters to the latest High Renaissance style and, along with the influx of Italian prints, helped to form the 'Antwerp Mannerist' style. Those painters in the northern Netherlands who adopted Italian ideas without the exaggerations of early Mannerism, came to be known as Romanists. Jan van Scorel (1495-1562) was the most important of these. He travelled widely to Italy, Jerusalem and Cyprus, and returned to Utrecht in 1524, where he achieved a balanced Classicism influenced by Raphael, Michelangelo and the Venetians. Most of his major altarpieces are lost, but his influence was immense, notably on his pupils Maerten van Heemskerck and the internationally successful Anthonis Mor (see plate 297).

Quinten Metsys

Quinten Metsys (or Matsys or Massys, 1465/6–1530) was born in Louvain. By about 1510, he was Antwerp's principal painter, giving the city a new artistic importance with his versatility. He knew Erasmus, and painted him in 1517 with the philosopher Petrus Aegidius in a

275 Quinten Metsys Ill-Matched Lovers c.1520–5
This is an early example of a genre scene with the type of moral found in the writings of Erasmus. The old man is duped into imagining the girl's attentions to be genuine, while in fact she is robbing him, thus illustrating the saying that a fool is soon parted from his money. This was a very popular theme in the art of the time, and the long ears on the hat of the background accomplice may also refer to the writings of Sebastian Brunt. Such subjects were soon adopted in Italian painting. The combination of the grotesque with the beautiful culminates in the paintings of Marinus van Reymerswaele (see plate 298).

'Friendship Diptych' for Sir Thomas More in England. His career seems to have been entirely successful and uncomplicated, and he had twelve children from two marriages, two of whom became painters.

Compared with that of his contemporary Dürer, Metsys' style is firmly rooted in the fifteenth century and his first dated work, the Saint Anne Altarpiece of 1507-9 (Musées Royaux des Beaux-Arts, Brussels), continues that tradition. His delightful Saint Christopher, probably painted about 1504-5 (Musée Royal des Beaux-Arts, Antwerp), shows originality in the use of light and chiaroscuro (perhaps gained from Leonardo) and psychological perception. Metsys began to demonstrate an increasing awareness of Italian ideas - notably Leonardo's - which indicate that he made an Italian journey. He seems also to have felt Dürer's influence, but in his natural eclecticism selected devices as they suited him. He happily mixed fifteenth-century ideas with newer concepts, as in his Madonna and Child with Angels (Courtauld Institute, London), and The Banker and his Wife (Musée du Louvre, Paris), whose sophisticated evocation of earlier Flemish art appealed to a subsequent owner, Rubens.

Metsys was primarily concerned with the human figure, which he often depicted with disarming directness

in his highly original portraits of Antwerp worthies. A prime example is the crisp, thoughtful *Portrait of a Lady* (c.1510–15) in the Metropolitan Museum of Art, New York. One unexpected feature is his love of the grotesque, most expressively presented in the *Old Woman* (National Gallery, London) with her hideous features and wrinkled *décolleté*, which probably carries an allegorical meaning. This is also seen in a more superficially naturalistic way in *Ill-matched Lovers* (see plate 275).

Landscape appears to have meant little to Metsys, and he was content to collaborate with Joachim Patinir in providing figures for the other artists' backgrounds (see plate 294). Such collaboration was common in the later Middle Ages and again became popular later in Northern painting and eventually in the work of artists like Claude Lorraine.

Joachim Patinir

Joachim Patinir (or Patenier or Patinier, before 1500–24) is principally remembered as the artist who first explored the idea of landscape for its own sake. Dürer used the word for the first time in Northern art when he called Patinir 'the good landscape painter'. His career, like Metsys', was nurtured by Antwerp's new prosperity, although he may have worked previously in Bruges. In 1515 he was made a free master of the Antwerp Guild. Patinir conceived the sweeping, bird's-eye view of nature, peopled with small saints or other figures who are gently integrated with their surroundings. This is best seen in the triptych showing the Baptism of Christ, Saint Jerome and Saint Anthony (Metropolitan Museum of Art, New York). Both these saints were favoured by landscape artists for having spent time in the wilderness. Patinir relates the figures with a marked degree of naturalism to their settings. His landscapes do not attempt to create mood as did the Danube School painters. Instead, he evokes atmosphere with careful gradations of colour in depth, using a deep green-blue foreground receding to cool blue distances punctuated by elaborate rock formations and mountains and expanses of water.

Gossaert and the 'Antwerp Mannerists'

In view of his later development, it is astonishing that Jan Gossaert (c.1478–1533) began painting in the style of Hugo van der Goes and Gerard David, and probably trained at Bruges. He is one of the most intriguing painters of his period, and his later work belongs to the group known as 'the Antwerp Mannerists'. He is also

called Mabuse, from his birthplace Maubeuge, in Hainault. He was entered in the Antwerp Guild Master's list in 1503, and in 1508/9 he made a journey to Italy with Philip of Burgundy. The latter became Gossaert's patron at Souburg, Middleburg, and later Utrecht, where he was made bishop.

Before going to Italy, Gossaert painted the Adoration of the Magi (National Gallery, London) which already shows his ability with tangible, almost Classic figures, each set in its own defined space amid textural richness and incident. After his Roman visit he united Northern with Southern elements, but Vasari says that he was the first 'to bring the true method of representing nude figures and mythologies from Italy to the Netherlands'. On his return, Gossaert painted the ravishing Malvagna Triptych of 1510-11 (see plate 276). One of the jewels of Flemish art, this still pretends allegiance to Gothic detail. A few years later, however, he suddenly launched into the Italianate with Saint Luke painting the Virgin (National Gallery, Prague) – his first essay in figures amid splendid Classical architecture. Soon after he was painting the aggressively pseudo-Classical Neptune and Amphitrite (Staatliche Museen, Berlin), a Raphaelesque Venus and Cupid in 1521 (Musées Royaux des Beaux-Arts, Brussels) and in 1527 his masterpiece in this genre, Danaë (see plate 295).

The Neptune and Amphitrite formed part of a series showing mythological couples commissioned from Gossaert and Jacopo de'Barbari by Philip of Burgundy for his castle at Suytborg. De'Barbari is thought to have died in 1516, leaving Gossaert to complete the series. Its peculiar form of Classicism shows de'Barbari's influence, and is a good example of how Northern painters coupled the Italianate Classical nude with the German approach of Dürer. These nudes are, however, derived from prints, such as those by Marcantonio Raimondi, and show little sign of having been drawn or even conceived from life. Gossaert was also increasingly influenced by contemporary Italian sculpture, which shows in his treatment of heads and limbs, and such references may have attracted Northern humanist patrons. It was with his late mythological themes that Gossaert moved into the sphere of 'Antwerp Mannerism'.

Gossaert was one of the most gifted portraitists of his day, reaching his peak in the 1520s with his depictions of the aristocracy and intelligentsia. His *Jan Carondelet Adoring the Virgin and Child* (Musée du Louvre, Paris) marks a high point of psychological insight in portraiture. Carondelet was Erasmus's patron, and we are given a convincing sense of his reality. Gossaert's *Elderly Couple* (National Gallery, London) still retains a hint of caricature, however. He felt more at ease with grander sitters,

and this is in keeping with his increasing interest in Mannerist style, as is shown in the superb *Baudouin de Bourgogne* of the mid-1520s (Gemäldegalerie, Berlin).

'Antwerp Mannerism' appears to have been a short-lived phase initiated in the first decade of the century but most in evidence after 1520. A group of lesser painters (such as Jan de Beer and Jan van Dornicke) assumed an ornamental style in which fantastic architecture and an interest in night-scenes, particularly of the Nativity, are combined with the figure elongation and mannered poses associated with Italian painting of that time. Their work certainly had an impact on major painters in the city.

276 JAN GOSSAERT (MABUSE) The Malvagna Triptych 1510–11 Gossaert painted this small, jewel-like triptych on his return from Italy, and it is one of the most enchanting paintings of its kind from the period. The central panel shows the Virgin and Child with joyful Italianate musical angels, and the wings depict Sts Catherine and Dorothy. The Fall of Man appears on the rear, with figures borrowed from Dürer's Small Passion. Of particular beauty is the rich tracery of the Gothic architecture framing the figures, and the magical atmosphere of the background landscape and architecture. While the Madonna recalls Gerard David, there is no sign of the later interest which Gossaert was to take in Classical antiquity in either the figures or the architectural detail.

Joos van Cleve

Van Cleve or Van Cleef (Joos van der Beke, c. 1490–1540) was probably born in Cleves in the lower Rhine area, and based himself at Antwerp, where he became a master painter in 1511. He was previously identified with the Master of the Death of Mary, on the evidence of two paintings on this theme in Cologne. Like most of his Antwerp contemporaries, Van Cleve was eclectic. His success was rapid and he was dean of the painters' guild in 1515 and 1525, by which time he appears to have been the leading painter in Antwerp. Patinir died in the previous year, and Van Mander says he had collaborated with Van Cleve on a *Rest on the Flight into Egypt* now in the Musée Royaux, Brussels, and Metsys and Gossaert lived on for several more years.

Van Cleve's career seems in retrospect to have been international, but lack of information and documentation leaves much to conjecture. It was almost certainly his portraiture which most impressed his contemporaries (see plate 277) and he appears to have been influenced by Dürer. He also received Italian commissions, such as the important *Epiphany* in the Dresden Gemäldegalerie, which was painted for Genoa. He probably worked in France after 1530, portraying Francis I and his wife,

277 JOOS VAN CLEVE Margaretha Boghe c.1518

This is the companion portrait to that of Joris Vezeler, and commemorates the sitter's marriage to him. She is holding a pink, a symbol of betrothal, and a rosary. Its clarity and directness, and the way in which the figure fills the picture space, are typical of Van Cleve's portraiture, and support the possibility that he visited Italy and saw High Renaissance portraits there.

Eleanore, in an enamelled French manner with overtones of Leonardo's *sfumato* technique, which was popular there (see Chapter VI). These are now in the Johnson Collection, Philadelphia and the Royal Collection, Hampton Court.

Other painters of note in Antwerp were Pieter Coecke van Aelst (1502–50) and Jan Sanders van Hemessen (c.1500–c.1575). Van Aelst visited Constantinople and his interest in Italian painting, particularly Leonardo's, made him adopt 'Antwerp Mannerist' exaggerations, and look forward to a more rational style. Van Hemessen's paintings often illustrate parables and proverbs, and his satirical portraits parallel those of Metsys.

Painting in Brussels

Court taste at Brussels is best represented by Bernard (or Bernaert or Barend) van Orley (c.1490–1541). He fulfilled a wide range of court duties throughout his career, painting portraits, altarpieces, and designing tapestries (influenced by the Raphael cartoons whose weaving he supervised) and stained glass. His meeting with Dürer in 1520–21 had a strong impact on his painting, but he combined this with Italianate elements (see plate 283). Van Orley retained many features of 'Antwerp Mannerism', especially his love of fantastic architectural backgrounds, as in his *Job Altarpiece* of 1521 (Musées Royaux, Brussels). In about 1516, he painted one of the most memorable images of Charles V (Museum of Fine Arts, Budapest).

Other artists who worked for the court include Jan Mostaert, (c.1475–1555/6) who was employed by the Regent, Margaret of Austria, before 1519. He introduced the southern Netherlandish courtly style into his native Haarlem, where much of his work was lost in the Great Fire of Haarlem in 1576. Jacob Cornelisz van Oostsanen (1470–1533) preferred crowded compositions whose figures fill the foreground with colourful activity. His style is close to that of Cornelis Engelbrechtsz, the leading painter of Leiden, in the northern Netherlands.

Painting in Leiden

At the turn of the fifteenth century, Leiden was beginning to assume the importance it was later to enjoy fully in Dutch painting. Its leading painter was Cornelis Engelbrechtsz (1468–1533), who had been an apprentice in Brussels, where he must have absorbed the sophistication of the court. It seems that he returned to Leiden by way of Antwerp, and the 'Antwerp Mannerist' interest in elongated forms, startling colour effects and bizarre detail clearly intrigued him. The jewel-like quality of his smaller panels enabled him to achieve some images of remarkable concentration (see plate 278), which have been described as showing 'Late Gothic Mannerism'.

Engelbrechtsz was the master of Lucas van Leyden (1494–1533), who was said to have been active as a successful engraver by the age of nine. He was only fourteen when he made his first known print, *Mohammed and the Murdered Monk Sergius*, which has genre overtones. During his brief life, he was a highly successful painter, as is shown in his vibrant *Last Judgement* triptych of 1526–7 (Stedelijk Museum, Leiden). However, he was more occupied as a prolific engraver, and was influenced by Dürer, whom Vasari says he bettered. His prints (which

278 CORNELIS ENGELBRECHTSZ Emperor Constantine (?) and Saint Helena, after 1517

The Emperor Constantine the Great allegedly defeated his enemy Maxentius 'under the sign of the Cross', and his mother St Helena supposedly found the True Cross and had it transported to Constantinople. Probably a fragment of an altarpiece, it may have been connected with the supposed relic of the Cross which arrived in Leiden in 1517. Its high degree of stylization suggests both Gothic and Mannerist types.

sometimes include extensive and rationally presented architecture, as in the *Ecce Homo* of 1510) were influential even in Italy.

Lucas's travels took him to Antwerp in 1521 and he met Gossaert in Middleburg in 1527. Van Mander's endearing portrait of him (which agrees with Vasari) says that he often worked from his bed, and gives a slightly misleading picture of his superficiality – possibly a misinter-pretation of the welcome lightness which is often found in his work. Apart from his woodcuts, etchings, engravings and drawings, Lucas's lasting contribution may have been his pioneering enthusiasm for genre painting

bearing no religious or allegorical implication (see plate 279). This was soon to be adopted with unparalleled interest as a Dutch speciality, for example by Pieter Aertsen (see plate 296). There is a strong genre element in Lucas's *Worship of the Golden Calf* of the mid-1520s (see plate 280), coupled with an unusual ability to link figures and mountainous landscape which looks forward fifty years to developments which were to lead to the Baroque.

The transition between the paintings of Lucas van Leyden and Jan van Scorel and the next generation, who were to open the way for the great developments of seventeenth-century Dutch art, is seen in the work of Maerten van Heemskerck, Pieter Aertsen and Frans Floris. Heemskerck (1498–1574) made an Italian journey in 1532-5 which was dominated by his encounter with Michelangelo, whom he emulated on his return to Haarlem. The transformation which thereby occurred in his work is evident from a comparison of pre-Italian portraits, such as A Family Group probably of c.1530 (Staatliche Kunstsammlungen, Kassel), which still recalls Scorel, and his finest post-Italian painting, the Self Portrait (see plate 305). The latter is a milestone in the attitude of Northern painters to Italy and the antique, leaving behind all 'Antwerp Mannerist' and 'Romanist' pretensions to Mediterranean culture. Heemskerck's two Italian sketchbooks provide insight into this absorption with Roman art and architecture, and single him out as an antiquarian more in the manner of eighteenth-century artists.

Van Leyden had already experimented with a similar novel genre theme in his Chess Players of around 1510, and such subjects indicate an increasing interest in everyday life, since they almost certainly carry no meanings deeper than a warning of the dangers of gambling. It was from such experiments that the taste for this type of genre picture filtered into northern Italy during subsequent decades.

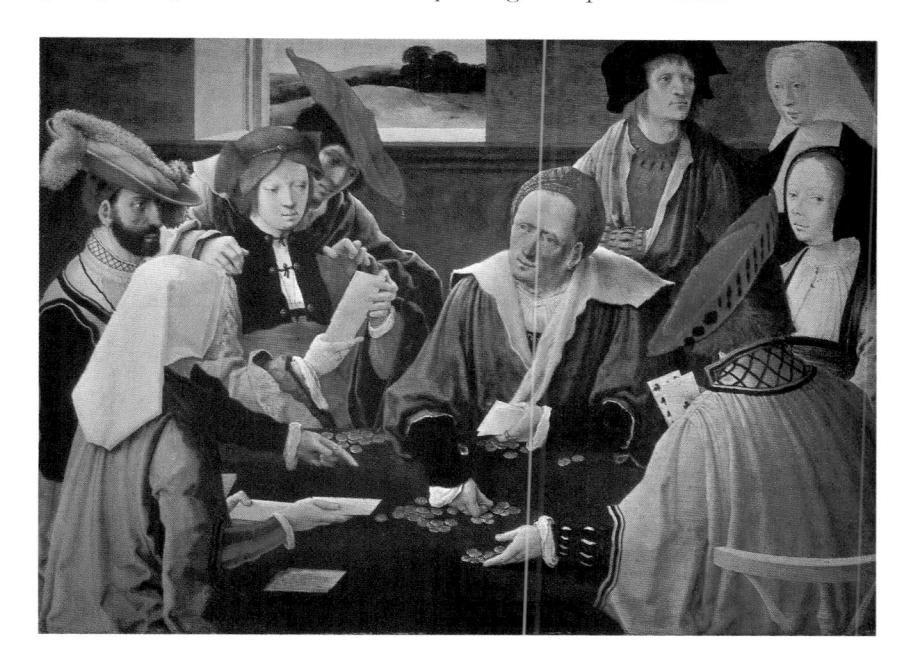

280 Lucas van Leyden Worship of the Golden Calf c.1525–8

(Above) Vasari rated Van Leyden above Dürer. Here he achieves a rare balance between spacious landscape and crowds of figures. Typically Mannerist is his placing of the main theme in the middle distance, while the genre groups in the foreground carry moral and symbolic overtones. The detail and rich colour in the costumes emulate the Italian High Renaissance.

281 MATHIS GRÜNEWALD The Small Crucifixion, c.1511–20 (Left) The anguish of all three figures here is carefully differentiated, and the crisp drapery folds, hand gestures and brilliant colour are offset by the dark background, which accentuates the terrible drama.

282 MATHIS GRÜNEWALD The Isenheim Altarpiece, completed 1515

(Right) Painted for the Antonite chapel at Isenheim, this was Grünewald's major work. Its original arrangement was dominated by the Crucifixion on the outside, and Sts Anthony and Sebastian in the wings. The first opening conceals the fixed wings and shows a concert of angels before the Virgin, flanked by the Annunciation and Resurrection. The second opening shows Sts Athanasius, Anthony and Jerome, with the meeting of Sts Anthony and Paul and the Temptation of St Anthony in the wings. The painting is permeated by a sense of terrible suffering, offset by the beauty of the angels' concert and the hope of the Resurrection. Such emotional intensity, achieved by gesture, dramatic outline, quasi-hallucinatory light effects and gruesome detail, had no precedent in European art.

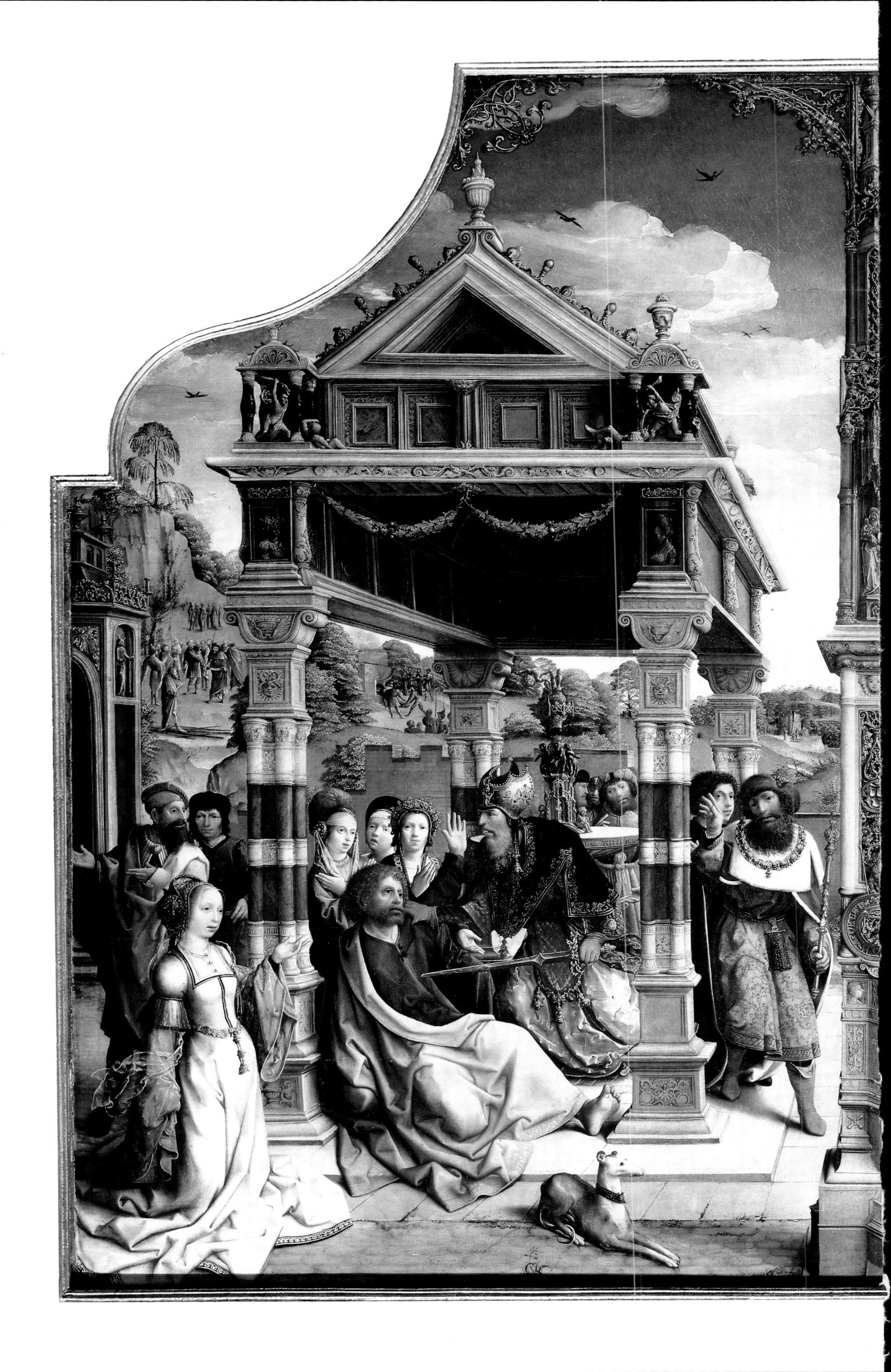

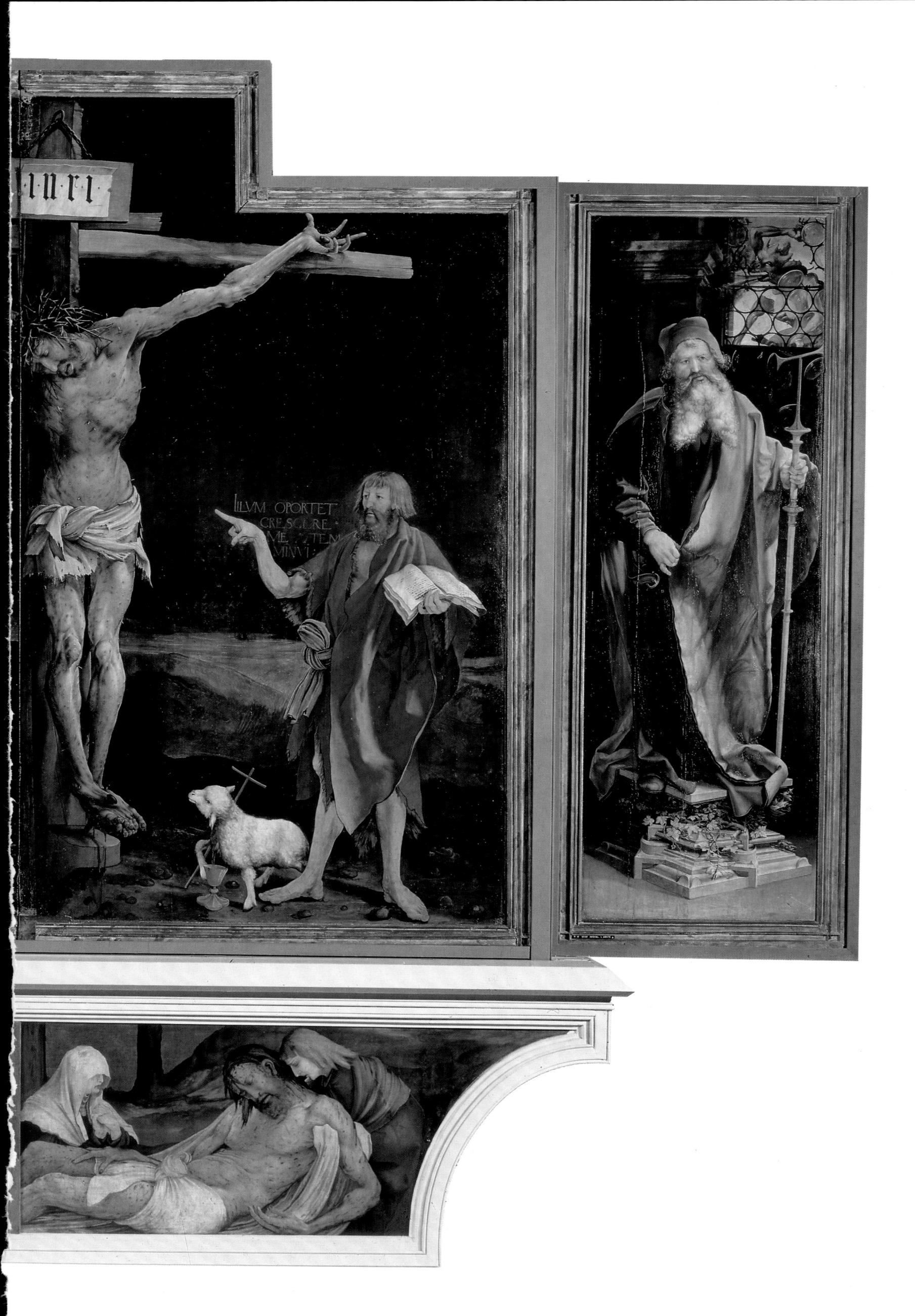

The increasing interest in genre (as an advance on the symbolic still-life detail which proliferates in fifteenthcentury painting) is one of the most unexpected aspects of mid-sixteenth century painting in Europe, particularly in the Netherlands, but also in Italy. As such scenes were most common in a mercantile society, it was natural they should become popular initially with that same bourgeois public. Transition to pure genre was not rapid and ostensibly genre scenes continued to contain religious or allegorical undertones, as in Aertsen's famous Egg Dance of 1557 (Rijksmuseum, Amsterdam). Pieter Aertsen (1508/9-75) was the leading painter in both his native Amsterdam and Antwerp, and his mature style is robust, full of realistic detail and vigorously composed. Unlike many of the Northern realists of the early Baroque period, his figures retain immense dignity (see plate 296), a legacy of the Renaissance.

The Netherlandish-German portrait tradition of the sixteenth century came to a close with the leading international portraitist, Anthonis Mor (c.1517/20–76/7). Mor achieved a perfect balance between Italian Mannerist hauteur and lavish if restrained detail, and an ability to render character. He travelled all over the Holy Roman Empire, and to England in 1554, where he painted one of the outstanding court likenesses of the century, Mary Tudor (Museo del Prado, Madrid). His Self Portrait (see plate 297) shows the grandeur of which he was capable, combining a Venetian atmosphere with a Northern attention to detail.

The portraits of Frans Floris exhibit a restrained naturalism that anticipates the work of later Dutch painters, such as Frans Hals. This can be seen most clearly in his Portrait of an Elderly Woman (The Falconer's Wife) of 1558 (Musée des Beaux-Arts, Caen). Floris, like Heemskerck before him, was overwhelmed by Rome, where he was present in 1541 at the unveiling of Michelangelo's Last Judgement in the Vatican's Sistine Chapel. His wide experience outside Antwerp appears to have drawn many pupils to his studio after his return. Particularly in his later pictures, his brushwork frees itself from the meticulousness still sought by many of his contemporaries. His pupil Martin de Vos (1531/2–1603) who also studied in Rome, Florence and Venice, became Antwerp's leading Italianate painter after Floris's death.

283 Bernard van Orley Saint Matthew c.1512

As one of the leading court painters to adopt Mannerist ideas in his maturity, Van Orley developed a style of some sophistication in which decorative architecture and other details are occasionally overwhelming. This altarpiece shows him uniting Italianate ideas with Northern prototypes.

Pieter Bruegel the Elder

Netherlandish painting in the sixteenth century comes to its natural conclusion with the great art of Pieter Bruegel (or Breughel, c.1525-69). Although firmly linked to many Netherlandish traditions in painting, he also stands alone. Known as Bruegel the Elder since he was the founder of a dynasty of painters, he has been described as a great comic illustrator (Van Mander) or a populist painter -'Peasant Bruegel'. Modern studies, however, reveal him as a sensitive and cultured figure in touch with the leading intellectual and political events of his day. Van Mander's story of Bruegel dressing up as a peasant to observe rural life at close quarters is indicative of a sophisticated approach to his subject matter, as his delightful late drawing, Artist and Connoisseur (Albertina, Vienna), proves. His work has struck a deep note in twentiethcentury consciousness, and certain of his pictures rank among the most popular images in European art.

Our information on Bruegel is limited to Van Mander's account and suppositions from dated paintings, so that he is one of the few major painters of his age who remains largely mysterious. The one area which he – alone among his contemporaries - appears to have avoided is painted portraiture. This seems odd, given his illustrious and discriminating patrons. These included Cardinal de Granvelle (Philip II's advisor who was more concerned about the loss of his Bruegels than anything else when his palace was sacked in 1572), and Niclaes Jonghelinck of Antwerp who owned sixteen of his pictures and in 1565 commissioned the Months series. Bruegel was equally gifted as a draughtsman, engraver and painter. Van Mander says he was born in Brueghel near Breda, but this is uncertain, and he studied under Pieter Coecke van Aelst whose daughter he married. In 1551-3 he travelled to France, Italy and Sicily, but was back in Antwerp after 1555.

Curiously, he seems to have remained impervious to the lure of Italy and the antique (as early critics rightly noted), which suggests that his art was intensely spontaneous and not susceptible to dramatic artistic changes elsewhere. Only in later life did he produce large-scale figure subjects. Since he collaborated in Rome with one of the greatest artists of his day, the miniaturist Giulio Clovio (see plate 258), who is known to have owned several of Bruegel's works, some influence from this source might have been expected. But Bruegel never depicted a Classical figure, and his drawings show only peasants and the grotesque underdogs of society, and were largely done for their own sake, not preparatory for other works.

Only drawings or engravings after drawings survive from 1552–5. As with Dürer, Breugel's return journey

from Italy through the Alps proved of incomparable inspiration for many deeply felt landscape drawings. He designed for the engraver Hieronymous Cock, producing *Big Fish Eat Little Fish* in 1556. His *Seven Deadly Sins* (1558) established his public reputation for engraved work, and he otherwise worked for private patrons.

Bruegel's first known paintings are landscapes and seascapes recalling Patinir's high viewpoint. The Fall of Icarus of c.1555 (Musées Royaux des Beaux-Arts, Brussels) is already full of a unique magic and uses ideas he explored in his landscape drawings of the Alps. Much influenced by Bosch, paintings from the end of third decade feature multi-figure scenes illustrating popular proverbs about humanity's folly, such as Netherlandish Proverbs of 1559 (Gemäldegalerie, Berlin), where the sadness of human existence underlies the comic. From the same year, the Combat between Carnival and Lent and Children's Games of 1560 (both Kunsthistorisches Museum Vienna) have high viewpoints which suggest our remoteness even from scenes which might normally seem familiar. They tell us much about Bruegel's purpose in future paintings.

The period of Bruegel's most intense and original images now followed. After his move to Brussels and his marriage in 1563, human beings occupy a smaller position

284 PIETER BRUEGEL THE ELDER Hunters in the Snow 1565 This is one of five paintings from an incomplete decorative scheme for Niclaes Jonghelinck's Antwerp house, in which the painter Frans Floris also participated. The whole year may have been represented by one painting for each two-month period. Hunters in the Snow was probably the first in the series to be completed, and it has become the classic representation of winter. Its high viewpoint, restrained colour and receding silhouetted trees, reveal Bruegel's direct observation of nature, based on his own sketches of Alpine scenery.

in nature which has become all-embracing. This is seen in his series of *Months* (the five surviving panels are now in New York, Vienna and Prague), which brings them closer to modern landscape than any previous landscapes. In *Two Monkeys* of 1562 (Gemäldegalerie, Berlin), the futility of man's effort is perhaps the real subject, as it certainly is in the *Tower of Babel* (see plate 286), one of the Renaissance's most moving images.

Bruegel brought to religious themes immense pathos and originality. In 1564, he painted the *Road to Calvary* (Kunsthistorisches Museum, Vienna) and the *Adoration of the Magi* (National Gallery, London). Compared with Dürer's painting of the latter subject (see plate 287), with its Renaissance humanist optimism, Bruegel's is heavy with pessimism, the scene craggy, the background crowd

threatening. From about the same date, his grisaille *Death* of the Virgin (Upton House, Banbury) is a night scene which, using an exaggerated Mannerist perspective, gives the impression of an event taking place in some indefinable distance, from which we are separated by darkness.

Bruegel is best known for his scenes of peasant life wedding dances, peasant feasts, hay-making, herding, hunts and parables current in everyday life. In his last years, he alternated between his large-figure style, as in the Peasant Wedding Feast (Kunsthistorisches Museum, Vienna) or the Land of Cockaigne (Alte Pinakothek, Munich) and single figure themes such as the Parable of the Bird's Nest of 1568 (Kunsthistorisches Museum, Vienna). In both types, figures have all the solidity and volume of High Renaissance art, but their 'idealization' consists in an unvarnished depiction of peasant models, which in itself assumes a kind of dignity. The subtlety of his inclusion of popular philosophies is such that only close observation of the figures reveals that they partake not in genre, but in what might be termed 'natural allegory'. It is this concern with a universal topicality which sets Bruegel apart from his contemporaries, and places his work in a modern context, deriving from Renaissance ideals but transcending them.

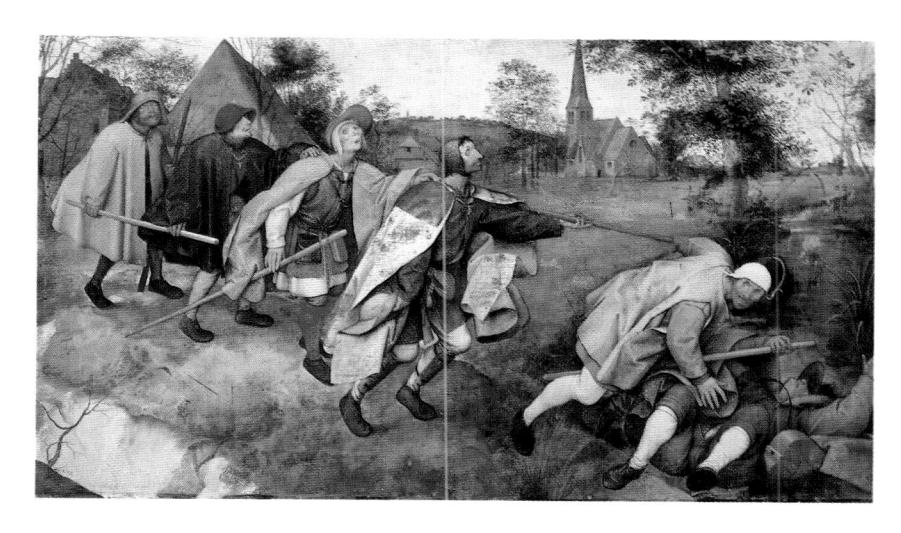

285 PIETER BRUEGEL THE ELDER Parable of the Blind 1568
This illustrates the words in the Gospel of St Matthew, 'If the blind lead the blind, both shall fall into the ditch.' The parable refers to the blindness of the soul closed to the truths of religion, symbolized by the church set in a closely-observed landscape.

286 PIETER BRUEGEL THE ELDER Tower of Babel 1563
Niclaes Jonghelinck owned sixteen paintings by Bruegel, among
which was a painting of this theme, probably this version. Two years
later, he commissioned the Months series from Bruegel. The tower is
probably modelled in part on the Colosseum.

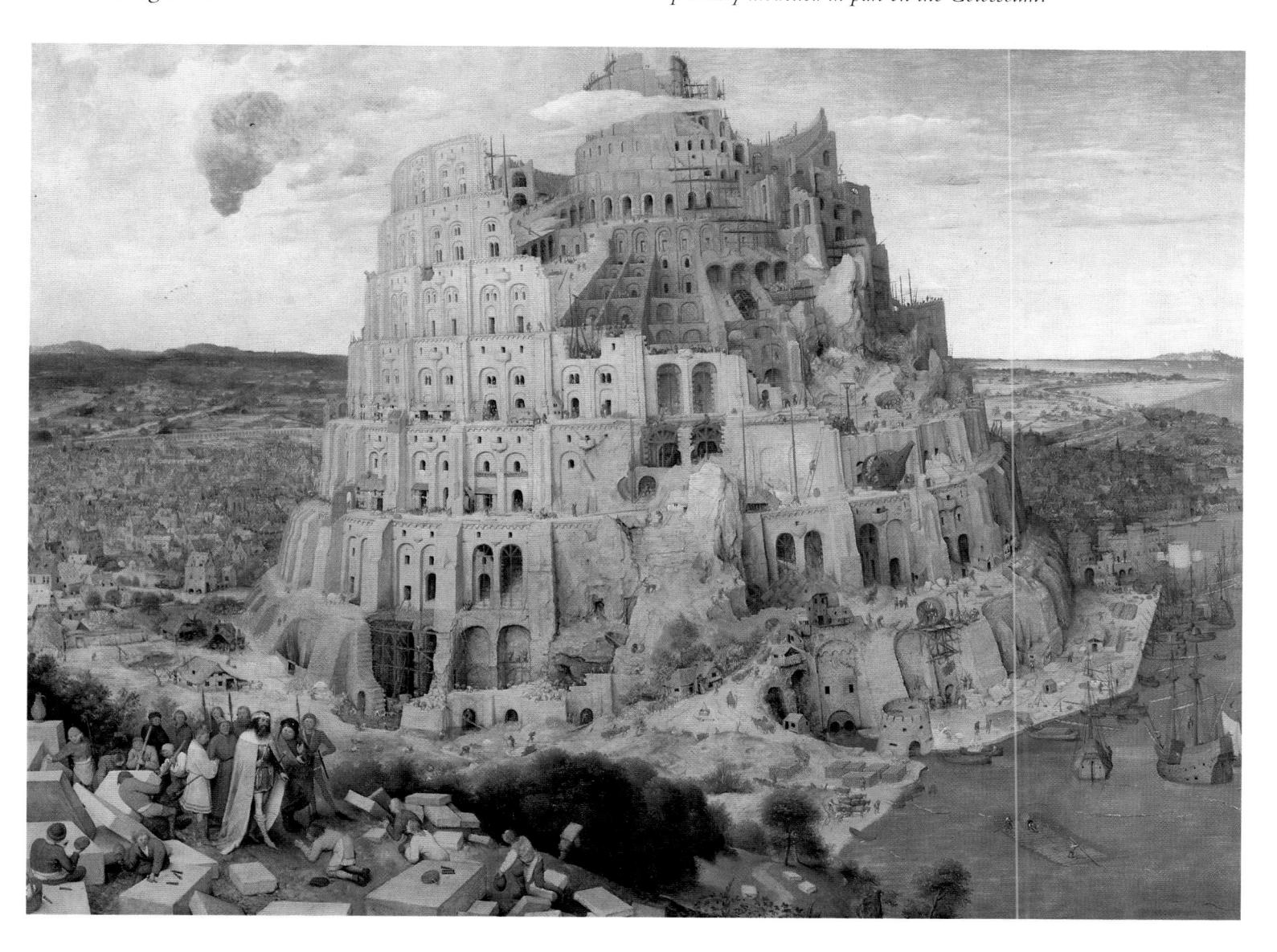

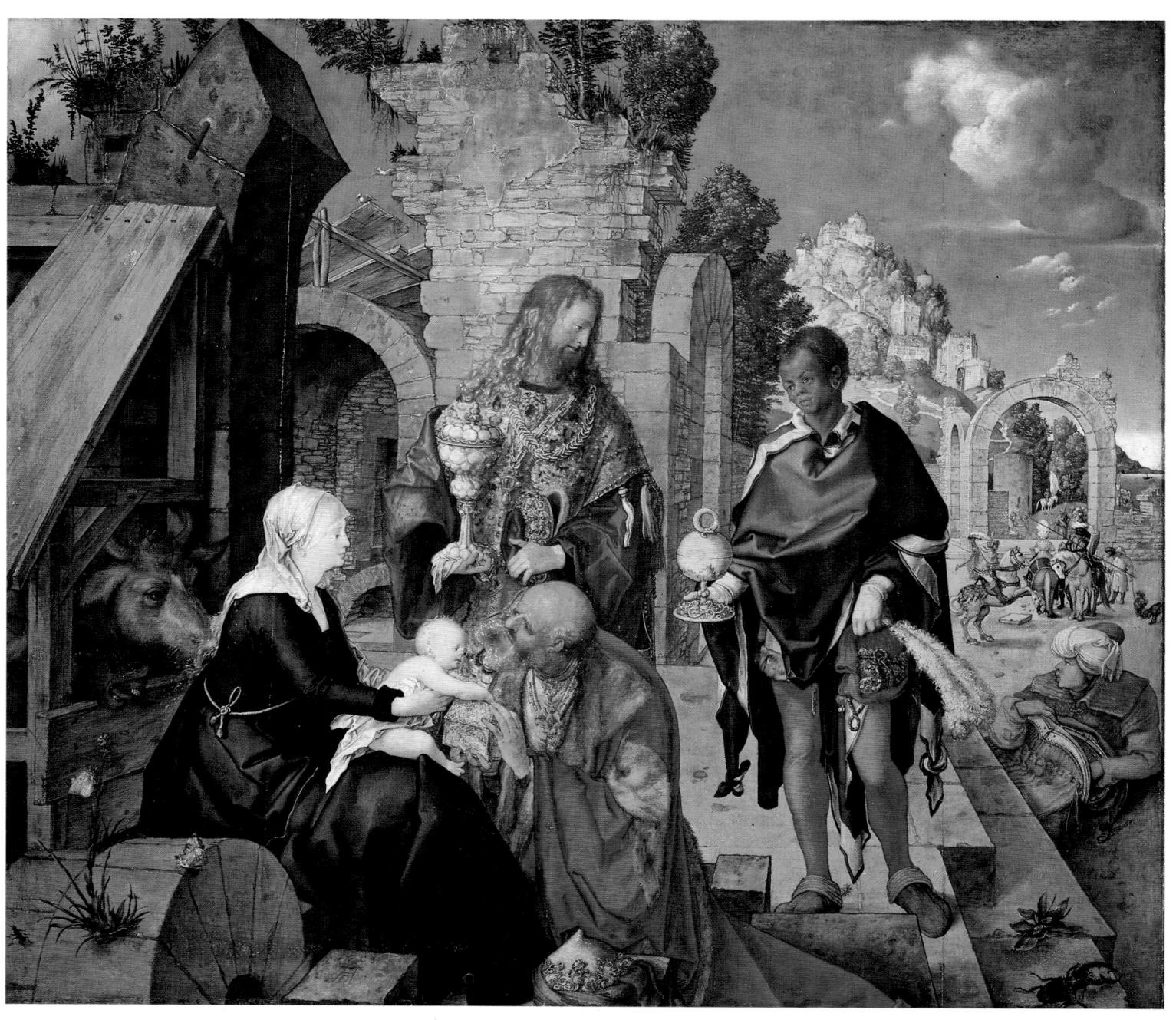

287 Albrecht Dürer Adoration of the Magi 1504 This composition was painted for Frederick the Wise, and the figures, the perspective and the ruined Classical architecture, indicate that Dürer knew the Leonardo da Vinci rendering of the theme. It ends the period immediately prior to Dürer's second Italian visit. Frederick was among the most respected and pious of the German Electors, and is portrayed in prints by both Dürer and Cranach.

288 Albrecht Altdorfer Birth of the Virgin c.1520–1

It is unusual to set this theme in a church, and St Anne's bed at the left almost recalls an altar. The figure entering at the right is cut off in a way that later became a frequent visual device in German Mannerism. Altdorfer's inspiration for the great ring of angels may come from Cranach. Strong colour and contrasts of light and shade intensify the drama.

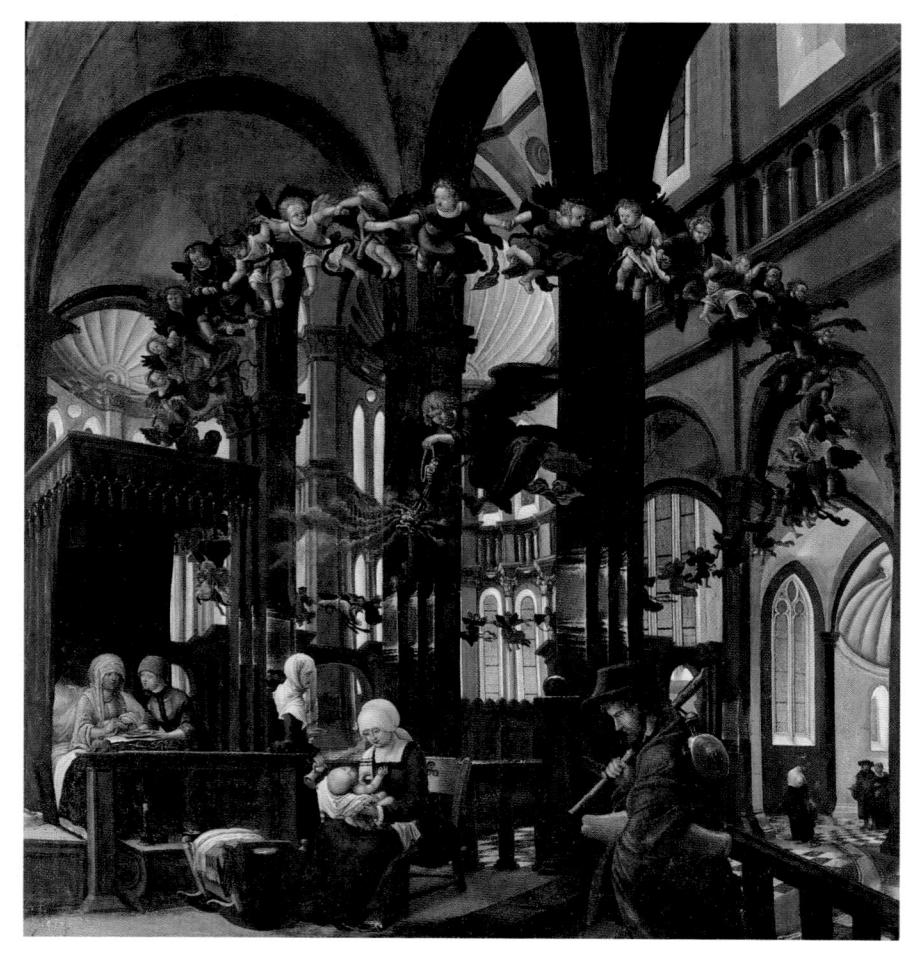

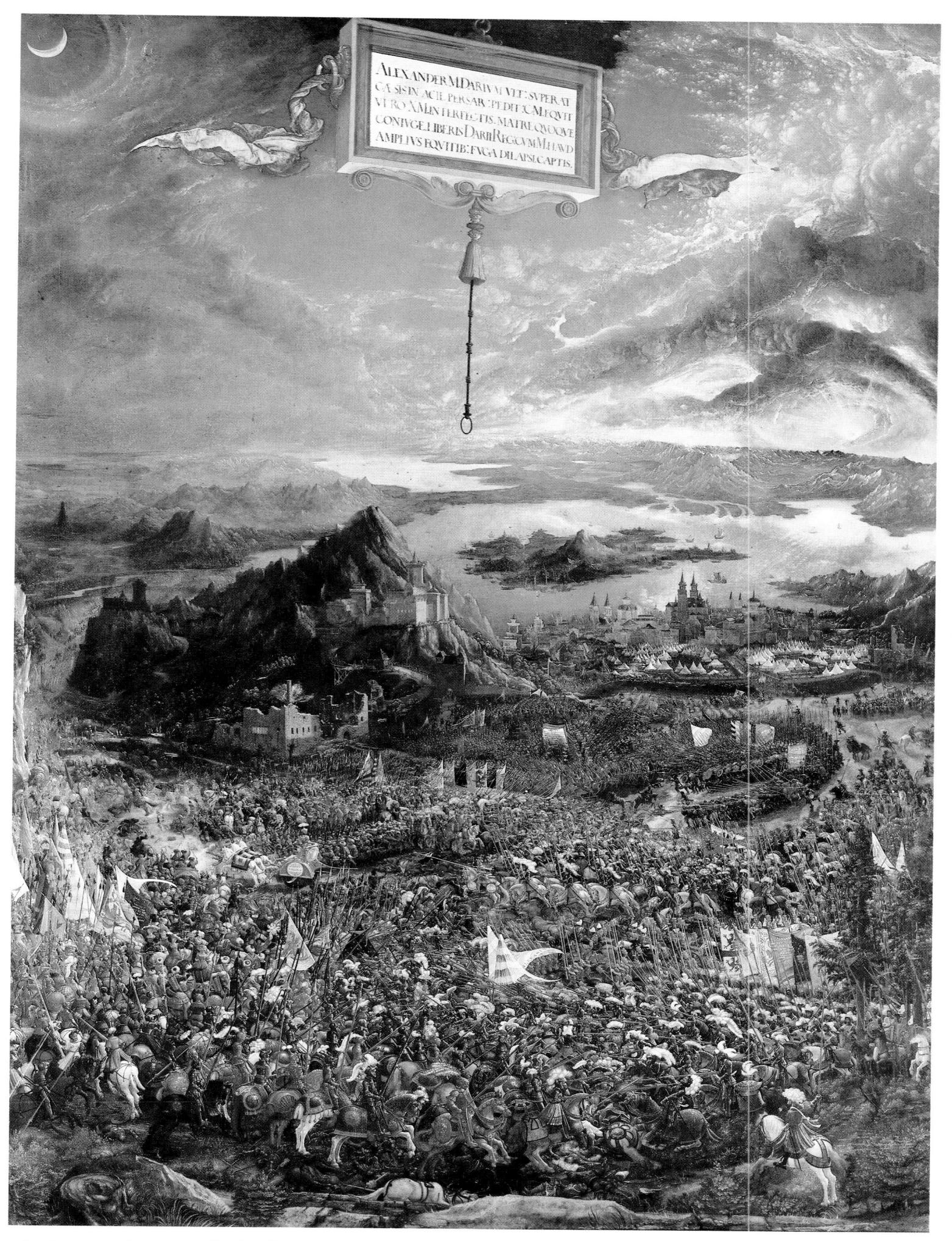

289 Albrecht Altdorfer Battle of Issus 1529
The painting shows the Battle of Issus of 333 B.C., but is also an allegory of the conflict of human forces compared with the dynamism of the universe. The figure of Alexander the Great can be clearly seen under the vertical line of the hanging cord, forcing the Persian King Darius to flee in his three-horse chariot.

290 Hans Holbein the Younger
Bonifacius Amerbach 1519
Holbein painted this portrait in the year of
his Italian visit. Amerbach was the son of
the Basle printer, and later became
Professor of Law at Basle University. He
was the close friend and heir of Erasmus
and a great admirer of Holbein, several of
whose paintings he saved from destruction
by the iconoclasts. The portrait is uniquely
intense for Holbein, and may have been
his first work after his admission as a
master to the painter's guild on 25
September 1519.

291 Hans Holbein the Younger Portrait of Georg Gisze 1532

(Left) The merchant is portrayed at the age of thirty-four, behind a work table in his office. He probably spent much of his life in London, where he is documented in the London Steelyard with which Holbein had connections. He is surrounded by a superb still life of objects connected with his profession; sealing-wax, a pewter writing case, quill pens, a gold balance and other luxurious items such as a table-carpet, a gold clock and a Venetian glass vase with carnations and other flowers referring to Gisze's qualities. As carnations symbolize love and fidelity, the portrait commission may date from the time of his betrothal to Kristine Krüger.

292 Lucas Cranach the Elder Judith with the Head of Holofernes c.1530

(Right) Cranach was the most successful purveyor of the female nude in the Northern European Renaissance. He also had considerable success with elaborately dressed and coiffed female figures, who wear the latest fashion in spite of their biblical or Classical identity. Here, the beautiful Old Testament heroine wears the type of large-brimmed hat with feathers which occurs in many Cranach paintings.

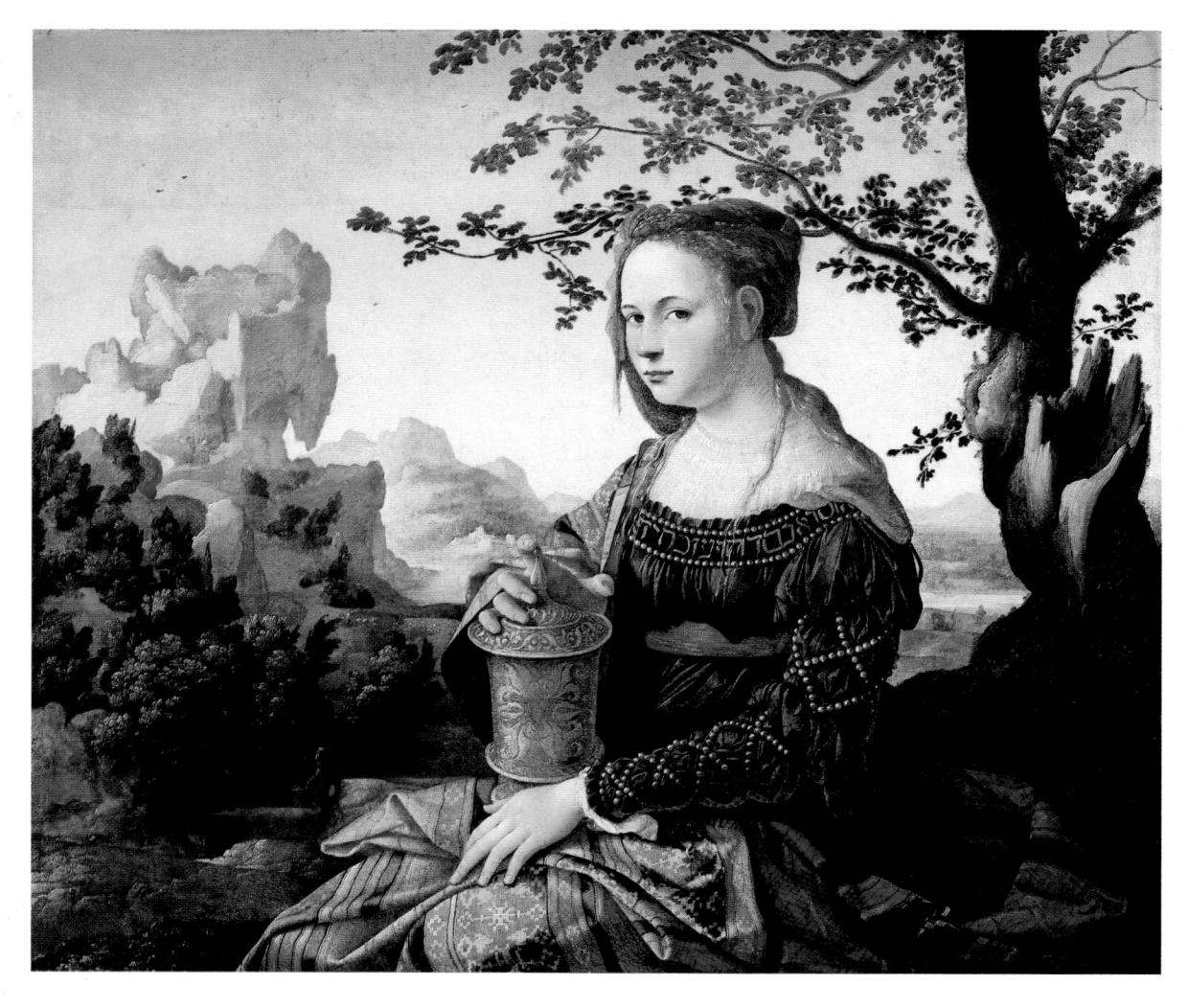

293 JAN VAN SCOREL Saint Mary Magdalen c.1529 (Above) One of the most delightful representations of the Magdalen in Northern painting, it conforms to the oblong format more usually associated with Venetian figure compositions set in landscape. This feature, coupled with the saint's lavish clothes, her somewhat ambiguous expression and the prevailing sense of calm, create an almost Italianate Classical effect.

294 JOACHIM PATINIR and QUINTEN METSYS Temptation of Saint Anthony c.1520-4

(Below) Both masters are documented as working on this, one of the most dramatic landscapes of the period. It shows many signs of the work of Patinir, such as the carefully differentiated foreground, middle distance and background. Its high, tilted viewpoint and varied scenery and cloudscape are unique.

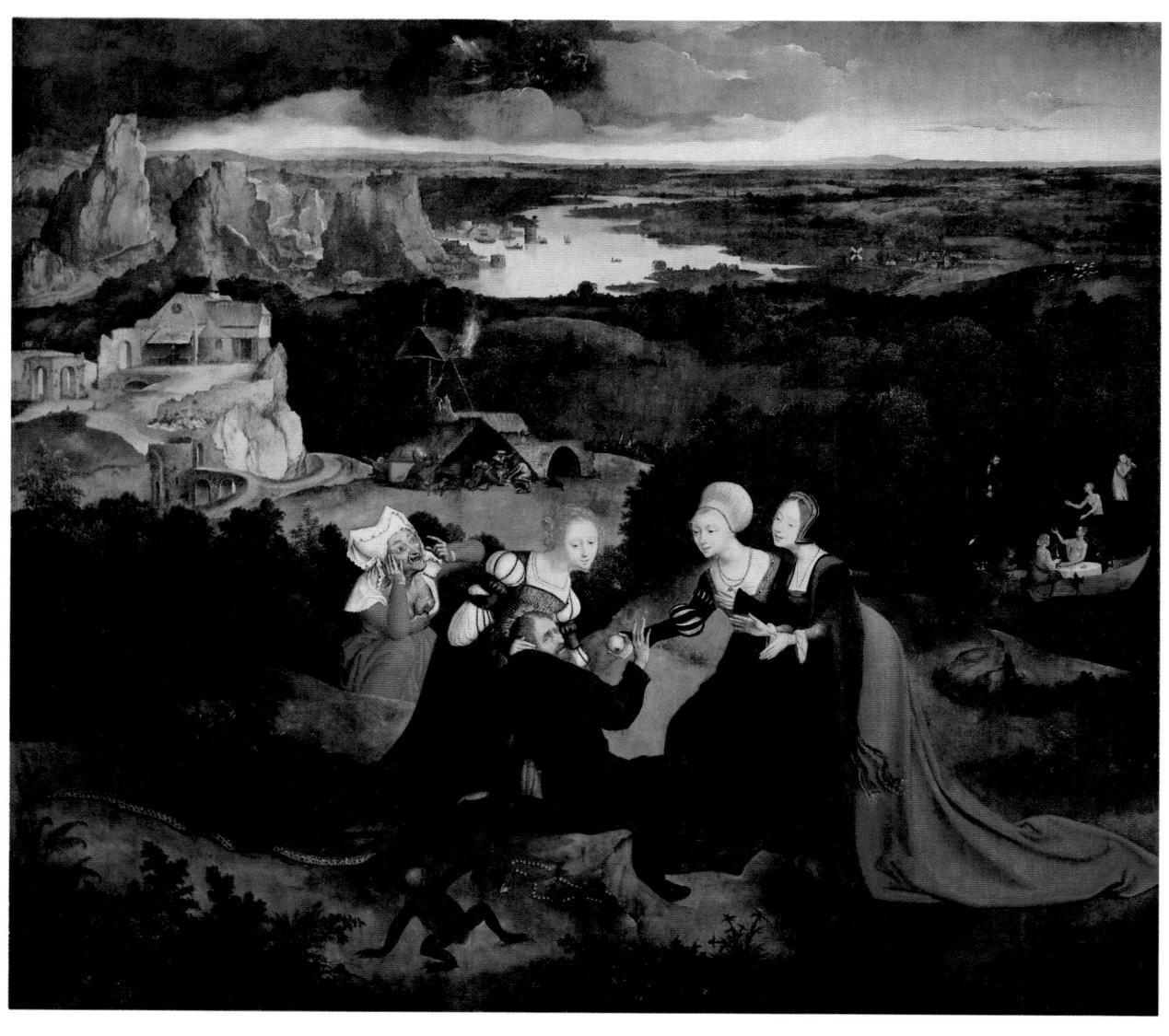

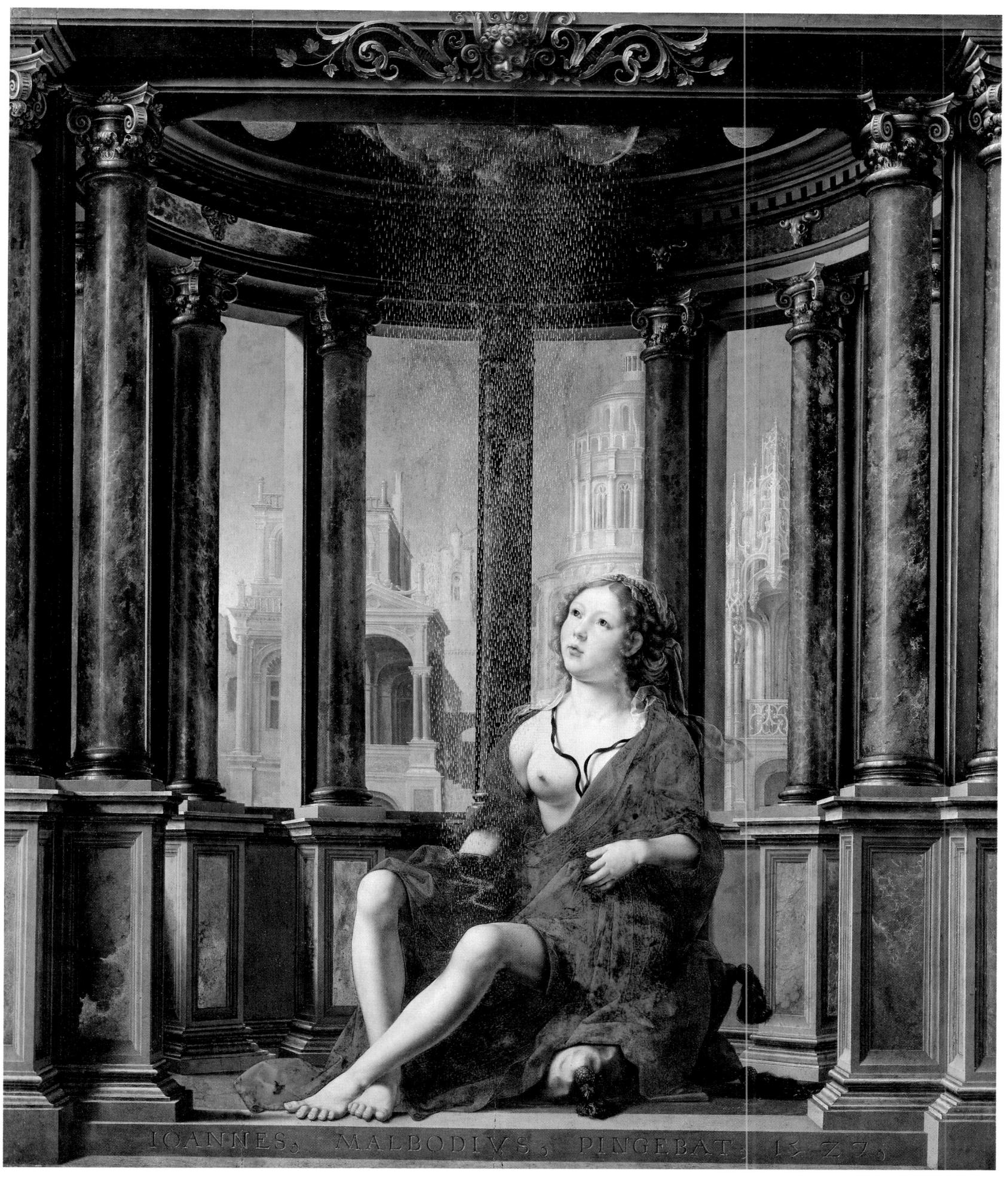

295 JAN GOSSAERT Danaë 1527

Danaë was locked by her father Acrisius of Argos in a 'chamber of brass' to prevent the prophesy of the Delphic Oracle that he would die at the hand of his daughter's son. Zeus, however, penetrated the chamber in a shower of gold, and their offspring was Perseus.

Correggio and Titian both painted the theme with a nude reclining Danaë, while Gossaert shows her dressed (if provocatively), probably

as an allegory of Chastity tempted by gold. Set in a glittering marble semicircle of columns, with fantastic background architecture of different periods, Danaë's rich blue robe is offset by the surrounding colours and her marmoreal flesh. Gossaert's late masterpiece, this probably belonged to Emperor Rudolph II in Prague, to whose rarefied taste it would have appealed.

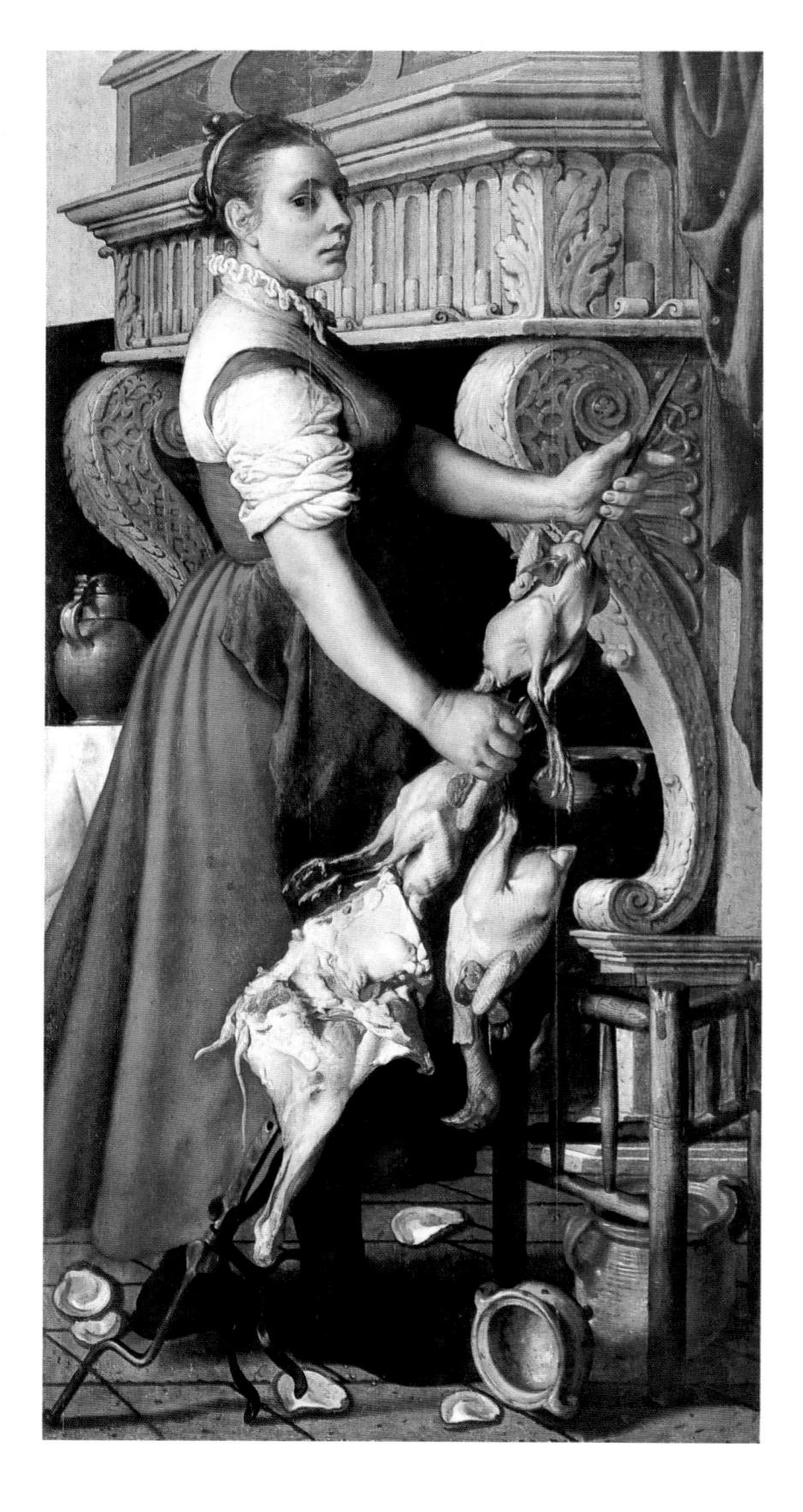

297 Anthonis Mor Self Portrait 1558 (Right) Mor met Charles V and his son Philip II in Brussels in 1550, and during the following four years he acted as royal portraitist for Spain in Rome, Lisbon, Madrid and London. He shared his court appointment with Titian and Coello. Mor's was a distinctly Northern manner, with forceful line, striking presence and a love of surface realism in flesh and costume. The austere grandeur of his images attracted the Spanish court. His sitters included Mary Tudor, whom he painted in 1554, for which he was apparently knighted.

296 PIETER AERTSEN The Cook 1559

(Left) Aertsen's life spans the Mannerist period, and he created genre pictures whose innate dignity harks back to the High Renaissance but which also foretell the vigour of Baroque realism. Many of his genre scenes also contain moral lessons and Christian symbolism in the fashion of the time, but incorporated with great subtlety and often humour. There is rarely any of the grotesque element found in his contemporaries. This remarkable image is one of many such striking scenes ostensibly from everyday life but imbued with a unique drama, created not only by the strong female figure but also by the superb Classical chimneypiece.

298 MARINUS VAN REYMERSWAELE Saint Jerome 1521 Reymerswaele remains unique for the quirky angularity of his quasicaricatural style, seen here to perfection with his passion for meticulous genre-like detail and still life.

One of the four Fathers of the Church, St Jerome is shown seated at work in his study. The book open on his reading stand contains an illumination of the Last Judgement, and the skull and candle on the desk reinforce the memento mori theme.

CHAPTER X

The End of Mannerism and the Dawn of the Baroque

The Renaissance began in Italy, and it was there that its demise was first and most clearly visible. Having filtered into the rest of Europe in widely differing forms and created many more variations, often being grafted on to irrepressible local traditions, Renaissance ideas lingered on in the North long after the Baroque had swept through Italy. This was nowhere more true than in Central Europe, while the French and Dutch, having been awakened to Italy's supremacy in art, clung longer to many aspects of Mannerism.

It has been argued that the Renaissance in Italy ended with the deaths of such major painters as Raphael (1520) and Correggio (1534), and that Michelangelo (died 1564) and Titian (died 1576) were survivors from a previous age who maintained Renaissance ideals while all around succumbed to the sophistries of Mannerism. Dürer's death

299 Annibale Carracci The Farnese Gallery, Rome c.1597–1600

Annibale Carracci was commissioned by Cardinal Odoardo Farnese to fresco the barrel vault of the Gallery, probably in honour of the marriage of Ranuccio Farnese and Margherita Aldobrandi in 1600. The central fresco, the Triumph of Bacchus and Ariadne, is the culmination of the whole scheme, which illustrates the transforming effects of love on the gods (Venus, Mars and others), monsters (such as Polyphemus) and mankind. Inspired partly by the Sistine Ceiling, Annibale combined scenes frescoed to resemble canvases set against the vault surface, fictive bronze roundels, 'sculpted' and naturally painted youths and fighting putti, possibly representing Eros and Anteros (in the corners). Annibale's biographer Bellori defined the theme as 'the war and the peace between celestial and earthly Love as instituted by Plato'. By combining countless drawings from the model with Classical and other sources, and a rich palette derived in part from Venetian art, Annibale created the liveliest work of art to bridge the transition from Renaissance ideas to the early Baroque.

in 1528, however, had no comparable significance, since it was only with his maturity that many true Renaissance concepts became current in Germany. It is therefore erroneous to impose on the period a notion of the Renaissance as representing certain inflexible ideas and clearly definable characteristics. While this approach remains more valid for the Baroque, Rococo and Neoclassical styles, it is difficult to apply convincingly to the Renaissance. Vasari's analysis of what we now call Mannerism, and his insistence on certain artistic 'codes of behaviour' led partly to an idea that Mannerism had little to do with Renaissance principles. But as we have seen, the style grew naturally out of elements present in the earlier Renaissance and had matured long before he set pen to paper on the subject.

In Italy, the transition from the late Renaissance and Mannerism to the Baroque was in many ways more perceptible and self-conscious than elsewhere, and partly resulted from a reaction against Mannerism on the part of both artists and theorists.

Italy led the way into the new style as it had throughout the development of the Renaissance in the fifteenth and sixteenth centuries. Vasari believed that there could be no real development from the art of Michelangelo, which for him and many of his contemporaries meant that the only possible way forward was Michelangelism. In terms of the Mannerist style, he was correct, but what he did not envisage was what actually happened for some later sixteenth-century artists – they reverted to the art of the High Renaissance itself for their inspiration.

Reactions to the demands of the Counter-Reformation and the 'Church Militant' for more comprehensible religious imagery in public settings varied widely in Italy and the other Catholic countries. Contrary to general belief, 'Jesuit art' (a term wrongly used as synonymous with the Baroque) was initially restrained

The Urbino painter Barocci combined his study of Correggio with many drawings from live models, resulting in a highly sensitive reaction to the artificiality of Mannerism. He also made use of small oil sketches, bozzetti, which prepared both artist and patron for the appearance of the finished work and became normal practice during the Baroque period. Barocci's ability to render miraculous events tangibly real is seen to perfection here, where the heavenly and earthly figures are barely distinguishable. This links earlier Renaissance compositional approaches to those of the nascent Baroque style. It was precisely this accessibility of sacred events to the ordinary man which Counter-Reformation theoreticians demanded, in order to counteract the alienating effects of so much Mannerist imagery.

Barocci painted this great altarpiece for the Pia Confraternità dei Laici della Madonna della Misericordia at Arezzo, together with a lunette showing God the Father. A large number of preparatory drawings document Barocci's meticulous preparation for the picture. This practice of his returned to High Renaissance principles, and ensured the importance of each gesture and expression in his pictures. Barocci was a brilliant colourist, using colour to heighten his innate genius for drama. He was among the first painters to perfect the use of pastel as a medium.

and didactic, in keeping with the Jesuits' rational and intellectual aproach to Catholic propaganda. The interior of the Jesuit mother church in Rome, the Gesù (1568–75), today one of the richest examples of lavish Baroque decoration, was planned to be bare of ornament so as to create no distraction to the faithful.

In Florence itself, under Vasari's own nose as it were, the decoration of the tiny studiolo of the Grand Duke Francis I de' Medici in the Palazzo Vecchio (1570-2), which Vasari supervised, included paintings by Santi di Tito (1536-1603) which already encompassed a partial rejection of the maniera extremes dear to Vasari in favour of a new directness and naturalism. This was rapidly followed by the early activities in the Medici capital of Jacopo da Empoli (1551–1640) and Lodovico Cigoli (1559-1613), now both seen as seminal 'reformers' of painting there. Cigoli turned for inspiration not to the masters of the mid-century but to Correggio, Titian and the Venetians. His precursor in many of his aims was Federico Barocci (c.1535–1612, see plate 300), a great, influential and seriously underestimated painter who was somewhat outside the mainstream of Italian art of the sixteenth century.

They too were the sources for the greatest reforming painters of the later years of the century, Annibale Carracci (1560–1609) and Michelangelo Merisi da Caravaggio (1571–1610). Both Caravaggio and Annibale are associated with the earliest manifestations of the Baroque, and indeed from their respective innovations sprang many features of the new style. However, in their different ways, they reverted to Renaissance prototypes forming the strongest link between the first and the last years of the sixteenth century. Annibale's superb *Pietà with Saints* (Galleria Nazionale, Parma) painted in 1585 has rightly been called 'the first Baroque picture', and is a remarkable reassessment of the century's great masters.

In addition to Correggio and the Venetians, Annibale also studied Raphael, Andrea del Sarto and the more classical aspects of Michelangelo. Annibale and his brother Agostino (1557–1602) and cousin Lodovico (1555–1619) were from Bologna and were influenced by the reforming theories of Cardinal Gabriele Paleotti (1522–97). They probably read his 1582 treatise on painting, the *Discourse Concerning Sacred and Profane Imagery*. It is important to realize that the tone of this and other such manuals was fundamentally different from the exploratory writings of the fifteenth century, of Alberti and his contemporaries. Counter-Reformation writing was didactic, not theoretical, intent on instigating change, not proposing an example. In Milan, parallels exist with the activities of Cardinal Federico Borromeo (1564–1631).

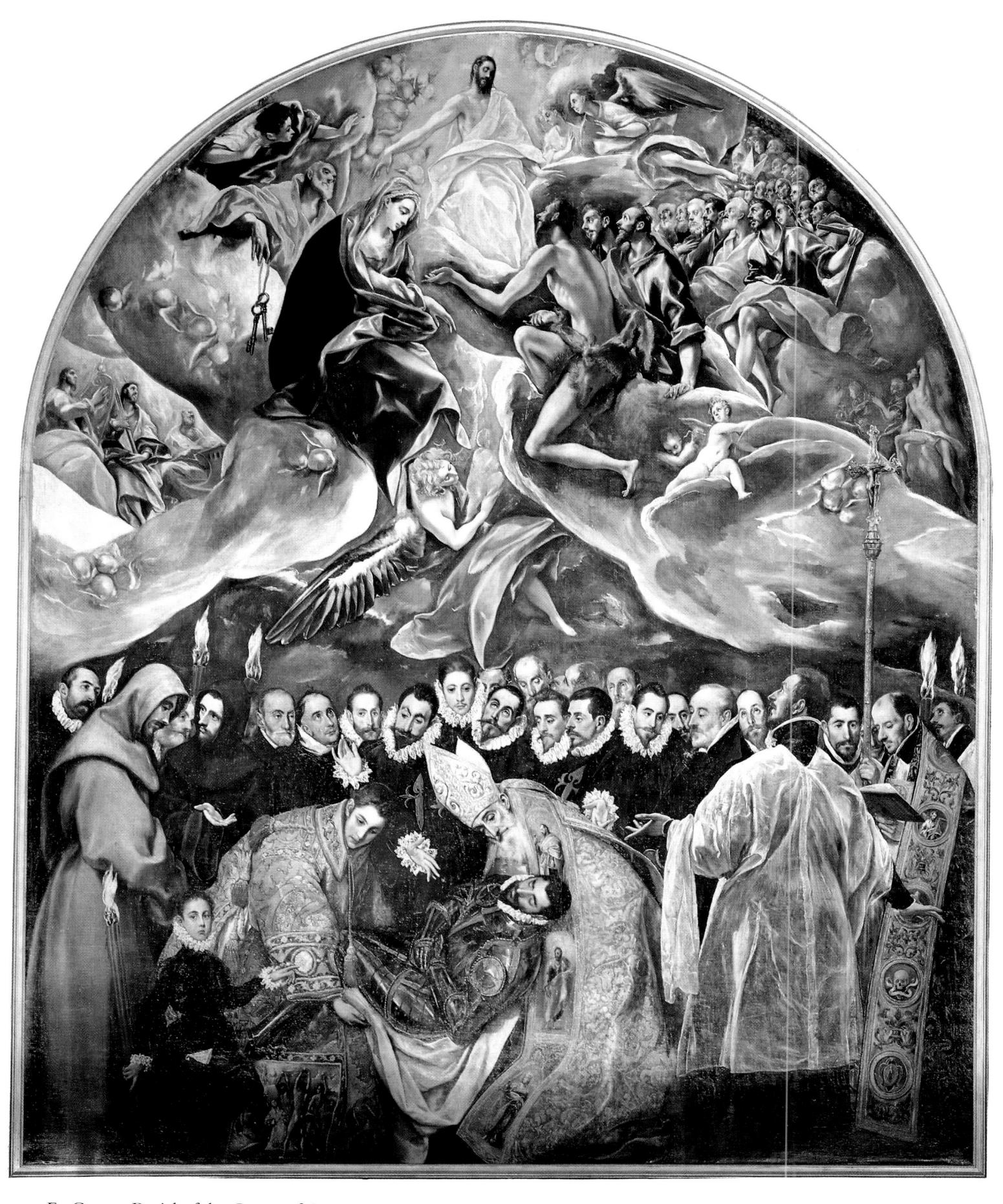

301 EL GRECO Burial of the Count of Orgaz 1586–8
This picture, painted for the parish church of Santo Tomé in Toledo, commemorates a supposed miracle in 1323 when Sts Stephen and Augustine appeared at the funeral of Gonzalo de Ruiz, Lord of Orgaz, and lowered his corpse into the tomb in acknowledgement of his charitable life. Royal recognition of the miracle was granted in 1583. While a priest chants a hymn the body is lowered, and an

angel guides Orgaz's soul to judgement before Christ. The Virgin and St John are shown interceding for him. Typical of the Counter-Reformation is the glorification of the saints in the role of intercessors; El Greco's familiarity with contemporary Catholic iconography is found in all his pictures. He owned and annotated copies of Vasari's Lives and Vitruvius's On Architecture.

The Carracci were long known as the 'Eclectics' and it was their conscious borrowing of style, colour, paint handling and even poses and compositions from earlier painters, coupled with a deliberate naturalism, which liberated them and their followers from the constraints of Mannerism. Annibale helped to found the tradition of Classical landscape painting which was to culminate in Claude Lorraine in the seventeenth century. This innovatory interest in nature also led him to experiment with caricature and genre. His earliest works are astonishingly direct in handling and subject matter such as the *Butcher's Shop* (see plate 302), and recall similar initiatives in Netherlandish art by Pieter Aertsen (see plate 296) and his pupil Joachim Bueckelaer (c.1535–74), which Annibale almost certainly knew through imports into Italy.

This, one of Annibale's earliest paintings, shows his passion for earthy, carefully observed detail verging on the caricature, which he also practised in drawings. Together with his Crucifixion with Saints in Bologna's Santa Maria della Carità of the same period, this shows how Annibale applied his close observation of nature with a directness forgotten during the Mannerist period. Most of his early work was in this vein, but was soon supplemented with conscious borrowings from High Renaissance masters which led to the Carracci family's being termed 'Eclectics'.

In complete contrast to such realism, which remained largely a Northern prerogative, Annibale's greatest legacy was the incomparable vault fresco of the Farnese Gallery (see plate 299). While announcing all the joyful exuberance of the Baroque, it is also a conscious homage to the finest achievements of mature Renaissance painting, and a fitting culmination to the sixteenth century.

Caravaggio, from Lombardy, was Annibale's near-contemporary and shared the ability to escape prevailing conventions. He too studied and understood his Classical predecessors, along with the style of Giorgione and his followers, notably Lotto and Savoldo. From them, he derived his dominant passion for light, whose dramatic and mysterious effects he turned to unique account. Although like Annibale, he went early to Rome, it was not with the aid of august patrons (Annibale's were the Farnese family). After very humble beginnings there, he rose gradually to a position of dubious fame, based on his startlingly novel pictures and his violent nature, which led to his committing a murder in 1606.

Even in his first paintings of fortune-tellers, melancholy, erotic youths and decaying still life (see plate 306), Caravaggio evolved a new pictorial language from his north Italian sources. About 1600 he achieved a maturity in his paintings evident in the Contarelli Chapel (San Luigi dei Francesi, Rome), the Cerasi Chapel in Santa

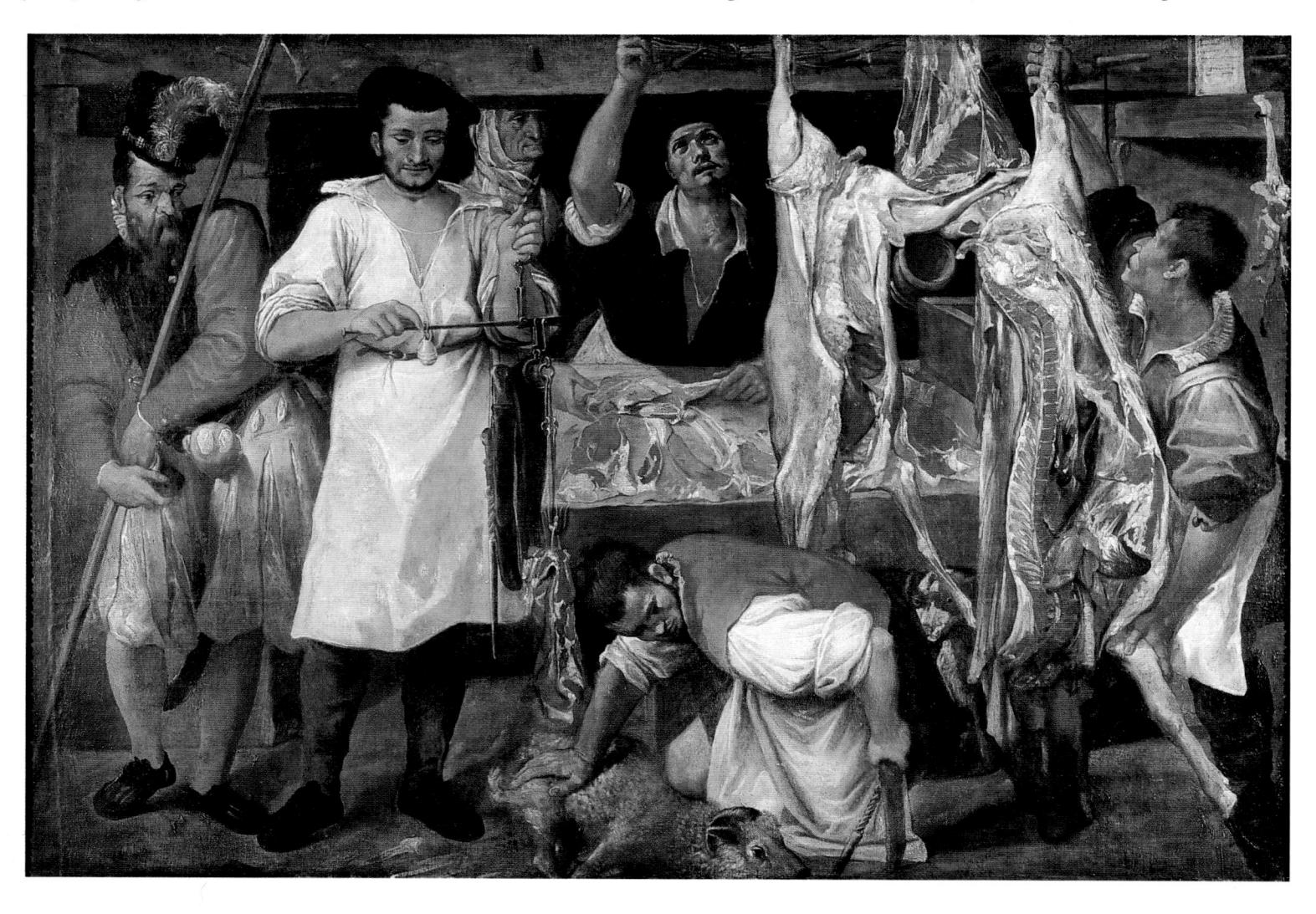

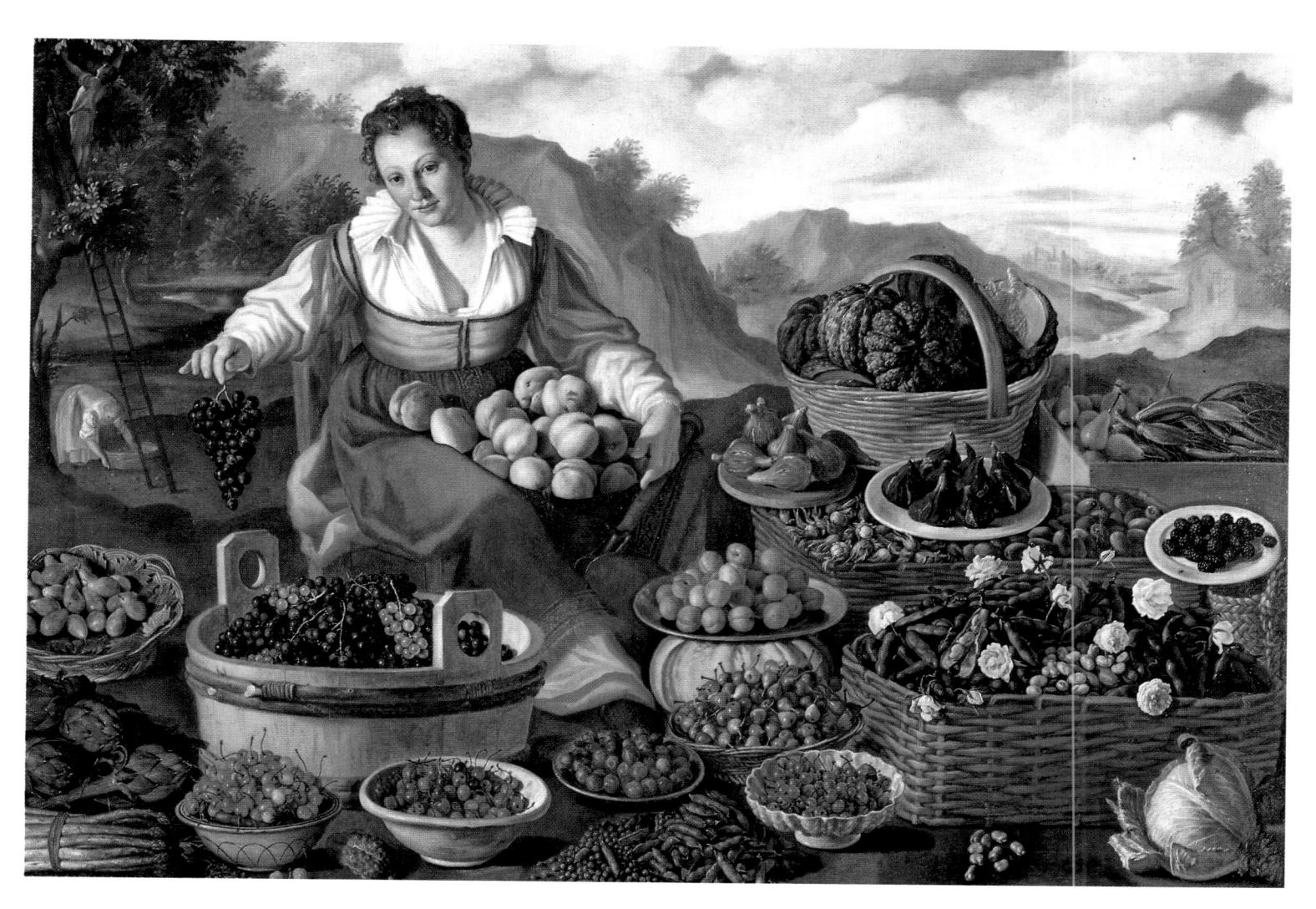

303 VINCENZO CAMPI The Fruit Vendor c.1580

Taking as his models such painters as Aertsen and Bueckelaer,
Campi appears to have painted his earliest still life scenes with
human figures during the later 1570s. The closest contemporary
parallels to this are in the Venetian works of the Bassani: their
interest in such still life for its own sake is new and totally different
from the work of a painter such as Arcimboldo in Milan, who
combined natural forms to create fantastic images. Thus was born one
of the greatest preoccupations of seventeenth-century Italian art.

Maria del Popolo, and grand altarpieces like the Death of the Virgin (Musée du Louvre, Paris). In these, he used forms and figure groups as imposing as Annibale's, although imbued with a brutal physical realism which led to their rejection, particularly by clerics. Like Annibale's compositions of the same years, these recall the magnificent approach to the human figure so typical of High Renaissance altarpieces. Interestingly, this was one feature of Caravaggio's art which found little favour with his imitators. As great innovators, both he and Annibale were fully aware of the importance of the past, perceiving in the pictorial clarity of Raphael and Michelangelo the route to an art which could directly and unselfconsciously touch the soul. But while it was Annibale's influence which was most lasting and far-reaching in Italy itself, Caravaggism extended rapidly throughout Europe,

particularly to Spain and the Netherlands. Caravaggio may be held responsible for the break with late Mannerism in Spain and the Netherlands, and, ultimately, for the emergence of the intensely national manifestations of Baroque ideas perfected in Rembrandt and Velazquez.

With the papacy of Clement VIII, Rome saw a sudden restoration of the position it had held during the High Renaissance, and the visual arts began to enjoy the resurgence which endured throughout the next two centuries. The glorious period of Julius II and Leo X's papacies became idealized during the century's last years. Foreign painters flocked to 'the city of saints', which celebrated them with fervour. Although they had been lured to Rome in increasing numbers from the fifteenth century onwards, the wealth of the great frescoes and altarpieces, ancient architecture and sculpture, made Rome even more attractive to painters during the sixteenth century.

Many Northern painters of the mid to late century lingered or settled there, including the Flemish landscapist Paul Brill (1554–1626), who, with the German Adam Elsheimer (1578–1610) played a vital role in the evolution of landscape painting. These were artists who were building on the achievements of Bruegel, German landscape painters and Flemish Mannerists, but finding direct inspiration from Italian art and nature. Thus, paradoxically, they brought the wheel of Italianate inspiration full circle.

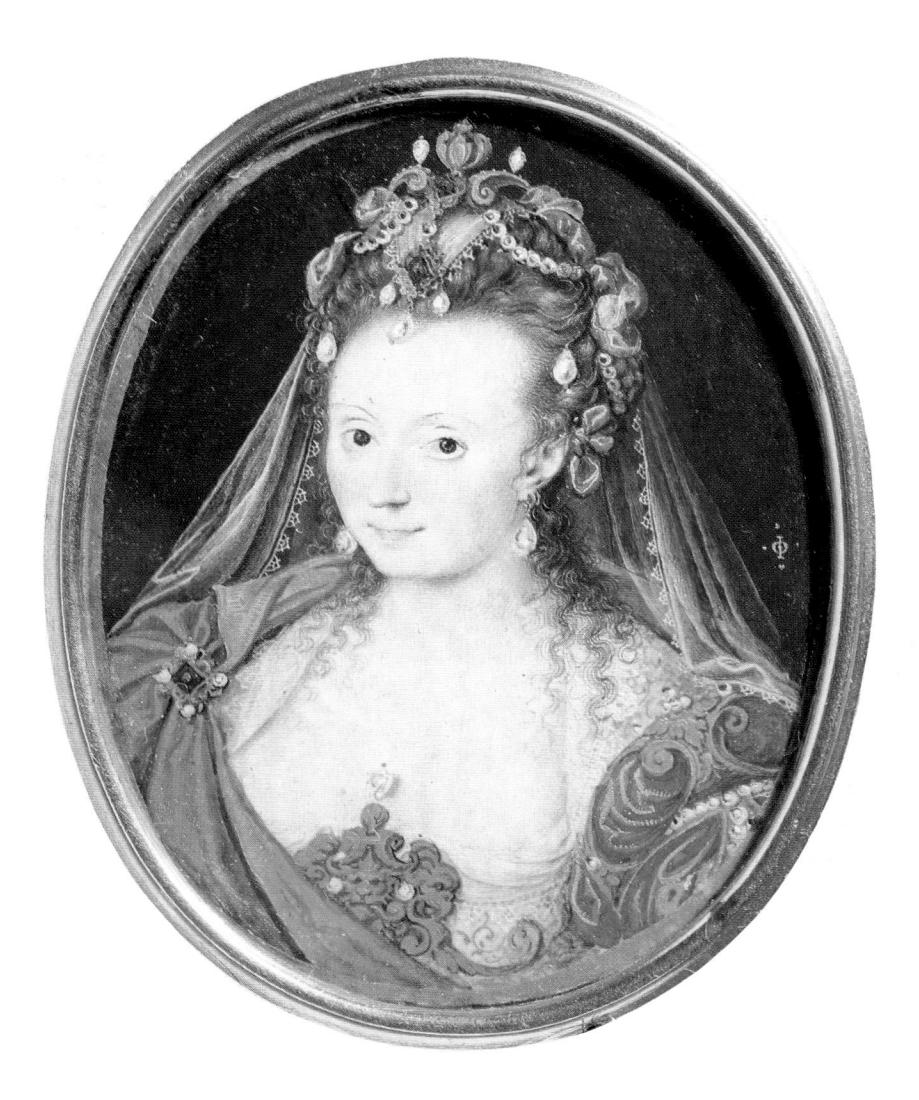

304 ISAAC OLIVER A Lady in Masque Costume 1610
Isaac Oliver was the most international miniaturist of his period. He was of French origin, and he had gained direct experience of European art on his visit to Venice in 1596. He is also known to have made direct miniature copies of the Old Masters. This portrait of a woman wearing a costume in Ben Jonson's 'Masque of Queens' reveals an awareness of the international trends implicit in the masque, which traced its origins back to entertainments such as those for the Medici in Florence.

Of all the painters who came to Italy from abroad and gained training and inspiration there, El Greco was perhaps the most notable in this period. His art belongs neither fully to the Mannerist nor to the early Baroque styles, yet he certainly must be classified as a 'Renaissance' artist, particularly in the light of the recent discovery of his extensive writings. He stands as an atypical product of the late Renaissance period, and particularly of extreme Counter-Reformation fervour.

We may think of El Greco (Domenikos Theotocopoulos, 1541–1614) as Spanish – 'El Greco of Toledo' – but he was born in Crete, a key Venetian possession since 1204. By 1568 he was in Venice, moving on to Rome, but he settled permanently in Toledo in 1577. The truth was probably that he had little success in Italy, and both during and after his lifetime he was regarded

by Spanish critics as 'capricious' and 'extravagant'.

In Venice, the quasi-expressionist aspects of Tintoretto's style were what most attracted El Greco, but he professed to disdain Michelangelo. Two versions of the *Purification of the Temple* (National Gallery of Art, Washington, and Minneapolis Institute of Arts,) together with his portrait of *Giulio Clovio* (see plate 258) typify his style while he was in Italy. Their elongated figures and novel, chilly palette are already fully his own, however, and this was the original manner which he further developed in Toledo. The German Expressionist painters of the early twentieth century claimed him as their precursor.

In Spain, he painted several very grandiose pictures, notably the *Martyrdom of Saint Maurice* of 1580–82 (El Escorial, Madrid). Nearly fifteen feet high, its composition unites High Renaissance monumentality with Mannerist spatial effects, but emulates neither. The *Burial of the Count of Orgaz* of 1586–8 (see plate 301) echoes Renaissance compositional ideas but is somewhat mundane in its figure grouping in spite of its bustling heavenly activity. What most distinguishes it and the best of El Greco's painting is a searing spirituality, which reminds us that his contemporaries were religious writers

305 MAERTEN VAN HEEMSKERCK Self Portrait with the Colosseum, Rome 1553

From 1532 Heemskerck spent four years in Rome, familiarizing himself with the ancient and modern monuments of the city through sketches. Those of the rebuilding of St Peter's are of particular interest. In contrast to the Mannerism of much of his religious work, this picture is surprisingly naturalistic, as if to indicate his admiration for the great Roman ruins. Although it seems to look forward to the souvenir portraits of the Grand Tour two centuries later, its intention is more scholarly, linking the artist directly with the inspiration to be derived from antiquity.

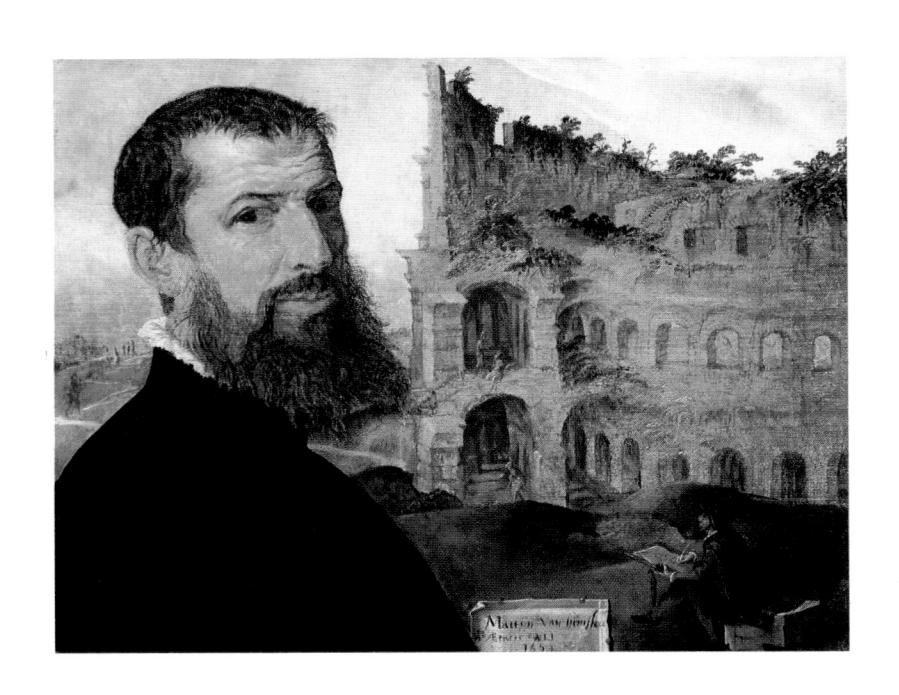

306 CARAVAGGIO Basket of Fruit c.1596

This is Caravaggio's only pure still life painting. It shows his ability with texture, light and even illusionism, since the basket overhangs its ledge as if to intrude into our space, much as later Baroque illusionism was to do on a larger scale. The picture encapsulates the sixteenth century's developing interest in still life painting as an expressive means, in which mundane objects could be imbued with symbolic associations: here the rotting fruit may suggest the transitoriness of life.

and visionaries such as St Theresa of Avila and St John of the Cross. As one of El Greco's finest critics, Paul Guinard, writes: '. . . the problems that haunted El Greco fall into a distinctly liberal order of meditation – that of a man of the Renaissance – embracing poetry, science and the purely technical side of the painter's art.'

The preoccupation of the sixteenth-century Northern Renaissance with questions of realism never impinged on El Greco in spite of its effects on Italian painting. Neither did it disturb the dream world of the so-called Elizabethan Renaissance in England, from which Spanish spiritual convulsions were firmly excluded, and where ideas promulgated in the 1540s remained current well into the

sixteenth century (see plate 304). It has even been said that while the Renaissance flowered in English literature, the 'discovery of man' so characteristic of humanist ideals was totally absent from most painting of the period in England, which was dominated by traditional and rigidly imposed court criteria.

Ultimately, the period described under the general heading 'the Renaissance' can only be truly perceived as the sum of its parts. Even then, conclusions are bound to be different according to national and historical perspectives. Given that our perception of the Renaissance is historically comparatively modern, dating from the midnineteenth-century studies of Jakob Burckhardt and others, it follows that constant shifts of emphasis are not only inevitable, but to be hoped for. If, however, the term Renaissance may be used to describe the aspects of civilization of the fifteenth and sixteenth centuries which broke the mould of the Middle Ages and established modern man's place in a shrinking universe, then our critical task is simplified. By this standard, it may be accepted that many of the paintings reproduced in this book will vindicate - at least in part - Vasari's understanding of the Renaissance as a continuing progress towards perfection.

Bibliography

EXHIBITION CATALOGUES (Listed Chronologically)

Baudoin, F. and Boon, K.G. *Dieric Bouts*, Musées royaux des Beaux-Arts, Brussels, 1958.

de Smet, (ed.) Bruegel, une dynastie de peintres, Musées royaux des Beaux-Arts, Brussels, 1980.

Chambers, D. and Martineau, J. (eds). *The Splendours of the Gonzaga*, Victoria and Albert Museum, London, 1981.

Ames-Lewis, F. and Wright, J. *Drawing in the Italian Renaissance Workshop*, British Museum, London, 1983.

The Genius of Venice 1500–1600, Royal Academy of Arts, London, 1983.

Spike, J.T. *Italian Still Life Paintings from Three Centuries*, National Academy of Design, New York, 1983.

From Borso to Cesare d'Este. The School of Ferrara 1450–1628, Matthiesen Fine Art, London, 1984.

Andrea del Sarto, Dipinti e Disegni a Firenze, Pitti Palace, Florence, 1986.

Roberts, J. Drawings by Holbein from the Court of Henry VIII, Orlando, 1987.

Goddard, S. (ed.) The World in Miniature: Engravings by the German Little Masters, 1500–1550, University of Kansas, Lawrence, 1988.

Martineau, J. (ed). *Mantegna*, Royal Academy, London, 1992.

Воокѕ

(Listed alphabetically under author)

Alberti, L.B. On Painting and Sculpture, ed. G. Grayson, London. 1972.

Ames-Lewis. F. Drawing in Early Renaissance Italy, New Haven and London, 1981.

Antal, F. Florentine Painting and its Social Background, London, 1947.

Anzelewsky, F. Dürer. His Art and Life, trans. H. Grieve, New York, 1981.

Arentino, P. Selected Letters, trans. G. Bull, London, 1976.

Baldini, U. and Casazza, O. *The Brancacci Chapel Frescoes*, London, 1992.

Baldwin Brown, G. (ed.) Vasari on Technique, New York, 1960.

Bartsch, A. Le peintre-graveur, Vienna, 1803-21.

Baxendall, M. Painting and Experience in Fifteenth-century Italy, Oxford, 1972.

Benesch, O. The Art of the Renaissance in Northern Europe, Cambridge, Mass., 1947, repr. 1967.

Berenson, B. The Drawings of the Florentine Painters, 3 vols., Chicago, 1938.

Bergstrom, I. *Dutch Still-Life Painting*, New York, 1956.

Blunt, A. Art and Architecture in France 1500–1700, London, 1982.

Artistic Theory in Italy 1450–1600, Oxford, 1978.

Borsook, E. The Mural Painters of Tuscany, Oxford, 1980.

Briganti, G. (ed.) La Pittura in Italia. Il Cinquecento, 2 vols., Milan, 1988.

Brown, P.F. Venetian Narrative Painting in the Age of Carpaccio, London, 1988.

Burckhardt, J. *The Civilization of the Renaissance in Italy*, trans. S.G.C. Middlemore, London,

Burke, P. The Italian Renaissance. Culture and Society in Italy, London, 1986.

Campbell, L. Van der Weyden, New York, 1980.

———— Renaissance Portraits. European Portrait Painting in the 14th, 15th and 16th Centuries, New Haven, 1990.

Castiglione, B. *The Book of the Courtier*, trans. G. Bull, London, 1967.

Cellini, B. *Autobiography*, ed. J. Pope-Hennessy, London, 1960.

Cennini, C. The Craftsman's Handbook: 'Il Libro dell'Arte', trans. D.V. Thompson, New Haven, 1993.

Chambers, D. *The Imperial Age of Venice* 1380–1580, London, 1970.

Chatelet, A. Early Dutch Painting. Painting in the Northern Netherlands in the Fifteenth Century, trans. C. Brown and A. Turner, Seacaucus N.J., 1980.

Christensen, C.C. Art and the Reformation in Germany, Athens, 1979.

Clarke, K. *Leonardo da Vinci*, rev. ed. Harmondsworth, 1988.

Cole, B. Giotto and Florentine Painting, London, 1969.

———— The Renaissance Artists at Work: from Pisano to Titian, New York, 1983.

Cox-Rearick, J. Dynasty and Destiny. Pontormo, Leo X and the two Cosimos, Princeton, 1984.

Cuttler, C.D. Northern Painting from Pucelle to Bruegel, Fort Worth, 1991.

Davies, M. Rogier van der Weyden, London and New York, 1972. Delaisse, L.M.J. A Century of Dutch Manuscript Illuminations, Berkeley, 1968.

Deusch, W. German Painting of the 16th Century, London, 1936.

Dhanens, E. Hubert and Jan van Eyck, Antwerp, 1980.

Dickens, A.G. *The Counter-Reformation*, London, 1968.

Politics, Patronage and Royalty 1400–1800, London, 1977.

Durrieu, P. La miniature flamande aux temps de la cour de Bourgogne, 2nd ed. Paris and Brussels,

Edgerton, S.Y. *The Renaissance Rediscovery of Linear Perspective*, New York, 1975.

Elton, G.R. Reformation Europe 1517–1559, London, 1963.

Ettlinger, L.D. Antonio and Piero Pollaiuolo, Oxford, 1978.

Fermor, S. Piero di Cosimo, London, 1993.

Fierens, P. and Gevaert, *Histoire de la Peinture Flamande*, Paris, 1927–9.

Freedberg, S.J. Painting of the High Renaissance in Rome and Florence, 2 vols., Cambridge, Mass., 1961.

Friedlander, M.J. From Van Eyck to Bruegel, London, 1956.

Friedlander, M.J. and Rosenberg, J. *The Paintings of Lucas Cranach*, rev. ed. Secaucus, N.J. 1978.

Friedlander, W. Mannerism and Anti-Mannerism in Italian Painting, New York, 1976.

Ganz, P. The Paintings of Hans Holbein, London, 1956.

Geisberg, M. *The German Single-Leaf Woodcut,* 1500–1550, rev. ed. W.L. Strauss, New York, 1974.

Gombrich, E.H. Symbolic Images: Studies in the Art of the Renaissance, London, 1985.

Gombrich, E.H. Norm and Form: Studies in the Art of the Renaissance, London, 1966.

Gould, C. The Paintings of Correggio, London, 1971.

Grossman, F. Bruegel, the Paintings: Complete Edition, London, 3rd ed., 1973.

Gudiol, J. Spanish Painting, Toledo, 1941.

Hale, J. The Civilization of Europe in the Renaissance, London, 1993.

the Renaissance, London, 1981.

Hall, M. Color and Meaning. Practice and Theory in Renaissance Painting, Cambridge, 1992.

Hartt, F. A History of Italian Renaissance Art, London, 1994.

Hauser, A. Mannerism. The Crisis of the Renaissance and the Origin of Modern Art, London, 1965.

Hibbard, H. Michelangelo, London, 1975.

Hind, A.M. Early Italian Engraving, 5 vols., London, 1938–48.

Hirst, M. Sebastiano del Piombo, Oxford, 1981.

Hope, C. Titian, London, 1980.

Huillet d'Istria, M. La peinture française de la fin du moyen age (1480–1530), Paris, 1961.

Joannides, P. Masaccio and Masolino. A Complete Catalogue, London, 1993.

Jones, R. and Penny, N. Raphael, New Haven, 1983.

Kemp, M. Leonardo da Vinci, The Marvellous Works of Nature and Man, London, 1981.

Kristeller, P.O. Renaissance Thought, New York, 1965.

Landau, D. and Parshall, P. *The Renaissance Print*, New Haven and London, 1994.

Lassaigne, J. Spanish Painting I. Geneva, 1952.

Lassaigne, J. and Delevoy, R. Flemish Painting II: From Bosch to Rubens, Geneva, 1958.

Lavalleye, J. Le Palais Ducal d'Urbin, Brussels, 1964.

Leonardo da Vinci, *Treatise on Painting*, trans. A.P. McMahon. 2 vols., Princeton, N.J. 1956.

Linfert, K. Bosch, London, 1989.

van Mander, C. Dutch and Flemish Painters, trans. C. van der Wall, New York, 1936.

Marijnissen, R. and Ruysselare, P. *Hieronymus Bosch. The Complete Works*, trans. T. Alkins et al., Antwerp, 1987.

Meiss, M. Painting in Florence and Siena after the Black Death, New York, 1964.

Mellen, P. Jean Clouet, Complete Edition of the Drawings, Miniatures and Paintings, London and New York, 1971.

McCorquodale, C. Bronzino, London, 1981.

Miegroet, H.J. Gerard David, his Life, his Oeuvre, Antwerp, 1989.

Murray, P. and Murray, L. The Art of the Renaissance, London, 1963.

von der Osten, G. and Vey, H. Painting and Sculpture in Germany and the Netherlands: 1500–1600, Harmondsworth and Baltimore, 1969.

Panofsky, E. Early Netherlandish Painting: its Origins and Character, Cambridge, Mass., 1953.

The Life and Art of Albrecht Dürer, 4th ed. Princeton, N.J. 1955.

Studies in Iconology, Evanston and London, 1962.

Pedretti, C. Leonardo, a Study in Chronology and Style, Berkeley, Ca., 1973.

Pevsner, N. Academies of Art, London, 1940.

Philip, L.B. The Ghent Altarpiece and the Art of Jan van Eyck, Princeton, N.J., 1971.

Pope-Hennessy, J. *The Portrait in the Renaissance*, New York, 1966.

Fra Angelico, 2nd ed., 1974.

Popham, A.E. The Drawings of Leonardo da Vinci, London, 1956.

Post, C.R. History of Spanish Painting, II-XII, Cambridge, Mass., 1930–58.

van Puyvelde, L. La peinture flamande, au siècle des Van Eyck, Paris, 1953.

The Flemish Primitives, Brussels, 1958.

Ragghianti, C. and dalli Regoli, G.G. Firenze, 1470–1480, Disegni dal Modello, Pisa, 1975.

Rosand, D. Painting in Cinquecento Venice: Titian, Veronese, Tintoretto, New Haven, 1986.

Rowlands, J. Holbein. The Paintings of Hans Holbein the Younger, Complete Edition, Oxford, 1985.

Ruda, J. Fra Filippo Lippi. Life and Work with a Complete Catalogue, London, 1993.

Schade, W. Cranach. A Family of Painters, trans. H. Sebba, New York, 1980.

Seznec, J. The Survival of the Pagan Gods, New York, 1953.

Shearman, J. Mannerism, Harmondsworth, 1967.

Silver, L. The Paintings of Quinten Massys with catalogue raisonné, Oxford, 1984.

Smart, A. The Dawn of Italian Painting 1200–1400, Oxford, 1978.

Smith, J.C. (ed.) Nuremberg, a Renaissance City, 1500–1618, Austin, Tx., 1983.

Snyder, J. Northern Renaissance Art, New York, 1985.

Stechow, W. Bruegel, London, 1990.

Steer, J.A. A Concise History of Venetian Painting, London, 1970.

Steinberg, L. Michelangelo's Last Paintings, London 1975.

Strauss, W.L. The Complete Drawings of Albrecht Dürer, 6 vols., New York, 1974.

The Intaglio Prints of Albrecht Dürer: Engravings, etchings and dry-points, 3rd ed., New York, 1981.

Strong, R. The English Renaissance Miniature, London, 1993.

Summers, D. Michelangelo and the Language of Art, Princeton, N.J. 1981.

de Tolnay, C. Le maître de Flemalle et les frères Van Eyck, Brussels, 1939.

Hieronymus Bosch, rev. ed. Baden-Baden, 1966.

Thompson, C. and Campbell, L. Hugo van der Goes and the Trinity Panels in Edinburgh, Edinburgh, 1974.

Vasari, G. *Lives of the Artists*, trans. G. Bull, Harmondsworth, 1987.

Vedman, I. Maarten van Heemskerck and Dutch Humanism in the Sixteenth Century, Maarsen, 1977.

Wasserman, J. Leonardo da Vinci, London, 1987.

Wethey, H. Titian, 3 vols., London, 1969-75.

White, J. The Birth and Rebirth of Pictorial Space, London, 1957.

Art and Architecture in Italy 1250–1400, London, 1966.

Wilde, J. Venetian Art from Bellini to Titian, Oxford, 1974.

Winzinger, F. Albrecht Altdorfer, Die Gemälde, Munich and Zurich, 1975.

Wolfflin, H. Classic Art, Oxford, 1986.

Zeri, F. (ed.) La Pittura in Italia. Il Quattrocento, Milan, 1987.

Picture Acknowledgements

The author and publishers would like to thank the following collectors, galleries and picture archives for permission to reproduce their illustrations:

- I RAPHAEL: Pope Julius II, c.1512 oil on panel 108 × 80 cm The National Gallery, London
- 2 AGNOLO BRONZINO: Duke Cosimo I de' Medici in Armour, c.1545 panel 86 × 67 cm Uffizi, Florence (Scala, Florence)
- 3 JUSTUS VAN UTENS: The Villa Medici at Poggio a Caiano, after 1598 tempera on panel 141 × 237 cm Museo di Firenze com'era (Scala, Florence)
- 4 UNKNOWN TUSCAN PAINTER: The Martyrdom of Savonarola, 1498 tempera on panel 100 × 115 cm Museo di S. Marco, Florence (Scala, Florence)
- 5 LEONARDO DA VINCI: Isabella d'Este, 1500 black chalk, charcoal & pastel 63 × 46 cm Musée du Louvre, Paris (Réunion des musées nationaux, Paris)
- 6 Antonio Pisanello: Lionello d'Este, 1441–4 tempera on panel 28 × 19 cm Galleria dell'Accademia Carrara, Bergamo (Scala, Florence)
- 7 TITIAN: Emperor Charles V at Muhlberg, 1548 Oil on canvas 332 × 279 cm Prado, Madrid (Arxiu Mas, Madrid)
- 8 JEAN FOUQUET: Charles VII, c.1447 panel 86 × 71 cm Musée du Louvre, Paris (Réunion des musées nationaux, Paris)
- 9 Christoph Amberger: Christoph Fugger, 1540 panel 97.5 × 80 cm Alte Pinakothek, Munich (Artothek, Munich)
- IO LUCAS CRANACH: Martin Luther as Junker Jorg, after 1521 woodcut 28.3 × 20.4 cm British Museum, London
- 11 AGNOLO BRONZINO: Eleonora of Toledo, c.1545 oil on panel 115 × 95 cm Uffizi, Florence (Scala, Florence)
- 12 RAPHAEL: Baldassare Castiglione, 1514-15 oil on canvas 82 × 66 cm Musée du Louvre, Paris (Réunion des musées nationaux, Paris)
- 13 SEBASTIANO DEL PIOMBO: Christopher Columbus, 1519
 oil on canvas 106.7 × 88.3 cm
 The Metropolitan Museum of Art, New York, gift of J. Pierpont Morgan, 1900(00.18.2)
- 14 HANS HOLBEIN THE YOUNGER: Erasmus of Rotterdam, 1523 panel 42 × 32 cm Musée du Louvre, Paris (Réunion des musées nationaux, Paris)
- 15 PEDRO BERRUGUETE: Federico da Montefeltro and his Son Guidobaldo, undated oil on canvas 134.5 × 75.5 cm Palazzo Ducale, Urbino (Scala, Florence)
- 16 JEAN CLOUET: Francis I, undated panel 96 × 74 cm Musée du Louvre, Paris (Réunion des musées nationaux, Paris)

- 17 Attributed to Robert Peake: *Eliza Triumphans, c.*1600

 oil on canvas 132 × 190.5 cm

 Private Collection
- 18 HENDRICK GOLTZIUS: Sine Cerere et Libero friget Venus (Without Ceres and Bacchus Venus is A-Chill) 1599–1602
 oil on linen 106.5 × 80 cm
 Philadelphia Museum of Art: Purchased: The Mr. and Mrs. Walter H. Annenberg Fund for Major Acquisitions, The Henry P. McIlhenny fund in memory of Frances P. McIlhenny bequest (by exchange) of Mr. and Mrs. Herbert C. Morris, and gift (by exchange) of Frank and Alice Osborn
- 19 Albrecht Dürer: Self Portrait as a Journeyman, 1491-2 pen and ink on paper 20.4 × 20.8 cm Universitätsbibliothek Erlangen-Nürnberg
- 20 François Clouet: Francis II c.1553 black, red and white chalk on off-white paper 30.9 × 21.5 cm The Harvard University Art Museums. Loan from the Houghton Library (2.1968)
- 21 LEONARDO DA VINCI: The Anatomy of a Shoulder, c.1510 pen and ink with wash over black chalk 28.9 × 19.9 cm Royal Collection © 1994 Her Majesty the Queen
- 22 AGOSTINO VENEZIANO: Baccio Bandinelli's Studio c.1531
 copper plate line engraving 27 × 29.5 cm
 The Courtald Institute Galleries, London, Witt Print Collection
- 23 FOLLOWER OF ANTONELLO DA MESSINA: Five compositional studies, undated pen and brown ink on paper tinted pink 24.5 × 12.3 cm
 British Museum, London
- 24 WORKSHOP OF MASO FINIGUERRA: Seated Youth Drawing, c.1450?
 pen, ink and watercolour on paper 19.2×11.4 cm
 British Museum, London
- 25 CIMA DA CONEGLIANO: Virgin and Child with Saint Andrew and Saint Peter, 1490s panel 55.6 × 47.2 cm The National Gallery of Scotland, Edinburgh
- 26 Andrea del Verrocchio: Head of a Woman, undated black chalk, heightened with white, on paper pricked for transfer 40.8 × 32.7 cm The Governing Body, Christ Church, Oxford
- 27 HANS HOLBEIN THE YOUNGER: Sir Thomas More, his Father and his Household, 1527-8 pen and ink on paper 38.7 × 52.4 cm Kunstmuseum, Basle (Colorphoto Hans Hinz, Allschwil)
- 28 GIOVANNI DA MILANO: Detail from the Rinuccini Chapel, c.1365 fresco Santa Croce, Florence (Scala, Florence)
- 29 LUCA SIGNORELLI: The Damned in Hell, detail, 1499-1504 fresco
 Duomo, Orvieto (Scala, Florence)
- 30 LUCA SIGNORELLI: Three Horsemen, undated black chalk on paper pricked for transfer 34.2 × 27.2 cm British Museum, London

- 31 STYLEOFFRANCESCODIGIORGIO MARTINI: Cassone with Solomon and the Queen of Sheba, c. 1470–80 wood decorated with gilt and gesso H.99 W.190. D.66 cm

 The Trustees of the Victoria & Albert Museum, London
- 32 MICHELANGELO: Head of Cleopatra, c.1533 lead pencil on paper 23.4 × 18.2 cm Uffizi, Florence, Gabinetto dei Disegni e delle Stampe (Scala, Florence)
- 33 JAN VAN EYCK: *Cardinal Niccolò Albergati, c.*1431 silverpoint with white chalk on paper 21.4 × 18 cm Staatliche Kunstsammlungen, Dresden
- 34 JAN VAN EYCK: *Saint Barbara*, 1437 oil on panel 32.2 × 18.6 cm Musée des Beaux-Arts, Antwerp (Giraudon, Paris)
- 35 Albrecht Dürer: View in the Val d'Arco, 1495 watercolour, pen and ink and gouache 22.3 × 22.2 cm

 Musée du Louvre, Paris (Réunion des musées nationaux, Paris)
- 36 PAOLO VERONESE: Battle of Lepanto, 1572-81 oil over grey chalk on paper coloured red, squared in grey chalk 30 × 40.7 cm British Mueum, London
- 37 GIORGIO VASARI: Page from the 'Libro de'
 Disegni', undated
 metalpoint heightened with white bodycolour
 56.2 × 12.3 cm overall
 Private Collection (Christie's Images, London)
- 38 Andrea del Castagno: Sinopia for 'The Resurrection,' detail, c.1445 chalk on paper
 S. Apollonia, Florence (Scala, Florence)
- 39 Andrea del Castagno: The Resurrection, 1445–50 fresco
 S. Apollonia, Florence (Scala, Florence)
- 40 MICHELANGELO: *The Deluge*, 1508 fresco Sistine Chapel, The Vatican (Scala, Florence)
- 41 LEONARDO DA VINCI: Last Supper, 1495-7 oil on plaster S. Maria delle Grazie, Milan (Scala, Florence)
- 42 ROGIER VAN DER WEYDEN: The Saint Columba Altarpiece, c. 1435 middle panel 138 × 153 cm Bayerische Staatsgemaldesammlungen, Alte Pinakothek, Munich
- 43 Albrecht Dürer: *Knight, Death and the Devil*, 1513-14 copperplate engraving 24.4 × 18.9 cm British Museum, London
- PIETRO CAVALLINI: Angels, before 1308 fresco
 S. Cecilia in Trastevere, Rome (Scala, Florence)
- 45 Giotto: The Stigmatization of St. Francis, c.1325 fresco
 Bardi Chapel, S. Croce, Florence (Scala, Florence)
- 46 CIMABUE: Crucifixion (before flood damage), undated panel 448 × 390 cm S. Croce, Florence (Scala, Florence)
- 47 GIOTTO: Enrico Scrovegni Offering his Chapel to the Virgin, 1306 fresco
 Arena Chapel, Padua (Scala, Florence)

- 48 General view of the upper church, c.1290-1307 S. Francesco, Assisi (Scala, Florence)
- 49 Giotto: The Stefaneschi Altarpiece, c.1300? tempera on panel front 220 × 245 cm Pinacoteca, The Vatican (Scala, Florence)
- 50 TADDEO GADDI: The Life of the Virgin, 1332-8 fresco Baroncelli Chapel, S. Croce, Florence (Scala, Florence)
- 51 Duccio: *The Rucellai Madonna, c.* 1285 panel 450 × 290 cm Uffizi, Florence (Scala, Florence)
- 52 Duccio: Christ's Entry into Jerusalem (detail of the Maestà) 1308-11 panel 102 × 53.5 cm Museo dell'Opera Metropolitana, Siena (Scala, Florence)
- 53 SIMONE MARTINI: *The Apotheosis of Virgil*, 1340 vellum 29.5 × 20 cm Pinacoteca Ambrosiana, Milan (Scala, Florence)
- 54 Ambrogio Lorenzetti: Allegories of Good and Bad Government, 1338-9 fresco Sala della Pace, Palazzo Pubblico, Siena (Scala, Florence)
- 55 AMBROGIO LORENZETTI: Presentation in the Temple, 1342 panel 257 × 168 cm Uffizi, Florence (The Bridgeman Art Library, London)
- 56 Giotto: Interior of the Arena Chapel, Padua, 1303-6 fresco (Scala, Florence)
- 57 Giotto: *The Ognissanti Madonna, c.*1305-10 panel 325 × 204 cm Uffizi, Florence (Scala, Florence)
- 58 CIMABUE: Santa Trinità Madonna, early 1280s panel 353 × 223.5 cm Uffizi, Florence (Scala, Florence)
- 59 Duccio: Madonna and Child with Saints and Angels, 1308-11 front panel 213.5 × 396 cm Museo dell'Opera Metropolitana, Siena (Scala, Florence)
- 60 BERNARDO DADDI: *Madonna and Child*, 1346-7 panel 250 × 180 cm Orsanmichele, Florence (Scala, Florence)
- 61 SIMONE MARTINI: *Maestà*, 1317 fresco Palazzo Pubblico, Siena (Scala, Florence)
- 62 PIETRO LORENZETTI: Birth of the Virgin, 1342 panel 186.5 × 181.5 cm Museo dell'Opera Metropolitana, Siena (Scala, Florence)
- 63 MASTER OF THE TRIUMPH OF DEATH: Music-making in a Garden, pre-1348 fresco
 Camposanto, Pisa (Scala, Florence)
- 64 Ambrogio Lorenzetti: The Effects of Good Government in the City, 1338-9 fresco Palazzo Pubblico, Siena (The Bridgeman Art Library, London)
- 65 ALTICHIERO: The Crucifixion, c.1379 frescoS. Antonio, Padua (Scala, Florence)
- 66 Andrea Bonaiuti: Triumph of the Church, 1365-7 fresco Spanish Chapel, S. Maria Novella, Florence (Scala, Florence)

- 67 PAOLO VENEZIANO: St. Mark's Body Carried to Venice, undated panel 58 × 42 cm
 Museo S. Marco, Venice (Scala, Florence)
- 68 PINTURICCHIO: Scenes from the Life of Pio II, detail of Aeneas Silvius Piccolomini, 1502-9 fresco Piccolomini Library, Duomo, Siena (Scala, Florence)
- 69 GENTILE DA FABRIANO: Adoration of the Magi, 1423
 panel 300 × 282 cm
 Uffizi, Florence (Scala, Florence)
- 70 MASACCIO, MASOLINO AND FILIPPINO LIPPI: The Brancacci Chapel general view, 1425–7 and 1481–83 fresco Church of the Carmine, Florence (Scala, Florence)
- 71 MASOLINO DA PANICALE: Feast of Herod, 1435 fresco
 Baptistry, Castiglione Olona (Scala, Florence)
- 72 Fra Angelico: *The San Marco Altarpiece*, 1438-40 panel 220 × 227 cm Museo di S. Marco, Florence (Scala, Florence)
- 73 FILIPPINO LIPPO: The Virgin Appearing to Saint Bernardo, c. 1482–6 panel 208.5 × 195.5 cm Badia, Florence (Scala, Florence)
- 74 PAOLO UCCELLO: The Flood and the Recession of the Waters, 1446-8 fresco S. Maria Novella, Florence (The Bridgeman Art Library, London)
- 75 PAOLO UCCELLO: Cenotaph to Sir John Hawkwood, 1436 fresco transferred to canvas 820 × 515 cm Duomo, Florence (Scala, Florence)
- 76 Andrea del Castagno: Last Supper, 1447-50 fresco
 S. Apollonia, Florence (Scala, Florence)
- 77 ANTONIO DEL POLLAIUOLO: Battle of the Ten Nudes, after 1483? engraving 40.4 × 59 cm British Museum, London
- 78 SANDRO BOTTICELLI: Adoration of the Magi, c. 1475
 panel 111 × 134 cm
 Uffizi, Florence (Scala, Florence)
- 79 SANDRO BOTTICELLI: Lamentation of Christ, after 1490 tempera on panel 140 × 207 cm Alte Pinakothek, Munich (Artothek, Munich)
- 80 VITTORE CARPACCIO: The Arrival of the Ambassadors, 1490-4
 oil on canvas 275 × 589 cm
 Accademia, Venice (Scala, Florence)
- 81 PIERO DI COSIMO: Cleopatra (so-called Simonetta Vespucci)
 c. 1485-90
 panel 57 × 42 cm
 Musée Condé, Chantilly (Giraudon, Paris)
- 82 LEONARDO DA VINCI: Adoration of the Magi, 1481-2 panel 244 × 246 cm Uffizi, Florence (The Bridgeman Art Library, London)
- 83 Andrea del Verrocchio: Baptism of Christ, 1472-5 panel 176.5 × 151 cm Uffizi, Florence (Scala, Florence)

- 84 BARTOLOMMEO DELLA GATTA: Stigmatization of Saint Francis, 1486
 panel 186 × 172 cm
 Pinacoteca, Castelfiorentino (Electa, Milan)
- 85 CIRCLE OF PIERO DELLA FRANCESCA: View of an Ideal City, c. 1470 panel 60 × 200 cm Palazzo Ducale, Urbino (Scala, Florence)
- 86 PIERO DELLA FRANCESCA: Dream of Constantine, 1455 fresco S. Francesco, Arezzo (Scala, Florence)
- 87 Andrea Mantegna: Pallas Expelling the Vices from the Garden of Virtue, c. 1499-1500 oil on canvas 160 × 192 cm Musée du Louvre, Paris (Giraudon/Bridgeman Art Library, London)
- 88 Andrea Mantegna: *Man of Sorrows with Two Angels, ε.* 1500 oil on canvas 70 × 49.5 cm Statens Museum for Kunst, Copenhagen
- 89 Antonello da Messina: *Virgin Annunciate*, 1474 panel 45 × 34 cm Galleria Nazionale della Sicilia, Palermo (Scala, Florence)
- 90 GIOVANNI BELLINI: *The San Giobbe Altarpiece*, before 1490 panel 471 × 258 cm Accademia, Venice (Scala, Florence)
- 91 Cosmè Tura: Virgin and Child Enthroned, c. 1480 panel 239 × 101 cm The National Gallery, London
- 92 ANTONIO PISANELLO: Saint George and the Princess, 1437–8 fresco S. Anastasia, Verona (Scala, Florence)
- 93 MASACCIO: Trinity, 1425-8 frescoS. Maria Novella, Florence (Scala, Florence)
- 94 Fra Angelico: Saint Dominic Adoring the Crucifix, after 1442 fresco Museo di S. Marco, Florence (Scala, Florence)
- 95 Fra Angelico: Annunciation, c. 1450 fresco Museo di S. Marco, Florence (Scala, Florence)
- 96 LUCA SIGNORELLI: Calling of the Elect, 1500-4 fresco
 Duomo, Orvieto (Scala, Florence)
- 97 FILIPPO LIPPI: Dance of Salomé (Herod's Feast), 1452-66 fresco Duomo, Prato (Scala, Florence)
- 98 DOMENICO GHIRLANDAIO: The Birth of Saint John the Baptist, 1485 -90 fresco
 S. Maria Novella, Florence (Scala, Florence)
- 99 PIERO DELLA FRANCESCA: The Brera Altarpiece, 1472-4 tempera on panel 248 × 170 cm Pinacoteca di Brera, Milan (Scala, Florence)
- PIERO DELLA FRANCESCA: Flagellation of Christ,
 1455
 tempera on panel 59 × 81.5 cm
 Palazzo Ducale, Urbino (Scala, Florence)
- 101 &102 PIERO DELLA FRANCESCA: Federico II da Montefeltro and Battista Sforza, 1465 tempera on panel each 47 × 33 cm Uffizi, Florence (Scala, Florence)

- 103 DOMENICO GHIRLANDAIO: An Old Man with a Young Boy, c. 1480 panel 63 × 46 cm Musée du Louvre, Paris (The Bridgeman Art Library, London)
- 104 Andrea Mantegna: The Ceiling Oculus of the Camera degli Sposi, 1465-73 fresco Palazzo Ducale, Mantua (Scala, Florence)
- 105 Andrea Mantegna: The Gonzaga Court, 1465-74 fresco Palazzo Ducale, Mantua (Scala, Florence)
- 106 GIOVANNI BELLINI: Doge Leonardo Loredan, c. 1501 panel 61.6 × 45.1 cm The National Gallery, London
- 107 GIOVANNI BELLINI: Giovanni Emo, c.1475-80 tempera and oil on panel 48.9 × 32.2 cm National Gallery of Art, Washington D.C., Samuel H. Kress Collection (1939.1.224)
- 108 Antonello da Messina: Saint Jerome in his Study, 1474
 panel 45.7 × 36.2 cm
 The National Gallery, London
- 109 VITTORE CARPACCIO: Hunting on the Lagoon, c. 1490-6
 oil on panel 75.4 × 63.8 cm
 Collection of the J. Paul Getty Museum,
 Malibu, California
- VITTORE CARPACCIO: Two Women seated on a Balcony, c. 1490–6
 oil on panel 94 × 64 cm
 Civico Museo Correr, Venice (The Bridgeman Art Library, London)
- 111 VITTORE CARPACCIO: Young Knight in a Landscape, 1510 oil on canvas 218.5 × 151.5 cm Museo Thyssen Bornemisza, Madrid
- 112 PIERO DI COSIMO: The Building of a Palace, c.
 1515-20
 oil on panel 82.6 × 196.9 cm
 The John and Mable Ringling Museum of Art,
 Sarasota
- 113 PIETRO PERUGINO: Christ Handing the Keys to Saint Peter, 1482 fresco Sistine Chapel, The Vatican (Scala, Florence)
- 114 Benozzo Gozzoli: Journey of the Magi, 1459 fresco Palazzo Medici Riccardi, Florence (Scala, Florence)
- 115 SANDRO BOTTICELLI: Primavera, c.1478 panel 203 × 315 cm Uffizi, Florence (Scala, Florence)
- 116 SANDRO BOTTICELLI: Birth of Venus, 1484–6 oil on canvas 175 × 279.5 cm Uffizi, Florence (The Bridgeman Art Library, London)
- SANDRO BOTTICELLI: Minerva and the Centaur,
 c. 1480
 oil on canvas 207 × 148 cm
 Uffizi, Florence (The Bridgeman Art Library, London)
- 118 LEONARDO DA VINCI: A Lady with an Ermine, 1485-90 tempera on panel 55 × 40.4 cm Czartorysky Museum, Cracow (Scala, Florence)
- 119 LORENZO COSTA: A Concert, 1487-1500 panel 95.3 × 75.6 cm
 The National Gallery, London

- 120 MELOZZO DA FORLÌ: Musical Angel, 1478-80 fresco
 Pinacoteca, The Vatican (Scala, Florence)
- 121 GENTILE BELLINI: A Procession in Piazza San Marco, 1496
 oil on canvas 367 × 745 cm
 Accademia, Venice (Scala, Florence)
- 122 CARLO CRIVELLI: The Annunciation with Saint Emidius, 1486 panel transferred to canvas 207 × 146.7 cm The National Gallery, London
- 123 JAN VAN EYCK: *Man in a Turban*, 1433 panel 25.7 × 19 cm
 The National Gallery, London
- 124 THE MASTER OF FLÉMALLE: Saint Veronica, c.1430-34 panel 151.5 × 61 cm Stadelsches Kunstinstitut, Frankfurt (Artothek, Munich)
- 125 JAN VAN EYCK: The Madonna in the Church, c.1425 panel 31 × 14 cm Staatliche Gemäldegalerie, Berlin (Artothek, Munich)
- 126 JAN VAN EYCK: Madonna and Child with Canon van der Paele, 1434-6 oil on panel 141 × 176.5 cm Groeningemuseum, Bruges (The Bridgeman Art Library, London)
- 127 PETRUS CHRISTUS: Portrait of a Young Woman,
 c. 1460-73
 panel 29 × 22.5 cm
 Gemäldegalerie Staatliche Museen Preussischer Kulturbesitz, Berlin (Jorg P. Anders, Berlin)
- 128 Rogier van der Weyden: Portrait of a Lady, c. 1450-60 panel $36.2 \times 27.6 \text{ cm}$ The National Gallery, London
- 129 ROGIER VAN DER WEYDEN: Last Judgement Altarpiece, c. 1444-8 panel 215 × 110 cm Hôtel-Dieu, Beaune (Giraudon, Paris)
- 130 DIERIC BOUTS: Deposition Altarpiece, c.1450-55 oil on panel central panel 191 x 145 cm Capilla Real, Granada (Arxiu Mas, Madrid)
- 131 HUGO VAN DER GOES: Adam and Eve (The Fall of Man), c. 1468-70
 panel 33.8 × 23 cm
 Kunsthistorisches Museum, Vienna
- 132 GEERTGEN TOT SINT JANS: The Baptist in the Wildemess, c. 1490-95 panel 42 × 28 cm National Galerie, Berlin (Artothek, Munich)
- 133 HUGO VAN DER GOES: The Trinity Altarpiece, King James III, c.1478-9 panel 78 × 38 cm The Royal Collection © 1994 Her Majesty the Queen. On loan to the National Gallery of Scotland, Edinburgh
- 134 HUGO VAN DER GOES: The Trinity Altarpiece, Queen Margaret, c. 1478-9 panel 78 × 38 cm The Royal Collection © 1994 Her Majesty the Queen. On loan to the National Gallery of Scotland, Edinburgh
- 135 HANS MEMLINC: Saint Christopher Altarpiece, 1484 panel 123 × 156 cm Groeningemuseum, Bruges (The Bridgeman Art Library, London)

- 136 GERARD DAVID: Christ Nailed to the Cross, c. 1480-85 panel 48.3 × 94 cm The National Gallery, London
- 137 HIERONYMUS BOSCH: Christ Carrying the Cross, c.1501-2
 oil on panel 74 × 81 cm
 Museum voor Schone Kunsten, Ghent (Scala, Florence)
- 138 HIERONYMUS BOSCH: Garden of Earthly Delights, c.1505-10 panel 220 × 389 cm Prado, Madrid (Arxiu Mas, Madrid)
- 139 MARTIN SCHONGAUER: Christ Carrying the Cross, c. 1480 engraving 28.4 × 43.4 cm Christie's, New York
- 140 ROGIER VAN DER WEYDEN: Annunciation, c.1433 panel 86 × 93 cm Musée du Louvre, Paris (Réunion des musées nationaux, Paris)
- 141 ROGIER VAN DER WEYDEN: Deposition, c.1438 panel 220 × 262 cm Prado, Madrid (Arxiu Mas, Madrid)
- 142 JAN VAN EYCK: Madonna of the Chancellor Nicolas Rolin, c. 1434 central panel 66 × 62 cm Musée du Louvre, Paris (Giraudon-Bridgeman Art Library, London)
- 143 ROGIER VAN DER WEYDEN: Saint Luke Drawing the Virgin, c.1435-7
 oil on tempera on panel 137.5 × 110.8 cm
 Museum of Fine Arts, Boston. Gift of Mr. and
 Mrs. Henry Lee Higginson
- 144 JAN VAN EYCK: The Marriage of Giovanni Arnolfini and Giovanna Cenami, 1434 panel 81.8 × 59.7 cm The National Gallery, London
- 145 PETRUS CHRISTUS: Saint Eligius and the Lovers, 1449
 oil on panel 99 × 85 cm
 The Metropolitan Museum of Art, New York,
 Robert Lehman Collection 1975 (1975.1.10)
- 146 HIERONYMUS BOSCH: *Haywain*, 1495-1500 oil on panel 135 × 200 cm Prado, Madrid (Arxiu Mas)
- 147 HIERONYMUS BOSCH: Death and the Miser,
 c. 1485-90
 oil on panel 93 × 31 cm
 National Gallery of Art, Washington D.C.
 Samuel H. Kress Collection
- 148 DIERIC BOUTS: Last Supper Altarpiece, 1464-7 central panel 180 × 151 cm St. Peter's, Louvain (The Bridgeman Art Library, London)
- 149 JAN VAN EYCK: The Ghent Altarpiece, completed
 1432
 exterior panels 375 × 260 cm interior panels 365
 × 520 cm
 St. Bavo Cathedral Ghent (Giraudon, Paris)
- 150 The Master of Flémalle: Triptych of the Annunciation (The Mérode Altarpiece), c. 1426 oil on panel central panel 64.1 × 63.2 cm The Metropolitan Museum of Art, New York. The Cloisters Collection 1956 (56.70)
- 151 Hugo van der Goes: *The Portinari Altarpiece*, 1474-6 central panel 253 × 304 cm Uffizi, Florence (Scala, Florence)
- 152 GERARD DAVID: Annunciation, undated panel 40 × 32 cm Stadelsches Kunstinstitut, Frankfurt (The Bridgeman Art Library, London)

- 153 Hans Memlinc: Portrait of a Man with a Medal, c. 1475-80 parchment 29 × 22 cm Musées Royaux des Beaux-Arts, Antwerp (Scala, Florence)
- 154 Hans Memlinc: *Bathsheba*, 1484 panel 191.5 × 84.6 cm Staatsgalerie, Stuttgart
- 155 Konrad Witz: Miraculous Draft of Fishes, 1444 panel 132 × 154 cm Musée d'Art et d'Histoire, Geneva (Colorphoto Hans Hinz, Allschwil)
- 156 STEPHAN LOCHNER: Madonna of the Rose Bower, c. 1450 panel 50.5 × 40 cm Wallraf-Richarts Museum, Cologne (Colorphoto Hans Hinz, Allschwil) (Also on page 6)
- 157 The Master of Moulins: Annunciation, c. 1510 oil on panel 72 × 50.2 cm
 The Art Institute of Chicago, Mr. and Mrs.
 Martin A. Ryerson Collection, 1933.1062
 photograph © 1994
- 158 LIMBOURG BROTHERS: Month of February from the Très Riches Heures du Duc de Berry, begun c. 1413 parchment 29 × 21 cm Musée Condé, Chantilly (Giraudon, Paris)
- 159 Jean Fouquer: Fall of Jericho, from the Antiquités Judaïques, 1470-6
 vellum 19.2 x 16.5 cm
 Bibliothèque Nationale, Paris (Giraudon, Paris)
- 160 Francesco Primaticcio: Ulysses Shooting through the Rings, c. 1555-9
 red chalk and white heightening on pink prepared paper 24.5 × 32.4 cm
 Walker Art Gallery, Liverpool
- 161 Rosso Florentino: Venus, 1534-40 fresco Galerie François I, Fontainebleau (Réunion des musees nationaux, Paris)
- 162 Jean Clouet: Guillaume Budé, c. 1535 tempera and oil on panel 39.7 × 34.3 cm The Metropolitan Museum of Art, New York. Maria DeWitt Jesup Fund, 1946 (46.68)
- 163 FRANCOIS CLOUET: Pierre Quthe, 1562 panel 91 × 70 cm Musée du Louvre, Paris (Réunion des musées nationaux, Paris)
- 164 CORNEILLE DE LYON: Clement Marot, undated panel 12 × 10 cm Musée du Louvre, Paris (Réunion des musées nationaux, Paris)
- 165 ROWLAND LOCKEY: Sir Thomas More, his Household and Descendants, c. 1595-1600 vellum on panel 24.6 x 29.4 cm The Trustees of the Victoria & Albert Museum, London
- 166 HANS HOLBEIN THE YOUNGER: Simon George of Comwall, 1535 panel diameter 31 cm Städelsches Kunstinstitut, Frankfurt (Artothek, Munich)
- 167 HANS HOLBEIN THE YOUNGER: John More the Younger, c.1527-8 black and coloured chalks on unprimed paper 38.1 × 28.1 cm The Royal Collection © 1994 Her Majesty the Queen
- 168 SIMON BENNICK: Self Portrait aged 75, 1558 vellum 8.1 × 5.3 cm
 The Trustees of the Victoria & Albert Museum, London (The Bridgeman Art Library, London)

- 169 NICHOLAS HILLIARD: Man Clasping A Hand from a Cloud, 1588 vellum 6 × 5 cm The Trustees of the Victoria & Albert Museum, London (The Bridgeman Art Library, London)
- NICHOLAS HILLIARD: Young Man Leaning against a Tree, 1588
 watercolour 13.5 × 7.3 cm
 The Trustees of the Victoria & Albert Museum, London (The Bridgeman Art Library, London)
- 171 NICHOLAS HILLIARD AND ASSISTANTS: *The Mildmay Charter*, detail, 1584 parchment charter 79 × 56 cm detail 21.5 × 18 cm Emmanuel College, Cambridge
- 172 BARTOLOMÉ BERMEJO: Saint Michael and the Dragon, 1468 oil on panel 188 × 81 cm Werner Collection, Luton Hoo, Bedfordshire (The Bridgeman Art Library, London)
- 173 PEDRO BERRUGUETE: King David, after 1483 panel 94 × 65 cm
 S. Eulalia, Paredes de Nava, Palencia (Arxiu Mas, Madrid)
- 174 ATTRIBUTED TO SANCHEZ COELLO: View of Seville, undated oil on canvas 210 × 163 cm Museo de America, Madrid (Arxiu Mas, Madrid)
- 175 The Master of Moulins: Young Princess, c. 1498
 tempera on panel 34.3 × 24 cm
 The Metropolitan Museum of Art, New York,
 Robert Lehman Collection, 1975 (1975.1.130)
- 176 JEAN FOUQUET: *The Court Jester Gonella, c.* 1445 panel 36 × 24 cm Kunsthistorisches Museum, Vienna
- 177 JEAN FOUQUET: Etienne Chevalier with Saint Stephen, 1477 panel 93 × 85 cm Staatliche Museen zu Berlin, Preussischer Kulturbesitz Gemäldegalerie (Foto Jorg P. Anders, Berlin)
- 178 ATTRIBUTED TO NICCOLO DELL'ABATE: *The Story of Aristaeus*, *c.* 1558–59 oil on canvas 189.2 × 237.5 cm The National Gallery, London
- 179 JEAN COUSIN THE ELDER: Eva Prima Pandora, undated panel 98 × 150 cm
 Musée du Louvre, Paris (Réunion des musées nationaux, Paris)
- 180 Hans Holbein the Younger: The Ambassadors,
 1533
 panel 207 × 209.5 cm
 The National Gallery, London
- 181 Francois Clouet: A Lady in her Bath, c. 1571 oil on panel 93.1 × 81.3 cm National Gallery of Art, Washington D.C. Samuel H. Kress Collection
- 182 THE MASTER OF ST. ILDEFONSO: Investiture of Saint Ildefonso, c. 1475-80 panel 230 × 167 cm Musée du Louvre, Paris (Réunion des musées nationaux, Paris)
- 183 Luis de Morales: Virgin and Child, late 1560s panel 28.5 \times 20.4 cm The National Gallery, London
- 184 ALONSO SANCHEZ COELLO: The Infanta Clara Eugenia, 1579 oil on canvas 116 × 102 cm Prado, Madrid (Arxiu Mas, Madrid)

- 185 ENGUERRAND QUARTON: The Pieta of Villeneuveles-Avignons, c. 1460 panel 163 × 218 cm Musée du Louvre, Paris (Réunion des musées nationaux, Paris)
- 186 French School (?): Wilton Diptych, c. 1395 or later
 each panel 45.7 × 29.2 cm
 The National Gallery, London
- SCHOOL OF FONTAINEBLEAU: Gabrielle d'Estrées and one of her Sisters, c. 1591
 panel 96 × 125 cm
 Musée du Louvre, Paris (Réunion des musées nationaux, Paris)
- 188 NICCOLO DELL'ABATE: Eros and Psyche, undated oil on canvas 100 × 93 cm
 The Detroit Institute of Arts: Founders Society Purchase, Robert H. Tannahill Foundation Fund
- 189 BARTHOLOMAUS SPRANGER: Triumph of Wisdom, c. 1591 oil on canvas 163 × 117 cm Kunsthistorisches Museum, Vienna
- 190 GIORGIONE: The Tempest, 1505-10
 oil on canvas 82 × 73 cm
 Accademia, Venice (The Bridgeman Art Library, London)
- 191 LEONARDO DA VINCI: Virgin of the Rocks, 1483-6
 oil on canvas 199 x 122 cm
 Musée du Louvre, Paris (Réunion des musées nationaux, Paris)
- 192 Cesare da Sesto: *Leda and the Swan*, after 1515 oil on panel 96.5 × 73.5 cm Wilton House, Wiltshire (The Bridgeman Art Library, London)
- 193 LEONARDO DA VINCI: Saint John the Baptist, 1513-16 panel 69 × 57 cm Musée du Louvre, Paris (Réunion des musées nationaux, Paris)
- 194 LEONARDO DA VINCI: *Mona Lisa*, 1503-5 panel 77 × 53 cm Musée du Louvre, Paris (Réunion des musées nationaux, Paris)
- 195 RAPHAEL: Vatican Loggie, detail of the mural grotesques, 1518–19 fresco
 Raphael Loggia, The Vatican (Scala, Florence)
- 196 RAPHAEL: School of Athens, 1509–10 fresco Stanza della Segnatura, The Vatican
- 197 RAPHAEL: Self Portrait with a Friend, c. 1518 oil on canvas 99 × 83 cm

 Musée du Louvre, Paris (Réunion des musées nationaux, Paris)
- 198 RIDOLFO GHIRLANDAIO: A Man of the Capponi Family, undated oil on canvas 80 × 60.5 cm Museo Thyssen-Bornemisza, Madrid
- Andrea del Sarto: A Lady with Petrarch's Sonnets, 1528-9
 panel 87 × 69 cm
 Uffizi, Florence (The Bridgeman Art Library, London)
- 200 GIORGIONE: The Three Philosophers, c. 1510 oil on canvas 123.8 × 144.5 cm Kunsthistorisches Museum, Vienna
- 201 GIORGIONE: An Old Woman, 1508–10 oil on canvas 68 × 59 cm Accademia, Venice (Scala, Florence)

- 202 JACOPO DE'BARBARI: Still Life, 1504 panel 52 × 42.5 cm Alte Pinakothek, Munich (Artothek, Munich)
- 203 PALMA VECCHIO: Venus and Cupid, 1522-4 oil on canvas 118.1 × 208.9 cm Fitzwilliam Museum, Cambridge
- 204 CORREGGIO: Nativity, 1529-30 panel 256.5 × 188 cm Gemäldegalerie, Dresden (The Bridgeman Art Library, London)
- 205 RAPHAEL: Christ's Charge to Saint Peter, 1515–16 gouache on paper 343 × 532 cm
 The Trustees of the Victoria & Albert Museum, London (The Bridgeman Art Library, London)
- 206 Fra Bartolommeo: Carandolet Altarpiece, c. 1511 panel 260 × 230 cm Besançon Cathedral, (Giraudon, Paris)
- 207 GIOVANNI ANTONIO BOLTRAFFIO: Virgin and Child, late 1490s
 panel 83 × 63.5 cm
 Museum of Art, Budapest (Artothek, Munich)
- 208 LEONARDO DA VINCI: Virgin with Child with Saint Anne and Saint John the Baptist, late 1490s black chalk heightened with white on paper 141.5 × 104.6 cm The National Gallery, London
- 209 Aristotile da Sangallo after Michelangelo: Battle of Cascina, c. 1542 grisaille on paper 76 × 132 cm Holkham Hall, Norfolk (The Bridgeman Art Library, London)
- 210 MICHELANGELO: Holy Family with Saint John the Baptist (Doni Tondo), 1504 panel 120 cm diameter Uffizi, Florence (Scala, Florence)
- 211 RAPHAEL: Madonna Alba, 1511
 oil on panel transferred to canvas 94.5 cm diameter
 National Gallery of Art, Washington D.C.,
 Andrew W. Mellon Collection
- 212 GIOVANNI BELLINI: *Madonna in the Meadow,* c. 1505
 oil on panel transferred to canvas 67.3 × 86.4 cm
 The National Gallery, London
- 213 Andrea del Sarto: Holy Family with the Youthful Saint John, c.1530 oil on panel 135.9 × 100.6 cm The Metropolitan Museum of Art, New York, Maria DeWitt Jesup Fund, 1922 (22.75)
- 214 RAPHAEL: Triumph of Galatea, 1511 fresco
 Palazzo della Farnesina, Rome (Scala, Florence)
- 215 GIOVANNI BELLINI: *Lady at her Toilet*, 1515 panel 62 × 79 cm Kunsthistorisches Museum, Vienna
- 216 SEBASTIANO DEL PIOMBO: Death of Adonis, c. 1512 oil on canvas 189 × 295 cm Uffizi, Florence (Scala, Florence)
- 217 MICHELANGELO: Lybian Sybil, 1511 fresco Sistine Chapel, The Vatican (Scala, Florence)
- 218 MICHELANGELO: Sistine Chapel Ceiling, 1508-12 (since cleaning) fresco
 Sistine Chapel, The Vatican (© Nippon Television Network Corporation Tokyo 1991)
- 219 TITIAN: Sacred and Profane Love, c. 1514 oil on canvas 120 × 280 cm Galleria Borghese, Rome (Scala, Rome)

- 220 GIORGIONE: Sleeping Venus, c. 1510 oil on canvas 108.5 × 175 cm Gemäldegalerie, Dresden (Artothek, Munich)
- 221 TITIAN: The Three Ages of Man, 1516 oil on canvas 90 × 150.7 cm Duke of Sutherland Collection, on loan to the National Gallery of Scotland, Edinburgh
- 222 CORREGGIO: Assumption of the Virgin, 1526-8 fresco
 Duomo, Parma (Scala, Florence)
- 223 CORREGGIO: Martrydom of Four Saints, 1524-6 oil on canvas 158.5 × 184.3 cm Galleria Nazionale, Parma (Scala, Florence)
- 224 CORREGGIO: *Io*, 1531 oil on canvas 162 × 73.5 cm Kunsthistorisches Museum, Vienna
- 225 MORETTO DA BRESCIA: Count Sciarra Martinengo Cesaresco, c. 1545-50 oil on canvas 113.7 × 94 cm The National Gallery, London
- 226 GIAN GIROLAMO SAVOLDO: Saint Mary Magdalene Approaching the Sepulchre, c. 1528-30 oil on canvas 86.4 × 79.4 cm The National Gallery, London
- 227 SODOMA: Marriage of Alexander with Roxana, 1516-17 fresco Palazzo della Farnesina, Rome (Scala, Florence)
- 228 AGNOLO BRONZINO: Allegory of Venus, Folly and Time, c. 1545
 panel 146.1 × 116.2 cm
 The National Gallery, London
- 229 MICHELANGELO: Last Judgement, 1535-41 fresco Sistine Chapel, The Vatican (Scala, Florence)
- 230 MICHELANGELO: Conversion of Saint Paul, 1542-5 fresco
 Pauline Chapel, The Vatican (Scala, Florence)
- 231 JACOPO PONTORMO: Pietà, c. 1526-8 panel 313 × 192 cm S. Felicità, Florence (Scala, Florence)
- 232 PARMIGIANINO: Madonna of the Long Neck, c. 1535 panel 216 × 132 cm Uffizi, Florence (Scala, Florence)
- 233 PERINO DEL VAGA: Martyrdom of the Ten
 Thousand, 1522-3
 pen and brown ink heightened with white and
 watercolour on paper 36.4 × 33.9 cm
 Albertina, Vienna
- 234 ROSSO FIORENTINO: Dead Christ supported by Angels, c.1525-6 oil on paper 135.5 104.1 cm Museum of Fine Arts, Boston, Charles Potter Kling Fund
- 235 AGNOLO BRONZINO: Deposition, 1545 oil on panel 268 × 173 cm Musée des Beaux Arts, Besançon (Scala, Florence)
- 236 TITIAN: Bacchanal of the Andrians, completed 1522 oil on canvas 175 × 193 cm Prado, Madrid (The Bridgeman Art Library, London)
- 237 TITIAN: Diana and Callisto, 1556-9 oil on canvas 187 × 204.5 cm Duke of Sutherland Collection, on loan to the National Gallery of Scotland, Edinburgh

- 238 TITIAN: Diana and Actaeon, 1556-9 oil on canvas 184.5 × 202.2 cm Duke of Sutherland Collection, on loan to the National Gallery of Scotland, Edinburgh
- 239 JACOPO TINTORETTO: Miracle of Saint Mark, 1548 oil on canvas 415 × 541 cm Accademia, Venice (Scala, Florence)
- PAOLO VERONESE: Interior View of the Villa Barbaro, Maser, 1561
 Fresco
 Villa Barbaro, Maser (Scala, Florence)
- 241 PAOLO VERONESE: Triumph of Venice, 1583 oil on canvas 904 × 580 cm Palazzo Ducale, Venice (Scala, Florence)
- 242 JACOPO BASSANO: Adoration of the Magi, early 1540s oil on canvas 183 × 235 cm The National Gallery of Scotland, Edinburgh
- 243 NICCOLÒ DELL'ABATE: A Concert, 1548-52 fresco
 Palazzo Poggi, Bologna (Scala, Florence)
- 244 PELLEGRINO TIBALDI: Adoration of the Shepherds, 1548-9 oil on canvas 157 × 105 cm Galleria Borghese, Rome (Scala, Florence)
- 245 PARMIGIANINO: A Lady 'The Turkish Slave', c. 1522
 panel 67 × 53 cm
 Galleria Nazionale, Parma (Scala, Florence)
- 246 LORENZO LOTTO: Andrea Odoni, 1527 oil on canvas 104 × 101 cm The Royal Collection © 1994 Her Majesty the Queen
- 247 LORENZO LOTTO: Brother Gregorio Belo of Vicenza, 1547
 oil on canvas 87.3 × 71.1 cm
 The Metropolitan Museum of Art, New York, Rogers Fund 1965 (65.117)
- 248 RAPHAEL: *Transfiguration*, 1518–20 oil on panel 405 × 278 cm
 Pinacoteca, The Vatican (Scala, Florence)
- 249 JACOPO PONTORMO: Joseph in Egypt, 1517-18 panel 96 × 109 cm The National Gallery, London
- 250 RAPHAEL: The Road to Calvary (Lo Spasimo di Sicilia), c. 1517 oil on canvas 318 × 229 cm Prado, Madrid (Arxiu Mas, Madrid)
- 251 Rosso Fiorentino: *A Young Man, c.* 1528 panel 120 × 86 cm Museo di Capodimonte, Naples (Scala, Florence)
- 252 AGNOLO BRONZINO: Giovanni de'Medici as a Baby, 1545 panel 58 × 45 cm Uffizi, Florence (Scala, Florence)
- 253 AGNOLO BRONZINO: *Laura Battiferi*, late 1550s oil on panel 83 × 60 cm Palazzo Vecchio, Florence (Scala, Florence)
- 254 TITIAN: Assumption of the Virgin, 1516–18 panel 686 × 361 cm
 S. Maria Gloriosa dei Frari, Venice (The Bridgeman Art Library, London)
- 255 TITIAN: *Pietro Aretino*, 1545 oil on canvas 98 × 78 cm Galleria Palatina, Florence (Scala, Florence)
- 256 TITIAN: *Pietà*, 1576 oil on canvas 352 × 349 cm Accademia, Venice (Scala, Florence)

- 257 FRANCESCO SALVIATI: Triumph of Camillus, 1543-5 fresco Palazzo Vecchio, Florence (Scala, Florence)
- 258 Et Greco: Giulio Clovio holding the Farnese Hours, 1570-2 oil on canvas 58 × 86 cm Museo di Capodimonte, Naples (Scala, Florence)
- 259 GIULIO CLOVIO: Pages from the Farnese Hours, completed 1546 vellum 17.3 × 11 cm © The Pierpont Morgan Library 1994, New York (Ms. M.69 f.59v-60)
- 260 SEBASTIANO DEL PIOMBO: Ferry Carandolet and his Secretaries, 1511-12
 oil on canvas 112.5 × 87 cm
 Museo Thyssen-Bornemisza, Madrid
- 261 PAOLO VERONESE: Marriage Feast at Cana, 1562-3 oil on canvas 666 × 990 cm Musée du Louvre, Paris (Réunion des musées nationaux, Paris)
- 262 JACOPO TINTORETTO: Susanna and the Elders, 1557 oil on canvas 146 × 199.6 cm Kunsthistorisches Museum, Vienna
- 263 GIULIO ROMANO: The Sala dei Giganti, Palazzo del Tè, 1532-4 fresco Palazzo del Tè, Mantua (Scala, Florence)
- 264 LORENZO LOTTO: Triumph of Chastity, c. 1531 oil on canvas 76 × 118 cm
 Private Collection, Rome (Scala, Florence)
- 265 PARMIGIANINO: Conversion of Saint Paul, 1527-8 oil on canvas 117.5 × 128.5 cm Kunsthistorisches Museum, Vienna
- 266 Dosso Dossi: *Jupiter, Mercury and Virtue, c.* 1529 oil on canvas 112 × 150 cm Kunsthistorisches Museum, Vienna
- 267 ALESSANDRO ALLORI: *The Pearl Fishers*, 1570-2 oil on canvas 115.5 × 86.5 cm Palazzo Vecchio, Florence (Scala, Florence)
- 268 ALBRECHT DURER: Self Portrait with a Fur-Trimmed Robe, 1500 panel 67 × 49 cm Alte Pinakothek, Munich (Blauel/Ghamm Artothek, Munich)
- 269 Albrecht Durer: *The Hare*, 1502 watercolour and bodycolour on paper 25.1 × 22.6 cm Albertina, Vienna (The Bridgeman Art Library, London)
- 270 Albrecht Durer: A Young Woman, 1506 panel 28.5 × 21.5 cm Staatliche Gemäldegalerie, Berlin (Artothek, Munich)
- 271 ALBRECHT ALTDORFER: Landscape with a Footbridge, c. 1518–20 parchment on panel 41.2 × 35.5 cm The National Gallery, London
- 272 LUCAS CRANACH THE ELDER: Johannes Cuspinian, c. 1502 panel 59 × 45 cm Reinhart Collection, Winterthur (Colorphoto Hans Hinz, Allschwil)
- 273 HANS BALDUNG GRIEN: The Three Ages of Woman and Death, 1509-11 panel 48.2 × 32.7 cm Kunsthistorisches Museum, Vienna

- 274 Hans Holbein the Younger: Christ in the Sepulchre, 1521-2 tempera on panel 30.5 × 200 cm Offentliche Sammlung, Basle (Colorphoto Hans Hinz, Allschwil)
- 275 QUINTEN METSYS: *Ill-Matched Lovers*, c. 1520-25 oil on panel 43.2 × 63 cm
 National Gallery of Art, Washington D.C., Ailsa Mellon Bruce Fund
- 276 JAN GOSSAERT: The Malvagna Triptych, 1510—11. oil on panel central panel 45.5 × 35 cm side panel 45.5 × 17.5 cm Galleria Nazionale della Sicilia, Palermo (Scala, Florence)
- 277 JOOS VAN CLEVE: Margaretha Boghe, c. 1518 panel 57.1 × 39.6 cm National Gallery of Art, Washington D.C., Andrew W. Mellon fund
- 278 CORNELIS ENGELBRECHTSZ: Emperor Constantine (?) and Saint Helena, after 1517 panel 87.5 × 56.5 cm
 Alte Pinakothek, Munich (Joachim Blauel/Artothek, Munich)
- 279 LUCAS VAN LEYDEN: *The Card Players, c.* 1514 oil on panel 33.5 × 47.5 cm Wilton House, Wiltshire (The Bridgeman Art Library, London)
- 280 Lucas van Leyden: Worship of the Golden Calf, c. 1525-8 central panels 93×67 cm side panels 91×30 cm Rijksmuseum, Amsterdam
- 281 MATHIS GRÜNEWALD: The Small Crucifixion, c. 1511-20 oil on panel 61.6 × 46 cm National Gallery of Art, Washington D.C., Samuel H. Kress Collection
- 282 Mathis Grünewald: *The Isenheim Altarpiece*, completed 1515 central panel 269 × 307 cm Unterlinden Museum, Colmar (The Bridgeman Art Library, London)
- 283 BERNARD VAN ORLEY: Saint Matthew, c. 1512 panel 140 × 180 cm Kunsthistorisches Museum, Vienna
- 284 PIETER BRUEGEL THE ELDER: Hunters in the Snow, 1565 panel 117 × 162 cm Kunsthistorisches Museum, Vienna
- 285 PIETER BRUEGEL THE ELDER: Parable of the Blind, 1568
 distemper on canvas 86 × 154 cm
 Museo di Capodimonte, Naples (The Bridgeman Art Library, London)
- 286 PIETER BRUEGEL THE ELDER: Tower of Babel, 1563 panel 114 × 155 cm Kunsthistorisches Museum, Vienna
- 287 Albrecht Dürer: Adoration of the Magi, 1504 panel 100 × 114 cm Uffizi, Florence (Scala, Florence)
- 288 Albrecht Altdorfer: Birth of the Virgin, c. 1520-1
 panel 140.7 × 130 cm
 Alte Pinakothek, Munich (Joachim Blauel/Artothek, Munich)
- 289 Albrecht Altdorfer: Battle of Issus, 1529 panel 158.4 × 120.3 cm Alte Pinakothek, Munich (Joachim Blauel/Artothek, Munich)

- 290 Hans Holbein the Younger: *Bonifacius Amerbach*, 1519 tempera on panel 28.5 × 27.5 cm Kunstmuseum, Basle (Colorphoto Hans Hinz, Allschwil)
- 291 HANS HOLBEIN THE YOUNGER: George Gisze, 1532 panel 96.3 × 85.7 cm Staatliche Gemäldegalerie, Berlin (The Bridgeman Art Library, London)
- 292 Lucas Cranach the Elder: Judith with the Head of Holofemes, c. 1530 tempera and oil on panel 89.6 × 62 cm The Metropolitan Museum of Art, New York, Rogers Fund 1911 (11.15)
- 293 JAN VAN SCOREL: Saint Mary Magdalen, c. 1529 panel 67 × 76.5 cm Rijksmuseum, Amsterdam
- 294 Joachim Patinir and Quinten Metsys: Temptation of Saint Anthony, c. 1520-4 oil on canvas 155 × 173 cm Prado, Madrid (Arxiu Mas, Madrid)
- 295 JAN GOSSAERT: *Danaë* 1527 panel 113.5 × 95 cm Alte Pinakothek, Munich (Joachim Blauel/Artothek, Munich)
- 296 PIETER AERTSEN: *The Cook*, 1559 panel 161 × 79 cm Palazzo Biano, Genoa (Scala, Florence)
- 297 Antonis Mor: Self Portrait, 1528 panel 113 × 87 cm Uffizi, Florence (Scala, Florence)
- 298 MARINUS VAN REYMERSWAELE: Saint Jerome, 1521 oil on canvas 75 × 101 cm Prado, Madrid (Arxiu Mas, Madrid)
- 299 Annibale Carracci: The Famese Gallery, Rome, c. 1597-1600 fresco Palazzo Farnese, Rome (Scala, Florence)
- 300 FEDERICO BAROCCI: Madonna of the People, 1576-9 panel 359 × 252 cm Uffizi, Florence (Scala, Florence)
- 301 Et Greco: Burial of the Count of Orgaz, 1586-8 oil on canvas 487.5 × 360 cm
 Sto. Tome, Toledo (Arxiu Mas, Madrid)
- 302 Annibale Carracci: *The Butcher's Shop*, c. 1582-3 oil on canvas 190 × 271 cm The Governing Body, Christ Church, Oxford
- 303 VINCENZO CAMPI: *The Fruit Vendor, c.* 1580 oil on canvas 143 × 213 cm Pinacoteca di Brera, Milan (Scala, Florence)
- 304 ISAAC OLIVER: A Lady in Masque Costume, 1610 vellum 6.4 × 5.1 cm
 The Trustees of the Victoria & Albert Museum, London
- 305 MAERTEN VAN HEEMSKERCK: Self Portrait with the Colosseum, Rome, 1553
 panel 42.2 × 54 cm
 Fitzwilliam Museum, Cambridge
- 306 CARAVAGGIO: Basket of Fruit, c. 1596 oil on canvas 46 × 64.5 cm Pinacoteca Ambrosiana, Milan (Scala, Florence)

Index

Saint John Altarpiece, 266 Barbari, Jacopo de', 201, 260, 261, 262, Aegidius, Petrus, 267 Crucifixion, 140-1 Aertsen, Pieter, 271, 292 The Cook, Plate 296 Death of a Miser, 141, Plate 147 Burgundy, 15-17, 125 Burruguete, Alonso, 172 Still Life, Plate 202 Epiphany Triptych, 142 'Bardi St Francis Master', 52 Garden of Earthly Delights, 142, Plate Buti, Lucrezia, 80 Egg Dance, 277 Barocci, Federico, 34, 290

Madonna of the People, Plate 300 Alberti, Leon Battista, 12, 29, 73-4, 84, 97, 229, 259, 290 Albertinelli, Martiotta, 199 Haywain, 142, Plate 146 Callot, Jacques, 165 Saint John on Patmos, 142 Grandes Misères de la Guerre, 165 Visitation, 36 Cambiaso, Luca, 172 Campi, Vincenzo, *The Fruit Vendor*, Albizzi family, 9 Baroque style, 34, 38, 289-90 Seven Deadly Sins, 141 Albrecht V, 173 Albrecht von Brandenburg, 264 Seven Sacraments, 141 Bartolo, Taddeo di, 76 Bartolommeo, Fra, 34, 86, 196, 198-9, Temptations, 141 Plate 303 Alexander VI, Pope, 13, 14, 18, 190 Botticelli, Sandro, 29, 73, 80, 84, 85, Campin, Robert, 125, 126, 129, 131, 86-8, 91, 95, 96, 130, 192, 194 Adoration of the Magi, 87, Plate 78 Birth of Venus, 87-8, Plate 116 133 Canaletto, 98 Alfonso, King of Aragon, 21, 75 Carondolet Altarpiece, 191, 198, 204, Allori, Alessandro, 12, 226, 239 The Pearl Fishers, Plate 266 Plate 206 Marriage of Saint Catherine, 198 Candid, Pieter, 173 canvases, 39, 40 Caporali, Bartolomeo, 92 Caravaggio, Michelangelo Merisi da, Almedina, Fernando Yáñez de la, 172 Vision of Saint Bernard, 198 Lamentation of Christ, 88, Plate 79 Altheuma, Fernando Tantez de la, 1/2
Altdorfer, Albrecht, 33-4, 41, 261-2, 263
Battle of Issus, 259, 262, Plate 289
Birth of the Virgin, 262, Plate 288
Christ on the Mount of Olives, 262 Bassano, Francesco, 236 Minerva and the Centaur, Plate 117 Bassano, Jacopo, 238

Adoration of the Magi, Plate 242 Mystic Nativity, 88, 193 Pallas and the Centaur, 88 290, 292-3 Basket of Fruit, Plate 306 Entombment, 238 Primavera, 12, 73, 87-8, 191, Plate 115 Danube Landscape near Regensburg, 262 The Finding of the Body of Saint Florian, Beccafumi, Domenico, 58, 239 The Triumph of Love, 87 Death of the Virgin, 293 Bedford Master, 161 Bedoli, Mazzola, 240 Boucicaut Master, 161 Bourbon, Pierre, Duc de, 161 Caron, Antoine, 163, 165 Carondelet, Jan, 268 Carpaccio, Vittore, 98, 201 Holy Night, 262 Beer, Jan de, 269 Bourdichon, Jean, 161, 162 The Arrival of the Ambassadors, Plate 80 Landscape with a Footbridge, Plate 271 Beham, Bartel, 261 Hours of Anne of Brittany, 162 The Umpire, 261 Beham, Hans Sebald, 261 Scenes from the Life of Saint Ursula, 15, Satyr Family, 262 Bouts, Dirk (Dieric), 125, 133-5, 137, Altichiero, 60 138 The Crucifixion, Plate 65 Bellange, Jacques, 34, 165 Deposition Altarpiece, 134, Plate 130 Scenes from the Lives of Saint George and Amberger, Christoph, 168, 261, 265, 266

Charles V, 266

Christoph Fugger, 266, Plate 9

Amboise, Cardinal, 162 Saint Jerome, 98 A Shooting Party on the Lagoon, 98, Bellini, Gentile, 97-8 Infancy Altarpiece, 134 Justice of the Emperor Otto, 134, 135 Last Supper Altarpiece, 134-5, Plate 148 Famous Cities, 98 A Procession in Piazza San Marco, Plate Plate 109 Pearl of Brabant, 134 Two Women Seated on a Balcony, 98, Ammanati, Bartolommeo, 232 Sultan Mehmet II, 98 Portrait of a Man, 134 Visitation, 134 Bramante, Donato, 12, 190, 196 Young Knight in a Landscape, Plate 111 Andrea del Sarto, 12, 18, 34, 36, 85, 162, Bellini, Giovanni, 73, 96, 97, 198, 200, 192, 198, 199-200, 229, 231, 290 Birth of the Virgin, 199 201, 202, 241, 261 Agony in the Garden, 97 Carpi, Girolamo da, 239 Carpi, Ugo de, 240 Carracci, Agostino, 290-2 Bril, Paul, 293 Broederlam, Melchior, 125 Charity, 162 Baptism of Christ, 97 Holy Family with the Youthful Saint Davis Madonna, 97 Doge Leonardo Loredan, 40, 97, Plate Carracci, Annibale, 238, 290-2, 293
Butcher's Shop, 292, Plate 302
The Farnese Gallery, Rome, Plate 299 Bronzino, Agnolo, 40, 164, 173, 200, John, Plate 213 226, 228, 229, 230, 231-2, 237, 239, A Lady with Petrarch's Sonnets, Plate 106 240, 261 Feast of the Gods, 233 Allegory of Venus, 163, 232, Plate 228 Pietà with Saints, 290 Giovanni Emo, Plate 107 Lady at her Toilet, Plate 215 Deposition, Plate 235 Duke Cosimo I de' Medici in Armour, Life of Saint Philip Benizzi, 199 Carracci, Lodovico, 290-2 Madonna of the Harpies, 199-200 Angelico, Fra, 51, 55, 73, 75, 78-9, 84, Carracci family, 37, 189, 228 cartoons, 38-9 Madonna in the Meadow, Plate 212 Plate 2 Portrait of Jörg Fugger, 97 San Giobbe Altarpiece, 97, Plate 90 San Zaccaria Altarpiece, 97 132, 160 Eleonora of Toledo, Plate 11 Castagno, Andrea del, 74, 81-3, 84 Annunciation, Plate 95 Guidobaldo della Rovere, 231 Famous Men and Women, 81-3 Last Supper, 81, Plate 76 Niccolò da Tolentino, 81 Last Judgement, 79 Laura Battiferri, 232 Martyrdom of St Lawrence, 232 Lives of Saints Stephen and Lawrence, 79 Woman at her Toilet, 97 Saint Dominic Adoring the Crucifix, Bellini, Jacopo, 97 Portrait of Giovanni de' Medici as a Resurrection, Plate 38 Plate 94 The San Marco Altarpiece, Plate 72 Bellini, Nicolosia, 97 Baby, Plate 252 Castiglione, Baldassare, 12, 224, 228 Belvedere Torso, 190 Portrait of a Lady, 231 Portrait of Laura Battiferi, Plate 253 Catherine of Siena, St, 57 Catholic Church, 16, 20, 21, 51-2, 190, Anjou, Duke of, 160 Bembo, Cardinal, 190 Anne de Beaujeu, 161 Benninck, Simon, Self Portrait aged 75, Story of Joseph, 232 223 Anselmi, Michelangelo, 239 Anthony of Burgundy, 16 Plate 168 Ugolino Martelli, 231-2 see also Papacy Berenson, Bernard, 80 Caulibus, John de, 52 Cavallini, Pietro, 53-4, 60 Angels, Plate 44 Young Man with a Lute, 231 Bruegel, Pieter the Elder, 267, 277-9, Antonello da Messina, 93, 97, 241 Bermejo, Bartolomé, 171-2 Five compositional studies, Plate 23 293 Saint Michael and the Dragon, 171, San Cassiano Altarpiece, 97 Virgin Annunciate, Plate 89 Adoration of the Magi, 278-9 Cellini, Benvenuto, 162, 163, 224, 231 Artist and Connoisseur, 277 Big Fish Eat Little Fish, 278 Plate 172 Cennini, Cennino, 32, 34, 37, 39, 51, Antonino, Saint, 79 Berruguete, Pedro, 172 4, 60, 73, 232 'Antwerp Mannerists', 268-9, 270 Apollo Belvedere, 190 Federico da Montefeltro and his Son Guidobaldo, Plate 15 King David, Plate 173 Children's Games, 278 chalks, 34 Combat between Carnival and Lent, 278 Crippled Beggars, 266 Death of the Virgin, 279 charcoal, 34 Apollonio, 52 Charlemagne, Emperor, 9, 19 Charles I, King of England, 170 Charles IV, Emperor, 60, 126, 159 Aretino, Pietro, 36, 202, 230, 235 Berry, John, Duke of, 160 Aretino, Spinello, 60 Ariosto, Lodovico, 13, 98 Bess of Hardwick, 170 Bettes, John the Elder, 168 The Fall of Icarus, 278 Charles IX, King of France, 165 Charles V, Emperor, 9, 10, 15, 19, 20, Hunters in the Snow, 259, Plate 284 Arnolfo di Cambio, 53 Bibbiena, Cardinal, 190 Land of Cockaigne, 279 Months, 277, 278 Bladelin, Peter, 132 Austria, 17, 20 21, 172, 202, 223, 261, 264, 265, 266, Boccaccio, Giovanni, 52, 54 Netherlandish Proverbs, 278 270 Baço, Jacomart, 75 Baldovinetti, Alessio, 84-5 Decameron, 9 Parable of the Bird's Nest, 279 Charles V, King of France, 160 Boltraffio, Giovanni Antonio, 191 Parable of the Blind, Plate 285 Peasant Wedding Feast, 279 Charles VI, King of France, 160 Baldung Grien, Hans, 33, 261, 264-5 Virgin and Child, Plate 207 Charles VII, King of France, 17, 18 Adoration of the Magi Altarpiece, 265 Bonaiuti, Andrea, Triumph of the Church, Road to Calvary, 278 Charles VIII, King of France, 18, 162, Plate 66 Bordone, Paris, 235 Borghini, Raffaele, *Il Riposo*, 224 The Bewitched Groom, 265 Coronation of the Virgin, 265 Count Palatine Philip the Warlike, 265 Seven Deadly Sins, 278 190 Tower of Babel, 278, Plate 286 Charles the Bold, Duke of Burgundy, 16, 125, 133 Charles the Rash, Duke of Burgundy, 16 Charonton, Enguerrand see Quarton, Two Monkeys, 278 Brunelleschi, Filippo, 74, 78 Bueckelaer, Joachim, 292 Borgia, Lucrezia, 13 Fall, 264 Borgia family, 18 Nativity, 265 The Three Ages of Woman and Death, Borrassá, Luis, 170 Bugatto, Zanetto, 75, 132 Enguerrand Borromeo, Cardinal Federico, 290 Plate 273 Bugiardini, Giuliano, 85 Chevrot, Jean, Bishop of Tournai, 132 Bosch, Hieronymus, 125, 139, 140-2, Wild Horses, 265 Chigi, Agostino, 198 Christ in the Tomb (Boulbon altarpiece), Buontalenti, Bernardo, 34, 35 The Witches, 265 Burckhardt, Jakob, 12, 295 Burgkmair, Hans the Elder, 265, 266 Bandinelli, Baccio, 231 Christ Carrying the Cross, 142, Plate 137

Christus, Petrus, 125, 130-1, 134 Carthusian Saint, 131 Edward Grimston, 131 Exeter Madonna, 131 Lamentation, 131 Nativity, 131 Portrait of a Young Woman, 131 Saint Eligius and the Lovers, 131, Plate Saint Jerome in his Study, 130 Virgin and Child in a Gothic Interior, Virgin and Child with Saints Jerome and Francis, 131 Church of England, 21 Cigoli, Lodovico, 290 Cima da Conegliano, Giovanni Battista, Baptism of Christ, 98 Virgin and Child with Saints Andrew and Peter, 34 Cimabue, 37, 53, 54, 55, 59 Crucifix, 53, Plate 46 Crucifixion, 53 Santa Trinità Madonna, 53, 59, Plate 136 Cione, Jacopo di, 60 Cione, Nardo di, 60 Inferno, 60 Ciriaco Pizzicoli d'Ancona, 128 Claude Lorraine, 163, 268, 292 Clement VII, Pope, 19, 224, 230, 240 Clement VIII, Pope, 293 Clement XII, Pope, 12 Clouet, François, 29, 34, 164, 169 Bath of Diana, 164 Francis II. Plate 20 A Lady in her Bath, Plate 181 Mary, Queen of Scots in White Mourning, 164-5 Pierre Quthe, 164, 165, Plate 163 Clouet, Jean, 34, 164 Francis I, 164, Plate 16 Guillaume Budé, 164, Plate 162 Mme de Canaples, 164 Clovio, Giulio, 35, 236, 277
Pages from the Farnese Hours, Plate 259 Cock, Hieronymous, 278 Codex Vallardi, 32-3 Coecke van Aelst, Pieter, 270, 277 Coello, Alfonso Sánchez, 164, 172 The Infanta Clara Eugenia, Plate 184 View of Seville, Plate 174 Coeur, Jacques, 17 Cologne school, 142 Colombe, Jean, 161 Columbus, Christopher, 21 Condivi, Ascanio, 194, 226 contrapposto, 227 Corneille de Lyon, 164, 165 Clement Marot, Plate 164 Pierre Aymeric, 165 Correggio, 29, 34, 95, 163, 189, 191, 193, 202, 203-4, 227, 237, 240, 289 Assumption of the Virgin, 233, Plate 222 Io, Plate 224 Marriage of Saint Catherine, 203 Martyrdom of Four Saints, Plate 223 Nativity, Plate 204 Cossa, Francesco del, 98, 99 Costa, Lorenzo, 99, 203 A Concert, 99, Plate 119 Counter-Reformation, 13-14, 142, 190, 223, 226, 232, 237, 241, 289, 294 Cousin, Jean the Elder, 163-4 Eva Prima Pandora, 163, Plate 179 242 Life of Saint Mammès, 163-4 Cousin, Jean the Younger, 164 Cranach, Lucas the Elder, 35, 259, 262, Plate 43 Life of the Virgin, 260 Melancholia I, 260 Allegory of Redemption, 263 Paumgärtner Altar, 260 Henry the Pious, 263 Self Portrait, 260, 261

Holy Kinship Altarpiece, 263 Johannes Cuspinian, Plate 272 Judith with the Head of Holofernes, Plate Martin Luther as Junker Jorg, Plate 10 Self Portrait, 263 Cranach, Lucas the Younger, 263 Cranmer, Archbishop, 21 Crivelli, Carlo, *The Annunciation with* Saint Emidius, Plate 122 Cromwell, Thomas, 167 Daddi, Bernardo, 57 Madonna and Child, Plate 60 Dalmau, Luis, Virgin of the Councillors, Dante, 29, 53, 54, 60, 87 'Danube School', 259, 261-2, 263, 268 Daret, Jacques, 126 David, Bishop of Utrecht, 16 David, Gerard, 33, 125, 139-40, 265, 268 Annunciation, Plate 152 Canon Bernardinus de Salviatis and Three Saints, 139 Christ Nailed to the Cross, 139, Plate Crucifixion, 139 Judgement of Cambyses, 139 Madonna and Child with Saints and Musical Angels, 139 Rest on the Flight into Egypt, 140 Virgin and Child with a Bowl of Milk, De Gheyn family, 35 Della Rovere, Cardinal, 160 Della Rovere, Giovanna, 195 Dominic, St, 52 Dominicans, 78-9, 223 Dominici, Blessed Giovanni, 190-1 Donatello, 11, 29, 74, 78, 81, 92, 95, 96, Annunciation, 80 Jeremiah, 78 John the Evangelist, 78 Saint George, 78, 195 Dorigny, Charles, 163 Dornicke, Jan van, 269 Dossi, Dosso, 98, 201, 240-1 Feast of Cybele, 233 Jupiter, Mercury and 'Virtue', Plate 266 Melissa, 241 A Scene of Witchcraft, 241 drawing, 29-37 Dubois, Ambroise, 165 Dubreuil, Toussaint, 165 Duccio, 58-9 Christ's Entry into Jerusalem, Plate 52 Madonna and Child with Saints and Angels, Plate 59 Maestà, 57-8, 59, Plates 52, 59 The Rucellai Madonna, 59, Plate 51 Dumée, Guillaume, 165 Dürer, Albrecht, 20, 29, 33, 35, 40, 41, 96, 128, 136, 142, 229, 259-61, 263, 264-5, 270, 289 Adoration of the Magi, 259, 260, 278, Apocalypse, 260 Canon, 41 Christ Carrying the Cross, Plate 250 Feast of the Rose Garlands, 261 Four Apostles, 261 Great Passion, 260 The Hare, 261, Plate 269 Holy Family's Sojourn in Egypt, Plate The Knight, Death and the Devil, 260,

Self Portrait as a Journeyman, Plate 19 Self Portrait with a Fur-Trimmed Robe, Plate 268 Small Passion, Plate 276 View in the Val d'Arco, Plate 35 A Young Woman, Plate 270 Edward VI, King of England, 21 Eleonora of Toledo, 223, 232 Elizabeth I, Queen of England, 18, 21, 167, 168, 169, 170, 239 Elizabeth of York, 167 Elsheimer, Adam, 293 Empoli, Jacopo da, 290 Engelbrechtsz, Cornelis, 270 Emperor Constantine (?) and Saint Helena, Plate 278 England, 17, 20-1, 159, 166-70, 295 engraving, 40-1 Erasmus, 20, 167, 260, 266, 267, 268 Este, Alfonso d', 13, 202, 233, 240 Este, Borso d', 99 Este, Duke Ercole II, 240 Este, Francesco d', 133 Este, Cardinal Ipolito d', 13 Este, Isabella d', 13, 95, 96, 99 Este family, 13, 98 Estrées, Gabrielle d', 165 etching, 41 Eugenius IV, Pope, 74, 160 Eworth, Hans, 166, 168

Mary Neville, Baroness Dacre, 168 Falier, Doge, 15 Fancelli, Luca, 95 Farnese, Ottavio, 234 Farnese family, 292 Ferdinand I, King of Aragon, 21 Ferdinand I, King of Naples, 18 Ferdinand II, King of Aragon, 17, 18, 21, 172 Ferrarese, Riccobaldo, 54 Ferrari, Gaudenzio, 239 Ficino, Marsilio, 11, 12, 74 Figura serpentinata, 227 Filarete, Antonio, 128 Finiguerra, Maso, workshop of, Seated Youth Drawing, Plate 24 Fiore, Jacobello del, 97 Flanders, 15-17, 125 Flandes, Juan de, 172 Flick, Gerlach, 168 Floris, Frans, 173, 271, 277 Portrait of an Elderly Woman (The Falconer's Wife), 277 Fogliano, Guidoriccio da, 60 Foix, Cardinal de, 160 Fouquet, Jean, 18, 79, 160-1, 162 Antiquités Judaïques, 161, Plate 159 Charles VII, 161, Plate 8 The Court Jester Gonella, 76, 160, Plate 176 Descent from the Cross, 161 Etienne Chevalier with Saint Stephen, Plate 177 Hours of Etienne Chevalier, 161 France, 17-19, 159-65 Francesco di Giorgio, style of, Cassone with Solomon and the Queen of Sheba, Plate 31 Franciabigio, Francesco, 199 Francis I, King of France, 18-19, 162-3, 164, 165, 173, 193, 199, 269-70 Francis II, King of France, 19, 21, 164 Francis of Assisi, St, 52 Francis of Guise, 19 Franciscans, 10, 57, 223 Frederick III, Emperor, 17, 142

Frederick the Wise, Elector of Saxony,

262, 263 Fréminet, Martin, 165

fresco, 37-8

Friedlaender, Walter, 138, 226 Friedrich, Caspar David, 262 Froment, Nicolas, 161 Altarpiece of the Burning Bush, 161 Fugger family, 19, 265 Fuseli, Henry, 265 Gaddi, Agnolo, 60, 74, 78 Gaddi, Taddeo, 57 The Life of the Virgin, Plate 50 Madonna polyptych, 57 Tree of Life, 57 Gallego, Fernando, 171, 172 Retable of Saint Ildefonso, 171 Gallerani, Cecelia, 90 Garbo, Raffaellino del, 231 Gatta, Bartolommeo della, 93 Stigmatization of Saint Francis, Plate 84 Gemmingen, Archbishop Uriel von, 264 genre painting, 277 Gentile da Fabriano, 76-8, 79, 92, 96 Adoration of the Magi, 77, Plate 69 Strozzi Altarpiece, Plate 114 Germany, 17, 19, 20, 142-3, 259-66 gesso, 39-40 Ghiberti, Lorenzo, 29, 51, 53, 54, 57, 77-8, 81, 125, Plate 75 Ghirlandaio, Benedetto, 85 Ghirlandaio, Davide, 85 Ghirlandaio, Domenico, 12, 74, 84-5, 86, 90, 130, 194, 199, 200, 231 The Birth of Saint John the Baptist, Plate Birth of the Virgin, 85 Life of Santa Fina, 85 Madonna Terranuova, 195 Old Man with his Grandson, 85, Plate Saints Julian, Barbara and Anthony Abbot, 84 Ghirlandaio, Ridolfo, 85 A Man of the Capponi Family, Plate 198 Giambono, 97 Giorgione, 37, 163, 191, 193, 200-2, 232, 262, 292 Castelfranco Altarpiece, 201 Judith, 201, 202 Laura, 201 An Old Woman ('Col Tempo'), 201, Plate 201 Sleeping Venus, 201, 202, Plate 220 The Tempest, 201, 202, Plate 190 The Three Philosophers, 201, 202, 204, Plate 200 Venus, 234 Giotto, 9, 32, 37, 52, 53, 54-7, 58, 60, 74, 96 Allegory of Vainglory, 57 Arena Chapel frescoes, 51, 55-6, 95, Plate 56 Enrico Scrovegni Offering his Chapel to the Virgin, Plate 47 Last Judgement, 53 The Legend of Saint Francis, 52 Ognissanti Madonna, Plate 57 Stefaneschi Altarpiece, 56-7, Plate 49 The Stigmatisation of Saint Francis, Plate Upper Church of San Francesco, Assisi, 54-5, Plate 48 Virgin and Child, 54 Giovanni da Milano, Rinuccini Chapel fresco, Florence, Plate 28 Giovanni da Udine, 229 Giulio Romano, 162, 197, 198, 226, 229, 236 The Sala dei Giganti, Palazzo del Tè, Plate 263

Giustiniani, Michele, 75

Without Ceres and Bacchus, Venus is

Goltzius, Hendrick, 34

a-Chill, Plate 18

Gonzaga, Cardinal, 236 Gonzaga, Francesco, 13, 98 Gonzaga, Lodovico, 12, 96 Gonzaga family, 12, 236 Gossaert, Jan (Mabuse), 267, 268-9, 271 Adoration of the Magi, 268 Baudouin of Bourgogne, 269 Danaë, 268, Plate 295 Elderly Couple, 268 Jan Carondelet Adoring the Virgin and Child, 268 The Malvagna Triptych, 268, Plate 276 Neptune and Amphitrite, 268 Saint Luke Painting the Virgin, 268 Venus and Cupid, 268 gouache, 35 Gower, George, 168 Gozzoli, Benozzo, 74, 79, 84 Journey of the Magi, 79, Plate 114 Graf, Urs, 33, 41, 265 Granacci, Francesco, 85 Granvelle, Cardinal de, 277 El Greco, 171, 172, 236, 294-5 Burial of the Count of Orgaz, 294, Plate Christ Driving the Money-Changers from the Temple, 236 Giulio Clovio Holding the Farnese Hours, 294, Plate 258 Martyrdom of Saint Maurice, 294 Purification of the Temple, 294 View of Toledo, Plate 174 Grünewald, Mathis, 259, 263-4 Christ on the Cross, 264 Heller Altarpiece, 264 Isenheim Altarpiece, 264, 265, Plate 282 Lindenhardt Altarpiece, 264 Meeting of Saints Erasmus and Maurice, Small Crucifixion, 264, Plate 281 Virgin in the Garden, 264 Gualberto, Giovanni, 10 Gualdo, Matteo di, 92 Guicciardini, 224 Guinard, Paul, 295 Guise family, 19 Gusmin, Master, 77

Haarlem school, 135 Habsburg dynasty, 10, 15, 18, 19, 21 Hals, Frans, 277 Hameel, Alart du, 142 Hans von Aachen, 173 Hawkwood, Sir John, 57, 81 Hay, Jean, 161 Heemskerck, Maerten van, 267, 271 A Family Group, 271 Self Portrait with the Colosseum, 271, Plate 305 Heintz, Josef, 173 Hemessen, Jan Sanders van, 270 Henry II, King of France, 18, 19, 163, Henry III, King of France, 19 Henry IV, King of France, 19, 165 Henry VII, King of England, 167 Henry VIII, King of England, 19, 20-1, 166, 167, 168, 169 High Renaissance, 189-204 Hilliard, Nicholas, 168, 169-70 *Armada Jewel*, 169 Man Clasping a Hand from a Cloud, Plate 169 The Mildmay Charter, Plate 171 Treatise Concerning the Art of Limning, Young Man Leaning against a Tree, Plate Hoefnagel family, 35 Holbein, Hans the Elder, 33, 34, 265 Saint Sebastian Altarpiece, 265 Holbein, Hans the Younger, 10, 21, 29, 33, 34, 166, 167-8, 259, 265-6 Adam and Eve, 265 The Ambassadors, 167, Plate 180 Bonifacius Amerbach, 265, Plate 290 Christ in the Sepulchre, 265-6, Plate 274 Dance of Death, 167, 265
Elizabeth I as a Princess, 167
Erasmus of Rotterdam, 266, Plate 14
Henry VIII, 169
Jakob Meyer and his Wife, 265
John More the Younger, Plate 167
Madonna of Burgomaster Meyer, 265
Oberreid Altarpiece, 266
Portrait of Georg Gisze, 266, Plate 291
Simon George of Cornwall, Plate 166
Sir Thomas More, his Father and his
Household, Plate 27
Holy Roman Empire, 9, 15, 16, 19-20
Honnet, Gabriel, 165
Hornebolte, Lucas, 169
Huber, Wolfgang, 262
Huguet, Jaime, 171
Humanism, 12, 160, 162, 259
Hungary, 17, 19, 159
impasto, 40

Ingres, Jean Auguste Dominique, 161
Inquisition, 21, 173, 223, 266
International Gothic, 59, 79, 125, 126, 129, 159, 160, 171
intonaco, 37
Isabella, Queen of Spain, 17, 18, 21, 172
Isabella of Portugal, 129
Italy, 10–15
prelude to the Renaissance, 51–60
fifteenth century painting, 73–99
High Renaissance, 189–204
later Renaissance, 223–41
end of Mannerism, 289

Jacopo da Empoli, 239
James I, King of England, 170
Jesuits, 223, 289-90
John III, King of Portugal, 172
John of Bavaria, Count of Holland, 129
John federick, Elector of Saxony, 263
Jonghelinck, Niclaes, 277
Joos van Cleve, 267, 269-70
Epiphany, 269
Margarethe Boghe, Plate 277
Rest on the Flight into Egypt, 269
Julius II, Pope, 14, 95, 190, 193, 195-6, 224, 226, 233, 293

Koberger, Anthony, 260 Kulmbach, Hans von, 261

landscapes, 35, 292 Laocoön, 190, 233 Larkin, William, 168 Laurana, Luciano, 12 Leo X, Pope, 12, 14, 18, 19, 20, 190, 197, 203, 204, 228, 293 Leonardo da Vinci, 9, 12, 18, 29, 32, 34, 54, 73, 83, 84, 86, 87, 88-90, 99, 162, 172, 189, 191-4, 198, 199, 204, 229, 232, 259, 270 Adoration of the Magi, 90, 191, Plate 82 The Anatomy of a Shoulder, Plate 21 Battle of Anghiari, 172, 192-3, 195 La Belle Ferronière, 193 A Lady with an Ermine, Plate 118 Last Supper, 12, 38, 74, 90, 191, Plate . Madonna Litta, 90 Mona Lisa, 193, 195, 197, 203, Plate Portrait of a Musician, 90 Saint John the Baptist, 193, Plate 193 Trattato della Pittura, 30 Virgin and Child with Saint Anne, 90, 191-2, Plate 208 Virgin of the Rocks, 90, 163, 191, 193, 195, Plate 191 Limbourg brothers, 15, 126 Très Riches Heures du Duc de Berry, Plate 158 line engraving, 40-1 Lippi, Filippino, 12, 74, 80 The Virgin Appearing to Saint Bernardo,

Lippi, Fra Filippo, 74, 80, 85, 86, 88, 92, Annunciation, 80 Barbadori Altarpiece, 80 Brancacci Chapel frescoes, Plate 70 Dance of Salome (Herod's Feast), Plate Dead Christ, 80 Madonna and Child with the Birth of the Virgin and the Meeting of Joachim and Madonna of Humility, 80 Scene from Carmelite History, 80 Lochner, Stephan, 142 Adoration of the Magi, 142 Last Judgement Altarpiece, 142 Madonna of the Rose Bower, 142 Madonna with the Violets, 142 Lockey, Rowland, 170 Sir Thomas More and his Family, 167, 170, Plate 165 Lomazzo, Giovanni Paolo, 224, 227 Lorenzetti, Ambrogio, 60 Allegories of Good and Bad Government, 51, 60, Plate 54 The Effects of Good Government in the City, Plate 64 Presentation in the Temple, Plate 55 Lorenzetti, Pietro, 60 Birth of the Virgin, 60, Plate 62 Lorenzo Monaco, 76, 78 Lotto, Lorenzo, 201, 202, 235, 241, 292 Annunciation, 241 Brother Gregorio Belo of Vicenza, Plate Portrait of Andrea Odoni, Plate 246 Saint Lucy Altar, 241
Triumph of Chastity, Plate 264
Louis XI, King of France, 16-18, 161 Louis XII, King of France, 18, 90, 162 Louis of Anjou, 59 Loyola, St Ignatius, 52, 223 Lucas van Leyden, 40, 41, 229, 270-1 The Card Players, Plate 279 Ecce Homo, 271 Last Judgement, 270 Mohammed and the Murdered Monk Sergius, 270 Worship of the Golden Calf, 271, Plate Luini, Bernardo, 191 Luther, Martin, 19, 20, 259-60, 263, 265 Lyon, Corneille de, Mary of Guise, 21

Luther, Martin, 19, 20, 259-60, 263, 26; Lyon, Corneille de, Mary of Guise, 21 Machiavelli, Niccolò, 14, 224 'Magdalen Master', 52 Mander, Karel van, 128, 135, 136, 267, 269, 271, 277 Mannerism, 21, 34, 35, 163, 164, 165, 172, 173, 189-90, 193, 203, 204, 226-9, 232, 233, 241, 268-9, 289 Mantegna, Andrea, 12, 34, 38, 39, 73, 81, 95-6, 97, 99, 203, 261, 262 Agony in the Garden, 97 The Ceiling Oculus of the Camera degli Sposi, Palazzo Ducale, Mantua, Plate

The Gonzaga Court, Plate 105
The Introduction of the Cult of Cybele in Rome, 96
Man of Sorrows with Two Angels, Plate 88
Pallas Expelling the Vices from the Garden of Virtue, 73, 96, Plate 87
Parnassus, 96
Sea Gods, 96
Triumphs of Caesar, 96
manuscript illuminations, 159
Maratti, Carlo, 38
Margaret of Austria, 142, 270
Margaret of Scotland, 17
Margaret of York, 16, 17, 125
Martini, Francesco di Giorgio, 12
Martorell, Bernardo, 171
Altarpiece of Saint Peter of Púbol, 171

The Martyrdom of Savonarola, Plate 4

Mary of Hungary, 168

Mary Queen of Scots, 19, 21, 164-5 Mary Tudor, Queen of England, 21, 166, 277 Masaccio, 30, 37, 53, 55, 73, 74, 75, 77, 78, 79, 80, 81, 86, 92 Brancacci Chapel frescoes, 74, 78, 93, Expulsion from Paradise, 78, Plate 70 Trinity, 37, 74, 78, Plate 93 Maso di Bianco: The Legend of Saint Sylvester, 57 Saint Sylvester Quelling the Dragon, 57 Masolino da Panicale, 78, 81, 92, 159 Brancacci Chapel frescoes, Plate 70 The Fall, 78, Plate 70 Feast of Herod, Plate 71 Saint Anna Meterza, 78 Master Bertram, 126 Grabow Altar, 126 Master of the Death of Mary, 269 Master of Flémalle, 125, 126-8, 133 Betrothal of the Virgin, 127 Entombment, 126-8 A Man, 128 Mérode Altarpiece, 127 Nativity, 127 Portrait of a Woman, 128 Saint Clare, 127 Saint James the Greater, 127 St Veronica, 126, 127, Plate 124 Triptych of the Annunciation, Plate 150 Virgin and Child, 127 Virgin and Child before a Fire Screen, 127 Virgin in Glory, 127 Master Francke, 126 Englandfahrer Altarpiece, 126 Man of Sorrows, 126 Master Honoré, 159 Master of Ildefonso, 171 Investiture of Saint Ildefonso, 171, Plate Master of Moulins, 160, 161 Annunciation, Plate 157 Cardinal Charles II of Bourbon, 161 Nativity, 161 Saint Maurice with a Donor, 161 Virgin and Child in Glory with Donors, Young Princess, Plate 175 Music-making in a Garden, Plate 63 'Master of the Virgo inter Virgines', 137 Entombment, 137 Maugham, Somerset, 195 173, 223, 224, 231

Memmi, Lippo, 59 Metsys, Quinten, 139, 173, 267-8, 269 The Banker and his Wife, 267 Ill-matched Lovers, 268, Plate 275 Madonna and Child with Angels, 267 Old Woman, 268 Portrait of a Lady, 268 Saint Anne Altarpiece, 267 Saint Christopher, 267 Temptation of Saint Anthony, Plate 294 Metternich, Klemens, 10 Michelangelo, 12, 29, 34, 36, 53, 83, 85, 86, 88, 90-1, 99, 162, 189, 191, 193, 204, 224-6, 233, 235, 271, 289 Bathers, 85 Battle of Cascina, 38, 192-3, 195, 227, Plate 209 Cleopatra, 229 Conversion of Saint Paul, Plate 230 David, 192 Dawn, 234 The Deluge, Plate 40 Divine Head, 229, Plate 32 Doni Tondo, 192, 226, 227, Plate 210 Entombment, 195 Giuliano de' Medici, 231 Last Judgement, 195, 223, 224-6, 232, 277, Plate 229 Leda, 163 Lybian Sybil, Plate 217 Pietà, 91, 193 Raising of Lazarus, 232 Sistine Chapel ceiling, 15, 37, 190, 194-5, 197, Plate 218 Michelozzo, 11, 79 Michiel, Marcantonio, 75, 201, 224 miniatures, 21, 29, 35, 170 Mirandola, Giovanni Pico della, 12, 74 Montefeltro, Federico, Duke of Urbino, 12, 93, 172 Montefeltro family, 12 Mor, Anthonis, 172, 267, 277 Mary Tudor, 277 Self Portrait, 277, Plate 297 Morales, Luis de, 172 Virgin and Child, Plate 183 More, Sir Thomas, 167, 266, 267 Moretto da Brescia, 203 Presumed Portrait of Count Sciarra Martinengo Cesaresco, Plate 225 Morgues, Jacques Lemoyne de, 35 Mostaert, Jan, 270 Multscher, Hans, 143

Nanni di Banco, 78
Nelli, Ottaviano, 91-2
Life of the Virgin, 92
Neoplatonism, 12, 74, 85, 86-7
Netherlands, 11, 15, 17, 75, 125-42, 266-79
Niccolò dell'Abbate, 34, 162, 163, 165, 239
A Concert, Plate 243
Eros and Psyche, Plate 188
Landscape with Euridice and Aristarchus, Plate 178
Nicholas III, Pope, 54
Nicholas V, Pope, 79
oil paints, 39, 201

Oliver, Isaac, 170

A Lady in Masque Costume, Plate 304

Lamentation over the Dead Christ, 170
Oostsanen, Jacob Cornelisz van, 270
Orcagna, Andrea, 57, 60
Orléans, Duke of, 160
Orley, Bernard van, 34, 270

Job Altarpiece, 270

Saint Matthew, Plate 283
Ouwater, Albert van, 135, 137

The Raising of Lazarus, 135

Pacher, Michael, 143, 262 Saint Wolfgang Altarpiece, 262 'Palazzo Trinci Master', 92 Paleotti, Cardinal Gabriele, Discourse

Concerning Sacred and Profane Imagery, 290 Palladio, Andrea, 236, 237 Palma il Giovane, Jacopo, 239 Palma Vecchio, 202, 203, 234 Saint Barbara, 233 Venus and Cupid in a Landscape, Plate 203 Palomino y Velasco, Antonio, Museo Pictórico y Escala Optica, 171 panel paintings, 39-40 Papacy, 10, 13-14, 159-60 see also Catholic Church paper, 33 Parmigianino, 34, 41, 81, 163, 173, 203, 226, 228, 238-9, 240 Antea, 240 Conversion of Saint Paul, 163, Plate 265 A Lady 'The Turkish Slave', Plate 245 Madonna of the Long Neck, 228, 240, Plate 232 A Man with a Book, 240 Portrait of a Man, 240 Vision of Saint Jerome, 240 Passerini, Cardinal Silvio, 224 Patinir, Joachim, 267, 268, 269, 278 Baptism of Christ, Saint Jerome and Saint Anthony, 268 Temptation of Saint Anthony, Plate 294 Paul III, Pope, 223, 224, 226 Paul IV, Pope, 223 Peake, Robert, 168 Eliza Triumphans, Plate 17 pen and wash drawings, 33-4 Pencz, Georg, 261 Penni, Gianfrancesco, 198 Penni, Luca, 163 pentimenti, 36 Perréal, Jean, 162 Louis XII, 162 perspective, 29, 73 Perugino, Pietro, 79, 85, 91, 92, 93-5, 96, 137, 162, 195, 194, 196, 202, 224 Adoration of the Magi, 94 Christ Handing the Keys to Saint Peter, Pietà, 94 Vision of Saint Bernard, 94-5 Peruzzi, Baldassare, 198 Petrarch, 54, 60, 159-60 Peutinger family, 265 Philip II, King of Spain, 19, 20, 21, 142, 172, 173, 202, 234, 266 Philip the Bold, Duke of Burgundy, 15, 20, 125 Philip of Burgundy, Bishop of Utrecht, 268 Philip of Cleves, 16 Philip the Good, Duke of Burgundy, 16, 17, 20, 125, 129 Philip the Handsome, Duke of Burgundy, 17, 142 Piero della Francesca, 12, 73, 74, 81, 85, 91, 92-3, 94, 99 Baptism of Christ, 92 Brera Altarpiece, 93, 191, Plate 99 De Prospettiva Pingendi, 29-30, 92, Plate 85 Dream of Constantine, Plate 86 Federico II da Montefeltro and Battista Sforza, Plates 101, 102 Flagellation of Christ, 92, 93, Plate 100 Legend of the True Cross, 93 Madonna del Parto, 93 Madonna della Misericordia, 92 Nativity, 93 Quinque Corporibus Regularibus, 92 Resurrection, 93 View of an Ideal City, 93, Plate 85

Piero di Cosimo, 86, 199

The Building of a Palace, Plate 112

Scenes from the Life of Pius II, 95, Plate 68

Piombo, Sebastiano del, 202, 230, 232,

Cleopatra, 229, Plate 81 Simonetta Vespucci, 229

233

Pintoricchio, Bernardo, 95, 190

Christopher Columbus, Plate 13 Death of Adonis, Plate 216 Portrait of Ferry Carandolet, Plate 260 Pirckheimer, Willibald, 260 Pirez, Alvaro, 75 Pisanello, Antonio, 33, 60, 77, 92, 96-7 Lionello d'Este, Plate 6 Saint George and the Princess, Plate 92 Pisano, Giovanni, 52, 59 Pisano, Nicola, 52, 53 Plato, 74 Pliny, 73, 190 Polack, Jan, 262 Polidoro da Caravaggio, 229 Poliziano, Angelo, 12, 54, 87 Pollaiuolo, Piero, 83-4, 85, 93 Battle of the Nude Men, 83, 195, Plate The Labours of Hercules, 83 Martyrdom of Saint Sebastian, 83 Ponte, Giovanni del, 76 Pontormo, Jacopo, 12, 34, 192, 193, 198, 200, 226, 228, 229-30 Joseph in Egypt, 229, 230, Plate 249 Pietà, 228, 229, Plate 231 Visitation, 229 Il Pordenone, 233, 234 Portinari, Tommaso, 85 'portrait albums', 165 pouncing, cartoons, 38, 39 Predis, Ambrogio da, 191 Primaticcio, Francesco, 18, 162, 163, 165, 239 Ulysses Recounting his Adventures to Penelope, Plate 188 Ulysses Shooting through the Rings, Plate 'primitives', 51 Pucelle, Jean (Jehan), 59, 159 Pulci, Luigi, 12 Quarton, Enguerrand, 161 The Pietà of Villeneuve-lès-Avignons, 160, Plate 185 Raimondi, Marcantonio, 40, 198, 203, 268 Raphael, 9, 12, 29, 30, 36, 85, 162, 189, 190, 191, 192, 195-8, 203-4, 229, 233, Baldassare Castiglione, 197, Plate 12 La Belle Jardinière, 163, 195 Bridgwater Madonna, 195 A Cardinal, 197 Christ's Charge to Saint Peter, Plate 205 Colonna Madonna, 195 Deposition, 196 Disputà, 196, Plate 254 La Donna Velata, 197 Expulsion of Heliodorus, 196 Fire in the Borgo, 196 Holy Trinity with Saints, 196 Leo X with Cardinals Giulio de' Medici and Luigi Rossi, 197 Madonna Alba, 195, Plate 211 The Madonna and the Goldfinch, 195 Madonna del Granduca, 195 Madonna della Sedia, 195 Madonna Esterhazy, 196 The Madonna of the Meadow, 195 Marriage of the Virgin, 195, 196 Pope Julius II, Plate 1 The Road to Calvary, Plate 250 Saint Cecilia, 198, 228 School of Athens, 39, 196, 204, Plate Self Portrait with a Friend, Plate 197 Sistine Madonna, 198, 200, 204 Sistine tapestry cartoons, 38, 267 Small Cowper Madonna, 195 Lo Spasimo di Sicilia, 228, 238 Story of Psyche, 237 Tempi Madonna, 195 Transfiguration, 20, 198, 204, 228, 230, 232, Plate 248 Triumph of Galatea, 191, 198, Plate 214

Vatican Loggie mural grotesques, Valtean Eoggie Initial glotesques, Plate 195 Vatican Stanze, 15, 37, 190, 195-6 Villa Farnesina frescoes, 38 Reformation, 13, 19, 20, 21, 159, 166, 167, 170, 223, 259, 265 Reichlich, Max, 262 Rembrandt, 41, 293 retables, 170 Reymerswaele, Marinus van, Saint Jerome, 261, Plate 298 Reynolds, Sir Joshua, 189 Riario, Cardinal, 90 Ridolfi, 237 Robbia, Luca della, 12 Robert, King of Anjou, 59 Roberti, Ercole de', 98 Roch, St, 57 Rococo style, 289 Rolin, Nicholas, 16, 132 Romanesque sculpture, 52 Romanists, 267 Rosselli, Cosimo, 85, 86, 198 Rosso Fiorentino, 18, 162-3, 165, 193, 226, 228, 230, 232, 240, 265 Dead Christ supported by Angels, 230, Plate 234 Deposition, 230 Ecouen Pietà, 163 Leda, 163 Madonna with Saints, 230 Marriage of the Virgin, 230 Portrait of a Young Man, Plate 251 Resurrection, 230 Saint Michael, 163 Venus, Plate 161 Rubens, Peter Paul, 129, 233 Rudolph II, Emperor, 173 Ruskin, John, 78, 80, 98 Salviati, Francesco, 226, 231, 234, 236 Triumph of Camillus, Plate 257

Sandrart, Joachim, 263 Sangallo, Antonio da the Younger, 226 Sangallo, Aristotile da, 192 Battle of Cascina, Plate 209 Sangallo, Giuliano da, 12 Sansovino, Jacopo, 202, 230 Santi, Giovanni, 95, 128 Savoldo, Gian Girolamo, 203, 292 Saint Mary Magdalene Approaching the Sepulchre, Plate 226 Savonarola, Girolamo, 12, 18, 88 Sax, Marzal de, Retable of Saint George, Schaufelein, Hans, 261 Schiavone, Andrea, 235 Schongauer, Martin, 40, 142, 143, 229, 260, 266 Censor, 143 Christ Carrying the Cross, 143, Plate Madonna in the Rose Garden, 143, 260, Plate 156 Saint Michael, 143 Temptation of Saint Anthony, 143 'School of Fontainebleau', 163, 229 Gabrielle d'Estrées and one of her Sisters, Plate 187 Scorel, Jan van, 267, 271 Saint Mary Magdalen, Plate 293 Scotland, 17, 20-1 Scrots, William, 168 Sebastian, St, 57
'Second School of Avignon', 160
'Second School of Fontainebleau', 165 Segar, William, 168 Seisenegger, Jacob, 164, 168 Selvatico, Pietro, 51 Serlio, Sebastiano, 18 Sesto, Cesare da, 191 Leda and the Swan, Plate 192 Seton, George, 5th Lord, 21 Seymour, Jane, 167 Sforza, Battista, 12 Sforza, Bianca, 12, 20 Sforza, Bianca Maria, 75

Sforza, Francesco, Duke of Milan, 12 Sforza, Lodovico 'il Moro', 12, 18, 90 Sforza family, 12 sfumato, 192 Signorelli, Luca, 85, 194 Calling of the Elect, Plate 96 The Damned in Hell, Plate 29 Education of Pan, 85 Last Judgement, 85 Madonna and Child, 85 Three Horsemen, Plate 30 silverpoint, 33 Simone Martini, 59-60, 159-60 Annunciation, 59
The Apotheosis of Virgil, Plate 53
Madonna of Humility, 37 Maestà, 59, Plate 61 Saint Louis Altarpiece, 59 Saint Martin Renouncing the Sword, 59 The Story of Saint Martin, 59 sinopie, 37 Sint Jans, Geertgen tot, 136-7 The Baptism in the Wilderness, Plate Burning of the Bones of Saint John the Baptist, 136-7 Crucifixion, 136 Lamentation of Christ, 136 Nativity, 136 Sixtus IV, Pope, 194 Sluter, Claus, 125, 126, 127 Soderini, Piero, 195 Sodoma, 198 Marriage of Alexander with Roxana, Plate 227 Solario, Andrea, 191 Spain, 15, 17, 21, 159, 170-3 Spano, Pippo, 78, 159 Spranger, Bartholomeus, 34, 173, 229 Susanna and the Elders, 173 Triumph of Wisdom, 173, Plate 188 Squarcione, Francesco, 95 Starnina, 76, 171 still lifes, 35 Strozzi, Zanobi, 79 Sturmio, Hernando, 172 stylus-tracing, cartoons, 38-9 Sustris, Frederick, 173

Taffi, Andrea, 52
tapestries, 16
tempera, 39
Theodoric of Prague, Master, 60
Theresa of Avila, St, 295
Tibaldi, Pellegrino, 172, 239
Adoration of the Shepherds, Plate 244
Tiepolo, Giovanni Battista, 237
Tintoretto, Jacopo, 15, 40, 201, 228, 232, 234, 235-6
Christ in the Temple, 235
Crucifixion, 236
Fasti Gonzagheschi, 236
Last Supper, 235, 236
Miracle of Saint Mark, Plate 239

Miracle of the Slave, 235 Paradise, 236 Saint Mary of Egypt in Meditation, 235 Self Portrait, 235 Susanna and the Elders, 235-6, Plate Temptation of Christ, 236 Titian, 10, 20, 40, 172, 189, 201, 202-3, 227, 232, 233-4, 235, 236, 266, 289 Annunciation, 233 Ariosto, 203 Assumption of the Virgin, 202, 204, 230, 233, Plate 254 Bacchanal of the Andrians, 233, Plate Bacchus and Ariadne, 233 Battle of Cadore, 233 Cardinal Ippolito de' Rovere, 234 Concert, 202 Concert Champêtre, 202 Danaë, 234 The Death of Actaeon, 234 Death of Saint Peter Martyr, 233 Diana and Actaeon, 202, Plate 238 Diana and Callisto, Plate 237 Ecce Homo, 235 Eleonora Gonzaga, 234 Emperor Charles V at Muhlberg, 17, Plate 7 Garden of Love, 233 Jacopo Strada, 203 Magdalen, 163 Pesaro Madonna, 202 Pietà, 233-4, Plate 256 Portrait of Pietro Aretino, Plate 255 Resurrection, Annunciation and Saints, Roman Emperors, Plate 13 Sacred and Profane Love, 202, Plate 219 Self Portrait, 234 Tarquin and Lucretia, 233 The Three Ages of Man, 202, Plate 221 Venus of Urbino, 203, 234 Woman Taken in Adultery, 202 Tito, Santi di, 228, 239, 290 Tommaso da Modena, 60, 159 Torrigiano, Pietro, 166 Tura, Cosmè, 98, 99 Virgin and Child Enthroned, Plate 91

Uccello, Paolo, 74, 80-1, 83, 92, 93, 97
The Battle of San Romano, 81
Cenotaph to Sir John Hawkwood, 81,
Plate 75
The Flood and the Recession of the
Waters, 81, Plate 74
The Hunt in the Forest, 81
Profanation of the Host, 81
Saint George and the Dragon, 81
Utens, Justus van, The Villa Medici at
Poggio a Caiano, Plate 3

Vaga, Perino del, 34, 193, 226, 228, 229, 240

Martyrdom of the Ten Thousand, 229, Plate 233 Valois dynasty, 9, 15, 17, 18, 160 Van der Goes, Hugo, 135-6, 137, 139, Adam and Eve (The Fall of Man), Plate Adoration of the Magi, 135-6 Bonkil Panels (Trinity Altarpiece), 136, Plates 133, 134 Death of the Virgin, 136 Fall of Man, 135 Lamentation, 135 Portinari Altarpiece, 85, 135, 136, 138, 161, Plate 151 Portrait of a Man, 136 Virgin and Child with Saint Anne and a Franciscan Donor, 135 Van der Weyden, Rogier, 33, 75-6, 79, 125, 126, 131-3, 134, 137, 138, 143, 265 Annunciation, 132, Plate 140 Charles the Bold, 133 Deposition, 133, Plate 141 Entombment, 132 Francesco d'Este, 133 Last Judgement Altarpiece, 132, Plate 129 Laurent Froiment, 133 Madonna with Four Saints, 132 Miraflores Altarpiece, 132 Nativity, 132 Philippe de Croy, 133 Pietà, 132 Portrait of a Lady, Plate 128 The Saint Columba Altarpiece, 133, Plate 42 Saint Luke Painting the Virgin, 133, Plate 143 Virgin and Child, 132 Van Dyck, Sir Anthony, 238 Van Eyck, Hubert, 125, 128, 130 Annunciation, 130 Crucifixion, 130 Last Judgement, 130 Van Eyck, Jan, 15, 33, 75, 97, 125, 128-30, 131, 134, 137, 138, 167, 171, The Adoration of the Lamb, 130 Annunciation, 130 Cardinal Niccolò Albergati, Plate 33 Dresden Triptych, 130 Ghent Altarpiece, 128, 130, Plate 149 Ince Hall Madonna, 130 Lucca Madonna, 130 Madonna of the Chancellor Nicolas Rolin, 130, 133, Plate 142 Madonna and Child with Canon van der Paele, 130, Plate 126 The Madonna in the Church, 129-30, Plate 125 Man in a Turban, Plate 123 The Marriage of Giovanni Arnolfini and Giovanna Cenami, 130, Plate 144

Portrait of a Man in a Turban, 130 Saint Barbara, 128, Plate 34 Saint Jerome, 131 Turin-Milan Book of Hours, 130 Van Ghent, Joos, 172 Van Gogh, Vincent, 56 Vanson, Adrian, 21 Varchi, Benedetto, 224, 227 Vasari, Giorgio, 29, 34, 36, 37, 51, 52, 53, 54, 57, 60, 74, 78, 79, 80-1, 83, 84, 85, 86, 88, 92, 93-4, 95, 97, 128, 162, 163, 173, 189, 190, 192, 193, 195, 201, 202, 204, 223-4, 226, 230, 234, 289, Plate 37 Velazquez, Diego de Silva y, 293 vellum, 33, 35 Veneziano, Agostino, *Baccio Bandinelli's* Studio, Plate 22 Veneziano, Antonio, 76 Veneziano, Domenico, 83, 85, 92, 132 Veneziano, Paolo, 60 Saint Mark's Body Carried to Venice, Plate 67 Vergerio, Pier Paolo, 74 Veronese, 40, 189, 201, 203, 227, 232, 234, 236-8, 240 Alexander and the Family of Darius, 237 Battle of Lepanto, Plate 36 La Bella Nani, 238 Crucifixion, 237 Family Portrait, 238 Marriage Feast at Cana, Plate 261 Portrait of a Man, 238 Story of Esther, 236 Triumph of Venice, 237, Plate 241 View of the Villa Barbaro, Plate 240 Verrocchio, Andrea del, 12, 90, 93, 94 Baptism of Christ, 90, Plate 83 Head of a Woman, Plate 26 Villani, Ğiovanni, 60 Vitale da Bologna, 60 Vitruvius, Marcus, 73, 92, 259 Vivarini, Alvise, 97 Vivarini, Bartolomeo, 97 Sacra Conversazione, 97 Vivarini family, 97 Voltaire, 19 Voragine, Jacopo da, 52 Vos, Martin de, 277 watercolour, 35

watercolour, 35 Welser family, 265 Wilton Diptych, 159, Plate 186 Witz, Konrad, 142-3 The Miraculous Draft of Fishes, 143, Plate 155 Saint Peter Altarpiece, 143 Wolgemut, Michael, 260 woodcuts, 40, 41 Wtewael, Joachim, 34

Zelotti, Giovanni Battista, 238 Zuccaro, Federico, 34, 172, 173, 239 Zuccaro, Taddeo, 34, 239